THE ETCHINGS OF THE TIEPOLOS

Aldo Rizzi

The etchings of the
Tiepolos

Complete Edition

Phaidon

Translated by Dr. Lucia Wildt

Phaidon Press Limited, 5 Cromwell Place, London sw7

Published in the United States of America by Phaidon Publishers, Inc.
and distributed by Praeger Publishers, Inc.
111 Fourth Avenue, New York, N.Y. 10003

First published 1971
Originally published as *L'opera grafica dei Tiepolo: le acqueforti*
© 1971 by Electa Editrice® - Industrie Grafiche Editoriali S.p.a., Venice
Translation © 1971 by Phaidon Press Limited

ISBN 0 7148 1499 7
Library of Congress Catalog Card Number: 79-162313
All rights reserved

Printed in Italy

CONTENTS

INTRODUCTION

VENICE IN THE EIGHTEENTH CENTURY

During the eighteenth century, Venice lived through her golden sunset. Her political and military decline—the Treaty of Carlowitz in 1699 could not make up for the tragedy of losing Candia fifteen years earlier—was balanced by an extraordinary revival in the arts, literature, music and theatre.

The security of a careful agricultural economy, which had replaced seafaring and commercial enterprise, and the tolerant rule of a liberal government meant that old and new ideas—positivist speculation and theological dogmatism, a striving middle class and an aristocratic oligarchy—could live happily side by side, in the polite society of the drawing-rooms, and in complete ignorance of the disputes which set society alight in countries north of the Alps.

In a carefree atmosphere, euphoric although transitory and lacking a future, patricians and plebeians, bureaucrats and artisans shared the same ideal of beauty and strove to give their city a still richer and more sumptuous look. Each within his sphere, the patron and the worker, the technician and the official, they all worked in touching solidarity, almost with religious fanaticism. Official ceremonies, celebrations on the sea and spectacular receptions had the two-fold aim of reclaiming a lost influence as well as satisfying the eyes of the people. Venice lived thus through the most contradictory and the most impressive age of her thousand-year-long existence.

An outstanding handful of talents not only projected their interests on an international dimension, but, with their presence in European capitals and in the most important cultural centres, also greatly influenced the development of taste. Ricci, Pellegrini, Canaletto and Zuccarelli were active in London; Tiepolo in Würzburg and Madrid; Rosalba Carriera in Paris and Vienna; Pellegrini in Düsseldorf and The Hague; Amigoni in Germany and England; and Bellotto for many years in Dresden, Munich and Vienna. But Venice acquired a world-wide standing also through her singers, such as Farinelli and Bordoni, and above all through the versatile talent of Francesco Algarotti, engraver and collector, scientist and man of letters, author of *Newtonianism for the ladies*, friend of royalty and consultant to galleries, critic and patron of artists; his relationship with Tiepolo was to be particularly rewarding for both.[1] Nor should one forget Anton Maria Zanetti, whose relationship with Crozat and Mariette, as well as with such artists as Rosalba Carriera, the two Riccis and the Tiepolos, gave him a high standing in Venetian cultural circles, a position which he enhanced with his extremely rich collection of drawings and prints. Venice, cut off from the new Atlantic routes, and ousted from the political scene, thus assumed the role of a cultural centre, of a

generous distributor of the various cultural currents which converged and merged in her peaceful and neutral territory.

The arts

Theatre, music, literature and journalism faithfully reflect the fragile or un-prejudiced, lazy or aggressive currents of the century; one should remember Apostolo Zeno's critical works, Pietro Metastasio's poetry, Giuseppe Parini's satires or Goldoni's good nature, Giuseppe Baretti's polemics or Gaspare Gozzi's scathing style, as well as Benedetto Marcello's sonatas, the melo-drama of Baldassare Galuppi and the pathos of Antonio Vivaldi.

Religious architecture flourished, closely followed by civil architecture: churches and palaces rose as if by magic, although restrained in their style by a traditional vision which, often disenchanted with local environment, could not react against classical symmetry to look for pictorial values more conge-nial to the aesthetic contribution of the lagoon. Palladio's tradition, handed down by Longhena, provided rules and shackles for Giorgio Massari, above all others; he reacted against the structural emphasis and the excessive decor-ation of the Baroque to follow an ideal of measure and balance which paved the way for Neoclassicism.

Sculpture, which, as in the previous century, was complementary to ar-chitecture, brought to perfection the local seventeenth-century traditions by cultivating its own pictorial qualities and becoming pliable and airy. The best known exponents are Torretti, Corradini and Morlaiter, whose work is charac-terized by an archaic melancholy, a sensuousness of line and an impressionistic approach.

Painting was now in full revival, after the long but beneficial inactivity of the previous century. Its pioneers were Sebastiano Ricci and Gianantonio Pellegrini. Ricci, combining influences from Parma, Rome, Naples and Genoa, was able to mould the pompous Baroque style into an airy and decorative vision, which became truly Venetian in the variety of its colours, its frank and witty brush-stroke and its sparkling light effects. Pellegrini brought these tendencies to perfection with his rich and even more sensuous colour and his clear, silvery tonality in which hedonism is balanced by a bold control over formal techniques.

Sebastiano's nephew, Marco Ricci, working along the lines set by Carle-varijs, furthered Venetian landscape painting. At first he preferred romantic, rural and mountain views; later he turned to depicting archaeological ruins in the manner of the Roman school. His paintings show a unique communion with nature, a vivid and ebullient pictorial language. On the other hand, Ro-salba Carriera introduced Venice to the international taste for portrait paint-ing: a frivolous and flirtatious genre in which she indulged using soft and airy colours, with fluid and broken brush-strokes.

Federico Bencovich and Giambattista Piazzetta, trained in the school of Crespi, set themselves against Ricci's and Pellegrini's style: they contributed the architectural taste, the depth of structure and the human warmth which Venice had always lacked. Bencovich was more dramatic; he used angular constructions, an almost monotonous palette and deeply contrasting light and shadow. Piazzetta, more closely linked with local culture, used more elegant shapes, richer and more fluid colours, a more subtle chiaroscuro.

But the pictorial genius of the century, on a European level, is Giambattista Tiepolo. Before setting free the overbearing need for light and space which was pressing him from the inside, he submitted to a stern apprenticeship; under the influence of Bencovich and Piazzetta, he thoroughly studied architectural structures, plasticity and linearity, and essential chromatic values. His control

over these elements enabled him to organize his world of heroes and fairies bathed in dazzling light; Old and New Testament, history and mythology, present and past, come to life as if by magic, conjured up by an inexhaustible imagination and by an almost miraculous and superhuman technique.

Canaletto softened the rigid linear scheme of Carlevarijs' view paintings with a warm golden light, transferring the daily reality on to a metaphysical level. And while Zuccarelli and Zais dreamed of a second Arcadia—aristocratic and literary for the former, more familiar and domestic for the latter—Pietro Longhi explored real situations with middle-class wit and created a whole repertoire of naïve 'interiors'. Along the same lines, Giandomenico Tiepolo followed the exciting and sudden day-to-day events, going beyond the limitations of his own age: Goya's dramatic poetry is only round the corner.

Gianantonio Guardi, with his fluttering, soft brush, achieved an intimate merging of volumes in space: his talented compositions, painted with colours as crackling as fireworks, or with veils as delicate and soft as feathers, show a surprising technical freedom, and foreshadow the 'plein air' of Impressionism. Gianantonio's brother, Francesco, carried view painting to its ultimate technique, diluting Canaletto's mathematical approach with an orgy of dazzling lights and scintillating colours and achieving pre-Romantic effects.

Engraving

Even the so-called minor arts were not lagging behind: they reached effects and developments never previously achieved. The art of engraving in particular was used not only for artistic but also for practical, religious, educational, eulogizing and recreational purposes. In the wake of the seventeenth-century tradition, great artists and amateurs, men of letters and men of religion, collectors and typographers, they all produced engravings, not only in copperplate printing workshops and painters' studios, but also in the monasteries and the drawing-rooms. Eager research led to experiments with new techniques in treating the copper and obtaining from it unusual results combining virtuosity and poetic achievement.

The general thirst for knowledge had to be meet as well as the requirements of the international market. In 1703 Luca Carlevarijs published his *Le fabriche e vedute (Buildings and Views)*, in which he shows a new way to look at Venice, with a lively collection of 103 views. Domenico Lovisa, about fifteen years later, with the co-operation of the most famous Venetian engravers, published the *Gran Teatro di Venezia (Great Theatre of Venice)*, a gay, well co-ordinated kaleidoscope of local treasures. And while Anton Maria Zanetti tried to re-create the chiaroscuro of the sixteenth century by printing from several blocks using complementary colours, Andrea Zucchi, Domenico Rossetti, Antonio Luciani and Giovanni Faldoni concentrated on formal portraits. For his part, Marco Ricci pursued a romantic pictorial style which Canaletto transformed into a more lyrical and atmospheric one.

In 1739, stimulated by the internationally famous work of Coronelli, Wagner opened a printing workshop, which was soon to become one of the most important of the century.

THE ETCHINGS OF GIAMBATTISTA TIEPOLO

The fascinating world of etching also attracted Giambattista Tiepolo. 'He is extremely talented; that is why engravers and copyists try to reproduce his works on plates, to make use of products of his invention and whimsical inspiration.' Thus wrote Da Canal about Giambattista Tiepolo in 1732,[2] and

though he does not openly refer to his activity as an engraver, the words 'whimsical inspiration' seem a clear hint as to Tiepolo's future developments.

What is certain is that Tiepolo made an early start as an engraver when he worked with Lovisa on the reproduction of four masterpieces for the *Gran Teatro di Venezia*, the first edition of which was published in 1717: he copied Salviati, two works by Tintoretto, and Bassano, which Zucchi transferred on to copper.[3] Before 1730, Giambattista offered to advise on the etchings produced by Marco Ricci, and even corrected them.[4] In 1732 Scipione Maffei published his *Verona Illustrata (Views of Verona)*, obviously prepared a few years earlier. Tiepolo contributed 15 drawings on archaeological subjects, which were engraved by Andrea and Francesco Zucchi. 'In deserved praise of Gian Battista Tiepolo, who drew them all,' says the author, 'one should say that the study of antiquities would have been much easier and much more rewarding if they had been reproduced as accurately in all books. And how many talented painters have we tried out before we could find one who could satisfy us with his accuracy, his frankness, his rendering of forms, and above all his feeling for the antique!'[5] It is a significant testimony, which goes beyond the formulas of courtesy. To Milton's *Paradise Lost* (Paris, 1732) Giambattista contributed drawings for two engravings, and to Bossuet's *Oeuvres complètes* (1738), a drawing for the title-page of the second volume. He also provided vignettes, initials and tailpieces for other publications.[6] It was a short step form indirect contributions to a more personal involvement. The collection of 'finished' drawings, reassembled by Knox and datable at the very end of the 1730s,[7] is proof of considerable progress towards the acquisition of new means of expression; the views are no longer copied from other sources or dictated by the publisher, they are a development of personal ideas and inspiration. The last stage is the direct use of the etching technique: both the preparatory drawing and its translation on to plates are inseparable results of the same artistic expression.

This is the origin of Tiepolo's prints. Where does their history begin?

The first prints

I believe that the first indications of a talent for this form of artistic expression can be found in the 1730s. From the point of view of his iconography, they are already apparent in the hall of the Castle of Udine (1726), as pointed out by Kutschera Woborsky: 'The marvellous series of etchings for the *Scherzi di fantasia* comes to mind when one looks closely at the heads of the two magicians, on the wall between two doors. The expressions on their faces, twisted by a faunish grin, the unequalled arrogance of the necromancer, is evident in these images. Down to their waist their shapes are easily recognizable; lower down, the shape of the bodies is approximately and fortuitously outlined . . . What is missing at ground level is probably a snake twisted round a magic wand, a pedestal with a skull, an outstretched corpse, maybe the body of a hypnotized man, victim of the magic ritual.'[8]

As far as his technique is concerned, the fact that Tiepolo should have advised Marco Ricci and should have been so highly thought of by Lovisa, Maffei and the above-mentioned publishers, is proof of his expertise and authority.

The *St. Jerome*, here published for the first time, opens the series of etchings. It is still drawn in a shy, reserved and personal style, and is derived from contemporary graphic sources. The cultural incentives of Tiepolo's environment are strengthened by his study of the traditions of engraving, particularly in the seventeenth century. Obviously nothing escaped his research. He was helped by his friendship with Zanetti and his familiarity with the latter's collec-

tion of prints, which included examples of Rembrandt's chiaroscuro, and Stefano della Bella's linearity, of Ribera's pictorial dryness and Castiglione's light touch, of Salvator Rosa's dramatic lines and Testa's fire, of Carpioni's balance and Marco Ricci's quick jottings. But it is also true that Giambattista did not need to look elsewhere for inspiration: all he had to do was to look inside himself.

What inspired the *St. Jerome*? The swiftness and expressiveness of the lines remind one of Salvator Rosa, while the use of hatching recalls Carpioni's graphic techniques; the whole is bathed in Rembrandt's suggestive chiaroscuro. It is an early work (even the biting of the plate is uneven), which was to be rejected. In the two *Magicians*, the wavering line shows a new direction in his search, towards more tonal values. Rembrandt's influence is still there, but mediated through Castiglione's light and airy lines, from whom Giambattista however differs in the remarkable effect he achieves by the use of contrasting white paper, and in his concise linearity. He is still at an experimental stage, which openly reveals his sources. And this is why the two small prints were to follow *St. Jerome* in its fate.

The 'Scherzi'

Tiepolo's graphic work began with an extended series: the *Scherzi*. Art historians have not yet solved the problem of the thematic origins of the *Scherzi* or the *Capricci*. I believe it unnecessary to look for literary or philosophical sources in these series, not only because they are actual 'games' reflecting the extravagant whims of contemporary Venice, but also because they lack an overall theme and consist of bucolic episodes and magic scenes, of puppet scenes and rustic fables. The series is more of a personal and disenchanted repertoire, only concerned with the need for expression and completely lacking in mysterious implications.[9] However, in order to examine it adequately, it is useful to consider the origins of this kind of composition and the critical attitudes concerning it.

As we know, the 'capriccio' has its origins in the seventeenth century, as affirmation of the artist's poetic freedom, his rejection of traditional and literary limitations (religious compositions, landscapes, portraits, allegories, etc.) and his will to achieve a purely personal means of expression. Hence, such prints as the 'scherzi' by Fialetti, which brought down to earth Mantegna's repertoire; Callot's whimsical and bizarre 'capricci', with their social message; Castiglione's contemplative ones; and Stefano della Bella's almost purely decorative work. And one should not forget Carpioni, who brought religious episodes down to a human level, and Giuseppe Diamantino with his variations on the female nude. Tiepolo worked in this framework of creative freedom and reaction against tradition, thus paving the way for Piranesi and Goya. In spite of these significant precedents, critics have often lost their way in a labyrinth of complicated interpretations.

Focillon stressed the particular preoccupation of eighteenth-century Venice with magic and superstition: 'well before the magic pyramids of its last years, the occultist poetry of Baffo and Casanova's mystifications, which impudently exploited the credulous, Venice had been troubled by one of those crises which sometimes affect ageing civilizations. The proof is in the three treatises which the Marchese Maffei wrote against the increasingly fashionable magic beliefs. This craze lured even more stable minds than the one of the simple aristocrat hoaxed in his old age by Casanova's farces. A strange period in a strange country, where one can see the enlightened contemporary rationalism side by side with the most naïve mysticism, and sometimes efface itself in it. These reckless players, exhausted by pleasures, sleepless nights, dinners,

women, operas, gliding like shadows in their fiery darkness among the mirages of a misty sky and the phantasmagoric reflections, believe in anything, above all in mysteries and impossibilities. This weary excitement drives them to magic rituals. Hence their craze for magic as well as Gozzi's exquite dreams. In his etchings, Tiepolo is the contemporary of fairy tales, of those charming old wives' tales, composed by the most sensitive madman for a Shakespearian puppet show.'[10] Le Blanc too has mentioned 'the obscure allegories which cannot be explained even by the symbols used throughout by the artist.'[11] And Santifaller accurately traced the most varied sources of inspiration: ancient art and its revival during the Renaissance, the East, the sixteenth and seventeenth centuries, contemporary theatre (Gozzi above all), archaeological excavations, astronomy and astrology. The roots 'go back to the East, to Egypt, to the Jews and the Arabs. They consist of the representations of occultism: alchemy, magic and applied cabbala . . . Tiepolo's etchings are the key to a whole world of ideas and representations. One would, however, give a wrong interpretation of Tiepolo's nature if one thought that these representations had any deep influence on him. He freely mixed different elements to form a new entity. Line and light, the decorative construction of groups, are his *Leitmotiv*. Human skulls on smoking altars, twisted snakes, the old magician himself, have no weird connotations; the whole scene has no deeper meaning than a compositional balance. And while considering these enchanting works one remembers the saying, typical of the general character of eighteenth-century Venice, that "all things are but a mirror." '[12] Trentin discovered 'Tiepolo's magic in his light, nowhere else; it is born of light, of its orchestration and direction. When I am faced with it, nobody will convince me that his magic is in his subjects, as Focillon hints; that it is connected with superstition, however widerspread this was in Venice and elsewhere, and with that witchcraft so much publicized by Cagliostro and his followers.'[13] De Witt is of the same opinion: 'the titles chosen by Tiepolo are enough to show that it is all a matter of creative freedom, of a chance to relax and get away from more pressing chores: an incentive far from rare in the world of engravers, an historical privilege which earned them that fame of refined talent which such a critic as Baudelaire recognized as a *raison d'être*. Once we consider Tiepolo's sources in this light, it is obviously vain and irrelevant to the work of art itself to discuss the hidden psychological motive of the etchings; particularly when based on elements such as magic and superstition, which were within easy reach of certain circles of contemporary society.'[14]

On the other hand, Pallucchini believes that Focillon's opinion is acceptable, but does not affect the artistic values. 'Magic, yes, but of a totally different kind: a complete freedom to create, to evoke topical situations as means of expression. Old men from the East in their turbans, magicians, philosophers, soldiers, shepherds, fauns, women and all sorts of animals meet, break into groups, examine mysterious shapes, consult horoscopes, extract clues from skulls, skeletons, snakes, among ruins, altars and bas-reliefs. It is the magic direction of the chiaroscuro which suggests to Tiepolo these groups and their limpid atmosphere worn out by the sun, burnt by light, in which the composition is intersected only by tree trunks, leafless branches, spiky pine leaves. The sense of magic is born of the theme, originated all of a sudden by one of the most creative talents of Mediterranean art; a theme which becomes reality in the technique of engraving, connected as it is to the search for light.'[15] And Morassi remembers 'those surprising oddities which Tiepolo calls "Scherzi di Fantasia", because they are not rooted in any single theme or tale, but evoked by that boundless sense of creative freedom which guides the artist to his highest levels'.[16]

Knox is of a different opinion. He believes that the *Capricci* are 'by no

means pure fantasy' and that underneath the satirical surface are 'real links with the science and philosophy of the time'. He recalls the old Venetian tradition which looks at magic and astrology with a 'sceptical humour', as well as Niccolò Nelli's engraving of 1564 entitled *Proverbs*, the iconographic elements of which were to reappear in some of Tiepolo's prints.

In a period which saw the publication of the *Congresso Notturno delle Lammie* (1749), in which Girolamo Tartarotti tried to analyse and demolish all the literary tradition dealing with witch-hunting; and of the essays by Scipione Maffei and A. Lujato, entitled respectively *Arte Magica Dileguata (Vanished Magic Craft)* and *Osservazioni sopra l'opuscolo che ha per titolo Arte Magica Dileguata (Observations on the booklet entitled 'Vanished Magic Craft')*, it is not unlikely that themes connected with magic and witchcraft influenced Giambattista, together with the scientific and philosophical trends of the time. In this connection Knox refers to the above-mentioned *Newtonianism for the ladies* by Algarotti, who was closely connected with Tiepolo.[17] Focillon's thesis is partly accepted by Pignatti, who relates the obscure subjects of the *Capricci* and the *Scherzi* to a trend in the literary and pseudo-scientific fashion: magic. Quoting Knox, he too recalls *Newtonianism for the ladies* and the considerable occultist production (Tartarotti, Maffei, Lurato), and concludes that in the end 'what dominates the game . . . is an attitude closer to Gozzi's fairy-tale (of the Augellin Belverde) than to the musings of the *Wise Men* by Rembrantdt.'[18]

Knox also points out that a study of Venetian proverbs and of the popular interest in witchcraft could probably help in the interpretation of Tiepolo's themes.[19] Passamani, on the other land, stresses Tiepolo's taste for games, the feeling of relaxation, the pleasure derived from his own fantasy, the relish of the picturesque.[20] When we keep in mind the cultural framework of the eighteenth century, we can more easily understand the improvised and unpremeditated character of Tiepolo's etchings, free from spiritualistic, magic, alchemistic or philosophical limitations. This was the age of snuff-boxes and minuets, of the *conversazioni* and the drawing-rooms. Even the theatres became drawing-rooms, and the melodies by Pergolesi, Paisiello and Porpora seemed to interpret the tender melancholy of the refined audiences. Painters preferred idyllic scenes, pastorals and capricci; poetry dealt with Arcadian subjects and described a fragile and enchanted world; literature aimed at simplicity. But the eighteenth century was also the century of newspapers, of clear analysis, of the spreading of knowledge, of encyclopaedic erudition. The new ideas, spreading from France and England, did not shake and enliven only the narrow circles of culture, but, reaching further out, became the fashion. In Italy, everybody, innovators and conservatives, worked to popularize philosophy and science, in easy verse, to spread knowledge among the uninitiated (see the above-mentioned *Newtonianism for the ladies* by Algarotti, as well as *Il sistema dei cieli (The system of the skies)* and *Le origini delle idee (Origins of ideas)* by Della Torre di Rezzonico, the rules of geometry and trigonometry put into verse by Lorenzo Mascheroni, etc.). Didactic poems abounded, inspired by the desire to propagate knowledge; the most difficult doctrines and complex theories were exemplified and divulged in the language of polite conversation. In Italy, and above all in Venice, traditional ideas, with their nostalgic attitude towards Arcadian life, lived side by side with the new ideas, which arrived from abroad with their specifically pre-Romantic themes: the weird atmospheres of sepulchral scenes, the evocation of ancient tragedies and dark crimes, the revival of the world of fantasy populated by castles, knights, goblins, magicians, witches and ghosts. This cultural background is at the root of Tiepolo's production as an engraver. In his work, free from cultural and didactic aims, Giambattista was able to merge classical tradition (bas-reliefs, pagan sacrifices, pastoral scenes and landscapes) with romantic sensitivity

(magicians, snakes, owls, skulls), welding the two currents within his own style. His is therefore an art obviously impregnated with the century's spirituality, but void of parody and polemic, and without metaphysical undertones; an art which displays freedom of feeling, pure exercise of fantasy: authentic 'capricci' played on the edge of historical effrontery.

We come thus to the problem of dating the *Scherzi*. The first to tackle it was Goering who, on the basis of stylistic considerations, spread the series over a long period of time. 'Some of the etchings are stylistically related to the frescoes of Villa Valmarana, dated 1737 [Morassi had not yet moved the date forward by 20 years], and to the paintings of the following years. Others are probably datable about 1745, as shown by analogies of composition with scenes of the *Rinaldo and Armida* in Chicago.' According to Goering, the *Scherzi* are later than the *Capricci*.[21] Pallucchini also believes that the second series, 'usually dated 1749, but believed by Lorenzetti to have been produced earlier, probably in 1743,' should be dated before the *Scherzi*, about the dating of which he agrees with Goering.[22] Morassi is of the opinion that the *Capricci* were executed about 1743, and the second, richer collection about 1755-8.[23] Vigni denies that there was a long lapse of time between the two series: he bases himself on a group of drawings showing that 'the creative period of the *Capricci* was already operating about or soon after 1735 to merge later almost without interruption with the period of the *Scherzi*'; according to him both series were executed between 1740 and 1760.[24] Pittaluga agrees with Vigni's theory and believes the *Capricci* to have been started about 1740 and continued on and off until they merged with the *Scherzi*, on which the artist worked until about 1760.[25] Knox underlines the very small difference in style and subject between the two groups and does not accept any difference in date; he maintains that 'both sets were conceived and executed at much the same moment in the later forties.'[26]

Pignatti tends to agree with this theory: 'A large group of drawings at the exhibition [in the USA] represents the years of the *Scherzi* and *Capricci*, which together are dated by Knox to the years 1740-50. As a matter of fact, about thirty of the drawings are very uniform in style, enough to support the theory, advanced by Knox, that they were all executed before Tiepolo left for Würzburg, thus discrediting the traditional belief, which extends the dates of Tiepolo's etchings as far as the Spanish period. The existence, in the Museo Correr, Venice, of a number of copperplates for the *Scherzi di Fantasia* seems to prove that they were completed before the journey to Spain. Furthermore, the drawings in the Victoria and Albert Museum, London, which are obviously earlier than 1762, seem to indicate the same time limit.'[27] But four years later, Pignatti considerably alters Knox's dates by placing the *Capricci* within the years 1739-43 and the *Scherzi* in direct continuation down to the end of Giambattista's career in 1770.[28]

Knox reaffirms his own convictions, based on the more developed character of the *Capricci* and on the proof supplied by the drawings, which show how the themes recurring in the *Scherzi* already appear during the 1730s.[29] The author, on the basis of the indications supplied by Knox, suggests that the *Scherzi* should be dated aboud 1735-40; this dating would further by corroborated by the obvious influence which the collection had on Giandomenico and Lorenzo (see Nos. 13, 39, 78, 79), by the date 1737 on the print reproduced in No. 8, by the fact that the last two of the *Scherzi* (Nos. 24 and 25) were executed in an oblong format, thus anticipating the *Capricci*, and by comparisons with the drawings.[30]

During the International Tiepolo Congress held in Udine at the end of September 1970, Dr. Frerichs announced the important rediscovery of documents connected with the handing over to Mariette of some of Tiepolo's plates;

these documents seem to confirm that the *Scherzi* were almost complete by 1757–8.[31] Until the full report promised by the Dutch critic is available the author believes that these documents neither confirm nor disprove his thesis; they do disprove, however, that the *Scherzi* were carried out until as late as the Spanish period, as Pignatti suggested. The new sources show that Tiepolo had varnished a couple of copperplates 'with the intent to perfect them'; 'not having had the time to do so', notwithstanding Zanetti's powerful intervention, Giandomenico asked Mariette, to whom he had sent the plates, to retouch them with a quill. The points which arise are these: how did it come about that between 1757 and his death Giambattista had no time to finish the series, which was eventually published in 1775, still unfinished, by his son? We know that on the plate reproduced in No. 23 the pyramid is incomplete and two heads are missing, as well as the writing on the frontispiece, which was only later added by Giandomenico: is time an important factor with details such as these? Should not the word 'to perfect' be read as meaning that Mariette insisted on being sent the earliest among the plates with all necessary adjustments? One may reasonably wonder whether Giambattista might have refused to pick up again and retouch an old production, his artistic interests having changed in the meantime. One could also suspect that Giandomenico 'commercialized' his father's work (the series was only published after Tiepolo's death) almost without the latter's knowledge. On the other hand, how many drawings, produced as a series, did he sign and sell?

Documents apart, one should consider the logic of style: one fails to see how the *Scherzi* could be dated after the *Capricci*, unless one accepts a relapse, a reconsideration, which might have led him to 'hide' the first series. As a matter of fact, while the form of the *Scherzi* is classical and restrained, the *Capricci* have a free and impressionistic style; the former are hard and broken, the latter fluent and balanced; the preoccupation and imaginative harshness of the first period are replaced by an easy and alluring style. On the basis of all this, I believe I do not have to change my theory, although I am willing to discuss the problem on the basis of any new critical and documentary contribution, in the interests of truth and for the sake of throwing light on an aspect of Tiepolo's art which is still complex and riddled with problems.

To conclude, it looks as if Giambattista started on the *Scherzi* about 1735, that is during the period of the most intense engraving activity and in a particularly significant stage of his career, when he was at work in the Villa Loschi at Biron.[32] Tiepolo's varied artistic interests included a tendency to the bizarre and the visionary; this is demonstrated by the chiaroscuro paintings in the hall of Udine Castle[33] and by many drawings, among them those in Trieste[34] and those in Philadelphia and Vienna (see Nos. 14, 18 and 15). But the decisive influence must have been his familiarity with Castiglione's work (he owned one of the artist's monotypes), which he could have known from the comprehensive collection of his friend Zanetti. He could not help being impressed by the musical and imaginative sophistication of the Genoese artist. To this one should add the use of the same technique (like the Genoese, Giambattista used only one point) and the shared admiration for Rembrandt: Tiepolo's borrowings from Grechetto's works are numerous and significant (magicians, philosophers, satyrs, snakes, owls, monkeys, bas-reliefs, skulls, bones, etc.), but are used as a cultural background, transferred to a geometrical composition of different tonal levels and surrounded by a texture of free, pulsating lines. I believe that the first of the *Scherzi* can be identified with the one in No. 11: this is executed with a restless hand and short, broken lines on a background of shaded brightness—in other words, within Castiglione's tradition. This etching can be compared with No. 23, left unfinished. Later on, his lines became clearer, with a predominance of parallel strokes,

curls and pleasing 'hieroglyphics', with more stress being laid on plastic values (Nos. 7, 8, 9, 12, 20). The sheets of his later years (although still within a limited period of time) are characterized by a more airy style and wavering point, aimed at capturing as much air and light as possible, as shown even in the shadows (Nos. 13, 14, 15, 16, 17, 18, 19, 21 and 24). The last of the *Scherzi* (Nos. 22, 25, 26) are forerunners of the following series, the *Capricci*, as shown by the pyramidal compositions, the controlled execution and the silvery light.

Tiepolo worked unaffected by external influences and free from professional routine: in his hands, the art of engraving, academicized by three centuries of achievement, gained a new freedom of expression. He initiated a thoroughly free technique which exploited light on a new level as the essential means of poetic expression and the basic element of style. Against the clear, dazzling background of the paper, the darting lines have lost their tension and gained in fluency: they form a graphic composition with such a variety of tonal correspondences as to have no precedents in the history of engraving. Far from marking the plate with rationally parallel and continuous lines, thickening in the shaded areas, Tiepolo sketched with sudden impetus, creating wide spaces with scratches and curves which break up the light into shimmering beams and silvery sparkles. The lightness and variety of his graphic language enabled him to achieve a complete obliteration of shade (even the more intense areas are transparent, created out of light) and to compose a rich and fascinating orchestration of chromatic values and musical harmony with soft and fluid transitions. This is one of the reasons why Tiepolo's engravings, characterized by an extremely dynamic and original use of light which goes well beyond the traditional chiaroscuro, constitute an extraordinary chapter in the whole history of engraving as well as an exemplary educational medium for later generations.

The Adoration of the Magi

The *Adoration of the Magi* should be dated immediately after the *Scherzi* (about 1740). The rich web of lines, drawn with extreme craftsmanship and almost in competition with painting, the dense light and the religious intimacy, all contribute to make of this print one of the highest achievements of Tiepolo's production as an engraver.

The 'Capricci'

After completing the *St. Joseph and the Child*, which adds nothing to our knowledge of his activity, the artist started on the *Capricci*, which are more systematic and technically more coherent than the *Scherzi*. The series was first published in the second edition of Zanetti's *Diversarum Iconum*, which came out in Venice in 1743, and again in the edition of 1749;[35] it was published for a third time in 1785 with a dedication to Girolamo Manfrin.

The series is a rhapsody on Arcadian and military themes, with a parenthesis on necromancy, welded together by uniformity of vision and freedom of technique. The spiritual atmosphere has changed: the classical and detached solemnity of the *Scherzi* has given way to a more friendly and confident imagination at a romantic level; the mysterious and intellectualized structures of the earlier series are replaced with a more subdued vein.

Here again, research is free and personal and defeats all efforts to look for sources in mythology and ancient rituals. This is pure culture, used as imaginative pretext, through which even macabre elements (see *Death giving audience*) become sheer iconography in the flow of light. Like the *Scherzi*, the *Capricci* also show a progress of style, even though they were executed within a few

16

years (1740–3): the earliest one is probably No. 38 in our catalogue, which is close in style to the *Scherzo* No. 22 and in which the lines are still drawn in comb-like fashion. This etching was probably followed by Nos. 29, 30, 31, 33, 36, 37, in which the drawing achieves extreme delicacy and the traits are assured and picturesque. Very probably, the latest are Nos. 32, 34 and 35; here the agility of the lines, the lightness of touch and the masterly setting bring Tiepolo's expressiveness to its highest level. The wavering and broken style of the *Scherzi* is here replaced by a texture of lines which anticipates Corot's lyricism; the uneven and often difficult style of the previous works (which prompted the critics to spread them over a long period of years) gives way to a more coherent and spontaneous treatment.

Tiepolo, here at his best, flashed the needle on the plates. His treatment is less broken than in the earlier prints, more uniform and free, almost modern. The traditional tool of the etcher evoked, in its fluid marks and impetuous zig-zags, tonal values and a brightness which anticipated the Impressionists, and created poetical effects never before achieved. This is the summit of Venetian graphic art in the eighteenth century. Zanetti provided flattery and satisfaction by including the *Capricci* in his *Raccolta di varie stampe a chiaroscuro*, side by side with Parmigianino and Raphael.

It has often been stressed that Giambattista's etchings are a form of soliloquy, without thought of sales or self-advertisement. The painter who could dominate spaces and make enormous walls and vast ceilings the bearers of his pictorial vision, felt the need to withdraw, to find a peaceful haven in a few square inches of white paper. It was a healthy antidote to the arrogance of patrons, a refuge from obligatory themes; in one word, an intimate and subdued protest. That is why this series of etchings, free from anything that might hinder poetry and the pure vent of the soul, achieves the values of real and fascinating *nugae*.

Tiepolo's influence on the art of etching was to control the production of his sons Giandomenico and Lorenzo. From him many other artists also drew inspiration, often cleverly disguised, from Piranesi to Pitteri, from Boucher to Fragonard, from Goya's drama to Daumier's satire.

THE ETCHINGS OF GIANDOMENICO TIEPOLO

Giandomenico made his debut as an engraver by making etchings of the *Stations of the, Cross* which he had painted for the Venetian church of S. Polo (1748–9). As in his paintings, here too he worked within the framework of his father's teaching; from him he takes the comb-like linear patter, hardening it in the shaded areas with cross-like marks which are often unclear. His preoccupation with faithful reproduction was a serious obstacle. His style is more rational and thought-out than his father's and lacks the flashing quality and the sudden excitements of the *Scherzi* and *Capricci*.

The Flight into Egypt

In 1753, while working at Würzburg with his father and his brother Lorenzo, Giandomenico published his *Flight into Egypt*, thus revealing his qualities as an etcher.

This work is without precedent in inventiveness and the ability to produce graphic variations of a given theme. Artists had previously given two interpretations of this moving episode from the New Testament: the actual flight through the countryside, and the rest under the trees. Giandomenico, probably influenced by Dürer's woodcut cycles (*The Small Passion, The Large Passion, The Life of the Virgin*), which, however, use a wider iconographic repertoire

already borrowed for the *Stations of the Cross*, composed a rhapsody in which creativity and technique meet and merge. The theme of the Holy Family had been rendered sterile by centuries of use—and we cannot forget the important precedents by Pieter Bruegel, Camillo Procaccini, Claude Lorrain, Rembrandt, Stefano della Bella and Simone Contarini; Giandomenico gave back to the subject a new 'lease' of lyricism. Even though influenced by his father on an intellectual and cultural level, he contributed his own genuine and personal emotions; his awareness of reality, deeply contrasting with his father's mythical visions, drove him to a natural representation of the scenery, expressed with a less wavering style and more subdued light.

To give the subject a new aesthetic dignity, Giandomenico concentrated on details of landscape, such as trees, shrubs and views, and on domestic objects (the basket, the bag, the striped materials), which gave the episodes a feeling of truth, an ethical quality impregnated with poetry; besides all this, a homely atmosphere and a human fragrance which are unprecedented in the history of engraving. Not only was everyday reality not avoided (while his father was lost behind Arcadian or necromantic dreams) but it consituted the most important element of the story and often hovered over the anxious wandering of the Holy Family. Giandomenico thus showed himself as the true son of the rising middle and lower classes, and capable of understanding their most genuine feelings.

Only three of the etchings in the series are dated: No. 13 (cat. No. 79), 1750; No. 19 (cat. No. 85), 1752; and No. 21 (cat. No. 27), 1753. The first prints are easily recognizable from the numerous details which he borrowed from the *Scherzi* (the palm, the bas-relief, the pyramid) and by a free graphic style with arabesque-like lines; besides, the white areas still played an important part in the composition, as in his father's work, and there are still echoes of the *Stations of the Cross* (see Nos. 74, 76, 79, 80, 84, 86).

Later on, his graphic style became more mature and personal and acquired greater fluidity and constancy. The web of lines spread over the whole page with an extraordinary variety of accents, from a tight network of cross-hatching and waving parallel lines to the sudden curves and the diversity of geometrical signs, from delicate curls to dry hooks. Among the most typical sheets of this period are those here reproduced as Nos. 72, 75, 87, 88, and 89. The prints Nos. 70, 73 and 93 are probably to be dated towards the end of the period: the graphic composition is more relaxed and elegant, and he used stipple and rich areas of chiaroscuro with those tonal values which were to enable him to transfer his father's works confidently on to plates.

Light, the worry and delight of all artists, poured on to the graphic network, on the areas barely touched by the acid, struggling against the shadows. Giambattista needed stylistic syncopation to achieve the transfiguring, hyperbolic style of the Rococo; Giandomenico made use of a more vigorous and articulated composition, which reflected his intimate response to human emotions, against a background of changing historical factors.

Engravings after Giambattista's paintings

Apart from the prints mentioned above, Giandomenico only reproduced paintings by his father. His freedom of expression was here limited by the wish to praise and by his filial feelings. Even so, he can create a style which not only reproduced perfectly all shadings, colour vibrations, the dazzling light and the self-assured touch of the originals, but which also was characterized by a graphic language of extremely fine, parallel lines, strengthened in the shaded areas by small crosses, and capable of evoking an extraordinary depth of atmosphere and rich tonal variations. When we exclude the 'heads',

we are left with 56 engravings which either reproduce whole paintings or details. Giandomenico's involvement with this kind of work went far beyond the technical element: he actually 'lived' his father's masterpieces and recreated them with the help of his own emotions, thereby achieving not only a translation on a much smaller scale but discovering a new range of values in the use of black and white only. The engravings here reproduced as Nos. 98, 111, 123, 124, 131, 136 and 146, are among the most suggestive ones: in these, the artist was even able to achieve the airy feeling and the crisp light of his sources. These etchings also show a development in style: from a crowded and restless network of lines to a transparent modulation created by a point which barely touched the waxy surface of the plate.

The Heads

Studies of 'heads' made for their value as records of human individuals or to re-create the features of historical personalities first appear in prints of the seventeenth century. Perfect examples are provided by the etchings of Rembrandt, who gave his Biblical heroes the features of the Amsterdam rabbis. His example was followed by Schonfeld, who published a series of '13 different witty heads', and by Castiglione, who produced two series of etchings, 'The small heads of men in oriental head-dress' and 'The large heads of men in oriental head-dress'. Numerous drawings show that Giambattista also took an interest in the human head, even if in a purely mythical and fantastic context It is quite likely that he did paint such a series at the beginning of his artistic maturity, i.e. after 1750, 'with the aim of putting together a collection of typical characters, as Piazzetta had done with his "heads" later engraved by Pitteri'.[36] Giandomenico was obviously inspired by these predecessors when compiling his 'Collection'. This was officially published in 1773–4, with a dedication to Cavalier Alvise Tiepolo, ambassador to Pope Clement XIV Rezzonico; but some of the prints had been published before then, either loose or bound up in an album.[37] The 'Collection' was subsequently included in the edition of all Tiepolo etchings, published by Giandomenico in 1775.

Stylistically, the 'heads' can be divided into two groups, which Knox, in a recent study,[38] calls 'style A' and 'style B'. The first volume comprises 26 etchings in style A and 4 in style B, and the second 9 etchings in style A and 21 in style B. Their graphic treatment is so uneven that one could point out various other styles: an airy touch like that of the *Scherzi* (see Nos. 170, 190, 196, 200), a combination of stipple and hatching (Nos. 161, 180, 192, 194,) and finally a technique of extremely thin lines, either in parallels or in curves (Nos. 163, 164, 165, 166, 167, 168, 169 etc.). Giandomenico drew his inspiration not only from his father's paintings, copying the type which most interested him, but also from his drawings. Notwithstanding his stylistic debts, the unevenness of execution and the influence of Rembrandt and Castiglione, these 'heads' owe their artistic value to their chiaroscuro and penetrating psychology, which are worthy of a great artist. Giandomenico could not be further from the 'abstract' vision and lyricism of his father; he poured new vitality and new blood into these anatomical details, according to his own moods, now alert and now absent-minded, involved or detached. The result is an entertaining gallery of characters, an interesting document of human expression.

Giandomenico's catalogue

As we have said, the first Tiepolo etchings were published by Zanetti, who included the *Capricci* in his *Collection of prints with chiaroscuro* (1743). In 1749 Giandomenico issued his *Stations of the Cross*, followed, in 1753, by the *Flight into Egypt*. Later on, before 1774, Giandomenico published the two collec-

tions of 'heads'. There are no exact details, before 1775, about the publication of the other etchings. De Vesme says that Tiepolo's son, back in Venice after his father's death, published his etchings in proofs before letters or number.[39] Later on, Giandomenico assembled his father's etchings, his own and his brother's in one volume, which is dated 1775 and entitled 'Catalogue of various works contained in the present volume and invented by the famous painter Giambattista Tiepolo, Venetian, who worked for His Catholic Majesty and died in Madrid on 27th of March 1770, sixteen of which were engraved by himself and the remaining by his sons Giandomenico and Lorenzo, and are in the possession of Giandomenico together with other works of his.'[40] The volume opens with a print showing 'The arts paying homage to the papal authority of Pius VI' (see No. 158) and the dedication to Pius VI (No. 157); it contains 15 plates from the *Scherzi* (Nos. 7, 8, 9, 10, 15, 16, 17, 18, 19, 20, 21, 22, 25, 26, 28), including the *St. Joseph with the Christ Child* and the *Adoration of the Magi*. As far as Giandomenico's work is concerned, the volume contains 25 etchings from the *Flight into Egypt*, that is the whole series except for the dedication and the frontispiece (Nos. 67 and 68), the *Stations of the Cross* (Nos. 39–54), all the religious compositions (Nos. 55–63, 65, 66, 105, 106, 108–110, 114–121, 125–127, 130–134, 149), various non-religious scenes (Nos. 107, 124, 149–156,), ten ceilings (Nos. 98–102, 111, 113, 122, 123, 147) and the 60 plates of the 'heads' with their frontispieces (Nos. 159–221). Lorenzo's work is represented by six plates (Nos. 222–224, 226–228).

Later, probably still in 1775, Giandomenico issued a second edition of the volume, increasing the number of the etchings by adding the nine *Scherzi* missing in the first, the dedication and the frontispiece of the *Flight into Egypt*, some of the prints based on the frescoes in the Villa Valmarana (Nos. 136, 137, 138, 139, 140, 141, 142, 143, 145), the prints *Tarquin and Lucretia* (No. 103) and *Cleopatra honoured with gifts* (No. 104), two *Whimsical inventions* (Nos. 128 and 129) and five ceilings, two of them by Lorenzo (Nos. 111, 135, 148, 229, 230); he reduced the *Stations of the Cross* to 14 leaving out the dedication (No. 40). The new title reads: 'Catalogue of various works invented by the famous Giambattista Tiepolo at the Court of H.C.M., who died in Madrid on 27th of March 1770, with 25 plates engraved by himself, the others having been engraved by his sons Giandomenico and Lorenzo, owned by Giandomenico as well as other works of his.'

Finally a third edition came out, apparently with two new etchings (Nos. 144 and 225), but this cannot be traced. Molmenti published its list of plates,[41] but the information is not reliable: out of the ten etchings which he says 'have not been mentioned in Giandomenico's other catalogues' (Nos. 99, 100–102, 143, 144, 146, 150, 153, 157, 158) only two can be regarded as unpublished (Nos. 144 and 225). Since the volume is not available for inspection, it is impossible to add anything, or to quote its title.

These three editions did not include the *St. Jerome*, the two *Magicians* or the *Capricci*; this series was published again in 1785, dedicated to Girolamo Manfrin. It is not clear whether Giandomenico recovered the plates and issued them at this time or whether the publication was the work of an anonymous printer. In 1879–81 the Venetian Ferdinando Ongania published a facsimile edition of the *Catalogue*, which appeared again, in reduced format, in 1896, with a preface by Molmenti.

THE ETCHINGS OF LORENZO TIEPOLO

Up to now Lorenzo had been known through only nine etchings, all of them reproducing his father's works. We here propose to attribute to him a tenth

print, which is of special value as an independent creation. Although influenced by, and collaborating with, his brother (for their shared execution of the etchings after the London panels see the notes to Nos. 128, 129 and 226), Lorenzo shows great technical capabilities, which take advantage of the family's progress. He used a rough, simple technique in which parallel lines are predominant; but he still managed to extract from the plates the most varied tonalities of chiaroscuro, thus adding drama to his father's work.

The tiny print here published for the first time (*Four heads*, No. 231) has a theme Lorenzo was particularly fond of; he followed his brother's example but enriched it with Spanish influences like the representation of the life of the lower classes. As in his paintings of the period, he draws his characters with realism, particularly stressed in the foreground. His style is neat and metallic, and he does not indulge in mere illustration but rather seeks an almost impressionistic concentration.

Lorenzo died prematurely and was thus unable to follow up a career which would have freed him from his father's influence.

HISTORICAL CRITICISM

Critical opinion of Tiepolo's painting was influenced by Neoclassical taste and in particularly by Winckelmann's judgement ('Tiepolo can paint more in one day than Mengs in a week; but the works of the former are forgotten as soon as they have been seen, those of the latter are immortal'); his etchings, however, were not studied until later and remained unaffected by such polemics.

The first to write about them was Moschini, who stated that Tiepolo 'produced so many etchings as to make it almost impossible to list them all' and added: 'The gaiety and wit which permeate his paintings, and particularly his frescoes, can also be found in his prints; and he was as quick in engraving as in painting. He could well say: to conceive, draw and engrave is a matter of a minute for me.'[42]

Le Blanc gave unqualified praise to the poetic qualities of Tiepolo's etchings; although harsh in his judgement of the artist's paintings, he saw in him a master of the art of engraving, particularly with regard to the use of light: 'quivering and weightless, the engraver Tiepolo produced in the half-lights a silvery grey which is full of charm, an entrancing glow. It looks as if the acid had caressed the copper rather than bitten into it.'[43]

Duplessis, an admirer of Canaletto's engravings, added somewhat harshly: 'Giandomenico Tiepolo had learnt from his father the technique of his art; they worked together and used so identical a technique that we cannot tell whether an etching is by one or the other unless it is signed. The father reproduced only works of his own invention; the son translated onto copper his father's drawings with such faithfulness that, were it not for the inscriptions which he engraved on his work, one could regard them as original works. These artists rarely used the burin; usually the point was enough for their experienced hand to reproduce the most tonally intense paintings and the most complicated scenes: they gave their plates a lively and shimmering appearance, very pleasing to the eye. If one closely examines the characters in the compositions engraved by these talented Venetians one wonders that these artists, so clever in their use of chiaroscuro, gave so little thought to the human shape and paid so little attention to design.'[44]

Molmenti produced the first stylistic analysis of Tiepolo's work when he wrote: 'Giambattista avoided harsh passages and strong shadows, except in some of the *Capricci*, which were his first efforts. The light and colourful effect of his engravings was partly due to his habit of drawing parallel lines, slightly

wavy and almost never intersecting. Giandomenico's etchings, although devoid of Giambattista's genius, seem more accurate and more technically experienced, particularly in his control of the acid and his representation of tints by means of equal proportions of light and shade. Lorenzo followed his father's style, while at the same time studying the value of strong shading as used by Rembrandt.' Writing about Giambattista's etchings, he called the *Capricci* 'small pictures, full of vitality and light, which have no definite subject or title, nor, except for one (*Death giving audience*), is there anything odd, unusual or fantastic about them'. A sort of 'strange, lugubrious inspiration' can, on the other hand, be found in the *Scherzi*, in which 'the painter of dreams suffused in light is affected by visions of a different kind and gives shape to odd fancies. The ideas are forcefully engraved on the metal, which generates a fantastic world, to whose echoes the artist seems to be listening while trying to explore its mysteries. His art of engraving, merging Northern sensitivity with his rich imagination, recalls Rembrandt's powerful fancies or Dürer's mysterious symbolism. But just when the artist seems to get near to and merge with the art of the north, he becomes again the interpreter of the clear skies', with Italian, or more appropriately Venetian, feeling, and unites 'the dusky and profound poetry with the fresh placidity of the eclogue, the sadness of the elegy to the gaiety of satire.'[45]

Focillon praised 'not the gifts of a facile improviser, like Sebastiano Ricci, but a knowledge acquired with patience, enlarged by a tireless day-to-day experience, the beauty of a completely new range, a kind of revelation of light, a courageous feeling for the picturesque, which owes nothing to accepted conventions and everything to the impetus of imagination'. He added that Giambattista's etchings 'are always a delightful and significant expression of his genius'. Writing about the *Flight into Egypt* and the *Stations of the Cross* by Giandomenico, Focillon noted that 'these plates show a certain tonal acidity and their frankness is sometimes brutal: they are on the same level as the *Scherzi*, if not the *Capricci*, in which the point has an extraordinary suppleness. Giandomenico's technique evolved in his famous *Teste di Vecchi*. The influence of Rembrandt and Rubens (the Rubens of the *Magicians*) is obvious in the general character; the technique is more complex, and the lines cross and merge to create deep shades, beautiful veils and a happy chiaroscuro. This new preoccupation is even more evident in the youngest, Lorenzo, whose life was spent in the shade of his father's glory, but whose great talent as engraver of reproductions has been revealed by nine plates: it is the art of delicate passages between light and shade, of the steady tool and all kinds of blended qualities, which are the essence of the sober and radiant etchings by Giambattista, the admirable designer, the poet of luminosity and sunlight, the great spiritual Venetian of his great age.'[46]

De Vesme wrote about the etchings: 'obviously the master treated them as a game and without any intention of creating anything important, but at the same time he accomplished them with such charming imagination and such lightness of touch that they are justly numbered among the jewels of the art of engraving.'[47]

And Sack wrote: 'Tiepolo shows his uniqueness in his etchings even more than in his paintings. He developed a style which differs from the one previously used, both in its amazing lack of affectation and in its witty treatment [of the technique], whether unconscious or calculated. Obviously his technique recalls that of other artists, Salvator Rosa and above all Castiglione; his needle excels all others in a treatment which is at the same time nervous and assured. In the crucial shaded areas, where reality is conveyed by means of frequent lines, he leaves the light areas almost untouched. All his shadows are transparent and lit by reflections. Forceful areas of 'thickness' are cleverly distrib-

uted over the whole area, preserve the composition from becoming weak and sentimental and spread over it a clear silvery tonality. Thus Tiepolo's etchings, much more than his paintings, show such an amazing liveliness and, notwithstanding the oddities, such obvious truth and stimulating effect as to keep us constantly enchanted by his freshness and charm.'[48]

Pallucchini wrote that 'the persistence of a talented luminosity stresses the fanciful ways of a whimsical and magic inspiration translated into pure lyricism . . . Giambattista's atmospheric values are exceptionally well rendered. Giandomenico's interpretation of his father's art, translated into engravings, has a coherent style which, in his best moments, becomes pure lyricism. Giandomenico's own paintings, often praised beyond their value, can be better understood through the study of these etchings. While his paintings show excessive preoccupation with linear texture, which slightly stifles the rendering of colours still used under his father's influence, in his engravings Giandomenico acquires freedom and talent, precisely in his treatment of the lines, which are here extremely successful in creating light and atmosphere. His brother Lorenzo shows an extremely refined chiaroscuro, which faithfully translates the most subtle colour shadings of his father's paintings with exceptionally fresh airiness.'[49]

Trentin saw in Giambattista's engravings 'a new, different aspect of his work, probably the one in which he shows himself most clearly as he is: more intimate, more natural and spontaneous, more calm and relaxing, untouched by rhetoric and an often empty heroism'; in these compositions Tiepolo found 'the most absolute freedom to express the jokes and whims of his imagination. The miracle of his success was to have been able to impart life to the impalpable element of light. Everything in the composition is due to light, to its predominance: on it depend the very life and essence of all beings and objects. Everything is displayed according to these beams, to this avalanche of fire and warmth which falls from the sky, wrapping all bodies and shapes in a glowing and sparkling sea. The figures, the animals, the objects are unimportant in themselves; they acquire a value in so far as they are shapes which need no specific determination and against which the beams of light break and rebound like sparkling dust, thus creating an unreal, fantastic, almost abstract world: a shimmering sea in which the submerged bodies can only be seen as through a dazzling mist, which almost decomposes all shapes and lines into minute marks with a bare suggestion in their silvery hues of objects, faces and expressions.' Giandomenico, according to Trentin, could instil into his engravings 'his own personality, his own intimate vision with a lively style, at times witty and joking, sparkling with a deep feeling for caricature and grotesque, at times permeated with delicate emotion'.

Trentin finally wrote about Lorenzo: 'an interpreter endowed with a definite personality, an uncommon sensitivity which enables him to recreate a work of art through his own intimate vision'; and about his graphic language: 'complicated and involved, aiming at the expression of contrasting emotions; it goes beyond the limits of sheer diligence through an extraordinary richness of sensations and, in spite of the limited output, it reveals Lorenzo as being, together with Giandomenico and in this field sometimes even more than he, the greatest interpreter of his father's work among all those who tried this line, and one of the best engravers of reproductions in eighteenth-century Venice.'[50]

De Witt also praised Tiepolo for the luminosity of his compositions and for his technical freedom.[51]

Pittaluga stressed 'the effects of clarity' in Giambattista's work, obtained with a technical expediency, the 'working economy' or utmost reduction of the hatching which determines the shaded areas. 'Giandomenico also sees light

as the stylistic power to which the composition has to bow. But not in the same way as his father, from whom he considerably differs, in his frequently happy moments, whether he is painting or engraving, owing to his more thoughtful and careful talent, which was more humane than Giambattista's; the last of the Tiepolos, Lorenzo, is characterized by 'his less simple ways, which give the composition a more planned character.'[52]

Pignatti thus synthetizes the personalities of the three Tiepolos: 'grand and sunlike was the personality of Giambattista, who engraved with a light touch his figures of satyrs and magicians on a background dazzling with light; more tormented and elegiac that of Giandomenico, who covered his sheets with undulating lines in a melancholic vein; diligent and measured was Lorenzo's, restricted for too long by his role of assistant and reproducer of his father creations.'

'Giambattista bathed his characters in dazzling light and vaguely indicated their plastic relief with a profile of chiaroscuro; his spaces are unreal and detached . . . while Giandomenico's style is more intimate and fluent, aiming at a truthful and realistic story-telling . . . Unlike his father and his elder brother, Lorenzo is a technically correct, even traditional, engraver; his is a sophisticated art, made of delicate transitions from shade to light; an art which looks for the most authentic chromatic values in the works reproduced. There is no doubt . . . that Lorenzo was fully aware of the technical innovations introduced in Venice by Wagner and Pitteri to achieve a stronger chiaroscuro.'[53]

Trying to reach a more coherent explanation of the graphic language of the Tiepolos, Passamani examined both the drawings and the engravings and found that 'in both media the stroke is a vibrant conjurer of images and the process of formal creation is similar; this is based on the tense elementary dialogue between the pure light produced by the colour of the paper itself or, in the drawings, by the white lead, and the shaded areas, obtained in the drawings with sepia or watercolour, and on copper with a system of parallel furrows which vary in intensity and direction. The definition of the tonal planes is based on the control of light, which in Tiepolo is always at its highest: no natural light, but an almost abstract solar force, the life-giving element in a world where existence is unaffected by accidental events.'[54]

UDINE, FEBRUARY 1971 A.R.

NOTES

1. For Algarotti in particular, and the cultural background of patronage in general, see F. HASKELL, *Patrons and Painters*, London 1963.

2. V. DA CANAL, *Vita di Gregorio Lazzarini* (1732), published by G. A. Moschini, Venice 1809, page 32.

3. A. CALABI, *Note su G.B. Tiepolo incisore*, in *Die graphische Künste*, 1939, page 7.

4. B. PASSAMANI, *Acqueforti, disegni, lettere di G.B. Tiepolo al Museo Civico di Bassano*, catalogue of the exhibition, 1970, pages 10-11.

5. S. MAFFEI, *Verona illustrata*, Verona 1732, part 3, page 221.

6. E. SACK, *Giambattista und Domenico Tiepolo*, Hamburg 1910, page 279.

7. G. KNOX, *A group of Tiepolo drawings owned and engraved by Pietro Monaco*, in *Master Drawings*, no. 3, 1965.

8. O. KUTSCHERA-WOBORSKY, *Die Neuentdeckung der Tiepolo Fresken im grossen Saale des Kastells zu Udine*, in *Repertorium für Kunstwissenschaft*, 1922, page 5.

9. A. RIZZI, *Le acqueforti dei Tiepolo*, catalogue of the exhibition, Udine 1970, page 13.

10. H. FOCILLON, *Les eaux-fortes de Tiepolo*, in *Revue de l'Art*, 1912, page 411.

11. C. LE BLANC, *Histoire des Peintres...*, Paris 1868, page 9.

12. M. SANTIFALLER, *Die Radierungen G.B. Tiepolos*, in *Pantheon*, 1941, page 68.

13. G. TRENTIN, *G. Battista, G. Domenico e Lorenzo Tiepolo incisori*, Venice 1951, pages 14-15.

14. A. DE WITT, *Disegni e stampe del Tiepolo*, in *Letteratura ed arte contemporanea*, 1951, pages 6-8.

15. R. PALLUCCHINI, *Gli incisori veneti del Settecento*, catalogue of the exhibition, Venice 1941, page 73.

16. A. MORASSI, *Tiepolo*, Bergamo 1943, page 42.

17. G. KNOX, *Tiepolo Drawings in the Victoria and Albert Museum*, London 1960, page 22.

18. T. PIGNATTI, *Le acqueforti dei Tiepolo*, Florence 1965, page 11.

19. G. KNOX, *Le acqueforti dei Tiepolo*, in *The Burlington Magazine*, November 1966, page 585.

20. B. PASSAMANI, *op. cit.*, pages 16-18.

21. M. GOERING, entry on *G.B. Tiepolo*, in Thieme-Becker Künstler-Lexikon, Leipzig 1939, page 152.

22. R. PALLUCCHINI, *op. cit.*, page 73.

23. A. MORASSI, *op. cit.*, page 42; *idem*, entry *Tiepolo*, in *Enciclopedia dell'Arte*, Venice and Rome 1965, page 915.

24. G. VIGNI, *Disegni del Tiepolo*, Padua 1942, pages 21-22.

25. M. PITTALUGA, *Acquafortisti veneziani del Settecento*, Florence 1952, page 129.

26. G. KNOX, *Tiepolo drawings in the Victoria and Albert Museum*, page 22.

27. T. PIGNATTI, *Disegni di Tiepolo in mostra negli Stati Uniti*, in *Arte Veneta*, 1961, page 325.

28. T. PIGNATTI, *Le acqueforti dei Tiepolo*, page 13.

29. G. KNOX, *Le acqueforti dei Tiepolo . . .*, page 586.

30. A. RIZZI, *op. cit.*, page 12.

31. L. C. J. FRERICHS, *Nouvelles sources pour la connaissance de l'activité incisoire des trois Tiepolo* (forthcoming); also T. PIGNATTI, *In margine alla mostra delle acqueforti dei Tiepolo a Udine*, in *Arte Veneta*, 1970 (forthcoming).

32. A. RIZZI, *op. cit.*, pages 12-13.

33. See note 8 above.

34. G. VIGNI, *op. cit.*, page 25.

35. C. H. VON HEINCKEN, *Idée generale d'une collection complète d'estampes*, Leipzig-Vienna 1771, page 106; G. LORENZETTI, *Un dilettante incisore veneziano del XVIII secolo*, Venice 1917, pages 54-59.

36. A. Morassi, *Tiepolo*, London 1955, page 147, no 38.

37. One of these, comprising 28 'heads' and with contemporary binding, is in a private collection in Pavia.

38. G. Knox, *Domenico Tiepolo: Raccolta di Teste*, Udine 1970.

39. A. de Vesme, *Le peintre-graveur italien*, Milan 1907, page 379.

40. The indexes of the first and second edition of the catalogue are published by De Vesme, *op. cit.*, pages 379-381.

41. P. Molmenti, *Giambattista Tiepolo*, Milan 1909, pages 241-243.

42. G. Moschini, *Dell'incisione a Venezia* (1815), Venice 1924, page 162.

43. C. Le Blanc, *op. cit.*, page 9.

44. Duplessis, *Histoire de la Gravure*, Paris 1880, pages 72-73.

45. P. Molmenti, *op. cit.*, pages 233-235.

46. H. Focillon, *op. cit.*, page 413.

47. A. de Vesme, *op. cit.*, page 48.

48. E. Sack, *op. cit.*, page 289.

49. R. Pallucchini, *op. cit.*, pp. 13, 15.

50. G. Trentin, *op. cit.*, page 10.

51. A. de Witt, *Disegni e stampe del Tiepolo*, in *Letteratura e arte contemporanea*, 1951.

52. M. Pittaluga, *op. cit.*, page 125.

53. T. Pignatti, *Le acqueforti dei Tiepolo*, *op. cit.*, page 1.

54. B. Passamani, *op. cit.*, page 10.

CATALOGUE

Note

The measurements give the sizes of the plates rather than of the etched areas. The abbreviations used in the bibliographies to each note refer to the general bibliography on p. 449.

Giambattista Tiepolo was born in Venice in 1696. He was trained in the studio of Gregorio Lazzarini, and was also influenced by Piazzetta and Bencovich. In 1716 he was already working on his own and the following year he joined the 'Fraglia', or Guild. In 1719 he married Cecilia Guardi, who bore him nine children, among them Giandomenico and Lorenzo, his future collaborators. His activity as a fresco painter in Venetian churches and palaces started after 1720. In 1726–8 he worked at Udine (in the Archbishop's Palace, in the Cathedral and in the Castle), using a new pictorial language, in which the influence of Veronese transmitted through the work of Sebastiano Ricci and Pellegrini is evident; these paintings are gay and clear, realistic and rich with new ideas. In 1731 he was active in Milan and in 1732 in Venice and Bergamo, using an open, classic scenography. In 1736 he refused an invitation from the King of Sweden to decorate the royal palace. Later he produced the masterpieces in the Church of the Gesuati (1739), the Scuola dei Carmini (1743) and the S. Maria dei Scalzi (1744), all in Venice. Having completed his great fresco decorations for the Palazzo Labia, Venice (by 1750), he worked at Würzburg, in the Residenz of the Prince-Bishop, from 1751 to 1753, together with his sons Giandomenico and Lorenzo, using a melodramatic but extremely effective style. On his return to Italy, he worked in various places near Venice, particularly in the Villa Valmarana at Vicenza (1757) and in the Oratorio della Purità at Udine (1759). His use of colour at this time became more spiritual. In 1762, together with his two sons, he left for Spain, invited by King Charles III to decorate the royal palace in Madrid. There he encountered the early neoclassical currents, which led him towards a more intimate and dramatic style. He died suddenly in Madrid on 27 March 1770.

Tiepolo is one of the major figures in the history of painting. In the field of etching, he has left 38 prints, drawn with extremely free strokes vibrating with light and full of atmosphere.

1. St. Jerome in the desert

138 × 96 mm. Only state (Bassano Museum).

Among the etchings of disputed attribution, De Vesme, who did not know the two *Magicians* (see pl. 2 and 3), mentioned a *Holy hermit* in the municipal Museum in Bassano. The mount is inscribed: *Gio:Batta Tiepolo*, written in pen in eighteenth-century handwriting. According to Passamani, the print represents *St. Jerome in the desert* and could be attributed either to Giandomenico or to Lorenzo.

The etching reflects clearly enough Tiepolo's favourite subjects of the late 1720s, particularly those of the 'finished' drawings (Rizzi, 1965, 14–17), some of which were engraved by Pietro Monaco (Knox, 1965, p. 389). In iconography and in style, the etching is close to the *St. Jerome praying* (Rizzi, 1965, 6) and to the *St. Jerome in the desert* in the Museum at Bassano (fig. 1) with which it shares the conventional style: minute and concentrated strokes and a strong chiaroscuro. Nevertheless, the hatching technique and the neat curves already indicate a tendency towards stylistic enhancement, as shown by the short scratches on the trunks and by the sharp curves of the background vegetation which anticipate the style of the *Magicians* and the *Scherzi*. It is of course an early attempt (as proved also by the small size of the print), in which Giambattista has not yet discovered his technical mastery of the medium and which, therefore, was disowned. On the other hand, both Giandomenico and Lorenzo, had they been the authors, would have claimed authorship of the print and indicated its sources.

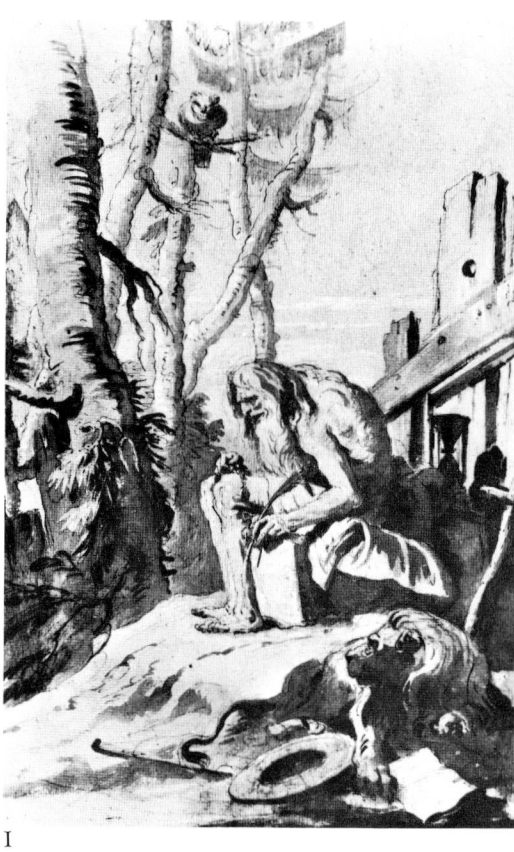

1

Bibliog.: De Vesme, 1906, p. 394, No. 11; Passamani, 1970, p. 9.

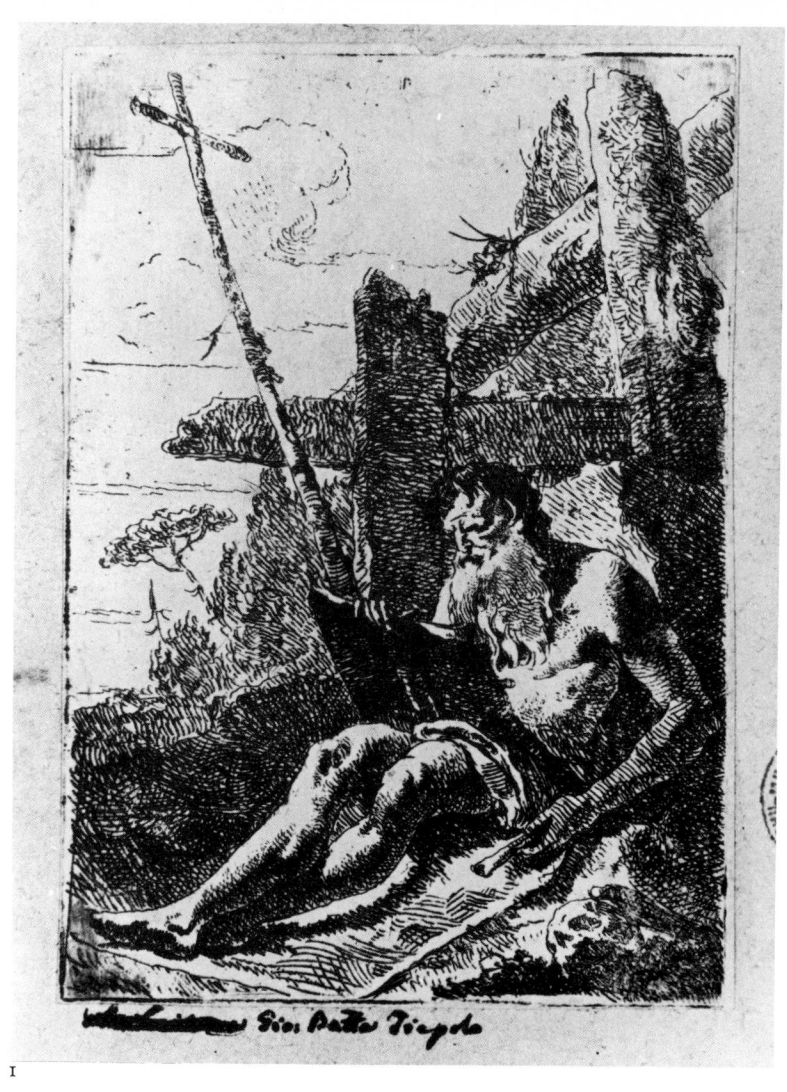

I

2. Magician with owl

98 × 60 mm. Only state (Correr Museum, Venice).

This small print, and the following one, do not appear in De Vesme's catalogue, and have been attributed to Tiepolo by Sack, who later obtained De Vesme's agreement. The attribution was rejected by Molmenti, Vitali, Goering, Pittaluga and Pallucchini, but is accepted by Hind and Pignatti. Trentin also denies Giambattista's authorship and suggests that the etchings might be by Giandomenico. This disagreement is explained by the late dating; in fact, these two prints represent the first examples of Giambattista's activity as an engraver (c. 1735); they are closely connected with the fresco cycle in the Villa Loschi (now Zilieri) in Biron, both in the figures—see the two allegories *Council* and *Homer*; their relationship is even more clearly apparent in the preparatory drawings of the Museum in Trieste (figs. II and III)—and in some significant details (the owl, the jars, the trees). Even the wavering and broken calligraphy is a prelude to that of the *Scherzi*.

Bibliog.: Sack, 1910, 36; Molmenti, 1911, p. 179; De Vesme, 1912, p. 316; Hind, 1921, p. 41; Vitali, 1927, p. 61; Pallucchini, 1941, p. 73; Trentin, 1951, p. 19; Pittaluga, 1952, p. 128; Pignatti, 1965, XXXVII; Rizzi, 1970, I.

3. Magician

97 × 61 mm. Only state.

See note to preceding plate. These two small prints are extremely rare. Note the comb-like lines which were to be characteristic of Giandomenico's first etchings, particularly the frontispiece of the Stations of the Cross (pl. 39).

Bibliog.: Sack, 1910, 37; Molmenti, 1911, p. 179; De Vesme, 1912, p. 316; Hind, 1921, p. 41; Vitali, 1927, p. 61; Goering, 1939, p. 152; Pallucchini, 1941, p. 73; Trentin, 1951, p. 19; Pittaluga, 1952, p. 128; Pignatti, 1965, XXXVI; Rizzi, 1970, 2.

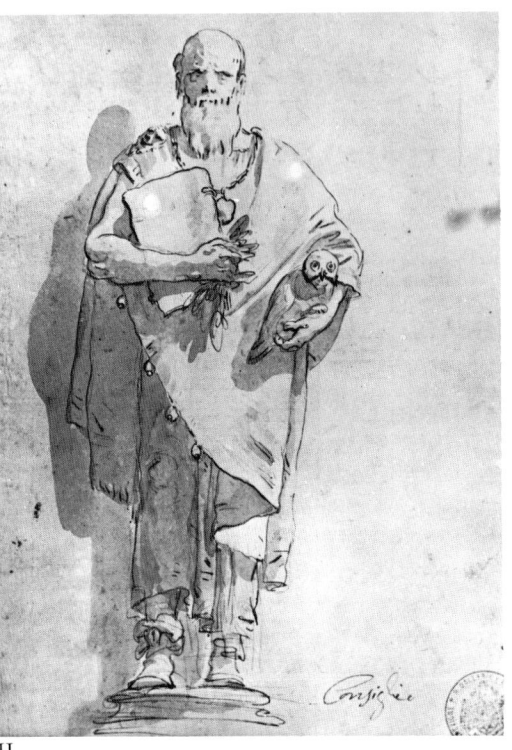

II

III

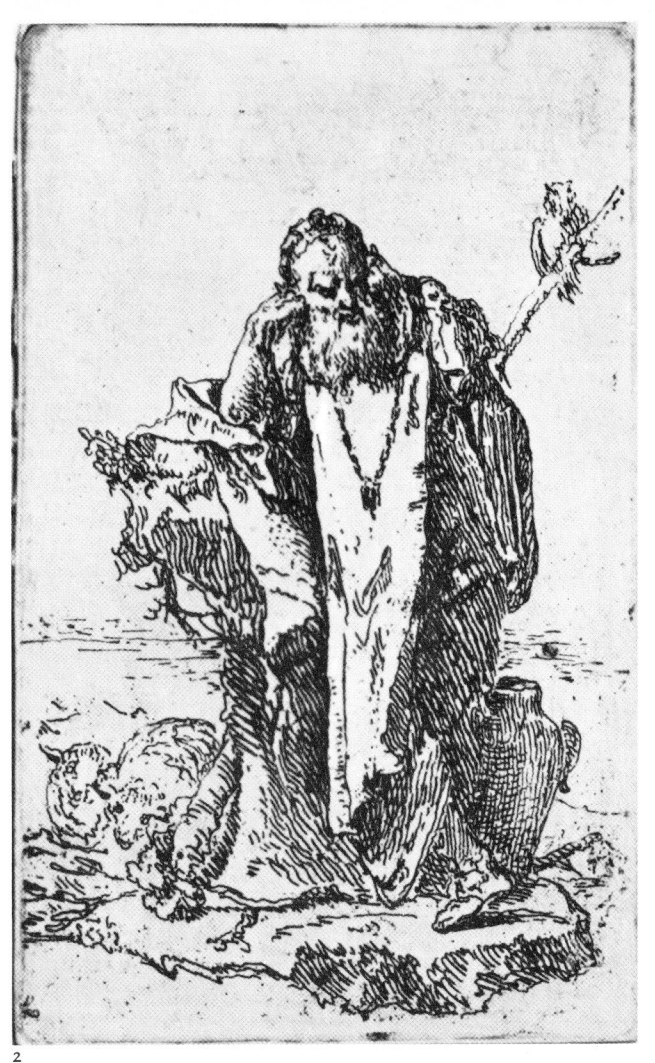

2

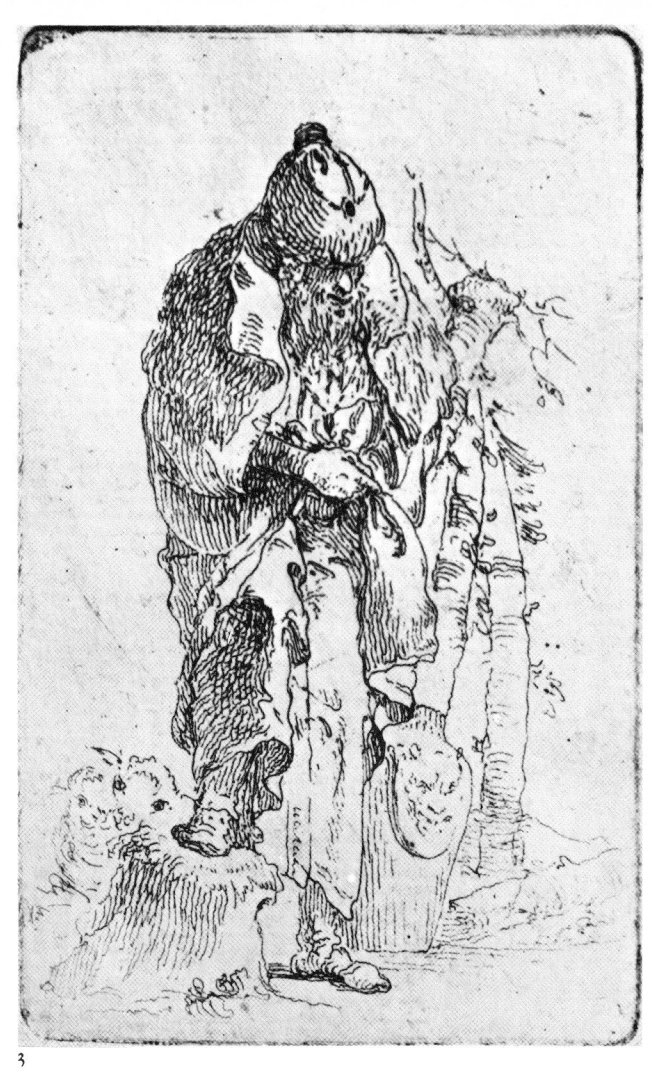

3

4. Scherzi
Frontispiece

226 × 180 mm. First state: before the number; second state: with *2* at top right and *1* at bottom right (according to De Vesme; Pignatti only mentions the *1* at the bottom) and thus inscribed by Giandomenico: *Scherzi di Fantasia N. 24 | del Celebre | Sig. Gio: Batta Tiepolo Veneto Pitore | morto in Madrid | al Serviggio di S: M: C: | Più hà inc. una Adorazion de Remagi.*

A first group of 14 *Scherzi* was published after Tiepolo's death by Giandomenico in the first collected edition of Tiepolo prints (1775). The second edition has a different numbering and the inscription on the frontispiece (fig. IV) includes all the 25 prints: 23 *Scherzi*, the 'St. Joseph and the Christ Child' (24) and the 'Adoration of the Magi' (25). The additions were probably made by Gian-domenico so as to collect in one volume all his father's autograph prints, the plates of which he then owned (those for the 'Capricci' came into his possession only later).

The dating of the *Scherzi* is controversial and ranges from the 1740s to the Spanish period. For reasons outlined in the introduction the author believes they should be dated between 1735 and 1740.

The composition of this frontispiece was copied by Giandomenico for the similar sheet which opens his 'Stations of the Cross' (see pl. 39). He also used it in a drawing now in the Ames Collection in Saunderstown, R. I., (Byam Shaw, 1962, pl. 46) (fig. V).

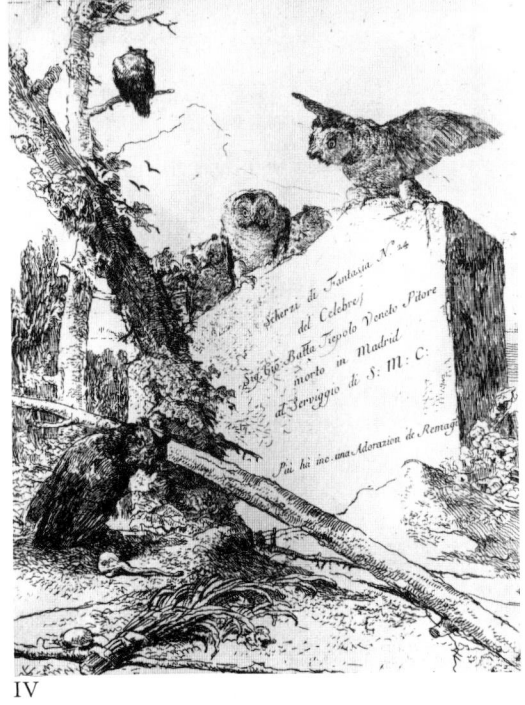

IV

V

Bibliog.: Nagler, 1847, 12; De Vesme, 1906, 13; Sack, 1910, 1; Hind, 1921, 13; Pallucchini, 1941, p. 73; Pittaluga, 1952, p. 137; Pignatti, 1965, XIII; Rizzi, 1970, 3.

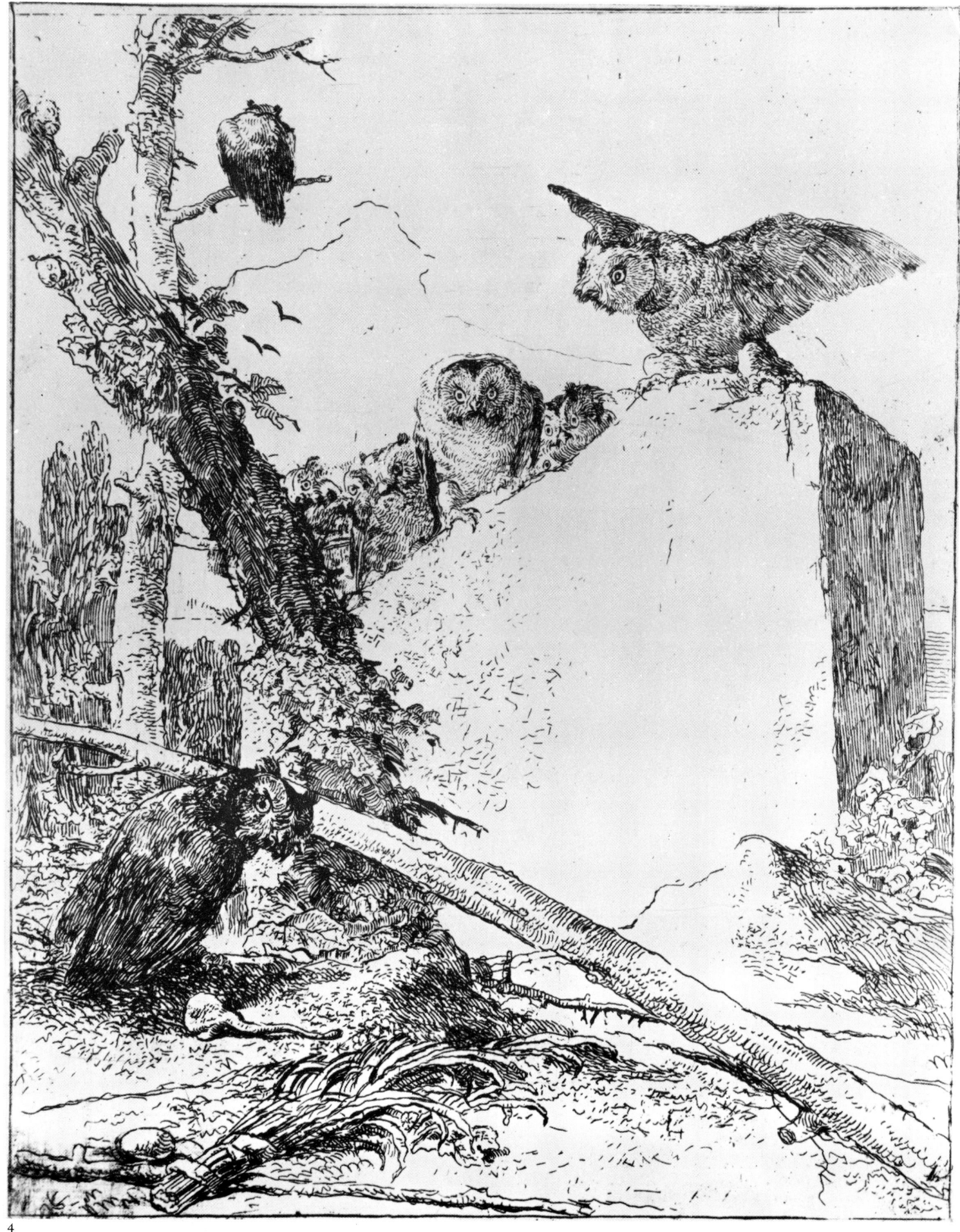

5. Scherzi
Three magicians burning a snake

222 × 180 mm. First state: before the number; second state: *2* at top right. Signed with the initials *B.T.*º at bottom right.

According to Vigni, the drawing No. 172 in the Museum in Trieste shows a certain similarity of composition with this 'Scherzo'. Pignatti considers this reference unjustified. The present author sees a closer relationship with a drawing in the Victoria and Albert Museum, No. 118 in Knox's catalogue (1960) (fig. VI). See also note to pl. 18.

VI

Bibliog.: Nagler, 1847, 12; De Vesme, 1906, 14; Sack, 1910, 2; Hind, 1921, 14; Vigni, 1942, p. 60; Pignatti, 1965, XLV; Rizzi, 1970, 4.

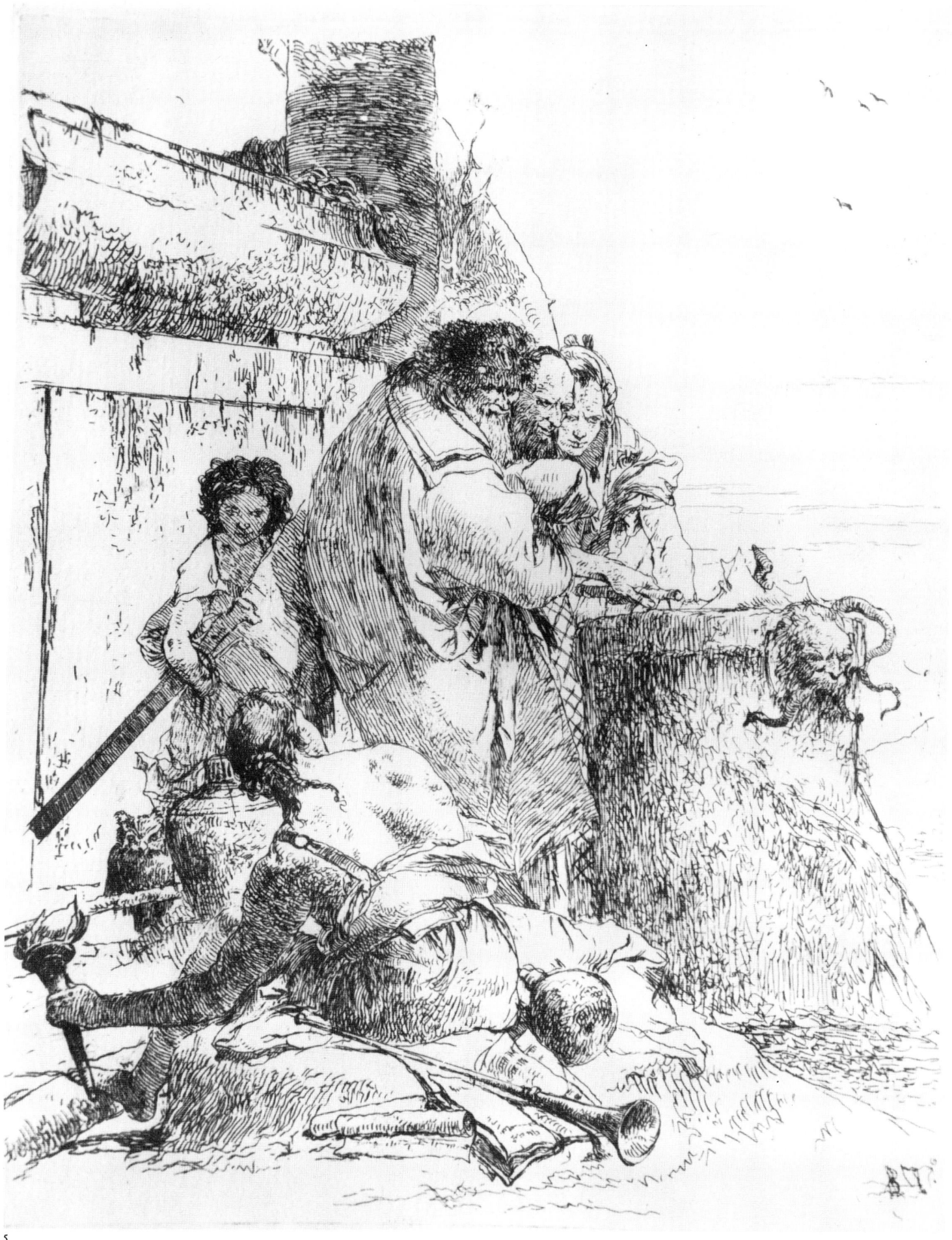

6. Half-dressed nymph with two children, surrounded by four men

222 × 175 mm. First state: before the number; second state: *3* at top right. Signed twice, at bottom left and centre: *Tiepolo*.

Reynolds, followed by Knox and Pignatti, has rightly connected this *Scherzo* with a drawing in the Victoria and Albert Museum, in which the female figure in the centre of the composition appears reversed (fig. VII). The other elements of the composition in the print are different from those in the drawing. The print is slightly more mature than those related to the cycle in the Villa Loschi (see also the articulation of the female figure, which recalls the ' Humility '), and precedes the sheets related to the frescoes in S. Francesco della Vigna.

Bibliog.: Nagler, 1847, 12; De Vesme, 1906, 15; Sack, 1910, 3; Hind, 1921, p. 15; Reynolds, 1940, p. 49; Pallucchini, 1941, 307; Pittaluga, 1952, p. 142; Pignatti, 1965, XV; Rizzi, 1970, 5.

VII

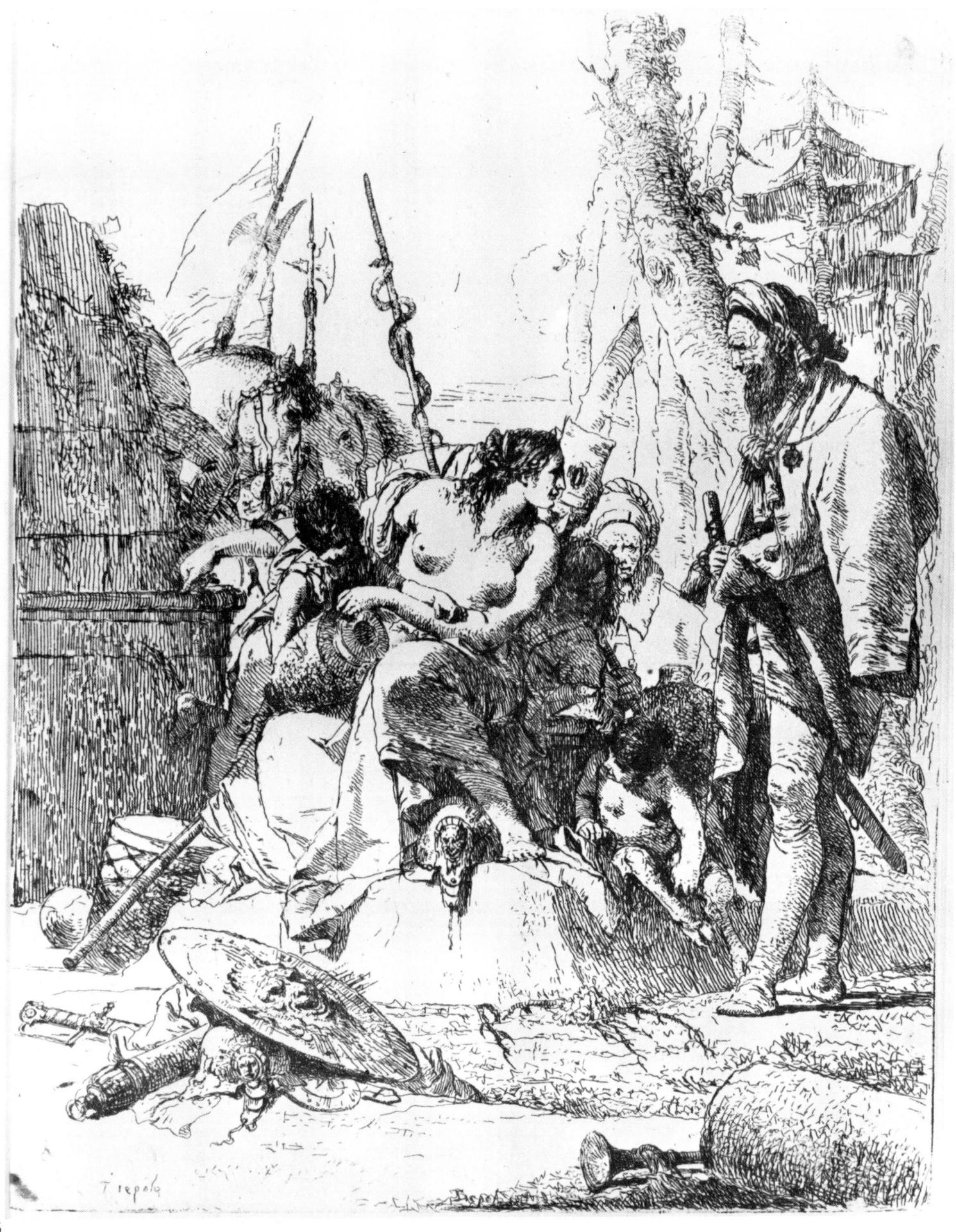

T.repolo

6

7. Scherzi
Magician pointing out a burning head to two youths

225 × 175 mm. First state: before the number; second state: *4* at top right. Signed at left: *B. Tiepolo*.

Reynolds has identified the preparatory drawing in the Victoria and Albert Museum (fig. VIII). Knox suggests a date of about 1743–4, while Pignatti compares it with those works which lead up to the *Death of Hyacinth* (Lugano, Thyssen Collection) of 1757. The present author believes that this drawing should also be placed among the works preceding the frescoes of Villa Loschi, with which it shares the strong 'patches' of chiaroscuro, and the studies for the Venetian church of S. Francesco della Vigna, as shown by the fluttering lines. On the other hand, Vigni notes that the first figure in the group of drawing No. 110 at Trieste strongly resembles in its expressiviness the one which appears in similar position in this print (1943, p. 49); and there is no doubt that the drawing should be dated to the late 1730s.

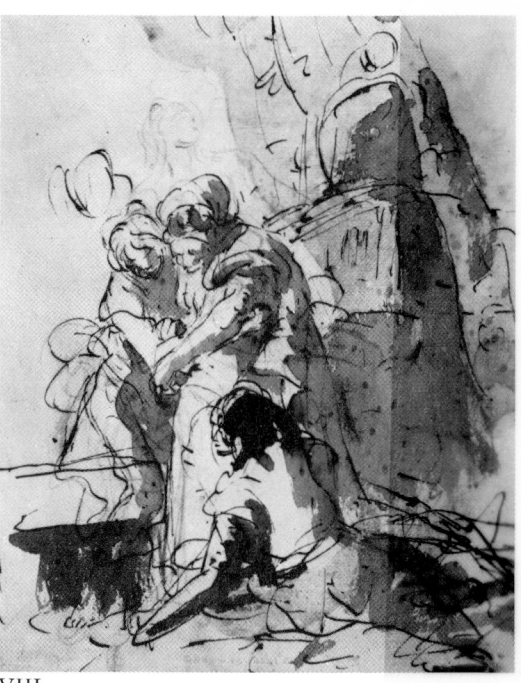

VIII

Bibliog.: Nagler, 1847, 12; De Vesme 1906, 16; Sack, 1910, 4; Hind, 1921, 16; Reynolds, 1940, p. 50; Knox, 1960, p. 127; Pignatti, 1965, XVI; Rizzi, 1970, 6.

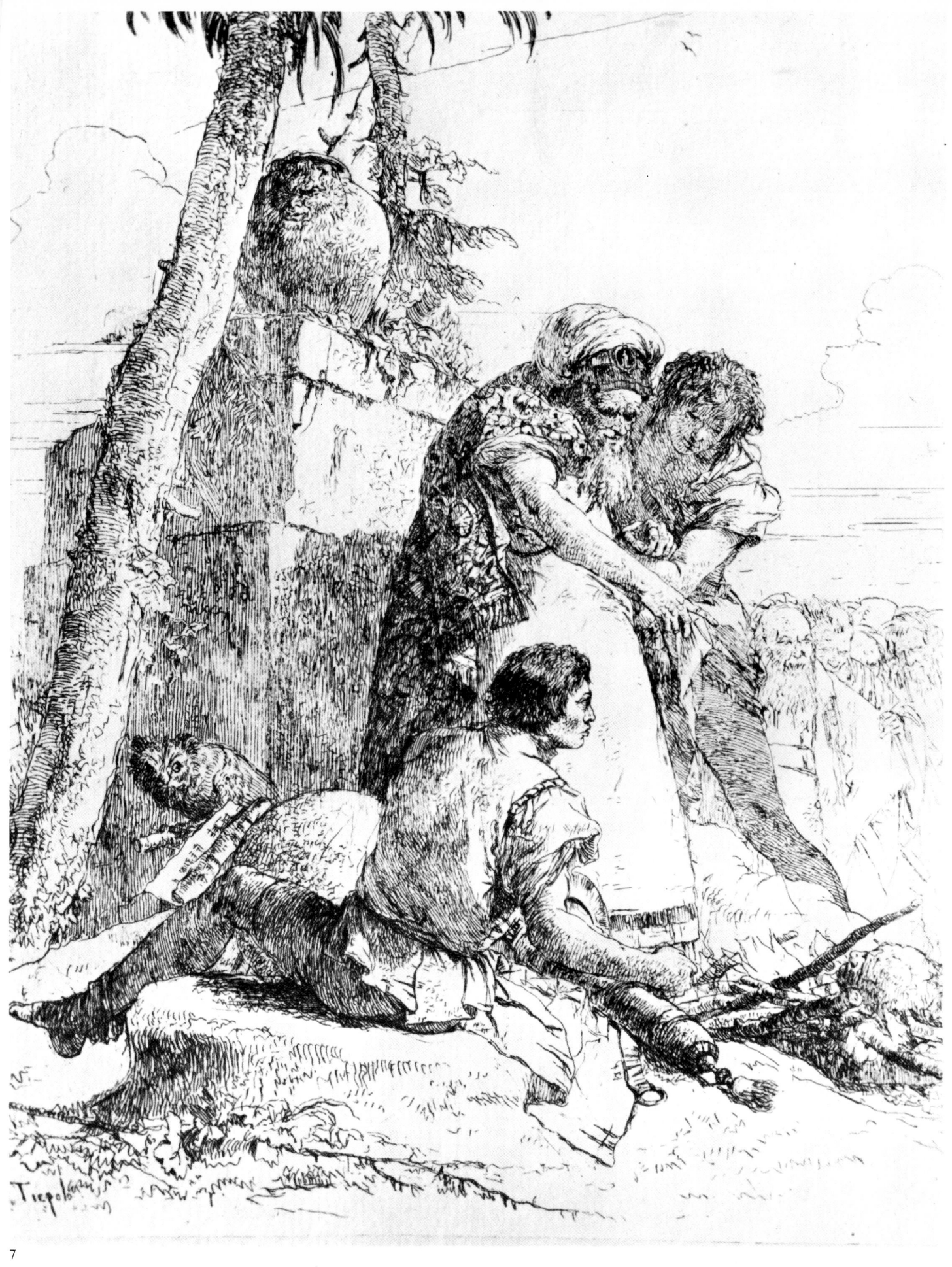

8. Scherzi

Seated magician, boy and four figures

225 × 175 mm. First state: before the number; second state: *5* at top right. Signed (and dated?) on the altar: *1737 / Tiepolo*. The signature and the date are repeated, respectively, in the bottom left corner and on the small column.

As stated by Knox, the preparatory drawing for this etching is in the Victoria and Albert Museum (1960) (fig. IX), where there is also a sheet with a preliminary idea. He has also pointed out that the British Museum possesses an 'unusual' sheet (19-46-713-101) in which the same scene is echoed, but without the magician in the centre (1966): this is probably a copy. The references to the London sheets suggested by Pignatti are incorrect. The reading of the date, which the artist has partially disguised —although one should also remember the etching technique—provides an important element for the dating of the series of etchings and perfectly agrees with the stylistic evidence.

Bibliog.: Nagler, 1847, 12; De Vesme, 1906, 17; Sack, 1910, 5; Hind, 1921, 16; Knox, 1960, 123 and 124; Pignatti, 1965, XVII; Knox, 1966, p. 585; Rizzi, 1970, 7.

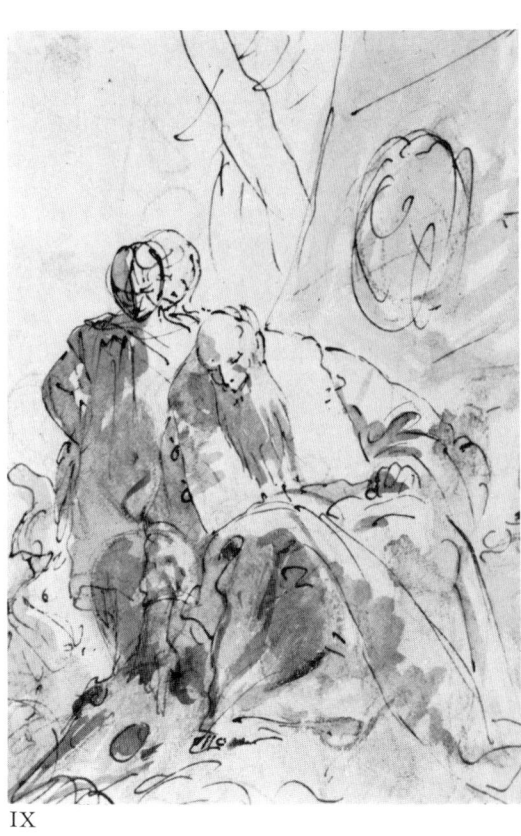

IX

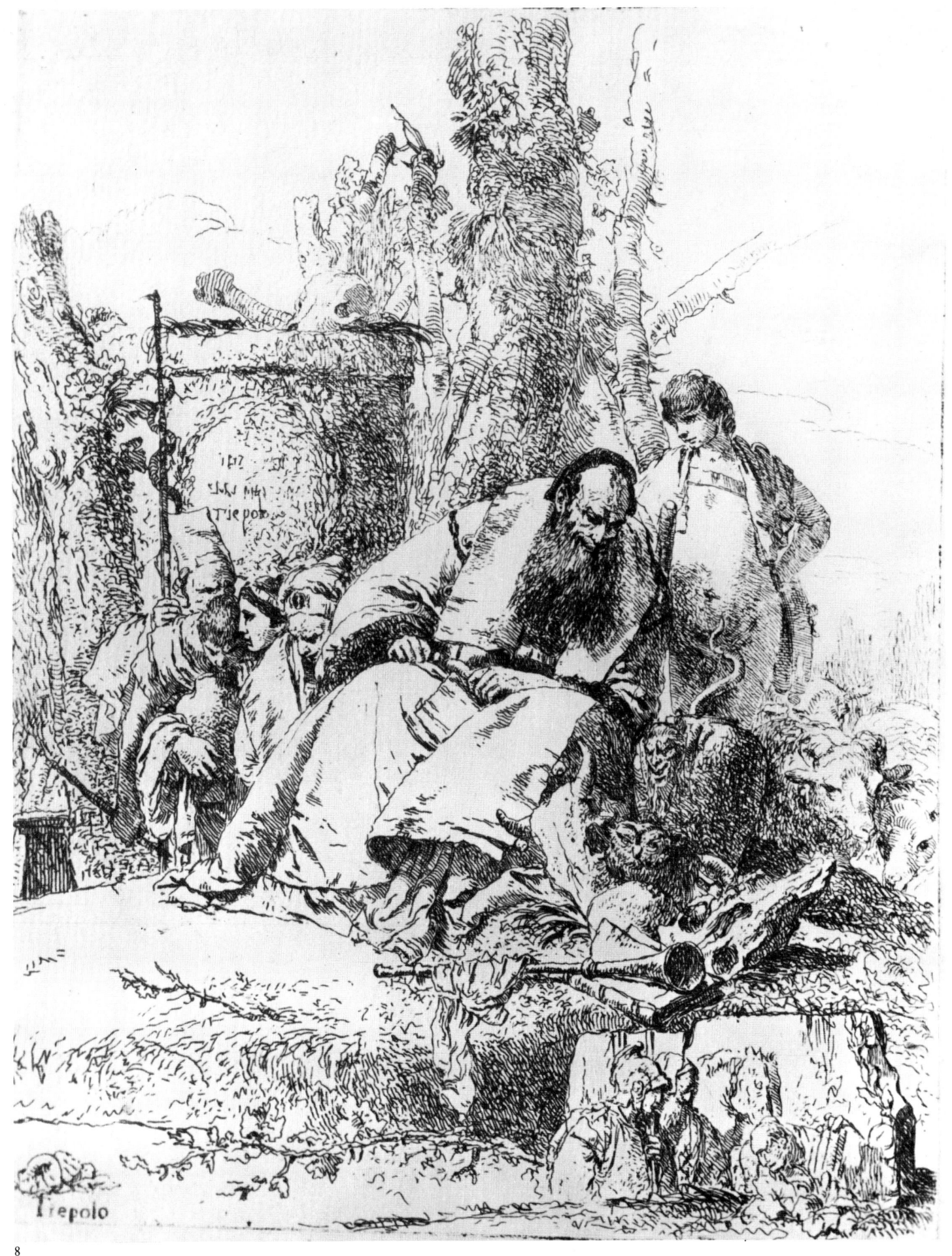

Tiepolo

9. Scherzi
Magician with four figures near a smoking altar

225 × 181 mm. First state: before the number; second state: 6 at top right. Signed, at bottom left: *G. B. Tiepolo*.

Pignatti believes this *Scherzo* to be one of the last of Tiepolo's etchings and relates it to the late paintings, between 1762 and 1770. The author thinks that the print cannot be later than the latest date proposed for the *Scherzi* (1740). As a matter of fact, the echoes of this etching are not far to seek: the magician was copied by Giandomenico in plate XI of the *Stations of the Cross*, while the youth with bare torso and wind-swept hair often appears in *The Flight into Egypt* (sheets 6, 12, and 24, twice, see pl. 74, 80 and 92). The Museo Bardini, Florence, has a drawing (fig. X), without doubt by Lorenzo, which reflects this particular *Scherzo* and the one on pl. 23, as happened also on other occasions (see pl. 13).

Bibliog.: Nagler, 1847, 12; De Vesme, 1906, 18; Sack, 1910, 6; Hind, 1921, 18; Pignatti, 1965, XVIII; Rizzi, 1970, 8.

X

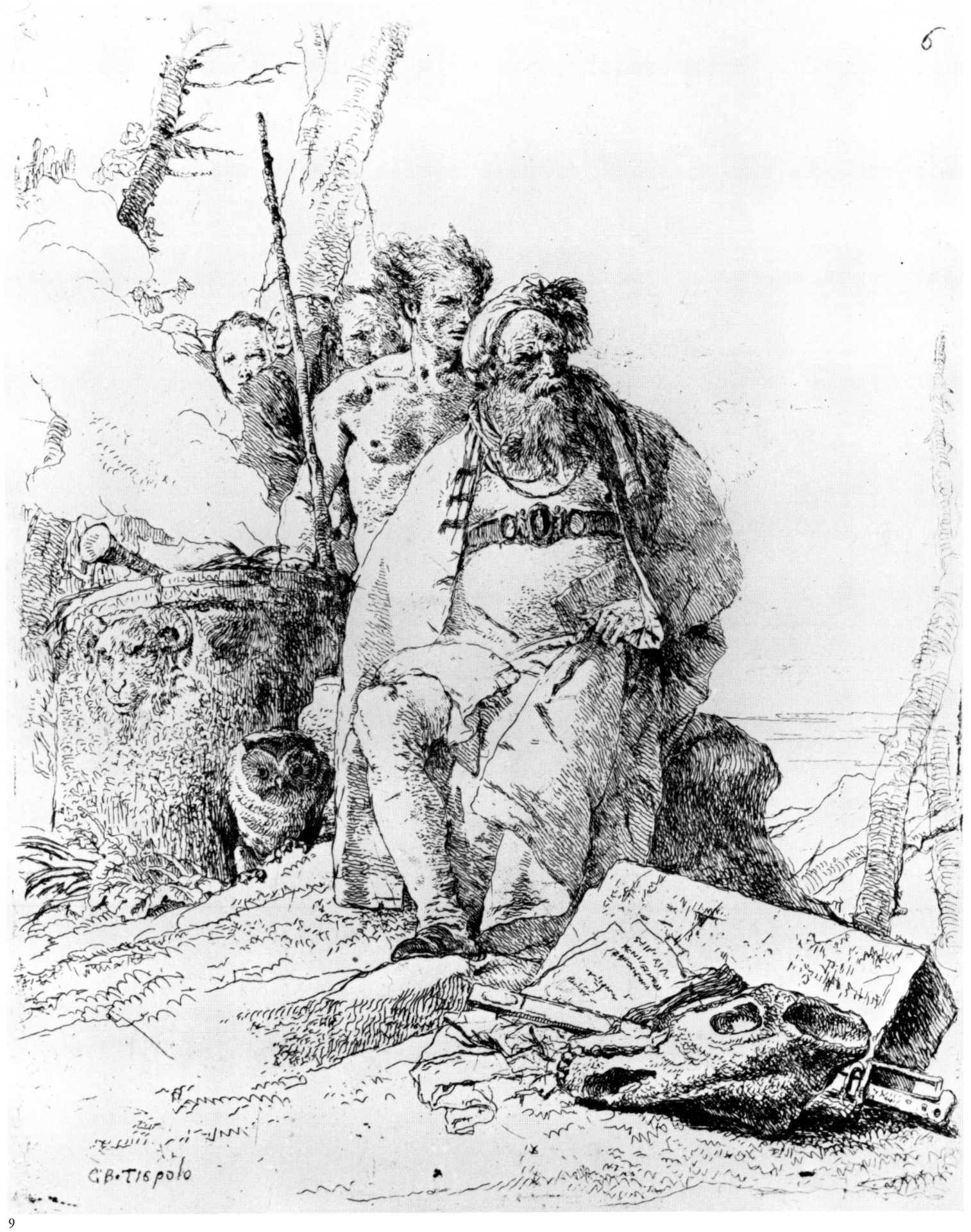

G.B.Tispolo

10. Scherzi

A magician, a soldier and three figures watching a burning skull

225 × 178 mm. First state: before the number; second state: *7* at top right. Signed with the initials *B.T.º* at bottom right.

According to Knox, drawing No. 125 in the Victoria and Albert Museum has elements in common with many etchings and particularly with this *Scherzo*, of which it might well represent a first idea (fig. XI).

XI

Bibliog.: Nagler, 1847, 12; De Vesme, 1906, 19; Sack, 1910, 7; Hind, 1921, 19; Knox, 1960, p. 64; Pignatti, 1965, XIX; Rizzi, 1970, 9.

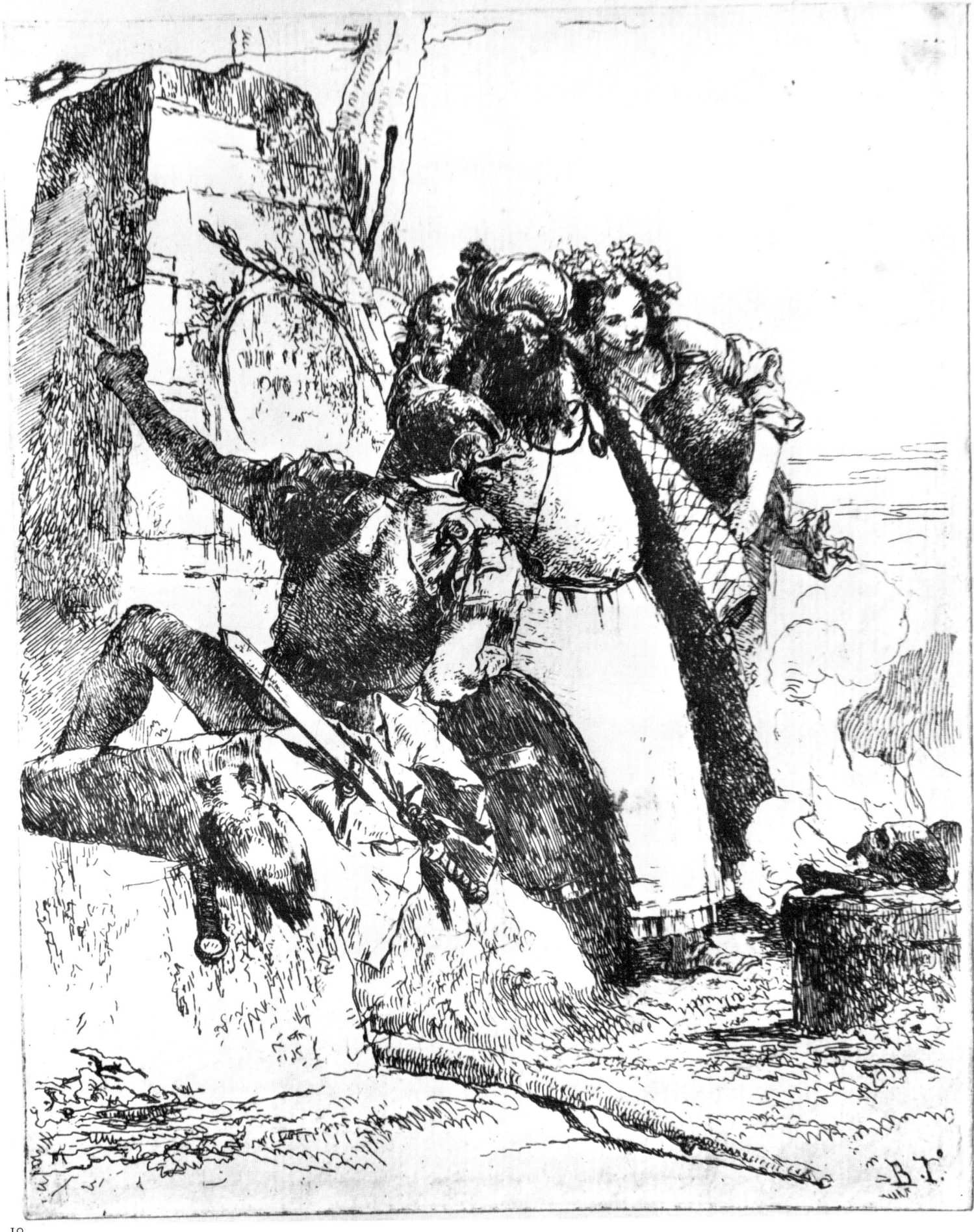

11. Scherzi
Woman kneeling in front of magicians and other figures

228 × 172 mm. First state: before the number; second state: *8* at top right. Signed bottom left, *G. B. Tiepolo*.

Knox refers, in connection with the *Scherzi* in general, to drawing No. 104 in the Victoria and Albert Museum (fig. XII), which, together with No. 105, has something in common with this etching.

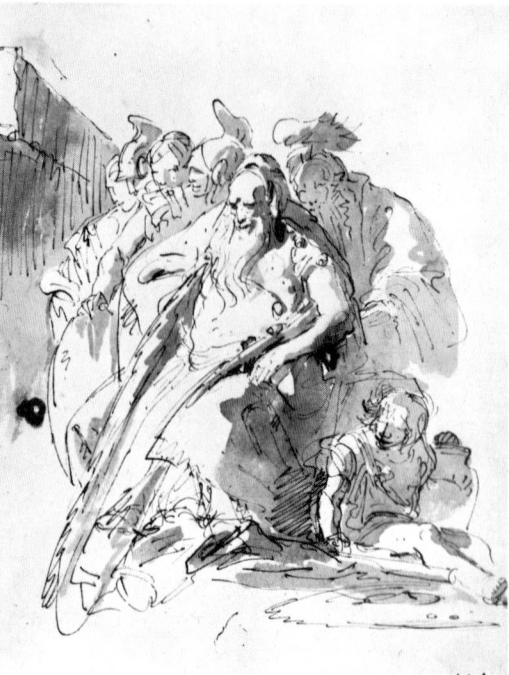

XII

Bibliog.: Nagler, 1847, 12; De Vesme, 1906, 20; Sack, 1910, 8; Hind, 1921, 20; Pallucchini, 1941, 308; Pittaluga, 1952, 145; Knox, 1960, p. 60; Pignatti, 1965, XX; Rizzi, 1970, 10.

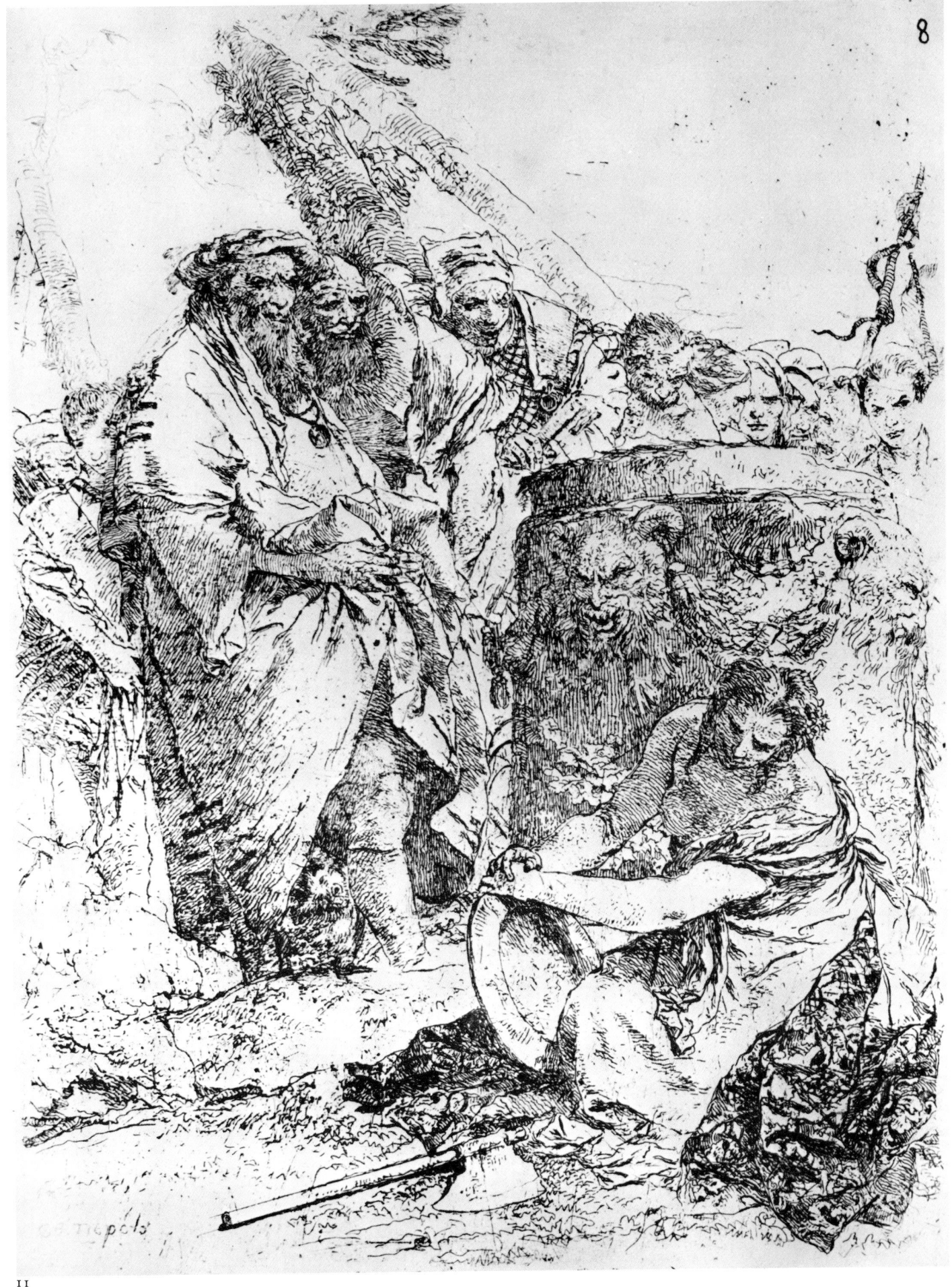

12. Scherzi
**Punchinello
talking to two magicians**

223 × 184 mm. First state: before the number; second state: *9* at top right. Signed with the initials *B.T.*º in reverse at bottom right.

Vigni connected this *Scherzo* with drawing No. 121 in the Trieste Museum, representing the heads of a punchinello and an old man, which may have preceded the two figures in the print (fig. XIII), and with drawing No. 110 for the heads in the background. Pignatti points out that the fir-trees of the Trieste drawings Nos. 175-185, which Vigni ' rightly dated between 1750 and 1760' (1942, p. 60), can be found in this and other *Scherzi*, thus making their dating easier. In the catalogue of the Udine exhibition of Tiepolo drawings (1965, No. 34) the author showed, in agreement with Vigni (1965, p. 211), that these trees should be dated about 1735.

It may be noted that the handsome calm figure of the naked ephebe, standing near the altar, had already appeared in the drawing of *Three Nudes* in the Udine Museum (Rizzi, 1970, 32). This figure was repeated by Giandomenico in the print of the 'River', which was based on an idea of his father's (see pl. 124).

Bibliog.: Nagler, 1847, 12; De Vesme, 1906, 21; Sack, 1910, 9; Hind, 1921, 21; Vigni, 1942, pp. 49, 51; Pignatti, 1965, XXI; Rizzi, 9610, 11.

XIII

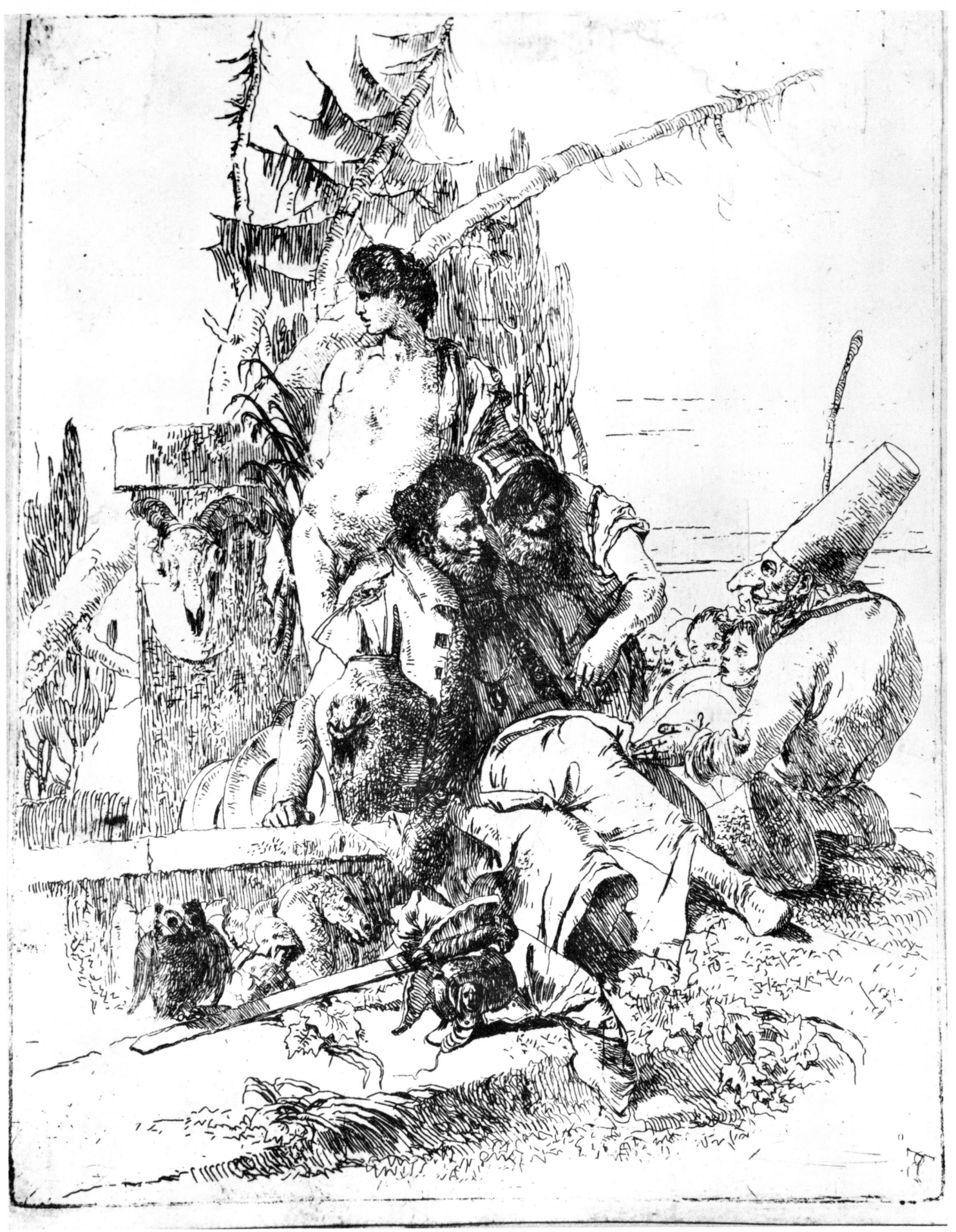

125054

13. Scherzi
The happy satyr and his family

225 × 178 mm. First state: before the number; second state: *10* at top right. Signed: *Tiepolo*, in reverse, at bottom left.

The large, leafy fir-trees, which already appeared in the Trieste drawings, are here repeated in the style of the 1740s. The beautiful series of 'Satyrs and faunesses' in the Horne Museum in Florence, created before 1740, may have suggested this and the next engraving (Ragghianti Collobi, 1968, p. 54).

Knox believes that a first idea for this *Scherzo* is represented by drawing No. 116 in the Victoria and Albert Museum.

The composition, like the one which follows, was paraphrased by Lorenzo in one of the drawings in the Würzburg Museum (fig. XIV).

XIV

Bibliog.: Nagler, 1847, 12; De Vesme, 1906, 22; Sack, 1910, 10; Hind, 1921, 22; Knox, 1960, p. 63; Pignatti, 1965, XXII; Rizzi, 1970, 12.

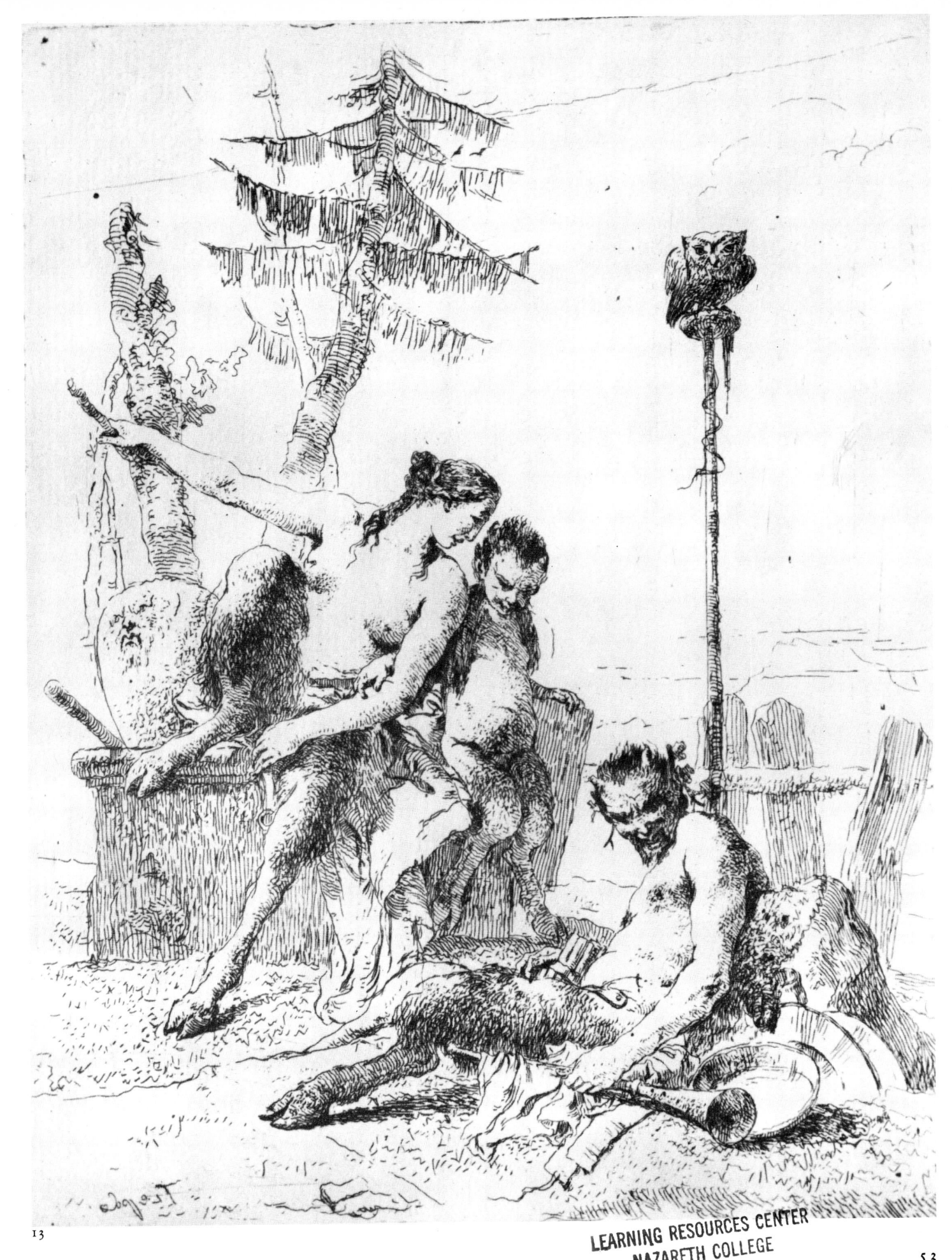

13

53

14. Scherzi
Satyr family with the obelisk

224 × 176 mm. First state: before the number; second state: *11* at top right. Signed *Tiepolo*, in reverse, at bottom left.

A tentative, first idea for this *Scherzo* appears in a drawing in the Wallraf Collection (Morassi, 1959, 52), which shows the pyramid and the figure seen from the back (fig. XV).

Knox believes that the etching could have been derived from the oval representing 'Satyresses and Cupids' in the Cailleux Collection, Paris, which can be dated around 1740, but it may equally well have preceded them. This Scherzo, like the previous one, was used by Lorenzo, for one of his sheets in the Würzburg Museum.

Bibliog.: Nagler, 1847, 12; De Vesme, 1906, 23; Sack, 1910, 11; Hind, 1921, 23; Pallucchini, 1941, 311; Pittaluga, 1952, p. 145; Pignatti, 1965, XXIII; Knox, 1966, p. 585; Rizzi, 1970, 13.

XV

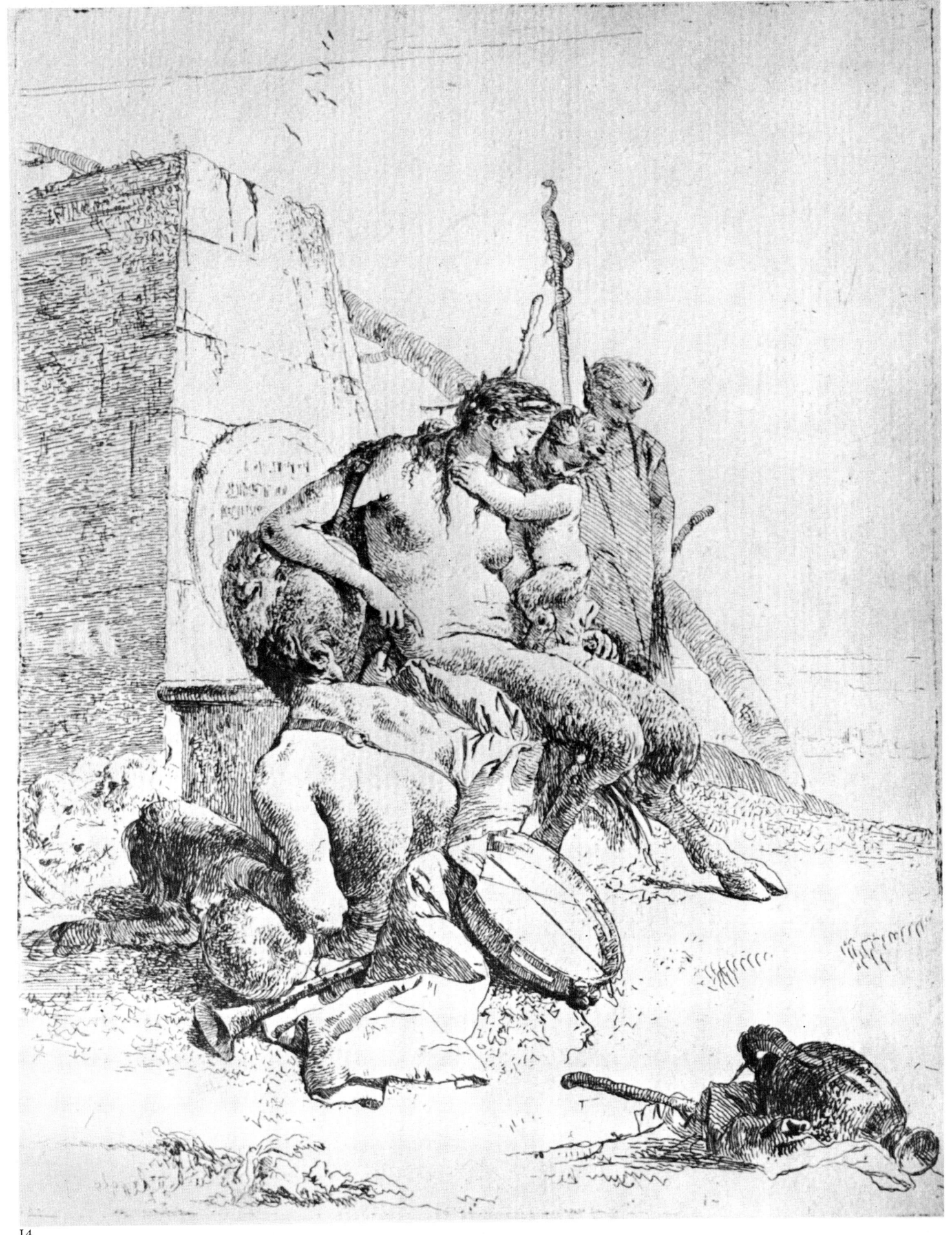

15. Scherzi
Six people watching a snake

225 × 175 mm. First state: before the number; second state: *12* at top right. Signed: *Tiepolo*, in reverse, twice, at bottom left.

The preparatory sketch for this etching was identified by Sack, in the Trieste drawing No. 171 (fig. XVI); the group of figures also echoes the drawing No. 110 in Trieste. There are strong similarities in the composition, the crowding of the figures and the decorative details, all of them, of course, in reverse. On the other hand, the connection with the Capriccio shown on pl. 29, suggested by Pittaluga, is unconvincing, or at least too general, as the diagonal emphasis is fairly common in Tiepolo's etchings. Reference has also been made to the sketch of *The Madness of Ulysses* (Borletti Collection, Milan) but this is much later.

XVI

Bibliog.: Nagler, 1847, 12; De Vesme, 1906, 24; Sack, 1910, 12; Hind, 1921, 24; Vigni, 1942, p. 60; Pallucchini, 1941, 312; Pittaluga, 1952, pp. 137–38; Pignatti, 1965, XXIV; Rizzi, 1970, 14.

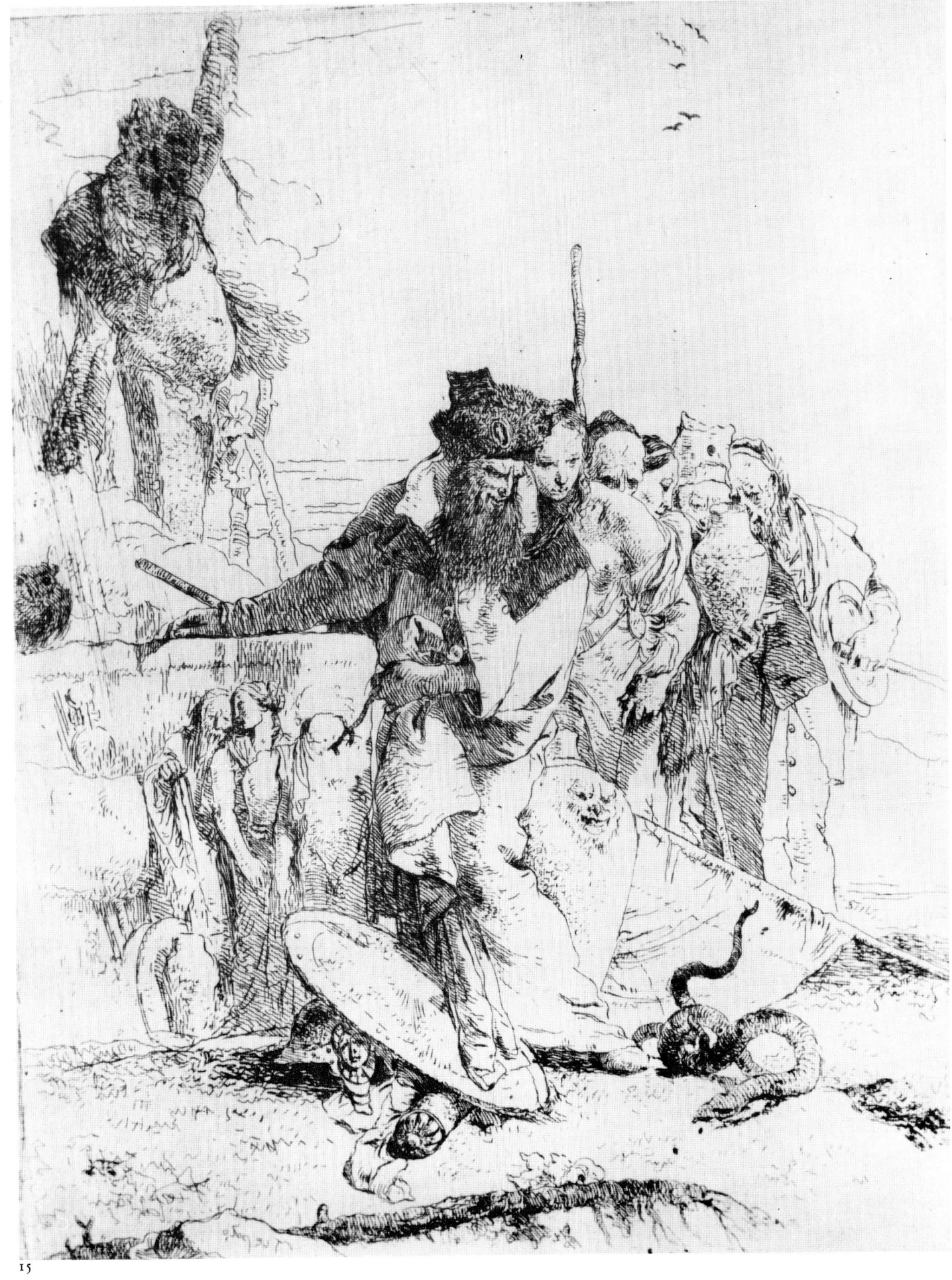

16. Scherzi
Two astrologers and a boy

225 × 175 mm. First state: before the number; second state: *13* at top right. Signed: *Tiepolo*, in reverse, at the bottom.

Knox refers to drawing No. 6312 in the Horne Museum, 'Three Orientals with a tree and a vase' (fig. XVII), which might have suggested this etching (or might be a later variation).

Bibliog.: Nagler, 1847, 12; De Vesme, 1906, 25; Sack, 1910, 13; Hind, 1921, 25; Pallucchini, 1941, 313; Pittaluga, 1952, p. 145; Pignatti, 1965, XXV; Knox, 1966, p. 585; Rizzi, 1970, 15.

XVII

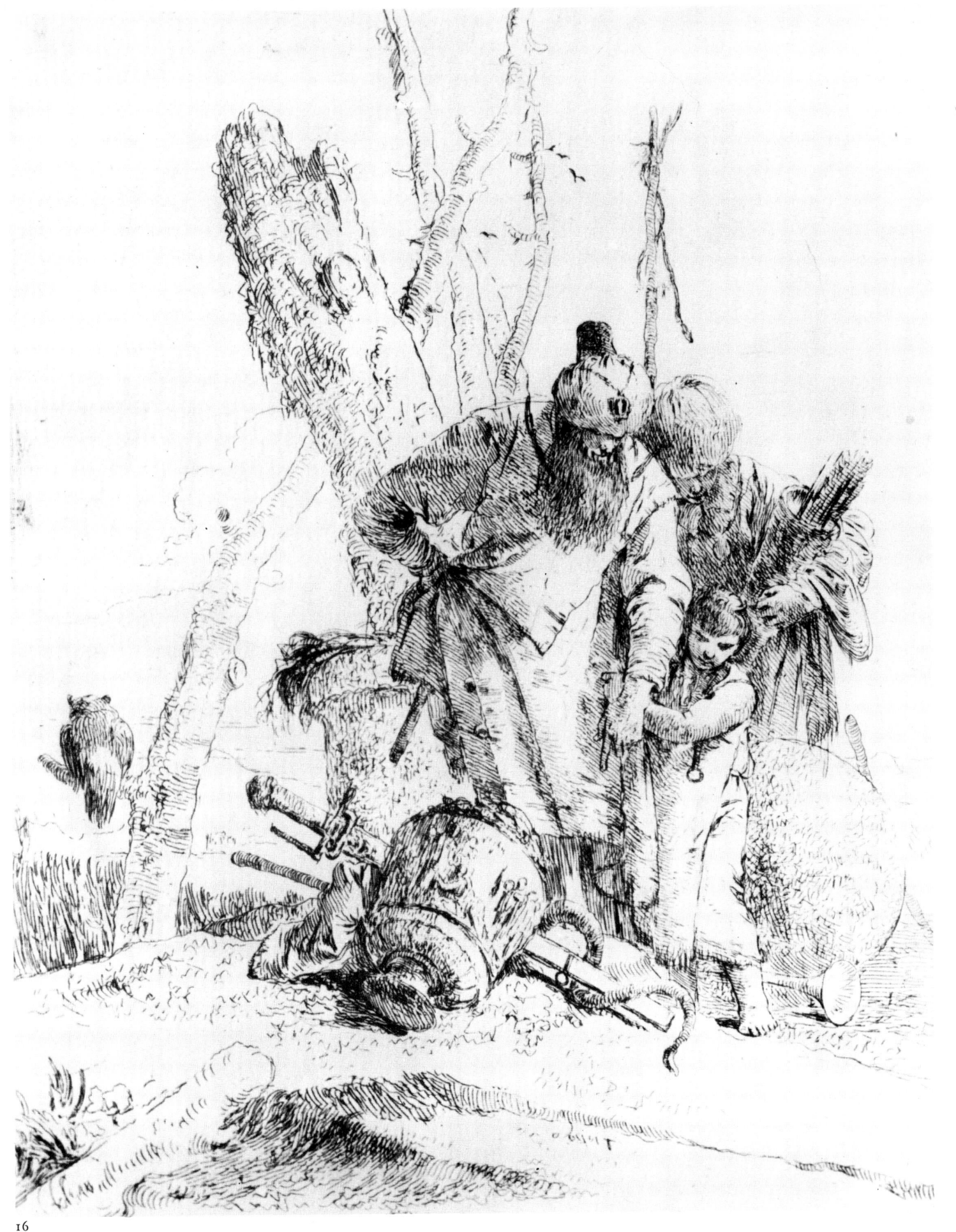

17. Scherzi
Two magicians and two boys

220 × 175 mm. First state: before the number; second state: *14* at top right. Signed: *Tiepolo*, at bottom right.

Reynolds discovered the preparatory drawing in the Victoria and Albert Museum (fig. XVIII), which Knox dates about 1743–4 for its stylistic similarities with the drawings for S. Francesco della Vigna. According to Pignatti, the drawing should be dated later, towards 1760. The author agrees with Knox, but would suggest a slightly earlier date (1740), because the preparatory drawings for Francesco show a lighter and more airy style. The head of the second magician resembles the one in the Trieste drawing No. 174.

Bibliog.: Nagler, 1847, 12; De Vesme, 1906, 26; Sack, 1910, 14; Hind, 1921, 26; Reynolds, 1940, p. 50; Pallucchini, 1941, 314; Vigni, 1942, 174; Knox, 1960, 119; Pignatti, 1965, XXVI; Rizzi, 1970, 16.

XVIII

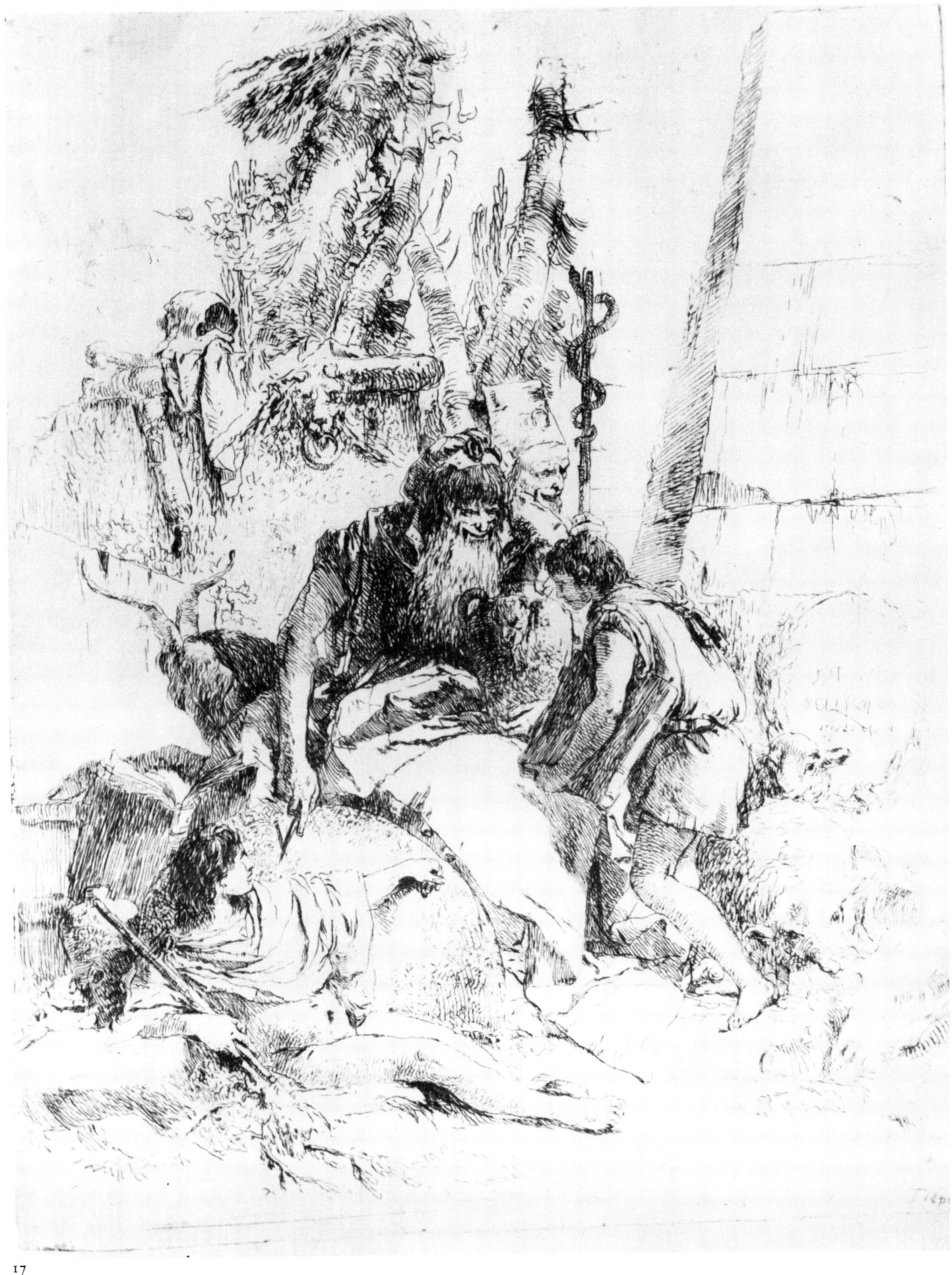

18. Scherzi
The family of the oriental peasant

225 × 175 mm. First state: before the number; second state: *15* at top right. Signed: *Tiepolo*, at bottom right.

Pignatti considers the etching to be ' one of the most delicate in the whole series, for the " Arcadian " group which links Nos. 15, 22, 23, 33 ' (pl. 6, 13, 14 and 24). According to Knox, this scene, and that of two other etchings (pl. 5 and 21), is echoed in a drawing in the Philadelphia Museum, which can be dated about 1735 (fig. XIX). Giandomenico's style in his ' Flight into Egypt ' derives from the iconography and the intimacy of these prints.

XIX

Bibliog.: Nagler, 1837, 21; De Vesme, 1906, 27; Sack, 1910, 15; Hind, 1921, 27; Pallucchini, 14, 315; Pittaluga, 1952, p. 145; Pignatti, 1965, XXVII; Knox, 1970, I, 17; Rizzi, 1970, 17.

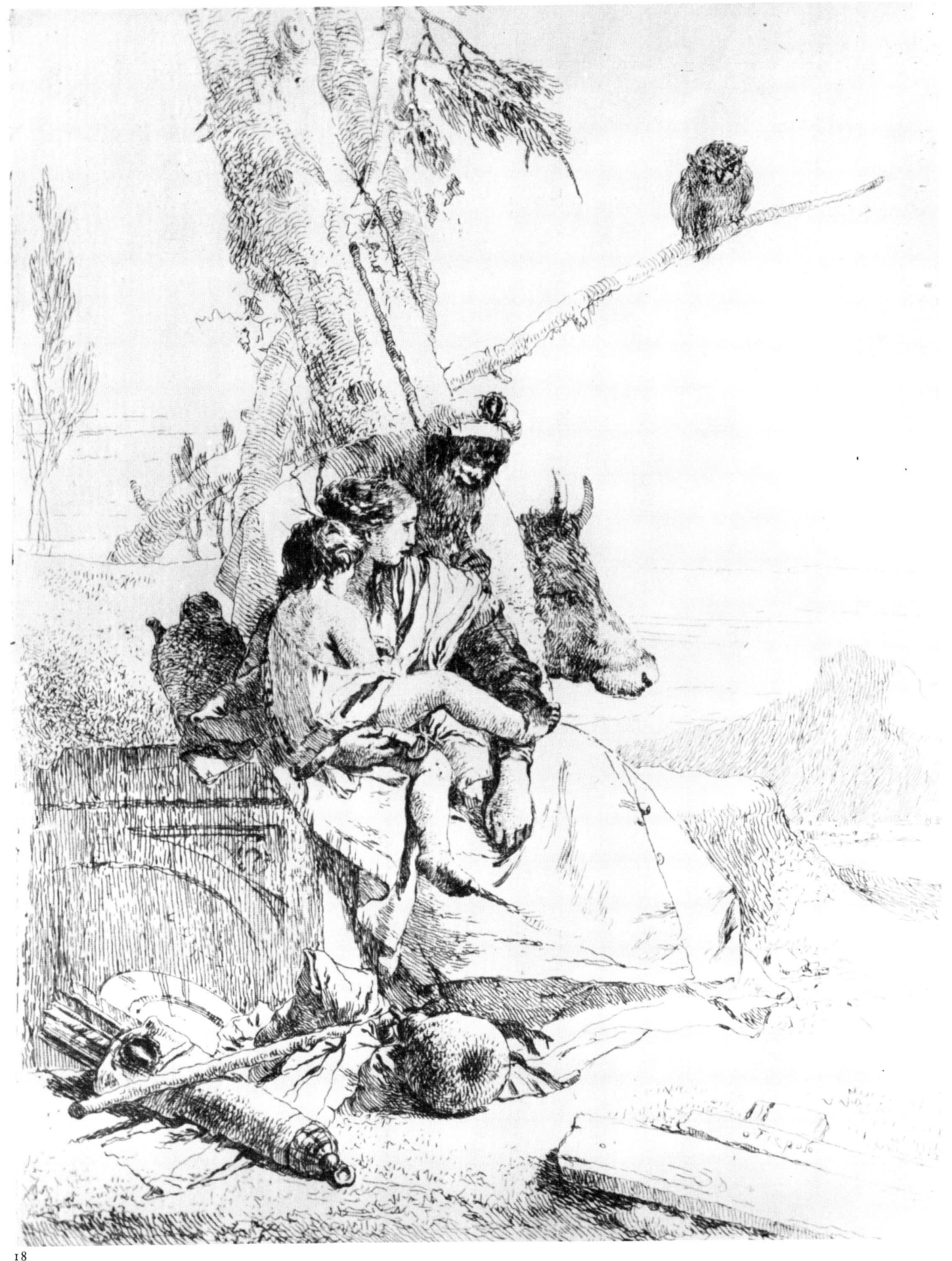

19. Scherzi
A shepherd with two magicians

223 × 175 mm. First state: before the number; second state: *16* at top right. Signed: *Tiepolo*, at bottom left.

Knox believes that this etching is based on drawing No. 6312 in the Horne Museum (fig. XVII), which is also connected with the *Scherzo* illustrated in pl. 16. The author would add a drawing in the Fabre Museum, Montpellier, published by Pallucchini (1937), which shows, in reverse, the standing figures, the one seen from the back and the vase (fig. XX). The bas-relief on the half-buried slab in the foreground is found again not only in the first volume of Giampiccoli's prints but also in other *Scherzi* (pl. 8, 15 and 21) and in Giandomenico's work.

Bibliog.: Nagler, 1847, 12; De Vesme, 1906, 28; Sack, 1910, 16; Hind, 1921, 28; Pignatti, 1965, XXVIII; Knox, 1966, p. 585; Rizzi, 1970, 18.

XX

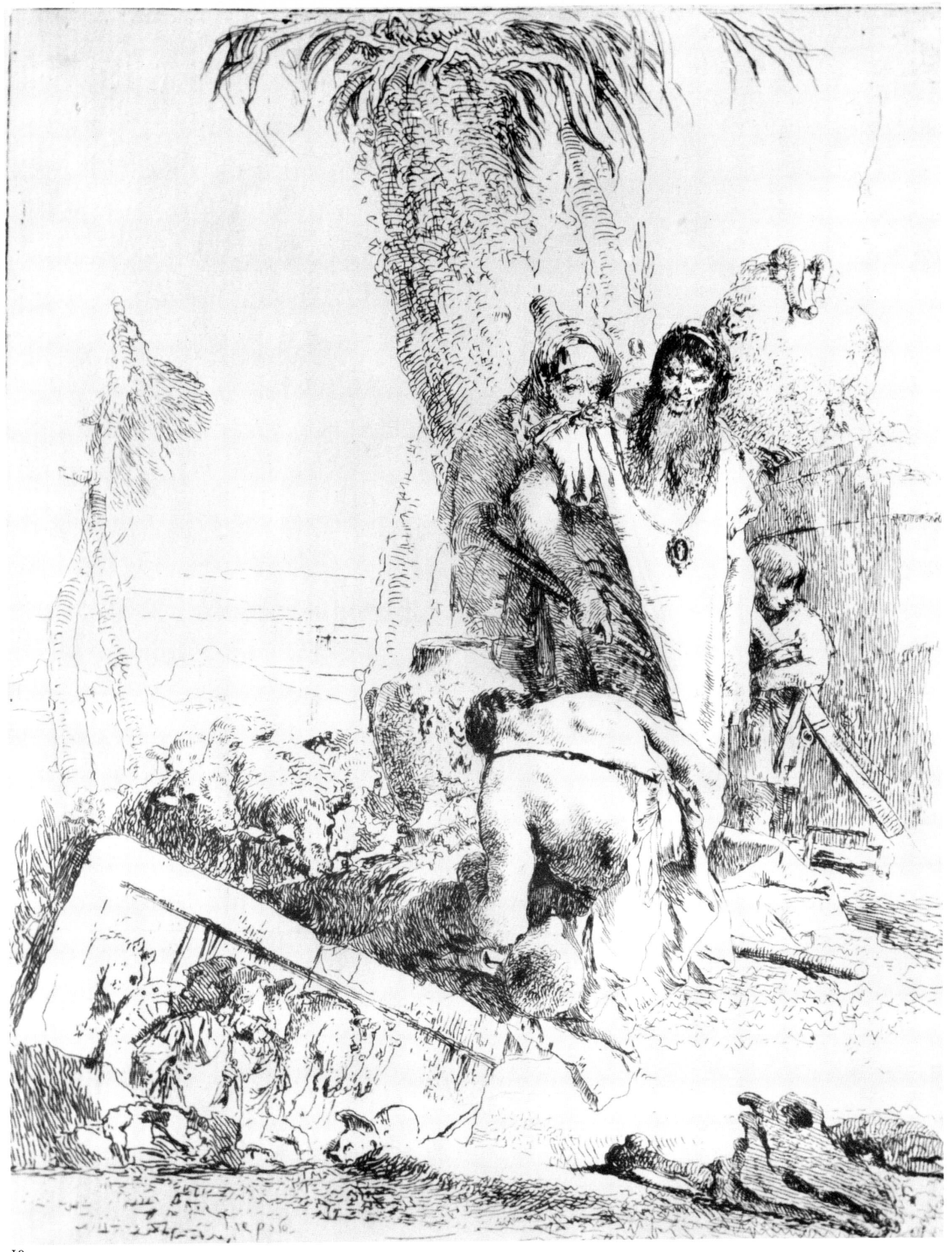

20. Scherzi
The discovery
of the tomb of Punchinello

232 × 182 mm. First state: before the num
ber; second state: *17* top right. Signed: *B
Tiepolo,* at bottom right.

The starting point for this etching
could have been, according to Knox
drawing No. 106r. in the Victoria and
Albert Museum. This connection is
rejected by Pignatti. Later, Knox
related the print to the drawing in the
Hermitage No. 40792 (Salmina, 1964
No. 70) (fig. XXI).

XXI

Bibliog.: Nagler, 1847, 12; De Vesme,
1906, 29; Sack, 1910, 17; Hind, 1921, 29;
Pallucchini, 1941, 316; Pittaluga, 1952, p.
142; Knox, 1960, p. 61; Pignatti, 1965,
XXIX; Knox, 1966, p. 585; Rizzi, 1970,
19.

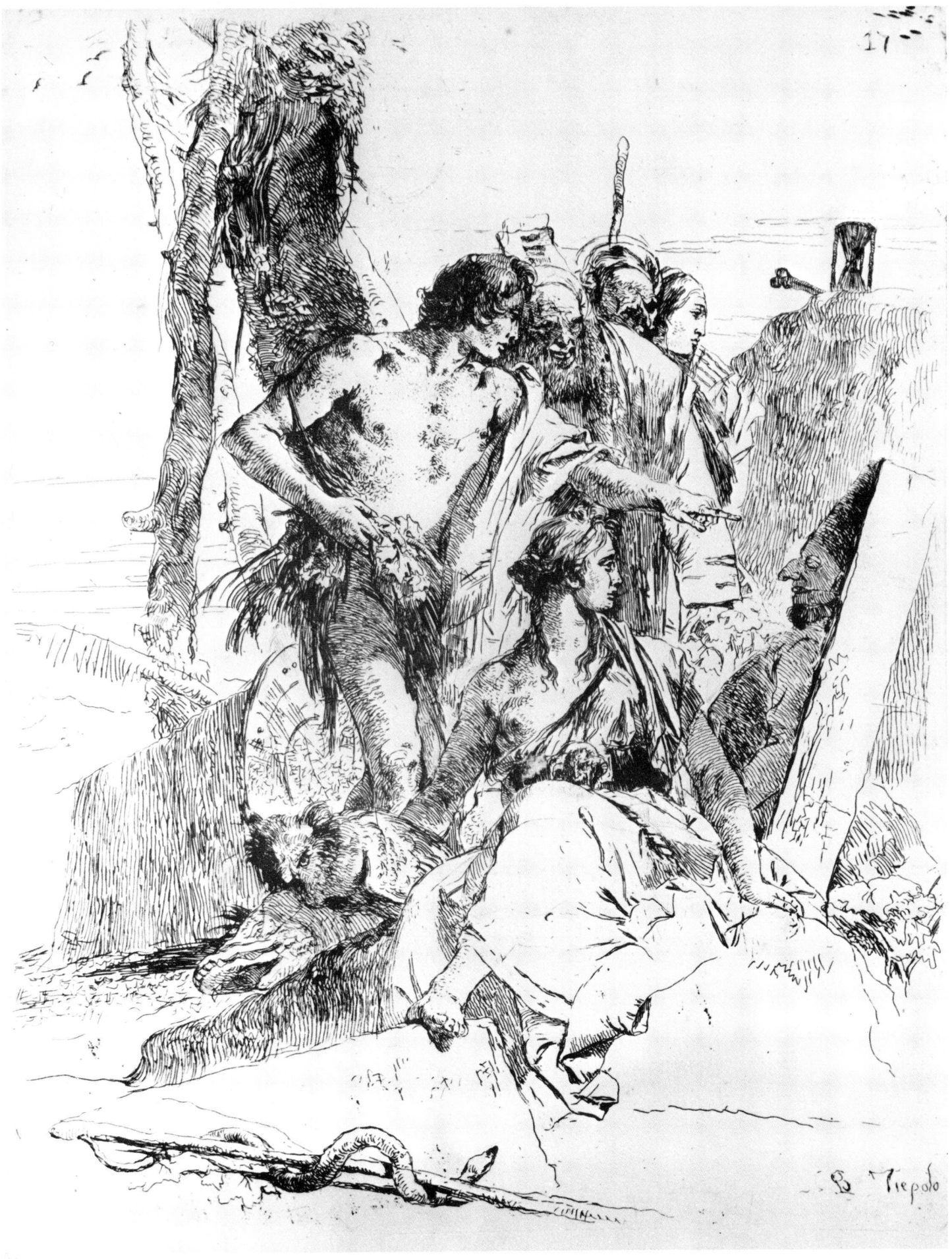

S. Tiepolo

20

21. Scherzi
Young shepherdess and old man with a monkey

226 × 176 mm. First state: before the number; second state: *18* at top right. Signed: *Tiepolo*, at bottom right.

There are significant analogies between this composition and drawing No. 47 in the Victorian and Albert Museum (fig. XXII); this is supported by Knox, but rejected by Pignatti as 'the style would seem to belong to the fourth decade'.

XXII

Bibliog.: Nagler, 1847, 12; De Vesme, 1906, 30; Sack, 1910, 18; Hind, 1921, 30; Pallucchini, 1941, 318; Pittaluga, 1952, p. 145; Knox, 1960, p. 50; Pignatti, 1965, XXX; Rizzi, 1970, 20.

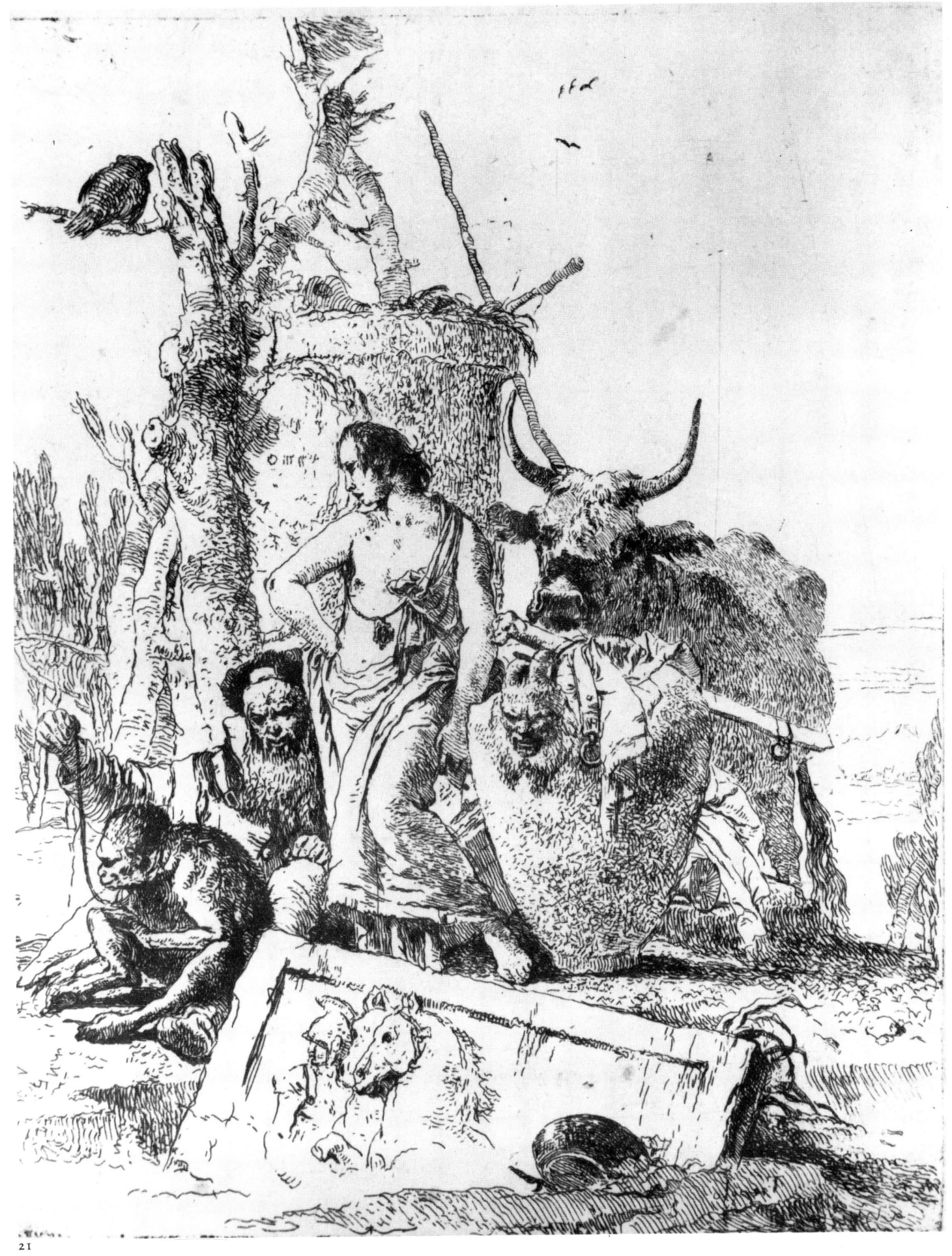

21

22. Scherzi

Three men standing beside a horse

223 × 178 mm. First state: before the number; second state: *19* at top right. Signed with the initials *BTº*, in reverse, at bottom left, on a stone. Beside it are traces of another monogram, apparently composed of the letters *b* and *T*, which has been deleted.

Reynolds identified the preparatory sketch in the Victoria and Albert Museum (fig. XXIII). Knox pointed out that it was gone over with a stylus, the traces of which can still be seen (Tiepolo also used this technique in other cases). The horse can be found again in *Capriccio* No. 38, but the rendering is more mature. This is one of the last of Giambattista's *Scherzi*, as is shown by the pyramidal construction centred on the page and by the greater atmospheric clarity; both were developed in the *Capricci*.

Bibliog.: Nagler, 1847, 12; De Vesme, 1906, 31; Sack, 1910, 19; Hind, 1921, 31; Reynolds, 1940, p. 50; Pallucchini, 1941, 319; Pittaluga, 1952, p. 145; Knox, 1960, 113; Pignatti, 1965, XXXI; Rizzi, 1970, 21.

XXIII

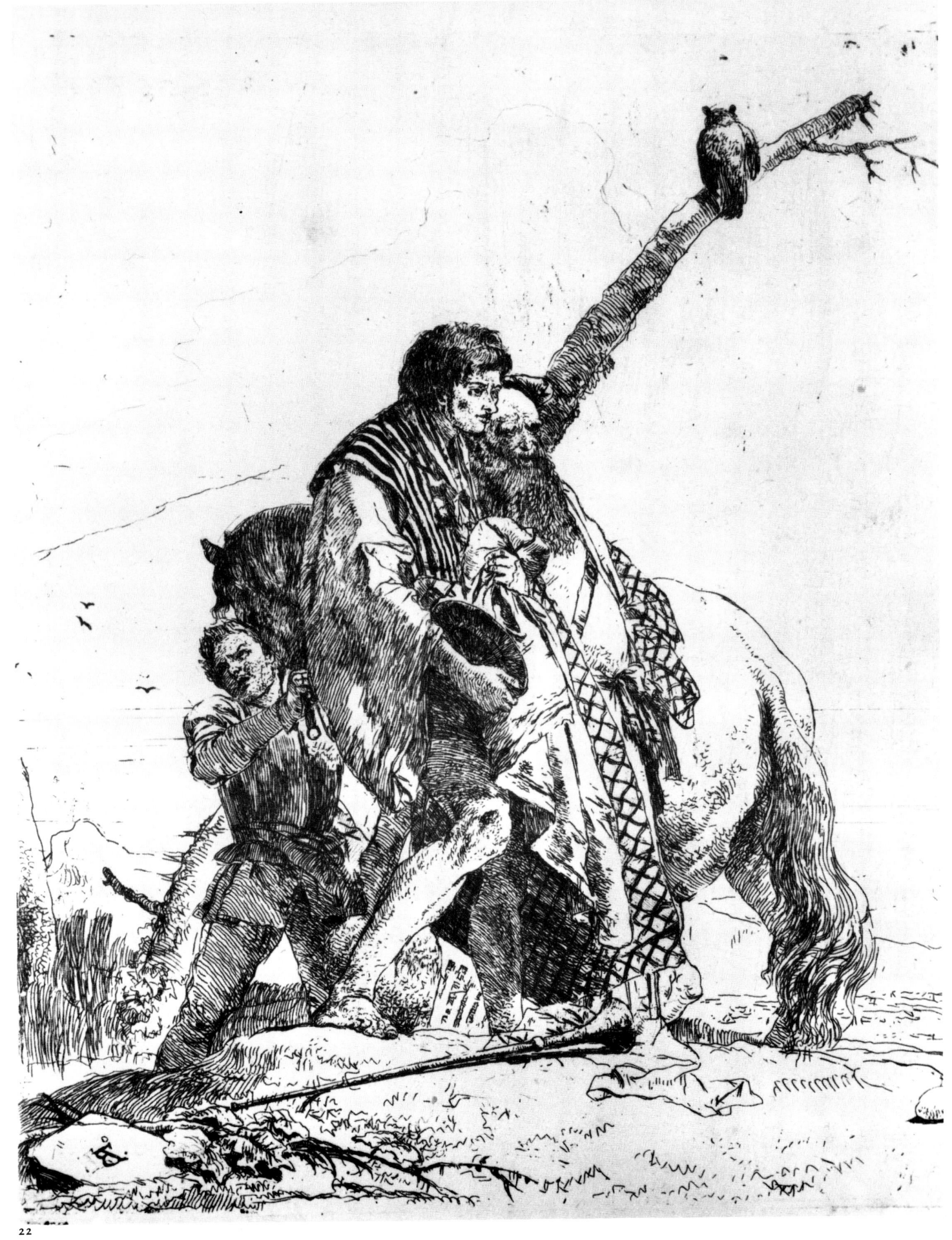

22

23. Scherzi
The philosopher

228 × 172 mm. First state: some impressions show two heads, badly placed between the book and the figure and therefore subsequently cancelled; these impressions are extremely rare; second state: without number; third state: *20* at top right. The signature, *G. B. Tiepolo*, slightly blurred, is at the bottom on the right.

This plate, which must have presented technical problems (proved by the fact that Tiepolo cancelled the two heads between the book and the figure), was left unfinished; nevertheless, Giandomenico included the print in the series of etchings he offered for sale. As Pignatti has noted, the fact that the pyramid on the left, from which a tree trunk rises, has only partly been bitten by the acid also confirms the defective execution. Pignatti regards this as one of the last etchings by Giambattista, datable from the last decades of his activity; the author believes that it is closely related to the prints datable from the end of the fourth decade. Its awkward style and its technical defects suggest that it was one of the first in the series.

Bibliog.: Nagler, 1847, 12; De Vesme, 1906, 32; Sack, 1910, 20; Hind, 1921, 32; Pallucchini, 1941, 320; Pittaluga, 1952, p. 145; Pignatti, 1965, XXXII; Rizzi, 1970, 22.

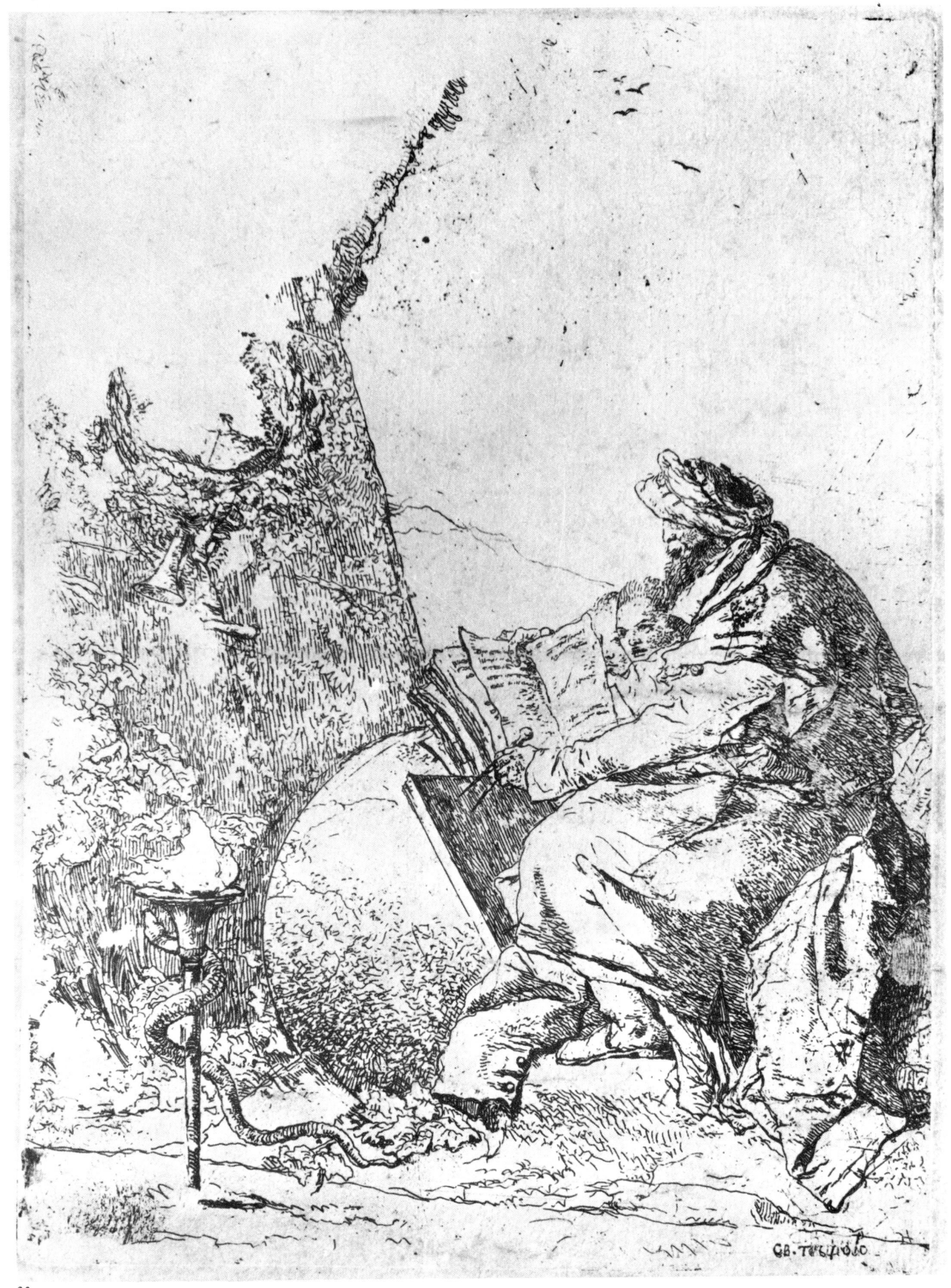

24. Scherzi
A mother with two children

226 × 175 mm. First state: before the number; second state: *21* at top right. Signed: *Tiepolo*, in reverse, at bottom centre.

Drawing No. 216 in the Trieste Museum (fig. XXIV) may have been a first sketch for the figures of the mother and the children. As Pignatti points out, the donkey was to be copied by Giandomenico in plate 13 of his *Flight into Egypt* (see pl. 79).

XXIV

Bibliog.: Nagler, 1847, 12; De Vesme, 1906, 33; Sack, 1910, 21; Hind, 1921, 33; Pallucchini, 1941, 321; Pignatti, 1965, XXXIII; Rizzi, 1970, 23.

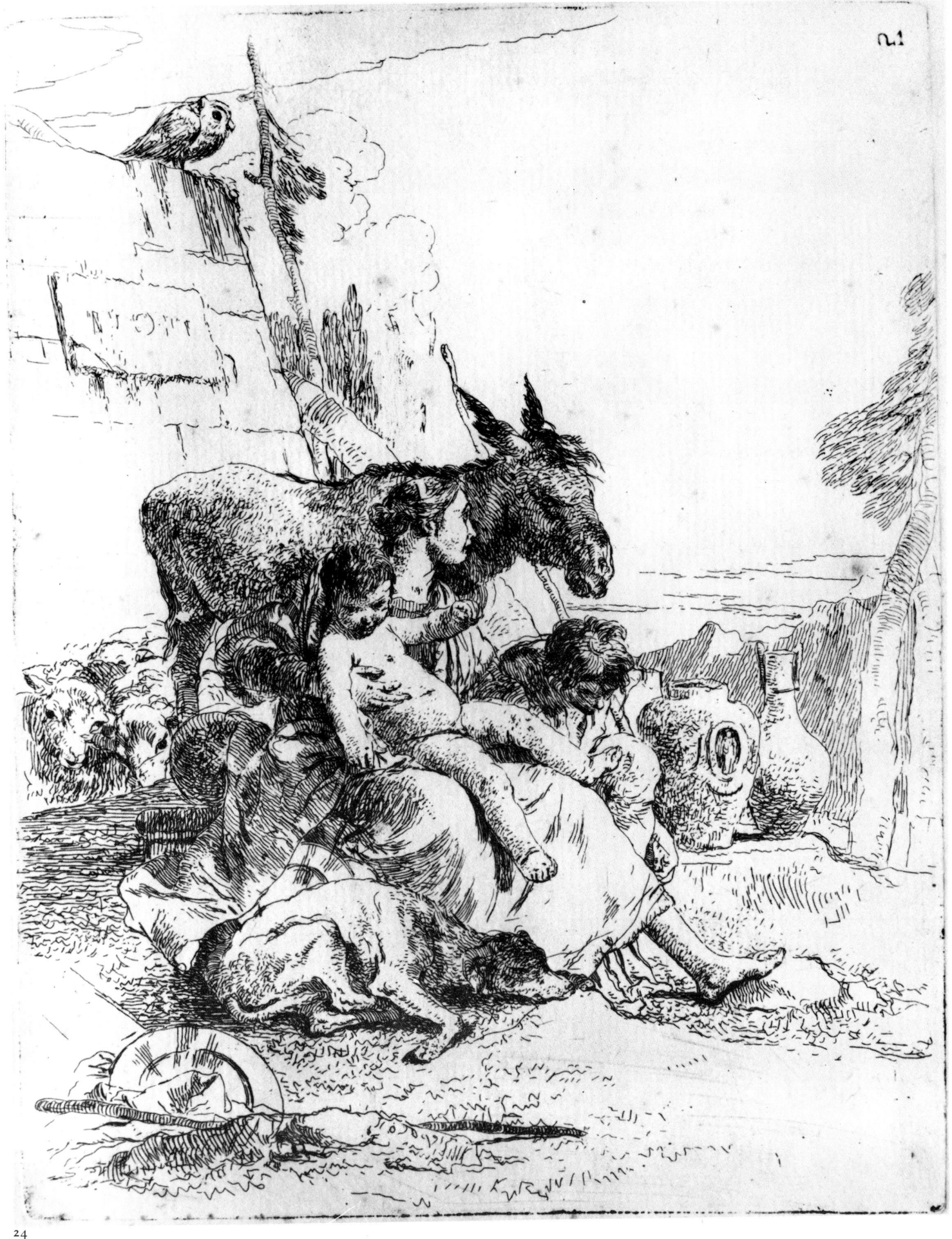

24

25. Scherzi
Two magicians and a child

140 × 188 mm. First state: before the number; second state: *22* at top right. Signed: *Tiepolo*, at bottom right, on a stone.

A preparatory sketch for this etching is identified by Sack in a drawing from the Eissler Collection, Vienna (fig. XXV), which, on account of its style, is dated by Pignatti from the fourth decade; consequently, Pignatti does not accept this drawing as a preliminary study, and concludes that 'at best, it could only be an earlier version'. Knox stresses that this page 'is very close in style to the drawing engraved by Pietro Monaco' and dates it about 1730 (1965). The Viennese drawing is closely connected in style with the one in the Wallraf Collection, which was used in another *Scherzo* (see pl. 14). The Eissler drawing was faithfully copied by Gianantonio Guardi (see A. Morassi, *Antonio Guardi as a draughtsman*, in *Master Drawings*, 1968, No. 2, pl. 26).

Reynolds saw a general connection between this etching and drawing No. 109v. in the Victoria and Albert Museum, which is close to the decoration of the Villa Loschi at Biron. The horizontal composition anticipates the format of the *Capricci*.

Bibliog.: Nagler, 1847, 12; De Vesme, 1906, 34; Sack, 1910, 22; Hind, 1921, 34; Reynolds, 1940, p. 50; Pallucchini, 1941, 322; Knox, 1960, p. 61; Pignatti, 1965, XXXIV; Knox, 1966, p. 585; Rizzi, 1970, 24.

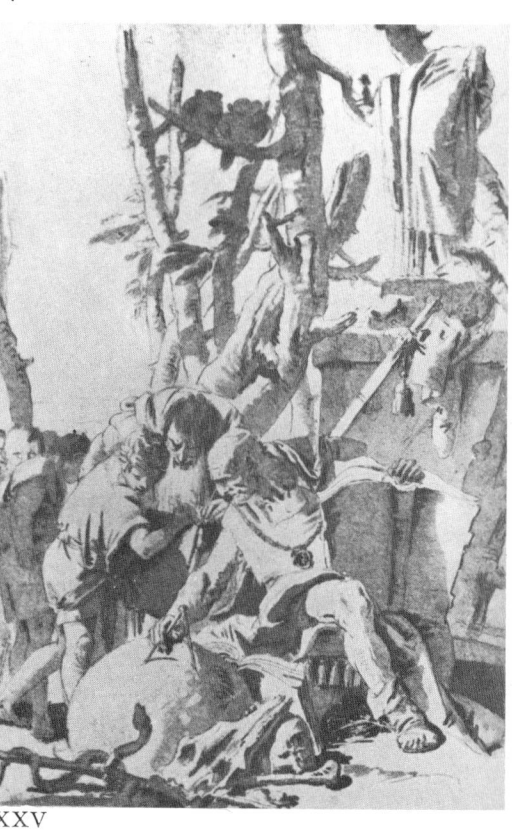

XXV

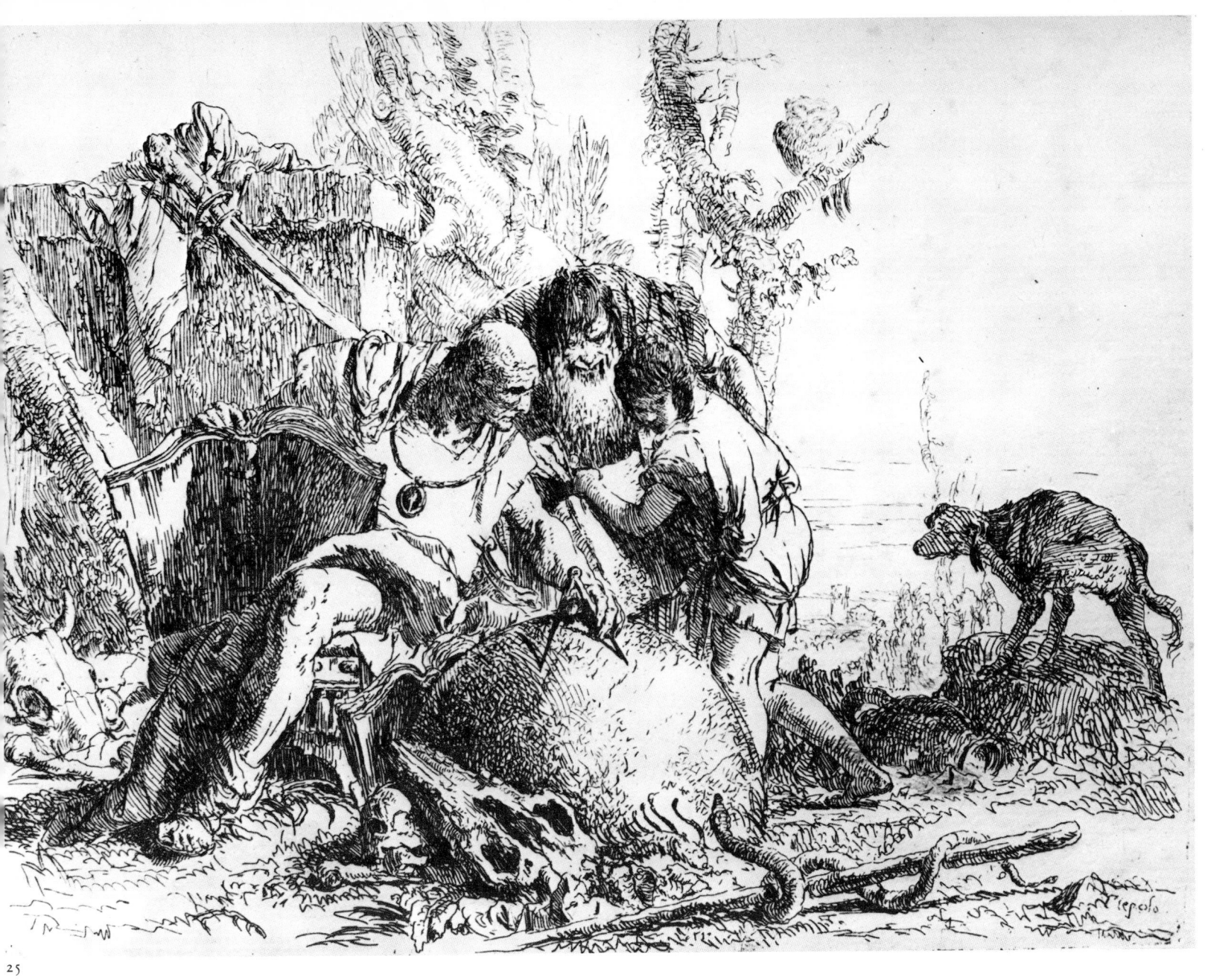

25

26. Scherzi
Bacchant, satyr and fauness

130 × 200 mm. First state: before the number; second state: *23* at top right. Signed with the monogram *BT*º, in reverse, at bottom left.

The leafy fir-tree, which has its origins in the Trieste drawings Nos 175–185, recalls other prints (pl. 6 12 and 13). As in the preceding *Scherzo*, the change to a horizontal format anticipates the Capricci.

Knox sees a close graphic and iconographic relationship with drawing No. 24 in the Victoria and Albert Museum (fig. XXVI), which is a study for 'a painting of the 30s' in the Cailleux Collection.

XXVI

Bibliog.: Nagler, 1847, 12; De Vesme, 1906, 35; Sack, 1910, 23; Hind, 1921, 35; Pallucchini, 1941, 323; Pignatti, 1965, XXXV; Knox, 1966, 585; Rizzi, 1970, 25.

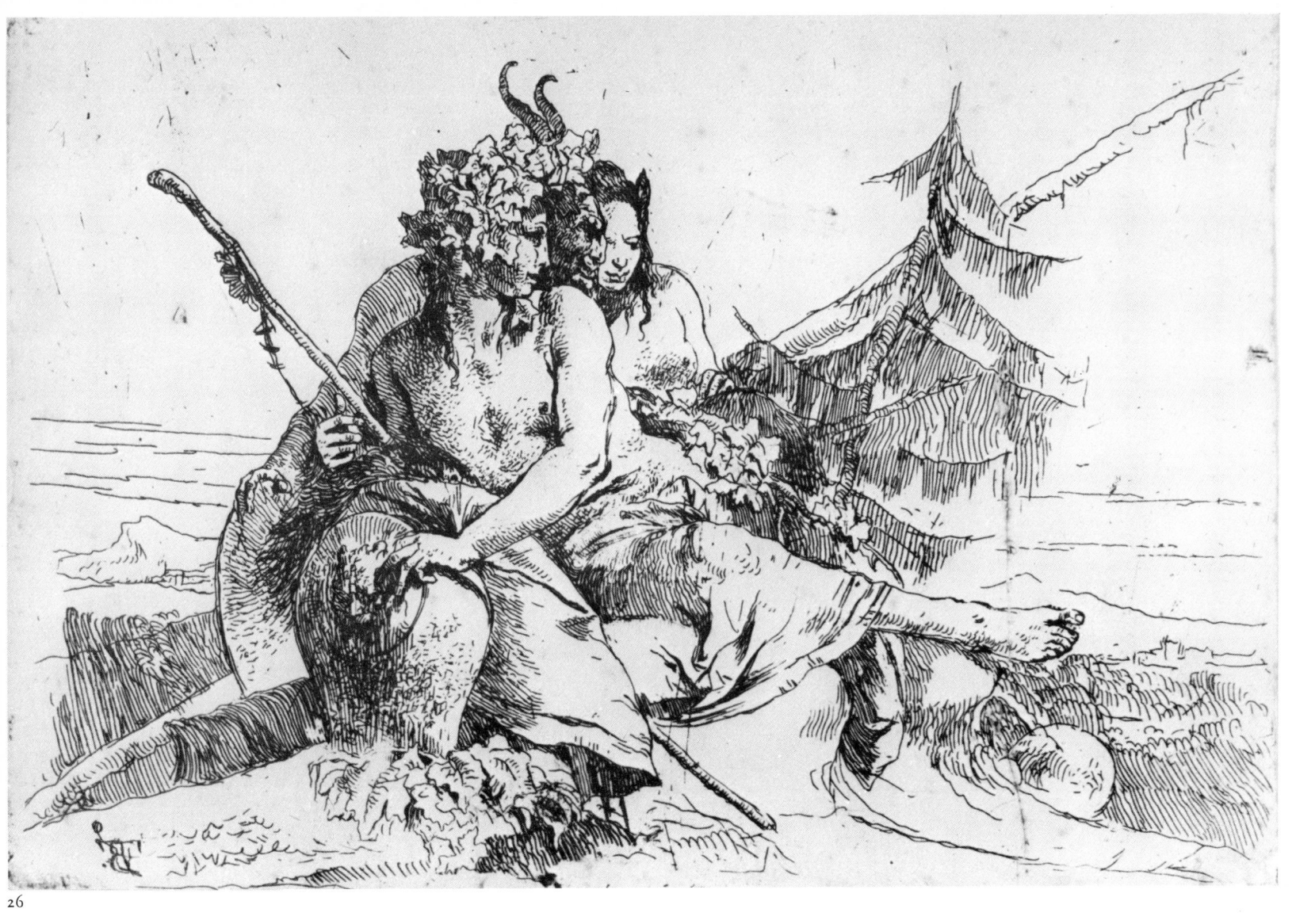

26

27. Adoration of the Magi

431 × 290 mm. First state: before the numbers; second state: *3* top left; third state: besides the *3*, *25* top right. Signed: *Tiepolo*, on a slab at bottom left. De Vesme and Sack mention a fourth state, retouched on the ground; but Pignatti's examination of the original copperplate in the Correr Museum, Venice, would seem to exclude it. This sheet was added by Giandomenico in 1775 to the 23 *Scherzi di Fantasia*, immediately following the *S. Joseph* (see pl. 28).

Nagler, in accordance with Bermudez and followed by De Vesme and others, linked this etching with a painting, now lost, for the chapel of the Royal Palace at Aranjuez, which was painted in 1766; Sack rejects the connection. According to Cailleux, who discovered a drawing likely to be a preparatory one, the etching is considerably earlier. Pignatti relates it to the painting executed for the Benedictine church of Schwarzach in 1753, now in the Munich Pinakothek, and finds close stylistic similarity to the *Scherzi* executed between 1750 and 1760.

The present author's proposal to date the *Scherzi* between 1735 and 1740 affects this sheet, for which it is easy to find parallels for the style and iconography in that period. The type of the Virgin is the same as in the 'Virgin and Child with an Angel' (Bergamo, private collection), datable about 1735 (Morassi, 1962, pl. 80), and was clearly copied by Giandomenico in his 'Rest on the Flight into Egypt' of 1750 (see pl. 79). We also know that Giandomenico, between 1735 and 1745, often used this theme for graphic experiments (Knox, 1970, I, 21). The sheet discovered by Cailleux, which Knox attributes to Giovanni Raggi, and the one in the Schickman Gallery in New York, attributable to the same artist, both of which are influenced by this print or by a common Tiepolo prototype, develop the figure types typical of the period. The stylistic similarity with the *Scherzi* allows us to date the etching about 1740.

Bibliog.: Cean Bermudez, 1800, p. 46; Nagler, 1847, 2; De Vesme, 1906, 1; Sack, 1910, 25; Hind, 1921, 1; Pallucchini, 1941, 325; Pittaluga, 1952, 148; Cailleux, 1952, 14; Pignatti, 1965, I; Knox, 1970, II, 22; Rizzi, 1970, 26.

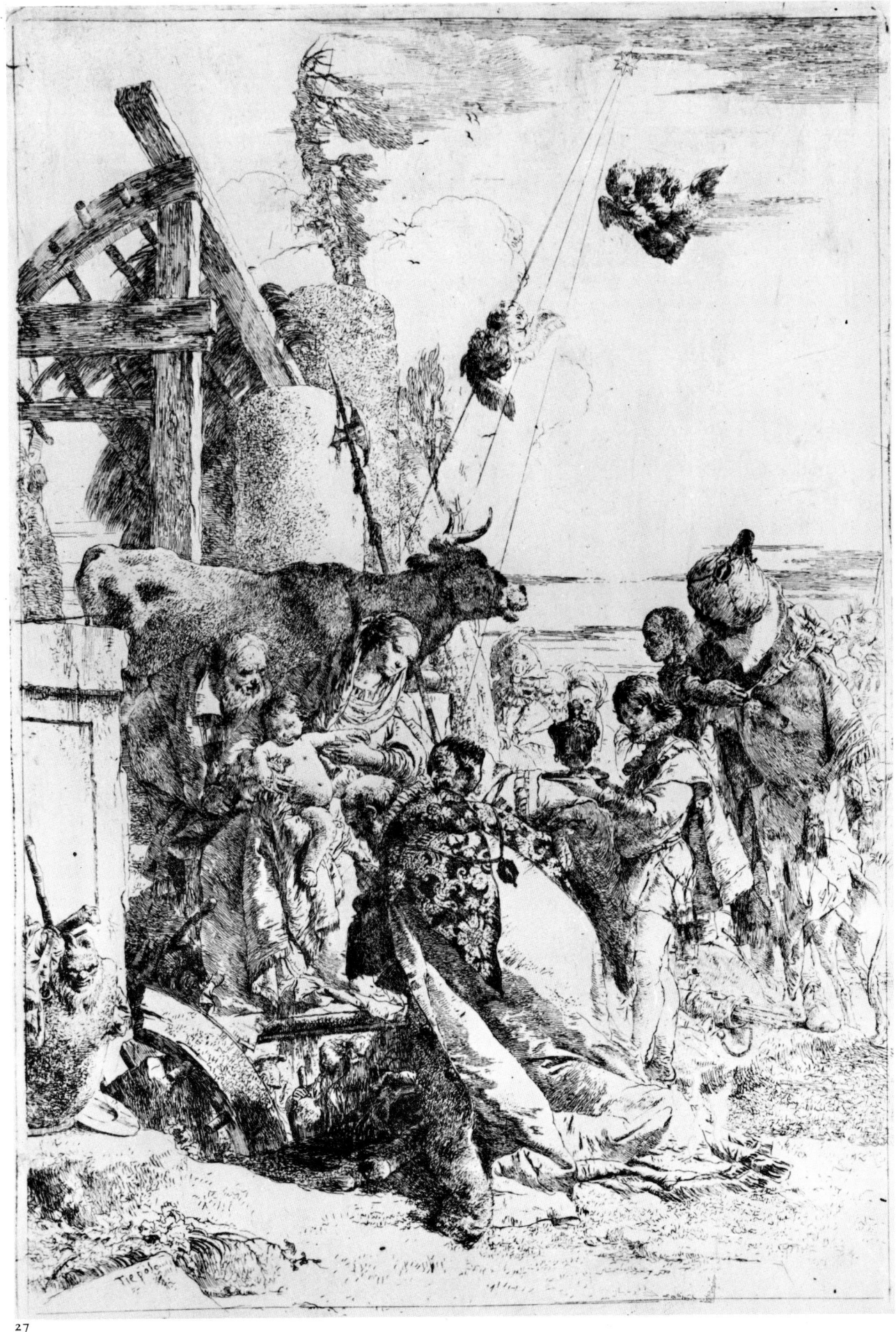

27

28. St. Joseph with the Child Jesus

96 × 87 mm. First state: before the number; second state: *24* at top right. Signed with the monogram *BTºF*, in reverse, at bottom right.

This small print appeared in the first edition of the ' Catalogue ' published by Giandomenico, as the fifteenth *Scherzo*; in the second edition it was placed after the 23 *Scherzi* and before the 'Adoration of the Magi'

According to Sack, the last catalogue of Tiepolo's etchings showed, as a pendant to this one, a ' Virgin and Child ' by Giandomenico, probably executed in Spain (see pl. 254). As Pignatti rightly stresses, this does not prove that the ' St. Joseph with the Child ' is a late etching for its style is close to that of the *Adoration*. Molmenti maintained that this plate was derived from the painting of the same subject in Stuttgart, which Morassi attributes to Giandomenico and dates about 1760–70 (1962, p. 50).

Bibliog.: Nagler, 1847, 9; De Vesme, 1906, 2; Sack, 1910, 24; Molmenti, 1911, p. 178; Hind, 1921, p. 2; Pallucchini, 1941, 324; Pignatti, 1965, II; Rizzi, 1970, 27.

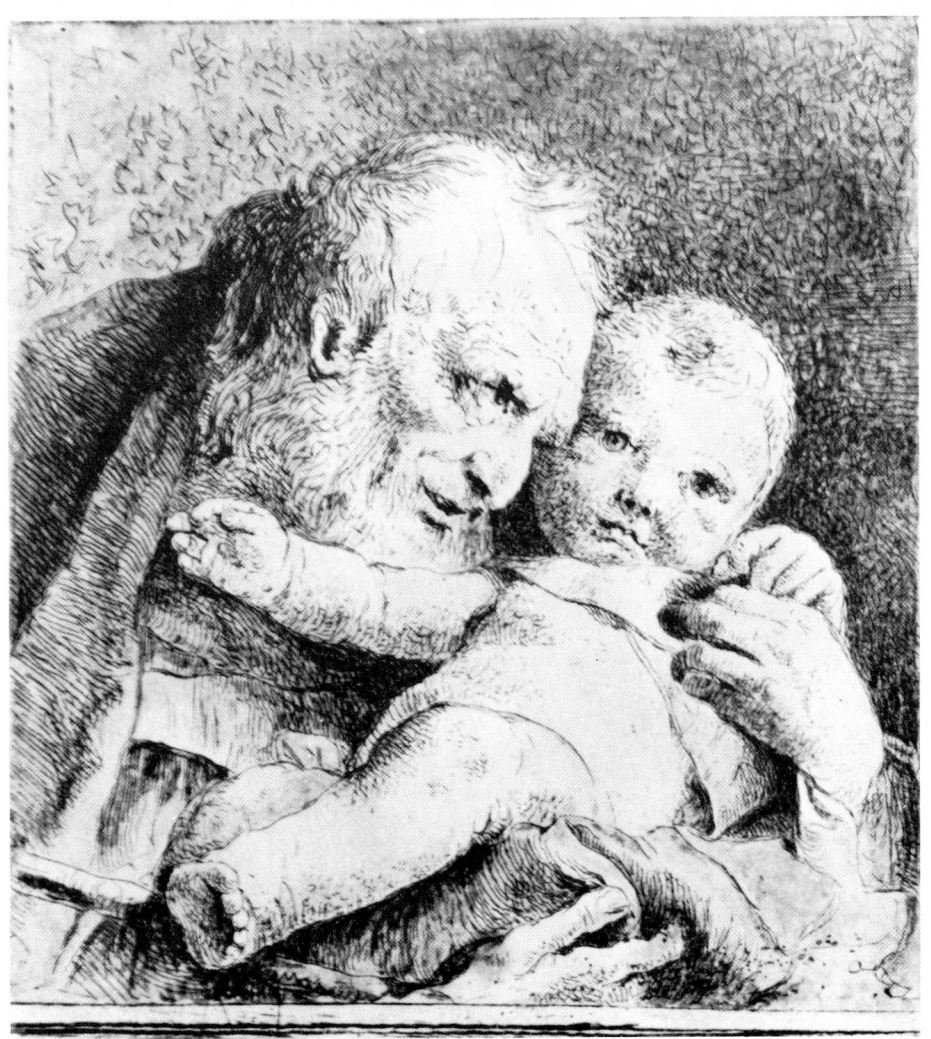

28

29. Capricci
**Seated youth
leaning against an urn**

140 × 180 mm. Signed: *Tiepolo*, on the vase.

The copperplates for the *Capricci* were probably taken from Giambattista by his friend Anton Maria Zanetti, the engraver and collector, who published them for the first time in the second edition of his 'Raccolta di chiaroscuri', issued in two volumes with the inscription: 'Diversarum Iconum / quas ex autographis schedis / Francisci Mazzuolae Parmensis / ex Museo suo / Deprompsit et monochromatos typis vulgavit / Anton Maria Zanetti / Serie Secunda'. The frontispiece of the first edition is dated 'Venetiis 1739-1743'. The volume includes 71 chiaroscuro prints by Zanetti and 29 copper engravings by various artists, among which, according to Lorenzetti, were 'probably also the ten *Capricci* by Tiepolo', which Zanetti himself added at the end of the second volume in the third edition of the 'Raccolta', published in 1749; this was inscribed: 'Raccolta / di varie stampe e chiaroscuro / tratte da disegni originali di / Francesco Mazzuola / detto il Parmigianino / e d'altri insigni autori / da / Anton Maria Zanetti, Q m. Gir. / che gli stessi disegni possiede / in Venezia MDCCXLIX.' The dedication addressed to the Prince of Liechtenstein is dated 26 January 1751, which led Lorenzetti to believe either that the 'Raccolta', although ready in 1749, was not published until 1751, or that the dedication was included at a later stage together with the list of contents, when the first copies of the 'Raccolta' were already being circulated. In this dedication Zanetti mentioned that he had added a few etchings 'which were created and engraved by the famous Gio. Battista Tiepolo himself, and which, being witty and highly tasteful, are worthy of the greatest esteem'.

In 1785, fifteen years after Giambattista's death, a separate edition of the *Capricci* was published, with a frontispiece carrying the following inscription: 'VARJ CAPRICCJ / Inventati, ed Incisi / DAL CELEBRE GIO. BATTISTA TIEPOLO / nuovamente Pubblicati / E DEDICATI / al Nobile Signore / L'ILL.mo S. GIROLAMO MANFRIN / MDCCLXXXV ' (fig. XXVIII). It can be assumed that the work was sponsored by Giandomenico when his father's plates were recovered.

The preparation for this etching, both in a figurative and a chronological sense, is found by Vigni in drawing No. 110 in Trieste (fig. XXVII), which can be dated on the basis of its style to the 1740s (an angular, sharp line which was later copied by Giandomenico).

Bibliog.: Nagler, 1847, 13; De Vesme, 1906, 3; Sack, 1910, 26; Lorenzetti, 1917, 54-59; Hind, 1921, 3; Pallucchini, 1941, 297; Vigni, 1942, p. 49; Pittaluga, 1952, p. 135; Pignatti, 1965, III; Rizzi, 1970, 28.

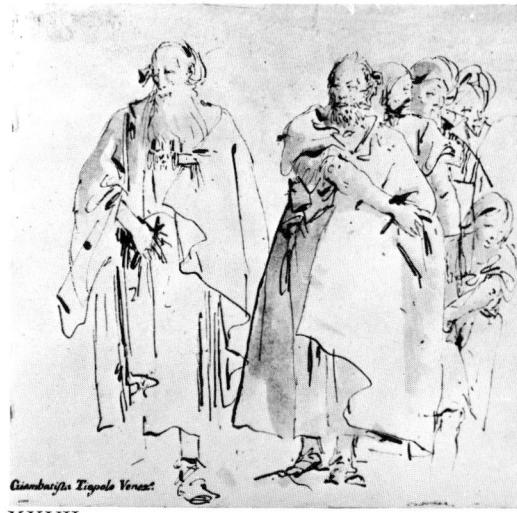

XXVII

XXVIII

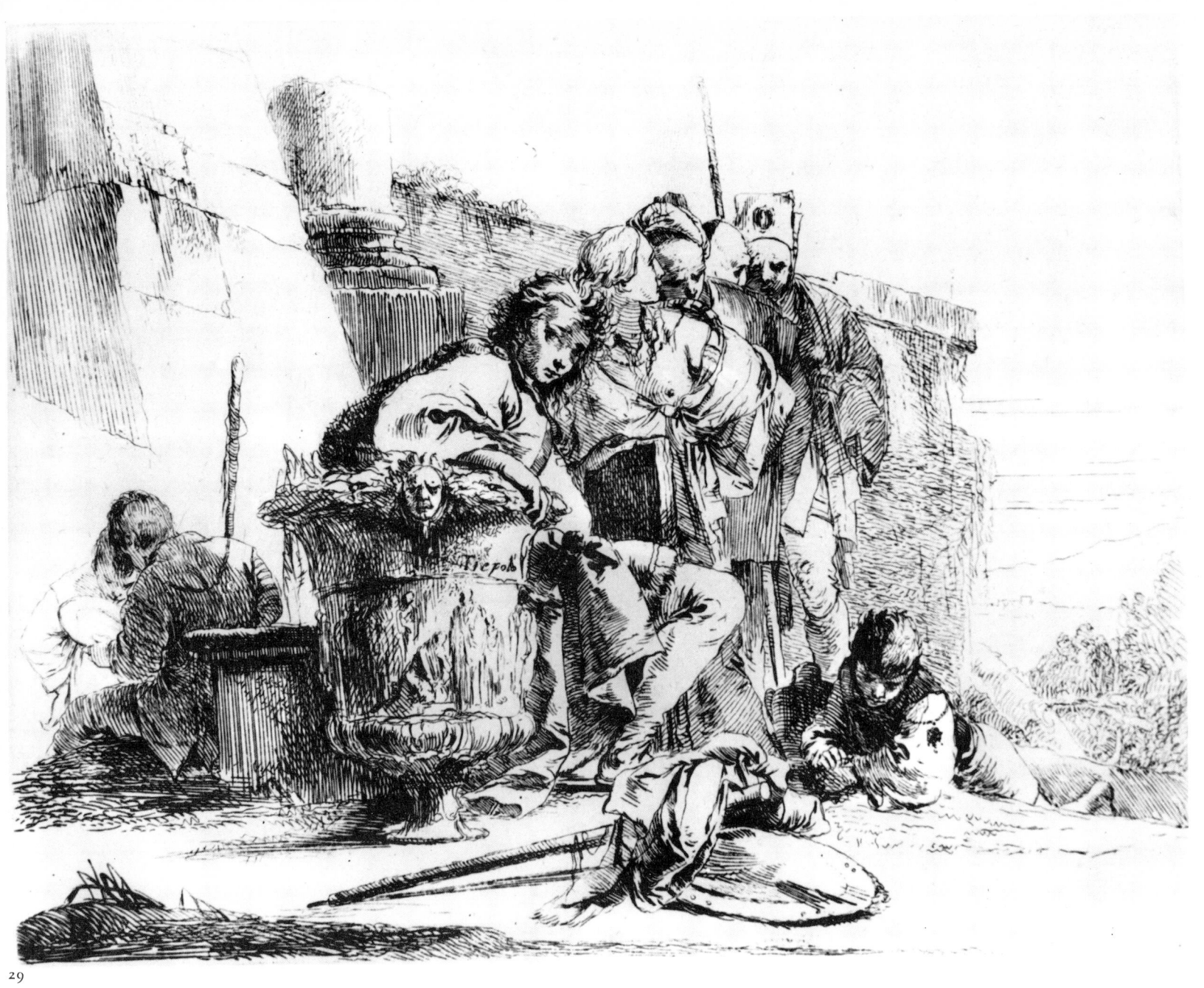

29

30. Capricci
Three soldiers and a boy

142 × 176 mm. Signed: *Tiepolo*, on the pyramid.

Vigni finds a certain similarity between the subject of this etching and the one of drawing No. 169 in Trieste (1942, p. 59) (fig. XXIX).
According to the present author, this etching is close, both in technique and in imagination, to some of the *Scherzi* (see pl. 10 and 19).
The standard-bearer derives from Piazzetta.

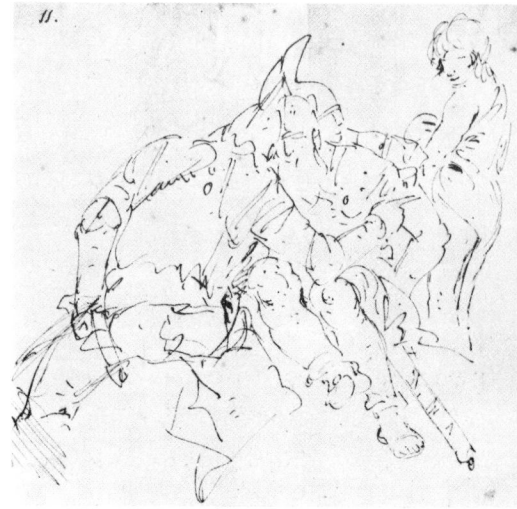

XXIX

Bibliog.: Nagler, 1847, 13; De Vesme, 1906, 4; Sack, 1910, 27; Hind, 1921, 4; Pallucchini, 1941, 298; Pittaluga, 1952, p. 132; Pignatti, 1965, IV; Rizzi, 1970, 29.

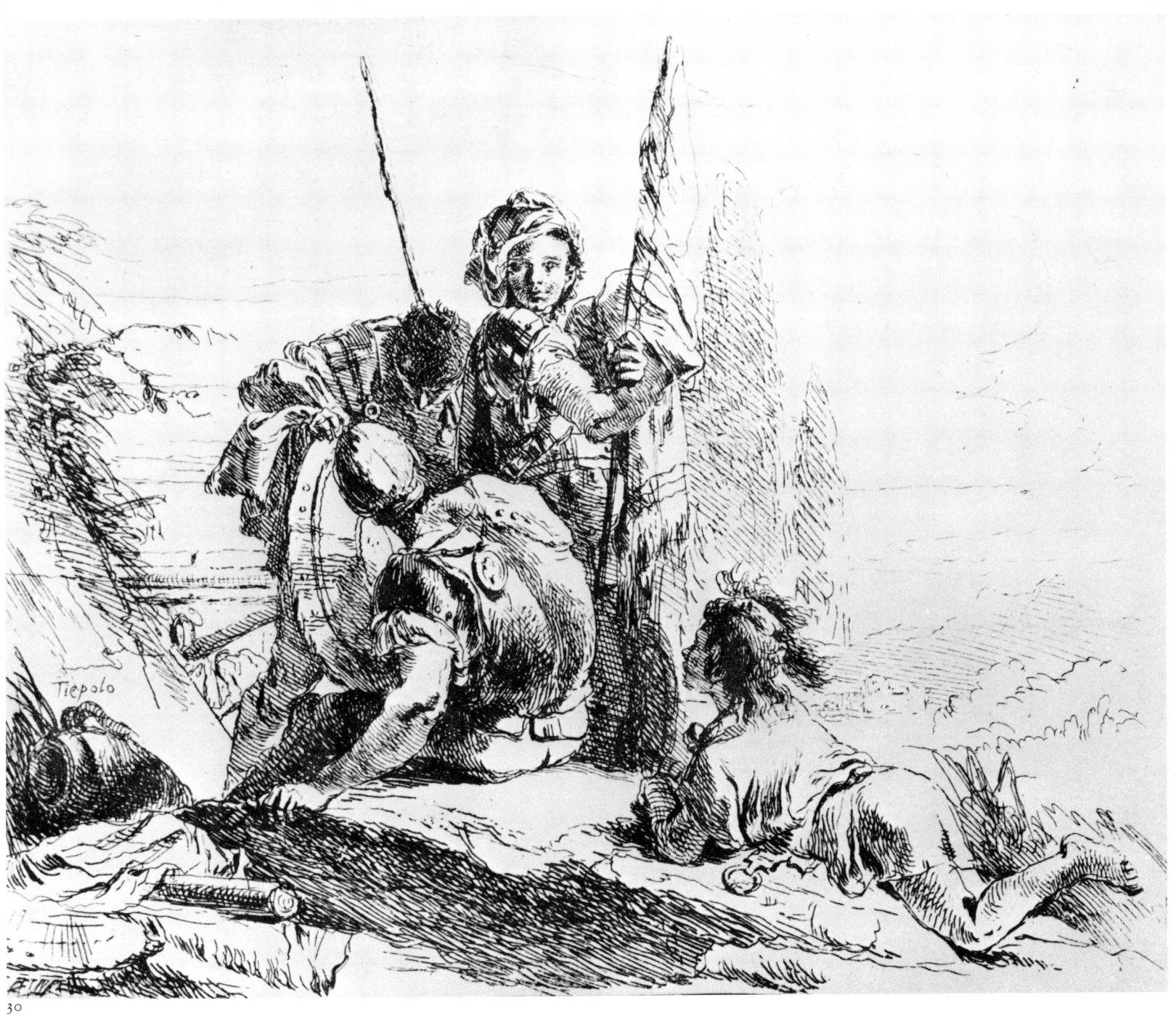

Tiepolo

30

31. Capricci
Two soldiers and two women

134 × 171 mm. Signed: *Tiepolo*, on the sarcophagus.

Knox links to this Capriccio the verso of drawing No. 110 in the Victoria and Albert Museum, which consists of a study for the seated soldier in the foreground (fig. XXX); although the figure is drawn in the same direction as in the etching, unlike real preparatory studies, one cannot fail to recognize a link between the two works. Knox also mentions the seated figure in drawing No. 46 in the Victoria and Albert Museum, stressing its general similarity.

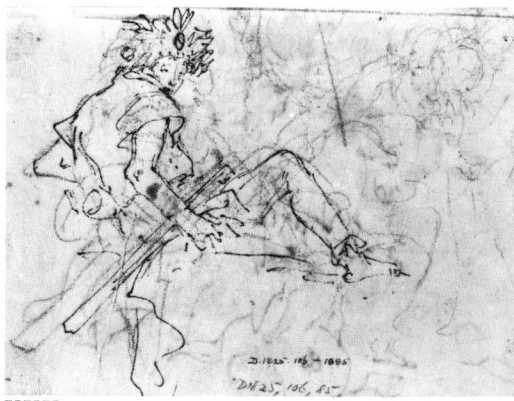

XXX

Bibliog.: Nagler, 1847, 13; De Vesme, 1906, 5; Sack, 1910, 28; Hind, 1921, 5; Pallucchini, 1941, 299; Pittaluga, 1952, p. 134; Knox, 1960, pp. 50 and 62; Pignatti, 1965, V; Rizzi, 1970, 30.

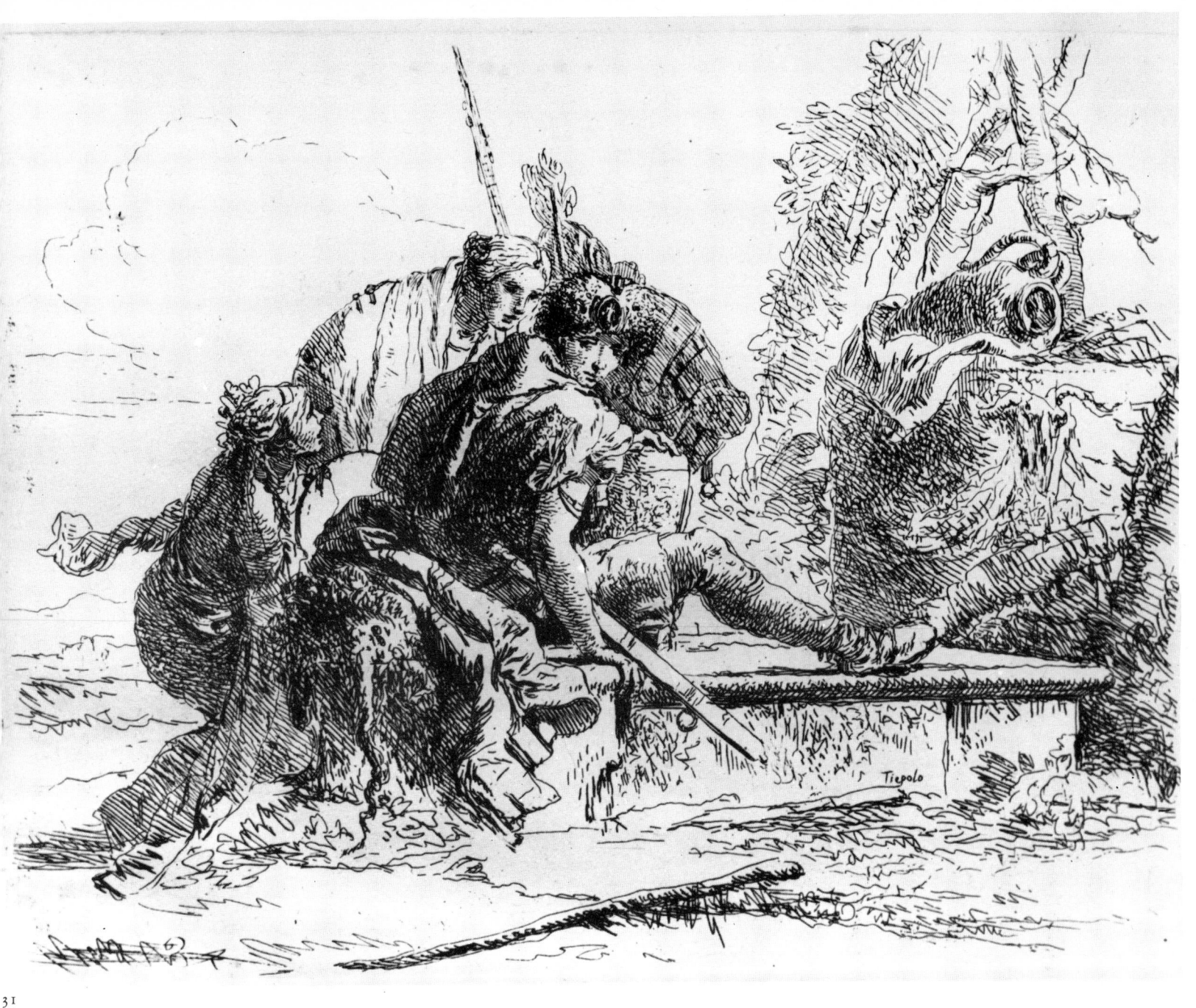

31

32. Capricci
A woman with her hands on vase, a soldier and a slave

137 × 175 mm. Signed: *Tiepolo*, on the bas of the pyramid.

The woman and the soldier with the helmet were preceded by drawing No 17 in the Victoria and Albert Museum (fig. XXXI). Pignatti points ou that the slave seen from behind appears, in reverse, in Gianantonic Guardi's altarpiece at Pasiano di Por denone in 1750. The same figure was often used by Giambattista in his *Scherzi*.

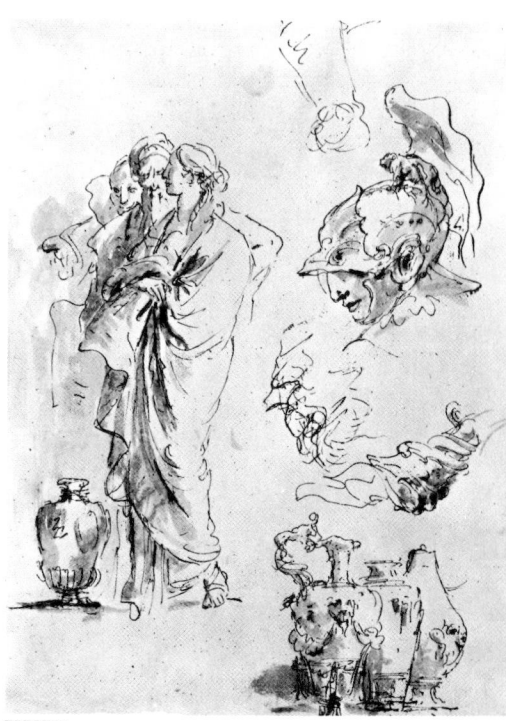

XXXI

Bibliog.: Nagler, 1847, 13; De Vesme, 1906, 6; Sack, 1910, 29; Hind, 1921, 6; Pallucchini, 1941, 300; Pittaluga, 1952, p. 132; Pignatti, 1965, VI; Rizzi, 1970, 31.

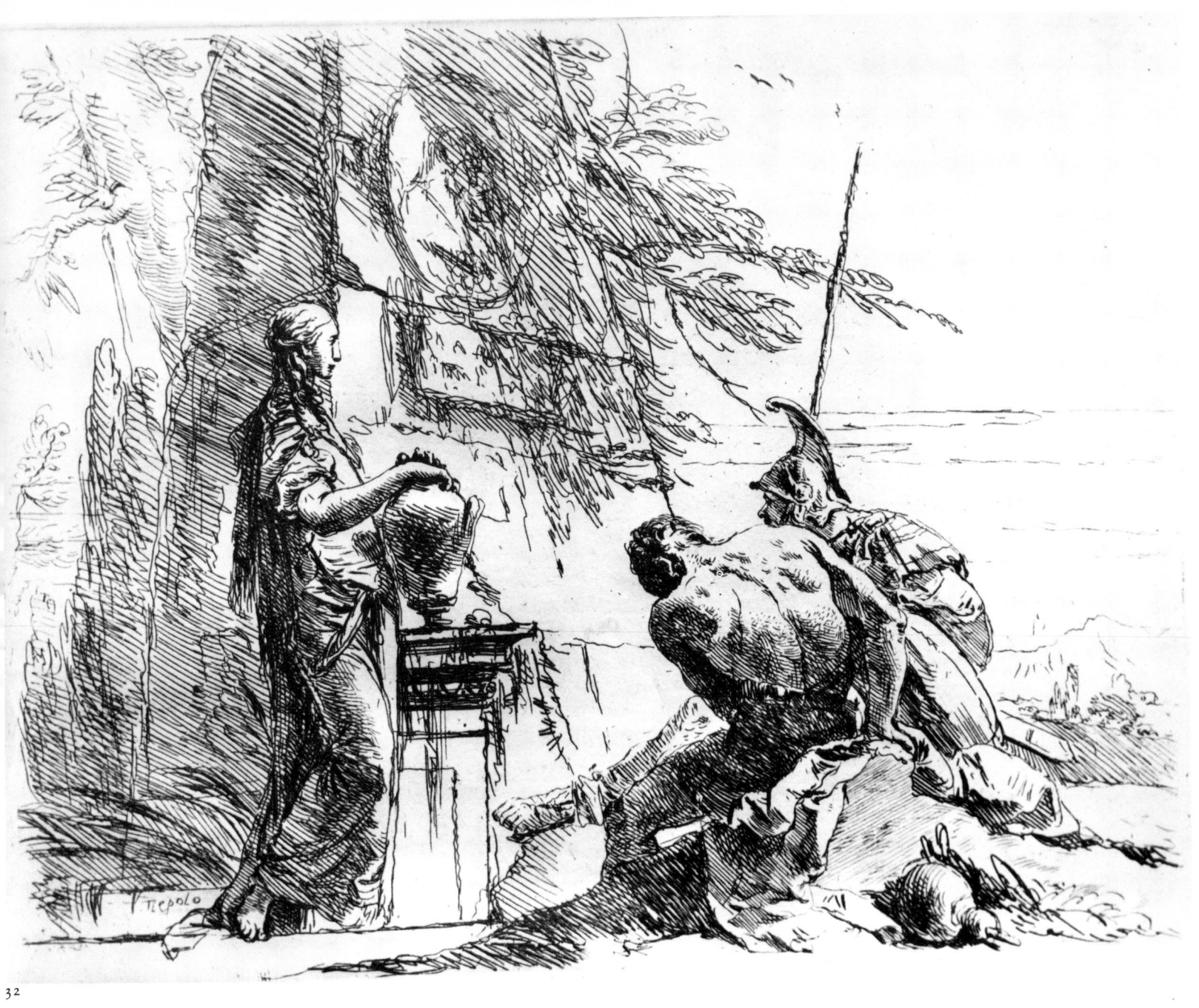

33. Capricci
A nymph with a small satyr and two goats

140 × 174 mm. Printed in sepia. Signed: *Tiepolo* on the tambourine. There are proofs before signature in the Gabinetto Nazionale delle Stampe, Rome, and in the Vicenza Museum.

According to Knox, the subject and the quality of the landscape suggest a connection with the style of drawing No. 24 in the Victoria and Albert Museum, already mentioned in connection with the *Scherzo* on pl. 26.

Bibliog.: Nagler, 1947, 13; De Vesme, 1906, 7; Sack, 1910, 30; Hind, 1921, 7; Pallucchini, 1941, 301; Pittaluga, 1952, p. 133; Pignatti, 1965, VII; Rizzi, 1970, 32.

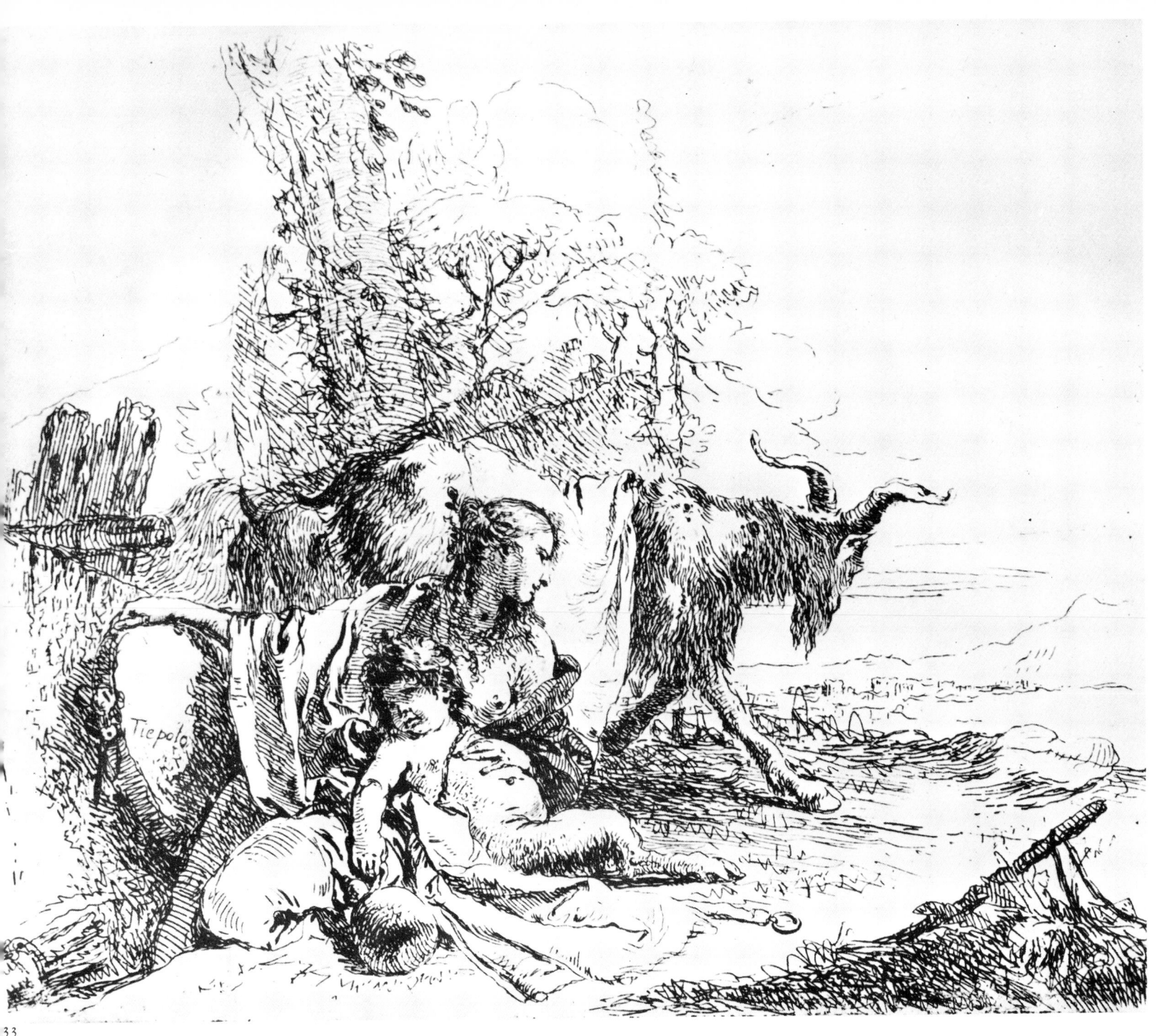

34. Capricci
Standing philosopher and two other figures

135 × 173 mm. Sepia proof, before the number, now in the Pavan Collection, Padua.
Signed: *Tiepolo*, on the marble slab in the foreground.

The old philosopher finds his predecessors in the 'Allegories' at Biron.

Bibliog.: Nagler, 1947, 13; De Vesme 1906, 8; Sack, 1910, 31; Hind, 1921, 8; Pallucchini, 1941, 302; Pittaluga, 1952, p 135; Pignatti, 1965, VIII; Rizzi, 1970, 33

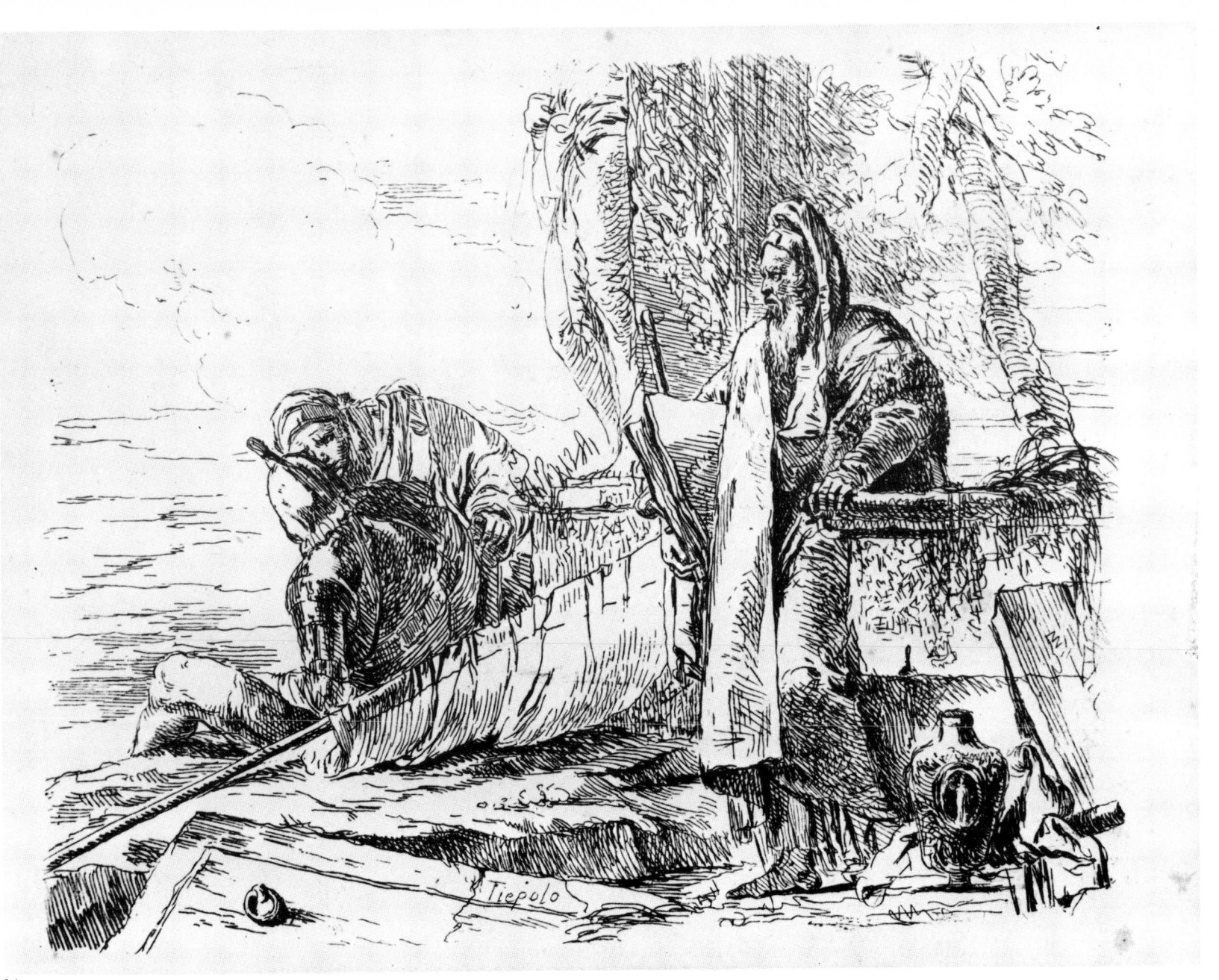

34

35. Capricci
A woman with her arms in chains and four other figures

137 × 176 mm. Signed: *Tiepolo*, on the base of the column.

According to Pignatti, the standing figure resembles some of Tiepolo's youthful drawings, often in red chalk, like the ' Soldier ' at Princeton; this prompts him to support the earlier dating of the *Capricci* in relation to the *Scherzi*, ' probably conceived even earlier than 1739, when Zanetti began to prepare his '' Raccolta di varie stampe '' '
The author believes the connection to be fortuitous.

Bibliog.: Nagler, 1847, 13; De Vesme, 1906, 9; Sack, 1910, 32; Hind, 1921, 9; Pallucchini, 1941, 303; Pignatti, 1965, IX; Rizzi, 1970, 34.

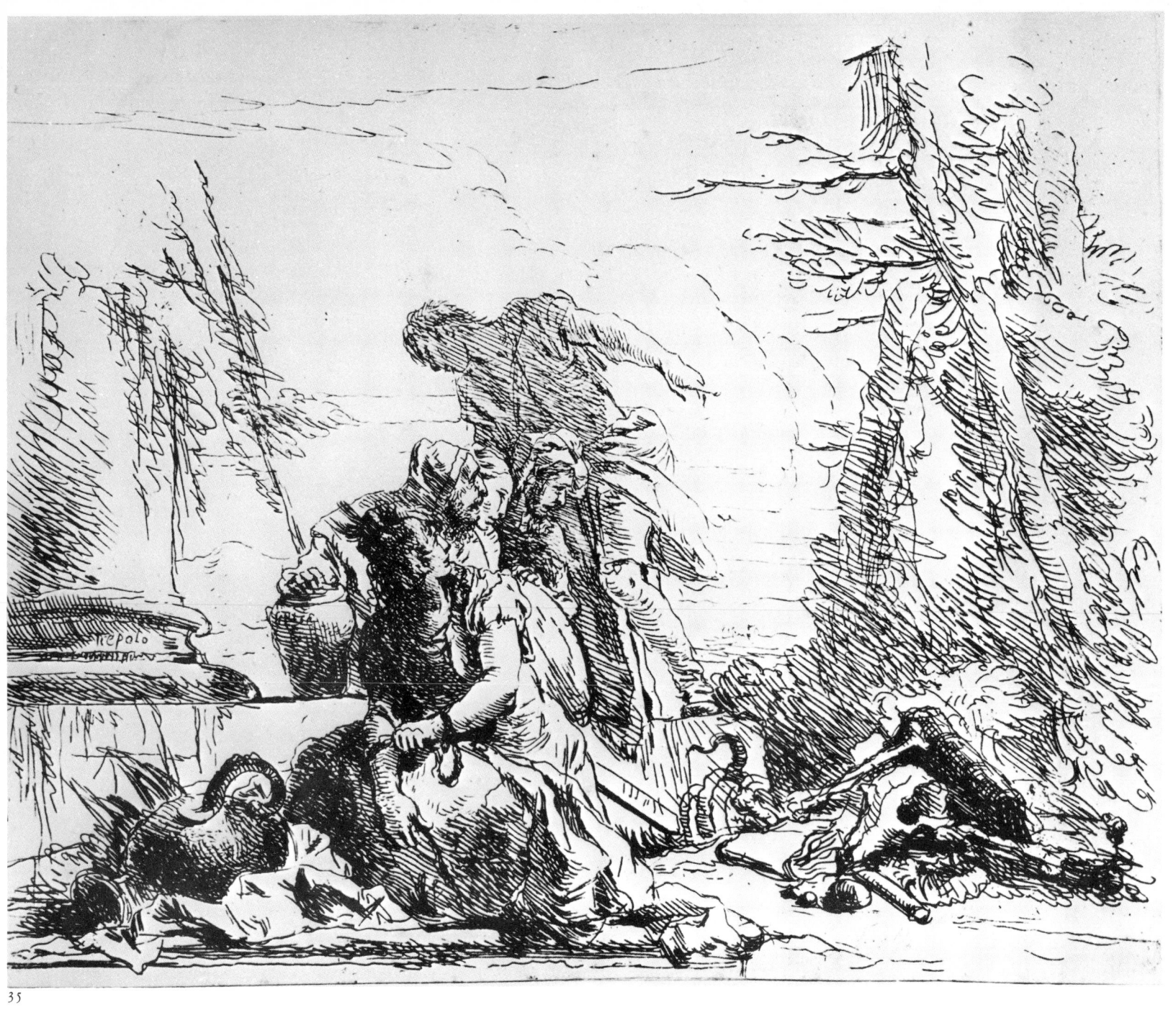

35

36. Capricci
Death giving audience

140 × 176 mm. There is a proof before signature in sepia in the Museum, Trieste. Signed: *Tiepolo*, under the altar.

The preparation of this etching—one of the most complex in the whole series—was long and meticulous, as is shown by the drawings in the Victoria and Albert Museum mentioned by Reynolds and Knox. The first (106v.) is more general, while closer to the etching are No. 107r. (fig. XXXII) and 107v.: the latter shows the dog, which is missing in the other two. According to Knox, No. 108 also anticipates the etching by developing the theme of death, whereas Pignatti denies any iconographic connection. Connected with the *Capricci* in general, but not with this one in particular, are, according to Pignatti, drawings 120, 121, and 128 also mentioned by Knox. Reynolds (1940, p. 49) linked this etching with the drawing 'Death giving audience', formerly in the Morelli Collection, published by Sack (1910, 286); but Pignatti, although he never examined the original, believes that it is not consistent with Tiepolo's style of about 1740. Vigni discerned a certain affinity with drawing 173 in Trieste, which is one of Giandomenico's compositions in the manner of his father.

Bibliog.: Nagler, 1847, 13; De Vesme, 1906, 10; Sack, 1910, 33; Hind, 1921, 10; Reynolds, 1940, 49; Pallucchini, 1941, 304; Vigni, 1942, p. 60; Pittaluga, 1952, 133–34; Knox, 1960, pp. 61, 64, 65; Pignatti, 1965, 10; Rizzi, 1970, 35.

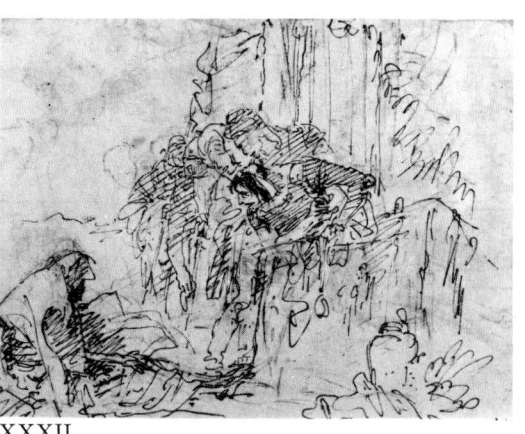

XXXII

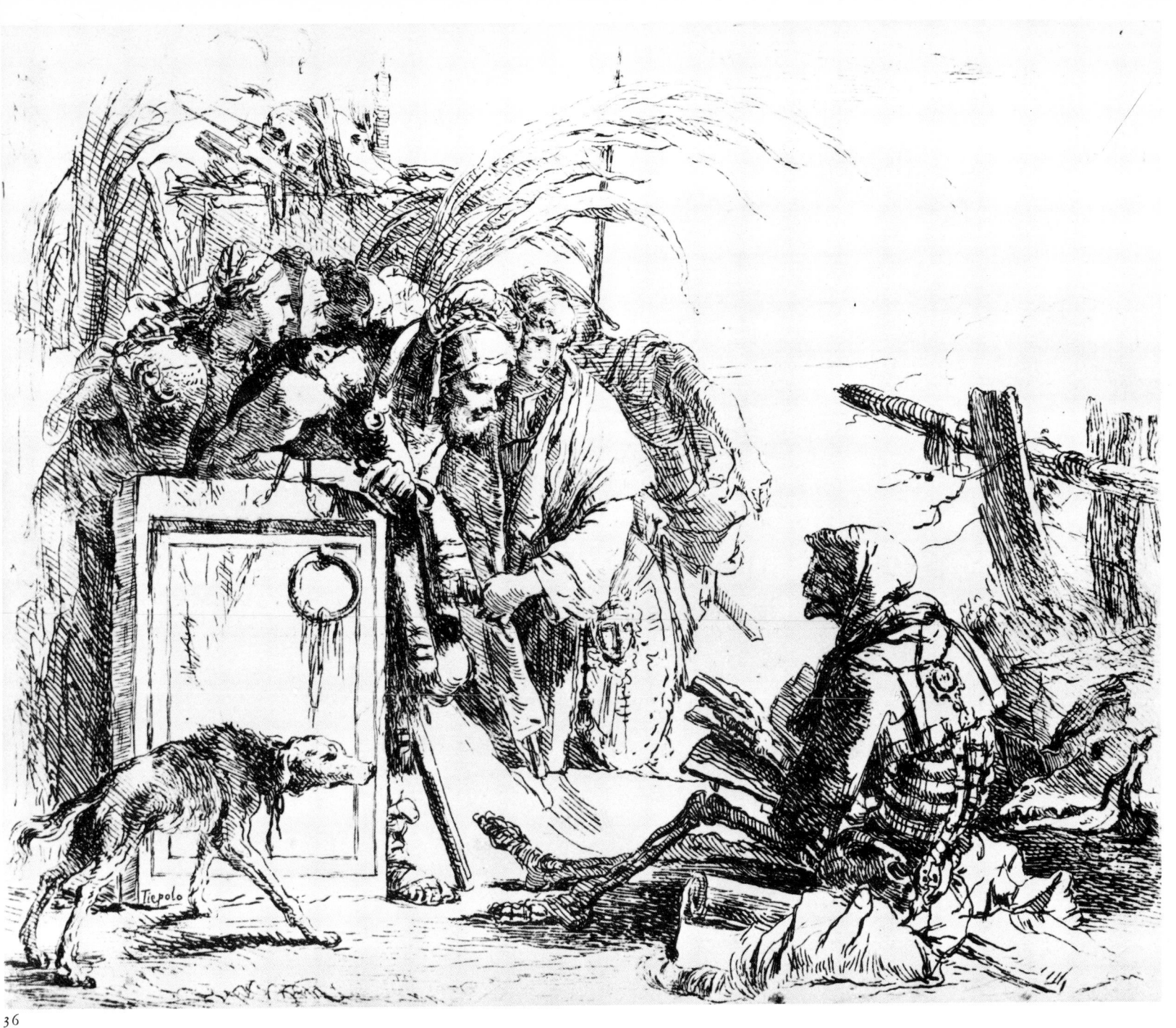

36

37. Capricci
**The astrologer
and the young soldier**

135 × 172 mm. Signed: *Tiepolo*, on the step.

Although many of the details were changed in the etching, Knox connects this print, for its theme, with drawing 45 in the Victoria and Albert Museum, which he dates about 1740, as does Pignatti (fig. XXXIII).

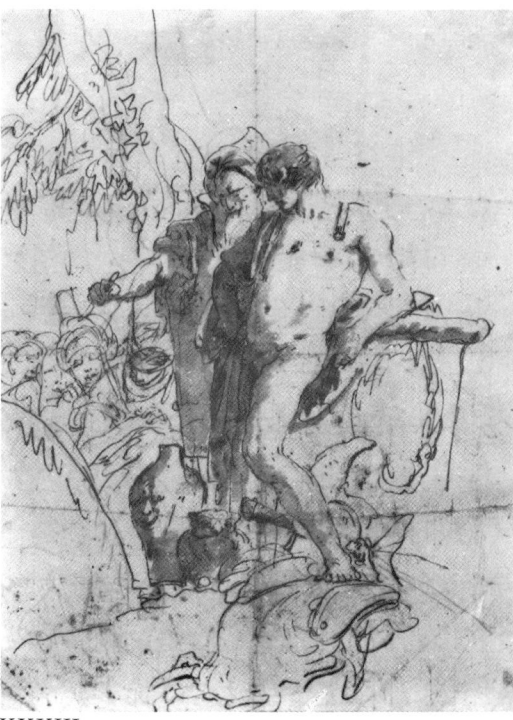

XXXIII

Bibliog.: Nagler, 1847, 13; De Vesme, 1906, 11; Sack, 1910, 34; Hind, 1921, 11; Pallucchini, 1941, 305; Pittaluga, 1952, 135; Knox, 1960, p. 50; Pignatti, 1965, XI; Rizzi, 1970, 36.

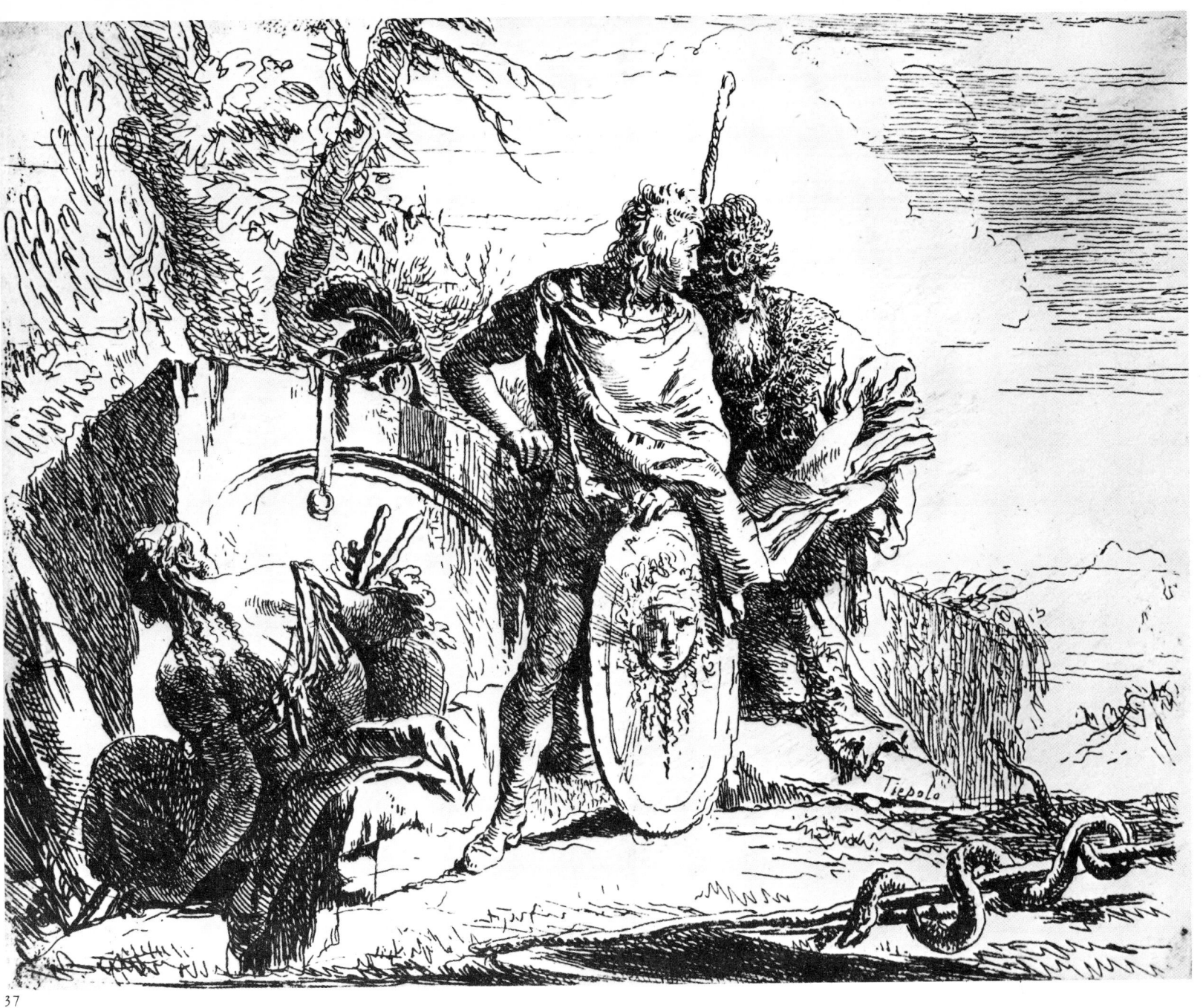

37

38. Capricci
The rider standing by his horse
140 × 178 mm. Signed: *Tiepolo*, on a stone

The preparatory drawing in the Victoria and Albert Museum (No. 111 in the catalogue by Knox) is without the dog and has two pages instead of one (fig. XXXIV). The composition was to be modified in the etching, as can be seen in the different posture of the rider.

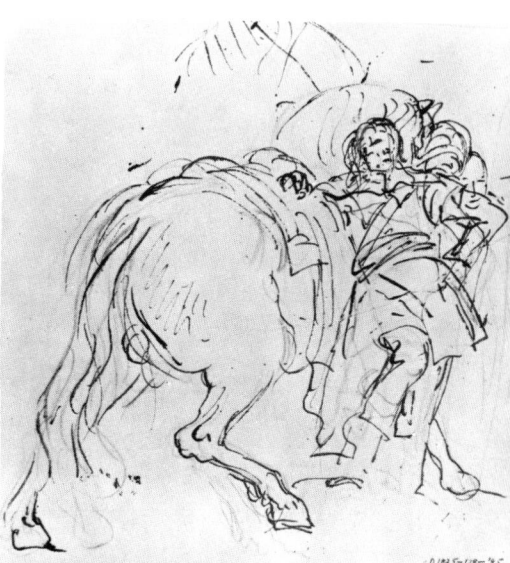

XXXIV

Bibliog.: Nagler, 1847, 13; De Vesme, 1906, 12; Sack, 1910, 35; Hind, 1921, 12; Hadeln, 1927, fig. 27; Reynolds, 1940, p. 49; Pallucchini, 1941, 306; Pittaluga, 1952, p. 106; Knox, 1960, p. 62; Reynolds-Knox, 1961, 55 and 55a; Pignatti, 1965, XII; Rizzi, 1970, 37.

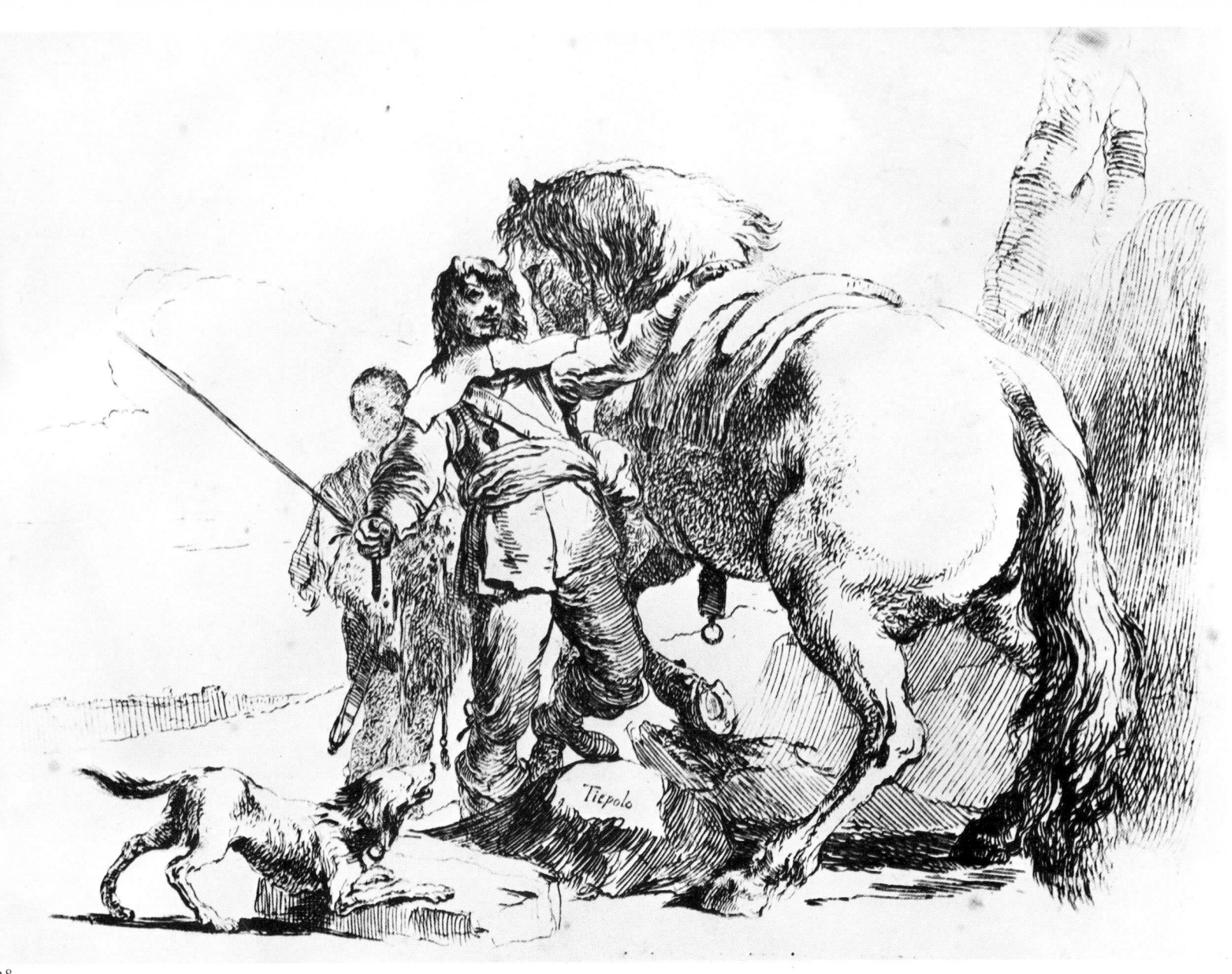

Giandomenico, the son of Giambattista, was born in Venice in 1727. He started his career, in his father's shadow, in 1747 with his *Stations of the Cross* in the Venetian church of S. Polo. Between 1751 and 1753 he was in Würzburg, where he worked both with his father and on his own. In 1756 he was elected a Member of the Venice Academy. In the following year, still with his father, he decorated the Villa Valmarana, where he displayed his personal satirical and anecdotal vein. In 1759 he went to Udine, where he painted frescoes, still under his father's guidance, in the Oratorio della Purità. In 1762 he left for Madrid with his father and his brother Lorenzo. After Giambattista's death in 1770, Giandomenico returned to Venice. In 1772 he was elected Master of the Academy and eight years later President. In 1784 he won the competition for a fresco in the Ducal Palace of Genoa. He died in Venice in 1804.

The revaluation of Giandomenico's personality, often sacrified to the glory of his father, whose great achievements he could not match, is still in progress. He shows a definite realistic bias in reaction to the Baroque and anticipating future developments. He made 181 etchings, 116 of which reproduce his father's works. They are characterized by mobile and airy lines and by a more intense chiaroscuro, less abstract than his father's.

39. Stations of the Cross
Frontispiece

210 × 185 mm. First state with the inscription: VIA CRUCIS / DOMENICO TIEPOLO INVENTÒ, PINSE, ED INCISE Anno MDCCXLIX / IN VENEZIA; second state: with the addition of the publication line *Theod. Viero exc.* and number *5*, top right; third state: with the words IN MILANO substituted for IN VENEZIA and without the name of the publisher. Two more states exist: one with the inscription, in the bottom left-hand corner, *Milano presso i Frat Vallardi in S. Marg. N. 1101* (it has been proved that in 1847 the plates of the series were in the hands of the Vallardi brothers publishers and print dealers in Milan and Venice); and the other with the words bottom right, *Milano, presso Scalco Giovann C.a del Cappello No. 4031.* According to Sack the latter is the third state; it is, however, the fourth or fifth.

The Stations of the Cross, comprising 16 plates—14 Stations preceded by the frontispiece and the dedication—are the first works in this medium produced by Giandomenico; they are derived from the series of paintings he had executed for the Oratorio del Crocifisso in the church of S. Polo in Venice. The painting of the Ninth Station is dated 1747 (Morassi, 1941, p. 281), while the corresponding etching is dated 1748. The series must therefore have been executed in that year and published in 1749, as shown by the frontispiece; this also carries the name of the engraver, which is not repeated on the other sheets. It was subsequently included in the catalogue published by the artist. Obviously, Giandomenico's frontispiece was influenced by his father's frontispiece to the *Scherzi*: see in particular the sarcophagus, and the diagonal position of the ladder and the cross, which recall the sloping of the stone and trees in Giambattista's print. Other prints in the series also show borrowings from the *Scherzi* as will be pointed out in the notes.

Bibliog. Nagler, 1847, 9; De Vesme, 1906, 34; Sack, 1910, p. 1; Pallucchini, 1941, 77; Morassi, 1941, p. 281; Pignatti, 1965, XLIII; Rizzi, 1970, p. 38.

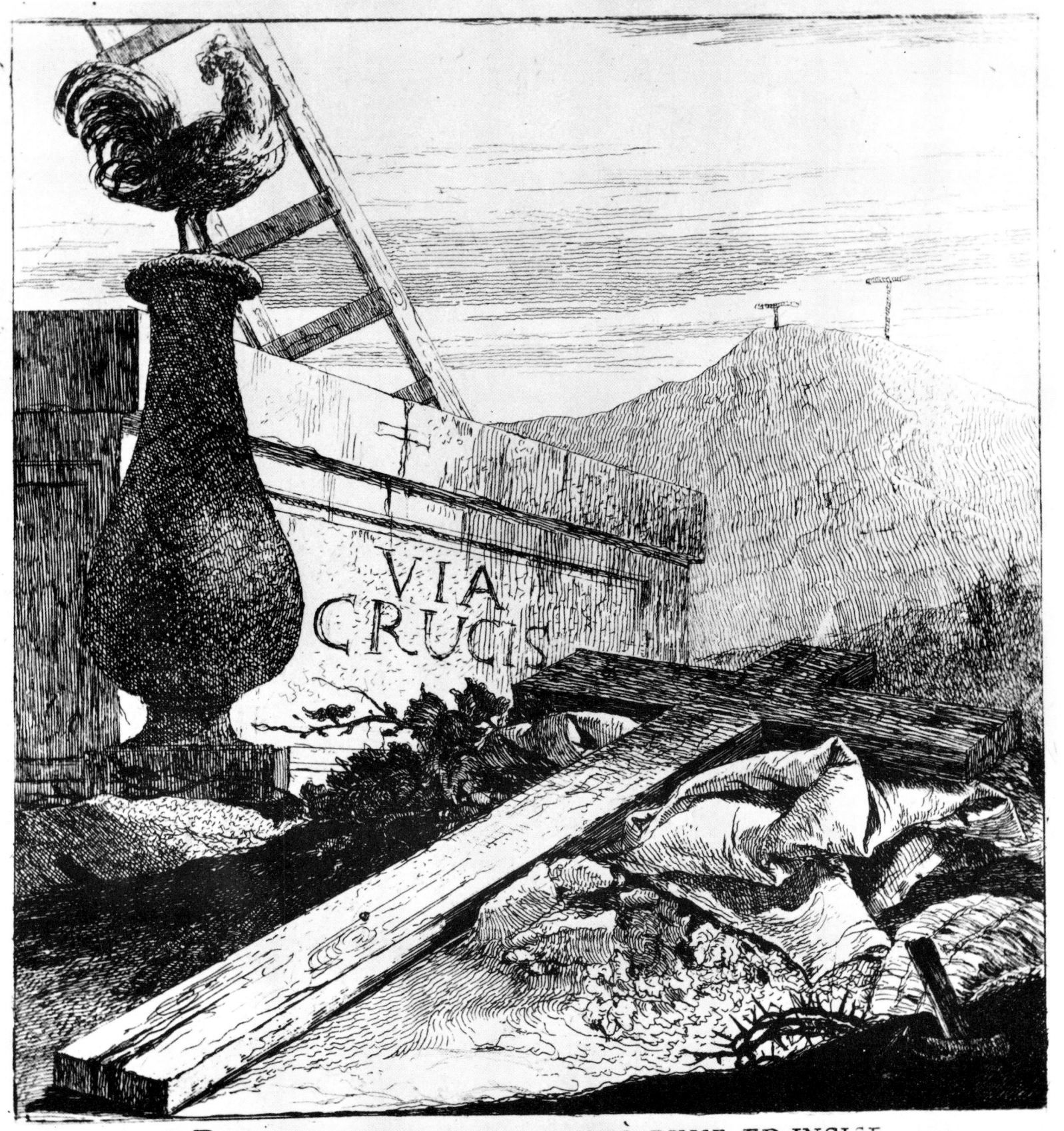

DOMENICO TIEPOLO INVENTÒ, PINSE, ED INCISE
Anno MDCCXLIX
IN VENEZIA

Dedication

207 × 183 mm. Top left, no. 5. Inscribed as follows:

Nobili Viro | Equestris Ordinis Melitensis | Commendatario | ALOYSIO CORNELIO | Patritio Veneto | Originis tuae claritas, Amplissime Vir, consilii maturitas, ac celsitudo | gradus iure merito me detinere debuissent, ac deterreri a devovendo | Tibi primos, immaturosque meae picturae, ac caelaminis fructus: | Viam scilicet Crucis pictam nepur, et aere incisam. Sed Crux | illa in pectore, ac virtutum omnium cumulus in animo tuo | fulgens erexerunt spiritum, et opus, ex imperitia mea sane | parvum, quia ex objecto magnum est, tuo Instituto ac pietate | non indignum dicere. Illud ergo, ea, qua polles humanitate, | suavique ingenio, unico dignare obtutu, et in addictissimae subje- | ctionis meae, et grati animi argumentum dicatum suscipe. | Humillimus et Obsequentiss.us Servus | Joannes Dominicus Tiepolo.

Bibliog.: Nagler, 1847, 9; De Vesme, 1906, 35; Sack, 1910, 2; Rizzi, 1970, 39.

Nobili Viro
Equestris Ordinis Melitensis
Commendatario

ALOYSIO CORNELIO
Patritio Veneto

Originis tuæ claritas, Amplissime Vir, consilii maturitas, ac celsitudo
gradus iure merito me detinere debuissent, ac deterreri a devovendo
Tibi primos, immaturosque meæ picturæ, ac cælaminis fructus:
Viam scilicet Crucis pictam nepur, et ære incisam. Sed Crux
illa in pectore, ac virtutum omnium cumulus in animo tuo
fulgens erexerunt spiritum, et opus, ex imperitia mea sane
parvum, quia ex objecto magnum est, tuo Instituto ac pietate
non indignum dicere. Illud ergo, ea, qua polles humanitate,
suavique ingenio, unico dignare obtutu, et in addictissimæ subje-
ctionis meæ, et grati animi argumentum dicatum suscipe.

Humillimus et Obsequentiss.us Servu
Joannes Dominicus Tiepolo

40

109

41. Stations of the Cross
Christ is condemned to death

210 × 183 mm. Inscribed: *STAZIONE I. | GESÙ CONDANNATO A MORTE. | Gesù vita immortal d'ogni Vivente, | per salvar l'Uomo, al suo morir consente.*

The darkening of the shadows in the foreground stresses the wish of the artist to minimize the essential details of the story with personal diversions, or 'scherzi'. Several figures are reminders of his father's *Magicians*.

Bibliog.: Nagler, 1847, 9; De Vesme, 1906, 36; Sack, 1910, 3; Pallucchini, 1941, 327; Pittaluga, 1952, 149; Rizzi, 1970,

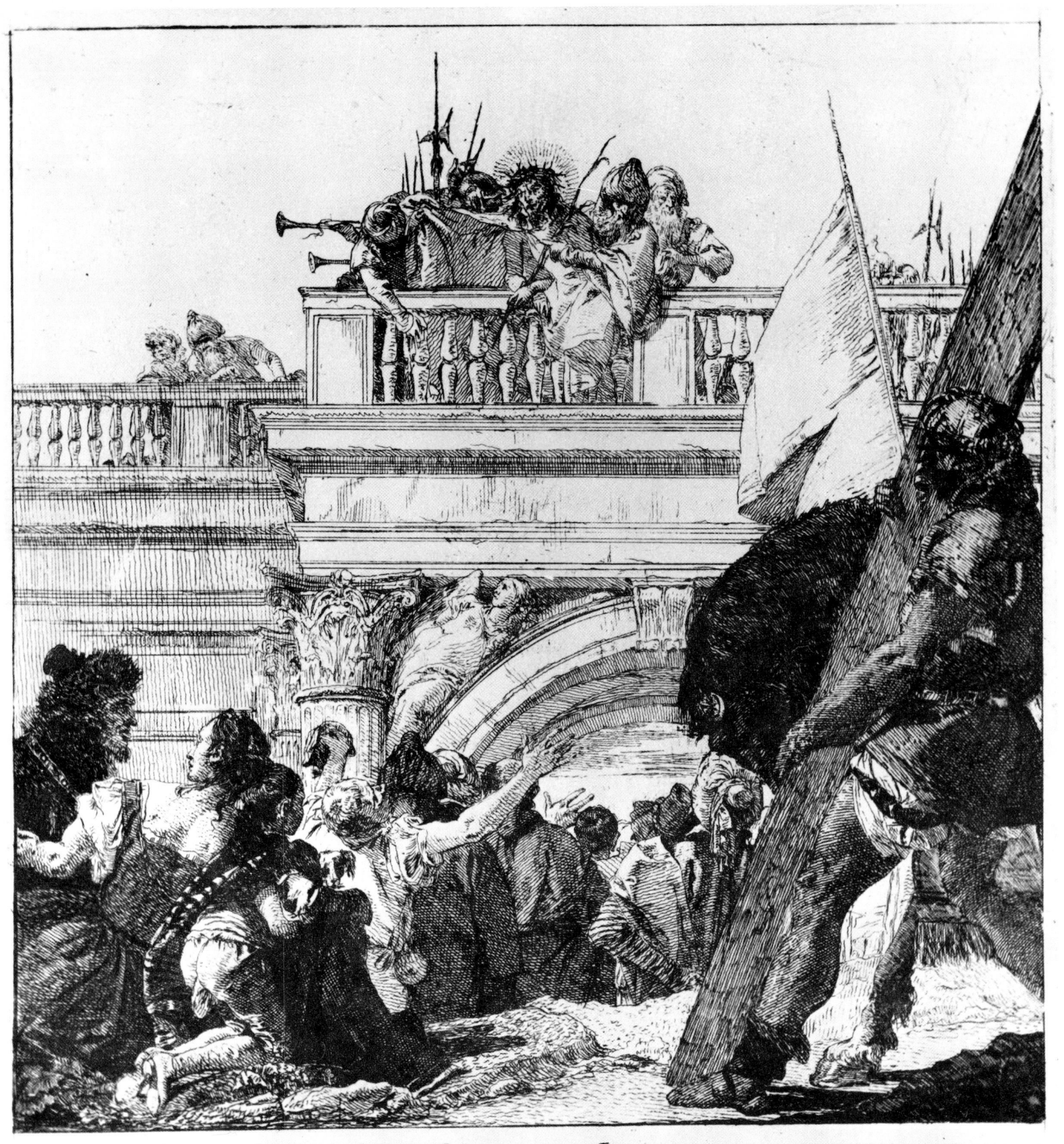

STAZIONE I.
GESÙ CONDANNATO A MORTE.
Gesù vita immortal d'ogni Vivente,
per salvar l'Vomo, al svo morir consente.

42. Stations of the Cross
Christ receives the Cross

218 × 187 mm. Inscribed: *STAZIONE II.
| RICEVE LA CROCE SÙ LE SPAL-
LE. | L'ubbidiente Isacco porta il Legno, | per
adempier del Padre il gran disegno.*

In this Station as well as in the follow-
ing ones can be seen the episodical
and discursive style which is charac-
teristic of Giandomenico.

Bibliog.: Nagler, 1847, 9; De Vesme, 1906,
37; Sack, 1910, 4; Pallucchini, 1941, 328;
Rizzi, 1970, 41.

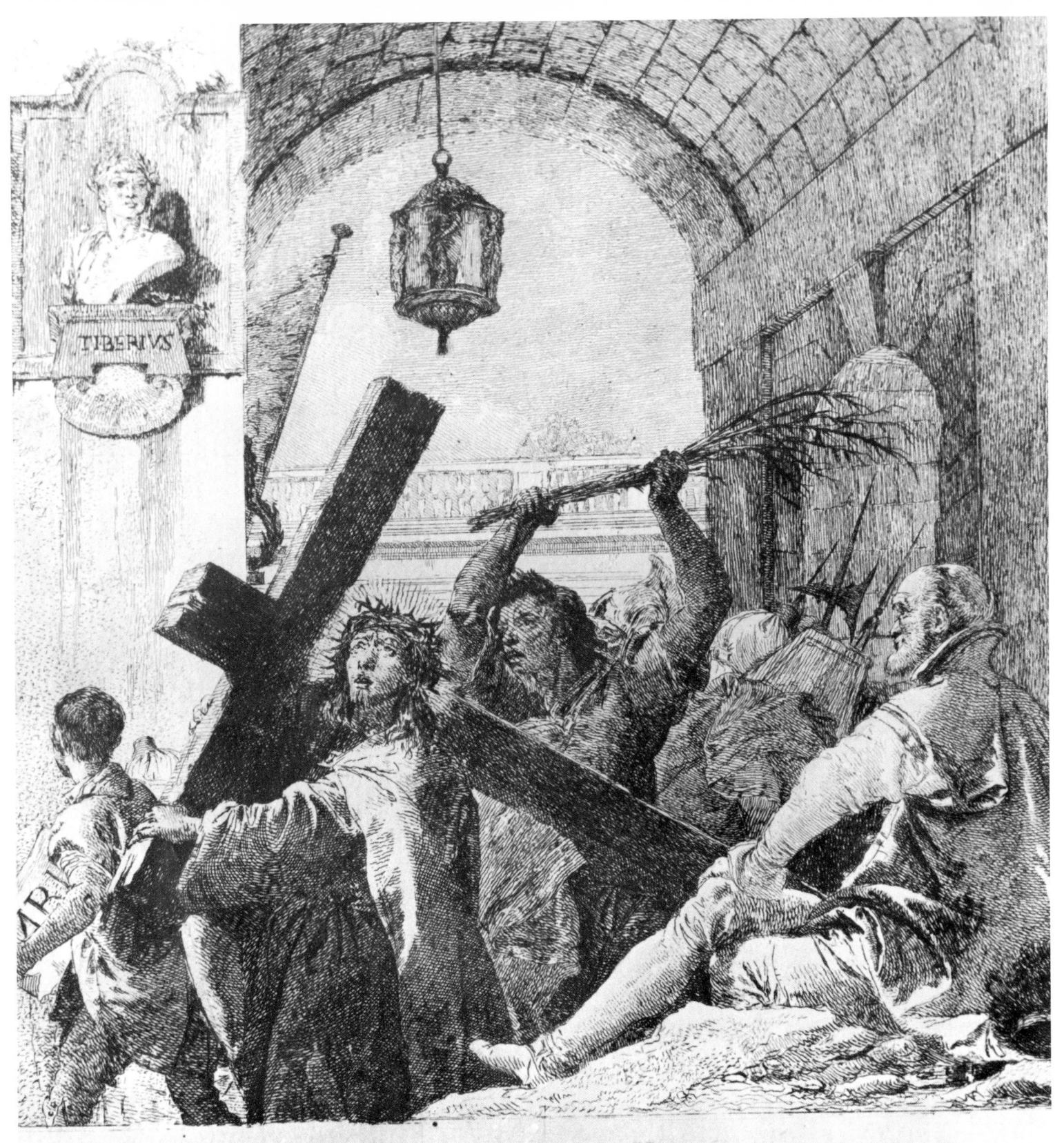

STAZIONE II.

RICEVE LA CROCE SU' LE SPALLE.

L'ubbidiente Isacco porta il Legno,
per adempier del Padre il gran disegno.

43. Stations of the Cross
Christ falls beneath the Cross for the first time

216 × 182 mm. Inscribed: *STAZIONE III | CADE SOTTO LA CROCE LA PRI MA VOLTA. | De' falli nostri al tropp grave peso | Gesù non regge, e cade al suol distese*

The two figures in the foreground are variations of the magicians appearing in Giambattista's *Scherzi*.

Bibliog.: Nagler, 1847, 9; De Vesme, 1906 38; Sack, 1910, 5; Pallucchini, 1941, 329 Rizzi, 1970, 42.

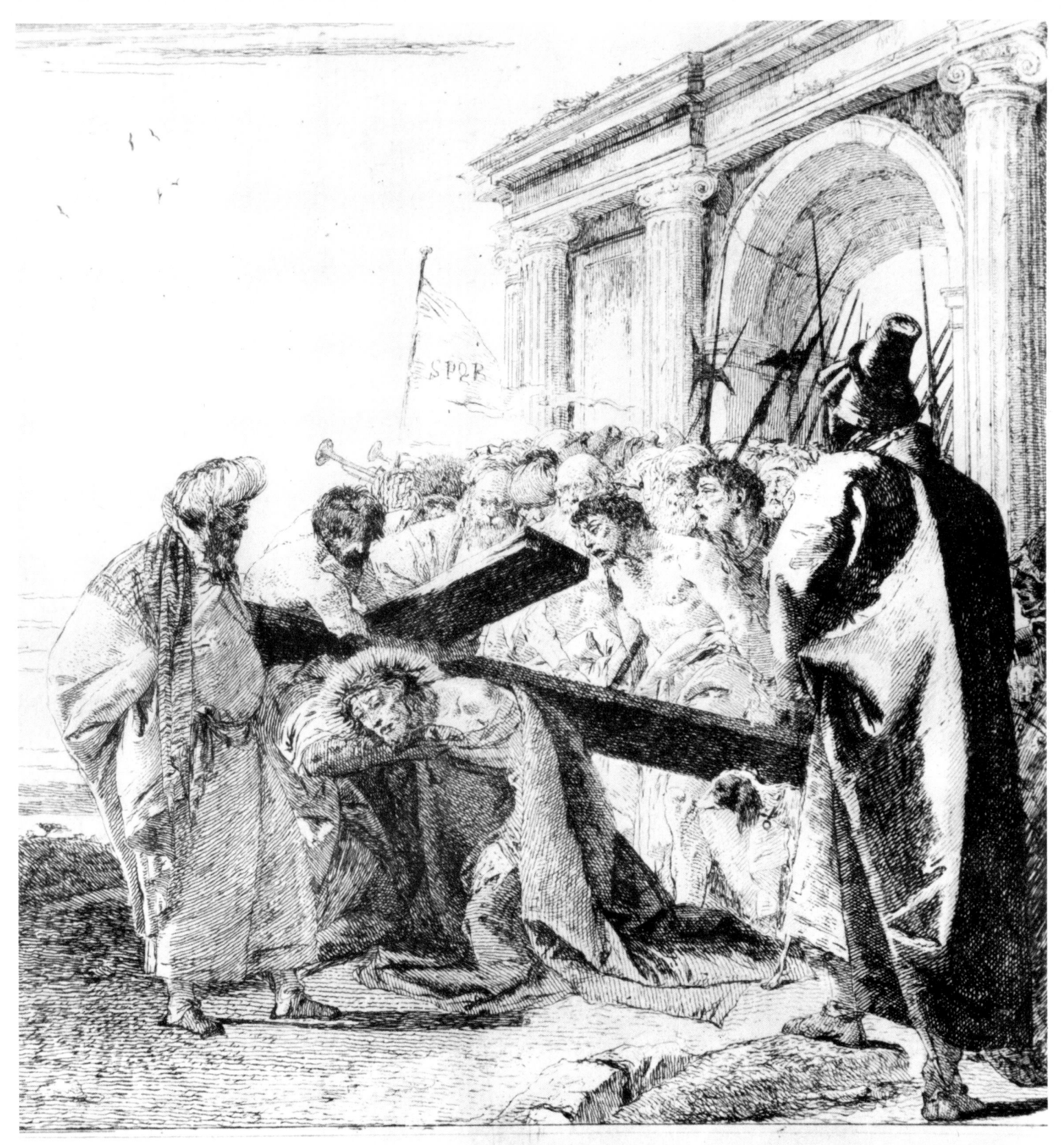

STAZIONE III.

CADE SOTTO LA CROCE LA PRIMA VOLTA.

De' falli nostri al troppo grave peso
Gesù non regge, e cade al suol disteso.

44. Station of the Cross
Christ meets his Mother

223 × 178 mm. Inscribed: *STAZIONE IV. | INCONTRA LA SUA SS.MA MA- DRE | I due Lumi del Ciel nel darsi un guardo, | son colpiti nel Cor d'acuto dardo.*

Here, too, the borrowings from the *Scherzi* are numerous, even if skilfully camouflaged: see the leafy trees (much more detailed than in the painting) and the bas-relief with soldiers and horses, which often appear in Giambattista's etchings (see pl. 7, 19 and 21); also the figure seen from the back, on the right (see pl. 14, 19 and 25), as well as the old men behind the cross and next to Jesus.

Bibliog.: Nagler, 1847, 9; De Vesme, 1906, 39; Sack, 1910, 6; Pallucchini, 1941, 330; Rizzi, 1970, p. 43.

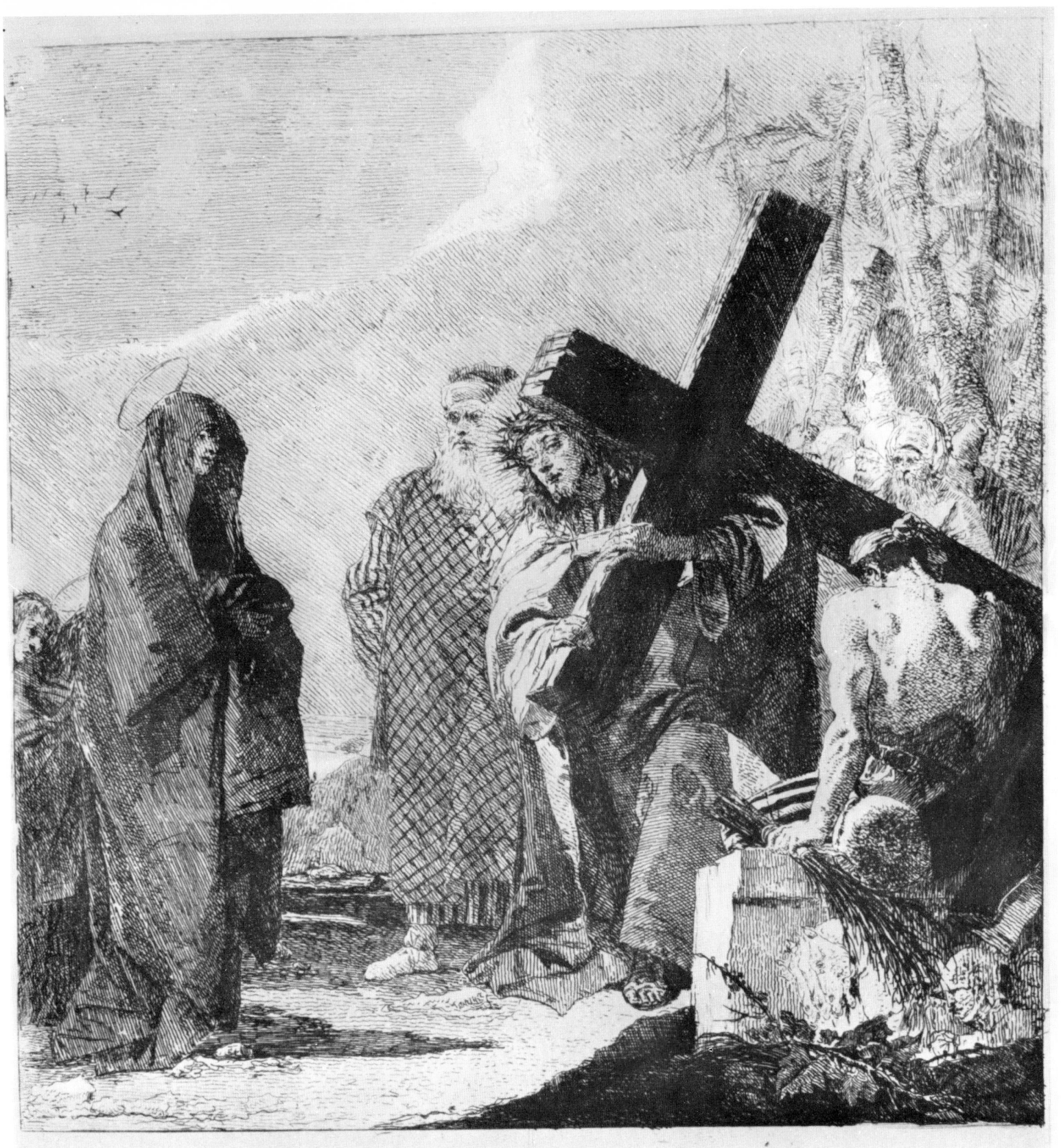

STAZIONE IV.
INCONTRA LA SUA SS.^{MA} MADRE
I dve Lumi del Ciel nel darsi un guardo,
son colpiti nel Cor d'acuto dardo.

45. Stations of the Cross
**Christ is helped
by Simon of Cyrene**

226 × 174 mm. Inscribed: *STAZIONE V. | VIENE AIUTATO DAL CIRENEO A PORTAR LA CROCE. | Seco Gesù ciascun Fedele invita | La sua Croce a portar, se vuol la vita.*

The figures crowding in the background recall those in Giambattista's *Scherzi.*

Bibliog.: Nagler, 1847, 9; De Vesme, 1906, 40; Sack, 1910, 7; Pallucchini, 1941, 331; Rizzi, 1970, 44.

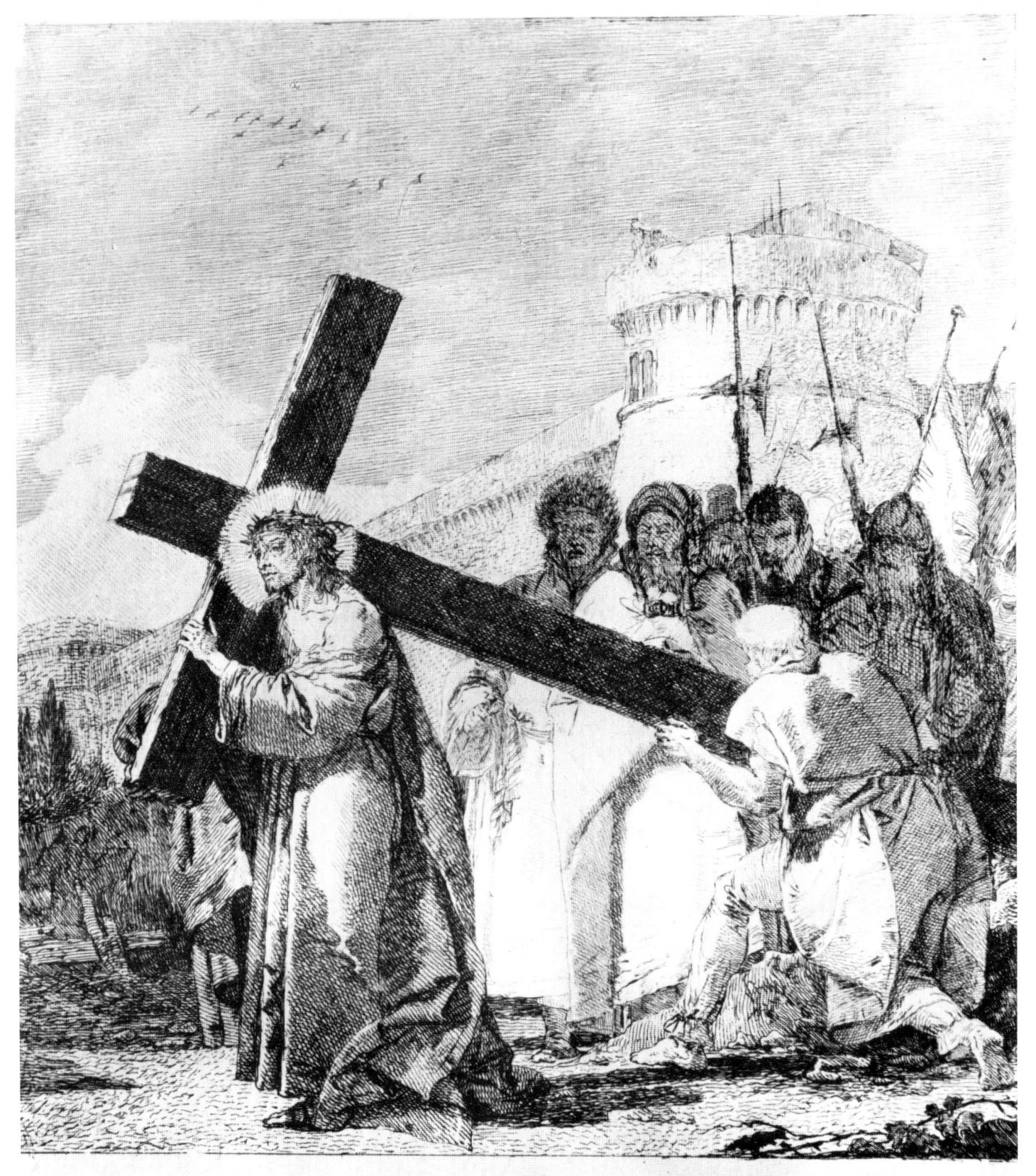

STAZIONE V.
VIENE AIUTATO DAL CIRENEO A PORTAR LA CROCE.

Seco Gesù ciascun Fedele invita
La sua Croce a portar, se uvol la vita.

45

46. Stations of the Cross
Christ's face
is wiped by St. Veronica
219 × 186 mm. Inscribed: *STAZIONE VI.
| GESÙ ASCIUGATO DA S.TA VE-
RONICA. | Ottien per l'atto pio la Donna
amante | L'imago impressa di Gesù penante.*

The soldier dragging Jesus has the same posture as the naked youth who points out Punchinello's grave in the *Scherzo* illustrated in plate 20. The old men, watching the scene, can also be easily recognized.

Bibliog.: Nagler, 1847, 9; De Vesme, 1906, 41; Sack, 1910, 8; Pallucchini, 1941, 332; Rizzi, 1970, 45.

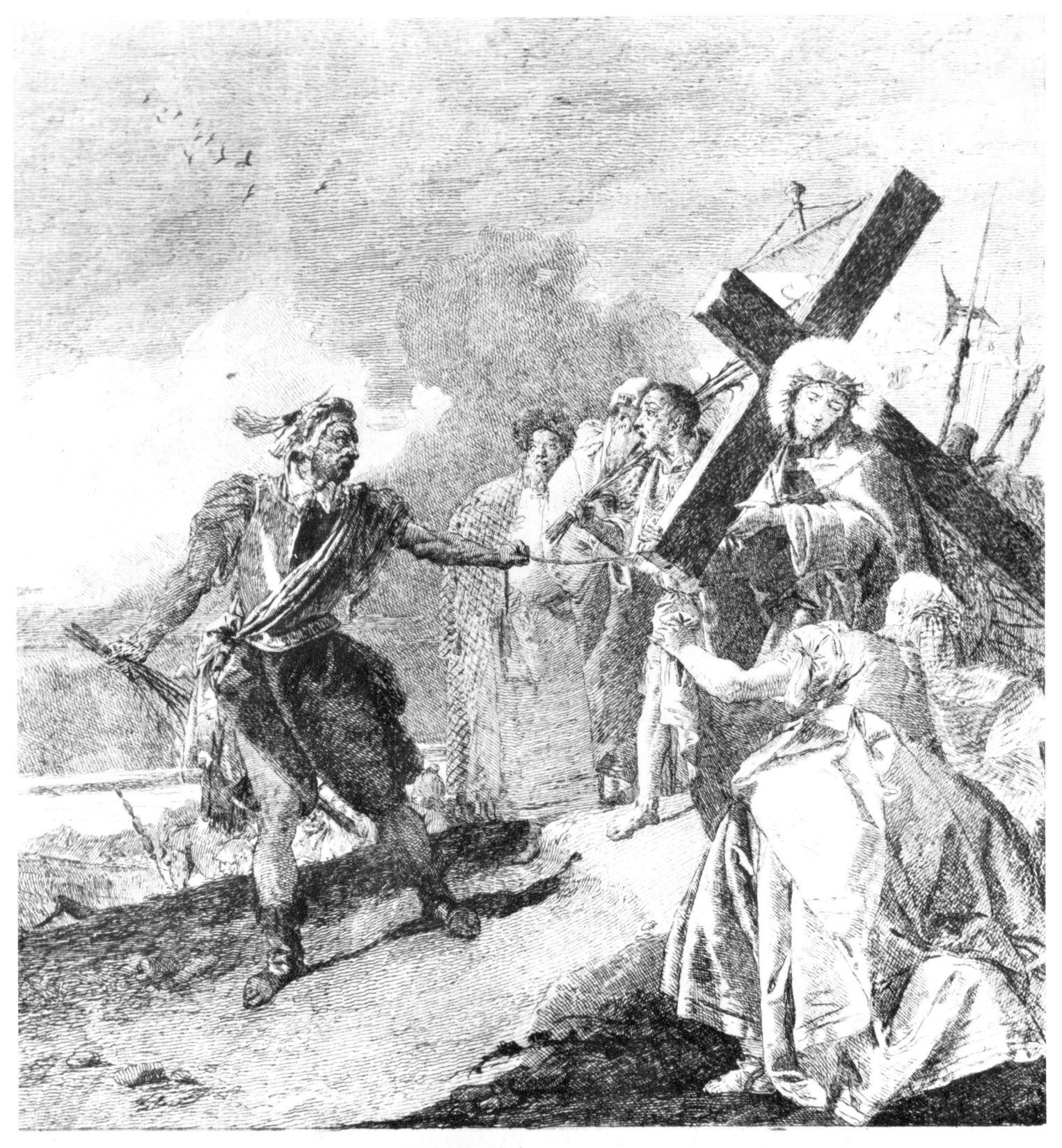

STAZIONE VI.
GESÙ ASCIUGATO DA S.ᵀᴬ VERONICA.
Ottien per l'atto pio la Donna amante
L'imago impressa di Gesù penante

47. Stations of the Cross
Christ falls beneath the Cross for the second time

218 × 180 mm. Inscribed: *STAZIONE VII. | CADE SOTTO LA CROCE LA SECONDA VOLTA. | Gesù ricade, e s'alza, e non si duole: | che nella Croce pur salvar ci uvole* (*sic*).

The Orientals seen from the back are borrowed from Giambattista's repertoire, starting with the *Adoration of the Magi*. Here too one finds the fringed trees, which appear in several of Giambattista's etchings (see pl. 6, 12, 13, 18 and 26) and which are anticipated in drawings 175–185 in Trieste.

Bibliog.: Nagler, 1847, 9; De Vesme, 1906, 42; Sack, 1910, 9; Rizzi, 1970, 46.

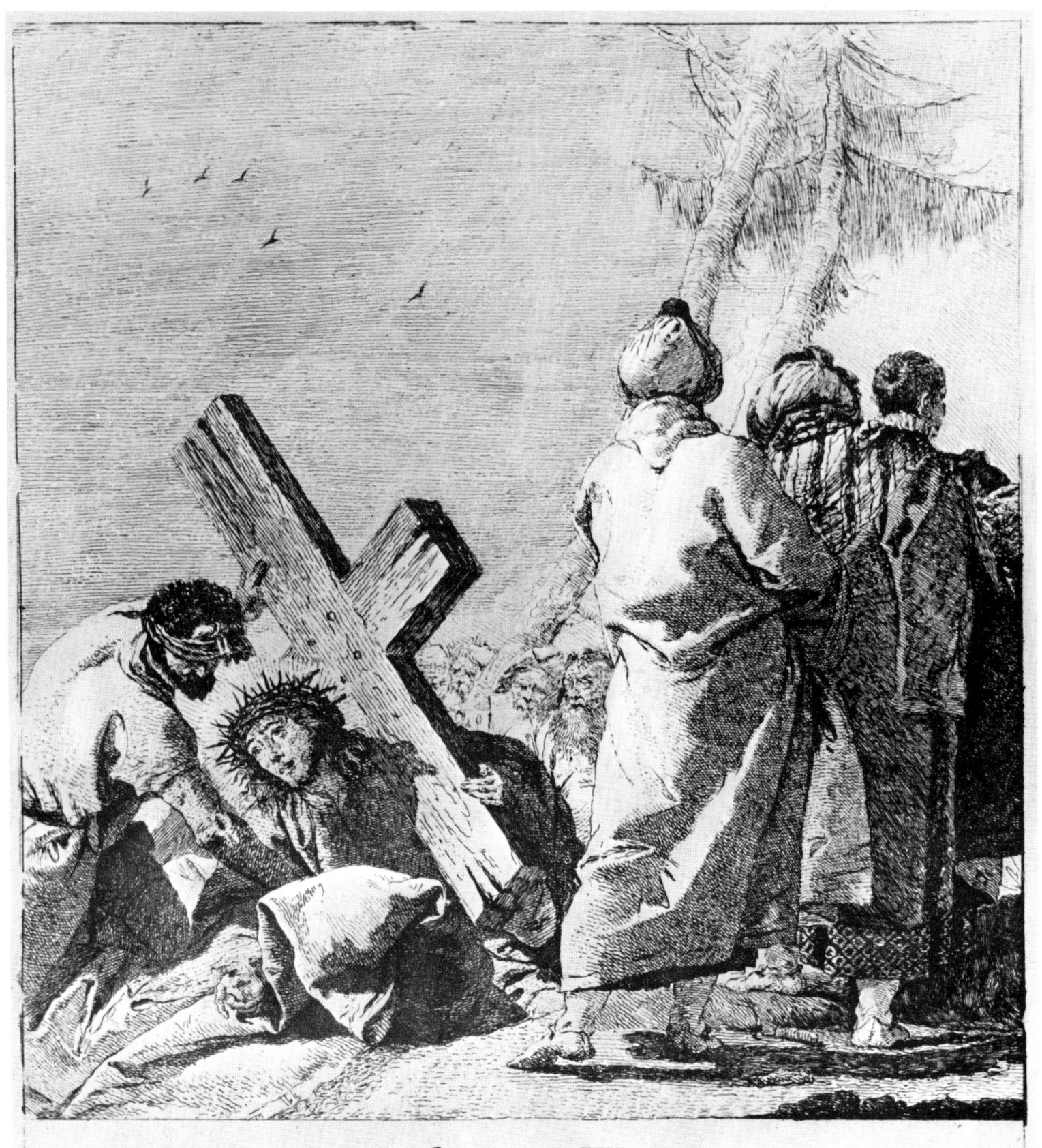

STAZIONE VII.

CADE SOTTO LA CROCE LA SECONDA VOLTA.

Gesù ricade, e s'alza, e non si dvole:
che nella Croce pur salvar ci vuole.

48. Stations of the Cross
Christ consoles the weeping women

218 × 187 mm. Inscribed: *STAZIONE VIII. | CONSOLA LE DONNE PIAN-GENTI. | Donne, dice Gesù, la mia passione | deh non piagnete, ma la rea cagione.*

Giandomenico is slowly acquiring an independent artistic personality: note the women with their large, square scarves, like nuns' hoods, and the children seen full face, which are true portraits.

Bibliog.: Nagler, 1847, 9; De Vesme, 1906, 43; Sack, 1910, 10; Pallucchini, 1941, 333; Pignatti, 1965, XLIII; Rizzi, 1970.

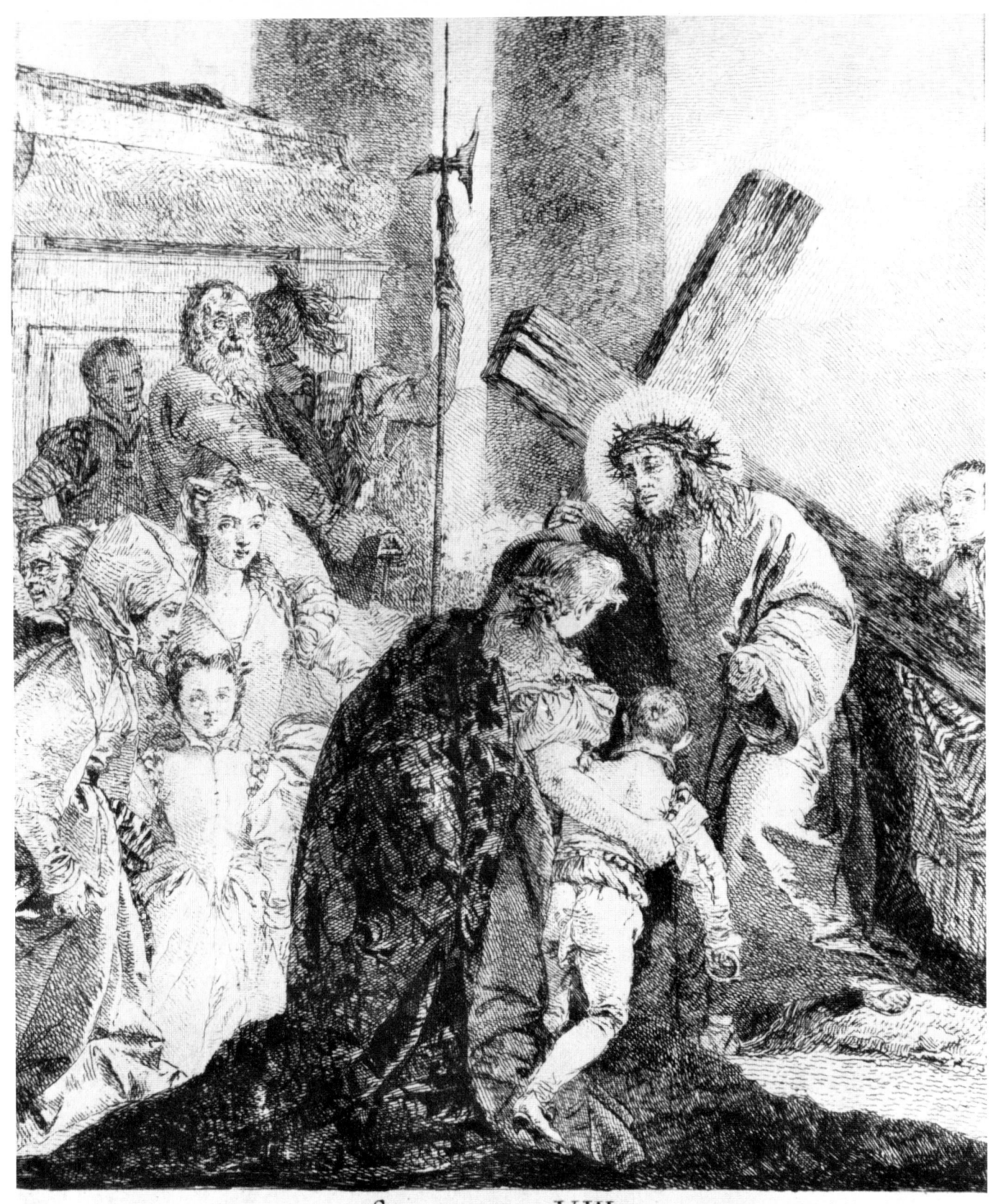

STAZIONE VIII
CONSOLA LE DONNE PIANGENTI.
Donne, dice Gesù, la mia passione
deh non piagnete, ma la rea cagione.

48

49. Stations of the Cross
Christt falls beneath the Cross for the third time

222 × 173 mm. Inscribed: *STAZIONE IX. | CADE SOTTO LA CROCE LA TERZA VOLTA. | Della Croce Gesù sotto il gran pondo, | vigor riprende a riscattare il Mondo*. On the stone top left, near the two figures watching the scene, is the date 1748

The similarities with Giambattista's prints are evident in the fringed trees, in the old man in the right foreground and the seated youth, seen from behind, and in the Orientals crowding around Jesus. Typical of Giandomenico, on the other hand, are the oval faces of the children, seen full face.

Bibliog.: Nagler, 1847, 9; De Vesme, 1906, 44; Sack, 1910, 11; Pallucchini, 1941, 334; Pignatti, 1965, XXLIII; Rizzi, 1970, 48.

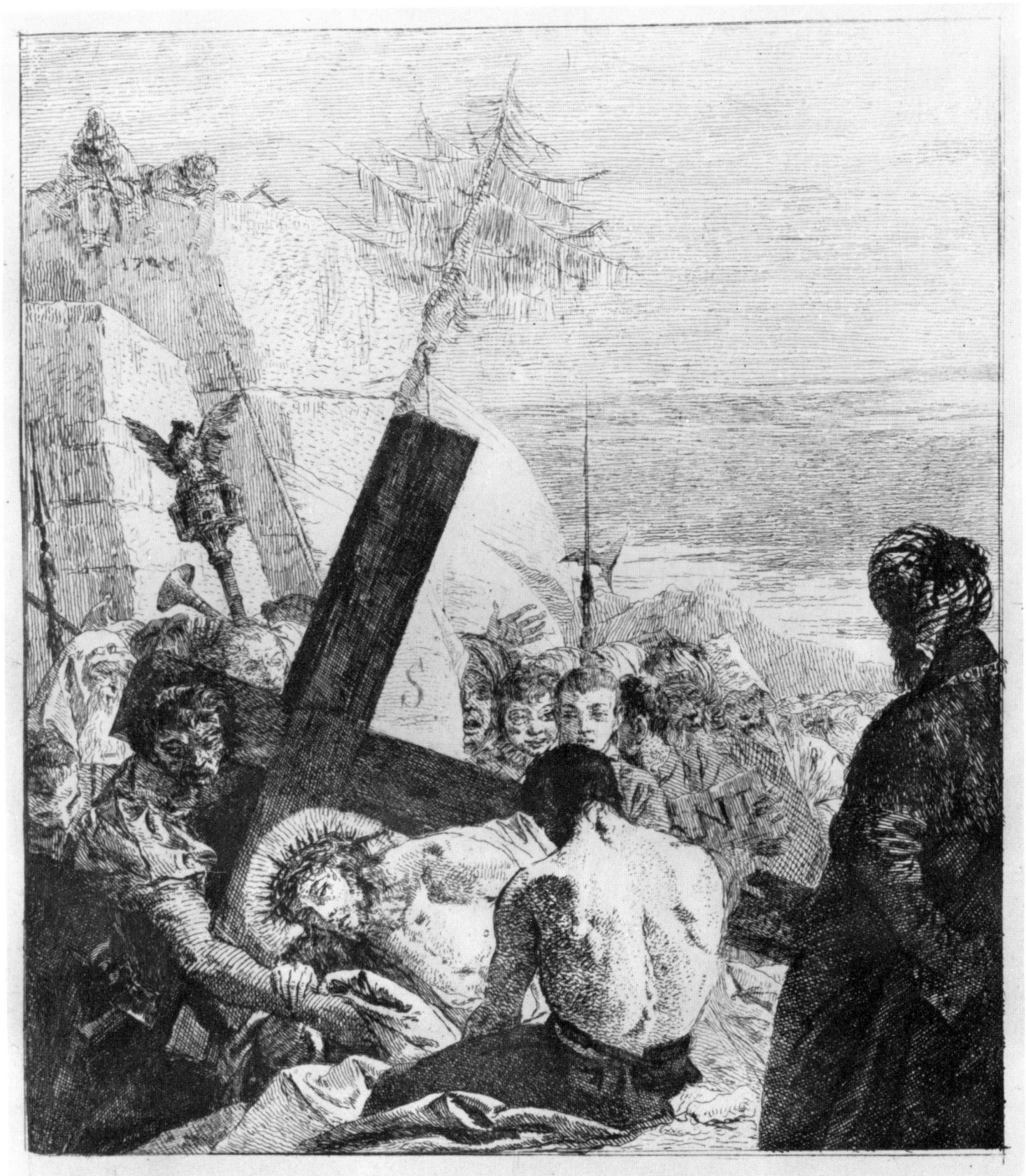

STAZIONE IX.

CADE SOTTO LA CROCE LA TERZA VOLTA.

Della Croce Gesù sotto il gran pondo,
vigor riprende a riscattare il Mondo.

49

50. Stations of the Cross
Christ is stripped of his garments

233 × 170 mm. Inscribed: *STAZIONE X. | GESÙ SPOGLIATO, ED ABBEVE- RATO CON FELE. | Giunto al Calvario, esangue il nostro Christo, | per suo conforto ha solo amaro Misto.*

One finds here again the various Orientals seen from behind. The 'portrait' to the extreme left shows once more Giandomenico's realistic vein.

Bibliog.: Nagler, 1847, 9; De Vesme, 1906, 45; Sack, 1910, 12; Pallucchini, 1941, 335; Pittaluga, 1952, 149; Pignatti, 1965, XLIV; Rizzi, 1970, 49.

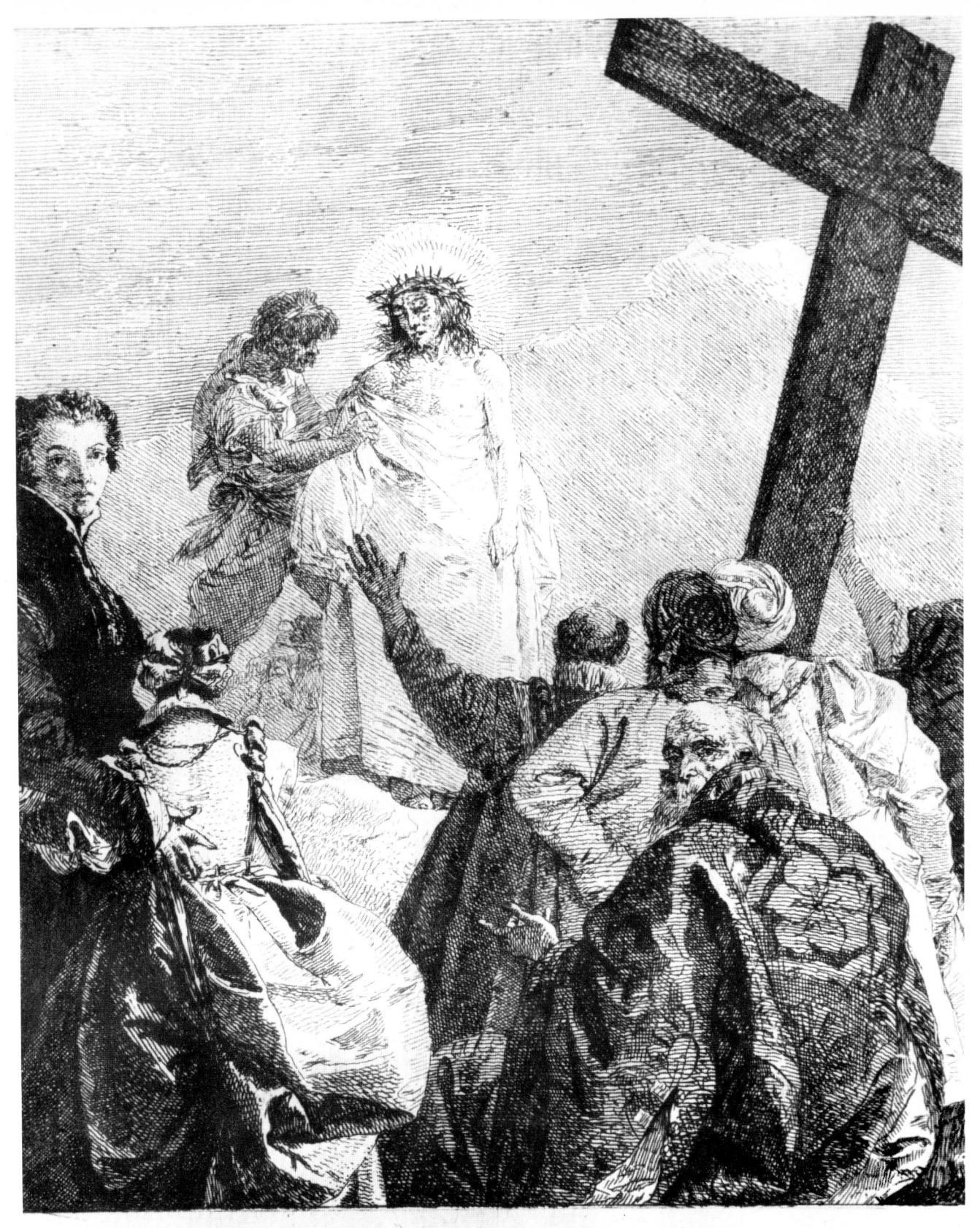

STAZIONE X.
GESÙ SPOGLIATO, ED ABBEVERATO CON FELE.
Giunto al Calvario, esangue il nostro Christo,
per svo conforto ha solo amaro Misto.

51. Station of the Cross
Christ is nailed to the Cross

225 × 174 mm. Inscribed: *STAZIONE XI | GESÙ INCHIODATO IN CROCE. | Disteso sù l' Altar, qual' innocente | Agnel, posa Gesù soavemente.*

The old Oriental beside the ladder stands out in his whiteness from the crowd and recalls in particular etching No. 9, which also shows figures grouped on the left.

Bibliog.: Nagler, 1847, 9; De Vesme, 1906, 46; Sack, 1910, 13; Pallucchini, 1941, 336; Pittaluga, 1952, p. 149; Rizzi, 1970, 50.

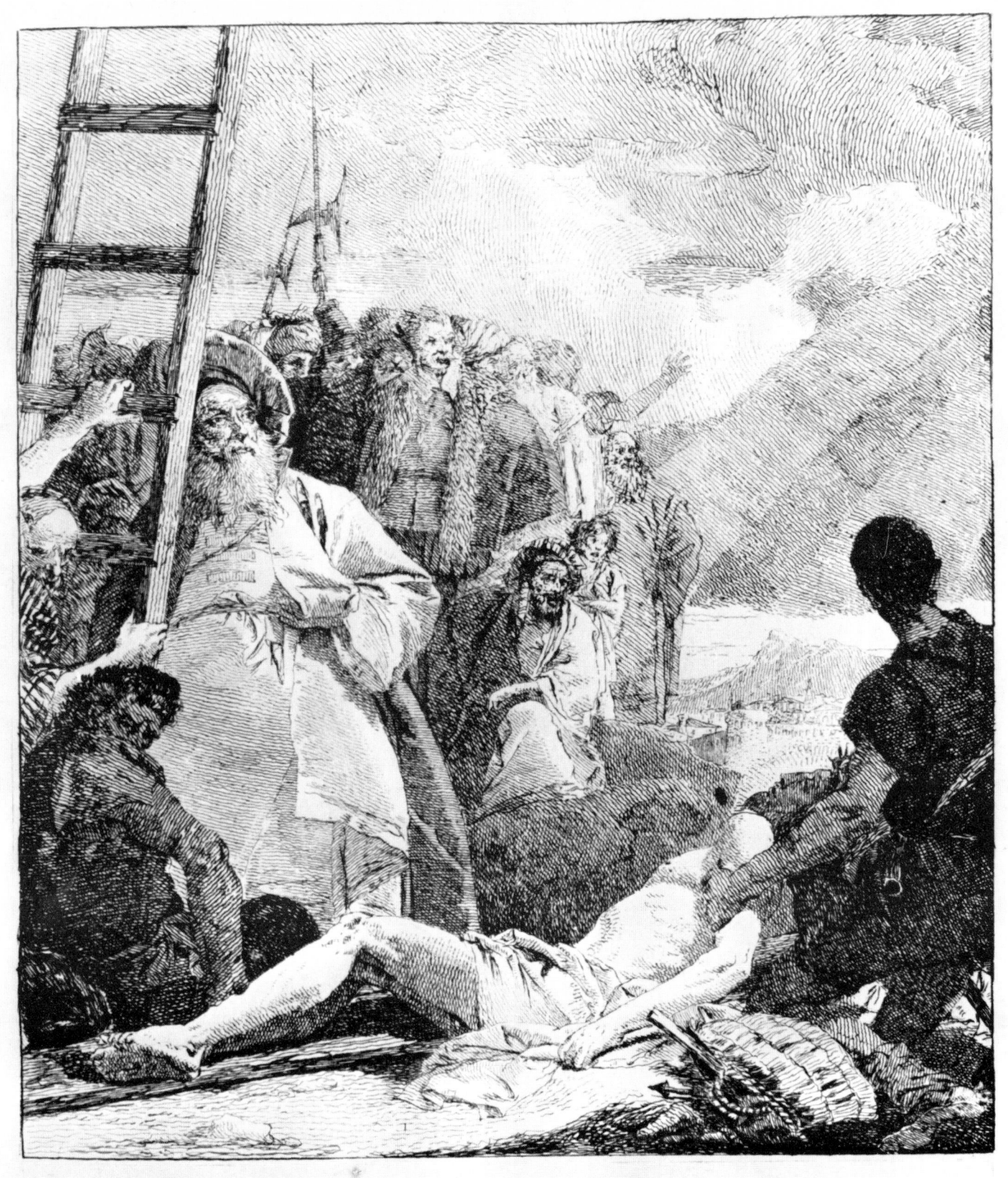

STAZIONE XI ·

GESÙ INCHIODATO IN CROCE.

Disteso sù l'Altar, qual'innocente

Agnel, posa Gesù soavemente.

52. Stations of the Cross
The Crucifixion

225 × 174 mm. Inscribed: *STAZIONE XII. | Sul Legno infame sta l'Uom de dolori | e' fal suo Trono per regnar su i cuori.*

The woman supporting the Virgin is inspired by the kneeling female figure in etching No. 11, by Giambattista; the old men, too, are similar to those to be found in the *Scherzi*.

Bibliog.: Nagler, 1847, 9; De Vesme, 1906, 47; Sack, 1910, 14; Pallucchini, 1941, 337; Pignatti, 1965, XLV; Rizzi, 1970, 51.

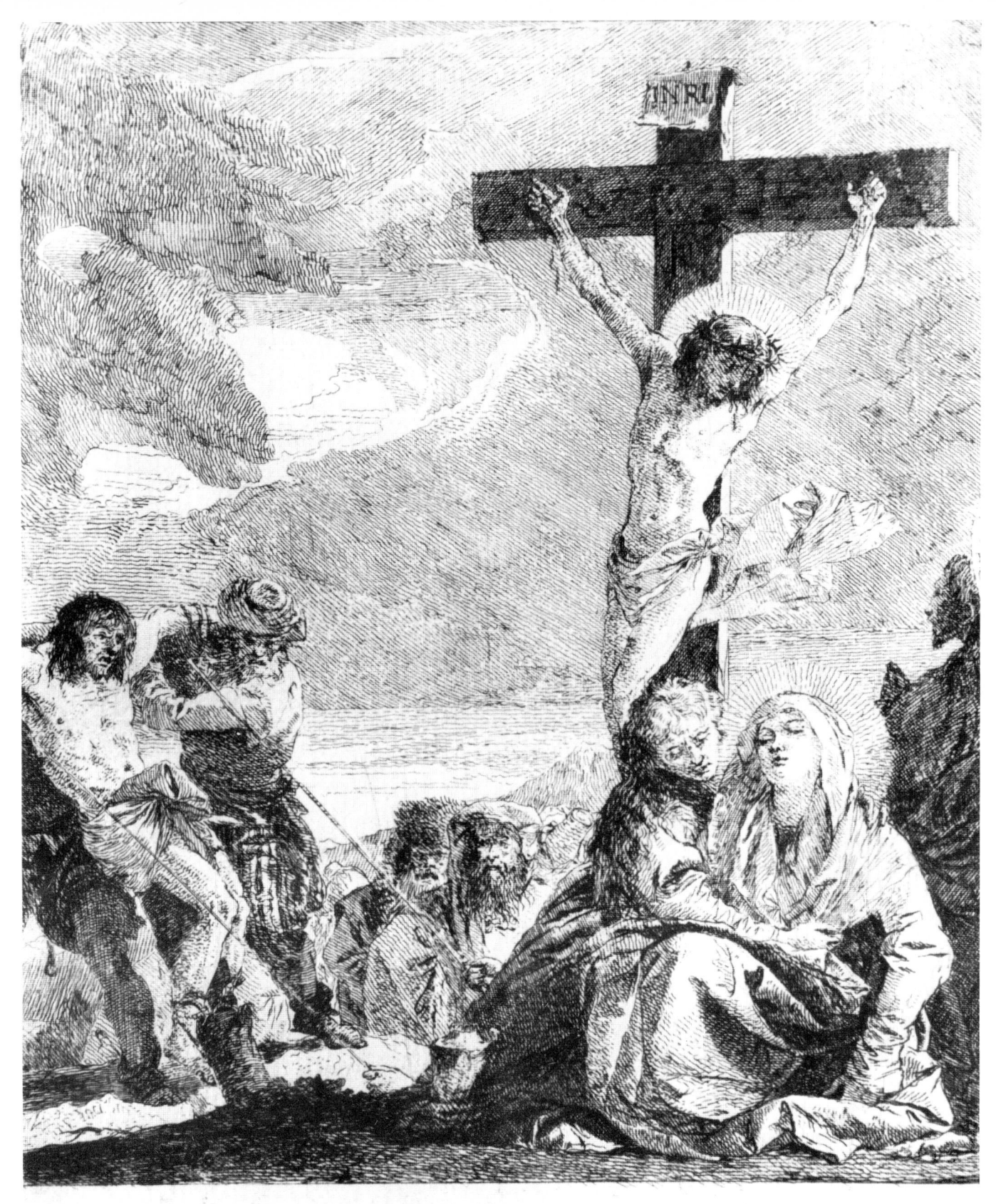

STAZIONE · XII ·

Sul Legno infame sta l'Vom de dolori,
e fal suo Trono per regnar sù i cuori.

53. Station of the Cross
The Deposition

229 × 174 mm. Inscribed: *STAZIONE XIII. | MORTO GESÙ, VIEN DEPOSTO DALLA CROCE IN SENO ALLA SUA SS.A MADRE. | Spira del Padre in sen l'Alma adorata | Gesù: resta a Maria la Spoglia amata.*

Byam Shaw has pointed out that the arrangement of the figures is similar to that in a drawing in the Harris Collection, London, also by Giandomenico.

Bibliog.: Nagler, 1847, 9; De Vesme, 1906, 48; Sack, 1910, 15; Pallucchini, 1941, 338; Byam Shaw, 1962, 19; Rizzi, 1970, 52.

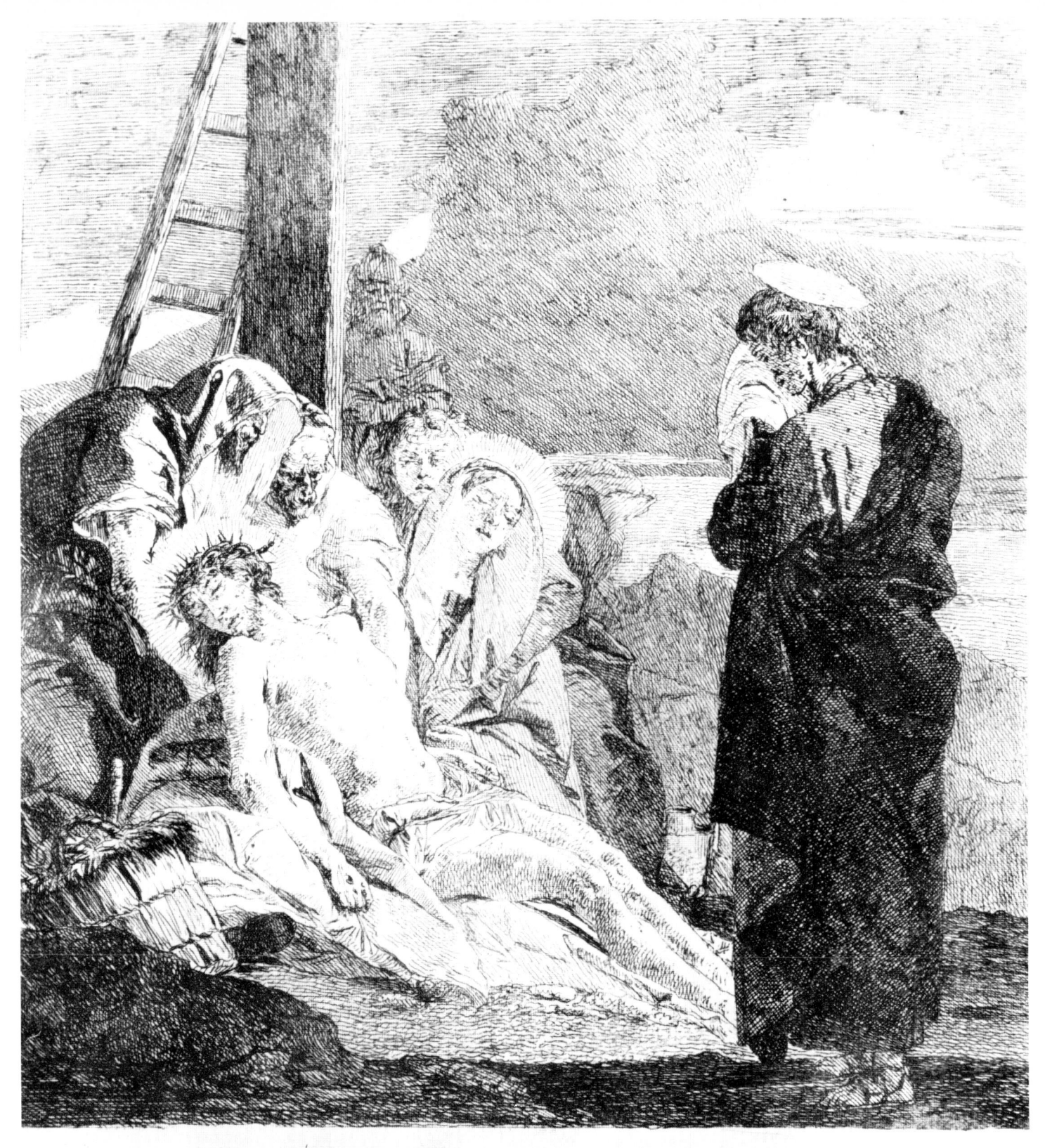

STAZIONE XIII·

MORTO GESÙ, VIEN DEPOSTO DALLA CROCE IN SENO ALLA SUA SSᵃ MADRE

Spira del Padre in sen L'Alma adorata
Gesù: resta a Maria la Spoglia amata.

54. Stations of the Cross
The Entombment

220 × 183 mm. Inscribed: *STAZIONE ULTIMA. | Vinto ha Gesù col suo morir la morte, | aprendo a noi del Ciel le chiuse porte.*

This last etching of the series, like the painting it is derived from, shows the influence of the style of Rembrandt.

Bibliog.: Nagler, 1847, 9; De Vesme, 1906, 49; Sack, 1910, 16; Pittaluga, 1952, 149–50; Pignatti, 1965, XLVI; Rizzi, 1970, 53.

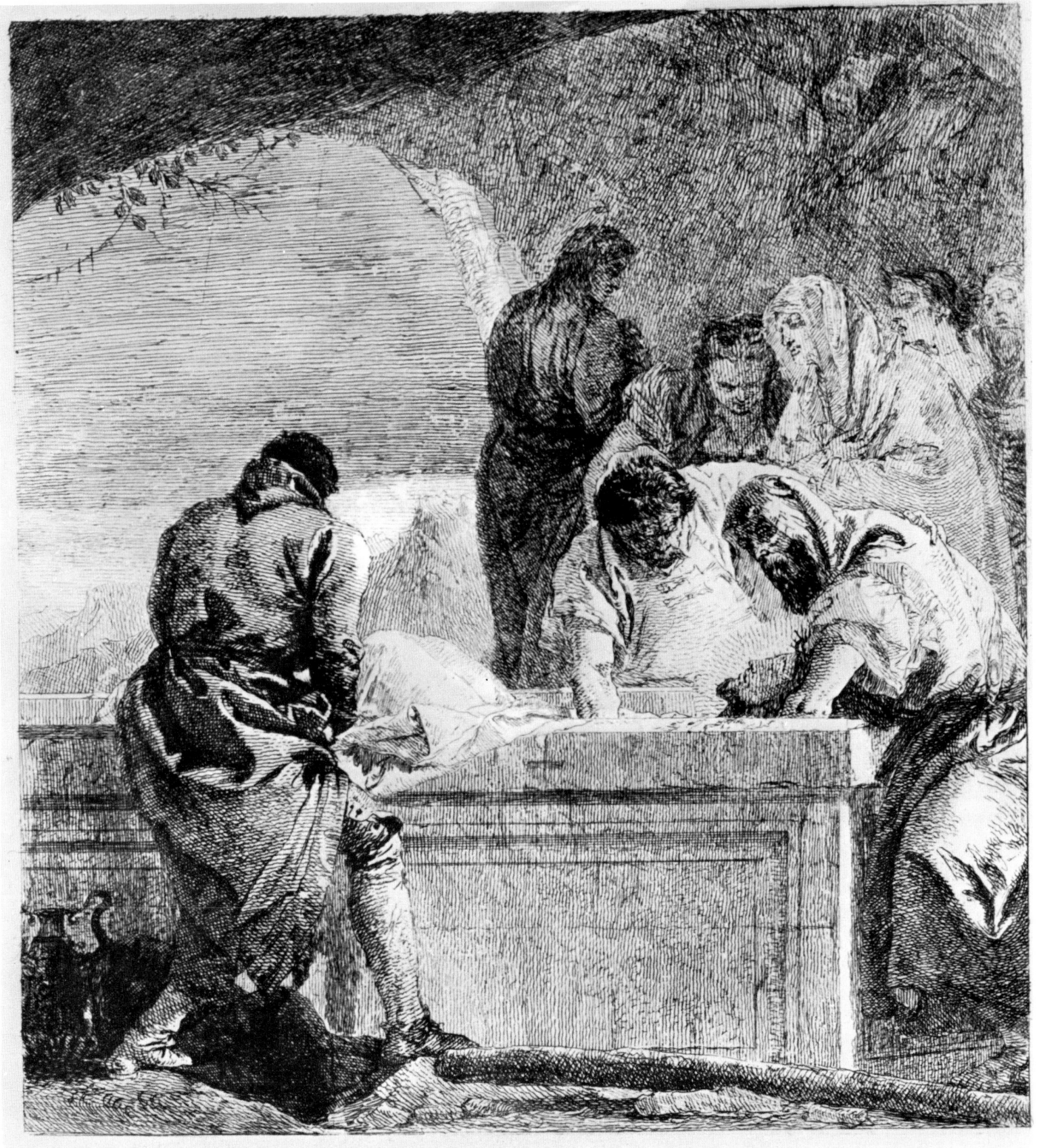

STAZIONE ULTIMA.
Vinto hà Gesù col suo morir la morte,
aprendo a noi del Ciel le chiuse porte.

55. S. Geronimo Emiliani

134 × 88 mm. Inscribed, on the lower edge
B.P. Hieronymus Aemilianus. | D. Tiepolo Fec

The style and the iconography prove this to be one of the very earliest etchings by Giandomenico to be connected with the series based on the paintings for S. Polo (1749).

Bibliog.: Nagler, 1847, 18; De Vesme 1906, 65; Sack, 1910, 50; Rizzi, 1970, 62.

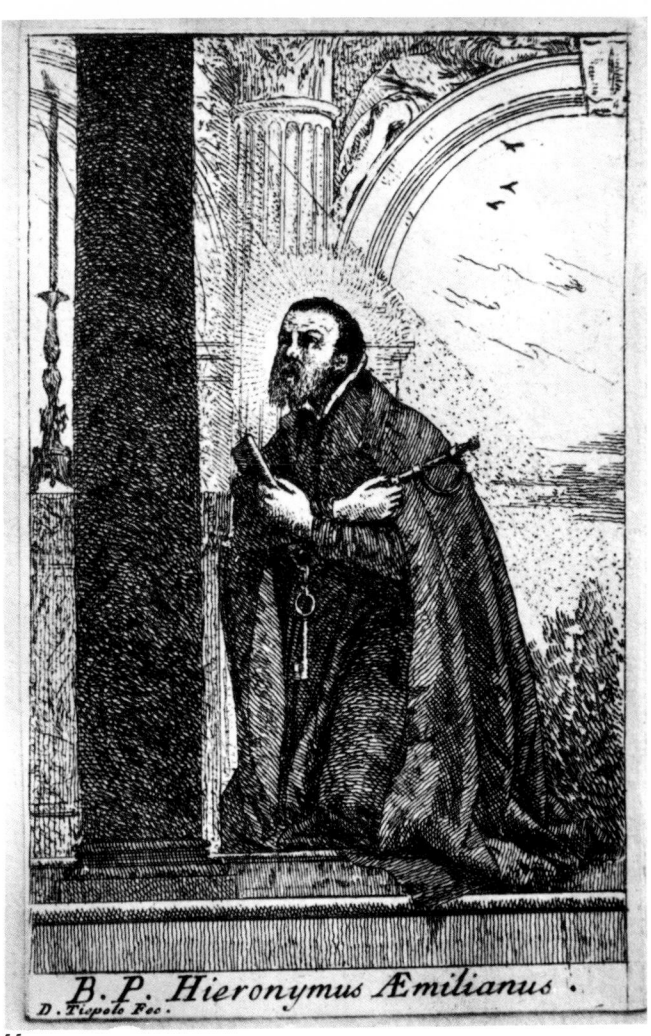

B.P. Hieronymus Æmilianus.

D. Tiepolo Fec.

55

139

56. S. Francesco da Paola cures a possessed man

167 × 97 mm. First state: with the inscription, but without various later additions; it lacks, for instance, the vertical strokes which appear in the second state at the right, both above and beneath the balustrade. Second state: with these additions. The inscription, adorned with a sphere between two palms, reads: *S. Francesco di Paula | Domenico Tiepolo inu: et incid:*.

The original painting was executed by Giandomenico in 1748 for the church of S. Francesco da Paola in Venice (Morassi, 1941, p. 266). See also the following plate.

Bibliog.: Nagler, 1847, 20; De Vesme, 1906, 61; Sack, 1910, 48; Rizzi, 1970, 54.

S. Francesco di Paula

Domenico Tiepolo inu: et in

57. The Holy Family with a beggar and his son

188 × 101 mm. Signed *Jo. Dom. Tiepolo Inventor et incisor* at bottom left.

The acid graphic style and the decoration on the lower edge link this sheet to the preceding one. The National Museum, Warsaw, has a drawing which has been regarded as a study for this etching; it is, however, feeble derivative work.

Bibliog.: Nagler, 1847, 3; De Vesme, 1906, 30; Sack, 1910, 46; Morassi, 1960, p. 27; Rizzi, 1970, 65.

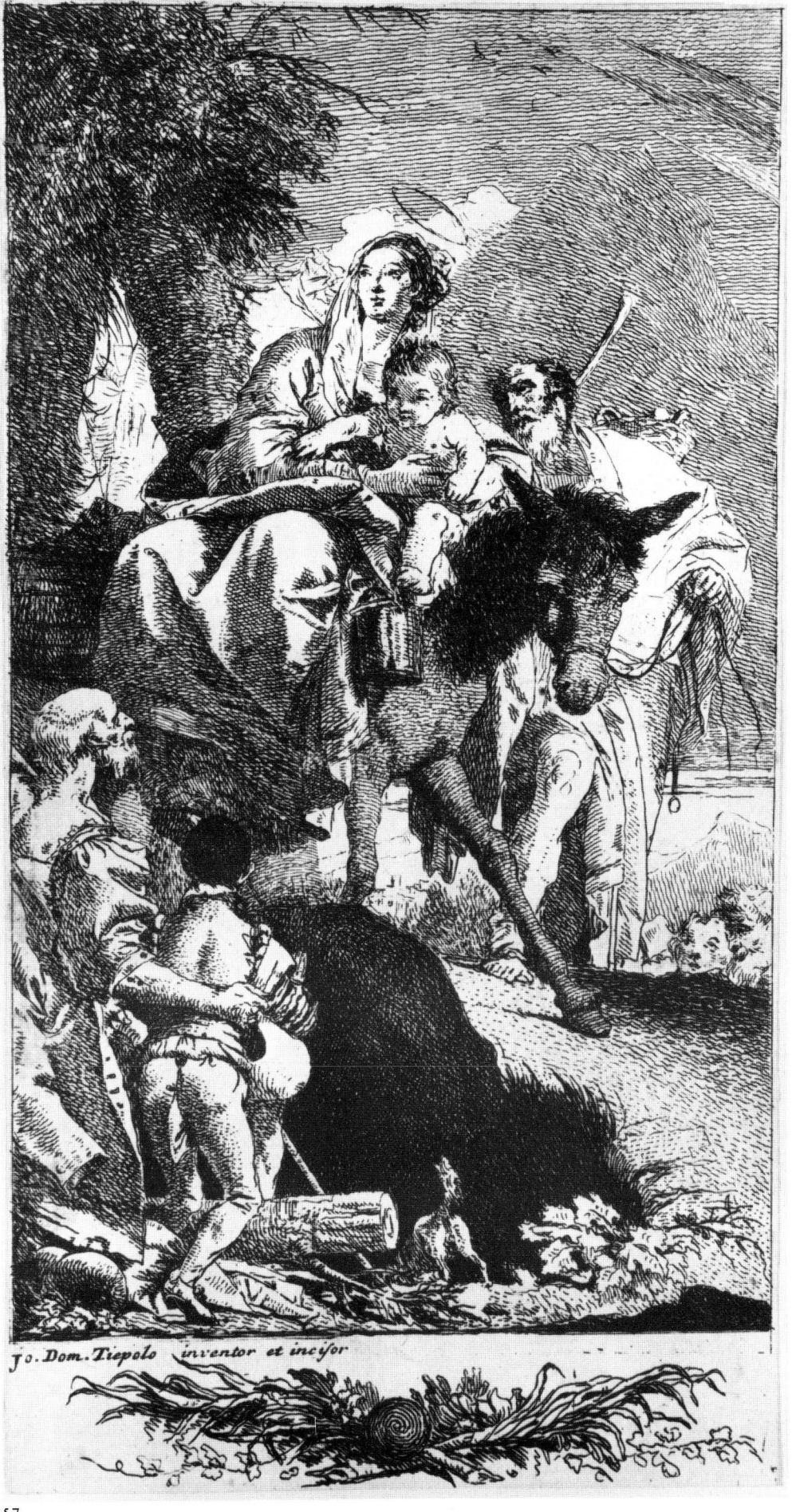

Jo. Dom. Tiepolo inventor et incisor

57

58. St. Helena finding the True Cross

219 × 142 mm. Inscribed, at the lower edge: *Joannes Dominicus Tiepolo | invenit pinxit et delin.*

This and the next six etchings are derived from paintings executed by Giandomenico between 1747 and 1749 for the Oratorio del Crocifisso in S. Polo, Venice. Some of these paintings are now lost. The etchings are contemporary with the Stations of the Cross.

Bibliog.: De Vesme, 1906, 82; Sack, 1910, 55; Rizzi, 1970, 55.

Ioannes Dominicus Tiepolo
invenit pinxit et delin.

59. S. Vincent Ferrer preaching in in the countryside

216 × 141 mm. First state: before all letters and before the head of the Saint. There is an impression of this in the British Museum. Second state: inscribed, near the lower edge: *S. Vincenzo Ferrerio.* | *Io.s Dominicus Tiepolo pinxit, et fecit.* The number *11* at top right.

See note to the previous plate.

Bibliog.: De Vesme, 1906, 71; Sack, 1910, 54; Pittaluga, 1952, 152; Rizzi, 1970, 56.

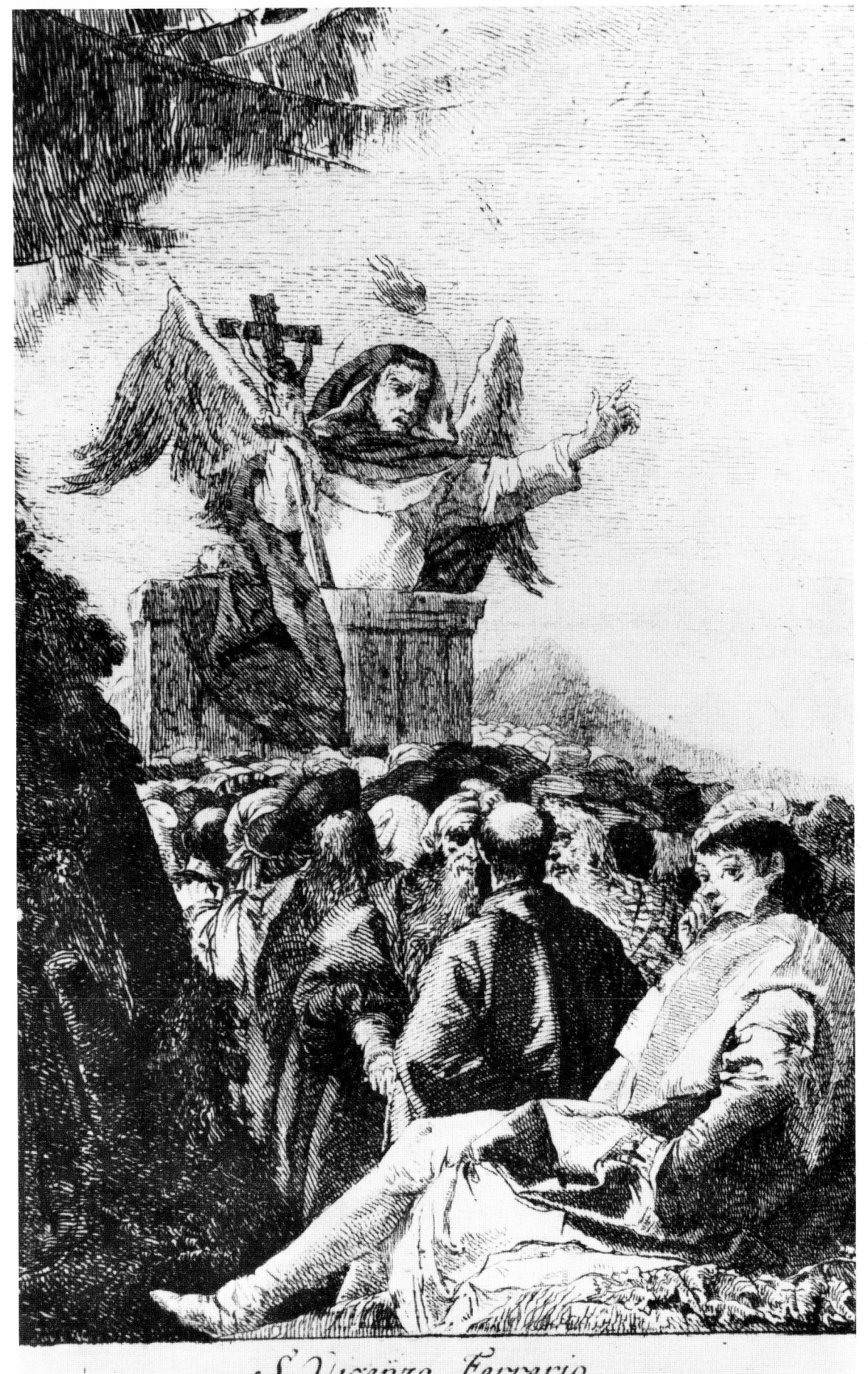

S. Vicenzo Ferrerio.

59

147

60. The Martyrdom of St. John Nepomuk

220 × 107 mm. Inscribed, near the lower edge: *Gio a: Domenico Tiepolo inv: pinx, et fecit.*

See pl. 58. The pendant of the painting from which this etching is derived depicts S. Joseph of Calasanza and is still in S. Polo. Strangely enough, Giandomenico did not engrave this painting.

Bibliog.: De Vesme, 1906, 64; Sack, 1910, p. 52; Pignatti, 1965, XLVII; Rizzi, 1970, 57.

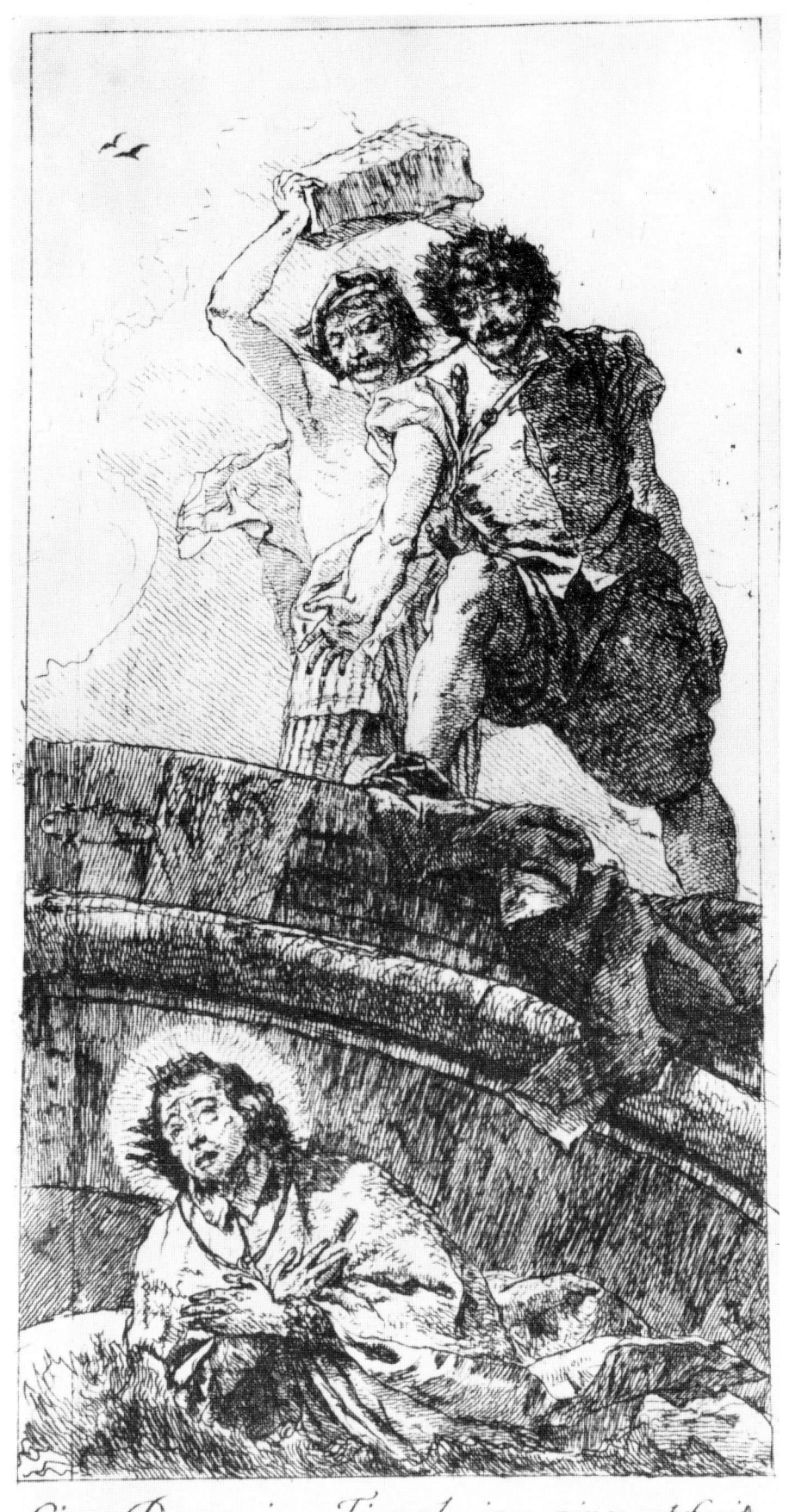

Gioa: Domenico Tiepolo inv: pinx, et fecit.

61. S. Geronimo Emiliani distributing food to the orphans

195 × 100 mm. First state: before the number; second state: *19* at top left. At the bottom, the inscription and a sphere between two palms: *B. HIERONYMUS AEMI LIANUS | Do. Tiepolo fec.*

Sack maintains that this etching is also derived from one of the paintings in S. Polo, now lost. The study for it is in the Museum at Besançon (fig. XXXV).

Bibliog.: Nagler, 1847, 19; De Vesme, 1905, 67; Sack, 1910, 47; Pallucchini, 1941, 359; Rizzi, 1970, 58.

XXXV

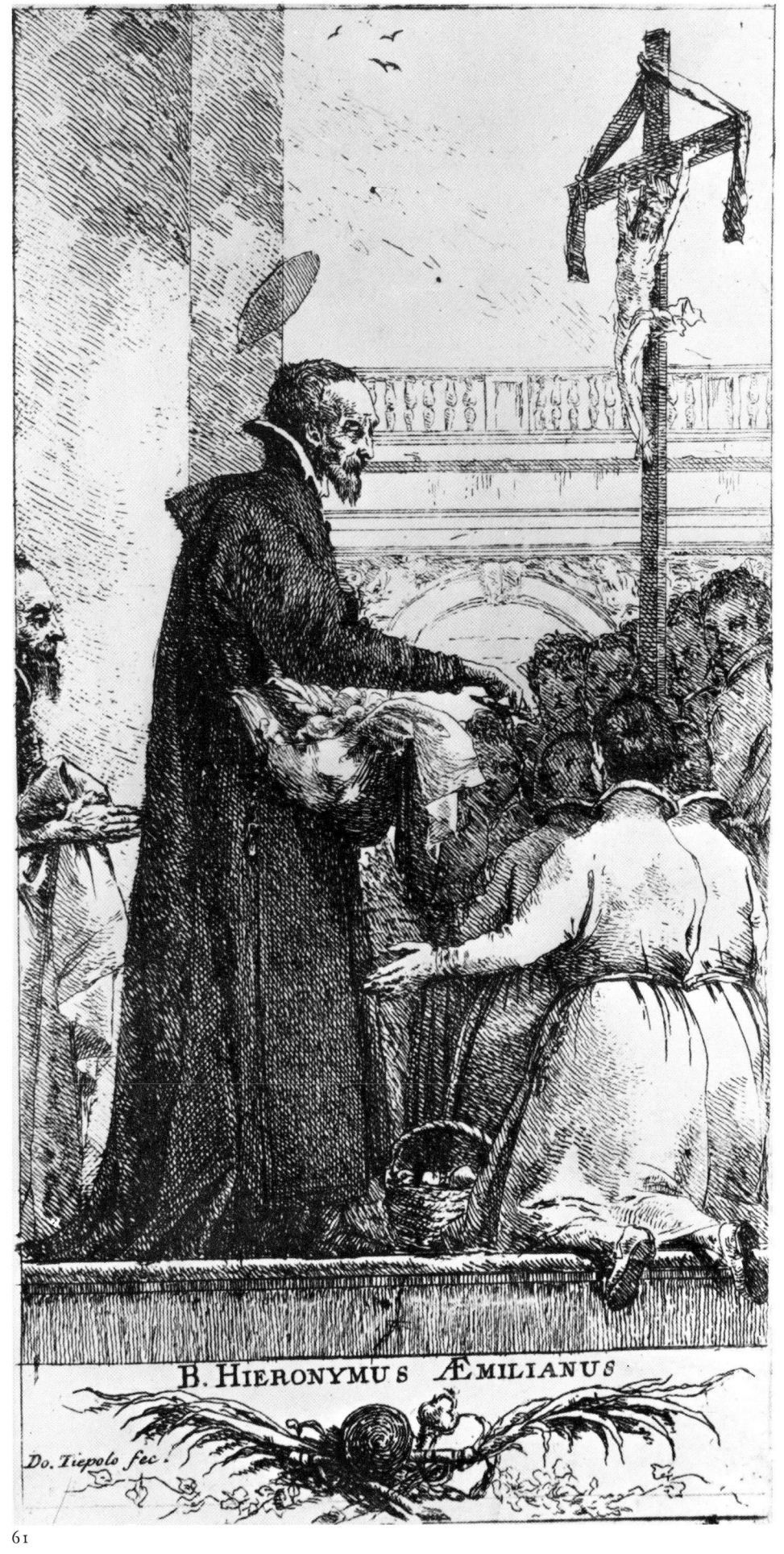

B. HIERONYMUS ÆMILIANUS

Do. Tiepolo fec.

62. S. Geronimo Emiliani with a kneeling youth

206 × 80 mm. Inscribed: *ITE ECCE | EGO MITO | VOS* on a paper held by the youth, and *Joannes Dominicus Tiepolo | invenit pinxit et delineavit* near the lower edge.

According to Sack, the etching depicts S. Joseph of Calasanza. It is derived from a painting for S. Polo, now lost. See also note to pl. 58.

Bibliog.: Nagler, 1847, 29; De Vesme, 1906, 66; Sack, 1910, 53; Pallucchini, 1941, 370; Rizzi, 1970, 59.

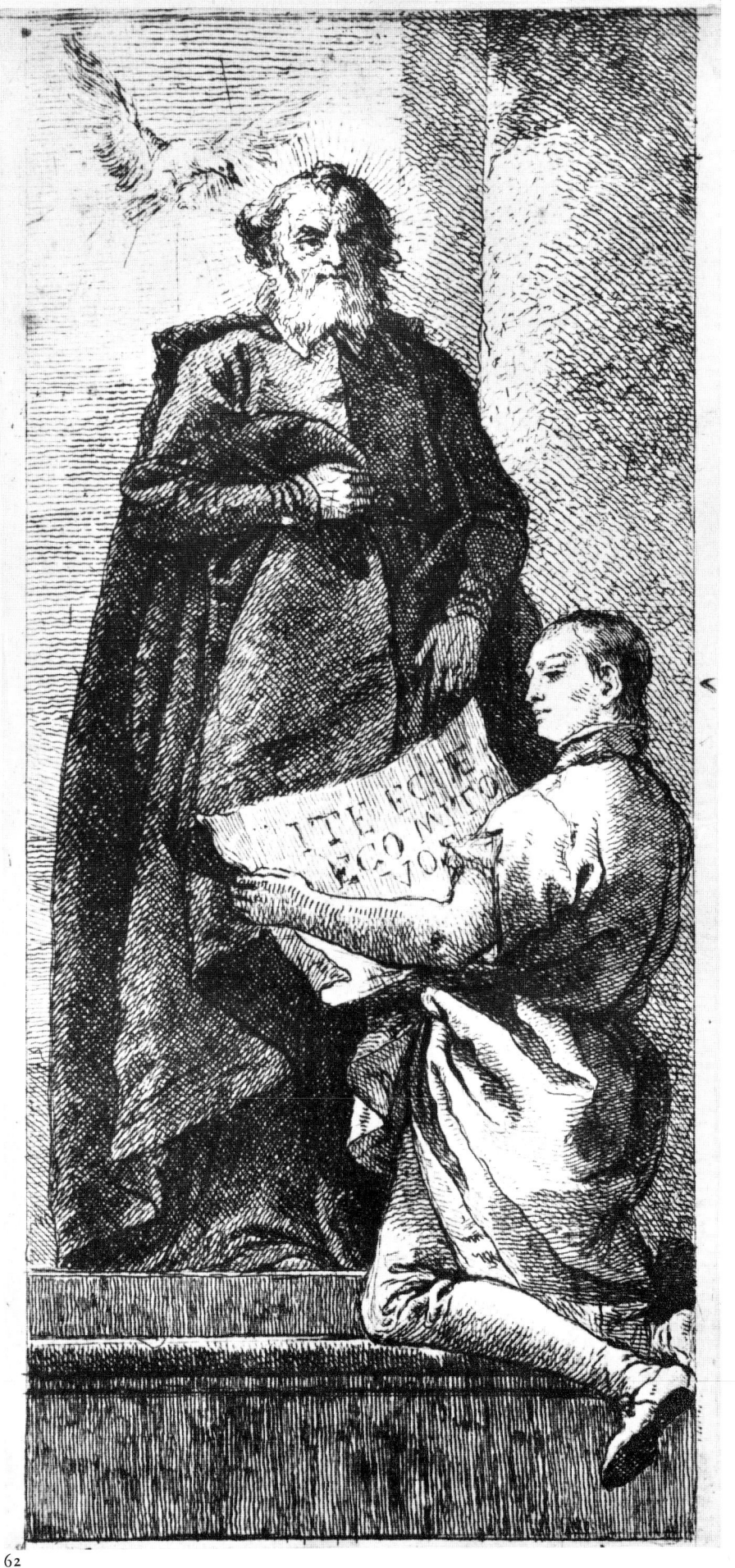

63. St. Margaret of Cortona adoring the Crucifix

252 × 92 mm. First state: before the number; second state: 7 at top right. Inscribed, near the lower edge: *Joannes Dominicus Tiepolo / invenit pinxit et delineavit.*

According to Sack, it is derived from a painting of this subject in S. Polo. The painting is now lost.

Bibliog.: Nagler, 1847, 28; De Vesme, 1906, 68; Sack, 1910, 51; Pallucchini, 1941, 369; Rizzi, 1970, 60.

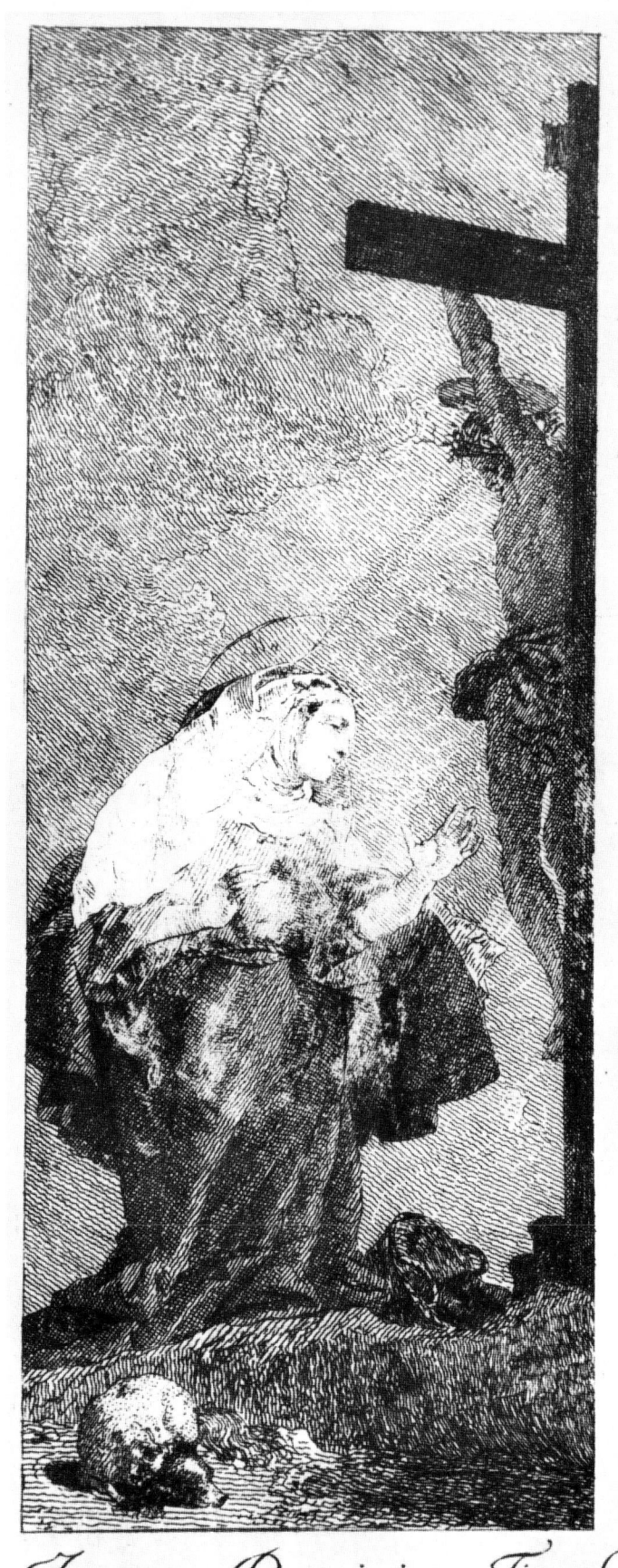

Ioannes Dominicus Tiepolo
invenit pinxit et delineavit

63

64. Glory crowning Virtue

390 × 199 mm. Inscribed, near the lower edge: *Io:s Dominicus Tiepolo pinxit et fecit*.

Sack maintained that the etching reproduced one of the frescoes for the ceiling of S. Polo. The two paintings in existence have no connection with this etching, which is stylistically close to the *Flight into Egypt*.

Bibliog.: Nagler, 1847, 45; De Vesme, 1906, 103; Sack, 1910 102; Pallucchini, 1941, 383; Pittaluga, 1952, 155; Rizzi, 1970, 61.

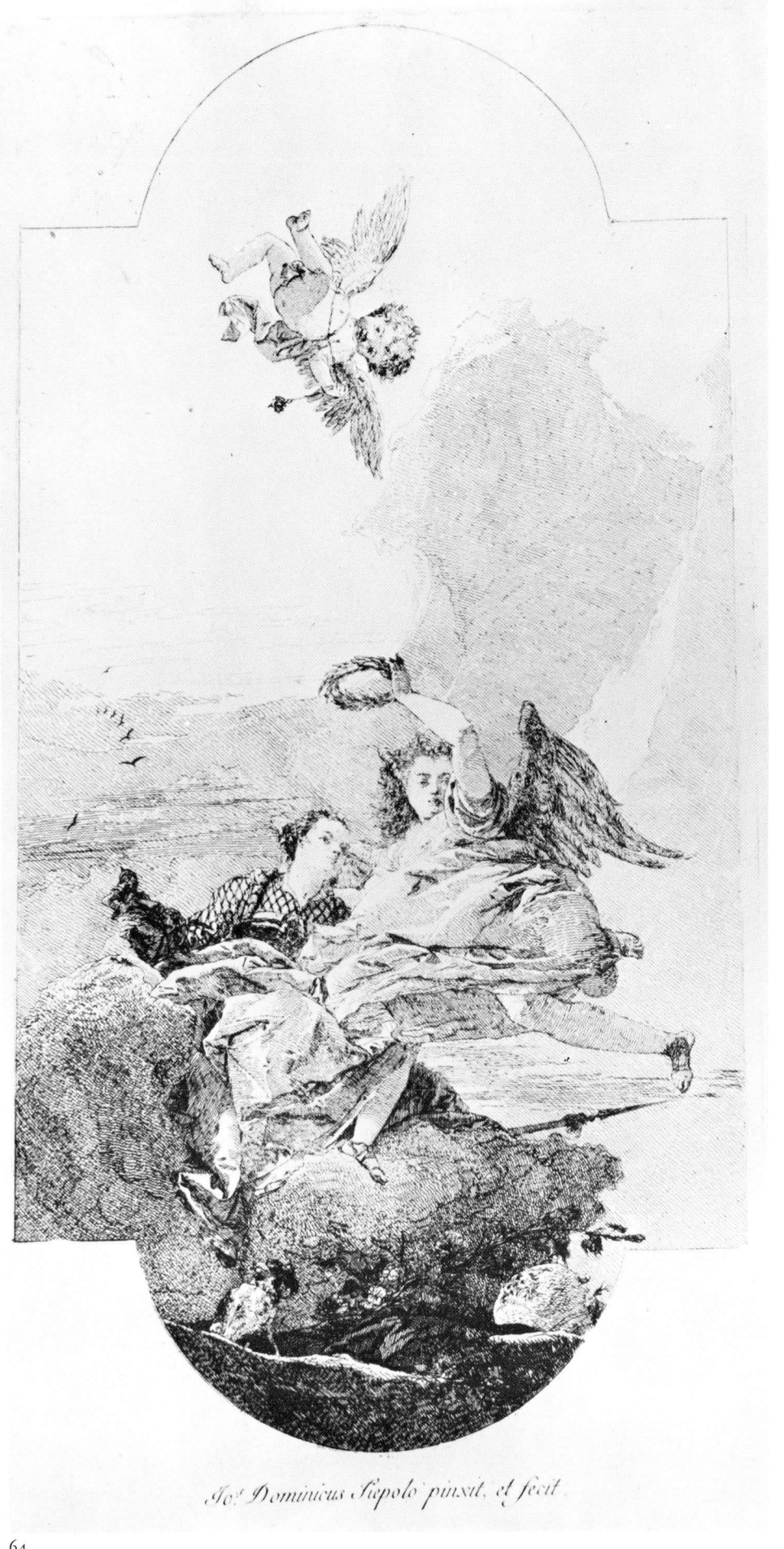

Io: Dominicus Tiepolo pinxit, et fecit.

64

65–66. Two scenes from the Flight into Egypt

189 × 257 mm. Pignatti mentions two states, the first numbered *12*, the second *9*. To the left, at the bottom, the inscription *Joannes Batta Tiepolo inv.;* to the right, *Jo. Dominicus Filius fecite.*

The drawings for these two etchings were in the Orloff Collection (figs. XXXVI and XXXVII): the first is now in a private collection in New York. According to Pignatti, some of Giambattista's paintings executed during the Spanish period can be compared with these etchings. The etchings, however, should be dated about 1750, as proved by the drawing in New York, which Knox rightly dated from the earlier decade, as well as by morphological details and the vegetation, which are inspired by the *Scherzi*.

It is quite likely that these two episodes were dropped from the series of the Flight into Egypt, and replaced, before publication, by others, in order not to contradict the wording of the title: 'Series invented and engraved by myself...'

Since Giandomenico used certain stylistic elements of his father's graphic work for this double scene, it may well be that it was engraved before the plate of the Flight into Egypt dated 1750 (see note to pl. 67).

XXXVI

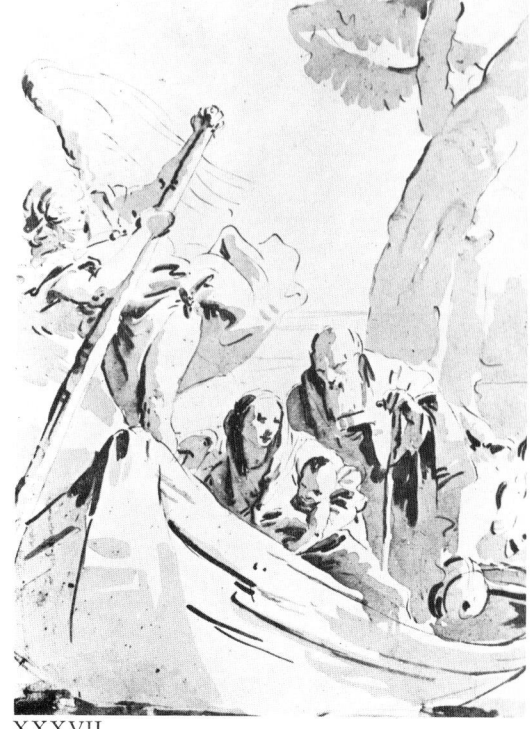

XXXVII

Bibliog.: De Vesme, 1906, 28–29; Sack, 1910, 44–45; Orloff Catalogue, 1920, 85 and 90; Morassi, 1960, p. 27; Pignatti, 1965, LXI; Knox, 1966, p. 585; ibid., 1970, 14; Rizzi, 1970, 63–64.

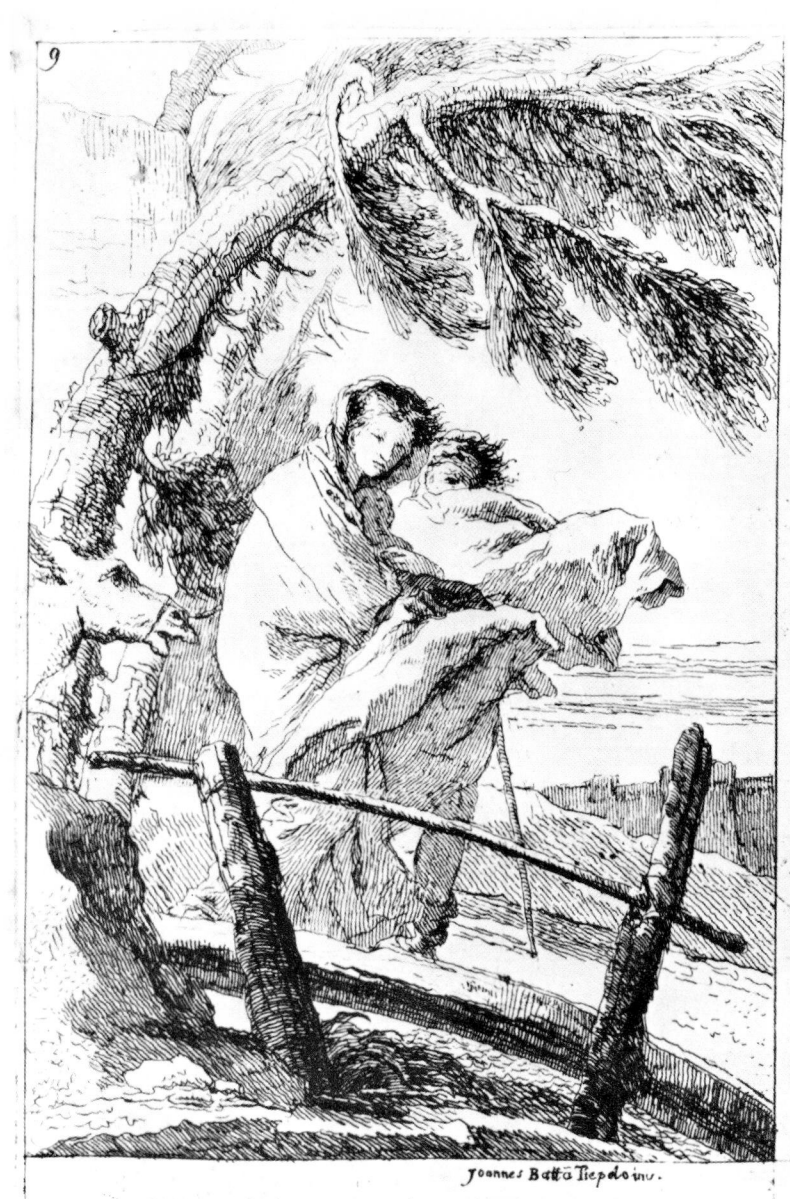

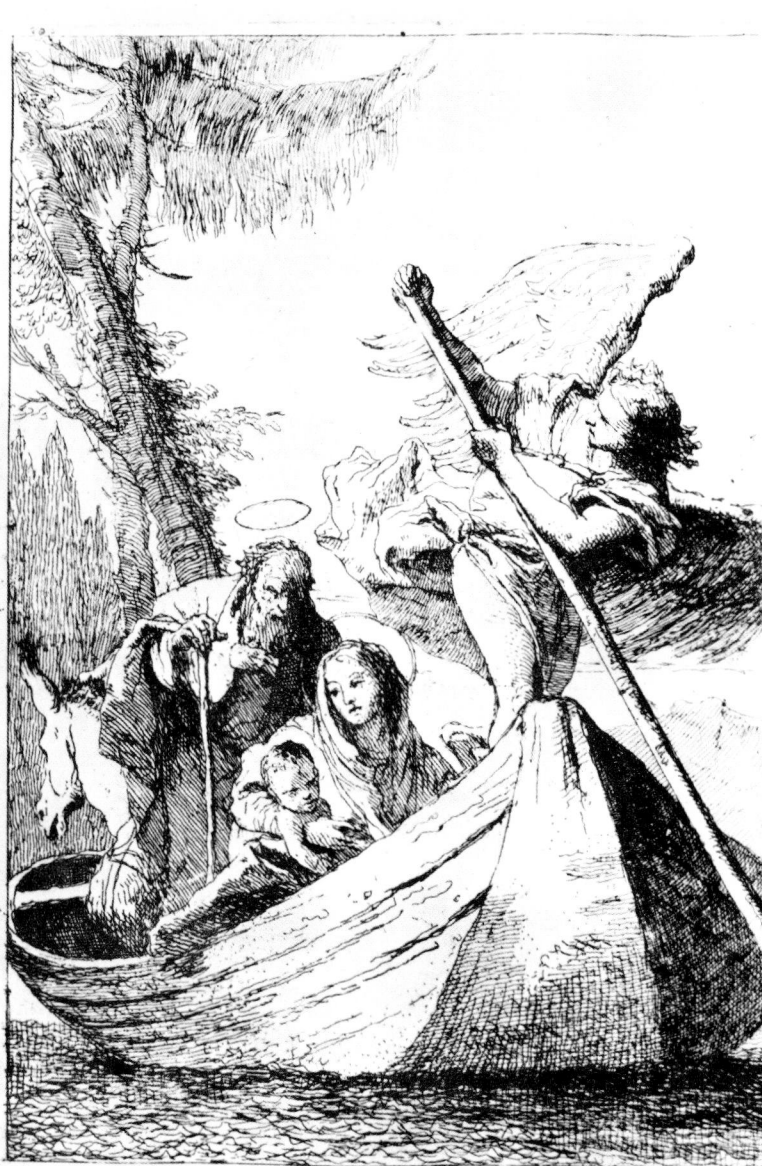

Joannes Batta Tiepolo inv.

Jo. Dominicus Filius fecit

67. The Flight into Egypt
Dedication

191 × 187 mm. Proof states of all the plates in the series before the number are known. First state: inscribed with *1* only, at bottom left; second state: besides the *1* of the first state, *3* at bottom left; third state: the whole series reworked. Each plate is numbered at the bottom, within the etched area. Inscribed: *A | Sua Altezza Reverendissima | Monsignor | Carlo Filippo | Prencipe del Sacro Romano Impero | Vescovo d'Herbipoli | e | Duca di Franconia | Orientale | &c &c.*

The series of etchings was published in Würzburg in 1753 and included 27 plates, numbered from 1 to 27: the dedication, the arms of the Prince-Bishop Carl Philipp von Greiffenklau, the title page, and 24 plates with scenes of the Flight into Egypt, many of them signed. Three plates are dated: No. 13 is dated 1750; No. 19, 1752 and No. 21, 1753. The series was included by Giandomenico in his Catalogues.

The theme of the Holy Family leaving their homeland to seek refuge in Egypt has always attracted the imagination of artists. This theme was one of Giambattista's many artistic interests, as shown not only by a rich series of drawings formerly in the Orloff Collection (Nos. 78–91); but also by other sheets, such as the one in the Bassano Museum, datable about 1730 (Ragghianti, 1953, p. 25, No. 4, has doubts about its authenticity as it was retouched by another hand; it would still constitute proof of the existence of a lost prototype), and the one in the Victoria and Albert Museum (Knox), datable from the middle of the fifth decade.

As we saw in connection with plates 57 and 65–66, Giandomenico had used this theme in his etchings even before launching into the series.

Sack stated that the 24 preliminary drawings for the *Flight* were in the Munich Print Room (the one for the frontispiece is in the British Museum); in fact, these drawings are derived from the etchings, according to Knox by Francesco Lorenzio. The Besançon Museum possesses a sheet on which Giandomenico drew sketches on the theme of the *Flight* side by side with drawings inspired by Giambattista's *Scherzi* (fig. XXXVIII); another two are in the University Museum in Würzburg (fig. XXXIX and XL).

XXXVIII

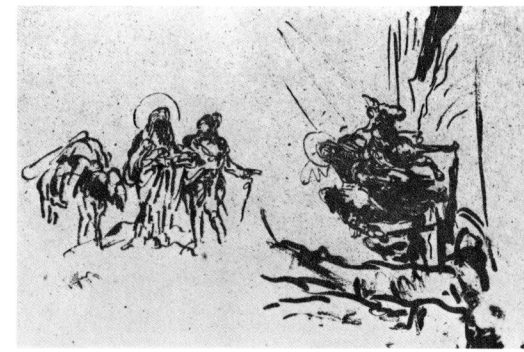

XXXIX

XL

Bibliog.: Nagler, 1847, 4; De Vesme, 1906, 1; Sack, 1910, 17; Morassi, 1941, 269; Pittaluga, 1952, 156; Knox, 1960, 236; Morassi, 1960, 1; Rizzi, 1970, 66; Knox-Thiem, 1970, 194–95.

A

Sua Altessa Reverendissima

Monsignor

CARLO FILIPPO

Prencipe del Sacro Romano Impero

Vescovo d'Herbipoli

Duca di Franconia

Orientale

&c &c

1

68. The Flight into Egypt
Frontispiece: the arms of Carl Philipp von Greiffenklau carried aloft by an angel
186 × 234 mm. Numbered 2 at bottom left.

The coat of arms of the Prince-Bishop, surmounted by a crown, is supported by an angel and preceded by Fame carrying a cross; lower down two winged putti carry the mitre and the stole. The etching stands out from the others in the series for its happy imagery and its picturesque view of the fortress at Würzburg, the Festung Marienberg.

Bibliog.: Nagler, 1847, 4; De Vesme, 1906, 2; Sach, 1910, 18; Pallucchini, 1941, 341; Morassi, 1960, 2; Pignatti, 1965, XLVIII; Rizzi, 1970, 67.

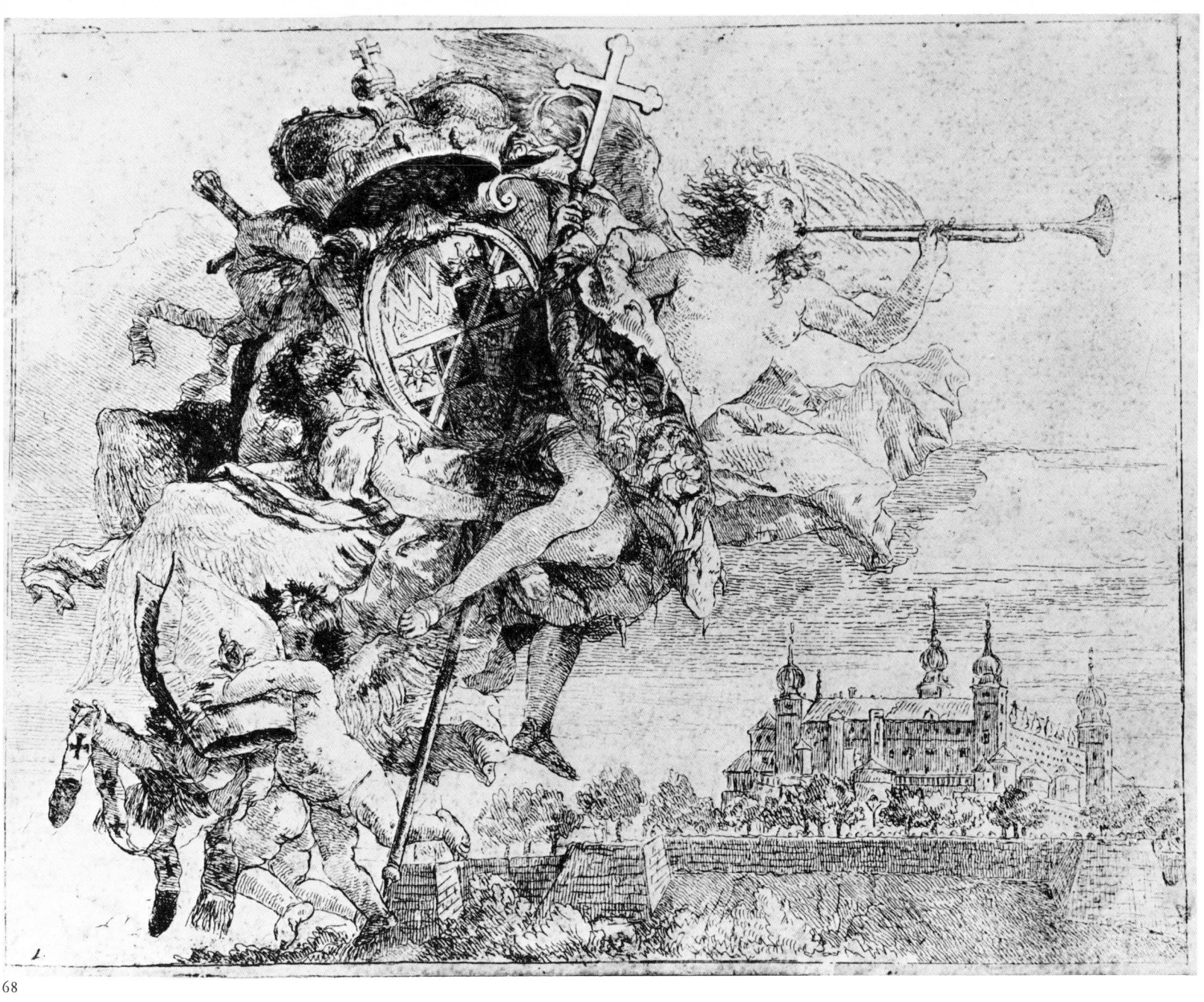

69. The Flight into Egypt
Title page

119 × 187 mm. Numbered *3* at bottom left.
Inscribed: *Idee Pittoresche | Sopra | La Fuga in Egitto | di | GIESU, MARIA e GIOSEPPE | Opera | inventata, ed incisa | da me | Gio: Domenico Tiepolo | in | Corte di detta | Sua Altezza Reverendissima &c &c | Anno 1753.*

In the first edition of Giandomenico's Catalogue the series of the Flight into Egypt opens with this sheet; the dedication and the frontispiece were omitted.

Bibliog.: Nagler, 1847, 4; De Vesme, 1906, 3; Sack, 1910, 10; Morassi, 1960, 3; Rizzi, 1970, p. 68.

Idée Pittoresche
sopra
La Fugga in Egitto
di
GIESV, MARIA e GIOSEPPE
Opera
inventata, ed incisa
da me
Gio: Domenico Tiepolo
in
Corte di detta
Sua Altessa Reverendissima &c. &c.
Anno 1753.

69

70. The Flight into Egypt
**Joseph tells Mary
of their forthcoming departure**

188 × 243 mm. Signed: *Do: Tiepolo in. et fe.* at bottom left; in the same corner, the number *4*; above the door to the right: *Do: Tiepolo fe.*

These realistic 'interiors' are typical also of Giambattista, Canaletto and Guardi; Giandomenico, probably influenced by the engravings of Canaletto, was particularly fond of them. Morassi has pointed out the incongruity of the bed with the round canopy, similar to the one in Rembrandt's etching known as *Le lit à la française*. In his catalogue (Leipzig, 1803, 4716) Winckler mentioned a 'Holy Family' with the inscription *J. B. Tiepolo inv. et fec.* It is in fact identical with this etching, whose signature was erroneously read, as De Vesme pointed out. Nagler also wrongly attributed it to Giambattista for the same reason.

Bibliog.: Nagler, 1847, 7; De Vesme, 1906, 4 and p. 392, 1; Sack, 1910, 20; Pallucchini, 1941, 342; Morassi, 1960, 4; Pignatti, 1965, XLIX; Rizzi, 1970, 69.

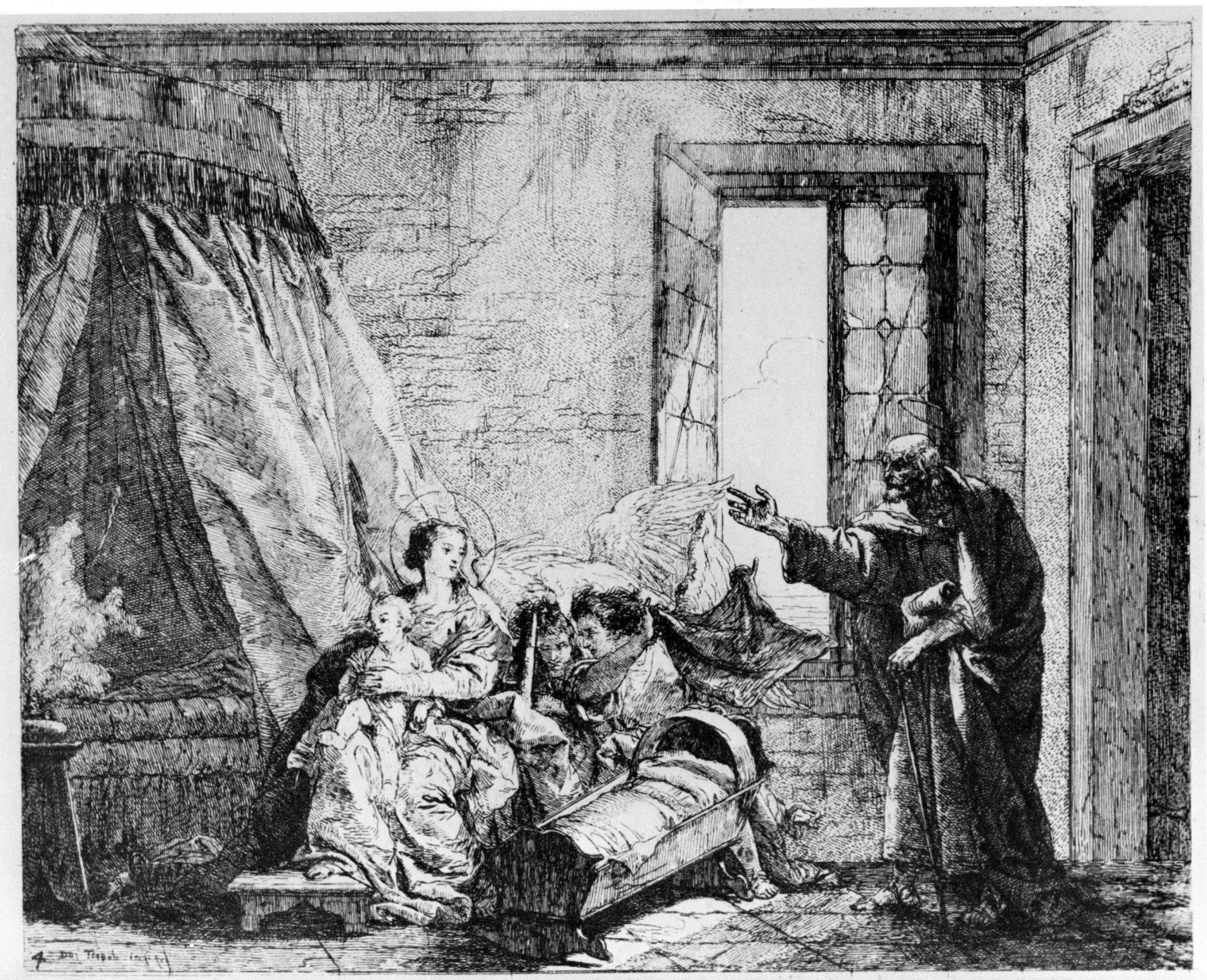

70

71. The Flight into Egypt
Joseph and Mary seeking shelter

188 × 243 mm. Signed: *Do. Tiepolo in. et Fecit*, at bottom left on a stone. In the left-hand bottom corner, the number *5*.

According to Morassi, the scene shows the family leaving their house. Sack mentioned the fact that the artist re-created the same subject in an oil painting which, in 1888, was in the Adelmann Collection in Würzburg; the painting later belonged to Baron von Reinach and in 1896 appeared in the Tiepolo exhibition held in that town. The palm tree had already appeared in Giambattista's work, although in a smaller size.

Bibliog.: Nagler, 1847, 4; De Vesme, 1906, 5 Sack, 1910, 21; Pallucchini, 1941, 343; Morassi, 1960, 5; Rizzi, 1970, 70.

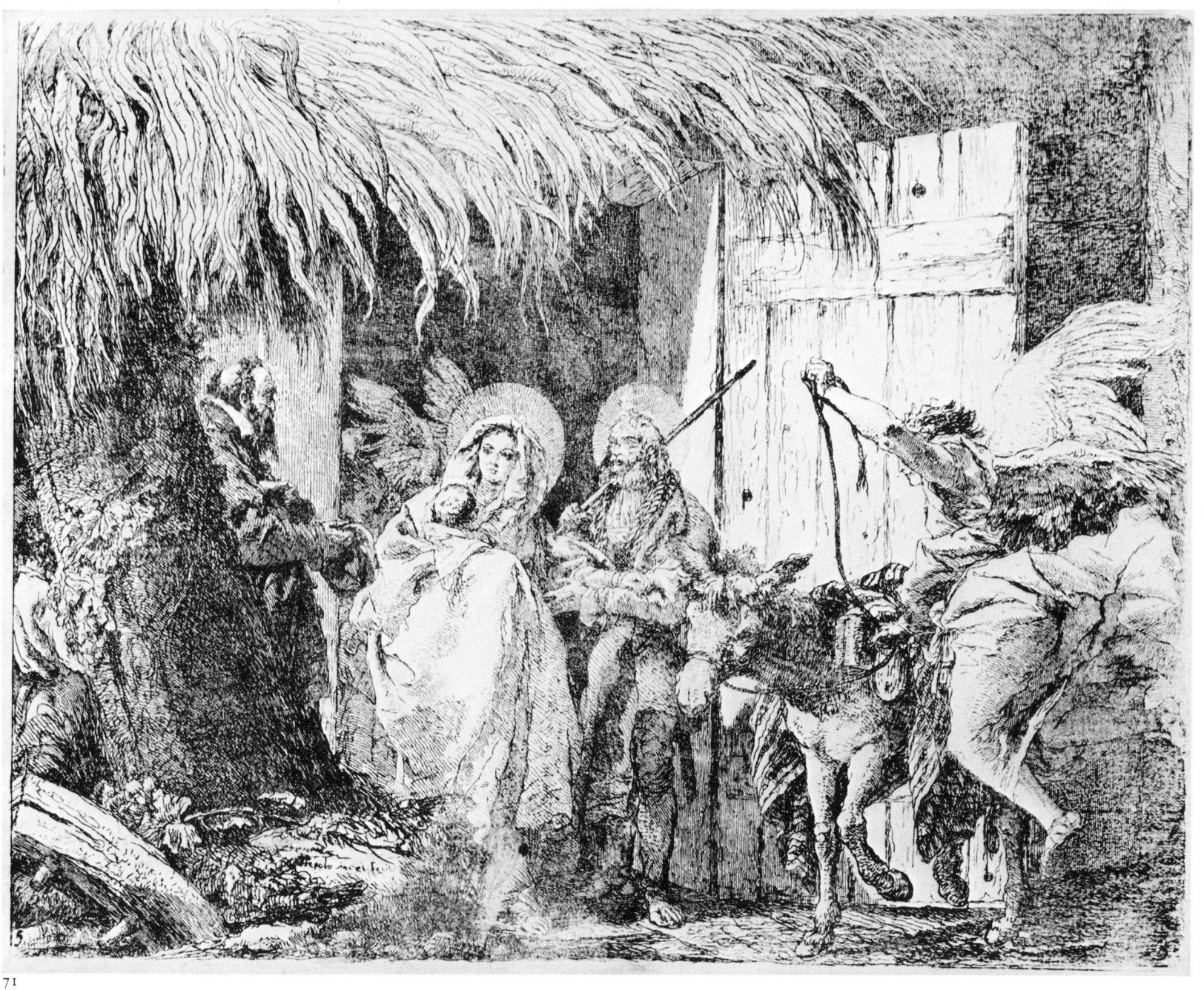

72. The Flight into Egypt
The Holy Family under a palm tree

186 × 244 mm. On a stone, by Joseph's feet, inscribed (not easily legible): *Do. Tiepolo inv. et fe.* In the left-hand bottom corner, the number *6*.

Here, as in the preceding sheet, the large palm tree answers the needs of scenography. The woman selling eggs, according to Morassi, is inspired by the one appearing in Titian's *Presentation of the Virgin* now in the Accademia, Venice.

Bibliog.: Nagler, 1847, 4; De Vesme, 1906, 6; Sack, 1910, p. 22; Pallucchini, 1941, 344; Morassi, 1960, 6; Rizzi, 1970, 71.

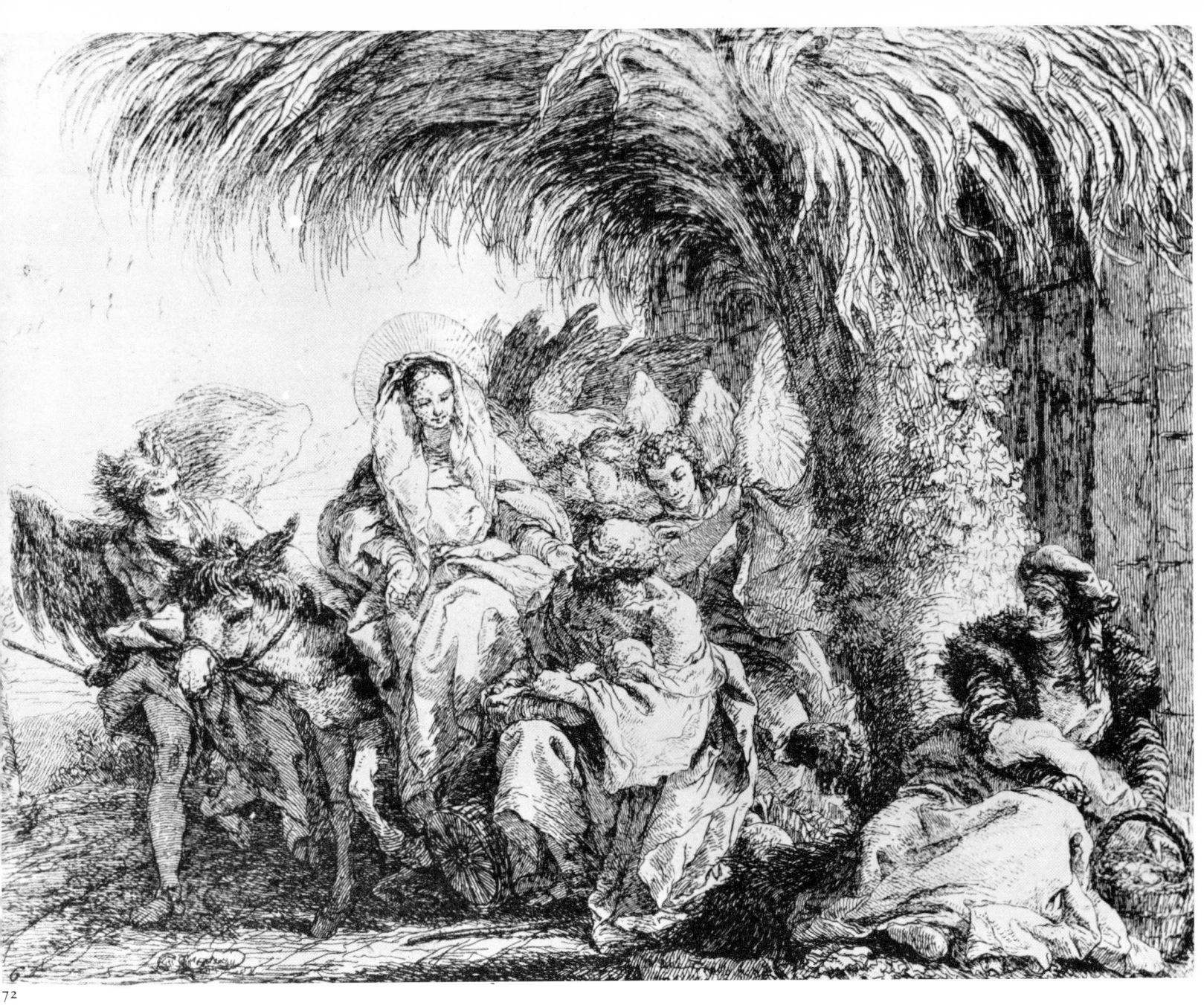

73. The Flight into Egypt
The Holy Family leaving by a city gate

187 × 241 mm. The plate carries two signatures: one engraved with the burin at bottom centre, *Do:º Tiepolo in: et fe:t;* the other etched not so clearly at bottom right: *Doº. Tiepolo fecit et de.* This inscription is quoted by Sack without the *et de;* Pignatti does not mention it at all. The first inscription is preceded by the number *7.*

Byam Shaw believes that the preparatory drawings of this sheet are in the *Quaderno Gatteri*, in the Correr Museum, numbered 5 and 75 in the Lorenzetti edition (Venice, 1946); they show a gentleman with his hands behind his back and a hunchback peasant girl seen from behind (fig. XLI); both are reversed in the print, which would seem to confirm a link between the drawings and the etching. Pignatti rejects Byam Shaw's suggestion on the grounds of stylistic and other differences.

The present author suggests that style is not a decisive element, since already in the 'Two scenes from the Flight into Egypt' (see pl. 65–66) Giandomenico drew inspiration from works by his father.

The architectural elements here are similar to those in the second of the Stations of the Cross, including the circular relief, which goes back to Titian (see pl. 42).

Bibliog.: Nagler, 1847, 4; De Vesme, 1906, 7; Sack, 1910, 23; Byam Shaw, 1962, 24; Morassi, 1960, 7; Pignatti, 1965, L; Rizzi, 1970, 72.

XLI

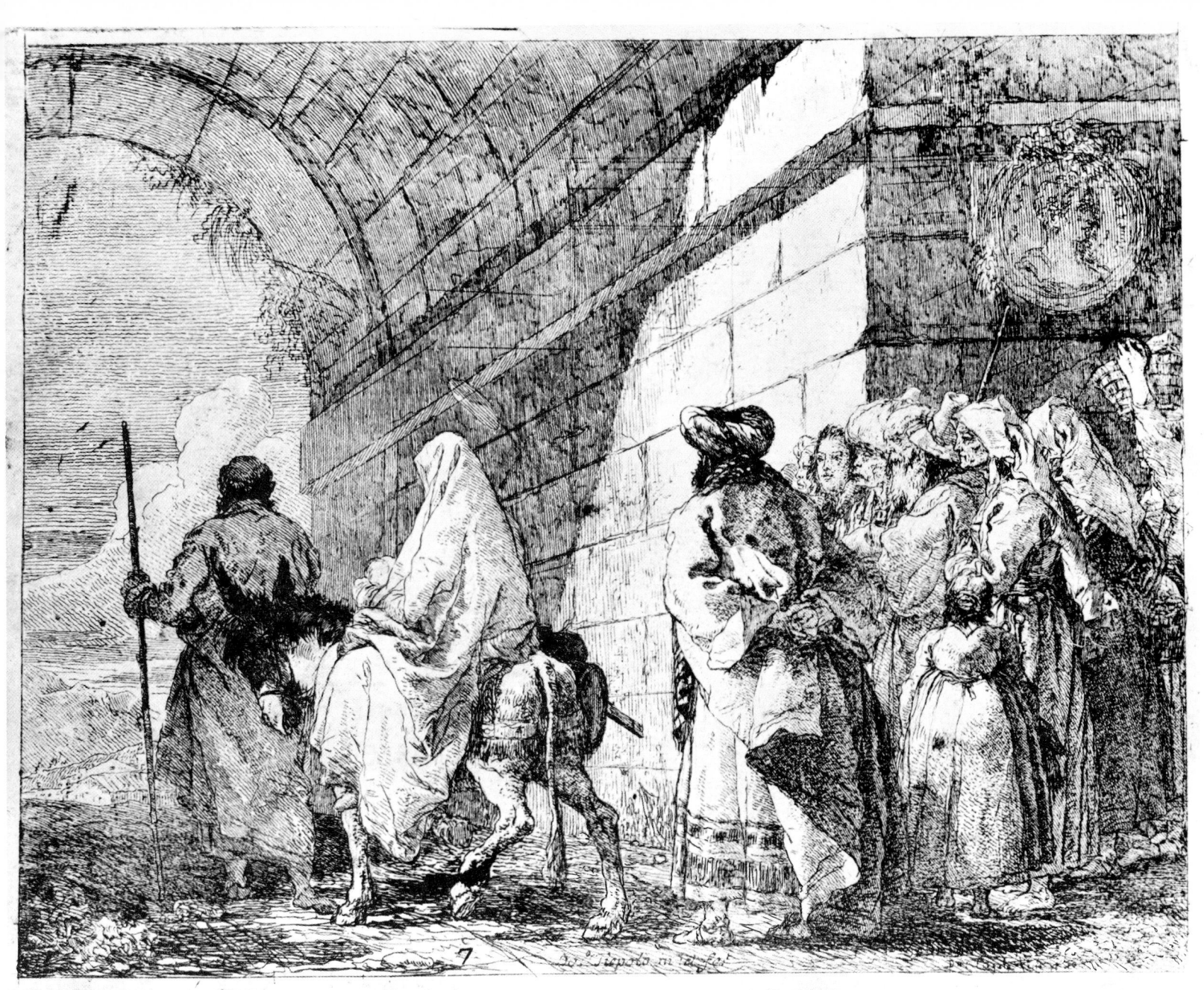

74. The Flight into Egypt
**The Holy Family walking along a
city wall. On the left, a shepherd
with his flock and God the Father.**
187 × 243 mm. De Vesme thought he saw
a signature *Tiepolo* in the grass to the right:
in fact, it is not there. The number *8* can be
seen at bottom centre.

Sack pointed out that drawings, with
variations, of Joseph led by the An-
gels are in the Correr Museum. Ac-
cording to Byam Shaw (1962, p. 12,
note 5) the towers in the background
are those of Brescia. The same ap-
plies to pl. 92.

Bibliog.: Nagler, 1847, 4; De Vesme, 1906, 8;
Sack, 1910, 24; Morassi, 1960, p. 8; Rizzi,
1970, 73.

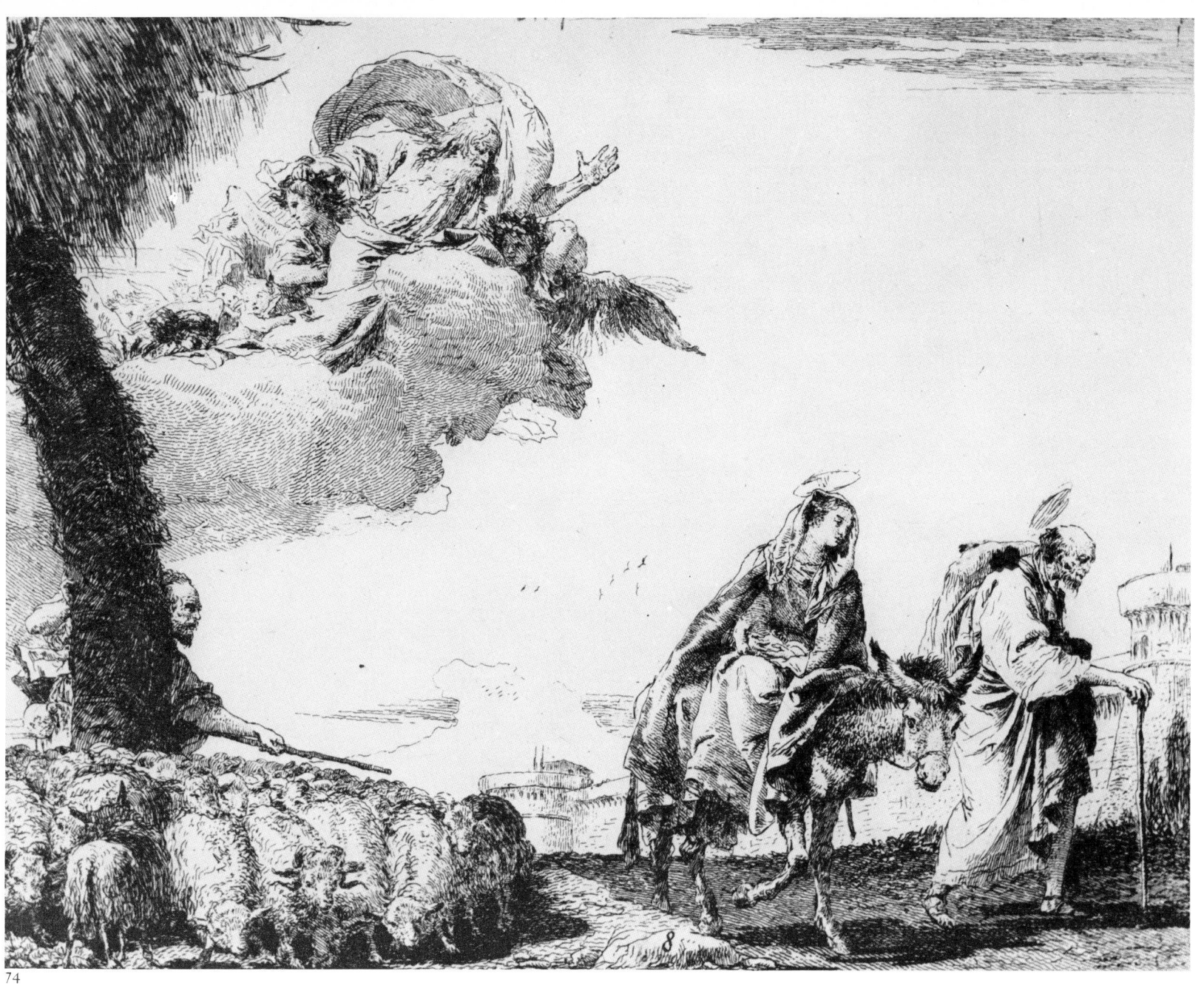

75. The Flight into Egypt
**Joseph adoring the Child,
who is held in Mary's arms**

187 × 243 mm. Signed: *Dom: Tiepolo inve et
fecit*, bottom centre, where the number *9* can
also be seen.

The fir-trees, first produced by Giambattista in the 1730s, reappear in this sheet. Typical of Giandomenico is the use of a ruler. The suggestive landscape is inspired by German elements.

Bibliog.: Nagler, 1847, 4; De Vesme, 1906, 9; Sack, 1910, 25; Morassi, 1960, 9; Pignatti, 1965, LI; Rizzi, 1970, 74.

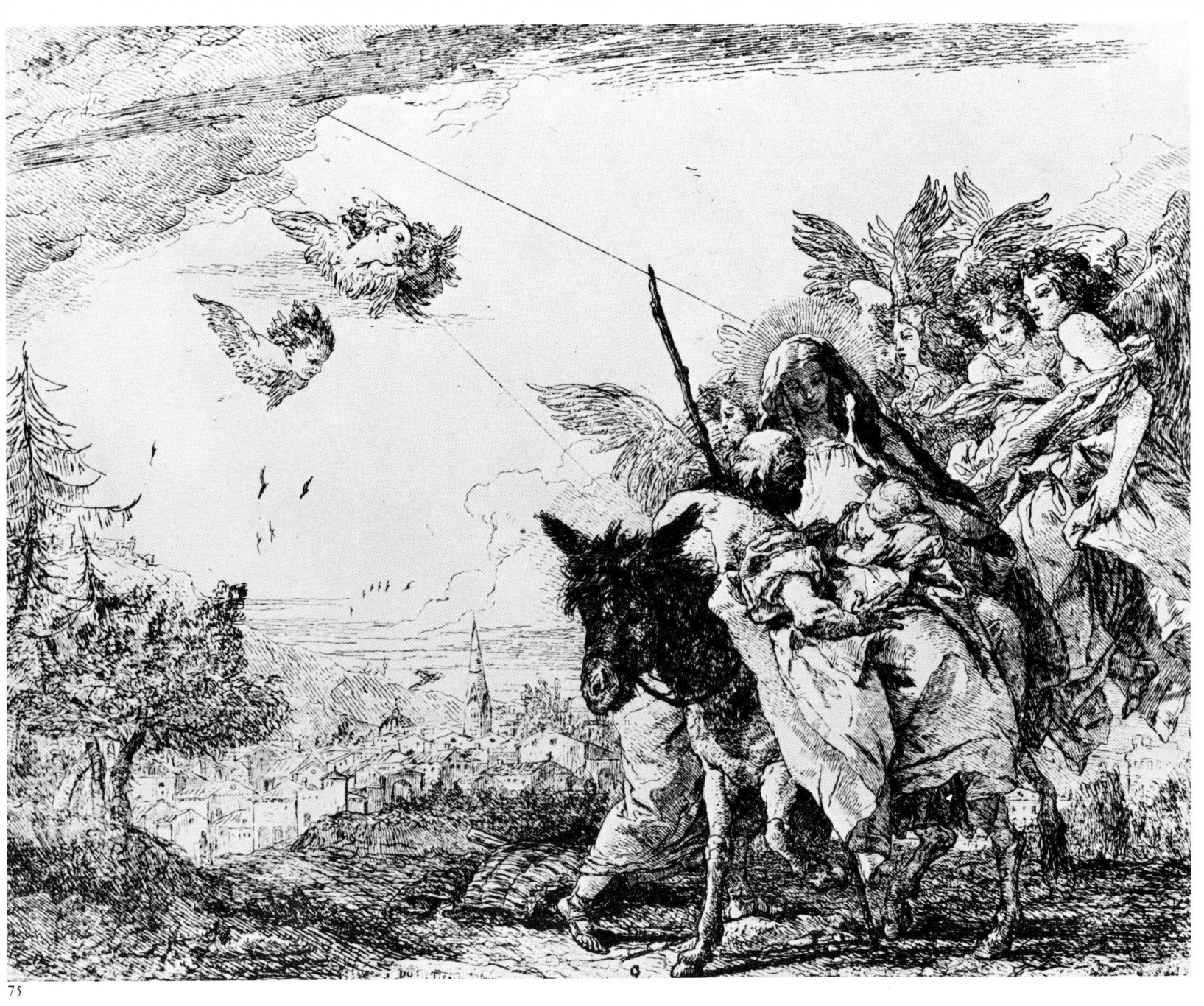

75

76. The Flight into Egypt
**Mary holding the Child in her arms
and Joseph with the basket**

187 × 247 mm. Signed: *Do: Tiepolo inv. et
fe*, on a stone, at bottom left, with *10* at
bottom centre.

As in the preceding etching, the beam
of light is rendered with two thin
lines. Note the 'constructed' land-
scape, with the temple and the tower
which also appear in Giambattista's
Trinity in Udine Cathedral (Rizzi,
1966, p. 188), painted in 1738. Ac-
cording to Morassi, the forest was
inspired by German artists of the
sixteenth century, such as Altdorfer,
Dürer and others.

Bibliog.: Nagler, 1847, 4; De Vesme, 1906,
10; Sack, 1910, 26; Pittaluga, 1952, 160;
Morassi, 1960, 10; Pignatti, 1965, LII; Rizzi,
1970, 75.

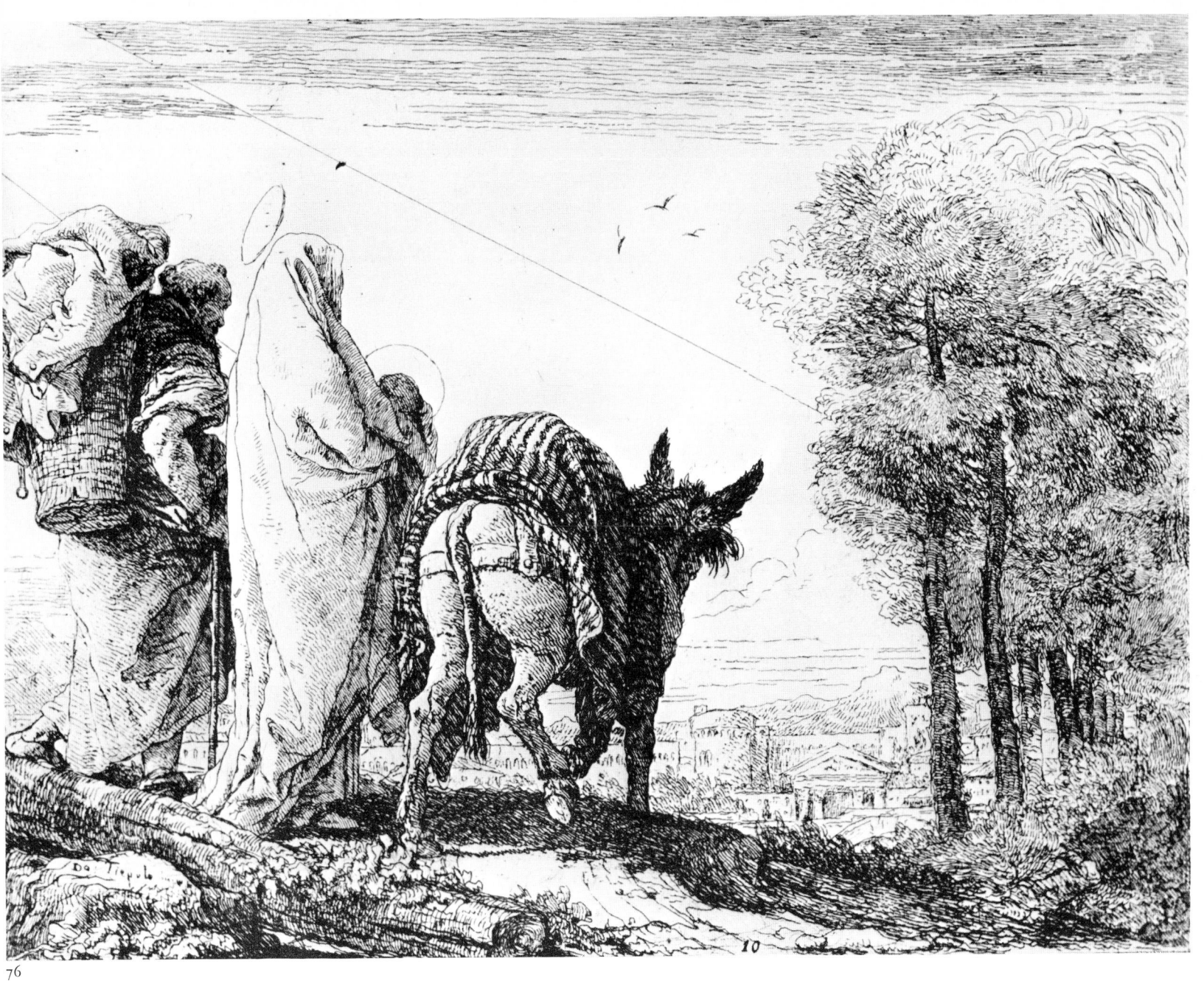

77. The Flight into Egypt
Joseph and Mary
passing a shepherd and his flock

188 × 242 mm. Signed: *Dome:° Tiepolo /
inv:° e inc*, on a stone, at bottom left. Numbered *11* at bottom centre.

Here too Giandomenico introduces geometrical lines in contrast with the pictorial rendering of the vegetation.

Bibliog.: Nagler, 1847, 4; De Vesme, 1906, 11; Sack, 1910, 27; Pallucchini, 1941, 345; Morassi, 1960, 11; Rizzi, 1970, 76.

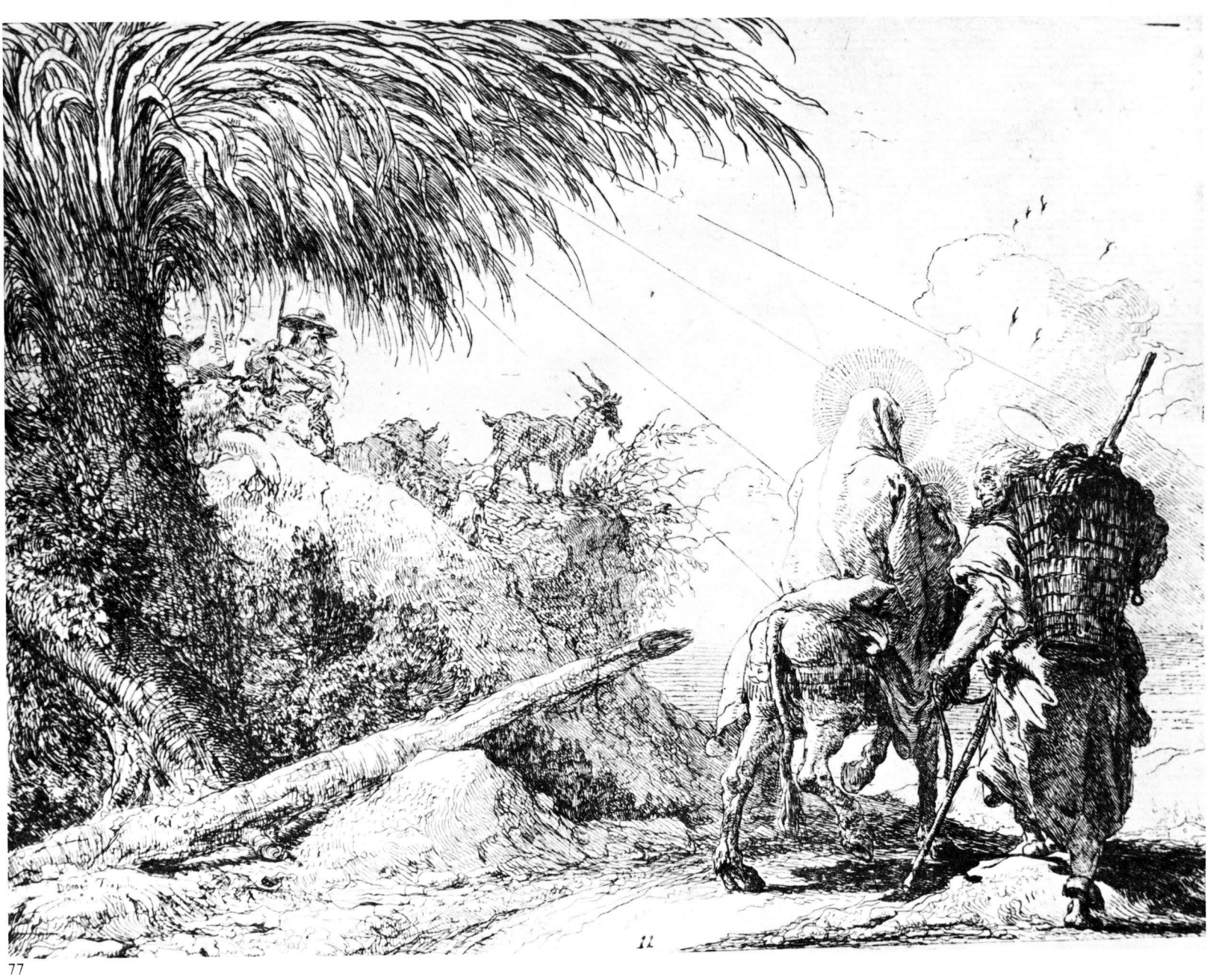

78. The Flight into Egypt
Mary and Joseph, holding the Child, are escorted by an Angel
186 × 247 mm. Signed: *Do: Tiepolo in: et fec.*, on a rock at bottom right. Numbered *12* at bottom left.

Sack pointed out that a painting corresponding to this etching was in the Adelmann Collection, in Würzburg, as a pendant to the painting mentioned in the note to pl. 70; it was sold in Cologne in 1888. The beam of light is again shown as two thin lines. The half-buried slab with a bas-relief and the busts of Orientals in the background recall the *Scherzi*.

Bibliog.: Nagler, 1847, 4; De Vesme, 1906, 12; Sack, 1910, 28; Pallucchini, 1941, 346; Morassi, 1960, 12; Rizzi, 1970, 77.

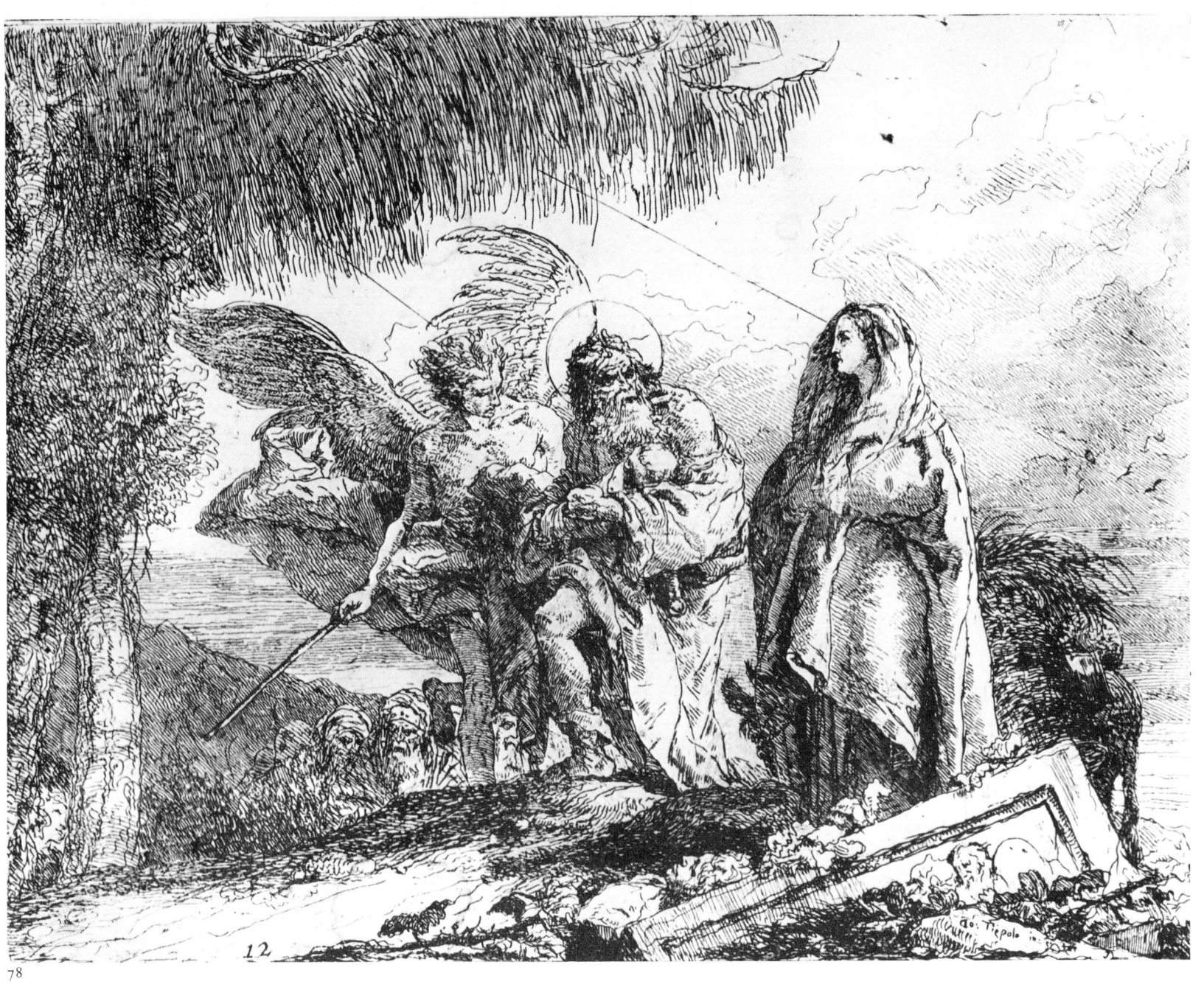

12

79. The Flight into Egypt
The Rest on the Flight

192 × 246 mm. Signed: *Dom: Tiepolo | inv:
et inc: | ANNO 1750*, on a stone to the left.
Numbered *13* at bottom centre.

The date shows this to be one of the
first etchings in the series executed
by Giandomenico: the figure of the
Virgin with the Child and the con-
struction of the entire scene connect
this sheet with the 'Adoration of the
Magi' by Giambattista (see pl. 27).
The same family atmosphere and a
similar type of woman and child can
be found in the *Scherzi* (see pl. 18
and 24), as well as the marble slab,
which also appears in the preceding
sheet.
Sack pointed out that a painting by
Giandomenico, showing the same
scene in reverse, was in the J.K. Beer
Collection in Budapest; it is now in
the Museum.

Bibliog.: Nagler, 1847, 4; De Vesme, 1906,
13; Molmenti, 1909, pp. 179–80; Sack,
1910, 29; Pallucchini, 1941, 347; Morassi,
1960, 13; Pignatti, 1965, LIII; Garas, 1968,
18; Rizzi, 1970, 78.

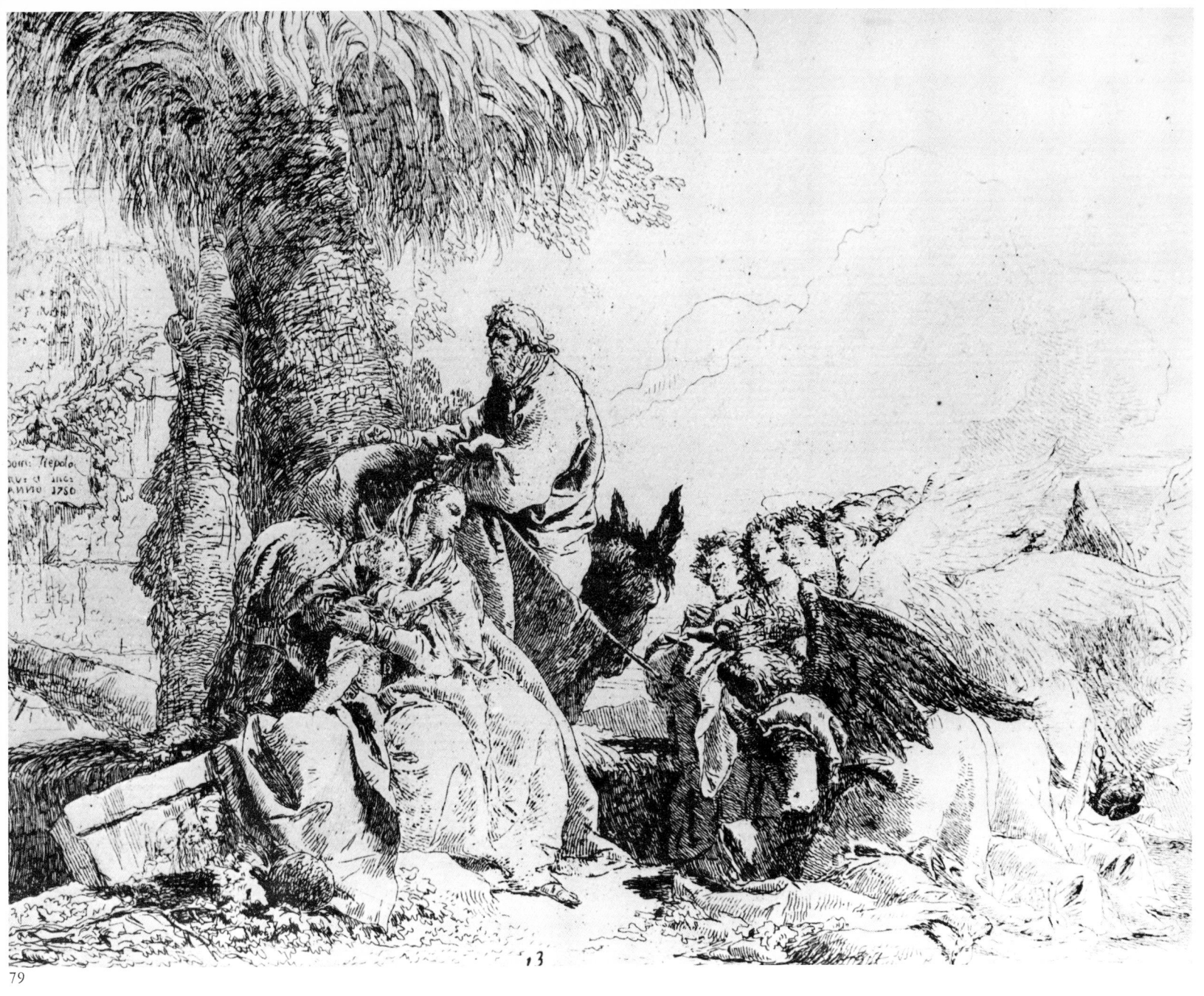

80. The Flight into Egypt
The Holy Family
on the bank of a river

189 × 246 mm. Bottom left the signature
Dom°: Tiepolo in: et fe: preceded by the
number *14*.

Two drawings by Giambattista, with
the detail of the ferry, were in the
Orloff Collection (87, 88). One of
them, No. 87, is now in the Cleveland
Museum of Art.

Bibliog.: Nagler, 1847, 4; De Vesme, 1906,
14; Sack, 1910, 30; Orloff Catalogue, 1920;
Pittaluga, 1952, 160; Morassi, 1960, 14;
Rizzi, 1970, 79.

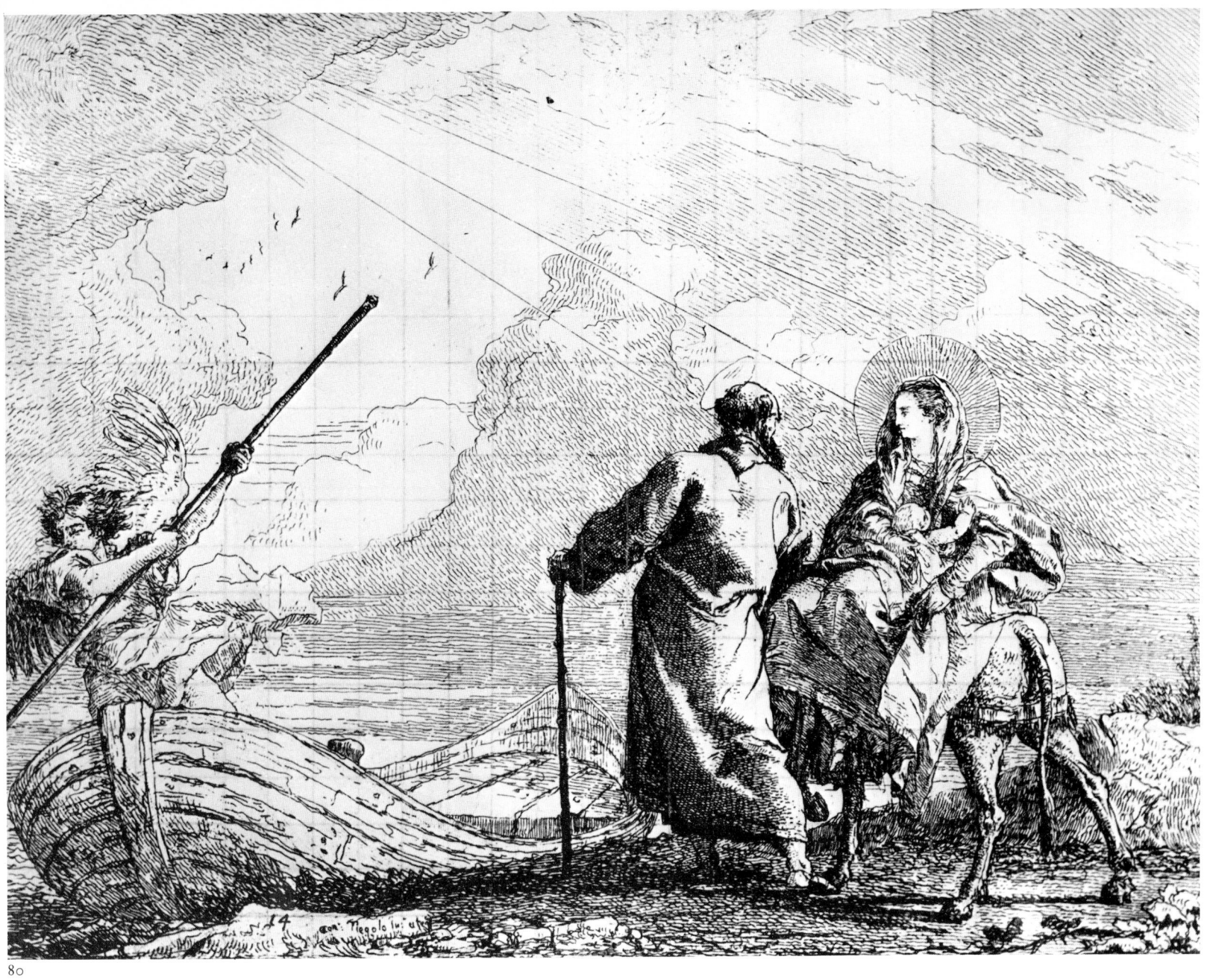

80

81. The Flight into Egypt
The Holy Family
stepping off the bank

187 × 241 mm. Signed, at bottom centre: *Do: Tiepolo in: et fe:* with the number *15*.

Byam Shaw believes drawing No. 28v. in the Correr Museum to be a study for the hand of the boatman holding the pole. Note the skilful balance in the construction.

Bibliog.: Nagler, 1847, 4; De Vesme, 1906, 15; Sack, 1910, 31; Pittaluga, 1952, p. 160; Morassi, 1960, 15; Byam Shaw, 1962, p. 24; Rizzi, 1970, 80.

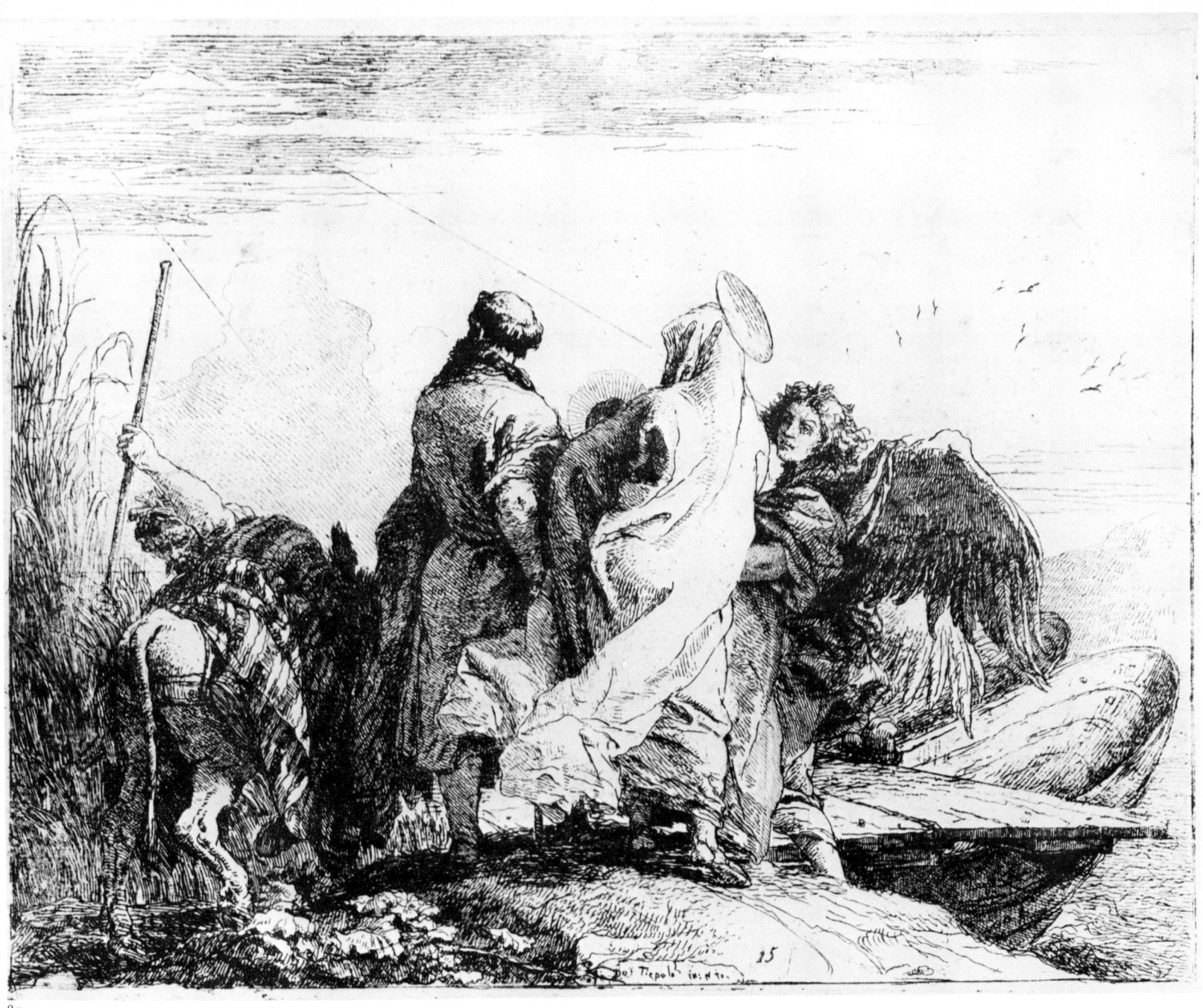

81

82. The Flight into Egypt
**The Holy Family entering the boat
with the help of the Angels**

180 × 238 mm. On a stone, to the left: *Do:
Tiepolo | fecit*. At the bottom, towards the
right, the number *16*.

The etching shows a general, icono-
graphic analogy with Giambattista's
drawing No. 8, formerly in the Or-
loff Collection.

Bibliog.: Nagler, 1847, 4; De Vesme, 1906,
16; Sack, 1910, 32; Orloff Catalogue, 1920;
Pallucchini, 1941, 348; Morassi, 1960, 16;
Rizzi, 1970, 81.

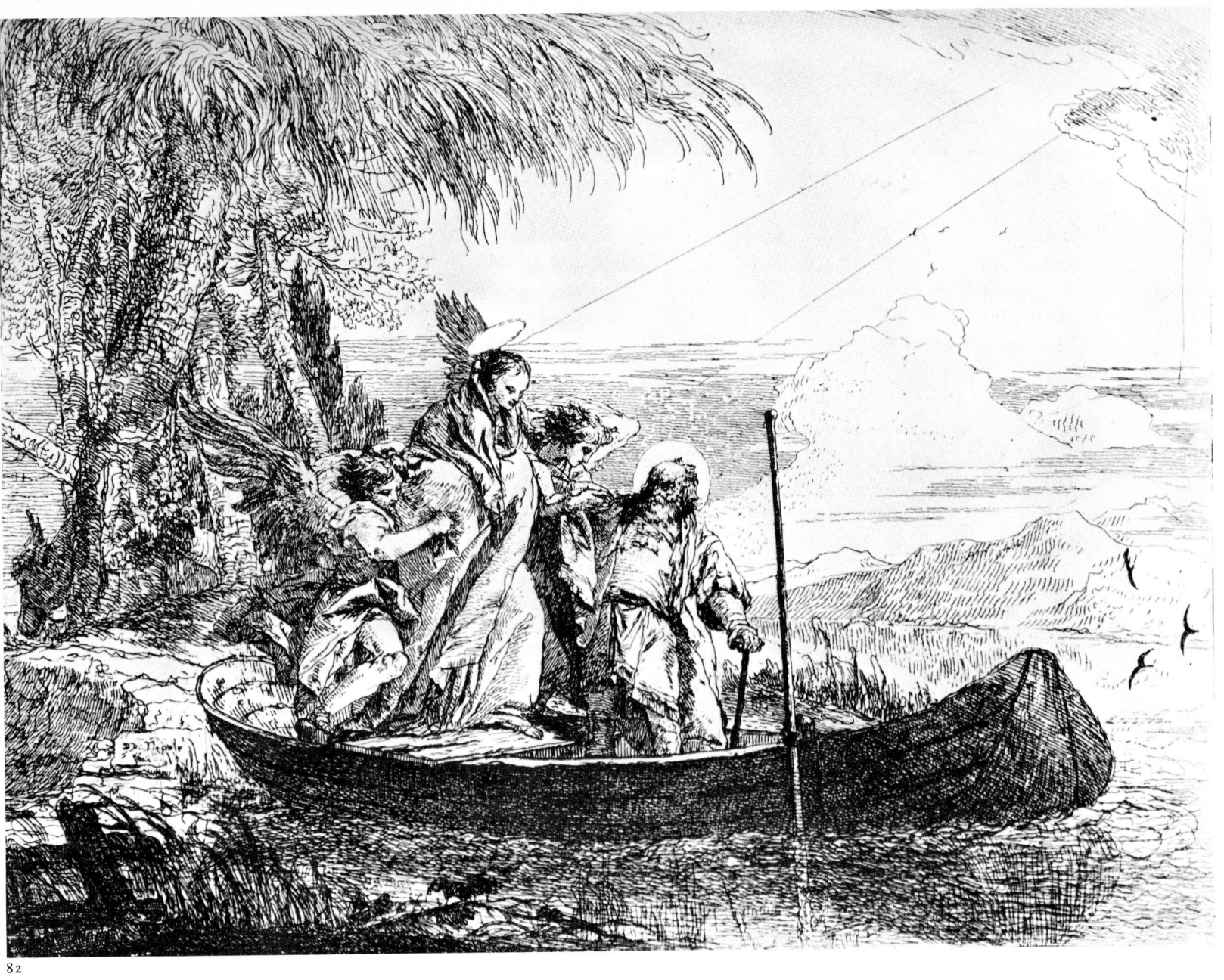

82

83. The Flight into Egypt
The Holy Family
crossing the lake in the boat

181 × 237 mm. The number *17* at bottom left.

A general link can be established between this scene and various drawings by Giambattista, formerly in the Orloff Collection, which develop the same theme (88, 89, 90 and 91).

Bibliog.: Nagler, 1847, 4; De Vesme, 1906, 17; Sack, 1910, 33; Orloff Catalogue, 1920; Pallucchini, 1941, 349; Knox, 1960, p. 80; Morassi, 1960, 17; Pignatti, 1965, LIV; Rizzi, 1970, 82.

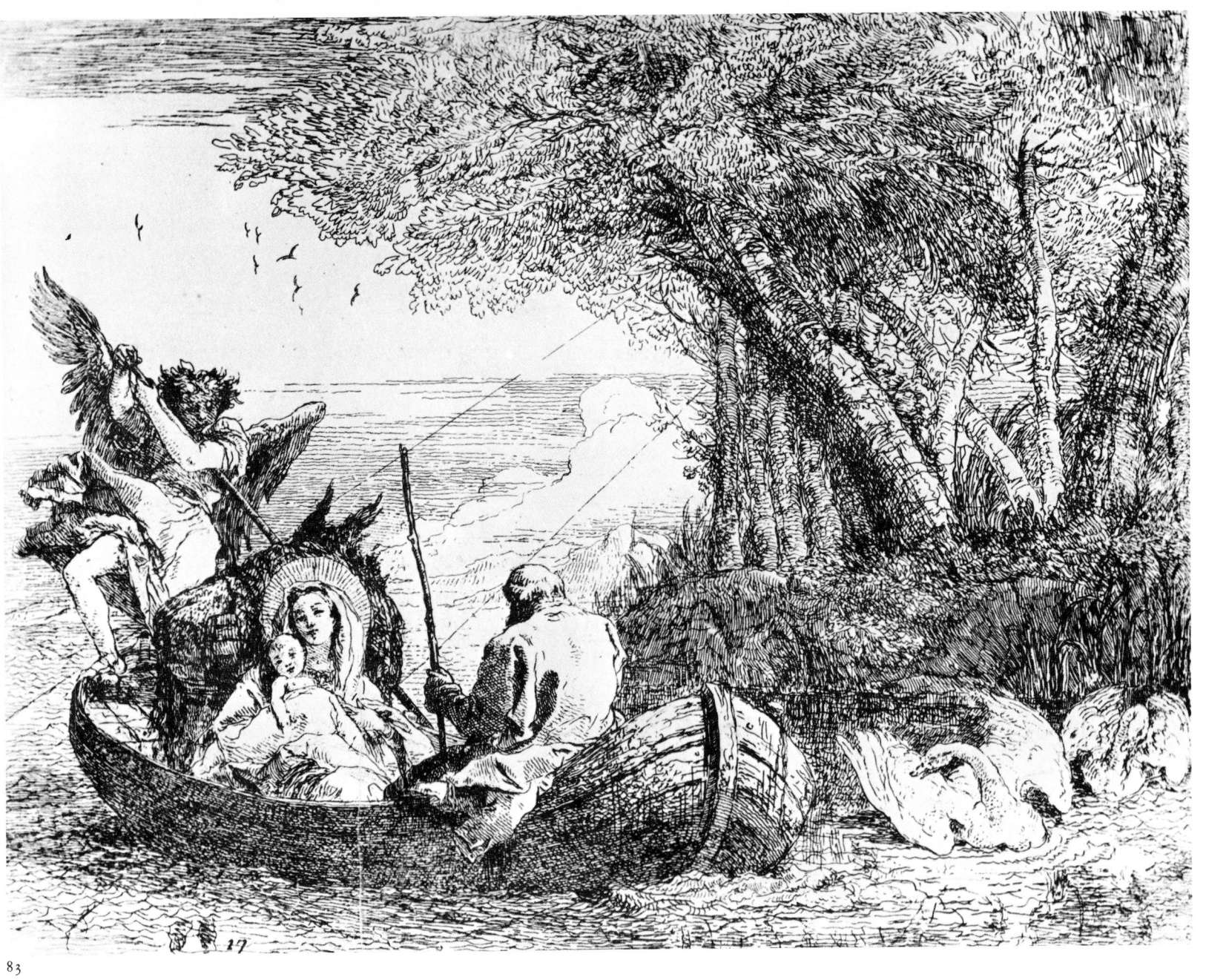

84. The Flight into Egypt
**Mary, helped by Joseph and
an Angel, stepping out of the boat**
189 × 246 mm. The number *18* at bottom
right.

The palm tree, although here much
richer, and the hatching on the trunks
are in Giambattista's manner (see
pl. 20).

Bibliog.: Nagler, 1847, 4; De Vesme, 1905,
18; Sack, 1910, 34; Pallucchini, 1941, 350;
Morassi, 1960, 18; Rizzi, 1970, 83.

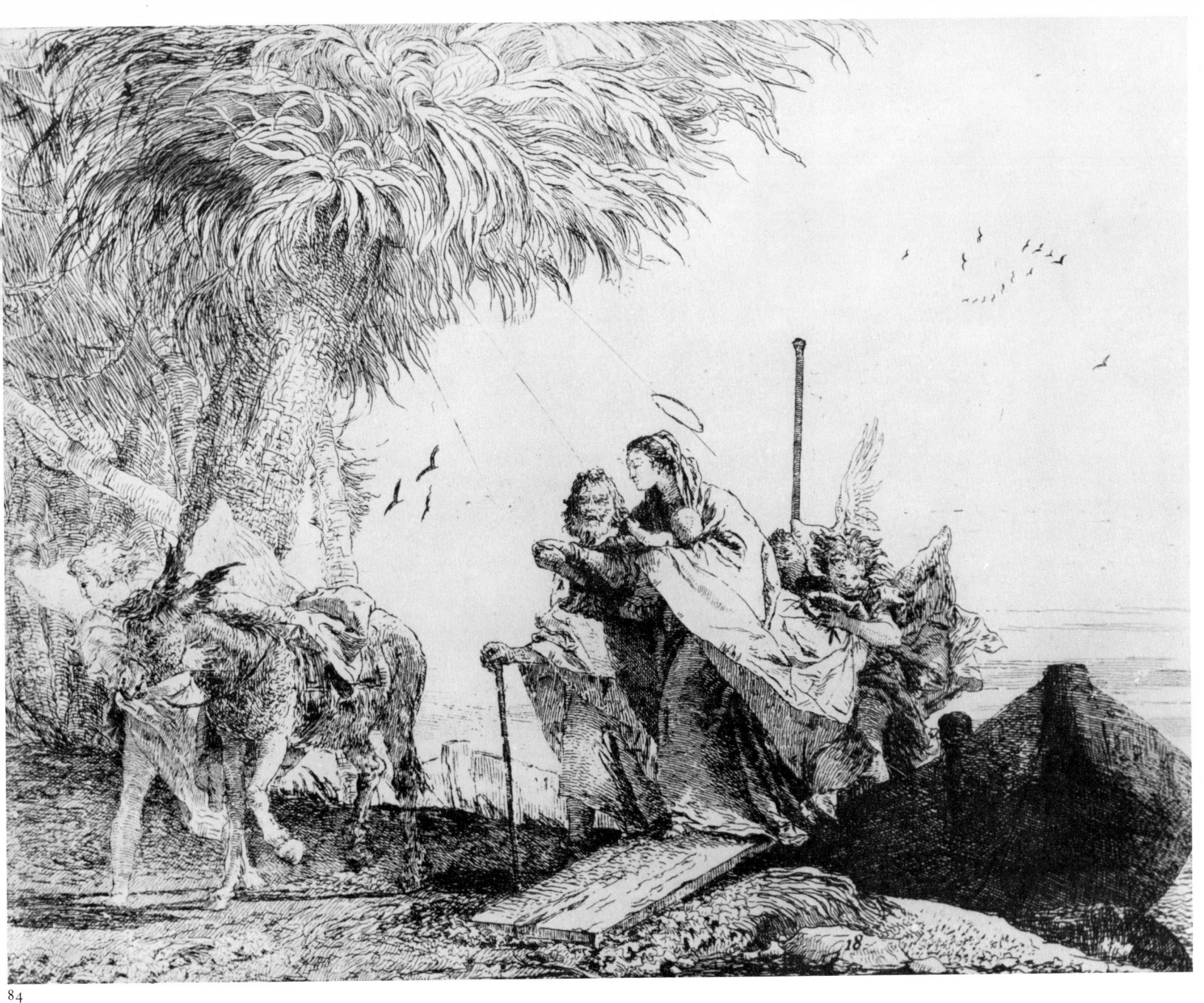

85. The Flight into Egypt
Joseph adoring the Child while two Angels sing

186 × 244 mm. Signed: *Do: Tiepolo fecit et inve. | Anno 1752* (the figure 7 in reverse), bottom left. To the right of the signature, the number *19*.

Drawing No. 79 in the Orloff Collection, by Giambattista, may have inspired this etching, which is enriched by the figures of the angels and the donkey. The thick vegetation and the straight beams recall other prints in the series.

Bibliog.: Nagler, 1847, 4; De Vesme, 1906, 19; Sack, 1910, 35; Orloff Catalogue, 1920, 79; Pallucchini, 1941, 351; Morassi, 1960, 19; Rizzi, 1970, 84.

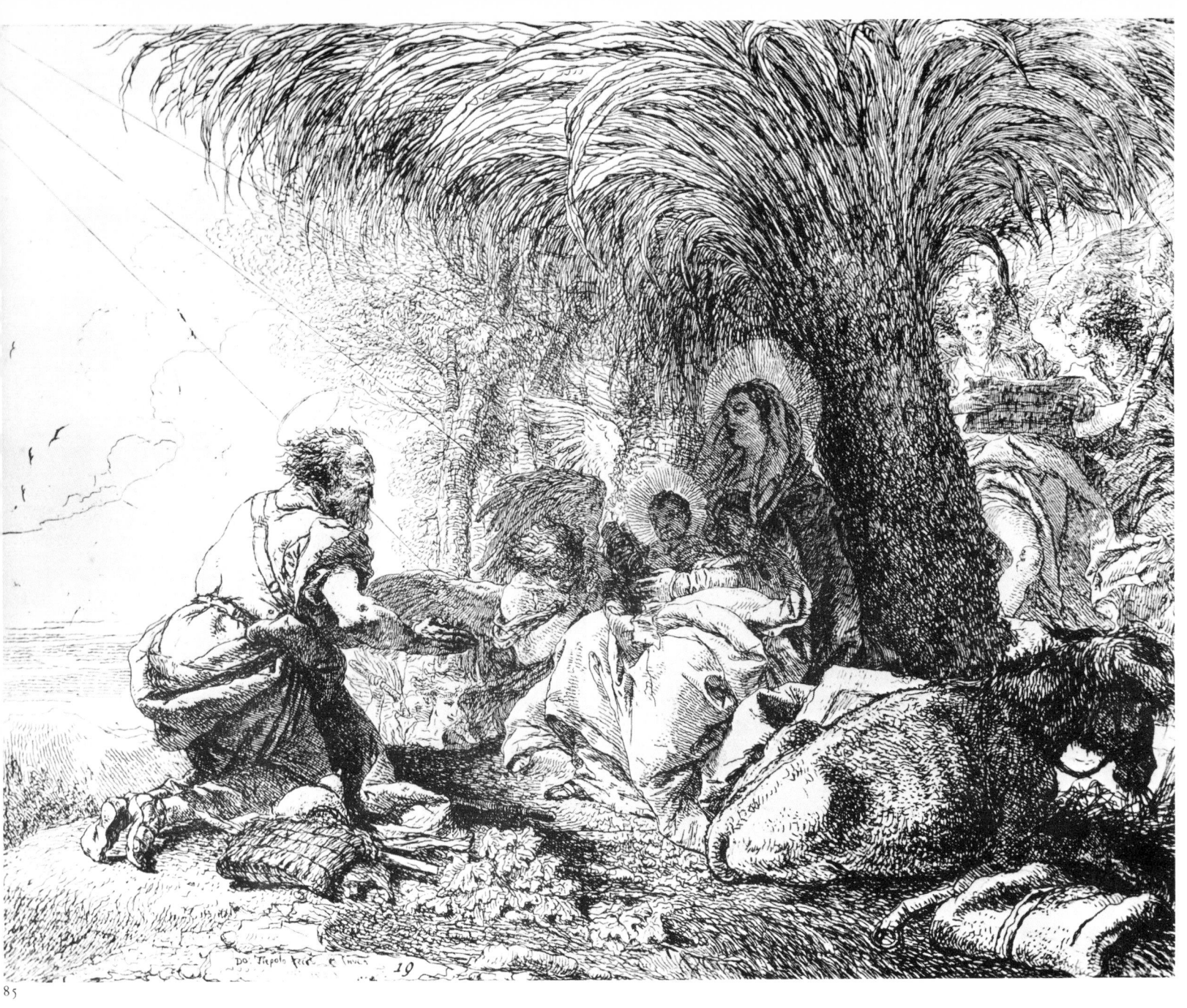

Do. Tiepolo fece . e inven. 19

86. The Flight into Egypt
**The Holy Family
passing by a pyramid**

187 × 241 mm. The number *20* at bottom
right.

The truncated pyramid is derived
from the *Scherzi* (see pl. 10, 14, 17, 24).
Byam Shaw believes a drawing in the
'Quaderno Gatteri' of the Correr
Museum to be a study for the figure
of the Virgin (fig. XLII). The sheet
is also linked to other etchings in the
series (see pl. 76 and 77).

Bibliog.: Nagler, 1847, 4; De Vesme, 1906,
20; Sack, 1910, 36; Pallucchini, 1941, 352;
Morassi, 1960, 20; Byam Shaw, 1962, p. 24;
Pignatti, 1965, LV; Rizzi, 1970, 85.

XLII

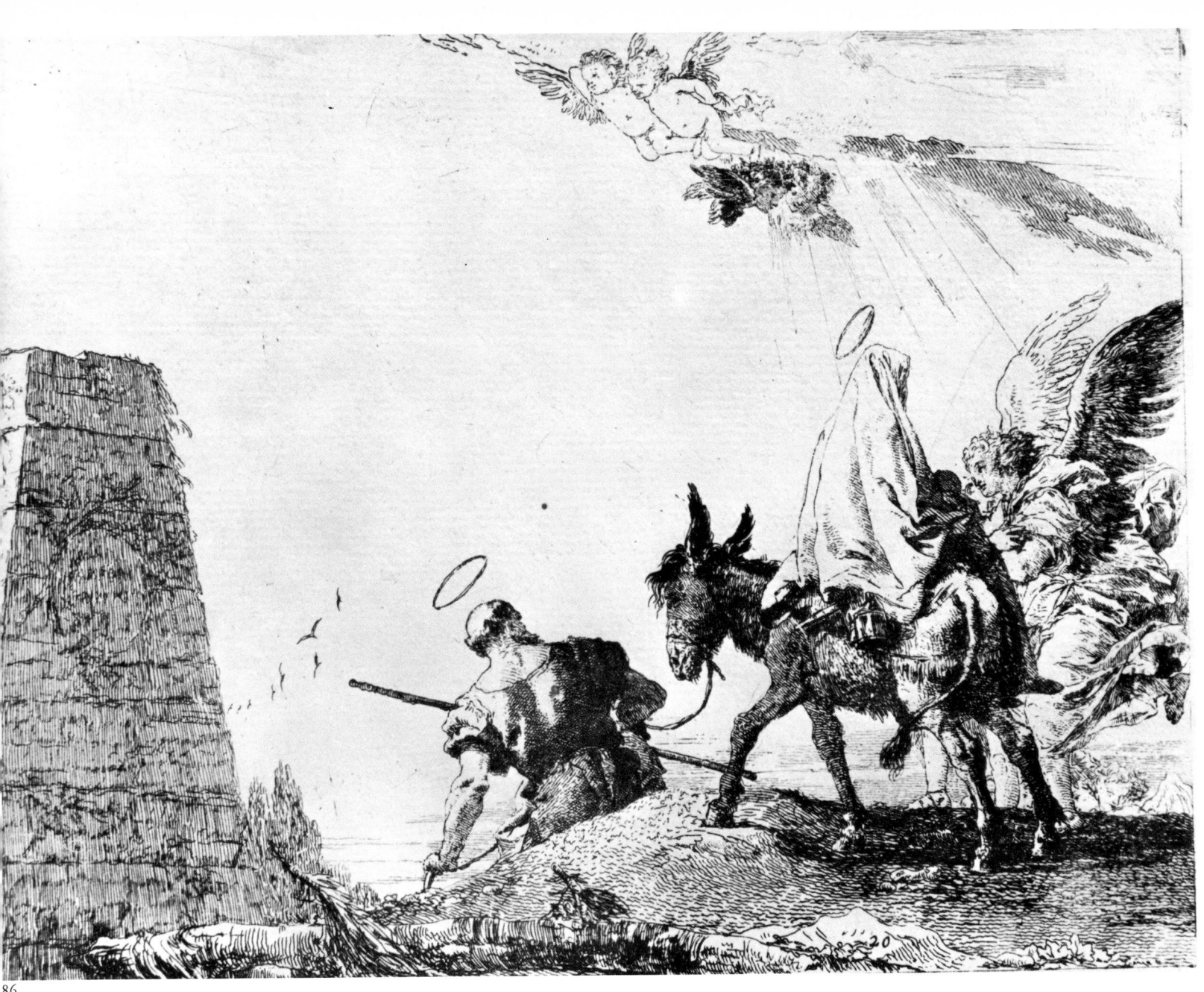

199

87. The Flight into Egypt
The Holy Family descending a forest path, near a flock and some shepherds

189 × 247 mm. Signed, bottom right: *Do. Tiepolo In: e fecit Anno 1753* (Sack read *1752*). The number *21* at bottom centre.

W. R. Juynboll has shown that the preparatory drawing for the Virgin, derived from works by Veronese (Byam Shaw), is in the 'Quaderno Gatteri' in the Correr Museum (fig. XLIII).

The palm trees are in the manner of some of the *Scherzi*, like the fringed fir trees which are similar, in particular, to the Trieste drawings. The heads of the shepherds and of Joseph can also be found in Giambattista's repertoire.

Bibliog.: Nagler, 1847, 4; De Vesme, 1906, 21; Sack, 1910, 37; Pallucchini, 1941, 353; Morassi, 1960, 21; Byam Shaw, 1962, p. 24; Rizzi, 1970, 86.

XLIII

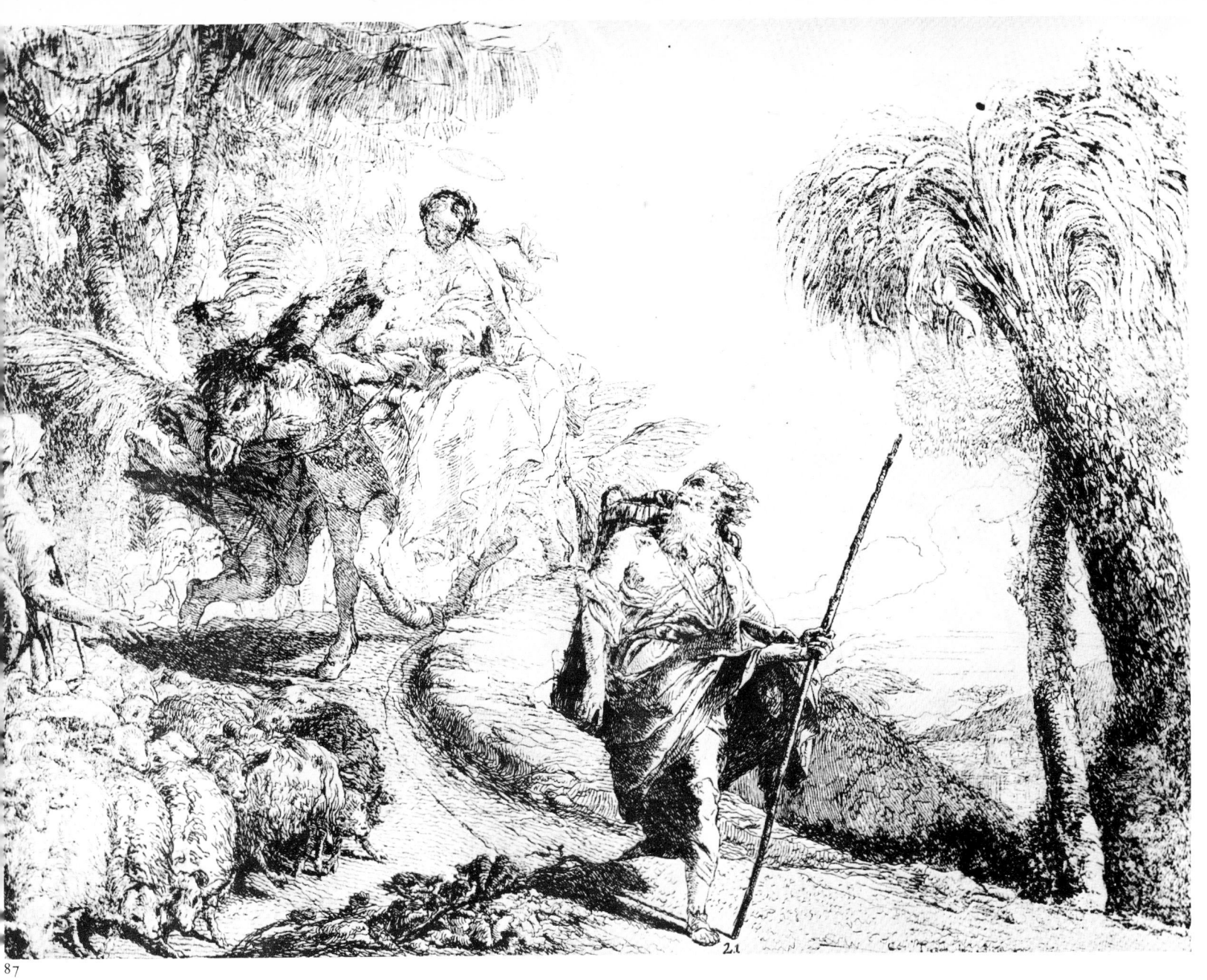

88. The Flight into Egypt

The Holy Family passing a statue, the head of which falls to the ground

189 × 241 mm. Signed: *Do: Tiepolo inv:* on a stone to the left. The number *22* at bottom centre.

The theme of this etching can be found in some drawings, particularly the one in the Louvre (Byam Shaw, fig. 29). However, since the drawing is ' completed ', it is doubtful whether it can be regarded as preparatory to the etching; it would be more logical to consider it a later version.

Bibliog.: Nagler, 1847, 4; De Vesme, 1906, 22; Sack, 1910, 38; Pallucchini, 1941, 354; Morassi, 1960, 22; Byam Shaw, 1962, p. 24; Rizzi, 1970, 87.

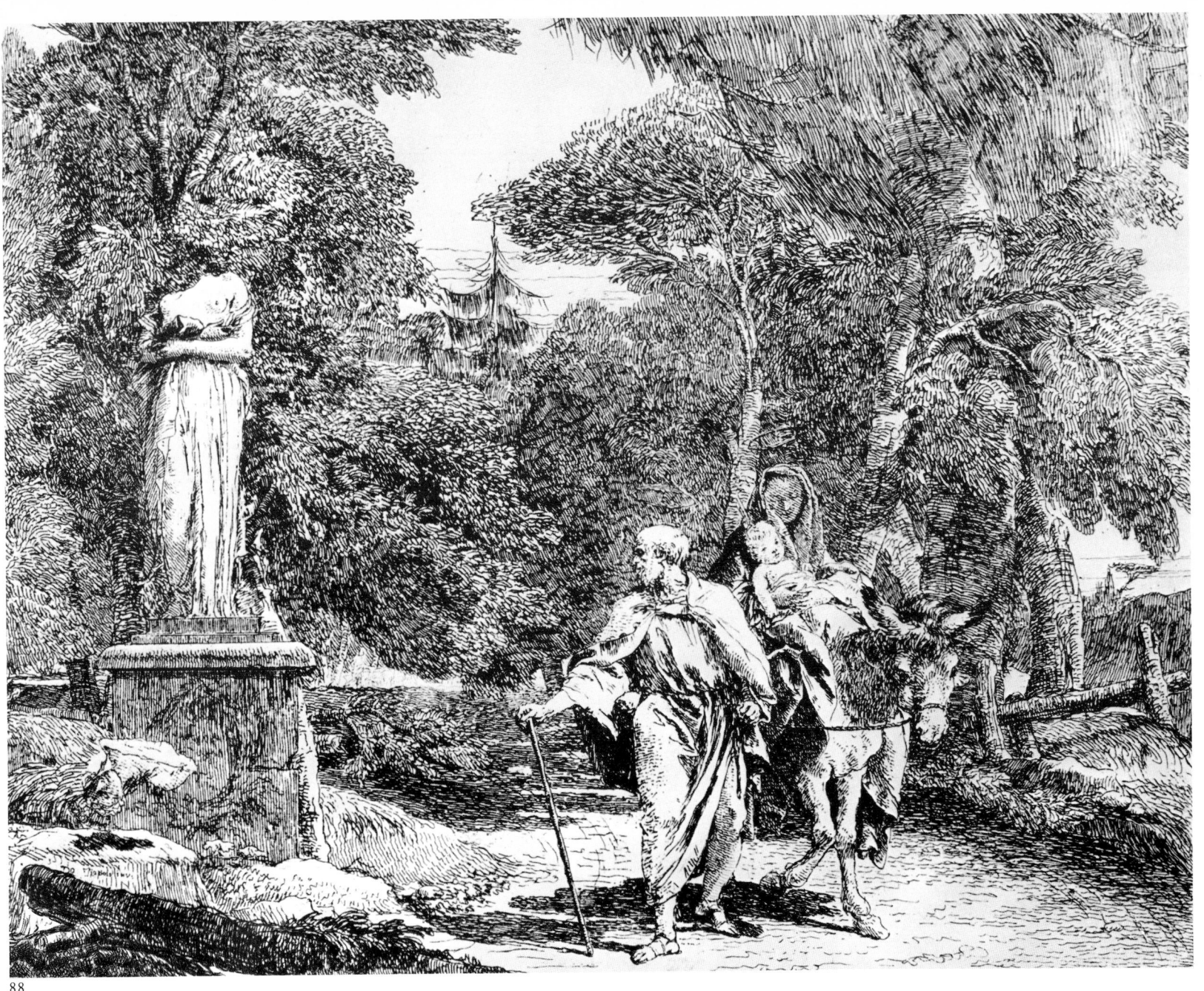

88

89. The Flight into Egypt
The Holy Family resting in a wood

191 × 237 mm. Signed: *Do: Tiepolo Inv: et fecit*, in the bottom left-hand corner. First state: before the number, and showing two small branches at the end of the diagonal tree-trunk (Stuttgart Museum); second state: on a stone, at bottom left, the number *23*.

The pyramid and the fir-trees have already been used in this series and are derived from Giambattista's *Scherzi*.

Bibliog.: Nagler, 1847, 4; De Vesme, 1906, 23; Sack, 1910, 39; Pallucchini, 1941, 355; Morassi, 1960, 23; Pignatti, 1965, LVI; Rizzi, 1970, 88.

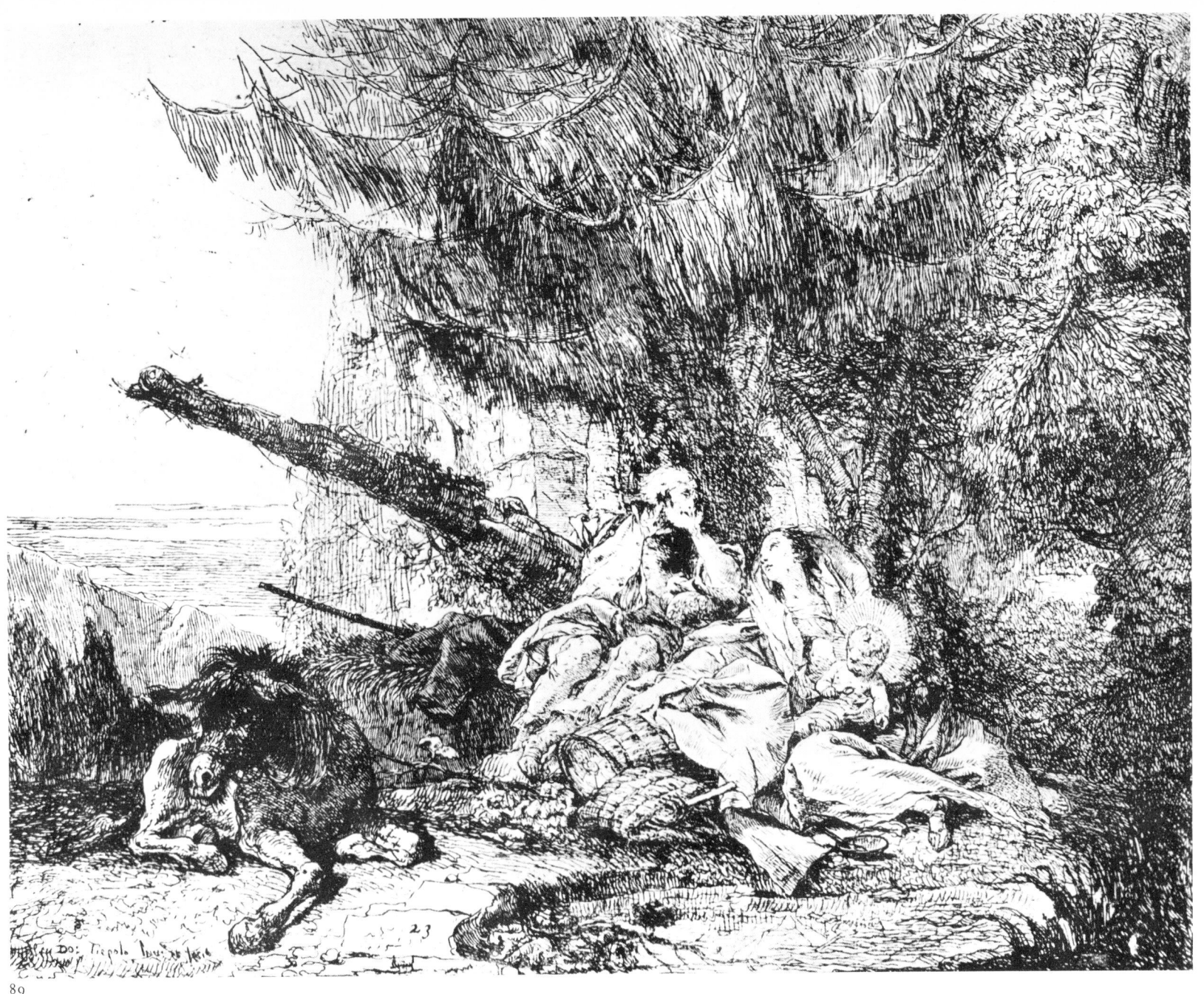

89

205

90. The Flight into Egypt
Mary, helped by an Angel, and Joseph carrying the basket, passing a flock

185 × 241 mm. Signed: *Do Tiepolo in: et fe:* at bottom right; the number *24*, also bottom right, by the path.

According to Byam Shaw (1962, p. 24), drawing No. 27 in the ' Quaderno Gatteri' (Correr Museum; Lorenzetti Catalogue, 1946) is a study for the hand of the Angel holding Mary's arm.

Bibliog.: Nagler, 1847, 4; De Vesme, 1906, 24; Sack, 1910, 40; Pallucchini, 1941, 356; Morassi, 1960, 24; Pignatti, 1965, LVII; Rizzi, 1970, 89.

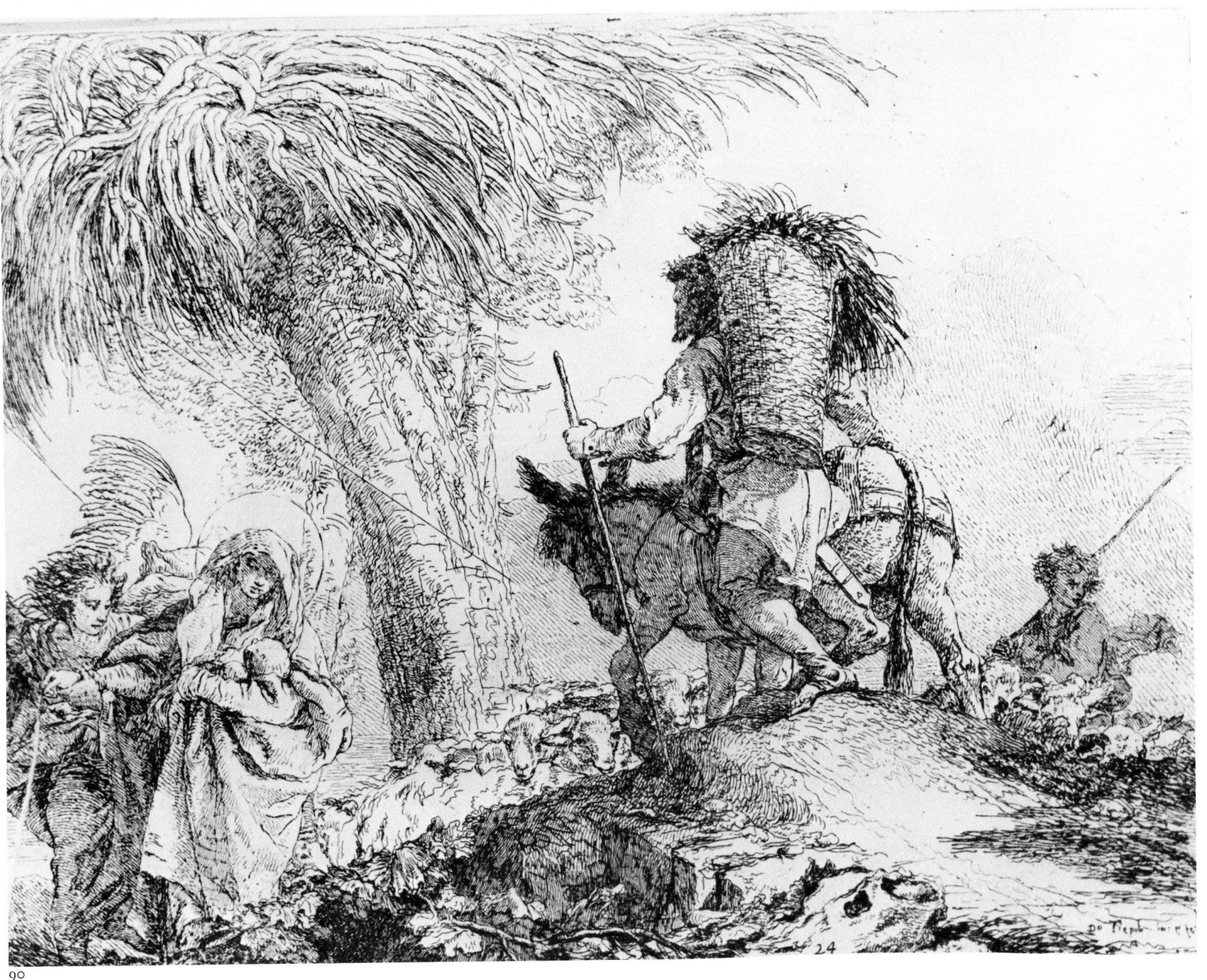

91. The Flight into Egypy
Mary, helped by two Angels, follows Joseph with the donkey

187 × 246 mm. Signed: *Dome:⁰ Tiepolo* bottom left. At bottom right, the number *25*.

The Angels and the Joseph are inspired by Giambattista's *Scherzi*.

Bibliog.: Nagler, 1847, 4; De Vesme, 1906, 25; Sack, 1910, 41; Pallucchini, 1941, 357; Morassi, 1960, 25; Pignatti, 1965, LVIII; Rizzi, 1970, 90.

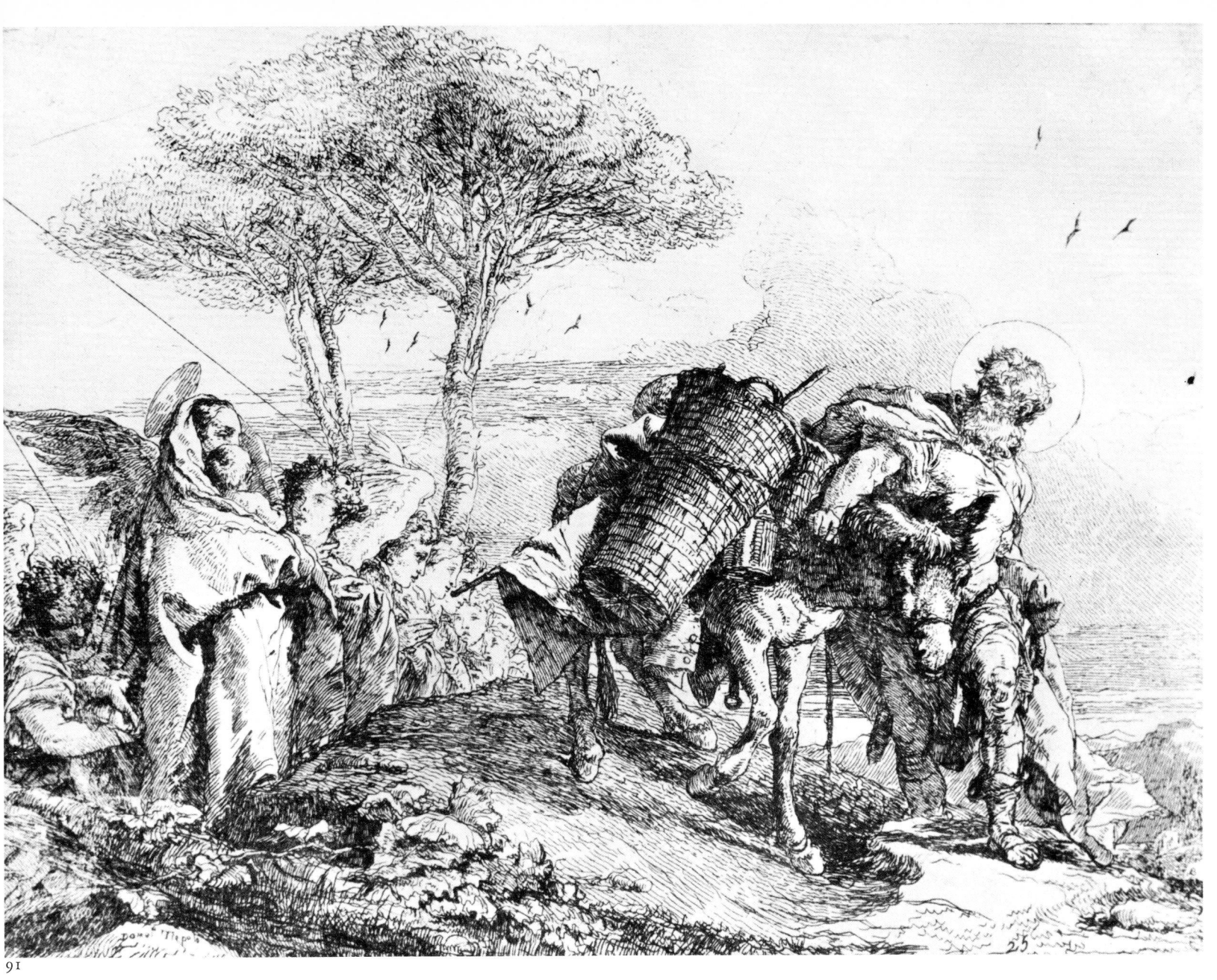

92. The Flight into Egypt
Mary, supported by two Angels, follows Joseph

187 × 243 mm. Signed: *Dom:ᵒ Tiepolo in: e fec* on a stone, bottom left. At bottom centre the number *26*.

The thick fringed fir-tree is reminiscent of Giambattista's manner, anticipated by the Trieste drawings. The heads of Joseph and the Angels are similar to those of many figures in the *Scherzi*.
See also pl. 74.

Bibliog.: Nagler, 1847, 4; De Vesme, 1906, 26; Sack, 1910, 42; Pallucchini, 1941, 358; Morassi, 1960, 26; Pignatti, 1965, LIX; Rizzi, 1970, p. 91.

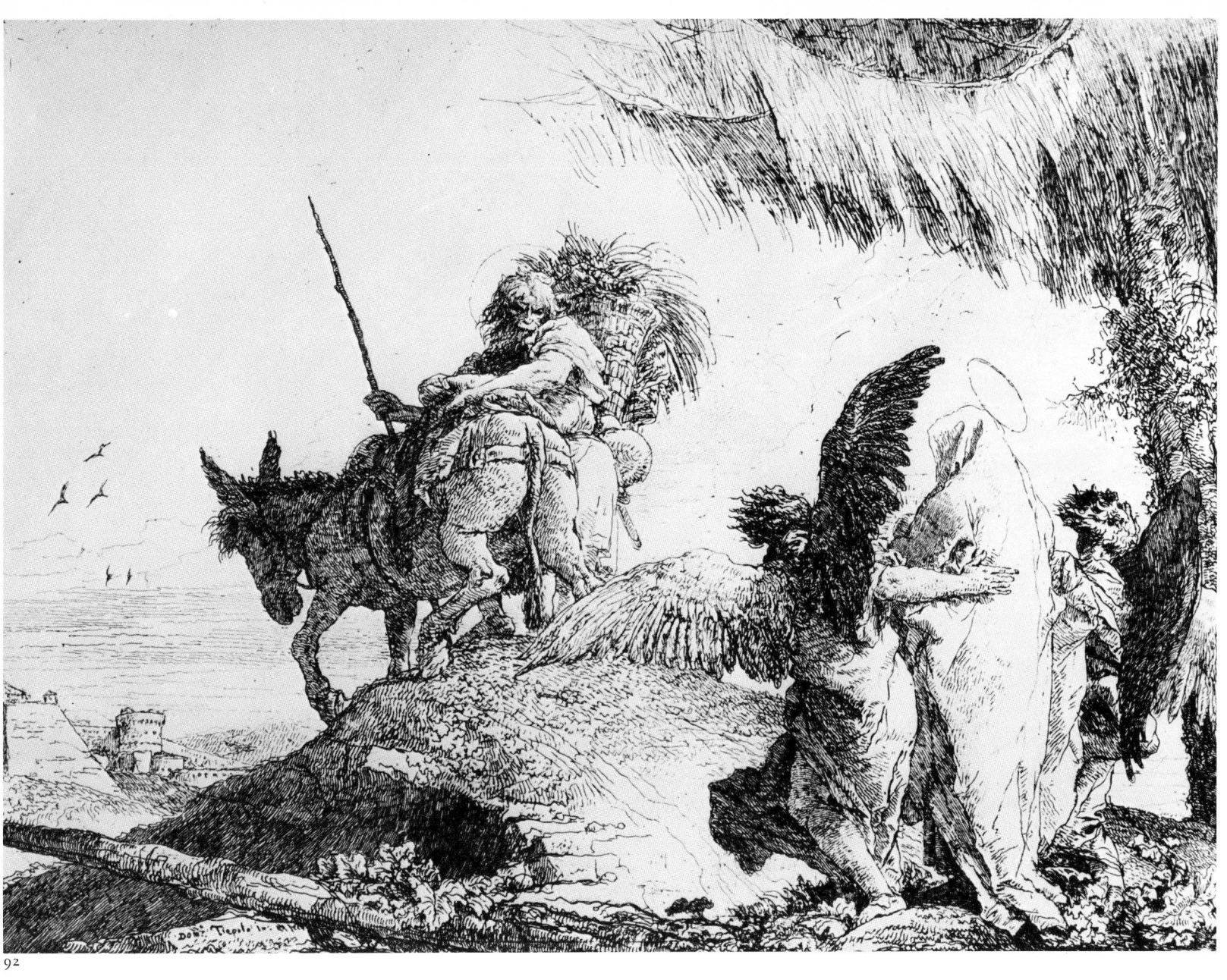

93. The Flight into Egypt
The Holy Family arriving at a city gate

187 × 248 mm. Signed: *Do. Tiepolo in. et fe:* on the low wall. At bottom left, the number *27.*

This is the last print of the series; the subject echoes that of sheet No. 7, in reverse (see pl. 73). The Virgin, according to Pignatti, is derived from the one drawn by Giambattista on sheet No. 77 of the ' Quaderno Gatteri ', in the Correr Museum (see Lorenzetti, 1946), which is, however, the same way round as in the etching.

Bibliog.: Nagler, 1847, 4; De Vesme, 1906, 27; Sack, 1910, 43; Morassi, 1960, p. 27; Byam Shaw, 1962, p. 24; Pignatti, 1965, LX; Rizzi, 1970, 92.

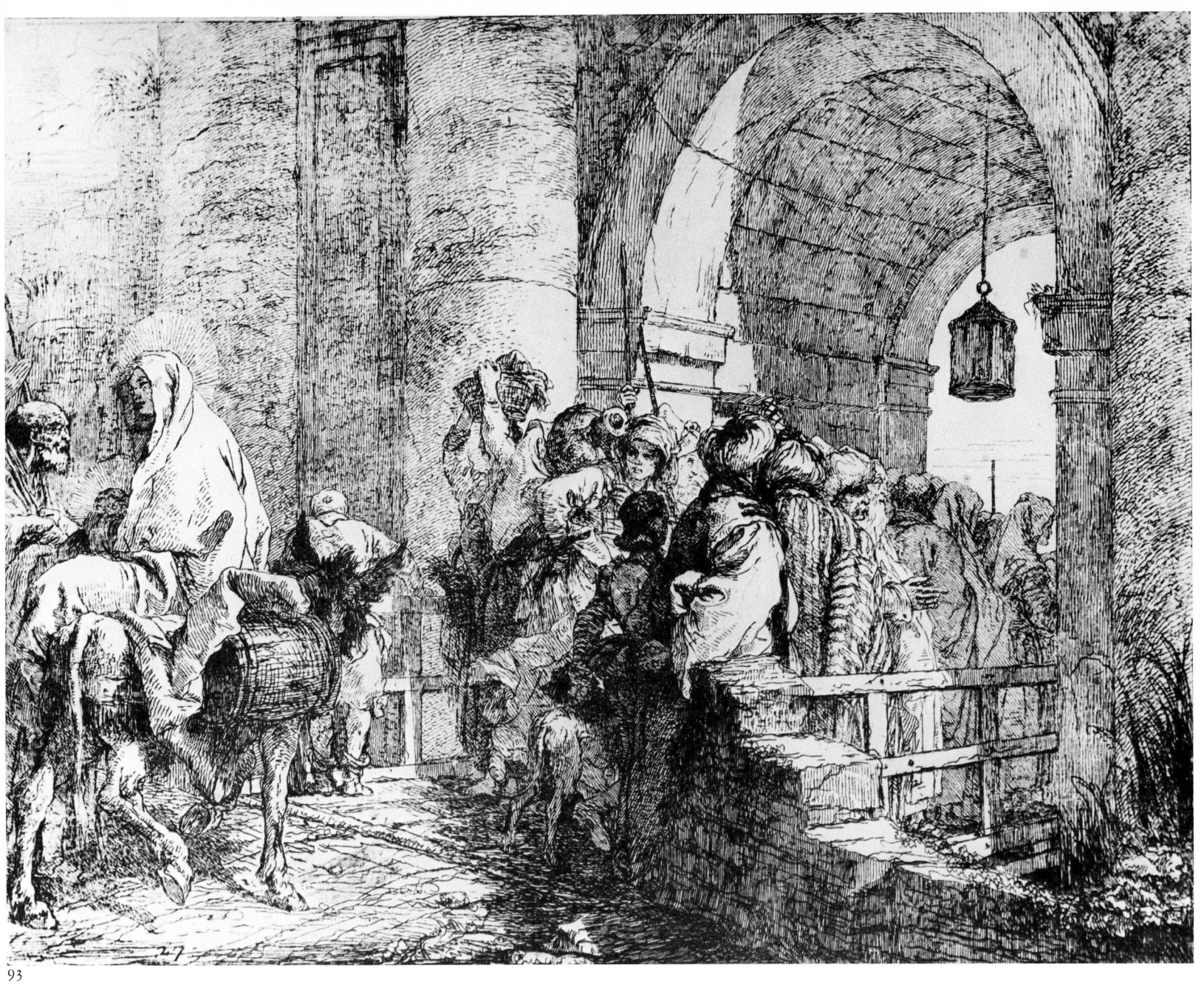

93

94. The Flight into Egypt
The Holy Family taking refuge from the wind under a palm tree

187 × 252 mm. Signed: *Do Tiepolo in: e fecit* at bottom left. First state: before the number (Museum, Trieste).

This etching was not included in the Würzburg series and was only recently reattributed to Giandomenico. It repeats details of other etchings in the series. The group of trees, with their smooth trunks marked by only a few horizontal lines, is in the manner of many of the *Scherzi*.
The figure of St. Joseph, whose cloak, caught by the wind, covers part of his face, is similar to the one in pl. 65; the composition in general echoes pl. 71.
Obviously this sheet was left out as not being original enough.

Bibliog.: Rizzi, 1970, 93.

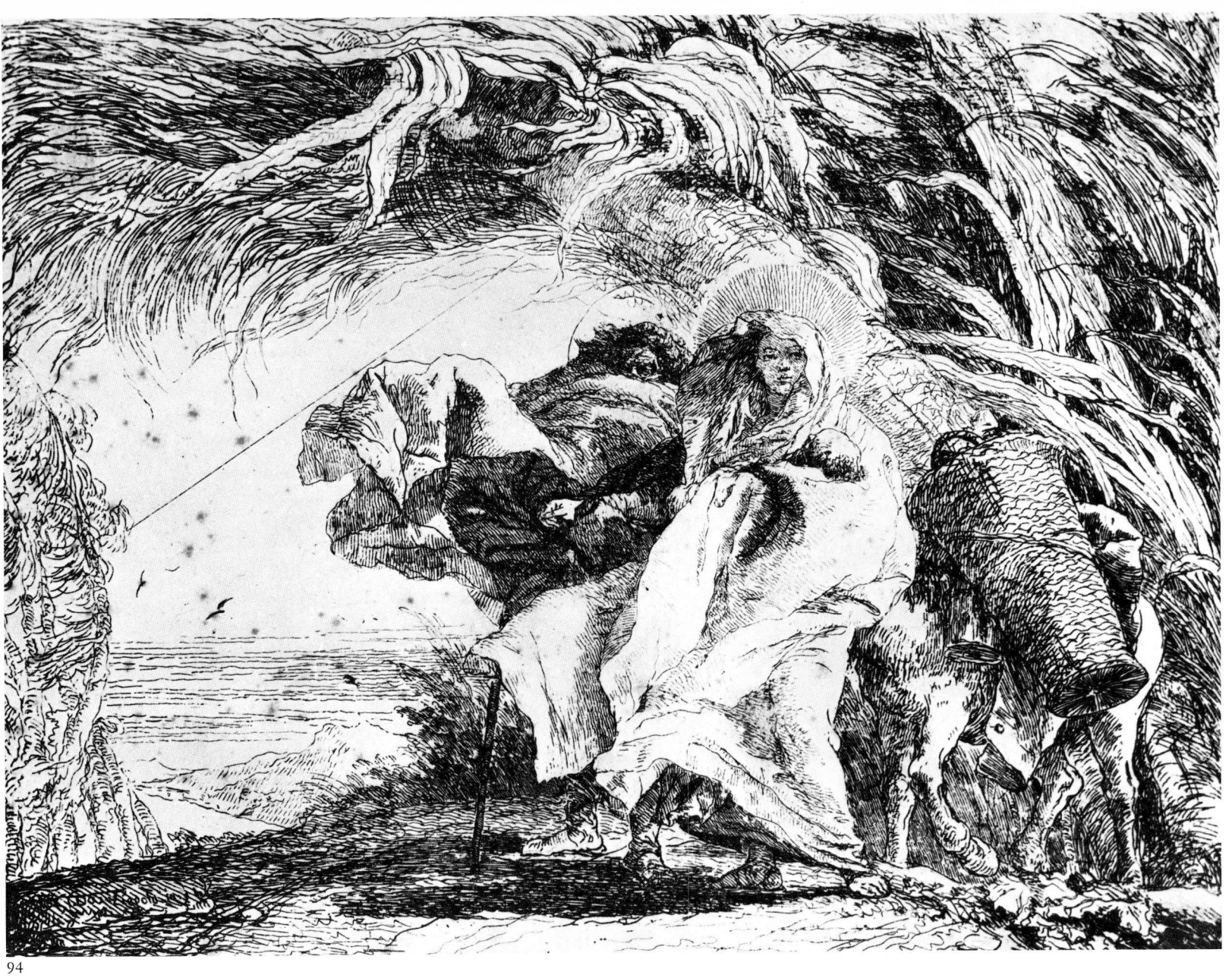

94

95. The Flight into Etypt
**Joseph adoring the Child, who is
being held by Mary standing by
the donkey and a boat**

177 × 234 mm. First state: before the number (Boymans–van Beuningen Museum, Rotterdam).

This etching was also left out of the series after an attempt at reworking it in red, probably because the figure of Joseph is too contracted. The altar, with the garland of leaves, is clearly borrowed from the *Scherzo* illustrated in pl. 8.

Bibliog.: Byam Shaw, 1962, p. 12, note 4.

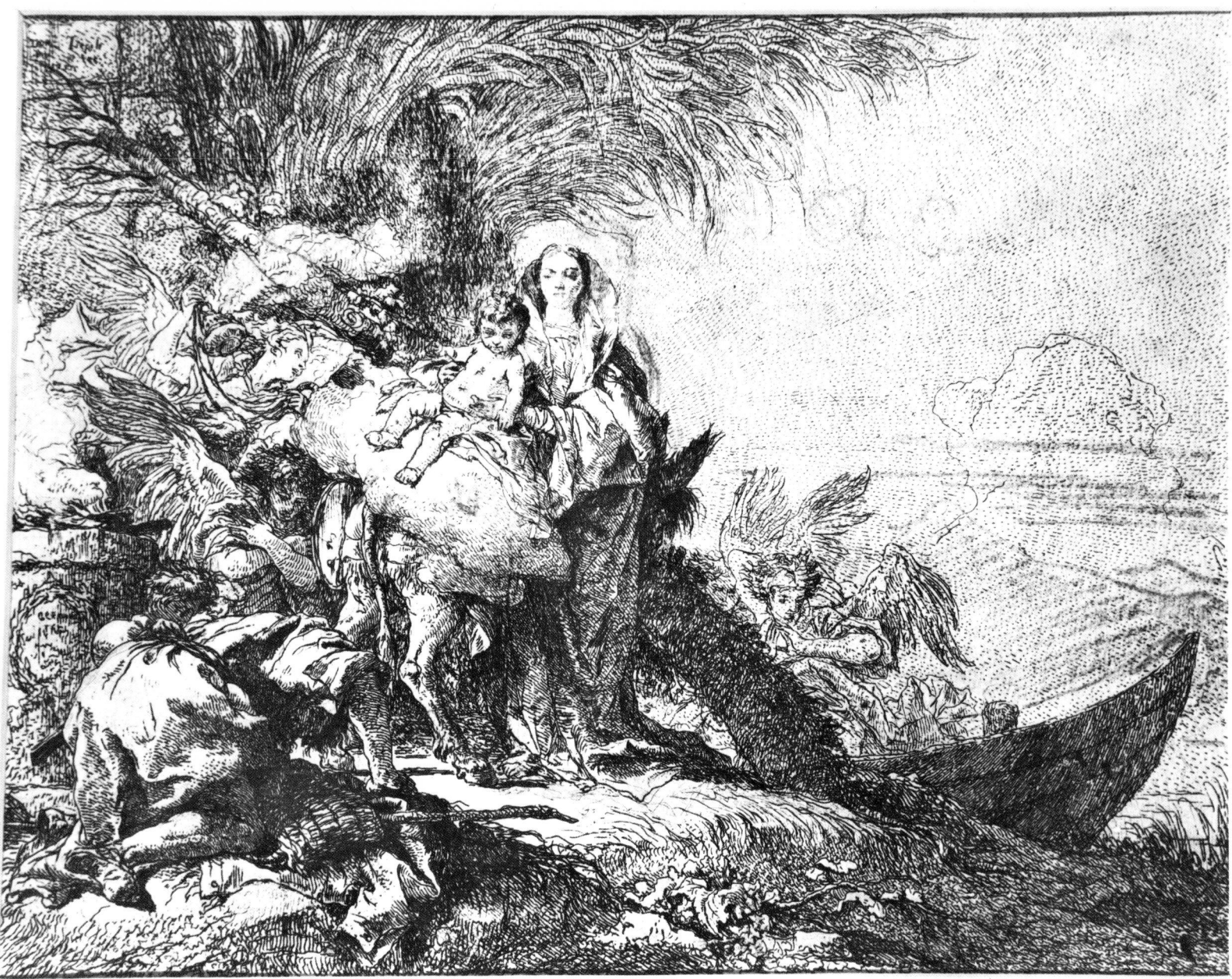

95

96. The Flight into Egypt
Mary with the Child sitting on the donkey led by an angel

172 × 243 mm. Signed: *Dome Tiepolo Inv. fece*, at the left, on a stone. First state: before the number.

This is the third etching of the *Flight* to have been abandoned, perhaps following some technical accident, as indicated by the large areas which have not been bitten by the acid. It shows a soft pictorial technique derived from Giambattista.

Bibliog.: Byam Shaw, 1962, p. 12, note 4.

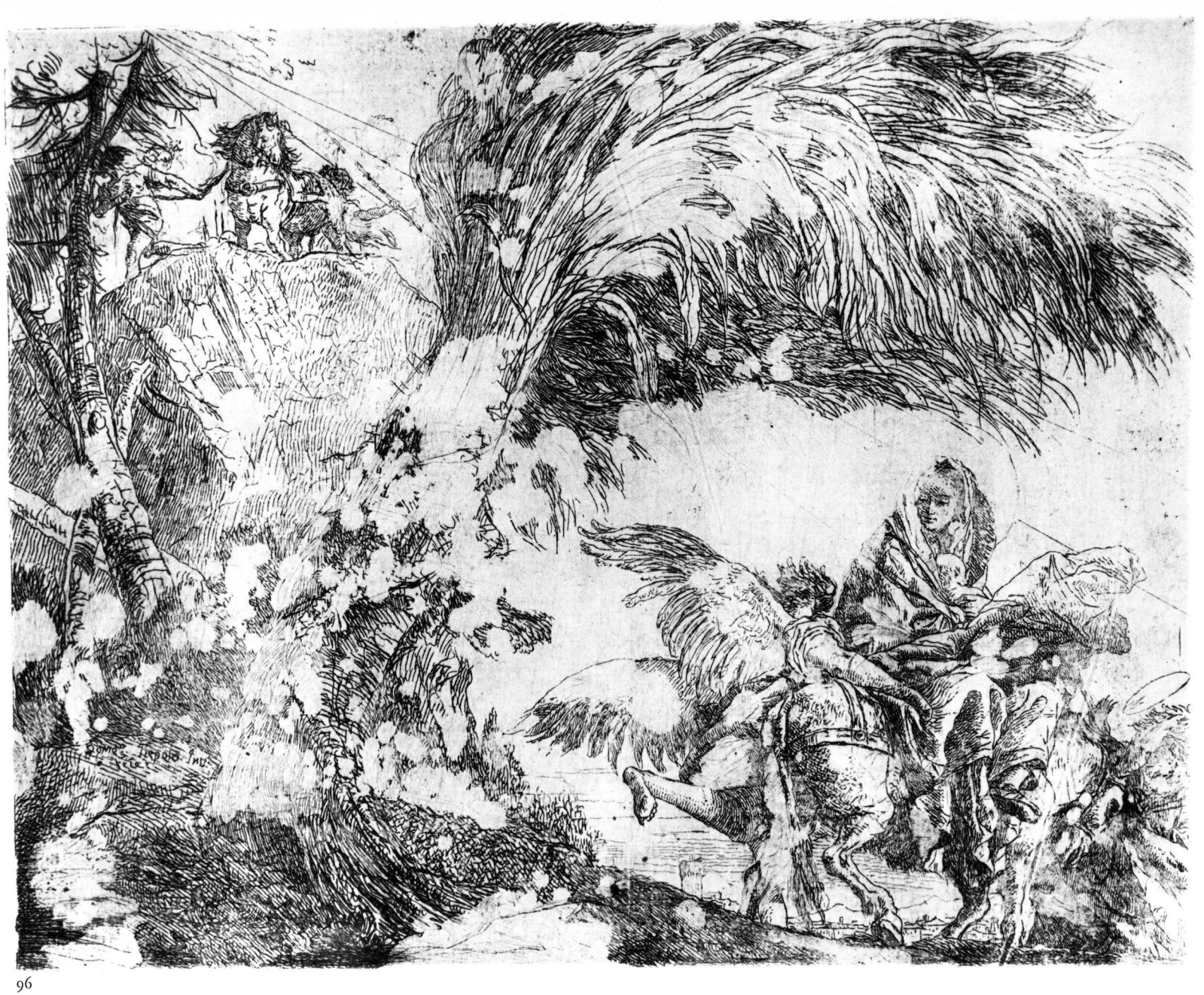

96

97. St. Peter Regalatus carried by the Angels across a river

319 × 216 mm. First state: before the letters; second state: inscribed *Jo. Dom. Theopolus. inven. et inc.* | *S. PETRUS REGALATUS* | *Ord: Min: Regul: Observ: S. Francisci* on the lower margin.

The preparatory drawing is now in the Hermitage, Leningrad (fig. XLIV). Giandomenico uses for the background the architectural elements of pl. 76 derived from his father's repertoire.

Bibliog.: Nagler, 1947, 17; De Vesme, 1906, 70; Sack, 1910, 57; Pallucchini, 1941, 371; Rizzi, 1970, 94.

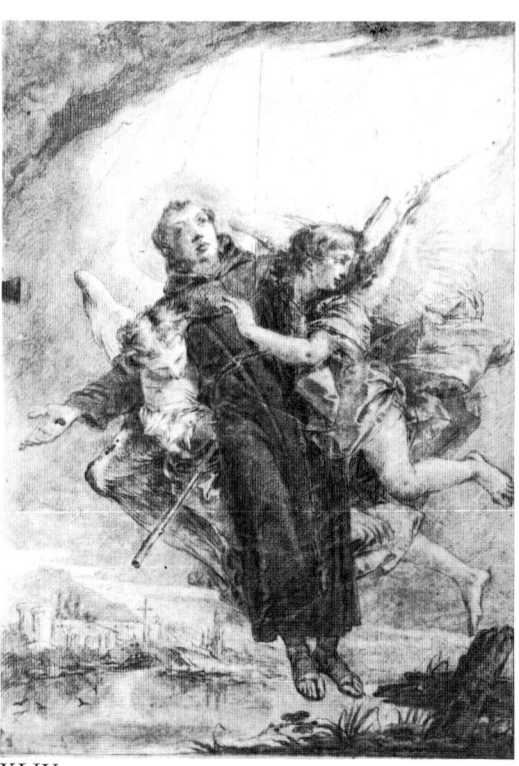

XLIV

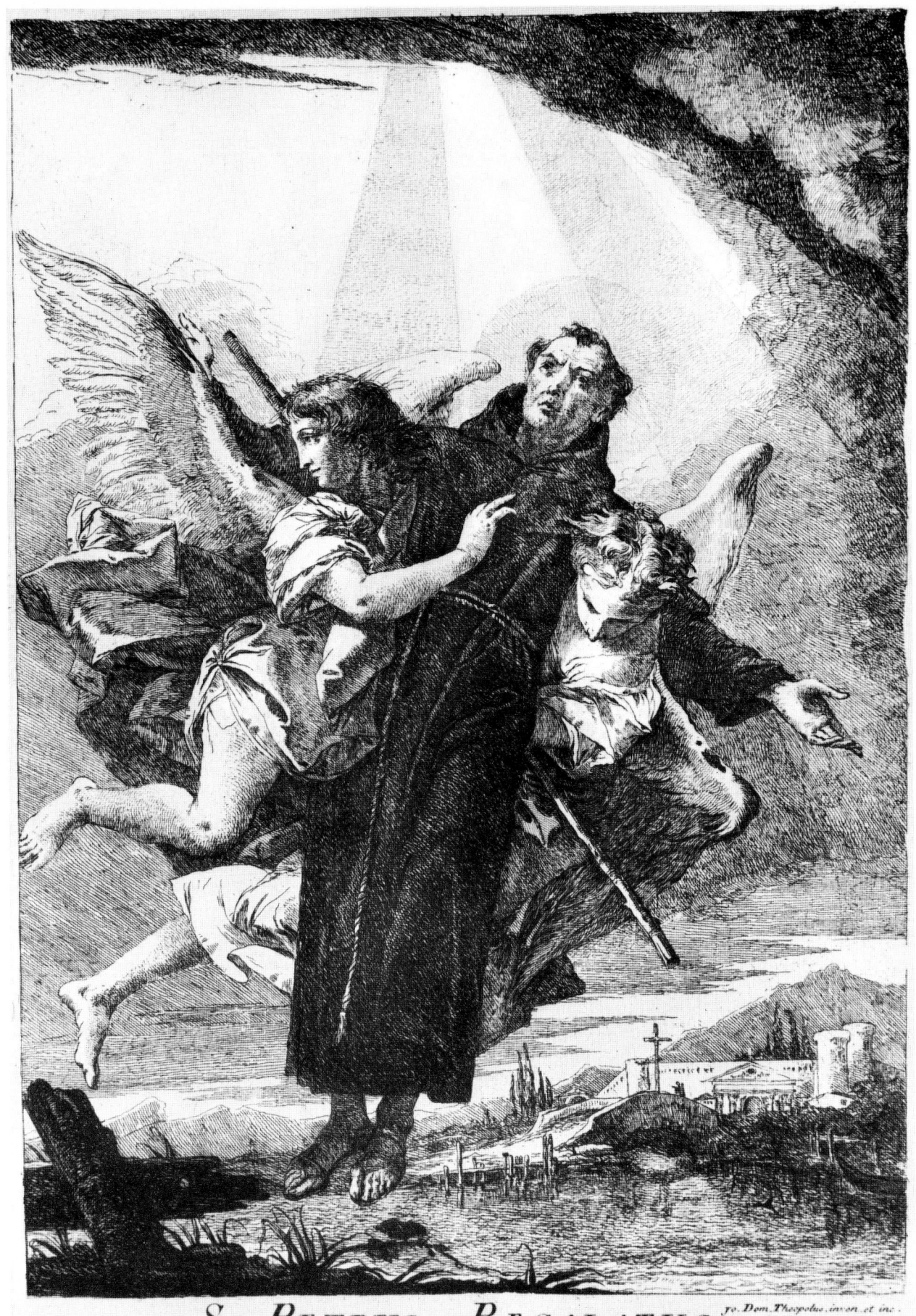

S. PETRUS REGALATUS

Jo. Dom. Theopolus. inven. et inc.

Ord: Min: Regul: Observ: S. Francisci.

98. The Virgin appearing to St. Simon Stock

604 × 395 mm. First state: before the number; second state: *40* in the top left corner. On a stone slab is the inscription, partly hidden by a bar: *(M) O D | MDC(C)LIX | XXIA(–)II*. In the bottom margin: *Joan:es Bapt.a Tiepolo inveniens et pingens. | In Sacello B: Mariae Virginis a Monte Carmelo, prope Ecclesiam aeiusdem Ordinis Venetiarum. | Domi.us Filius delineavit et incidit.*

This etching and the four which follow are derived from Giambattista's frescoes in the Scuola dei Carmini, Venice, painted between 1740 and 1743 (Morassi, 1962, p. 58).
The date on the etching is the year n which Giandomenico executed it; the painting is dated MDCCXL.

Bibliog.: Nagler, 1847, 11; De Vesme, 1906, 57; Sack, 1910, 80; Pallucchini, 1941, 365; Rizzi, 1970, 95.

Ioan.^{es} Bapt.^a Tiepolo inveniens et pingens.

In Sacello B. Mariæ Virginis a Monte Carmelo, prope Ecclesiam eiusdem Ordinis Venetiarum.

Domi.^{cus} Filius delineavit et incidit.

99. An angel carrying a scapular

147 × 361 mm. First state: before the number; second state: *1* at top left. At the bottom, in an oblong space, the inscription: *Joannes Baptta Tiepolo inv: et pinx. | in Sacello B. M. de Monte Carmelo Venetijs*, to the left; on the right: *Joannes. Domenicus Filius del: et fecit.*

See note to preceding plate.

Bibliog.: De Vesme, 1906, 75; Sack, 1910, 81; Rizzi, 1970, 96.

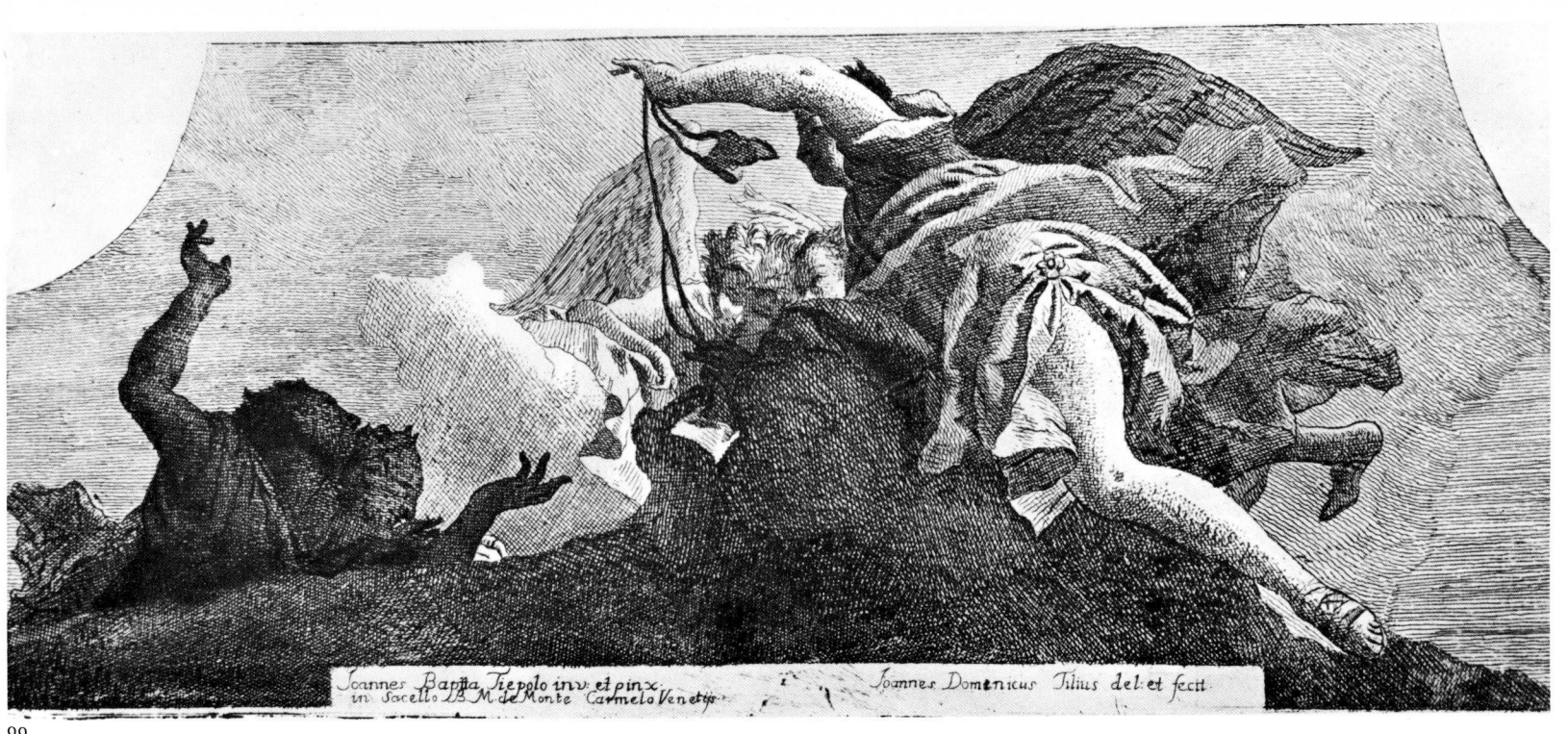

Joannes Baptista Tiepolo inv. et pinx.
in Sacello B.M. de Monte Carmelo Venetijs.

Joannes Domenicus Tilius del. et fecit.

99

100. An artisan saved from death by a scapular

150 × 364 mm. First state: without number; second state: *2*, upside-down, at bottom right. At the top the inscription: *Joannes Baptta Tiepolo inv: et pinx: in Sacello B: M: de Monte Carmelo Venetijs. Joannes Domicus* (sic) *Filius del: et fecit.*

See note to plate 98.

Bibliog.: De Vesme, 1906, 76; Sack, 1910, 82; Rizzi, 1970, 97.

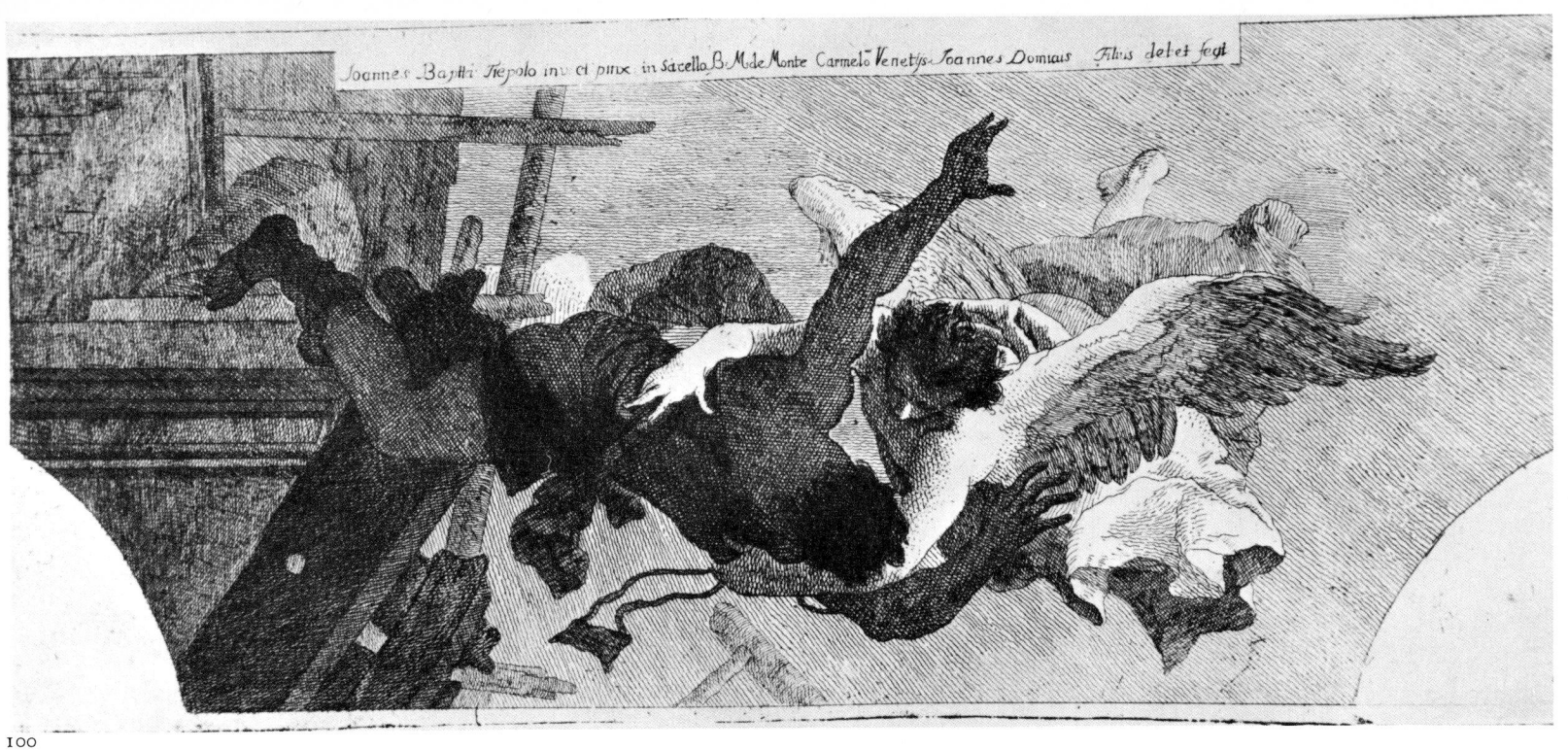

Joannes Baptti Tiepolo inv et pinx in sacello B. M de Monte Carmelo Venetijs Joannes Domicis Filius delet fegt

100

101. Three angels, one holding a scapular

192 × 332 mm. Inscribed: *Io. Bapta Tiepolo pinx: in Sacello B.M. | de Monte Carmelo Venetijs* in the bottom left-hand corner; and *Io: Dominicus Filius delin: et sculp.* in the right-hand corner.

See note to plate 98.

Bibliog.: De Vesme, 1906, 77; Sack, 1910, 84; Rizzi, 1970, 98.

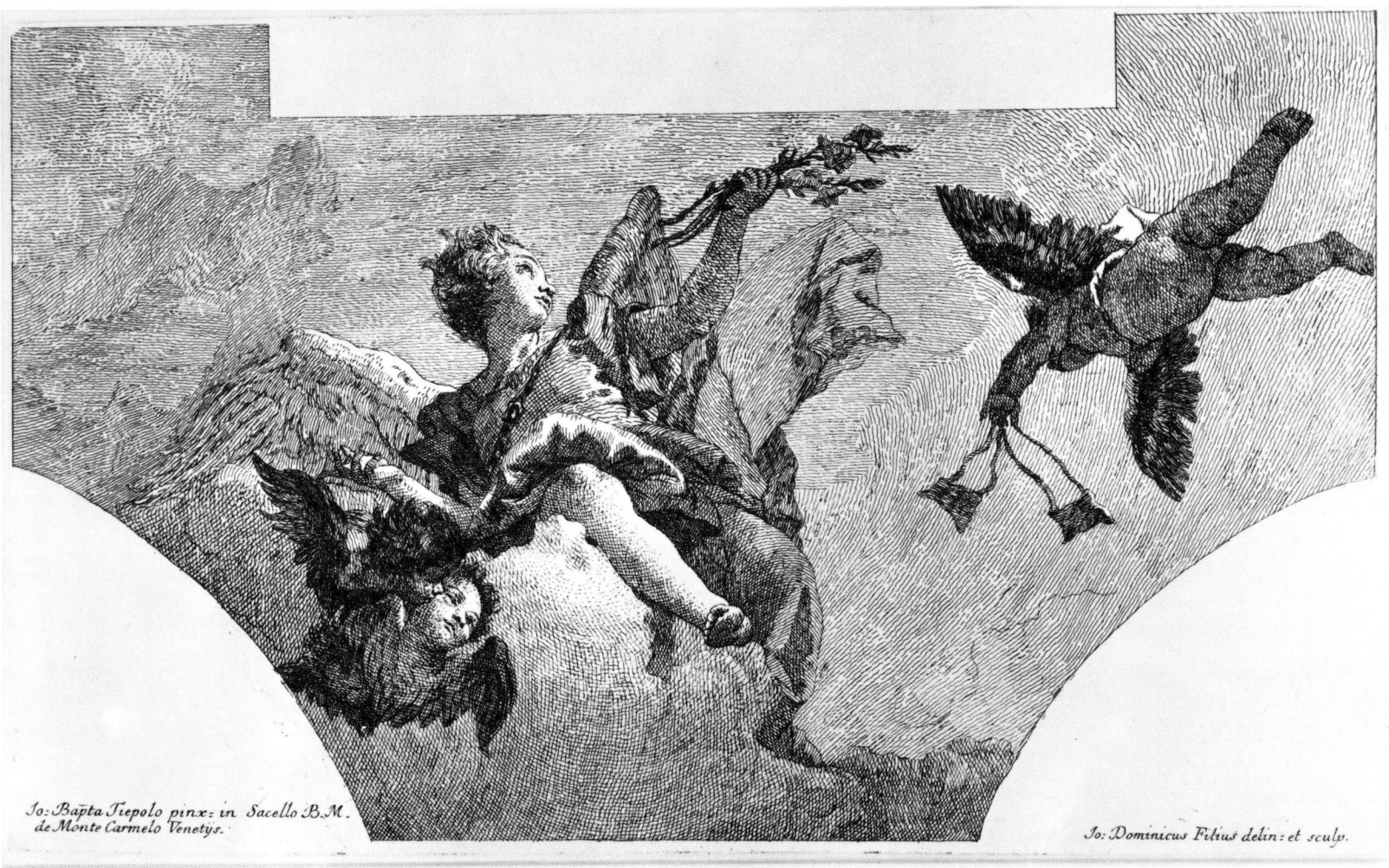

Jo: Bapta Tiepolo pinx: in Sacello B.M.
de Monte Carmelo Venetijs.

Jo: Dominicus Filius delin: et sculp.

101

102. Angels carrying the indulgences of the Carmelites

190 × 330 mm. At bottom left, the inscription: *Jo: Bapta Tiepolo pinx. in Sacello B.M. de | Monte Carmelo Venetijs.;* to the right: *Jo. Dominicus Filius delin: et sculp.*

This etching is mentioned by Sack, but not by De Vesme. It also is based on Giambattista's painting in the Scuola dei Carmini, Venice (see note to pl. 98).

Bibliog.: Sack, 1910, 83; Rizzi, 1970, 99.

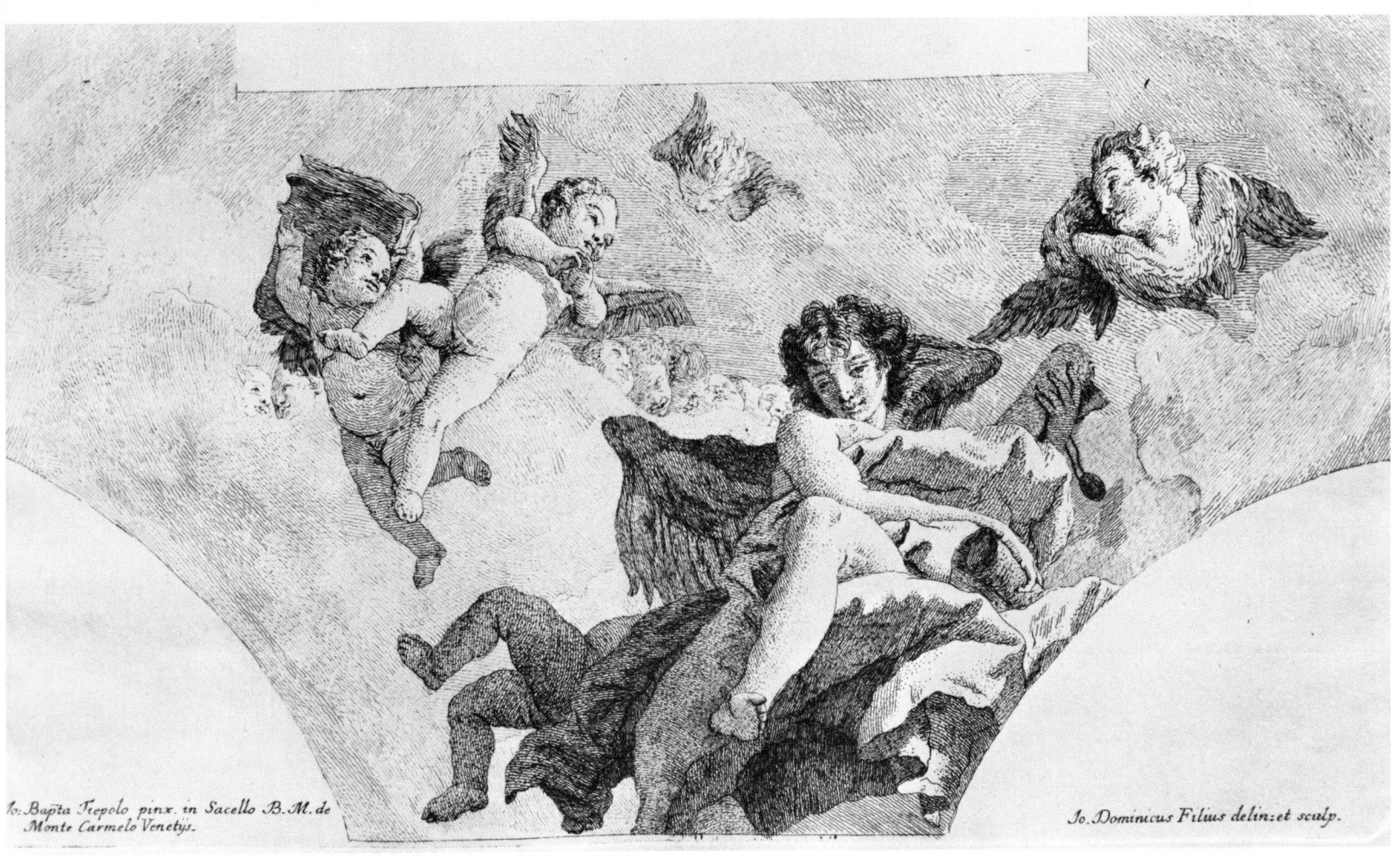

102

103. Tarquin and Lucretia

233 × 180 mm. Inscribed *Jo: Batta Tiepolo inv. et pin: | Do. Filius del: et in:* at the bottom.

Giambattista's original (from which Giandomenico derived this etching) was painted for the Barbaro Palace in Venice between 1745 and 1750 (Morassi, 1962, p. 2); it is now in the Augsburg Museum. The preparatory drawing is in the Stuttgart Museum (fig. XLV).

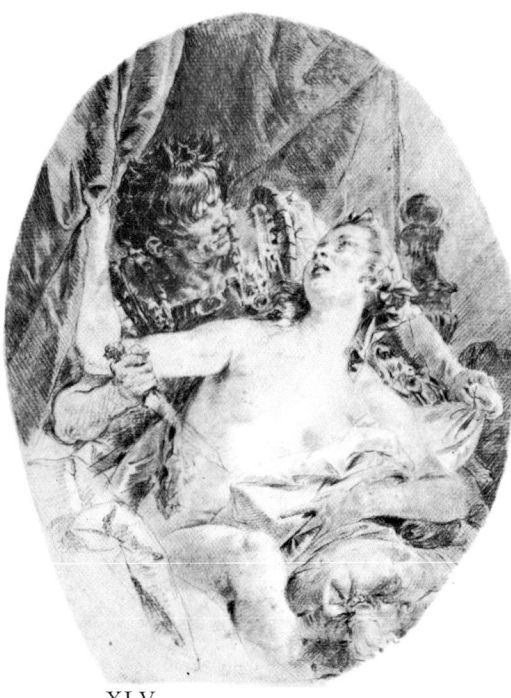

XLV

Bibliog.: Nagler, 1847, 31; De Vesme, 1906, 88; Sack, 1910, 98; Pallucchini, 1941, 389; Pittaluga, 1952, p. 155; Knox-Thiem, 1970, 66; Rizzi, 1970, 100.

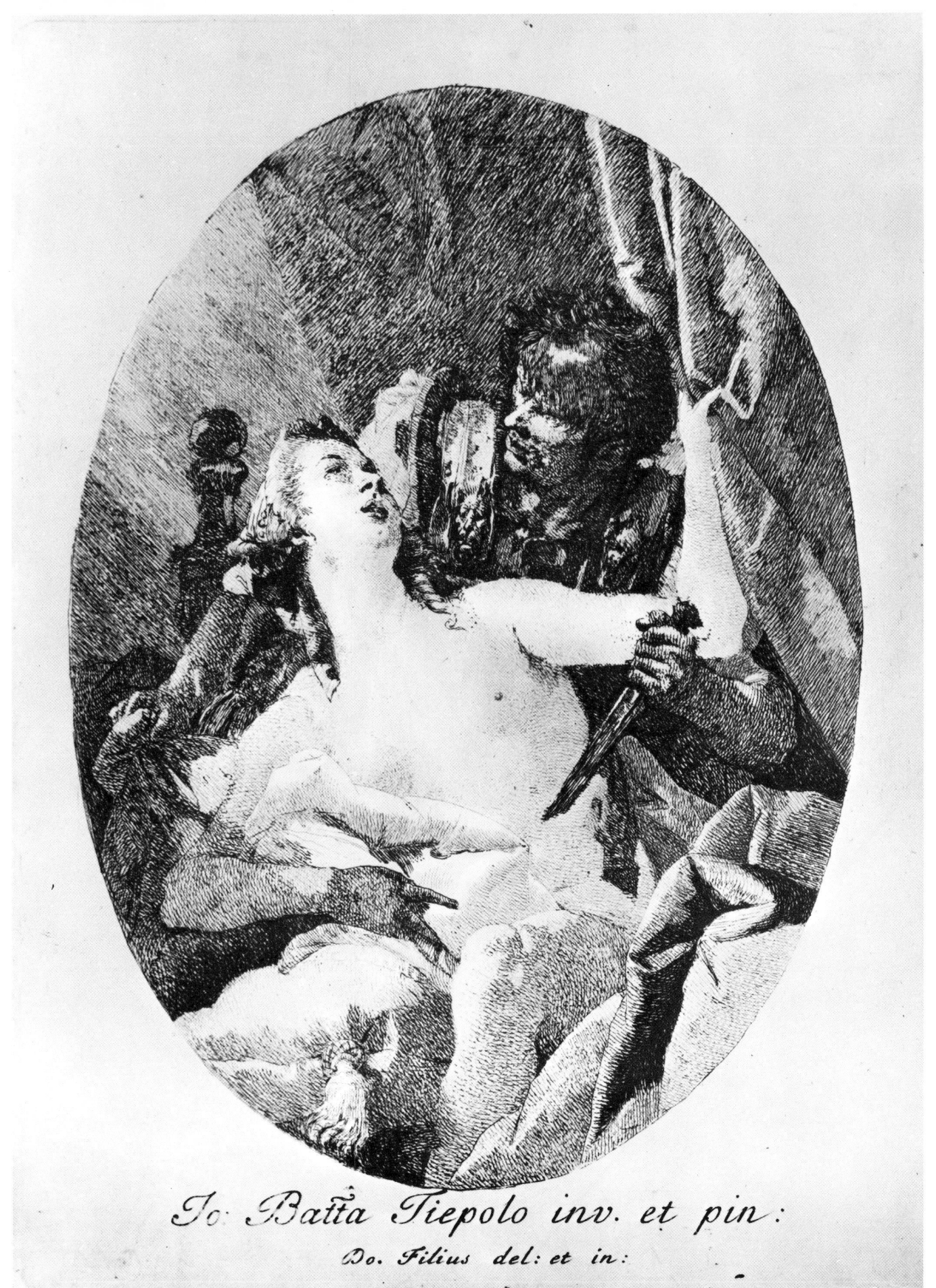

Io Batta Tiepolo inv. et pin:

Do. Filius del: et in:

104. Cleopatra honoured with gifts

234 × 183 mm. First state: before the number; second state: *10* at the top. Inscribed *Jo: Batta Tiepolo inv: et pin: | Do. Filius del: et in:* in the bottom margin.

The title mentioned by De Vesme is 'Three women show the body of Mark Antony to Cleopatra'.

This etching is a pendant to plate 103; the original, painted for the Barbaro Palace in Venice, is in the Necchi Collection in Pavia. The preparatory drawing is in the Stuttgart Museum (fig. XLVI).

Bibliog.: Nagler, 1847, 32; De Vesme, 1906, 89; Sack, 1910, 99; Knox-Thiem, 1970, 67; Rizzi, 1970, 101.

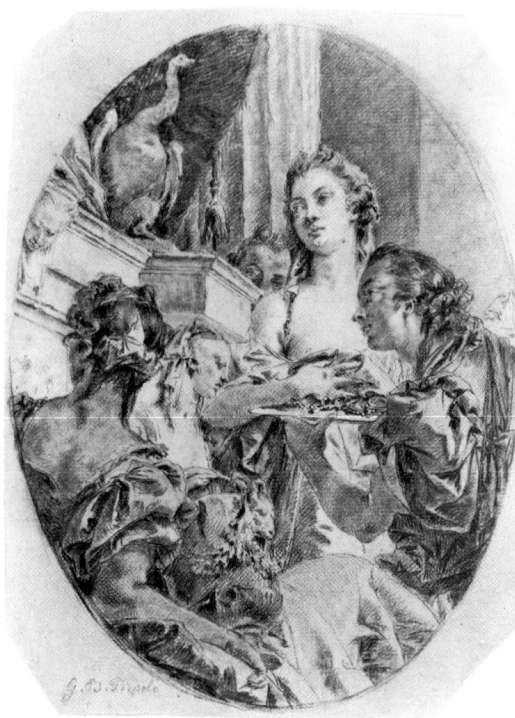

XLVI

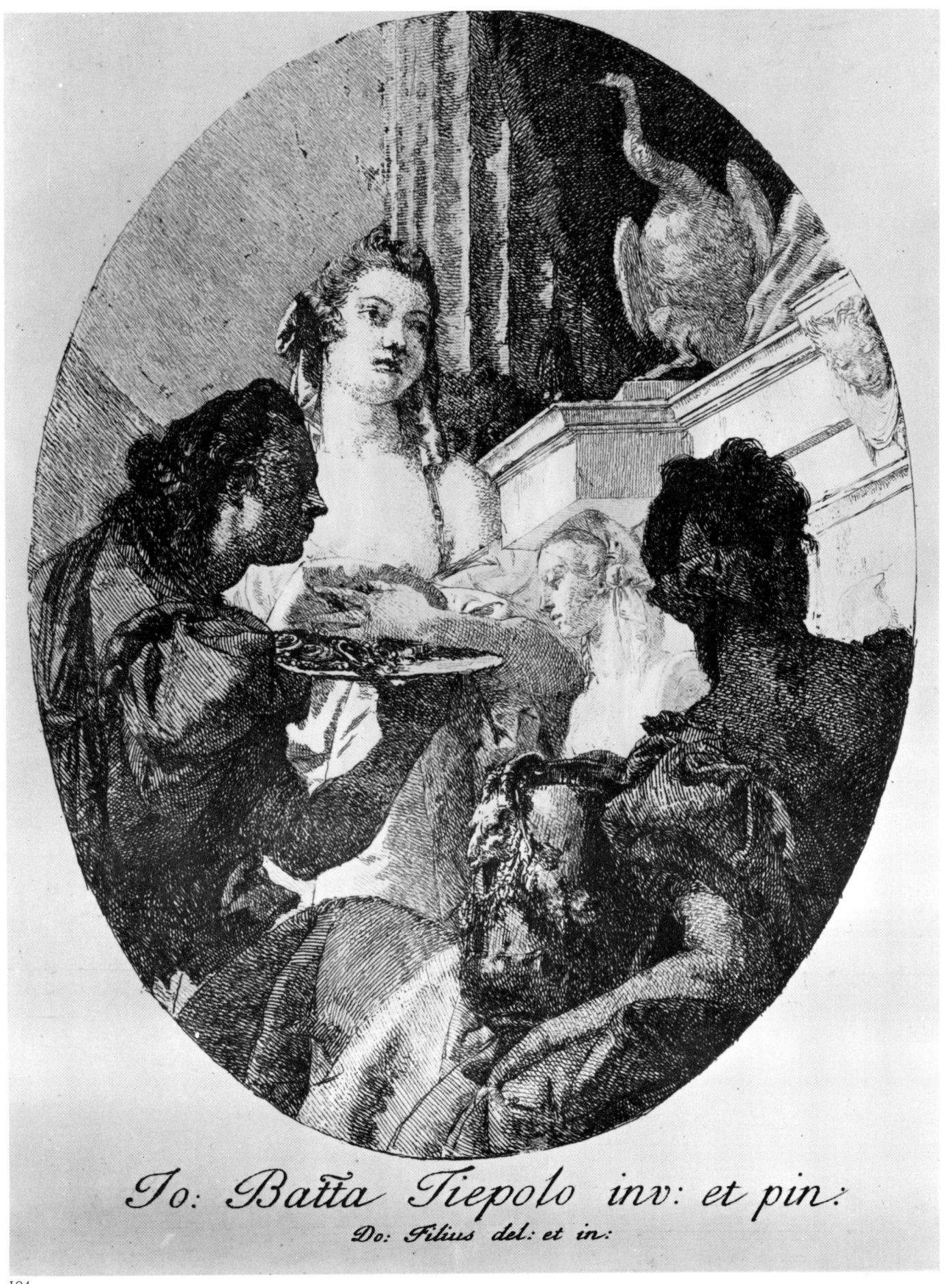

Io: Batta Tiepolo inv: et pin.

Do: Filius del: et in:

105. The Patron Saints of the Crotta family

255 × 360 mm. First state: before the inscription; second state: with the inscription but no number; third state: *15* at top right. In the margin, at the bottom: *Procerum ex Familia Crotta Sanctorum Icones, | Quas Pater pinxit, obsequi.mo animo Filius incidens | EXCEL.MO N.I VIRO D:D: IO.I ANTO.IO CROTTA Q: D: ALEXN. | D:D:D:.* Lower down, to the left: *Io.s Dom. Tiepolo Io.s Bapt.a Filius.* On some prints the inscription has been deleted and replaced, by adding a small plate, with the following wording: *Ioannes Batta Tiepolo inv. et pinxit | Io Ioanes Domenicus Tiepolo del. et fecit.* This, however, is not another state as the main etching has not been altered.

Giambattista's painting, from which this etching is derived, belonged to the Crotta family, Venice; it is now in the Städelsches Kunstinstitut, Frankfurt. Morassi dates it from about 1750 (1961, p. 12), Pallucchini between 1754 and 1755 (1968, No. 215).

Bibliog.: Nagler, 1847, 25; De Vesme, 1906, 74; Sack, 1910, 77; Rizzi, 1970, 102.

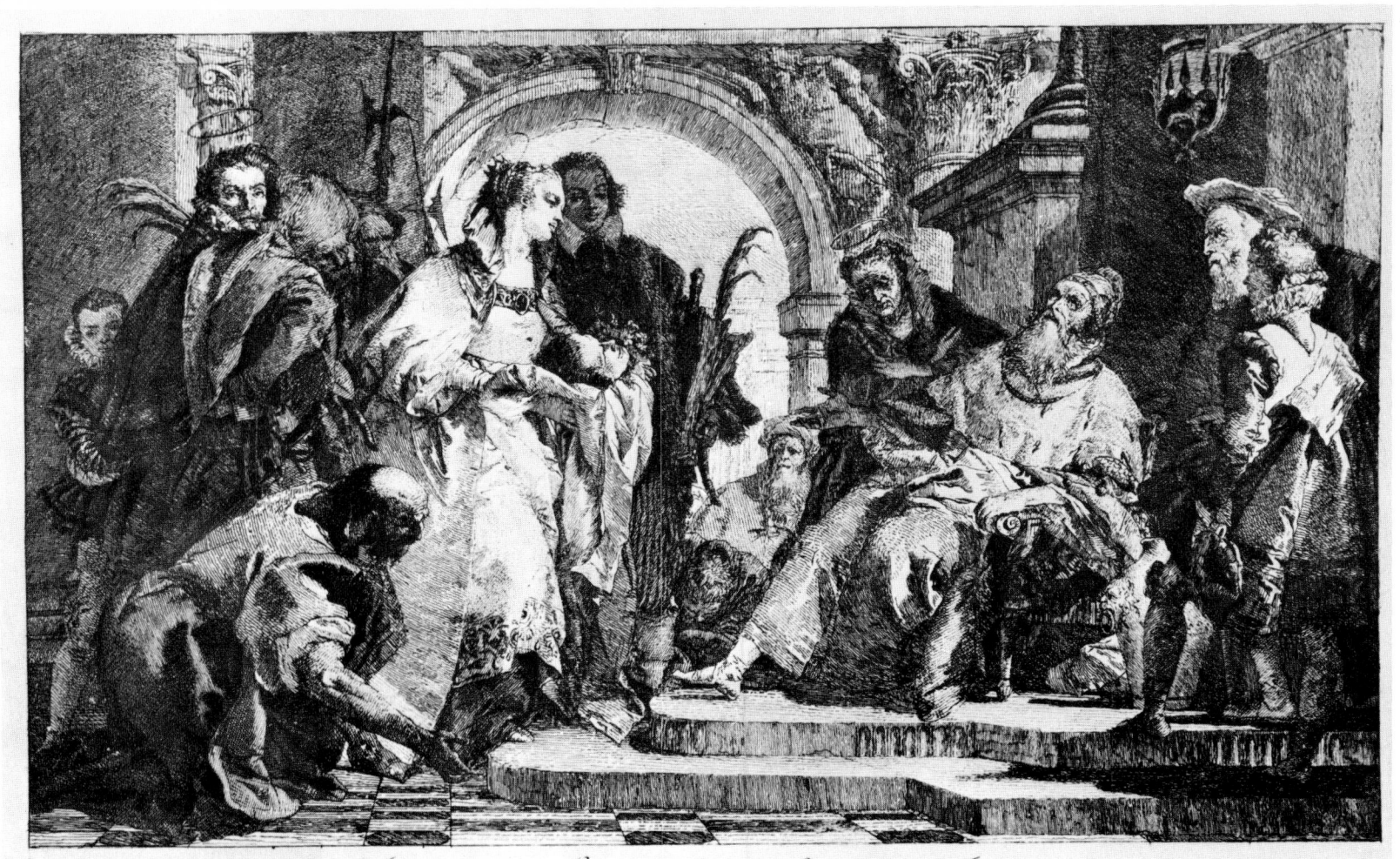

Procerum ex Familia Crotta Sanctorum Icones,
Quas Pater pinxit, obsequi[mo] animo Filius incidens
EXCEL.[MO] N.[I] VIRO D.D.IO.[I] ANTO.[IO] CROTTA Q.D.ALEXÑ.
D.D.D.

Io.ˢ Dom̃.Tiepolo Ⅰ:Bapt.ᵃ Filius.

105

106. St. Patrick cures a cripple

489 × 252 mm. First state: before the number; second state: No. *30* top left. At the bottom, on the etching, the inscription: *Joannes Baptista Tiepolo pinx. in Eccl. S. Joannis de Verdara Patavij.* Below in the margin: *Francisco Comiti Algarotto,* | *Illustrissimo aeque, ac Doctissimo Viro* | *Tabulam, quam IPSE e patris penicillo prodeuntem olim benigne acceperat, pingentem consilio adjuvans,* | *comitate fovens; aeri nunc a se incisam patri libentissime morem gerens humiliter dedicat.* | *Jo: Dominicus Tiepolo Filius.* De Vesme mentioned proofs of the second state in which the inscription does not appear; in the blank space a second inscription was later added, on a small sheet: *Joannes Batta Tiepolo inv. et pinxit* | *Io Ioanes Domenicus Tiepolo del. et fecit.*

According to Giandomenico's Catalogues, the etching depicts St. Paulinus. Giambattista's painting, from which the etching is derived, was painted in 1747 for the monastery of the Jesuits in Padua; it is now in the Padua Museum (Morassi, 1962, p. 38).

Bibliog.: Nagler, 1847, 14; De Vesme, 1906, 69; Sack, 1910, 75; Pallucchini, 1941, 375; Rizzi, 1970, 103.

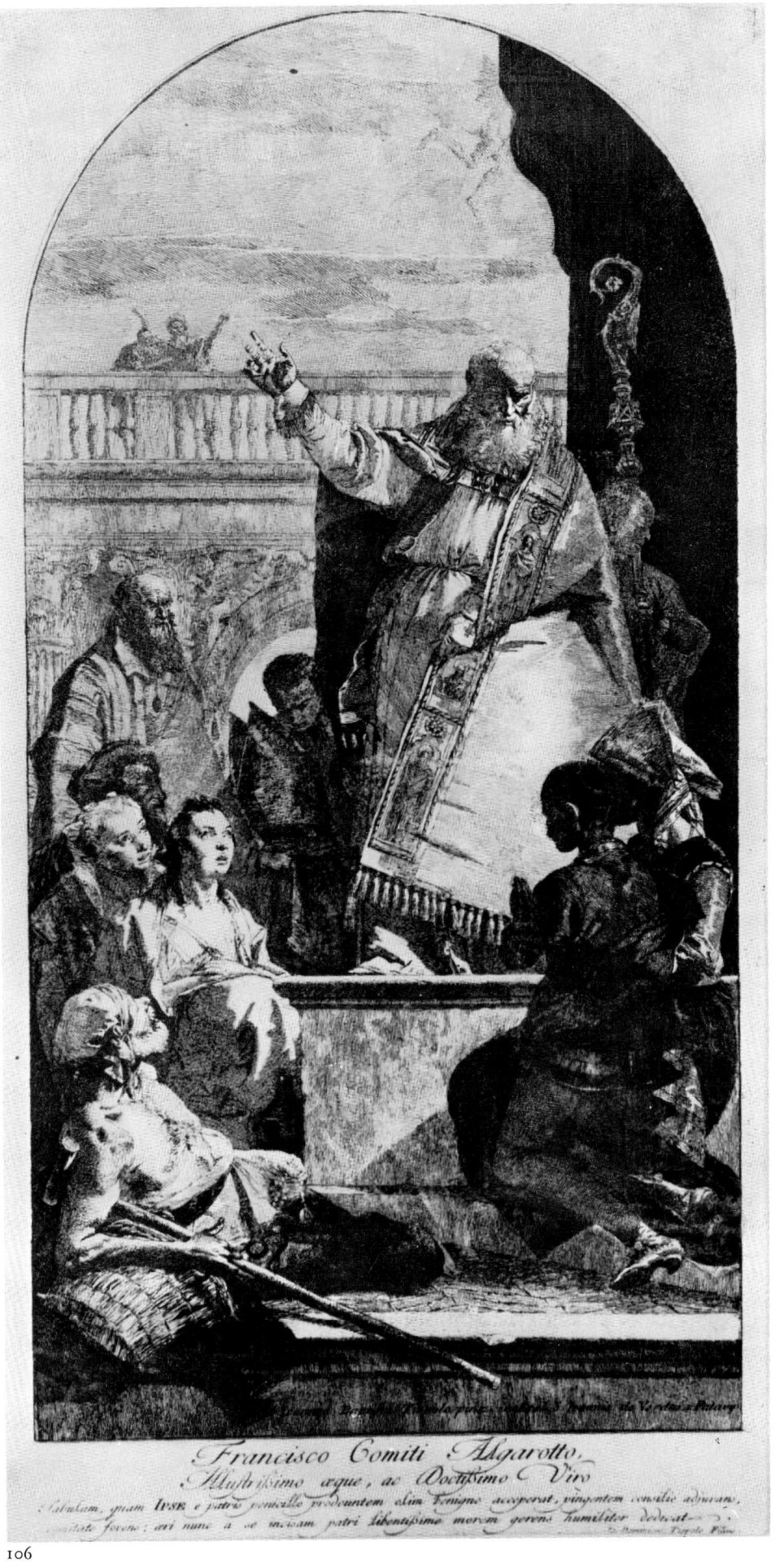

Francisco Comiti Algarotto,
Illustrißimo æque, ac Doctißimo Viro

Tabulam, quam IPSE e patris penicillo prodeuntem olim benigne acceperat, vingentem consilio adjuvans,
laudato fovens; æri nunc a se incisam patri libentißimo morem gerens humiliter dedicat
Jo: Dominicus Tiepolo Filius

107. Venice receiving Neptune's homage

191 × 360 mm. First state: before the number and the inscription; second state: *16* at top right; third state: reworked. At the bottom on the margin: *Joannes Bapta Tiepolo inv: et pinx.* / *Joannes Dominicus Filius del: et fecit.*

The allegory, from which Giandomenico's etching derives, was commissioned from his father for the Ducal Palace in Venice, about 1745–50 (Morassi, 1962, p. 58).

Bibliog.: Nagler, 1847, 35; De Vesme, 1906, p. 97; Sack, 1910, 97; Rizzi, 1970, 104.

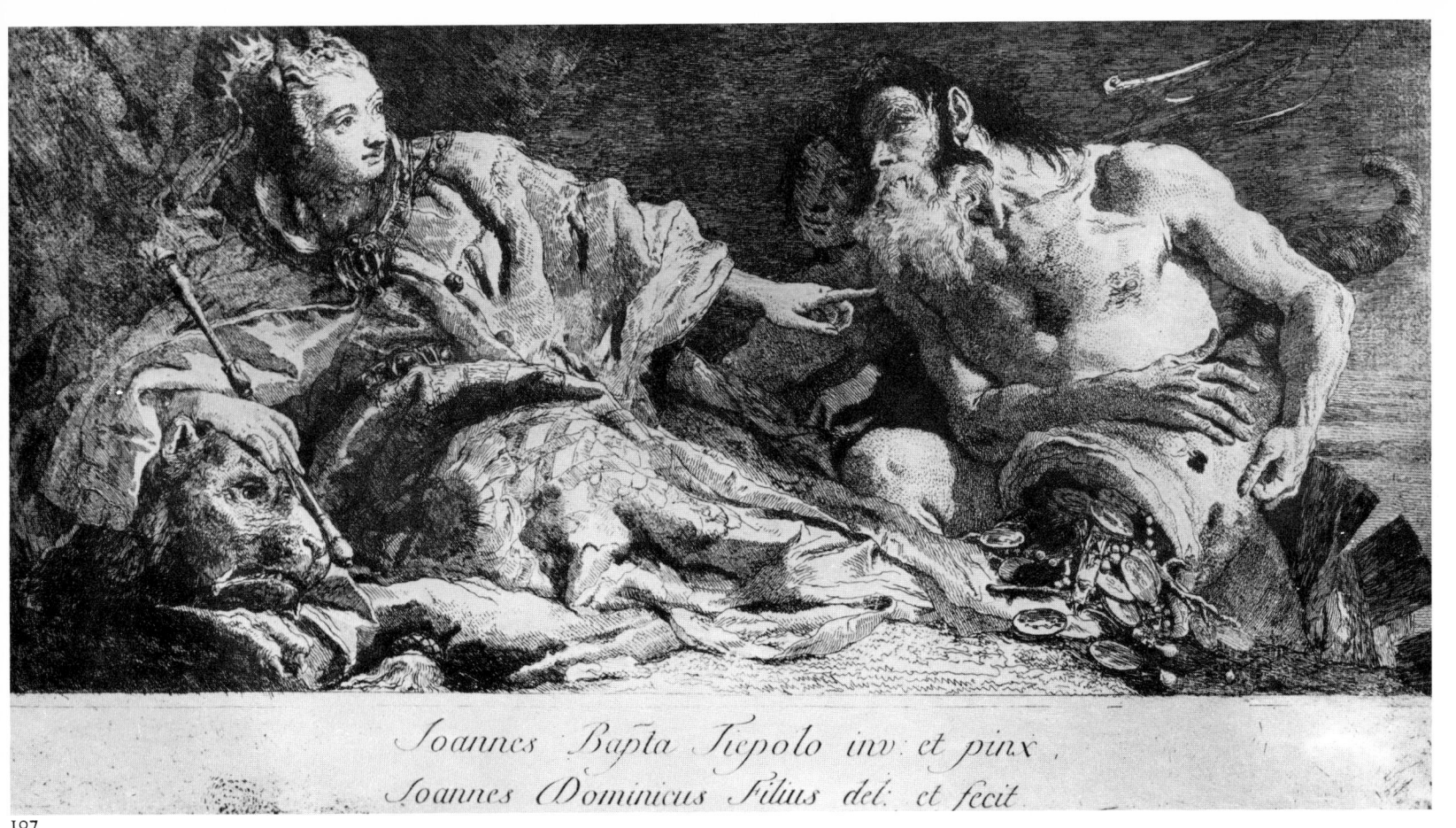

Ioannes Bapta Tiepolo inv. et pinx.
Ioannes Dominicus Filius del: et fecit

107

108. St. John the Baptist preaching

242 × 286 mm. First state: before the number and the inscription, on light blue paper (Dr. Urzi, Padua). Second state: before the number; third state: *18* at top right. In the margin at the bottom: *Ioannes Batta Tiepolo inv. et pinxit | Ioannes Dominicus Tiepolo del. et fecit.*

The etching reproduces Giambattista's fresco of the same subject painted for the Colleoni Chapel, Bergamo, in 1733 (Morassi, 1962, p. 3).
See also the next plate.

Bibliog.: Nagler, 1847, 2; De Vesme, 1906, 31; Sack, 1910, 79; Pallucchini, 1941, 339; Rizzi, 1970, 105.

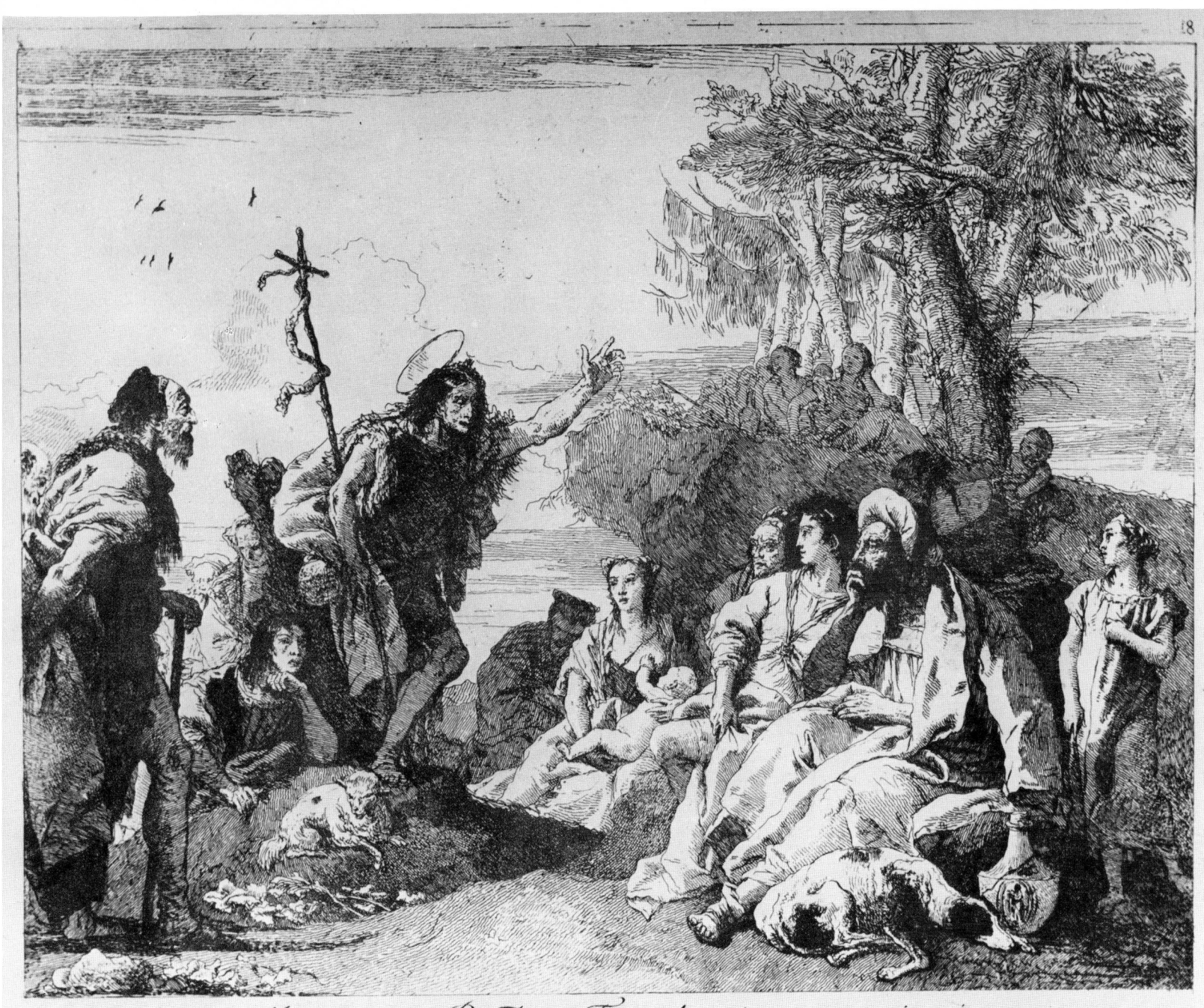

Ioannes Batta Tiepolo inv. et pinxit
Ioannes Dominicus Tiepolo del. et fecit.

109. The Baptism of Christ

238 × 306 mm. First state: before the inscription and the number; second state: with the inscription but before the number; third state: *17* at top right. Inscribed in the margin at the bottom: *Ioannes Batta Tiepolo inv. et pinxit.* / *Ioannes Dominicus Tiepolo del. et fecit.*

Sack maintained that the etching is derived from the painting executed by Giambattista for the Colleoni Chapel in Bergamo, which is, however, considerably different. The original by Giambattista is presumably lost. The theme of the ' Baptism of Christ ' appears in many of Giandomenico's drawings, now in the Morassi Collection, Milan, in the Ashmolean Museum, Oxford, in the Robert Lehman Collection and in the former Beauchamp Collection (see *Catalogue of drawings by Giovanni Domenico Tiepolo*, London, 1965, p. 7). See also note to previous plate.

Bibliog.: Nagler, 1847, 4; De Vesme, 1906, 32; Sack, 1910, 78; Byam Shaw, 1962, pp. 38–9; Rizzi, 1970, 106.

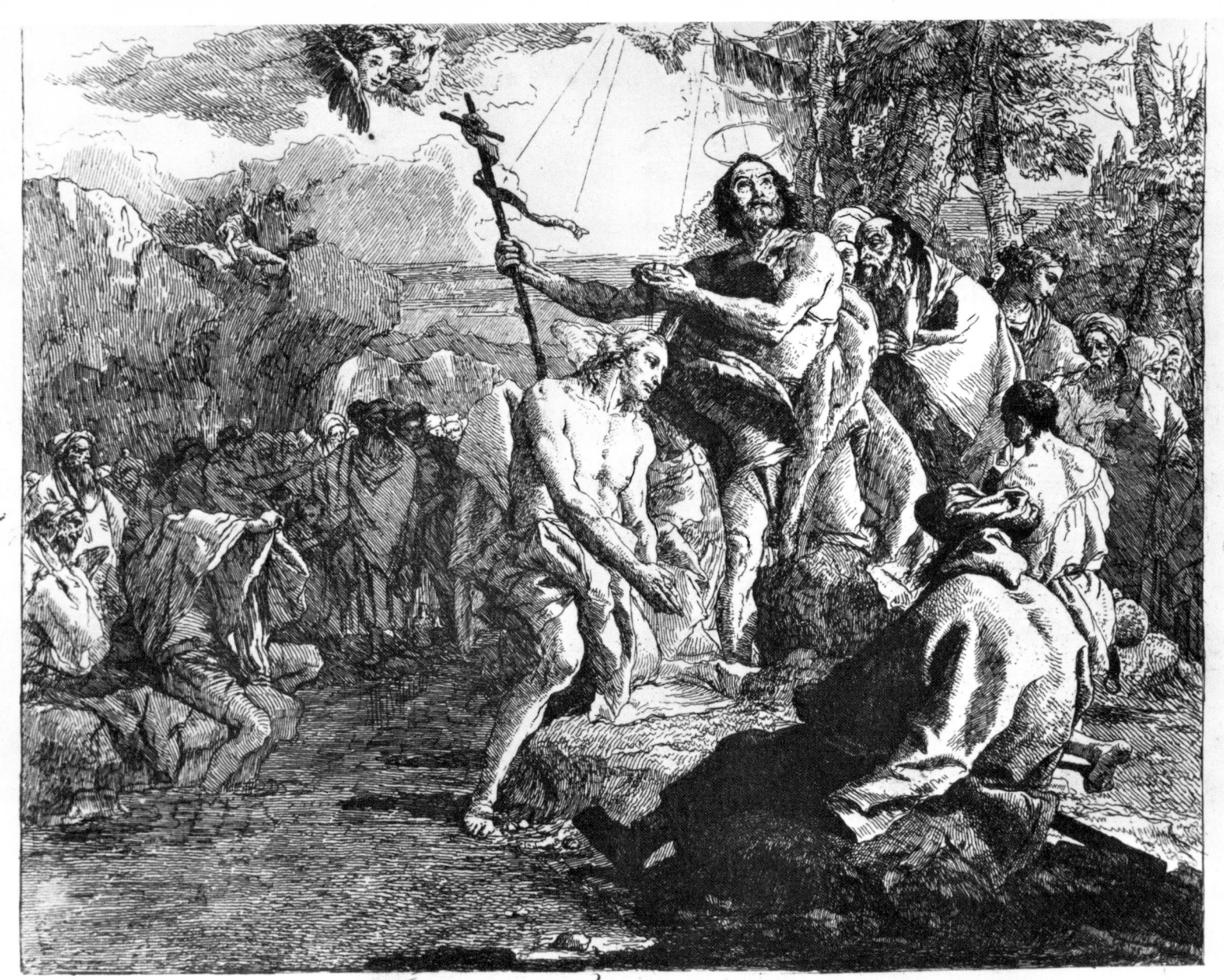

Ioannes Batta Tiepolo inv. et pinxit
Ioannes Dominicus Tiepolo del. et fecit.

109

110. The Last Supper

361 × 198 mm. First state: before the number; second state: *21* at top right. In the margin, the inscription: *Giov: Batta: Tiepolo Immaginò e dipinse e Giov: Dom: Figlio Delin. Scolpì e dedicò | quest'opera all'Ill.mo Sig.r Antonio Zanetti di Girolamo uomo eruditissimo. | Aquista l'opra dal tuo nome onore, | onor al nome tuo, rende la speme, | d'aver dal lume tuo gloria maggiore.* De Vesme, followed by Sack, mentioned examples of the second state in which the margin inscription has been covered and replaced with the following one, engraved on a small additional copperplate: *Joannes Batta Tiepolo inv. et pinxit, Jo. Joanes Domenicus Tiepolo del et fecit.*

The etching reproduces Giambattista's altarpiece at Desenzano, painted about 1738 (Morassi, 1962, p. 10). Nagler mentioned an etching by Giandomenico depicting 'The Marriage at Cana' and derived from a painting by Giambattista. Sack maintained that such a sheet does not exist and that Nagler must have been referring to the present etching.

Bibliog.: Nagler, 1847, 7; De Vesme, 1906, 33; Molmenti, 1909, p. 149; Sack, 1910, 62, and p. 342; Pallucchini, 1941, 340.

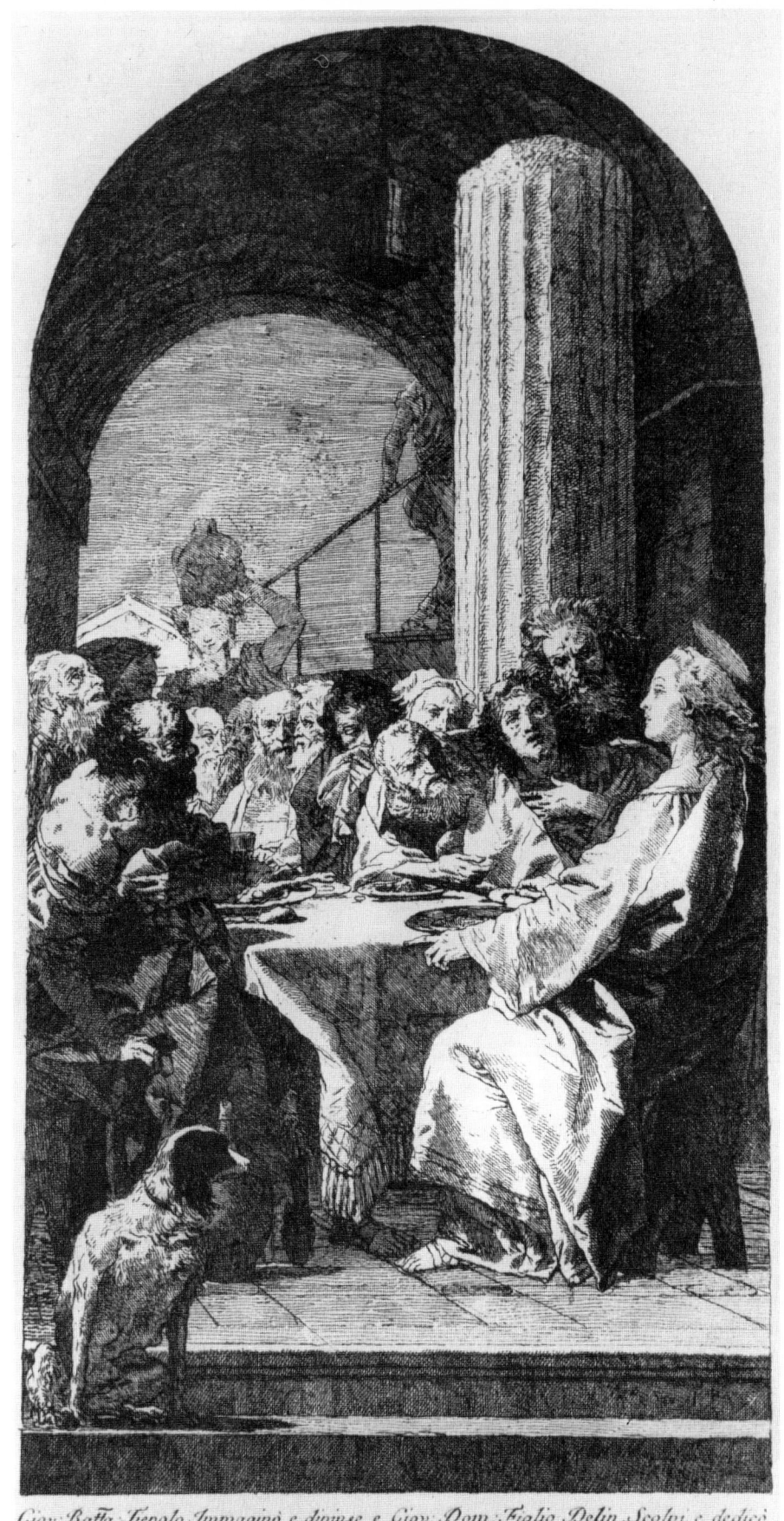

Giov. Batta Tiepolo Immaginò e divinse e Giov. Dom. Figlio Delin. Scolpi, e dedicò
quest'opra all'Illmo Sigr Antonio Zanetti di Girolamo vomo eruditissimo

Aquista l'opra dal tuo nome onore,
onor al nome tuo, rende la speme
d'aver dal lume tuo gloria maggiore.

110

111. Virtue and Glory chasing Avarice

405 × 484 mm. First state: before the number; second state: *38* at top left. At the bottom, the inscription: *Joannes Batta Tiepolo inv. et pinx. | Jo. Dominicus Filius del. et fecit.*

The etching is derived from the ceiling painted by Giambattista about 1740–50 for the Palazzo Manin in Venice, and now in the Contini-Bonacossi Collection in Florence (Morassi, 1962, p. 12), more commonly known as ' Triumph of Fortitude and Wisdom '. This is probably the sheet which Nagler mentioned under the title ' Truth triumphant over Deceit '. See also the next plate.

Bibliog.: Nagler, 1847, 42; De Vesme, 1960, 102; Sack, 1910, 104; Pallucchini, 1941, 384; Pittaluga, 1952, p. 155; Rizzi, 1970, 108.

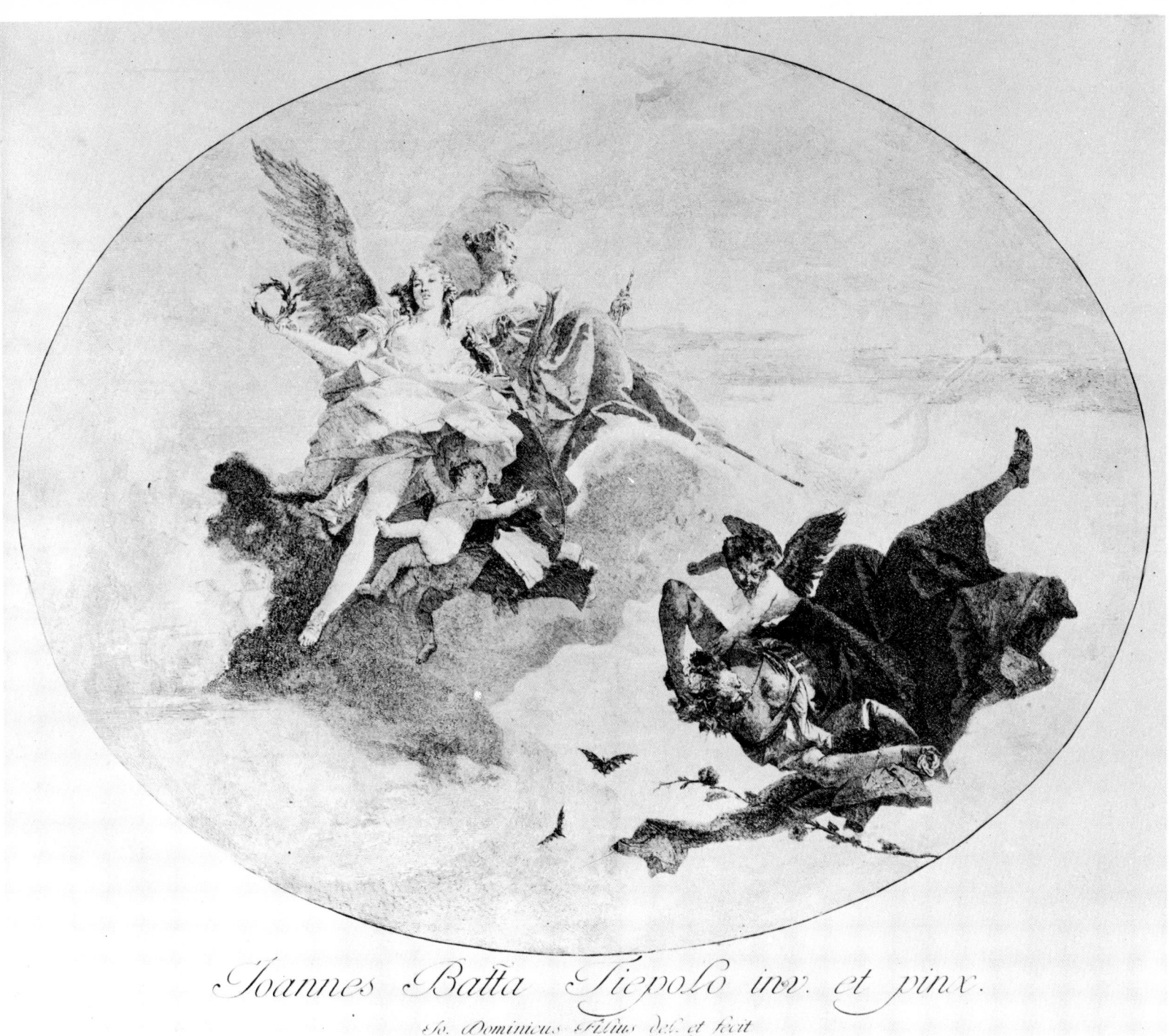

Ioannes Batta Tiepolo inv. et pinx.

Jo. Dominicus Filius del. et fecit

111

112. Virtue and Glory

Sack mentioned one of the etchings in his own collection, entitled by him *Nobility and Virtue*, but does not give the measurements; the composition seems to echo that of the previous plate, though without the minor figures and the frame and with shades of different intensity.

The etching was reproduced by Molmenti (1896, pl. 112), from whom the present illustration is taken, but it can no longer be traced.

See also the note to the previous plate.

Bibliog.: Sack, 1910, 105.

113. Valour
and other allegorical figures

364 × 540 mm. First state: before the number; second state: *37* at top left-hand corner. At the bottom, the inscription: *Joannes Batta Tiepolo inv. et pinx. / Jo. Dominicus Filius del. et fecit.*

In Giandomenico's catalogue this etching is entitlet 'VALOR, PRUDENZA E NOBILTA'. It is derived from a painting executed by Giambattista for the Barbaro Palace, Venice, between 1740 and 1750, now in the Metropolitan Museum, New York (Morassi, 1962, p. 33).

Bibliog.: Nagler, 1847, 43; De Vesme, 1906, 104; Sack, 1910, 103; Rizzi, 1970, 109.

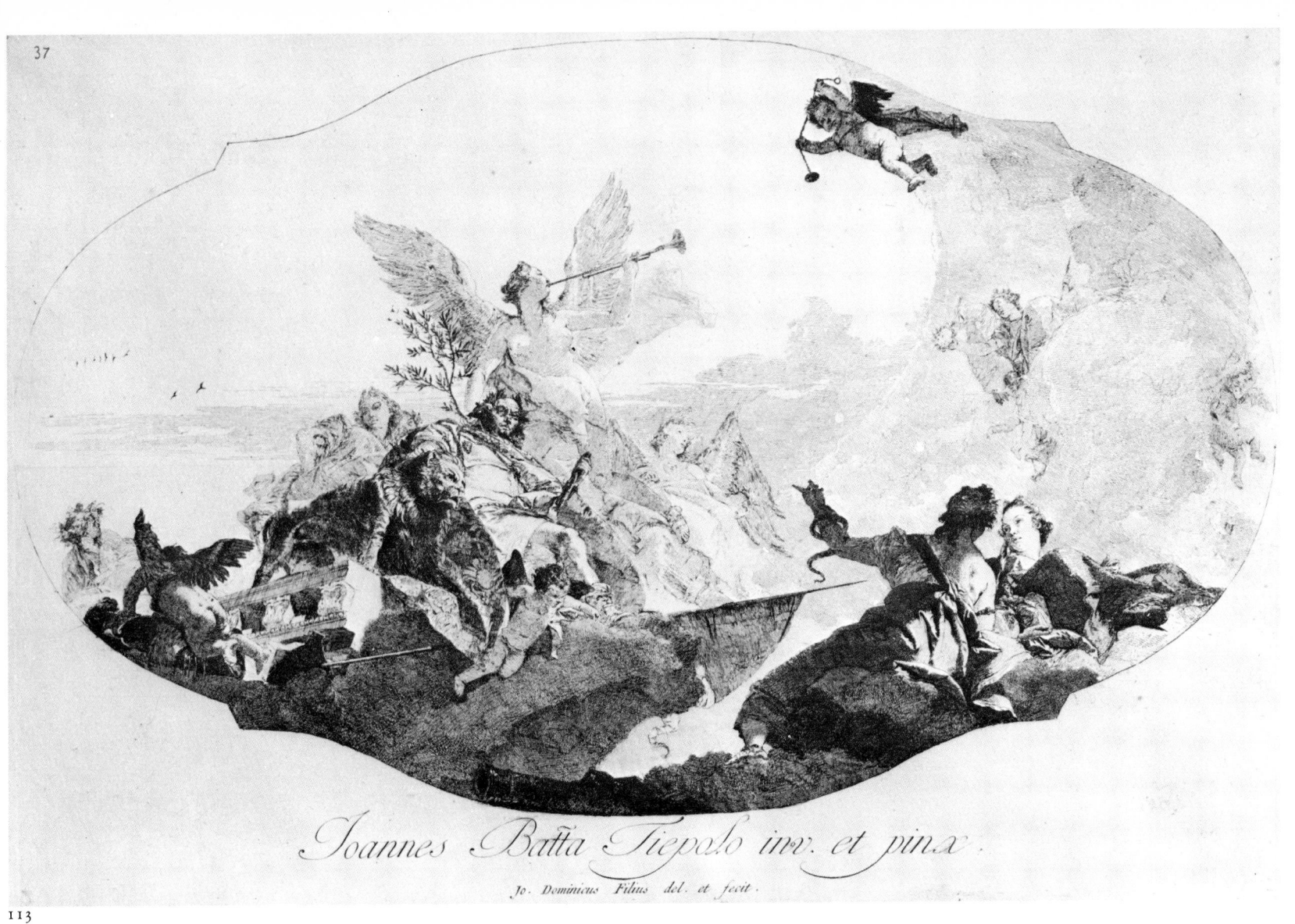

Ioannes Batta Tiepolo inv. et pinx.

Jo. Dominicus Filius del. et fecit.

114. S. Vincent Ferrer

159 × 108 mm. First state: before the number; second state: *9* at top left. In the margin at the bottom the inscription: *S. VINCENZO FERERIO* | *Do. Tiepolo fec.*

Probably an independent composition. Giandomenico also dealt with this subject in his painting, where, however, he introduced certain variations, as shown by the painting in the Municipal Museum in Udine (Rizzi, 1969, p. 38).

Bibliog.: Nagler, 1847, 21; De Vesme, 1906, 72; Sack, 1910, 49; Rizzi, 1970, 110.

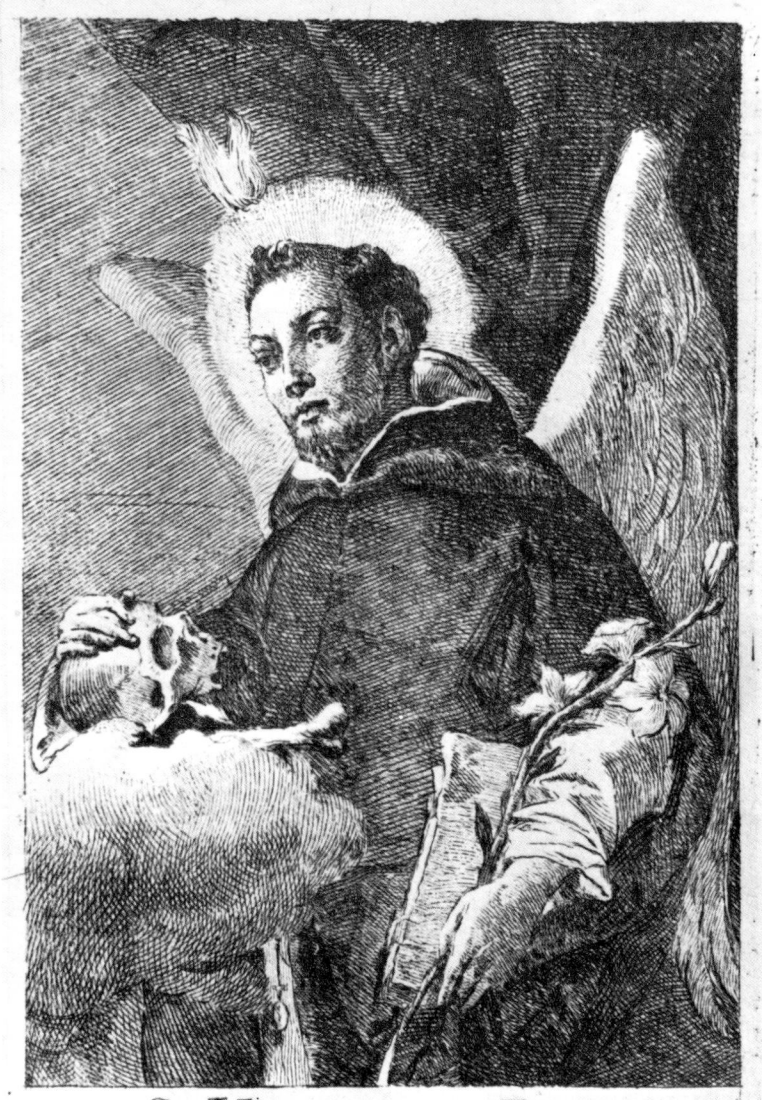

S. VINCENZO FERERIO

Do. Tiepolo fec.

114

115. The four Evangelists
St. Matthew

229 × 203 mm. The four etchings, with shaped bottom corners, are numbered *1* to *4* top left; on all of them, the number *8* top right. On each sheet, at bottom left, the inscription: *Opus in pariete pictum, in AEdibus | S. Francisci a Vinea Venetiarum. | Joan. Bapta Tiepolo inv., et pinx.* To the right: *Jo. Dominicus Filius del, et sc:.*

This and the following five etchings are derived from the frescoes painted by Giambattista in the Sagredo Chapel in the church of S. Francesco della Vigna, Venice, in 1743 (Morassi, 1962, p. 56).

Bibliog.: Nagler, 1847, 10; De Vesme, 1906, 50; Sack, 1910, 65; Pallucchini, 1941, 360; Rizzi, 1970, 111.

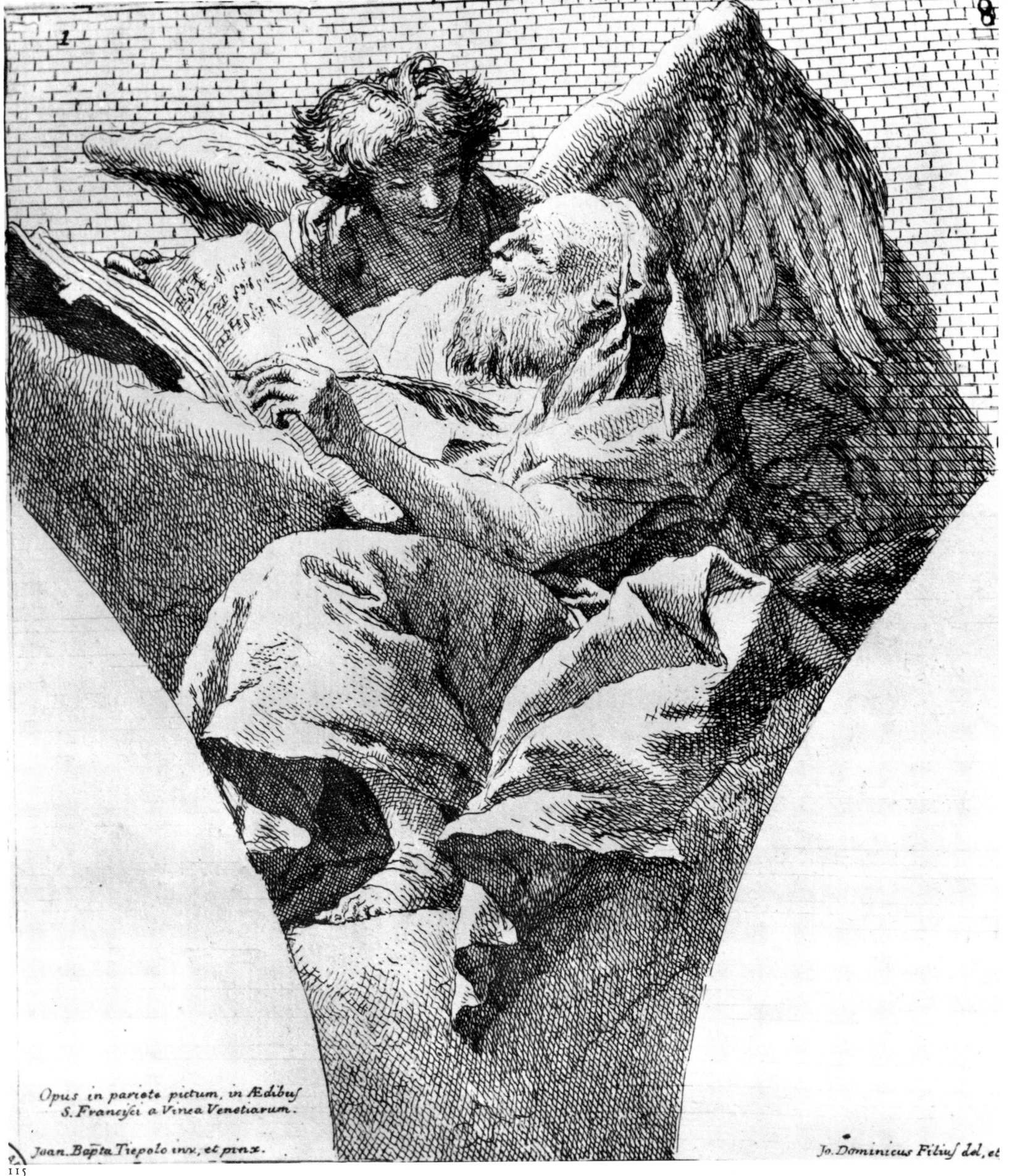

Opus in pariete pictum, in Ædibus
S. Francisci a Vinea Venetiarum.

Joan. Bapta Tiepolo inv. et pinx.

Jo. Dominicus Filius del. et

116. The four Evangelists
St. Mark

228 × 202 mm.

See note to preceding plate.

Bibliog.: Nagler, 1847, 10; De Vesme, 1906, 51; Sack, 1910, 66; Pallucchini, 1941, 361; Rizzi, 1970, 112.

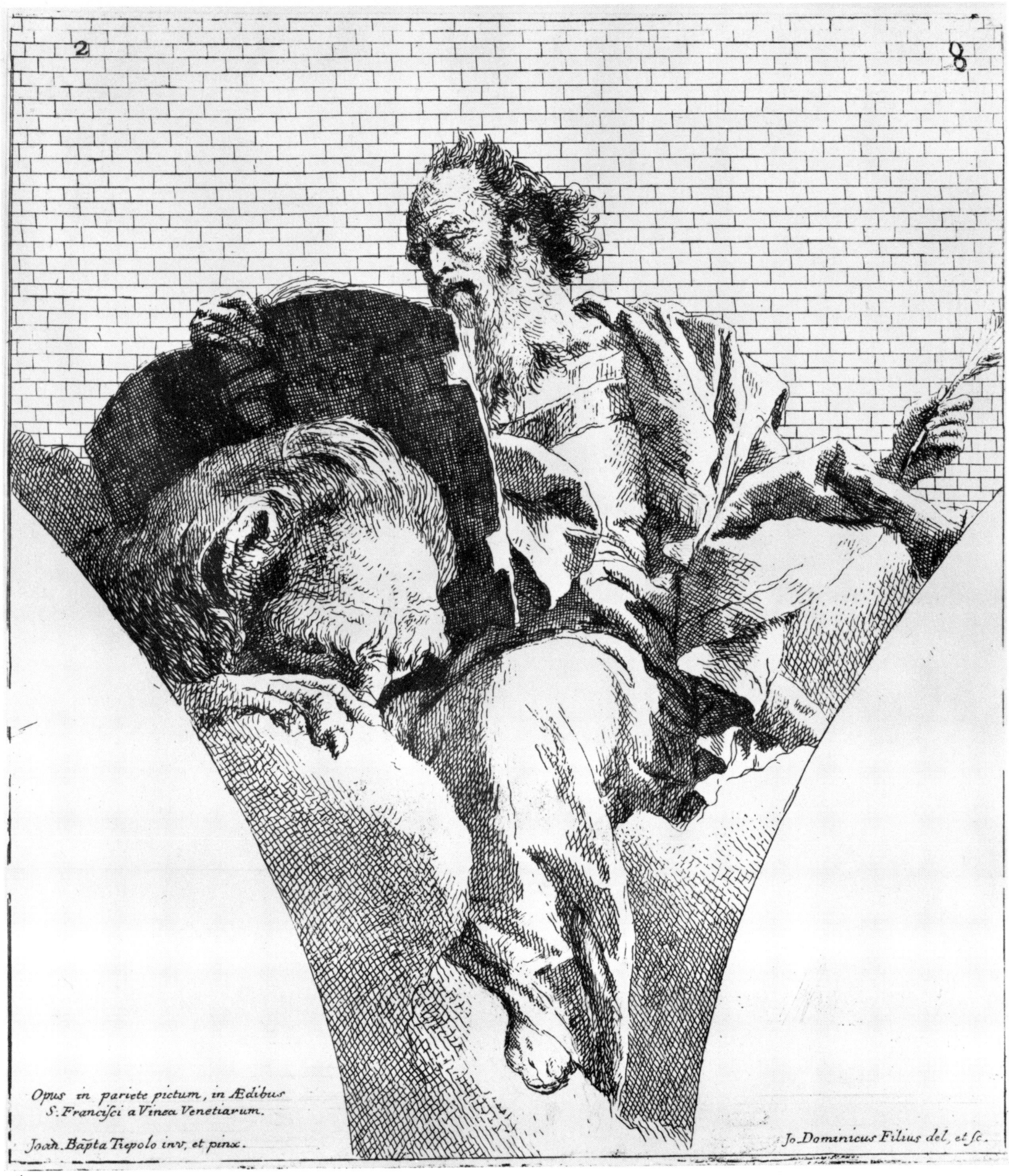

Opus in pariete pictum, in Ædibus
S. Francisci a Vinea Venetiarum.

Joan. Bapta Tiepolo inv. et pinx.

Jo. Dominicus Filius del, et sc.

117. The four Evangelists
St. Luke

228 × 203 mm.

See note to pl. 115.

Bibliog.: Nagler, 1847, 10; De Vesme, 1906, 52; Sack, 1910, 67; Rizzi, 1970, 113.

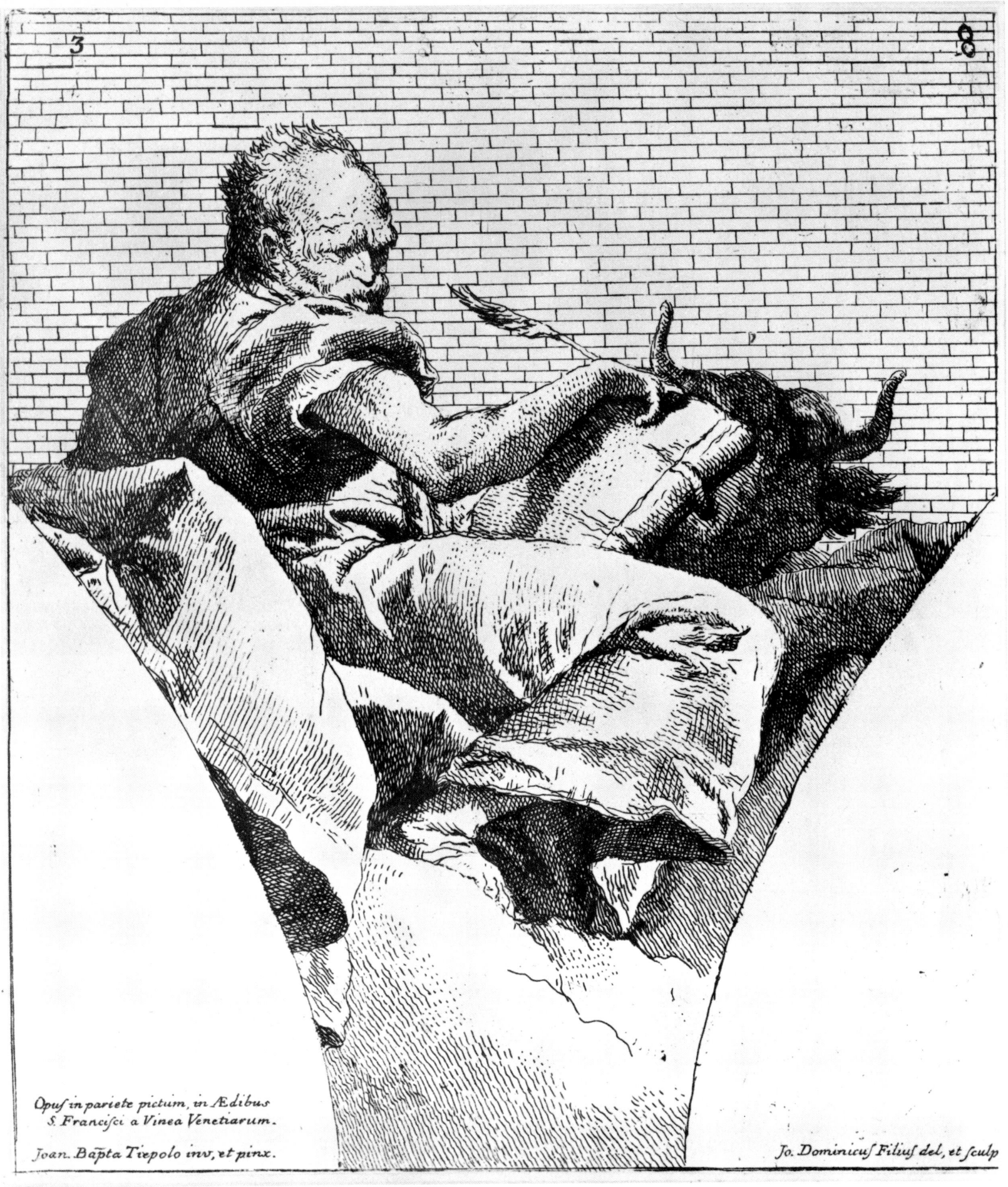

Opus in pariete pictum, in Ædibus
S. Francisci a Vinea Venetiarum.

Joan. Bāpta Tiepolo inv, et pinx.

Jo. Dominicus Filius del, et sculp

118. The four Evangelists
St. John

230 × 204 mm.

See note to plate 115.

Bibliog.: Nagler, 1847, 10; De Vesme, 1906, 53; Sack, 1910, 68; Rizzi, 1970, 114.

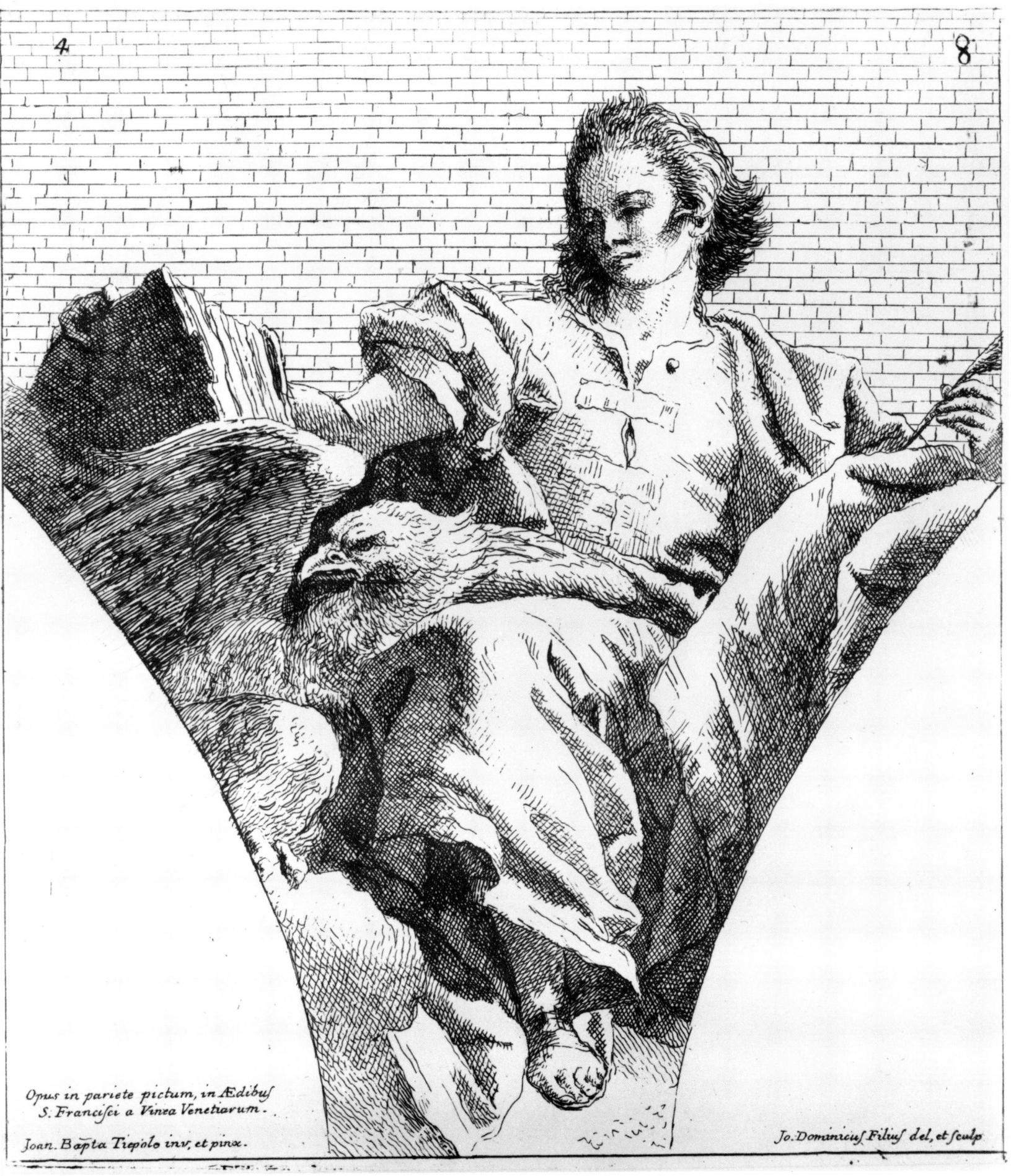

Opus in pariete pictum, in Ædibus
S. Francisci a Vinea Venetiarum.

Joan. Bapta Tiepolo inv. et pinx.

Jo. Dominicus Filius del, et sculp

119. The three Theological Virtues

173 × 160 mm. First state: before the number; second state: *8* at top right-hand corner; third state: added in the bottom margin, the inscription: *Opus in pariete pictum, in Aedibus S. Franc.i a Vinea Venetiarum.* At bottom left: *Joannes Batta Tiepolo inv. et pinx.* Right: *Jo. Dominicus Filius del. et fecit.*

See note to plate 115.

Bibliog.: Nagler, 1847, 34; De Vesme, 1906, 79; Sack, 1910, 63; Pallucchini, 1941, 372; Rizzi, 1970, 115.

raes Batta Tiepolo inv. et pinx.

Jo. Dominicus Filius del. et fecit.

120. Three allegorical figures

172 × 160 mm. First state: before the centre inscription; second state: with the inscription: *Opus in pariete pictum, in Aedibus S. Francisci | a Vinea Venetiarum.* Bottom left: *Joannes Batta Tiepolo inv. et pinx.;* right: *Jo. Dominicus Filius del. et fecit.*

See note to plate 115. In his two catalogues, Giandomenico entitled this and the preceding etching *The Cardinal Virtues.* De Vesme pointed out that they should be four (Prudence, Justice, Strength and Temperance) and their attributes are different from those shown here and in Giambattista's painting.

De Vesme called this etching *Three other Virtues* (with reference to the previous sheet) and interpreted the central figure as an allegory of Wisdom and the one to the right as an allegory of Liberality.

Bibliog.: Nagler, 1847, 33; De Vesme, 1906, 80; Sack, 1910, 64; Pallucchini, 1941, 373; Rizzi, 1970, 116.

Joannes Batta Tiepolo inv. et pinx. Jo. Dominicus Filius del. et fecit.

121. The stoning of St. Stephen

487 × 270 mm. First state: before the number; second state: *32* at top left-hand corner. In the bottom margin the inscription: *Ioannes Dominicus Tiepolo / invenit pinxit et delineavit.*

According to De Vesme, the original painting, now lost, was executed by Giandomenico for a German town; Sack maintains it was painted for the convent at Schwarzach.

Bibliog.: Nagler, 1847, 16; De Vesme, 1906, 60; Sack, 1910, 58; Pallucchini, 1941, 363; Rizzi, 1970, 117.

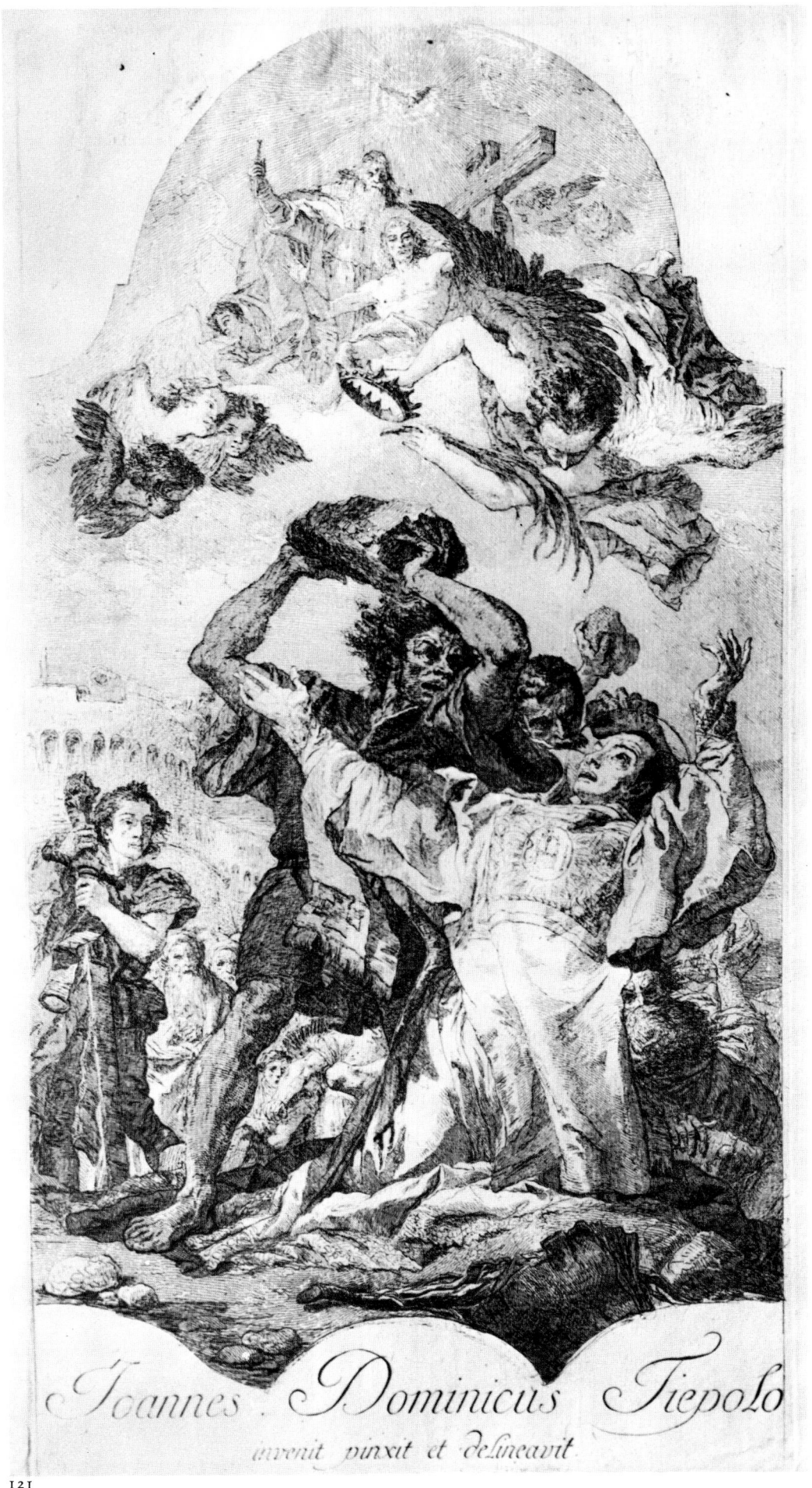

Ioannes Dominicus Tiepolo

invenit pinxit et delineavit

121

122. The three Theological Virtues

355 × 451 mm. At bottom left, the inscription: *Jo. Batta Tiepolo inv. et pinx. hoc Exemplar in pariete*; to the right: *Jo. Dominicus Filius del; et sc.*

This etching is derived from the fresco painted by Giambattista in the church of S. Maria della Pietà, Venice, and datable 1754–5 (Morassi, 1962, p. 57).

Bibliog.: De Vesme, 1906, 78; Sack, 1910, 69; Rizzi, 1970, 118.

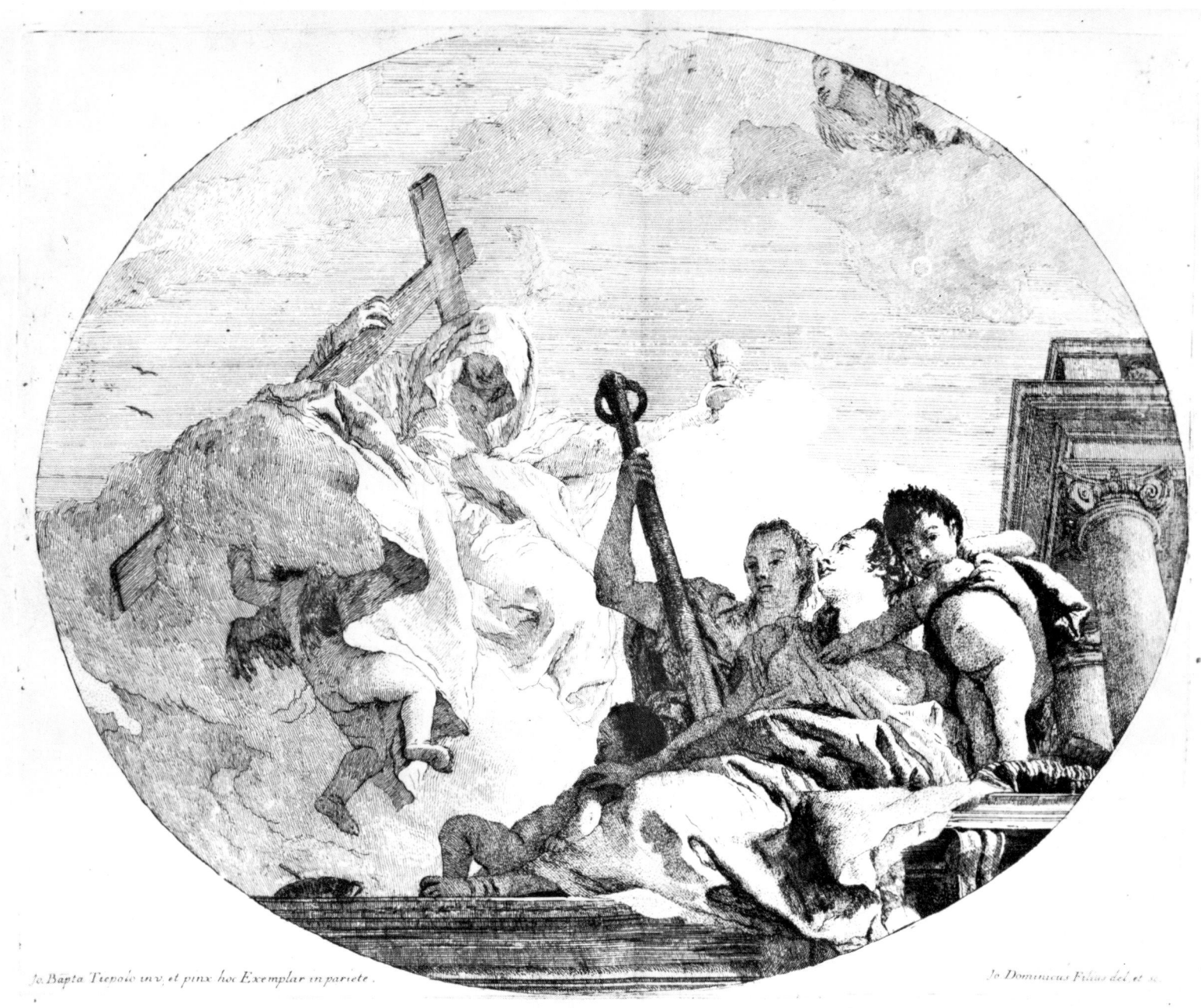

Jo. Bapta Tiepolo inv. et pinx hoc Exemplar in pariete .

Jo Dominicus Filius del et sc.

122

123. Fortitude and Peace

356 × 450 mm. First state: before the inscription; second state: at bottom left, the inscription *Jo: Bapta Tiepolo invent, et pin: hoc Exemplar in pariete.*; to the right: *Jo. Dominicus Filius del. et sc.*

This etching is probably the one mentioned by Nagler under the title *The Triumph of Painting and Sculpture*. Sack related it to a fresco executed by Giambattista for the church of S. Maria della Pietà in Venice.
The original painting, which must have been on the wall, as the inscription says, is now lost; only the modello is extant, in the Böhler Collection in Munich: it is datable about 1754 (Morassi, 1962, p. 31).

Bibliog.: Nagler, 1847, 36; De Vesme, 1906, 81; Sack, 1910, 70; Pallucchini, 1941, 378; Rizzi, 1970, 119.

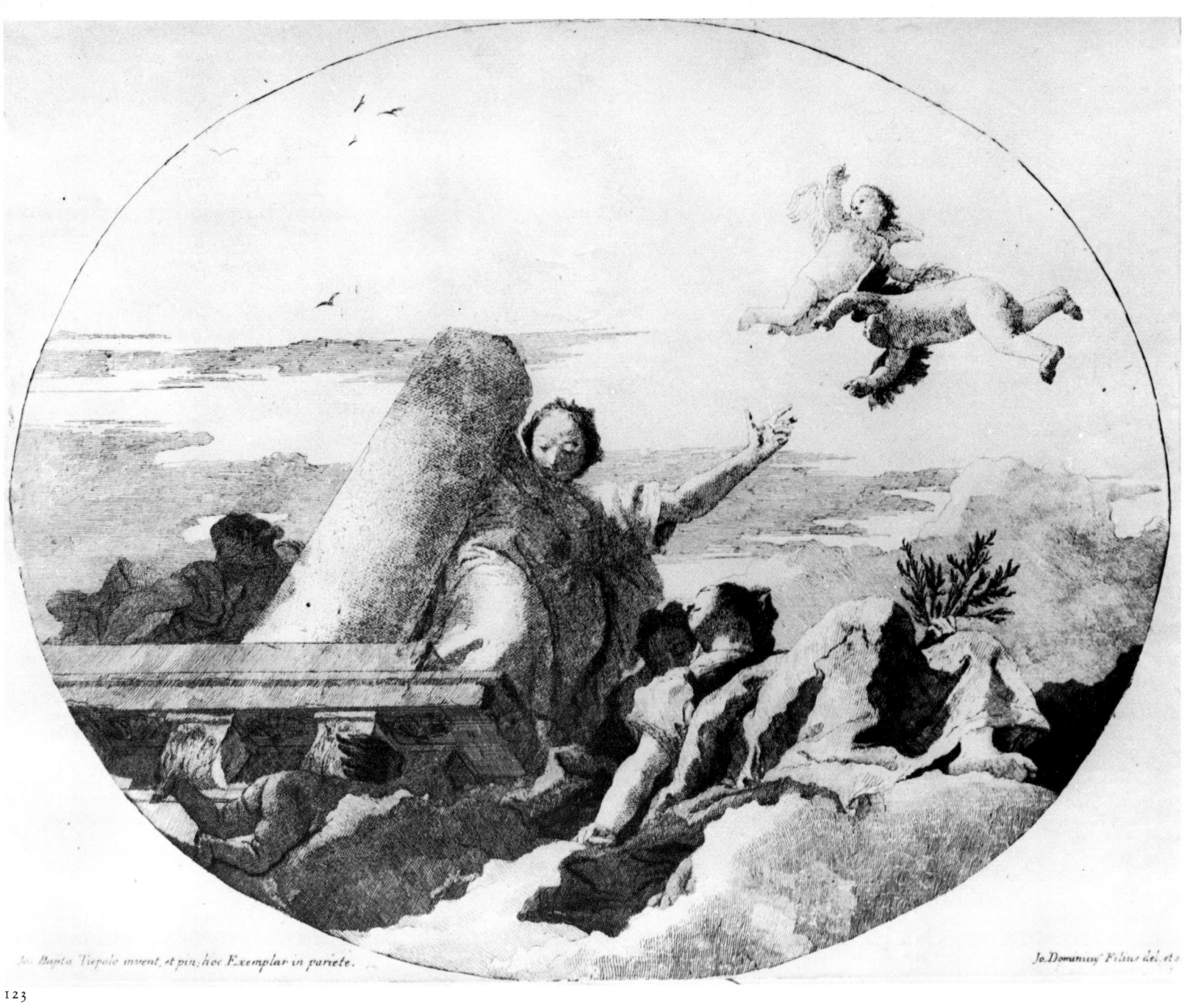

Jo: Bapta Tiepolo invent, et pin; hoc Exemplar in pariete. Jo. Dominicus Filius del. et s

123

124. River gods

313 × 223 mm. First state: before the number and the inscription; second state: *12* at top right-hand corner. In the bottom margin the inscription: *J. Batta Tiepolo inven. et del. / Dominicus Filius inc.*

According to Reynolds, who was followed by Knox, the etching was derived from drawings 129 and 130, recto and verso, by Giambattista, now in the Victoria and Albert Museum (Knox catalogue); they can be dated about 1745–50 (fig. XLVII). It is more likely that the etching was influenced by one of Giambattista's paintings, now lost, particularly since the two sheets mentioned are not similar enough to be regarded as preparatory.

Pignatti has pointed out that the reference to this etching in Giandomenico's catalogue is vague, and that therefore De Vesme's identification of the old man as the river Po, of the naiad as the Brenta and the putto as the Piave, is unfounded.

De Vesme chose *River figures* as a title, Pignatti *A river*. The latter believes that any painting which inspired the etching must have been late, on account of the allegorical character of the composition which Giambattista used around 1759, before leaving for Spain. I prefer to date it from the 1730s on the basis of its close links with the *Scherzi*, particularly the tree and the naked youth, which is similar to those in pl. 12.

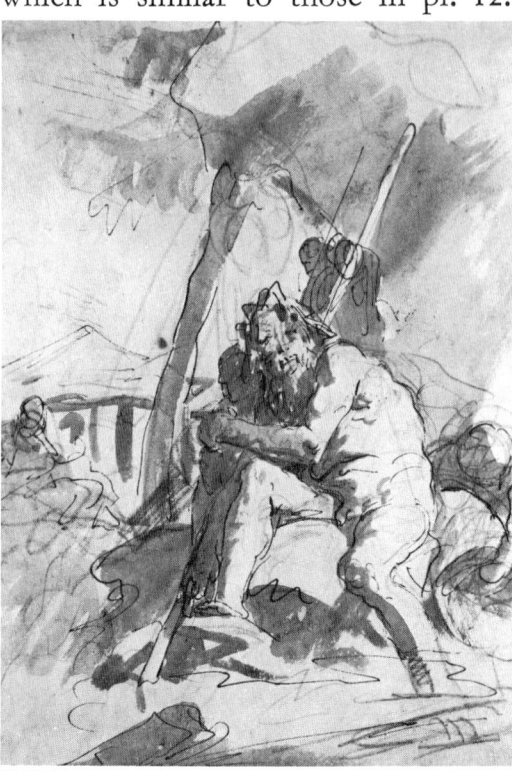

XVLII

Bibliog.: Nagler, 1847, 47; De Vesme, 1906, 99; Sack, 1910, 100; Pallucchini, 1941, 377; Knox, 1960, p. 65; Pignatti, 1965, LXII; Rizzi, 1970, 120.

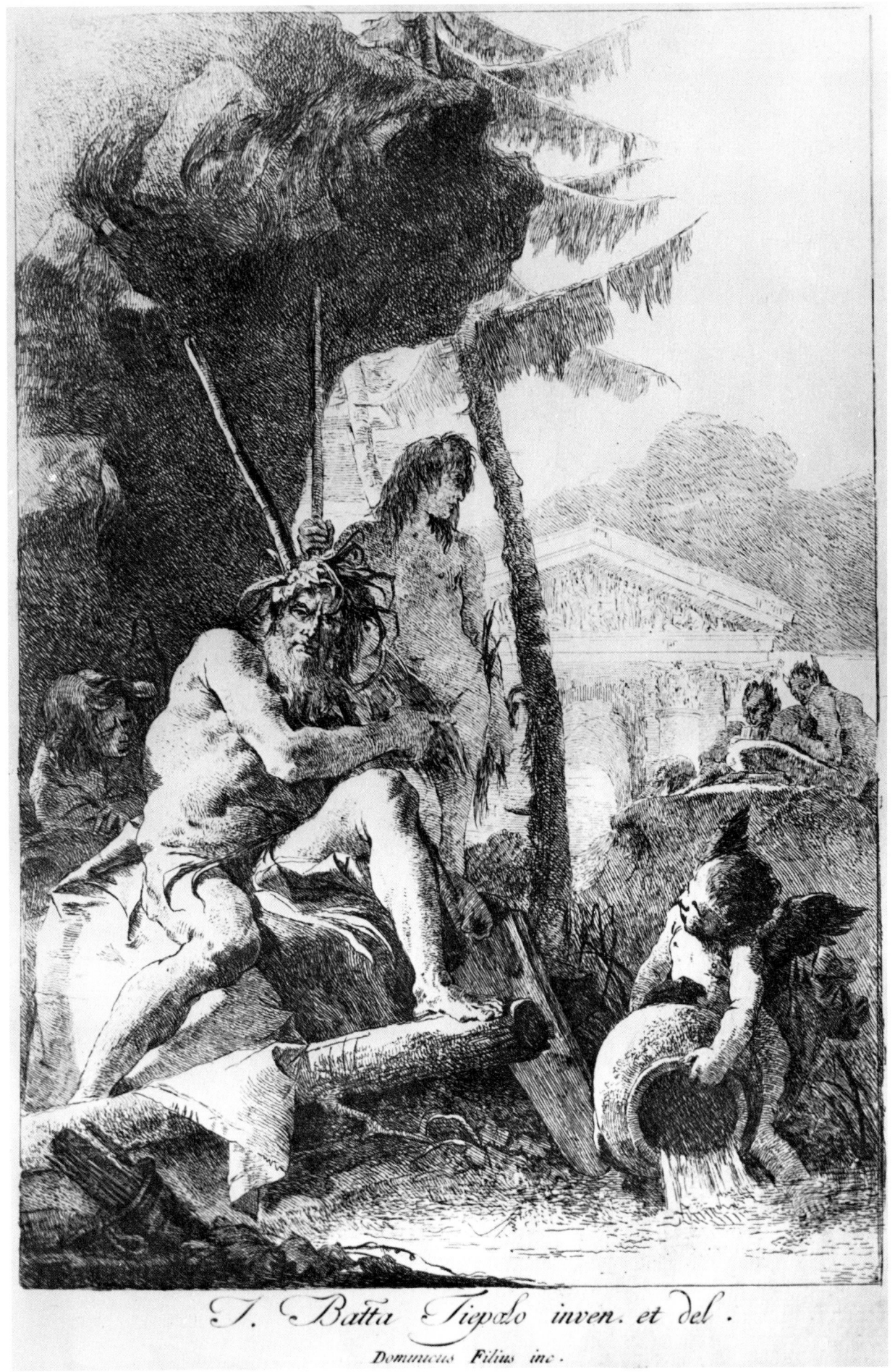

J. Batta Tiepolo inven. et del.

Dominicus Filius inc.

125. The Virgin and three Dominican Saints

512 × 227 mm. First state: without number; second state: *31* at top left-hand corner. In the bottom margin the dedication: *Excellentiss.mo D. Domino Iacobo Superantio Patritio Veneto ac Senatori Ampliss.mo | Joannes Dominicus Theopolus incisor* and the couplet: *Hoc, tibi quod praesto subjecta in imagine, munus | Exhibet obsequii pignora certa mei* and the signature *Io. Bapta Theupolus inven. et pin. Venetijs in Ecclesia B. e M.V. de Rosario.* On some numbered impressions the printing has deleted the inscription and a small added sheet carries the wording: *Joannes Batta Tiepolo inv. et pinxit | Jo. Joanes Domenicus Tiepolo del. et fecit.*

The etching was derived from the painting executed by Giambattista for the Venetian church of the Gesuati: the dating is doubtful and ranges from 1740 to 1746–8 (Rizzi, 1965, p. 86).

Bibliog.: Nagler, 1847, 12; De Vesme, 1906, 54; Sack, 1910, 76; Rizzi, 1970, 121.

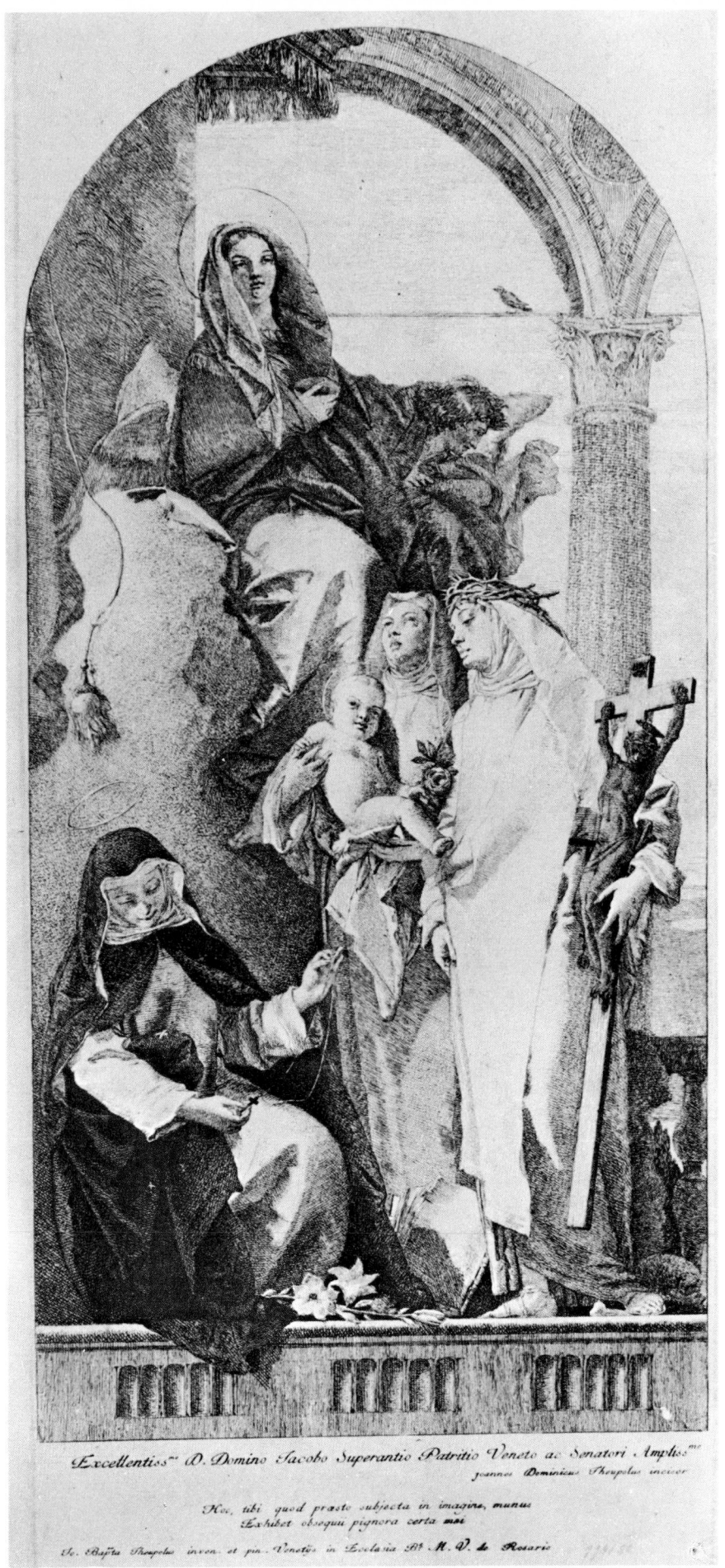

Excellentiss.º D. Domino Iacobo Superantio Patritio Veneto ac Senatori Ampliss.mo

Ioannes Dominicus Tiepolus incisor

Hec, ubi quod præsto subjecta in imagine, munus
Exhibet obsequii pignora certa mei

Io. Bapta Tiepolus inven. et pin. Venetijs in Ecclesia B.ª M. V. de Rosario

126. The Virgin with St. Anthony Abbot and St. George

235 × 118 mm. In the margin at the bottom the inscription: *Ioannes Bapta Tiepolo inv et pinx. | Dom.cus filius fecit.*

According to Sack, this etching was derived from an altarpiece by Giambattista, now lost. Morassi, however, has proved that it is based on the picture, datable from 1755, in the Spalletti-Trivelli collection in Rome (Morassi, 1962, p. 46).

Bibliog.: De Vesme, 1906, 55; Sack, 1910, 61; Rizzi, 1970, 122.

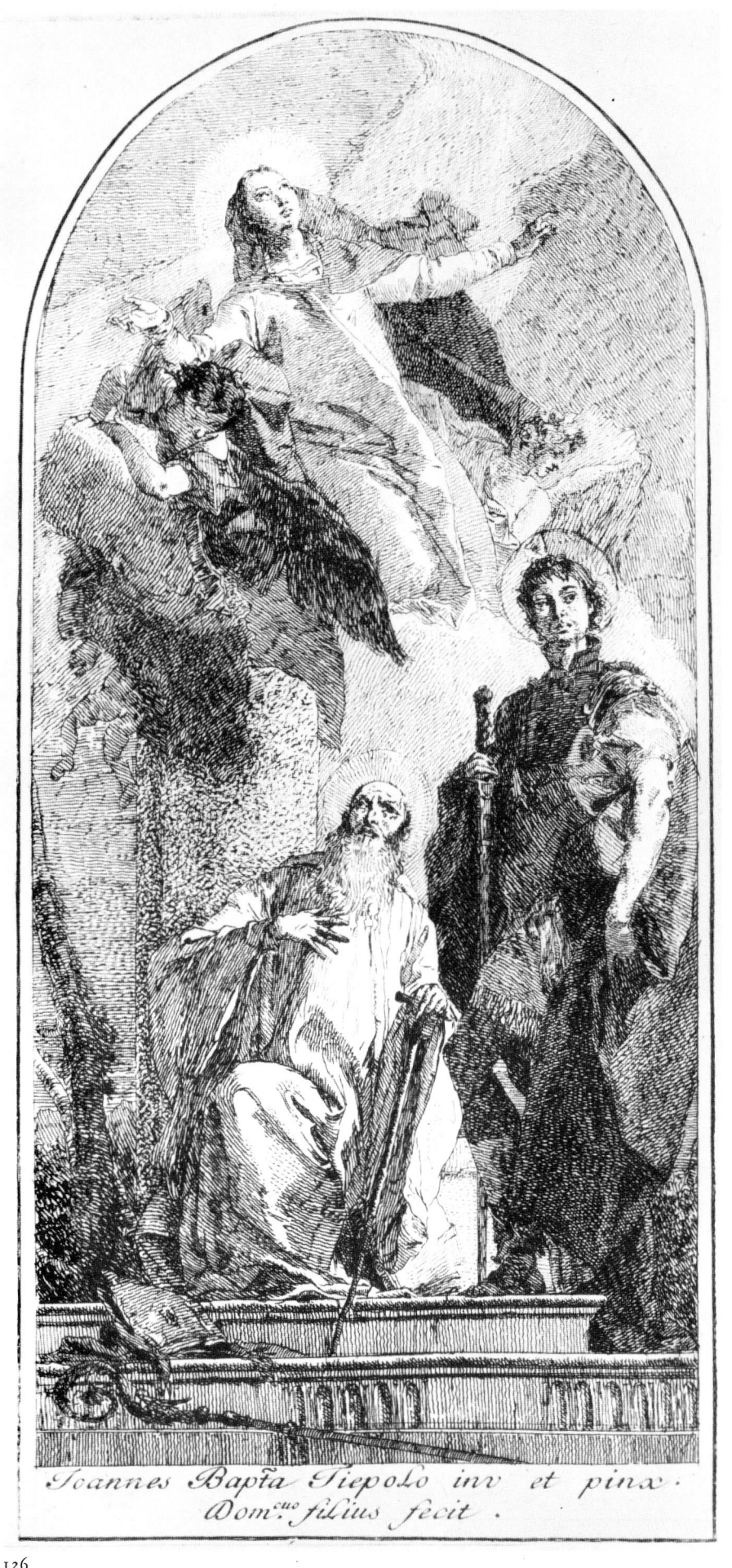

Joannes Bapta Tiepolo inv et pinx.
Dom.co filius fecit.

126

127. The Virgin and Child with St. Francis of Paola and St. Anthony of Padua

202 × 117 mm. First state: before the number; second state: *20* at top right-hand corner. In the margin at the bottom the inscription: *Io Bapta Tiepolo inv: et pin: | Dom: Filius del et in:*.

The etching is a reproduction of the small altarpiece in the Bearsted Collection (National Trust), Banbury, datable 1750–60 (Morassi, 1962, p. 2).

Bibliog.: Nagler, 1847, 13; De Vesme, 1906, 56; Sack, 1910, 60; Rizzi, 1970, 123.

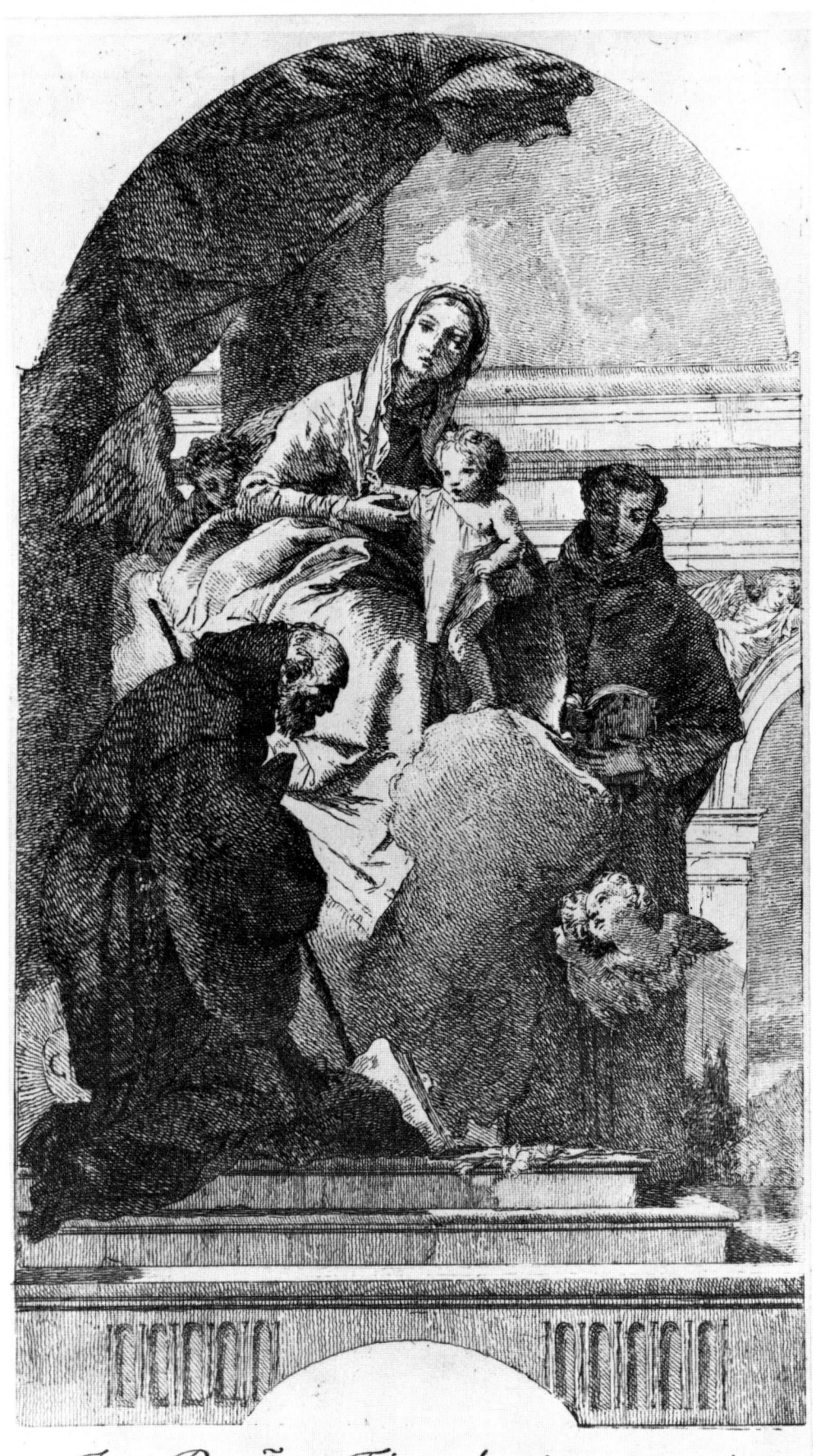

Io Bapta Tiepolo inv: et pin:
Dom: Filius del et in :

127

128. Two old men

279 × 87 mm. In the bottom margin to the left the inscription: *Io: Bapt: Tiepolo inv:;* to the right: *Io: Dom: Filius sculp:* (the last letter is reversed).

The etching was derived from one of Giambattista's paintings, previously in the Rothschild Collection, Frankfurt, and now in the National Gallery, London. The painting, one of a series of four depicting scenes from the *Gerusalemme Liberata*, was executed about 1750–55 (Morassi, 1962, p. 17).

See also notes to the following plate and to pl. 226.

Bibliog.: Nagler, 1847, 49; De Vesme, 1906, 110; Sack, 1910, 107; Rizzi, 1970, 124.

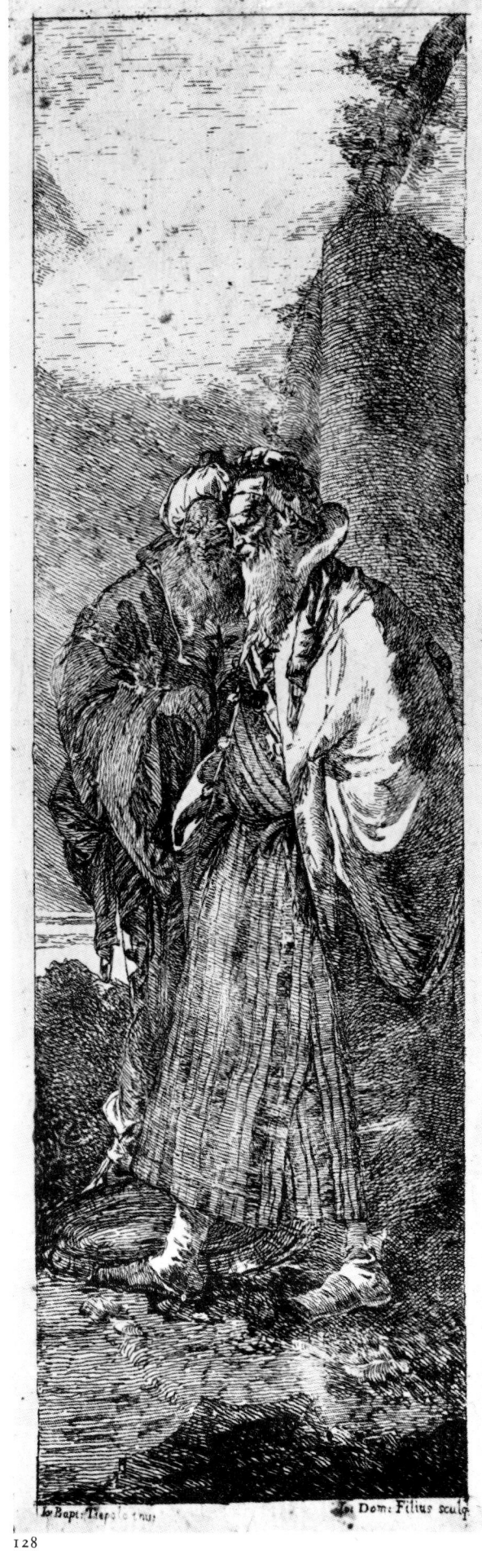

129. A seated man and a woman carrying a vase

282 × 90 mm. In the bottom margin, to the left, the inscription: *Io: Bap. Tiepolo inve:*; to the right: *Io: dom. Filius sculp:*.

According to Giandomenico's *Catalogue*, the scene is a 'fanciful invention'. The sheet forms part of a series with the preceding etching and pl. 226. Two of the four scenes of the London polyptych were engraved by Giandomenico and one by Lorenzo.

Bibliog.: Nagler, 1847, 50; De Vesme, 1906, 11; Sack, 1910, 108; Rizzi, 1970, 125.

Io: Bap: Tiepolo inve:

Io: Dom Filius sculp:

129

130. The Martyrdom of St. Agatha

441 × 250 mm. First state: before the number; second state: *26* at top left-hand corner; third state: reworked. In the bottom margin the inscription: *Joannes Bapta Tiepolo inv. et pinx. | Jo Dominicus Filius del. et fecit.*

Giambattista's painting, dated by Morassi about 1745–50 (1962, p. 4) and by Pallucchini from 1750 (1968), is now in the Staatliche Museen, Berlin. It lacks the arched top shown in this etching. A preparatory drawing for the executioner, in reverse, was shown at the *Sala delle Stagioni* at Pisa in 1970 and was attributed to Giambattista (No. 15/a) (fig. XLVIII).

Bibliog.: De Vesme, 1906, 58; Sack, 1910, 72; Rizzi, 1970, 126.

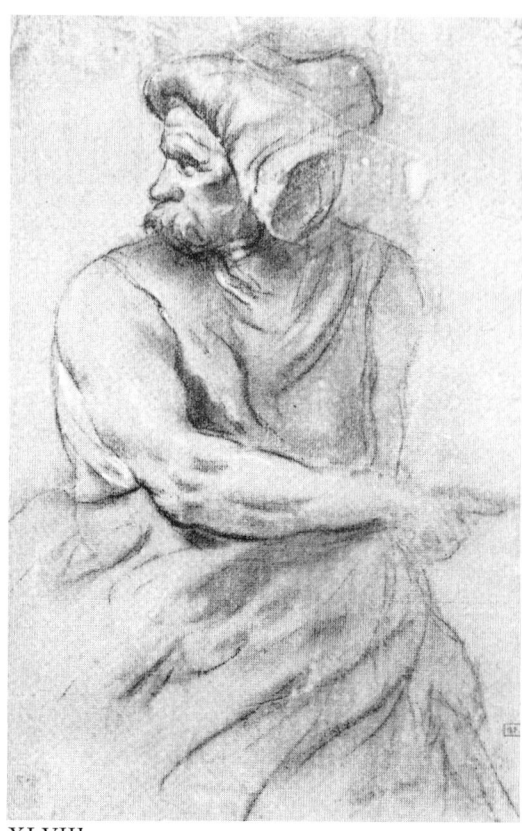

XLVIII

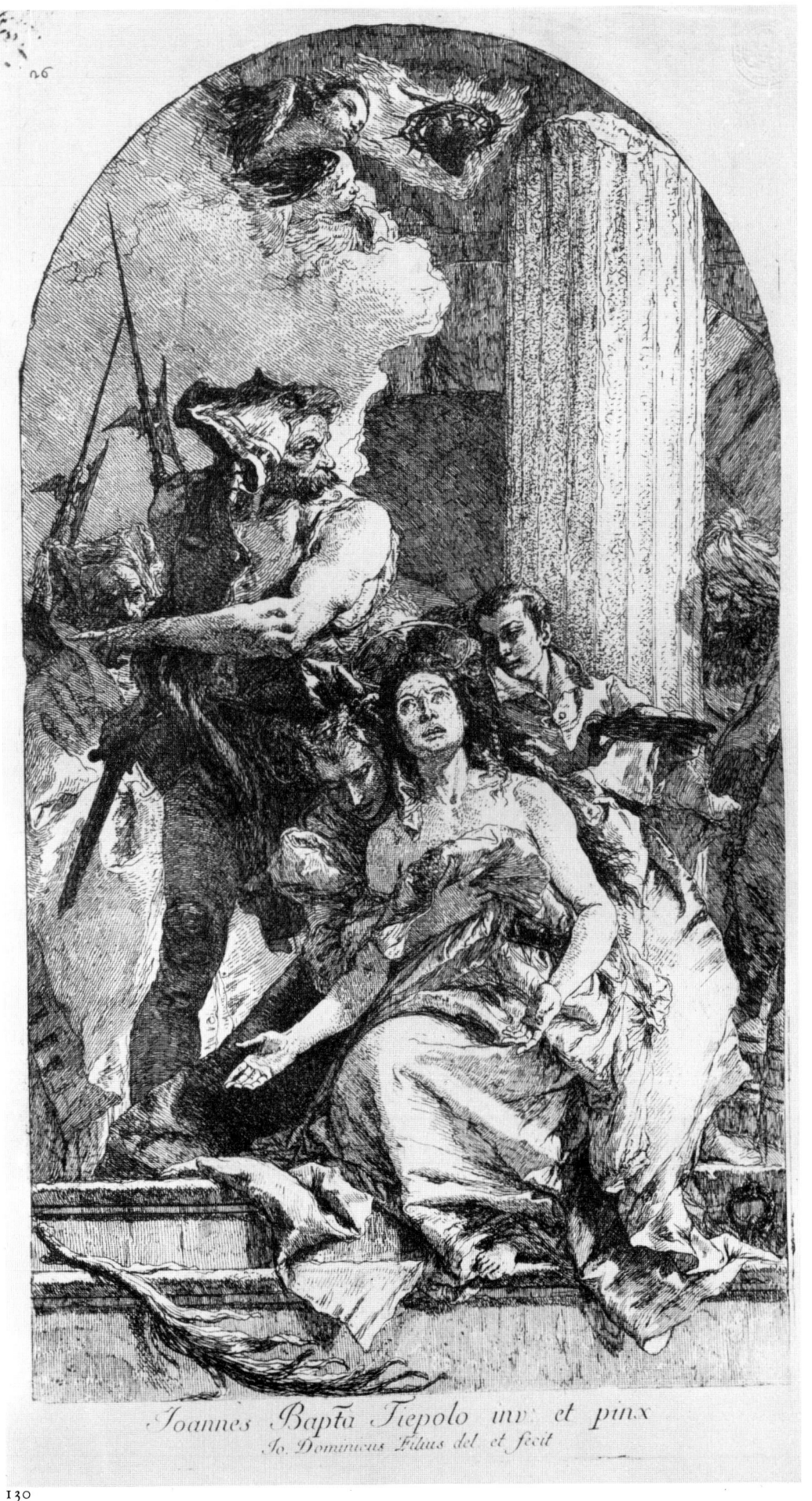

Ioannes Bapta Tiepolo inv: et pinx
Io. Dominicus Filius del et fecit

131. St. Gaetano of Thiene

370 × 222 mm. First state: before the number; second state: *23* at top right-hand corner. According to De Vesme, the etching has a blank margin in both states, without any inscription. But he himself quoted the inscription *Joannes Batta Tiepolo inv.* as appearing on the left of the bottom margin, and *Jo: Dominicus Filius fecite* on the right.

Sack maintained that Giambattista's altarpiece, from which this etching was derived, is lost; in fact, the painting is now in the church at Rampazzo (near Vicenza), where it was discovered by Pallucchini. It is datable from 1757 (Morassi, 1962, p. 45).

Bibliog.: De Vesme, 1906, 62; Sack, 1910, 56; Pallucchini, 1941, 364 and 1945, 159; Rizzi, 1970, 127.

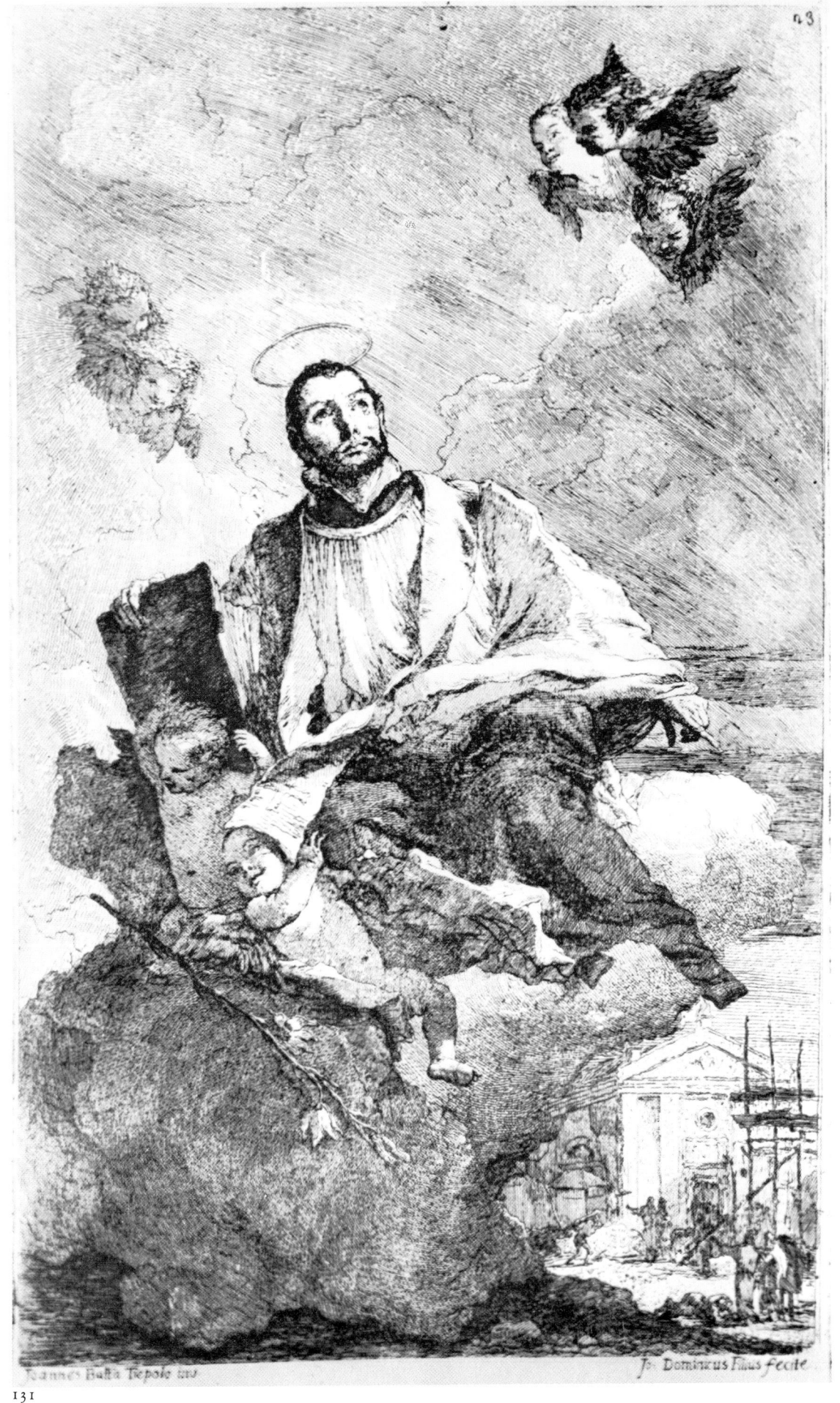

Ioannes Batta Tiepolo inv

Jo. Dominicus Filius fecit

131

132. St. James of Compostela

460 × 215 mm. First state: before the inscription; second state: with the inscription but before the number; third state: *27* at top left-hand corner. In the margin at the bottom the inscription *Ioannes Batta Tiepolo inv. et pinx. | Ioannes Dominicus Tiepolo del. et fecit*.

The etching is derived from a painting previously in the collection of Miklos Esterhazy, Vienna, and now in the Museum of Fine Arts, Budapest. Morassi dated the painting 1767 –70 (1962, p. 7), while Garas (1968, p. 15) and Pallucchini (1968, p. 241) date it from 1757–8. A drawing of the head of the little Moor is in the Talleyrand collection (Morassi, 1958, p. 38); this head was engraved again by Giandomenico for his own series (see pl. 180). The Budapest Museum has a drawing of the head of the Saint, made by Giandomenico after his father's painting (Fenyö, 1965, p. 91) (fig. XLIX).

XLIX

Bibliog.: Nagler, 1847, 22; De Vesme, 1906, 63; Sack, 1910, 73; Pallucchini, 1941, 366; Pittaluga, 1952, p. 152; Pignatti, 1965, LXXI; Rizzi, 1970, 128.

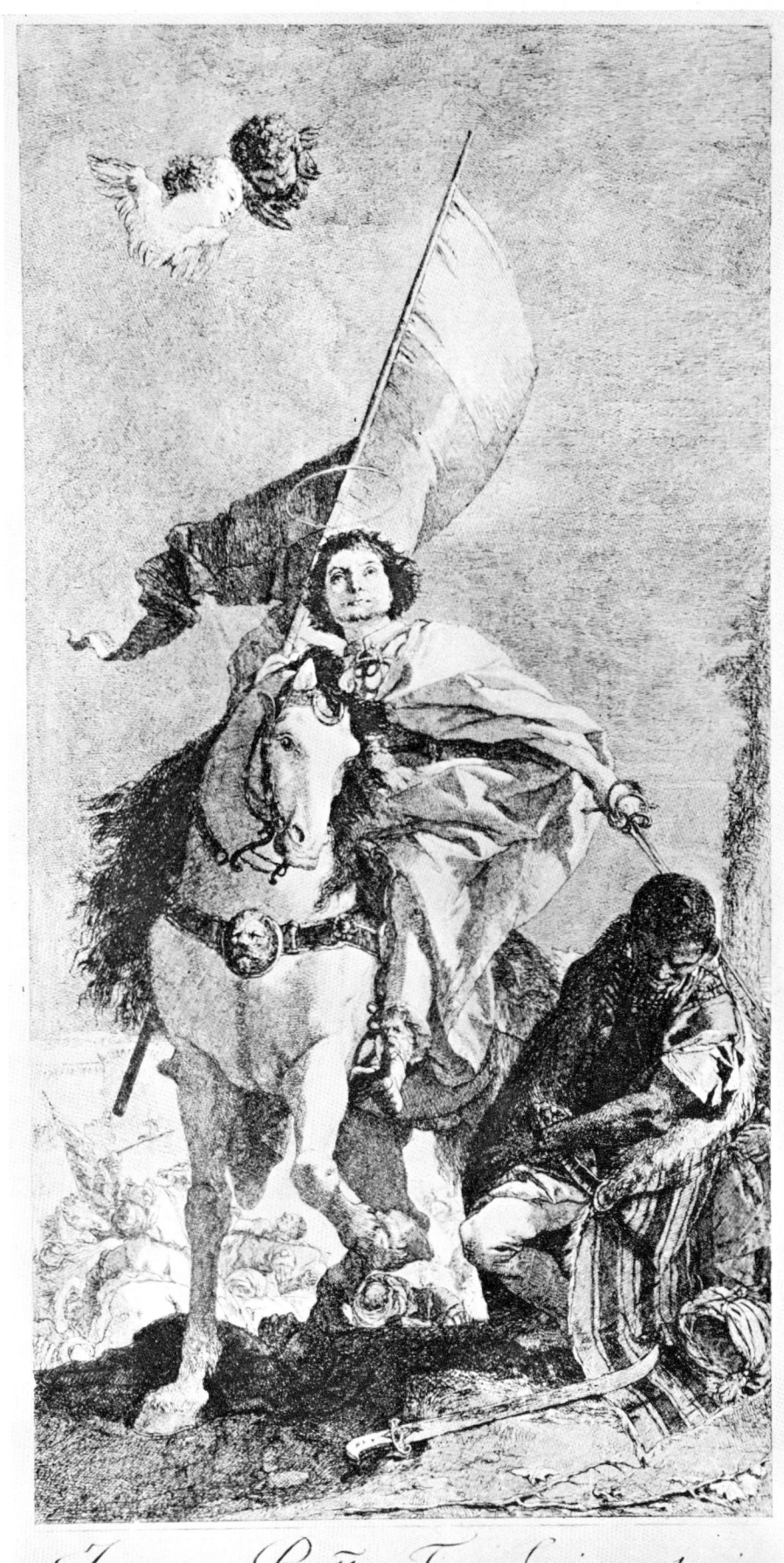

Ioannes Batta Tiepolo inv. et pin.

Ioannes Dominicus Tiepolo del et fecit

132

133. Four Saints of the Benedictine order

460 × 226 mm. First state: before the number; second state: *29* at top left. In the margin at the bottom the inscription: *Ioannes Dominicus Tiepolo Ping: in Templo | S. Michaelis Muriani postea excudit Venetijs.*

The altarpiece, as stated in the inscription, was painted by Giandomenico for the church of S. Michele on the island of Murano, near Venice; it is now in the Museum in Verona.

Bibliog.: De Vesme, 1906, 73; Sack, 1910, 59; Rizzi, 1970, 129.

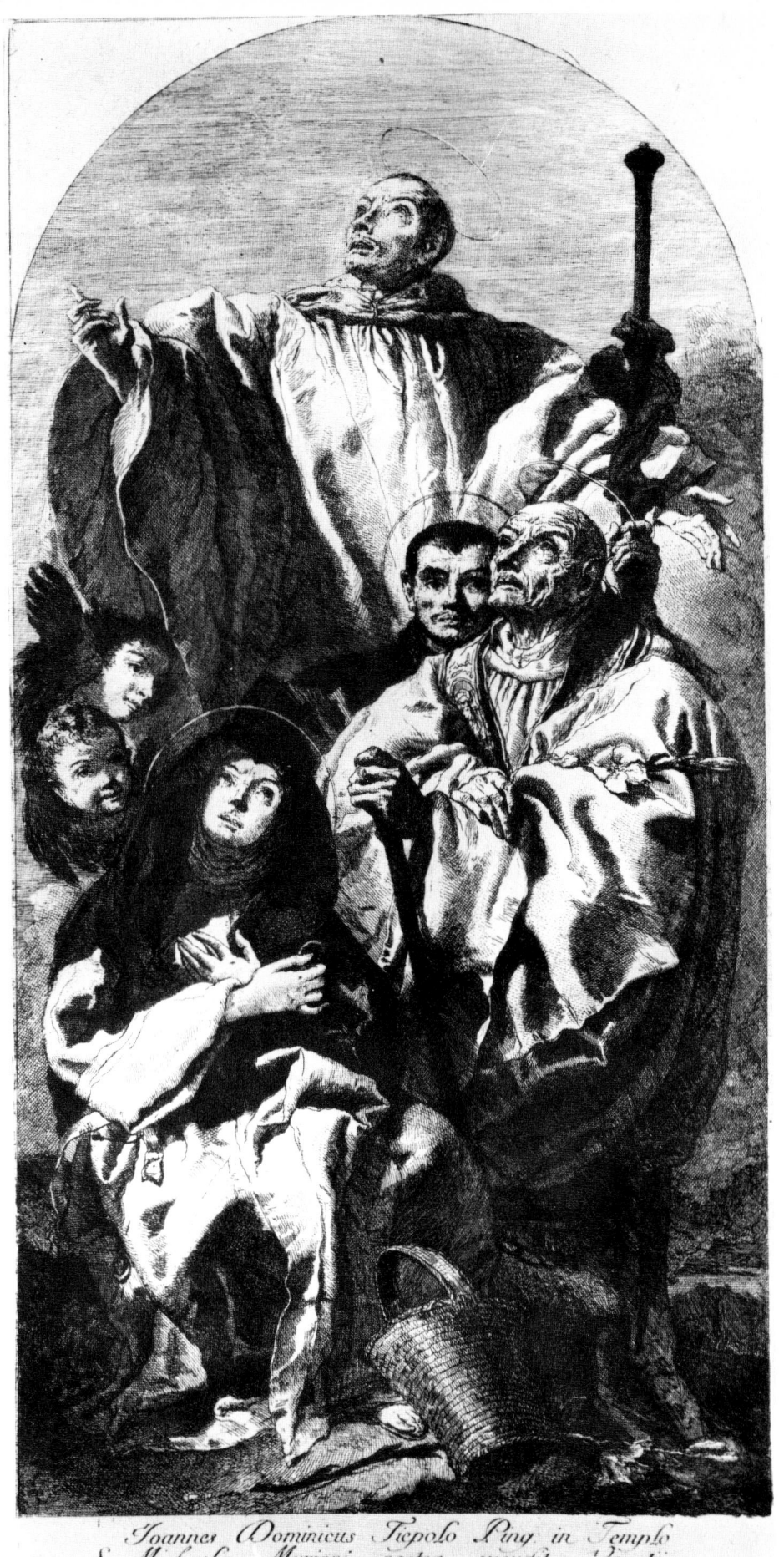

Ioannes Dominicus Tiepolo Ping in Templo
S. Michaelis Muriani postea excudit Venetiis

133

134. The Baptism of the Emperor Constantine

453 × 224 mm. First state: before the inscription and the number; second state: with the inscription but before the number; third state: *25* at top left-hand corner, and in the bottom margin, to the left, the inscription: *Ioan. Bapta Tiepolo inv. et pinx.* and to the right: *Io. Dominicus Filius del: sc.*; fourth state: reworked, with the inscription *Ioannes Batta Tiepolo inv.* to the left, and *Jo. Dominicus Filius del et fecit* to the right. Lower down, the dedication: *Nobili Viro Bartholomaeo Vitturi Patritio Veneto* ... De Vesme mentioned some proofs without the dedication, this having been masked during the printing.

The etching was wrongly attributed to Giambattista by Nagler, who, however, also listed it among Giandomenico's works under the title *A Pope baptizing an old man, with an angel carryind a tiara.* It is derived from Giambattista's altarpiece in the church at Folzano (near Brescia), painted about 1759 (Morassi, 1962, p. 12). Giandomenico also derived from the painting one of his *Heads* (see pl. 172).

Bibliog.: Nagler, 1847, 3 and 24; De Vesme, 1906, 83; Sack, 1910, 71; Pallucchini, 1941, 374; Rizzi, 1970, 130.

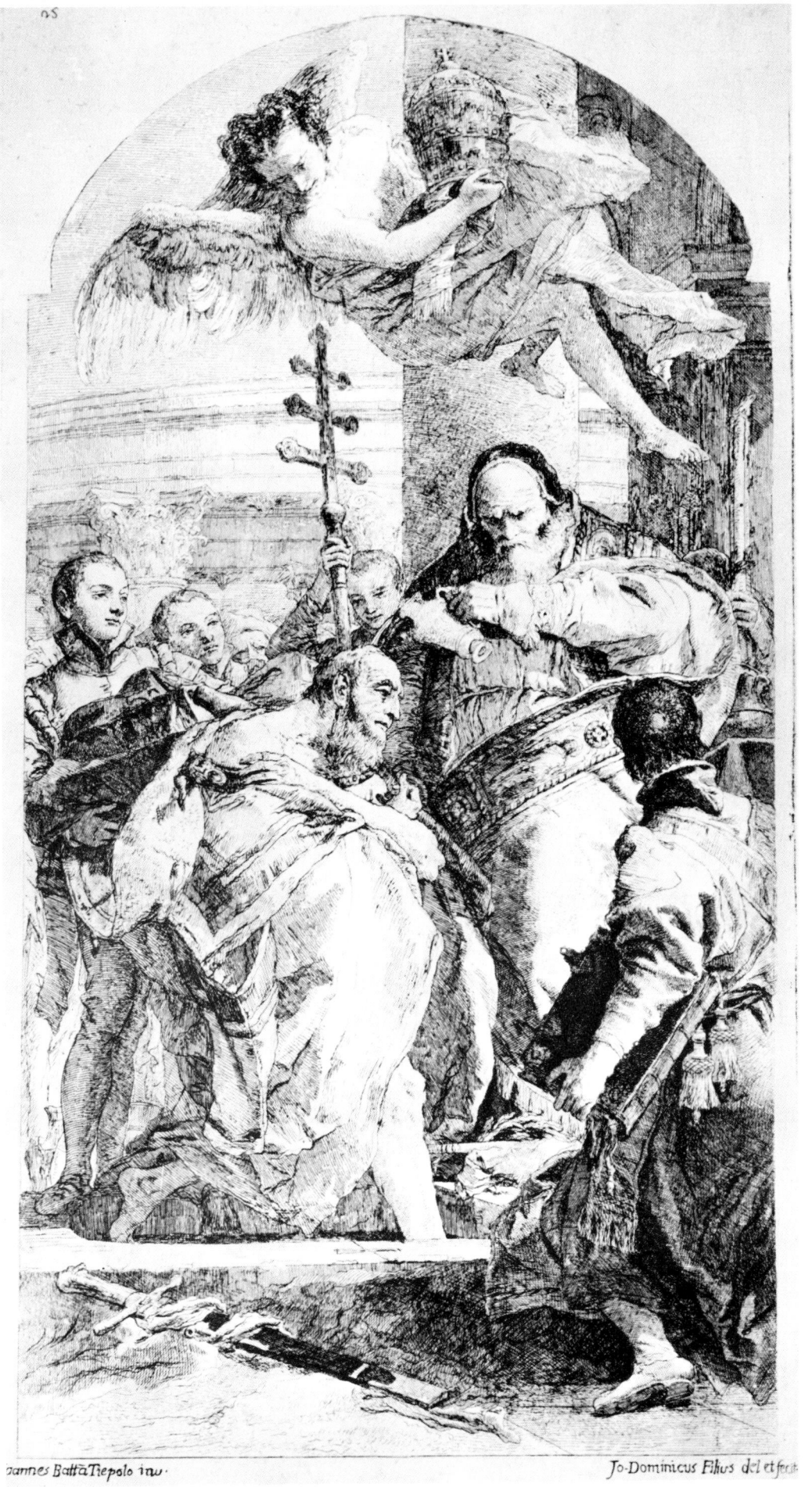

134

135. Diana descending from the sky to rescue Iphygenia

397 × 233 mm. First state: before the number; second state: *35* at top left-hand corner.

According to Giandomenico's *Catalogue* this etching is entitled *The Winds* and is also often called *The Night*, as mentioned by De Vesme. This etching, together with the next ten, was derived from the frescoes in the Villa Valmarana, near Vicenza, which were painted, as Morassi has established, in 1757 (Morassi, 1962, p. 64).

Pignatti noted how the series of etchings derived from the frescoes in the Villa Valmarana does not appear in the first Catalogue of Tiepolo prints (1775) and concluded that these sheets which were added in later editions of the Catalogue, should be dated after 1775.

However, they were already in existence during the 1750s.

Bibliog.: De Vesme, 1906, 84; Sack, 1910, 88; Pallucchini, 1941, 485; Pignatti, 1965, LXIII; Rizzi, 1970, 131.

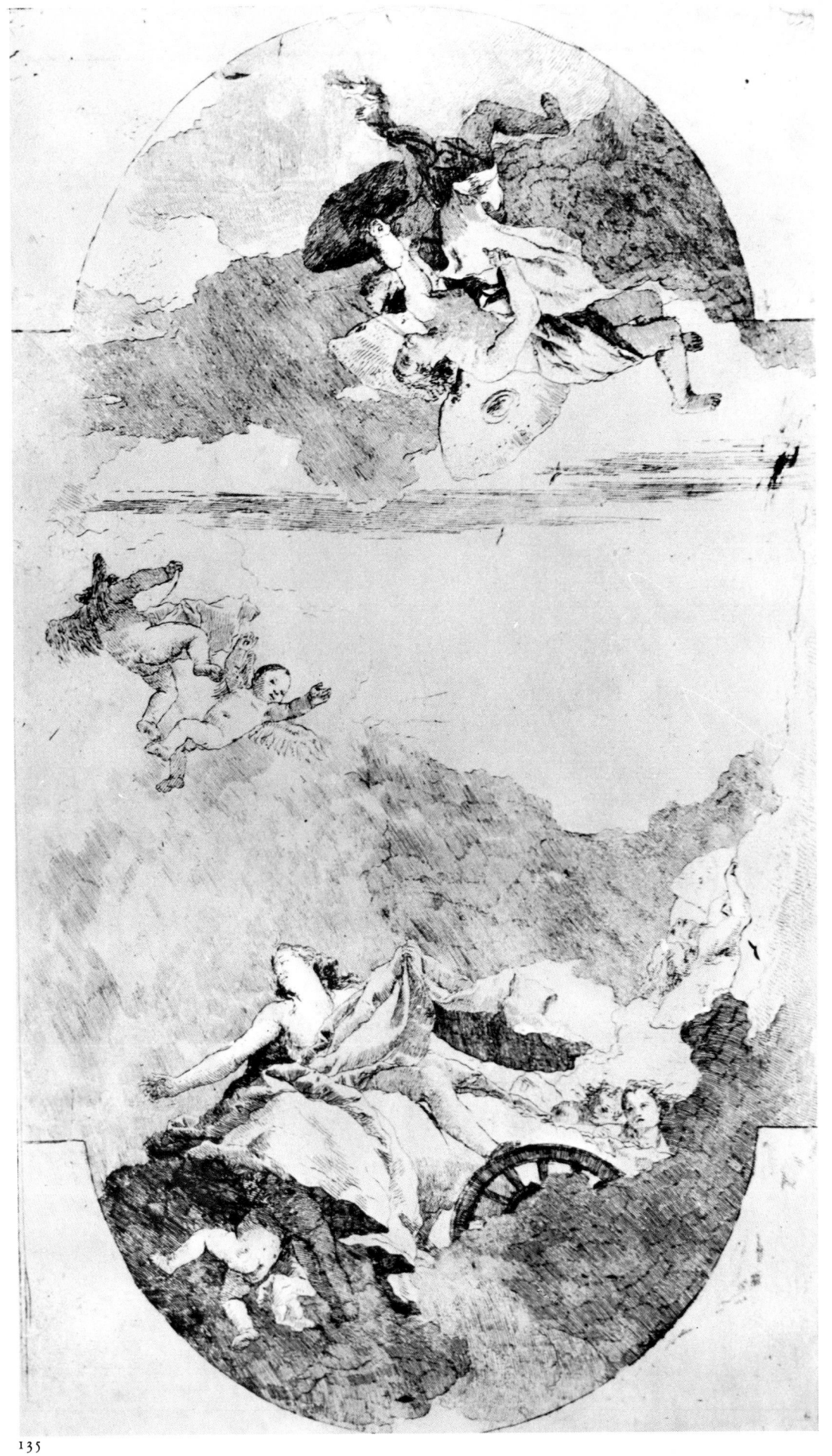

135

136. Mercury
appears to Aeneas in a dream

238 × 185 mm. First state: before the number; second state: 7 at top right-hand corner.

According to Giandomenico's *Catalogue*, this etching is entitled *Achilles sleeping*. See note to preceding plate.

Bibliog.: De Vesme, 1906, 85; Sack, 1910, 86; Pallucchini, 1941, 381; Rizzi, 1970 132.

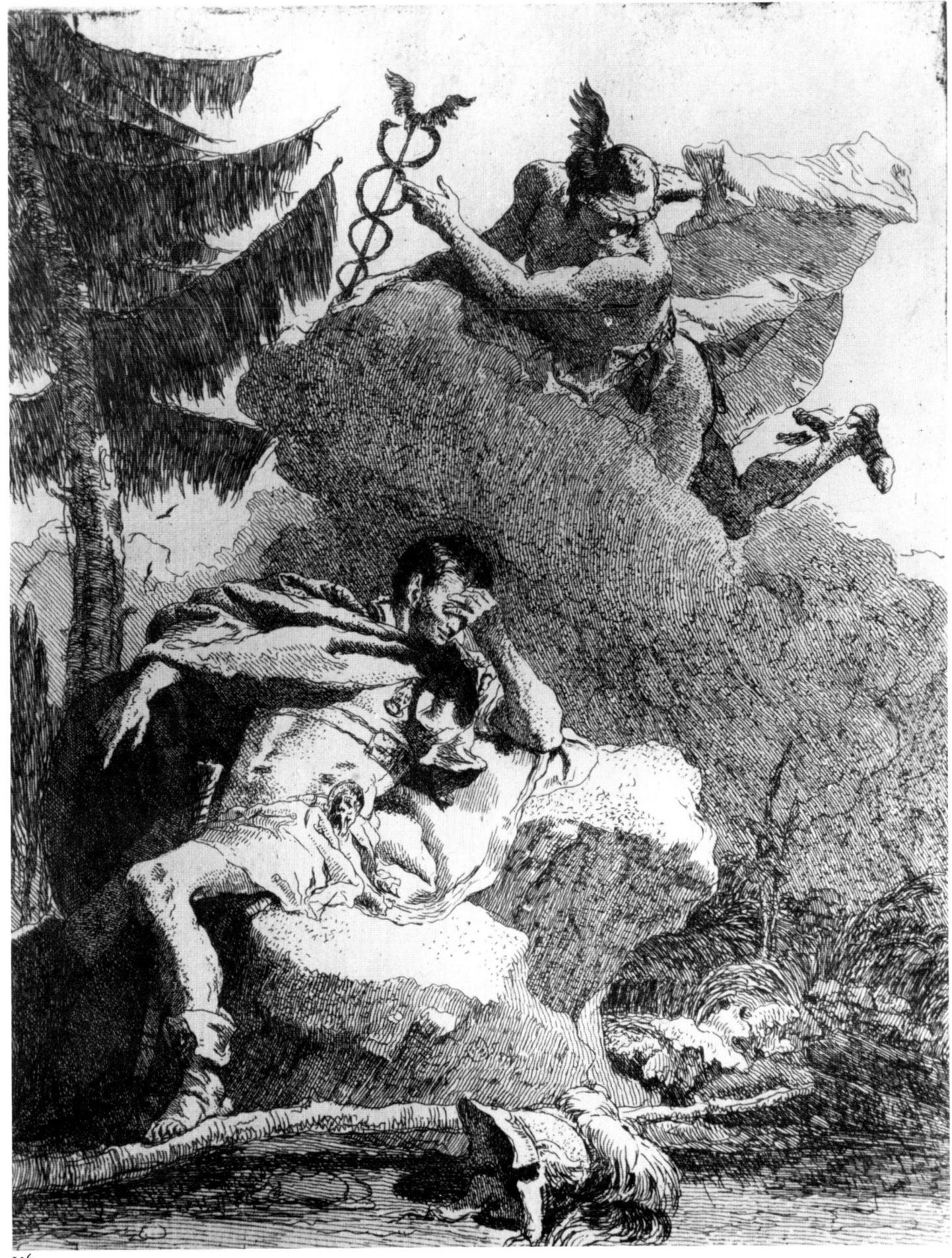

137. Aeneas recognizes Venus as she disappears in a cloud

231 × 173 mm. First state; before the numbers; second state: *1* at top left-hand corner and *6* at bottom right-hand corner.

See note to pl. 135.

Bibliog.: De Vesme, 1906, 86; Sack, 1910, 85; Rizzi, 1970, 133.

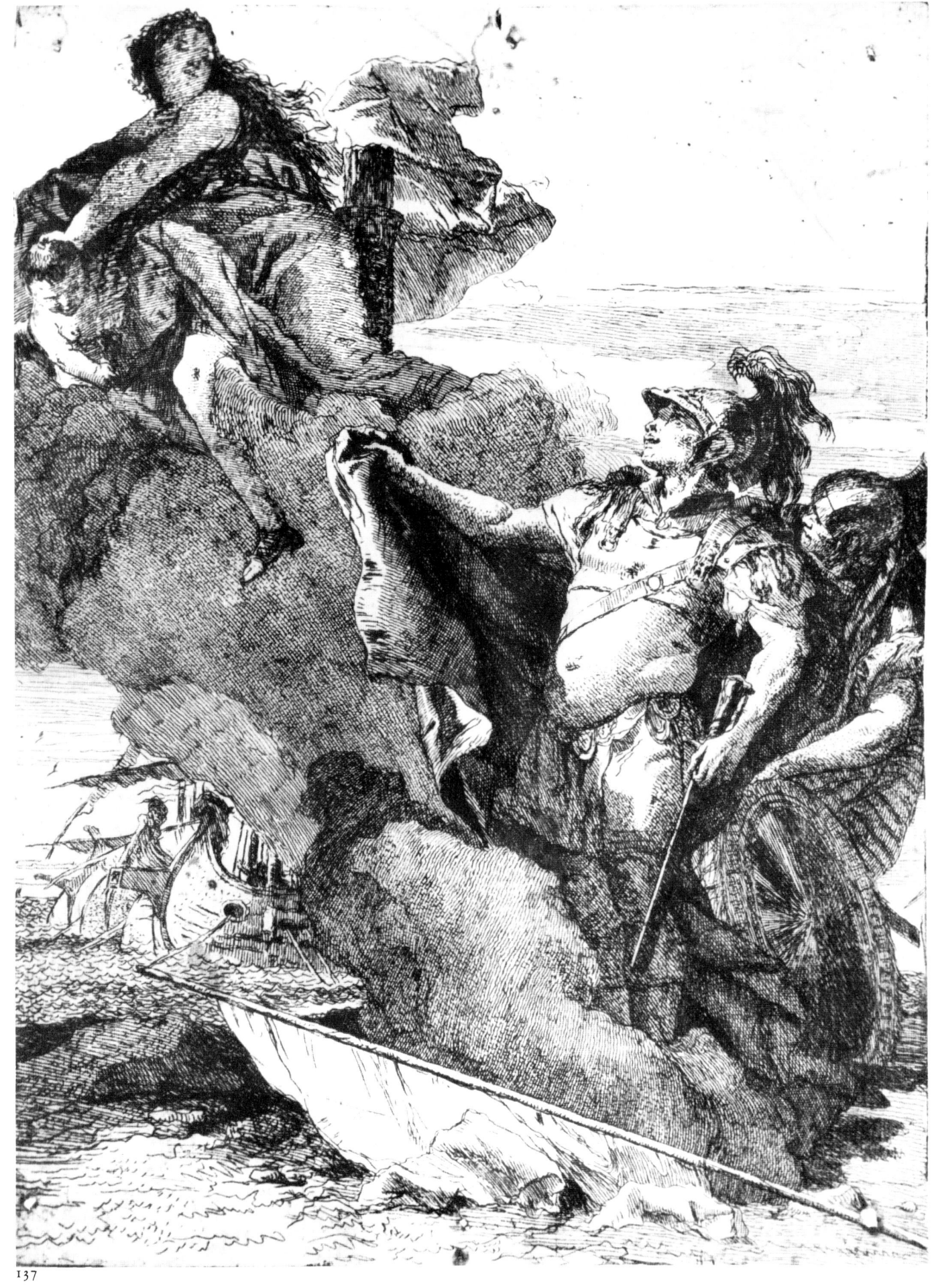

137

138. Aeneas introduces his son Ascanius to Dido

238 × 290 mm. First state: before the number; second state: *4* at top right.

According to Giandomenico's *Catalogue*, this etching is entitled *Achilles introducing Cupid to Deidamia*. It differs from the others in appearing 'unfinished': Giandomenico probably tried to reproduce more faithfully his father's *chiarismo* of the Valmarana frescoes.
See note to pl. 135.

Bibliog.: De Vesme, 1906, 87; Sack, 1910, 87; Rizzi, 1970, 134.

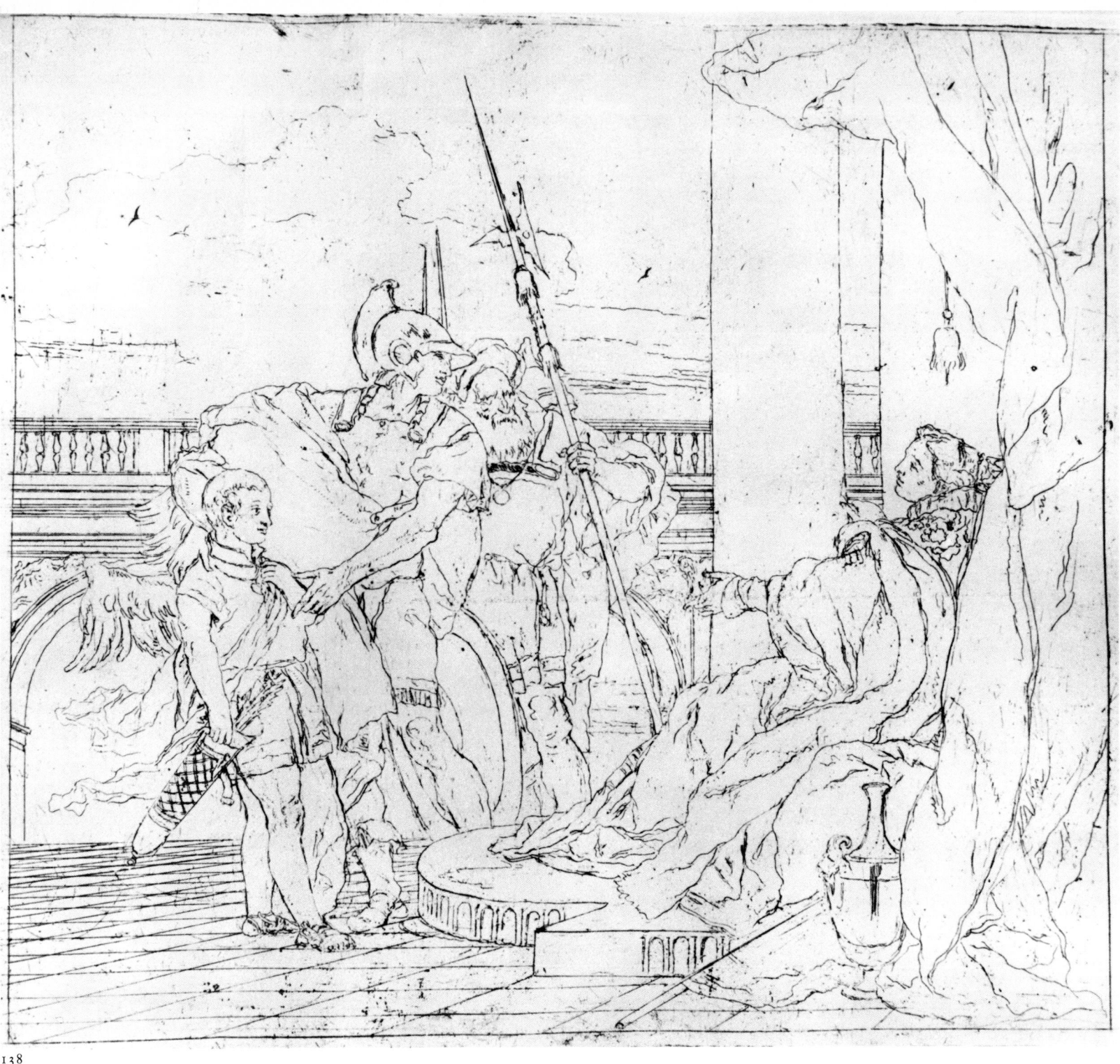

139. Angelica bound and about to be devoured by the sea monster

244 × 207 mm. First state: before the number; second state: *6* at top right-hand corner.

According to Giandomenico's *Catalogues*, it depicts *Andromeda* or *Ruggiero freeing Armida*. See also note to pl. 135.

Bibliog.: De Vesme, 1906, 90; Sack, 1910, 89; Pallucchini, 1941, 380; Rizzi, 1970, 135.

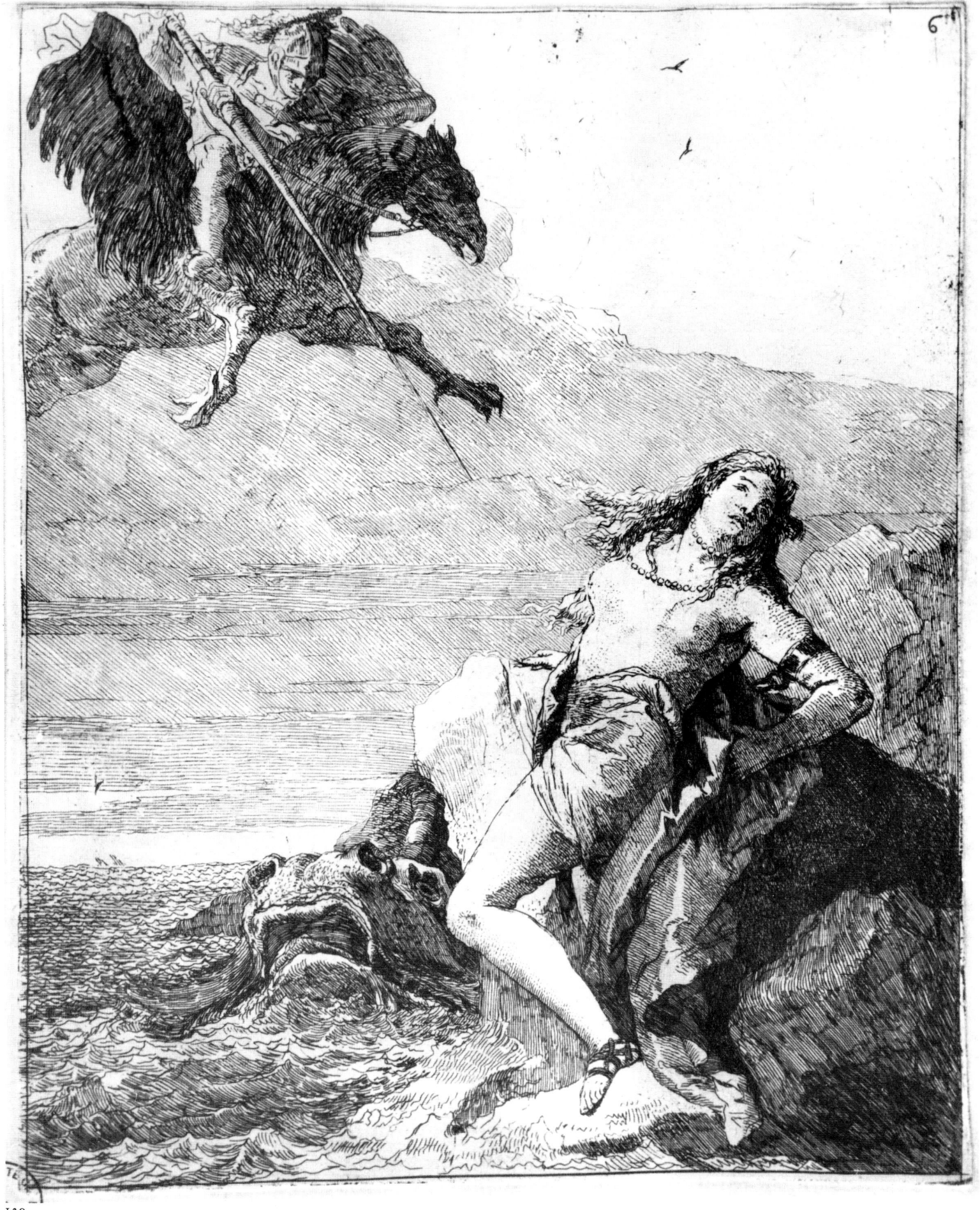

140. Medoro lying wounded

266 × 216 mm. First state: before the number; second state: *3* at top right-hand corner.

See note to pl. 135.

Bibliog.: De Vesme, 1906, 91; Sack, 1910, 90; Pignatti, 1965, LXIII; Rizzi, 1970, 136.

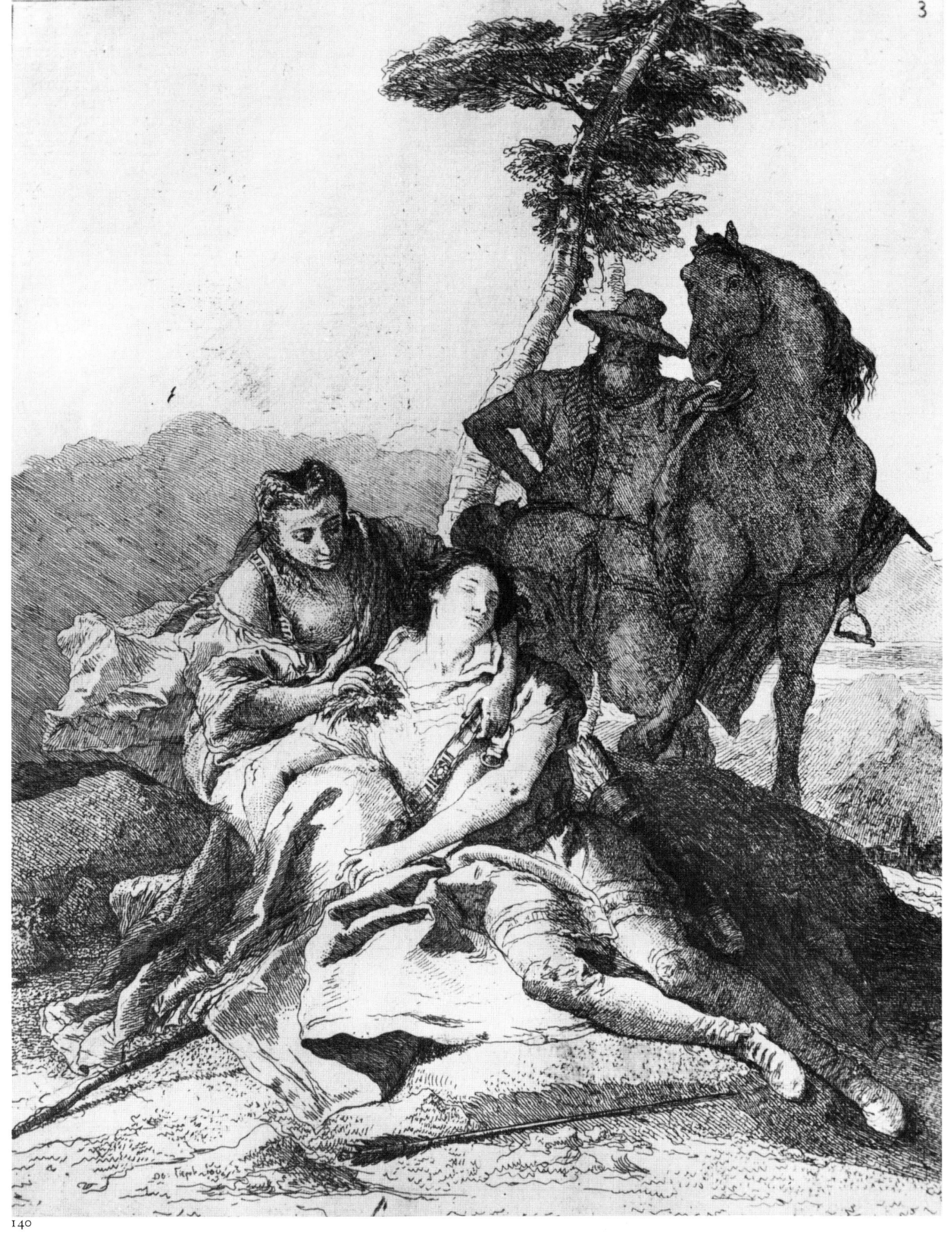

141. The Marriage of Angelica and Medoro

239 × 258 mm. First state: before the number; second state: 5 at top right-hand corner. On the ground, to the left, the inscription: *Do: Tiepolo inc.*

See note to pl. 135.

Bibliog.: De Vesme, 1906, 92; Sack, 1910, 92; Rizzi, 1970, 137.

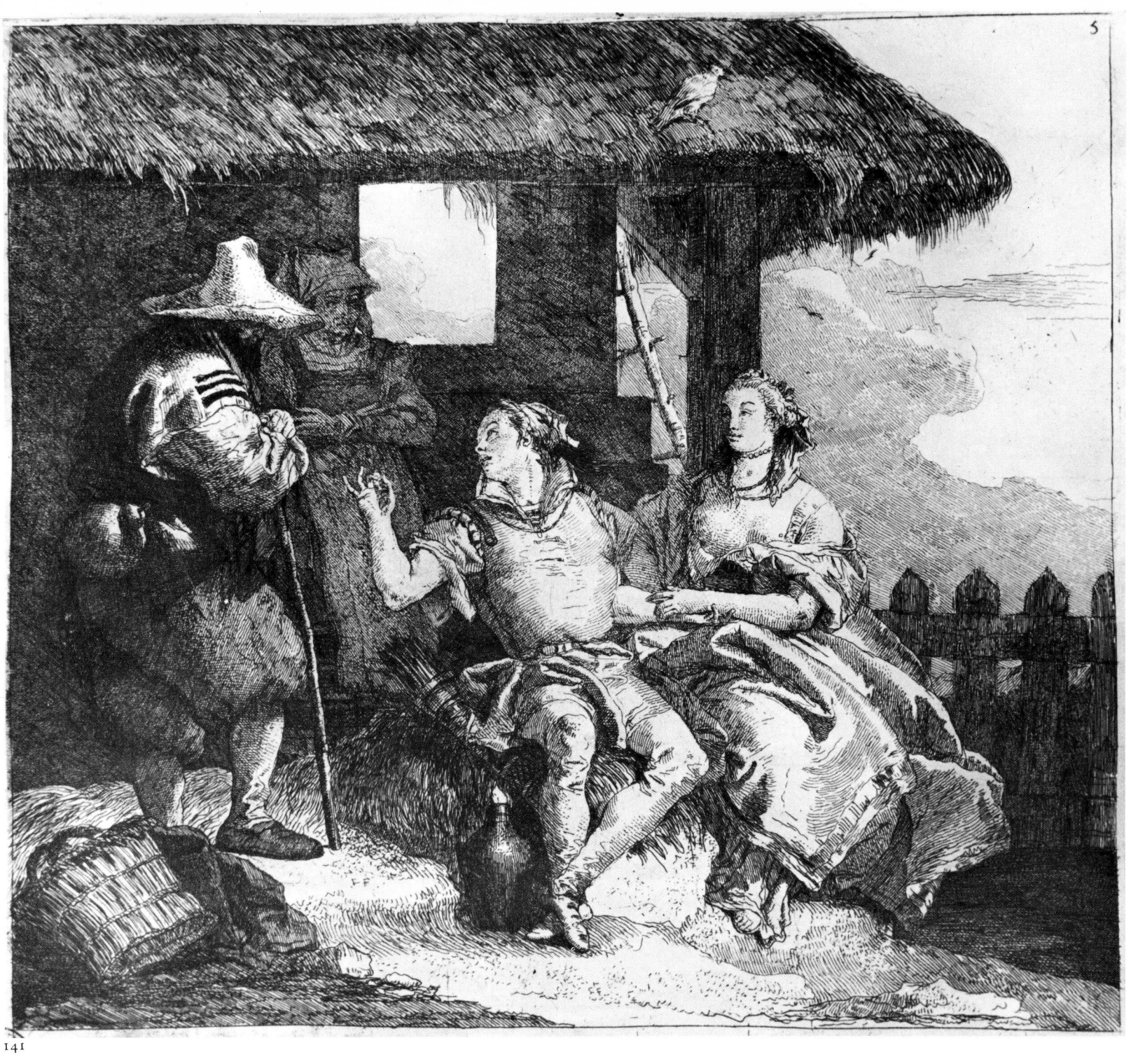

142. Angelica and Medoro engrave their names on the trees

264 × 196 mm. First state: before the number (the left-hand margin is at least 4 mm. wide); second state: before the number (the left-hand margin is reduced by about 1 mm.). Third state: *2* at top right-hand corner.

See note to pl. 135.

Bibliog.: De Vesme, 1906, 93; Sack, 1910, 91; Rizzi, 1970, 138.

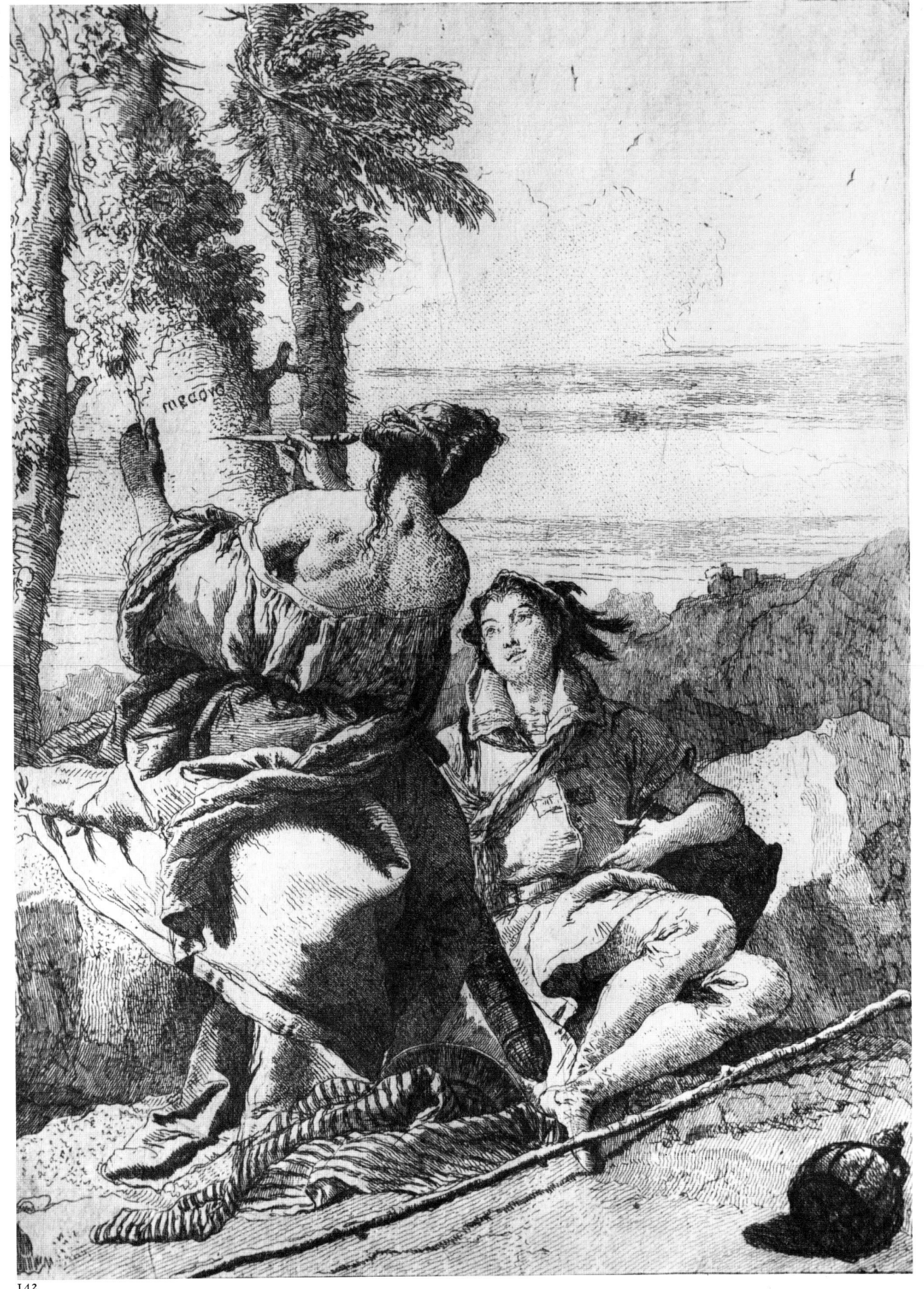

142

143. Rinaldo and Armida

294 × 200 mm. *50* at top left-hand corner. At the bottom, in a rectangular space, the inscription: *Ioannes Baptta Tiepolo inv. et: pinx.* to the left; *Ioannes Dominicus Filius del: et fecit.* to the right.

See note to pl. 135.

Bibliog.: De Vesme, 1906, 95; Sack, 1910, 93; Pallucchini, 1941, 392; Rizzi, 1970, 139.

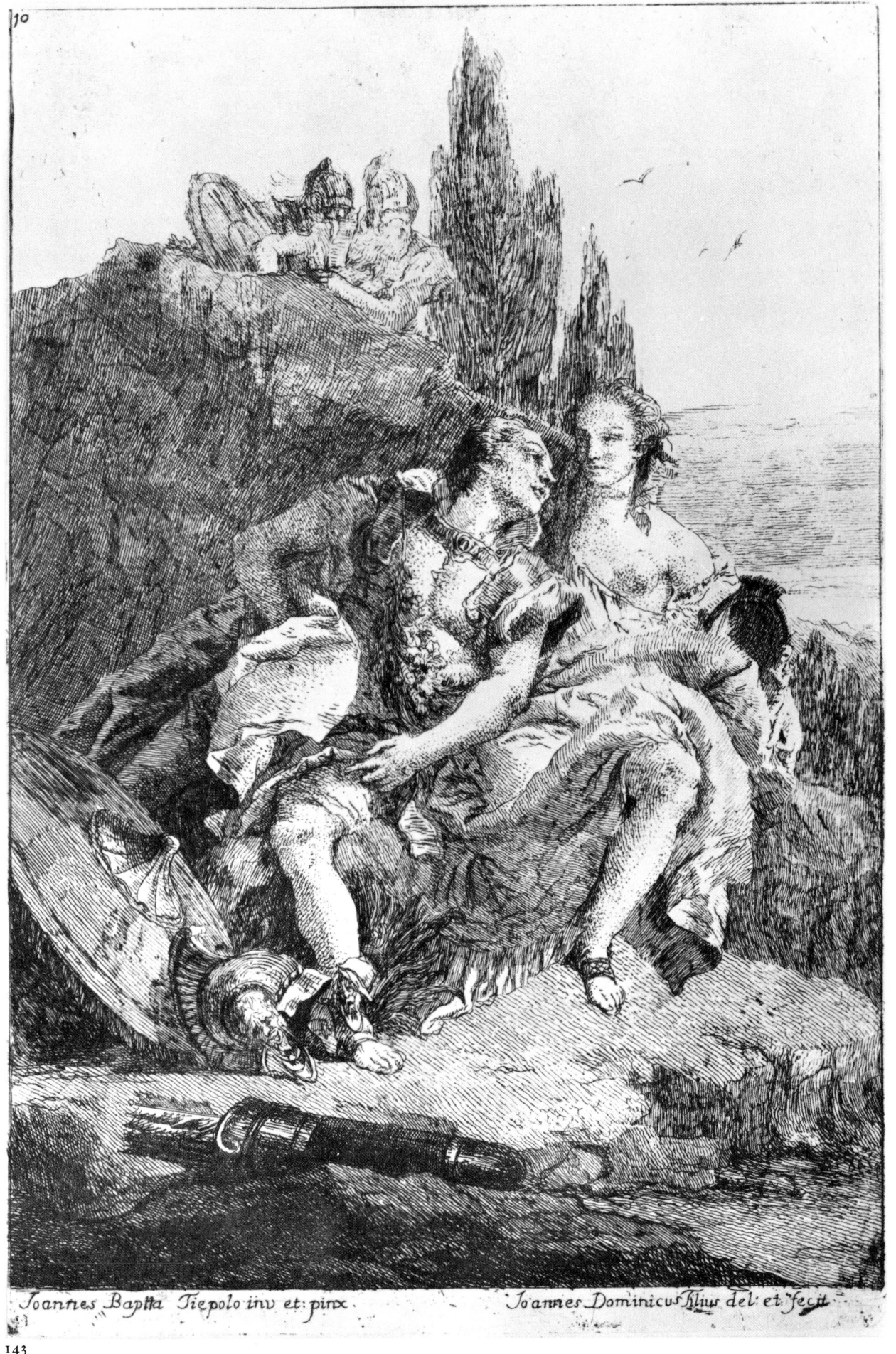

Joannes Bapta Tiepolo inv et: pinx. Joannes Dominicus filius del: et fecit.

144. Ubaldo and Carlo scold Rinaldo for his weakness

294 × 199 mm. In the top left-hand corner a number, probably *9*. De Vesme did not quote the inscription, which was mentioned by Sack: *Joannes Bappta Tiepolo inv: et pinx. | Joannes Domenicus Filius del: et fecit.*

See note to pl. 135.

Bibliog.: De Vesme, 1906, 96; Sack, 1910, 94; Rizzi, 1970, 140.

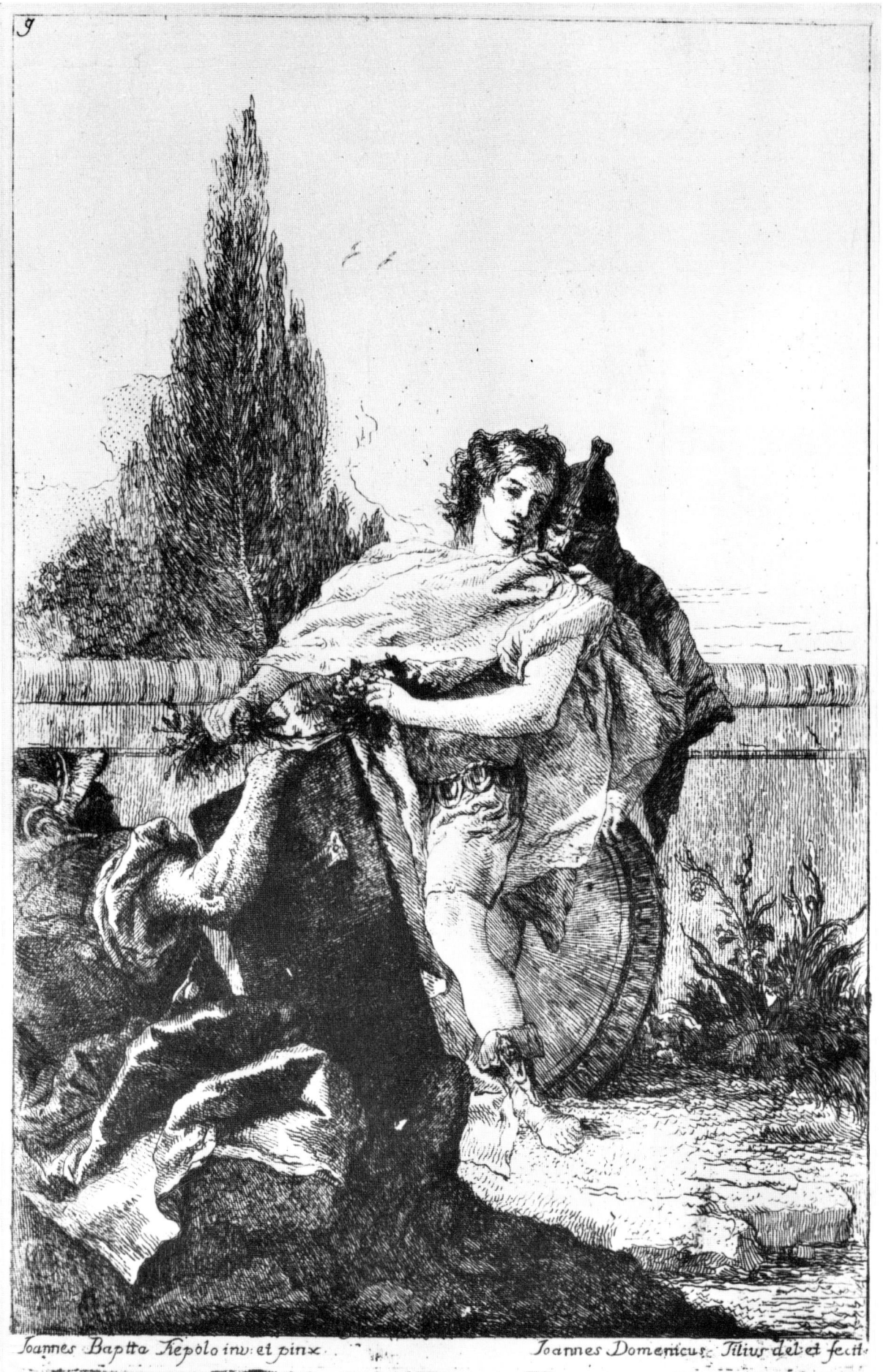

9

Ioannes Baptta Tiepolo inv: et pinx. Ioannes Domenicus Filius del et fecit

145. Rinaldo abandons Armida

257 × 361 mm. In the lower margin to the left the inscription: *Joannes Baptta Tiepolo inv. et pinx.*; to the right: *Joannes Dominicus Filius del. et fecit.*

This etching echoes one of the subjects of the Valmarana frescoes; it is omitted by De Vesme.

See also note to pl. 135.

Bibliog.: Sack, 1910, 95; Rizzi, 1970, 141.

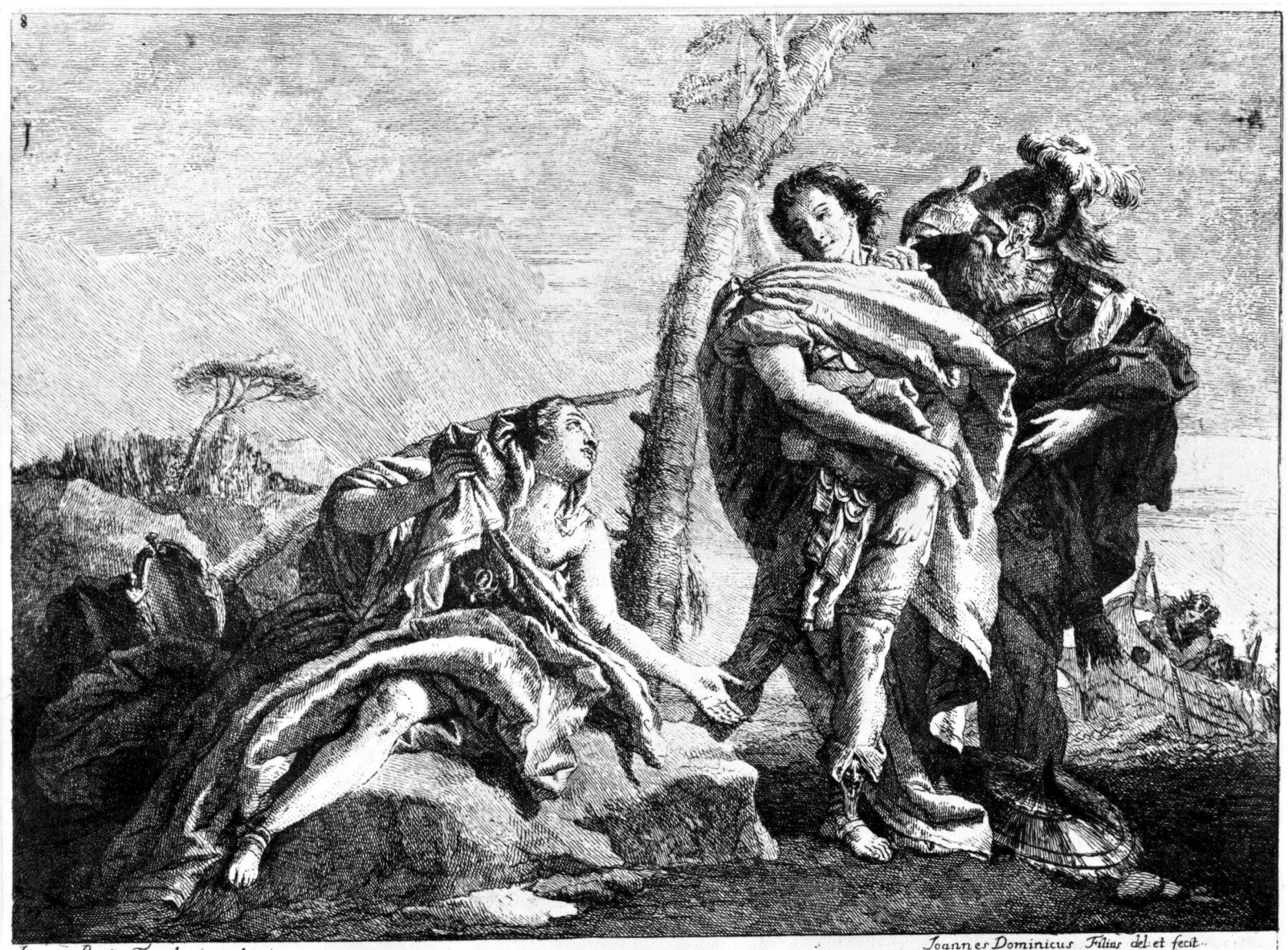

Ioannes Baptta Tiepolo inv et pinx. Ioannes Dominicus Filius del et fecit.

146. Armida
falls in love with Rinaldo

269 × 303 mm. First state: before the number; second state: 7 at top right-hand corner. In the bottom margin, to the left, the inscription: *Io. Bapta Tiepolo inv: et pinx.* to the right: *Io. Dominicus Filius del, sc.*

De Vesme mentioned that a similar scene was painted by Giambattista in the Villa Valmarana. But this etching is based on Giambattista's painting previously in the Venetian palace of Count Serbelloni, now in the Art Institute of Chicago, dated by Morassi 1750–5 (Morassi, 1962, p. 8).

Bibliog.: De Vesme, 1906, 94; Sack, 1910, 96; Pallucchini, 1941, 379; Rizzi, 1960, 142.

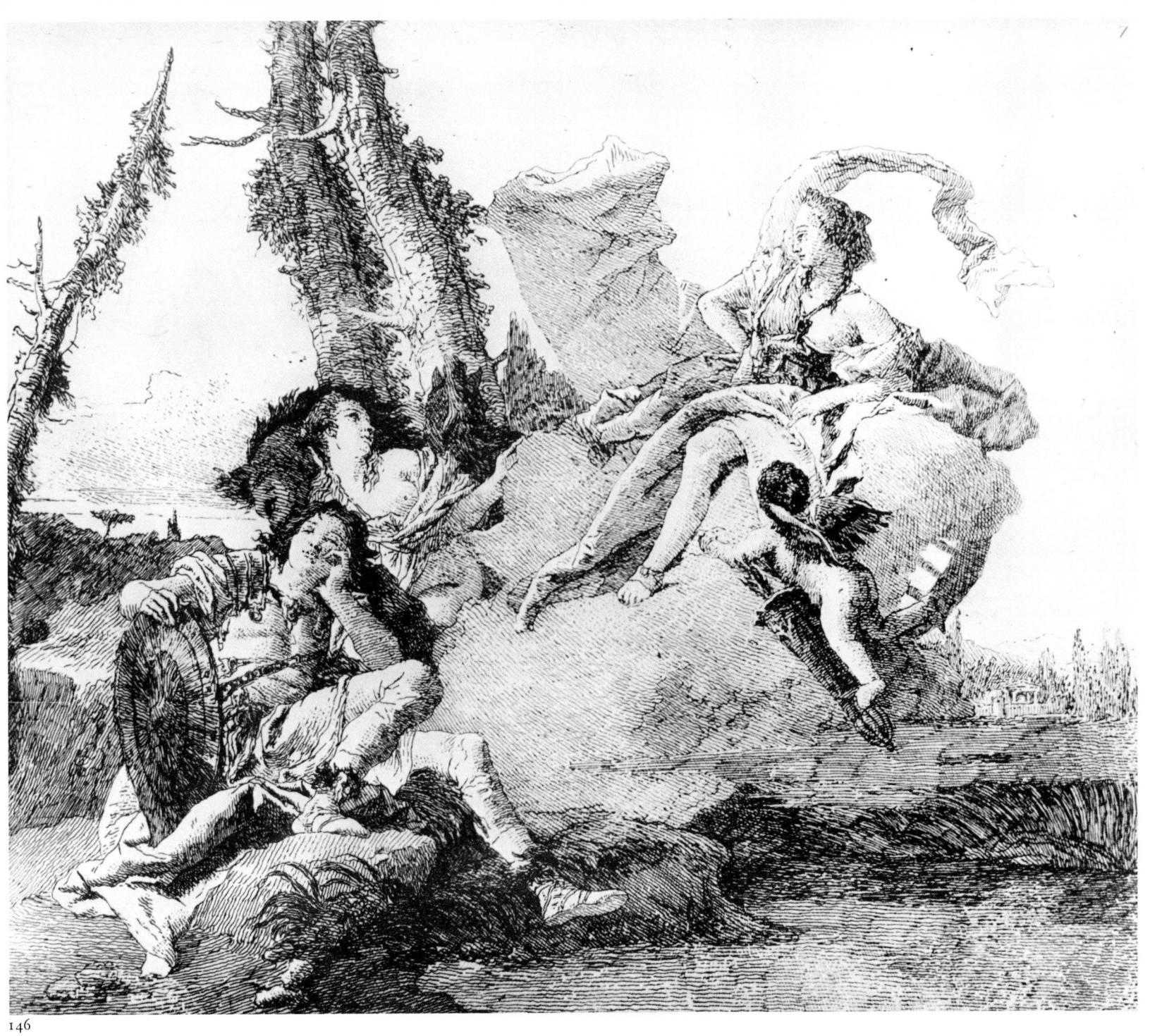

146

147. The Triumph of Hercules

690 × 507 mm. First state: before the inscription and the number; second state: with the inscription but before the number; third state: *42* at top left-hand corner. In the bottom margin: *Ioannes Dominicus Tiepolo / invenit pinxit, et delineavit.*

According to De Vesme, the etching is based on a painting for the Royal Palace in Madrid. Sack maintained that it was derived from a painting executed by Giandomenico for St. Petersburg; this is suggested by the index of the second *Catalogue* by Giandomenico, which contains the words *in Petroburgh* (42). In fact, the painting on which the etching is based was one of a series of four executed for St. Petersburg and the only one by Giandomenico. The others are by Giambattista and were engraved by Lorenzo (see pl. 228).

Bibliog.: Nagler, 1847, 37; De Vesme, 1906, 101; Sack, 1910, 106; Pallucchini, 1941, 405; Rizzi, 1970, 143.

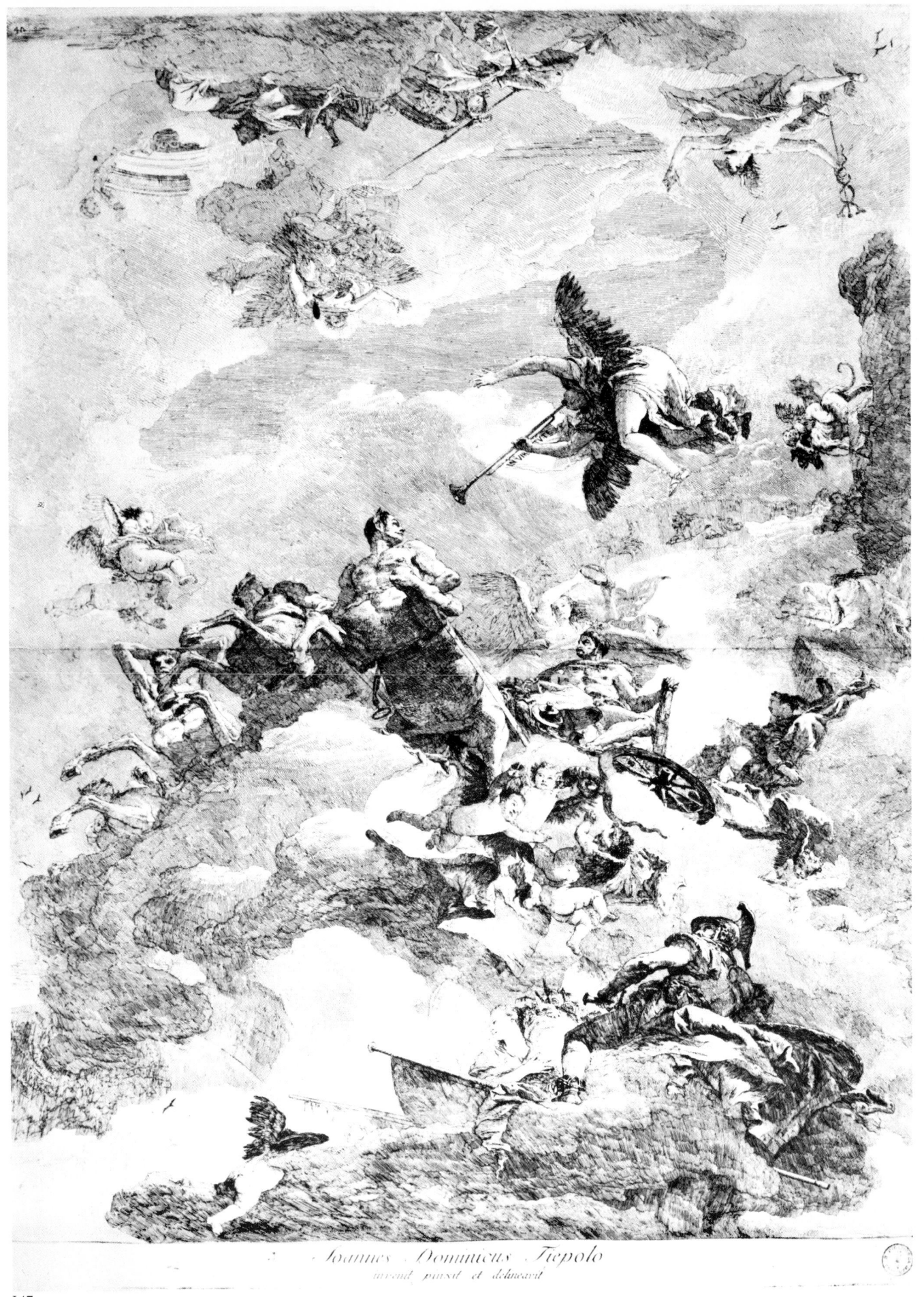

Ioannes Dominicus Tiepolo
invenit pinxit et delineavit

148. Venus entrusting Cupid to Time

453 × 293 mm. First state: before the inscription. The corners and other parts of the print are rough. Second state: with the inscription and *36* at top left-hand corner. The rough parts have been cleaned up. Beneath the oval the inscription: *Ioannes Bapta Tiepolo inv: et pinx. | Ioannes Dominicus Filius del: et fecit.*

In Giandomenico's *Catalogue* the print is entitled *Venus giving birth*. According to Sack, Giandomenico based this etching on a painting by his father which can no longer be traced. The painting is mentioned by Morassi (1962, p. 18) and has recently been acquired by the National Gallery, London (No. 6387).

Bibliog.: Nagler, 1847, 41; De Vesme, 1906, 100; Sack, 1910, 101; Rizzi, 1970, 144.

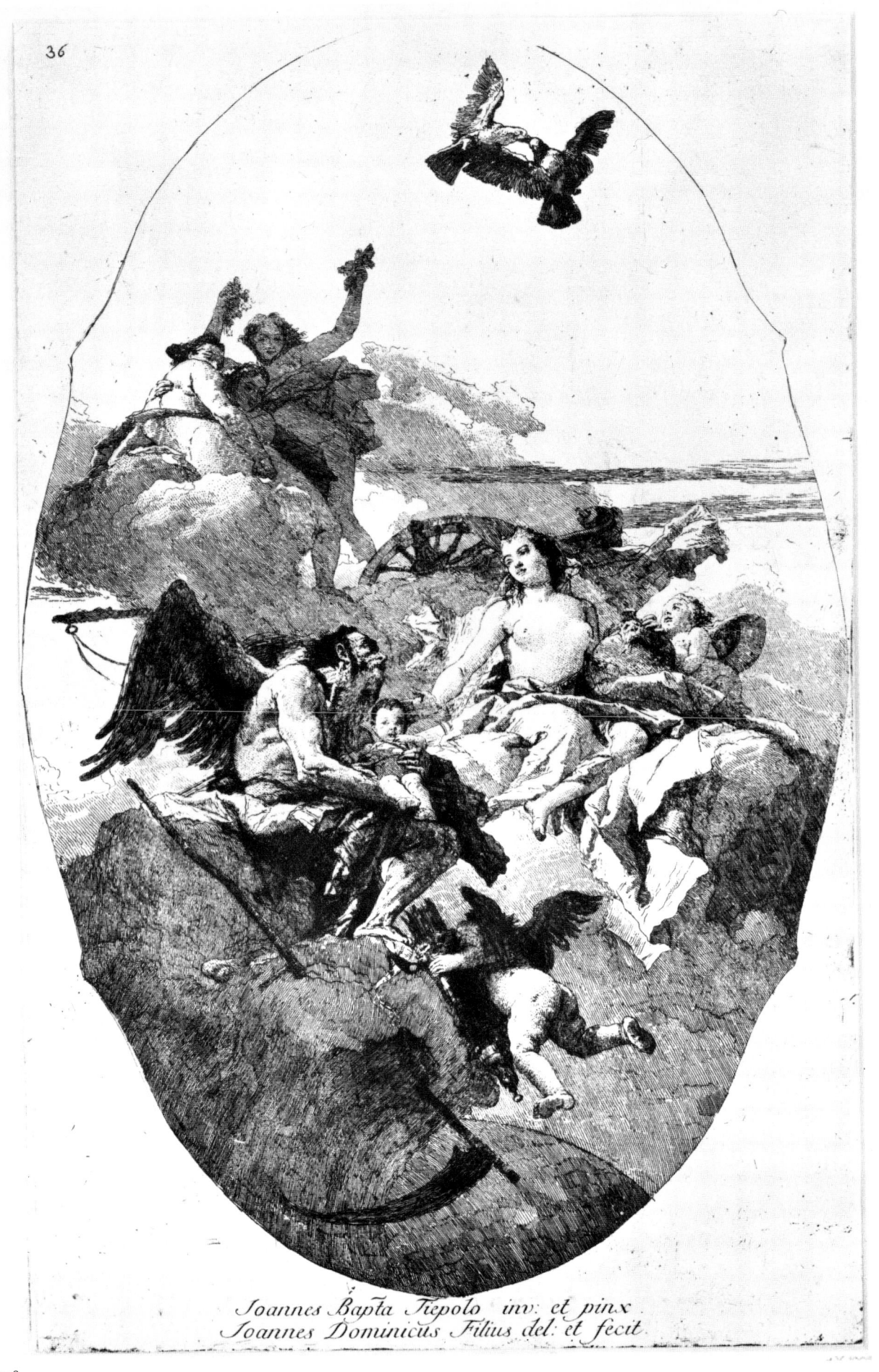

Ioannes Bapta Tiepolo inv: et pinx
Ioannes Dominicus Filius del: et fecit

149. The Angel appearing to St. Paschal Baylon

505 × 290 mm. *28* at top left-hand corner. In the margin the inscription: *Ioan: Bapta Tiepolo Venet: Pict: apud Hisp: Reg:, inv: et pinx: an: 1770 ante suum decessum.* | *Ioan: Dominic: Filius incid: Hisp:*.

According to Giandomenico's *Catalogues*, the original painting, which was executed for the high altar of the convent of S. Pasquale in Aranjuez, represented *St. Diego*. De Vesme established the correct interpretation of the scene. Giambattista finished the painting shortly before his death, as testified by his son; it was later cut up and the two surviving fragments are now in the Prado (Morassi, 1962, p. 21). De Vesme noted that Bermudez wrongly attributed the print to Giambattista: he had probably only seen a proof without the inscription. Nagler made the same mistake.

Bibliog.: Cean Bermudez, 1800, p. 46; Nagler, 1847, 4; De Vesme, 1906, 59, and p. 393, 10; Sack, 1910, 74; Pallucchini, 1941, 362; Pittaluga, 1952, p. 152; Rizzi, 1970, 145.

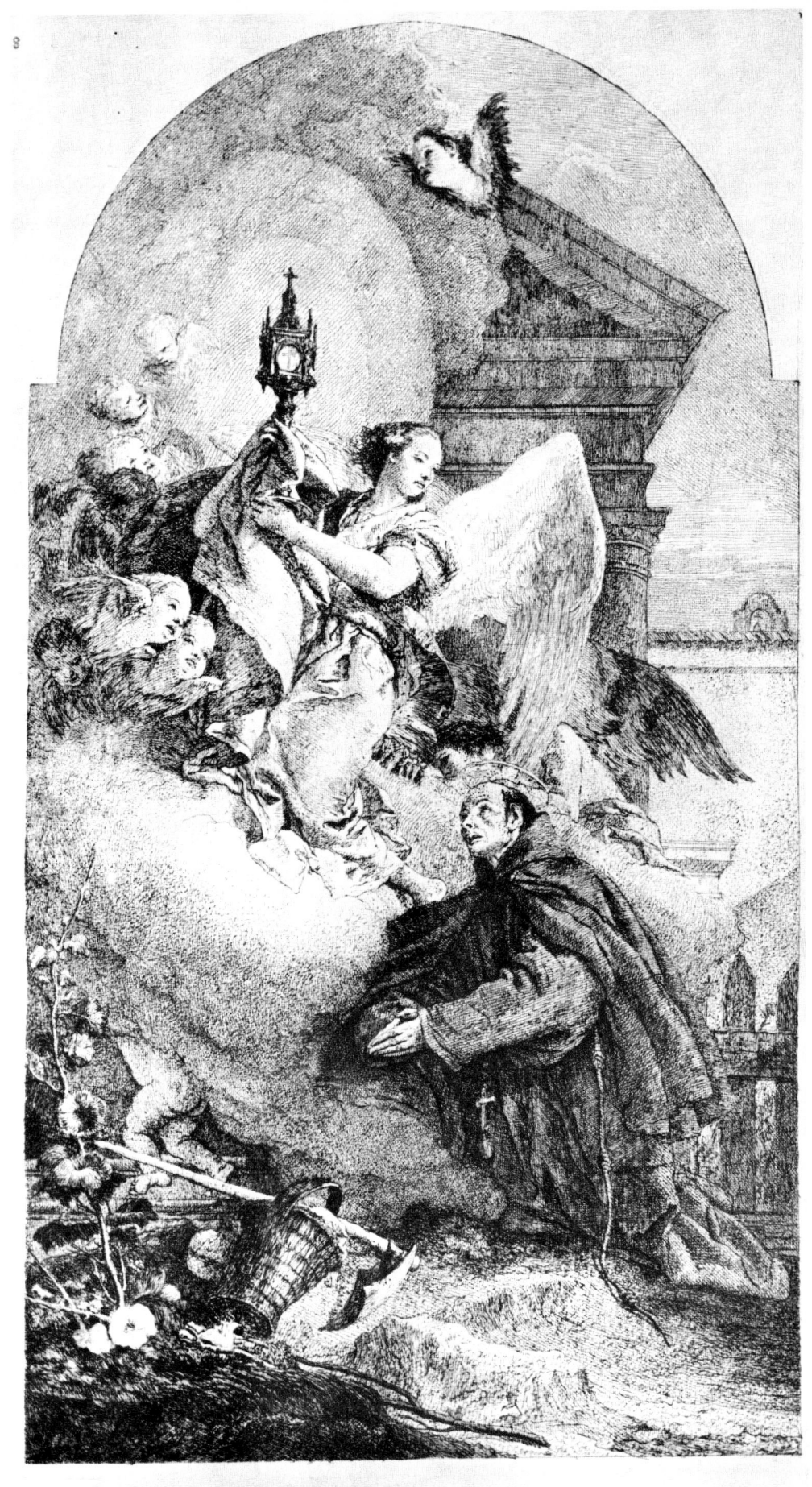

Ioan: Bapta Tiepolo Venet: Pict apud Hisp: Reg, inv. et pinx. an 1770 ante suum decessum.

150. A woman with three children

199 × 302 mm. At top left, the inscription: *Io. Bapta Tiepolo inv. et pin.* and right: *Io. Dominicus Filius del, et scul.*

The etching combines themes from the Würzburg decorations: the woman with the child in her arms and the page are taken from *The Family of Darius before Alexander*, in the University Museum, Würzburg (Morassi, 1962, pl. 283), while the page on the right is based on *The Investiture of Bishop Harold* in the Residenz.

Bibliog.: De Vesme, 1906, 105; Sack, 1910, 114; Pallucchini, 1941, 390; Rizzi, 1970, 146.

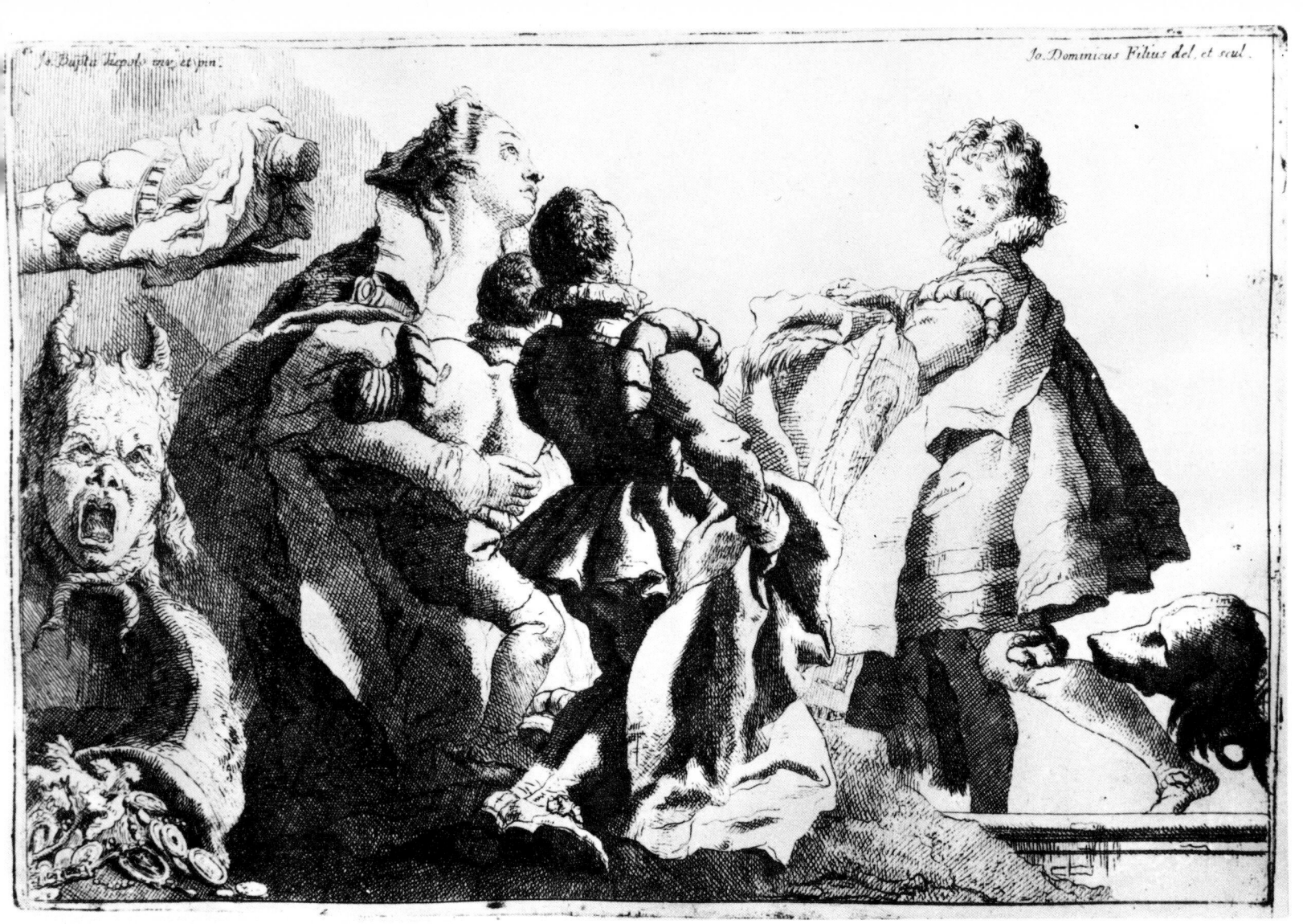

151. Figures of dwarfs and dogs

203 × 300 mm. First state: before the inscription and the number; second state: 7 at top right-hand corner. At the bottom to the left, the inscription: *Io. Bapta Tiepolo inv; et pinx.* and to the right: *Io. Dominicus Filius sculp.*

This etching combines details of frescoes by Giambattista in a rather unusual way. Pignatti has noted that the dwarf to the right and the Maltese dog supported by a female arm are derived from the *Marriage of Barbarossa* in Würzburg. Knox sees no direct connection with Würzburg except for the head of the dog above the inscription *Io. Dominicus Filius sculp*, which also appears in the fresco of the *Marriage*. The dogs to the left, above, are an adaptation of the drawing in the Metropolitan Museum in which are repeated details of *The Family of Darius* by Veronese, now in the National Gallery, London.

The dwarf to the left and the dog next to him are based on the Contarini fresco, in the Jaquemart-André Museum. And the dwarf to the right is derived from the *Banquet of Cleopatra*, formerly in the Jusupov Collection, now in the Archangel Museum (Morassi, 1962, pl. 311).

Pignatti dates this sheet 'from at least the seventh decade' from its style (the crossed lines with weak chiaroscuro) and its links with another 'composite' print, which depicts *Arms and trophies* and is dated 1774 (see pl. 155).

Bibliog.: De Vesme, 1906, 106; Sack, 1910, 109; Pignatti, 1965, LXV; Knox, 1966, p. 585; Rizzi, 1970, 147.

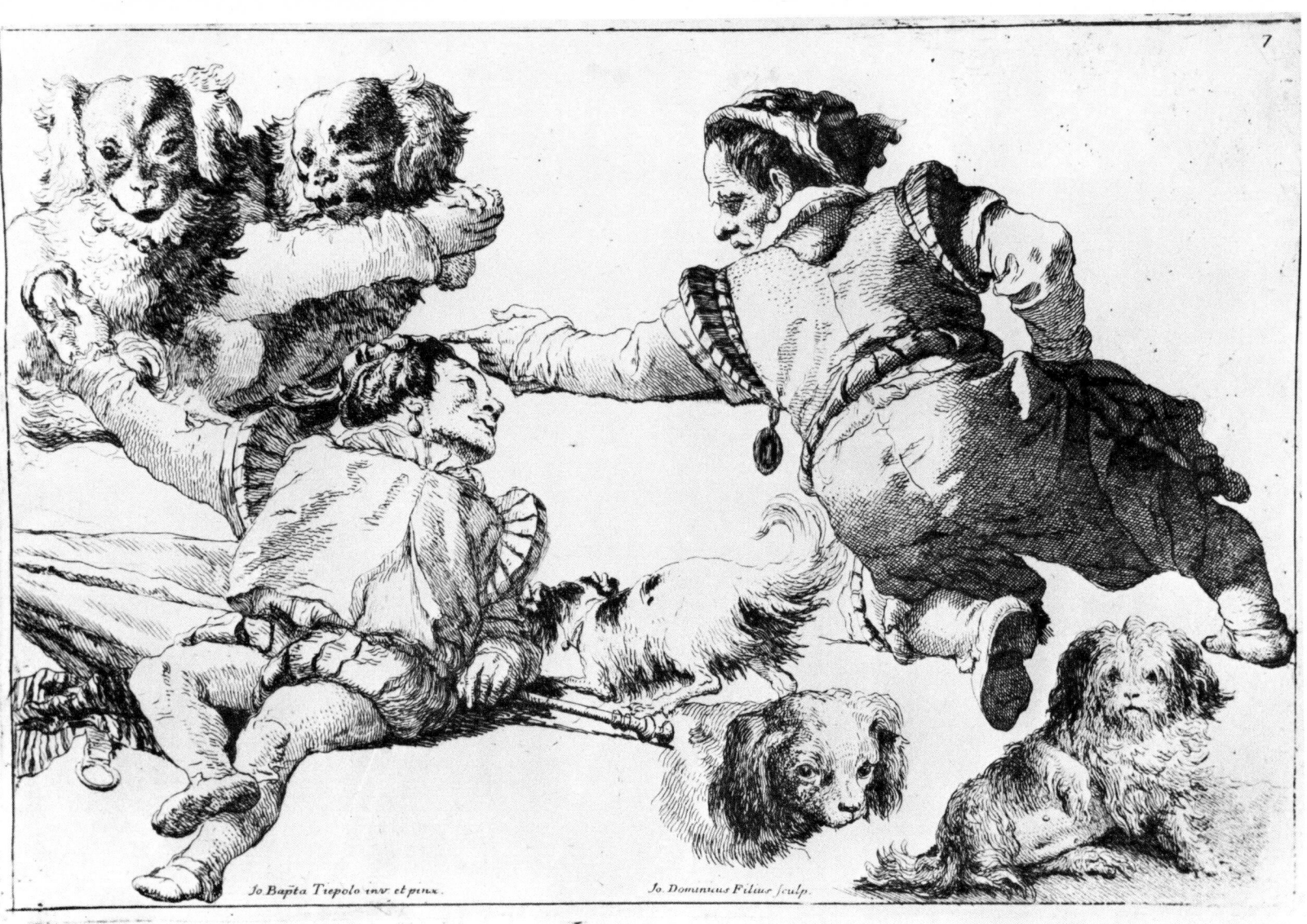

Jo Bapta Tiepolo inv et pinx. Jo Dominicus Filius sculp.

152. Figures of dwarfs and dogs

203 × 300 mm. At bottom left, the inscription: *Jo. Bapta Tiepolo inv. et pinx. Jo. Dominicus Filius sculp.* The number 7 at top right-hand corner.

Another *pastiche* of themes taken from Giambattista; the dwarf to the left comes from the *Meeting of Anthony and Cleopatra* in the Museum at Archangel (Morassi, 1962, fig. 313) and the one in the centre from the *Marriage* at Würzburg (Morassi, 1955, Plate VII).

Bibliog.: De Vesme, 1906, 107; Sack, 1910, 110; Rizzi, 1970, 148.

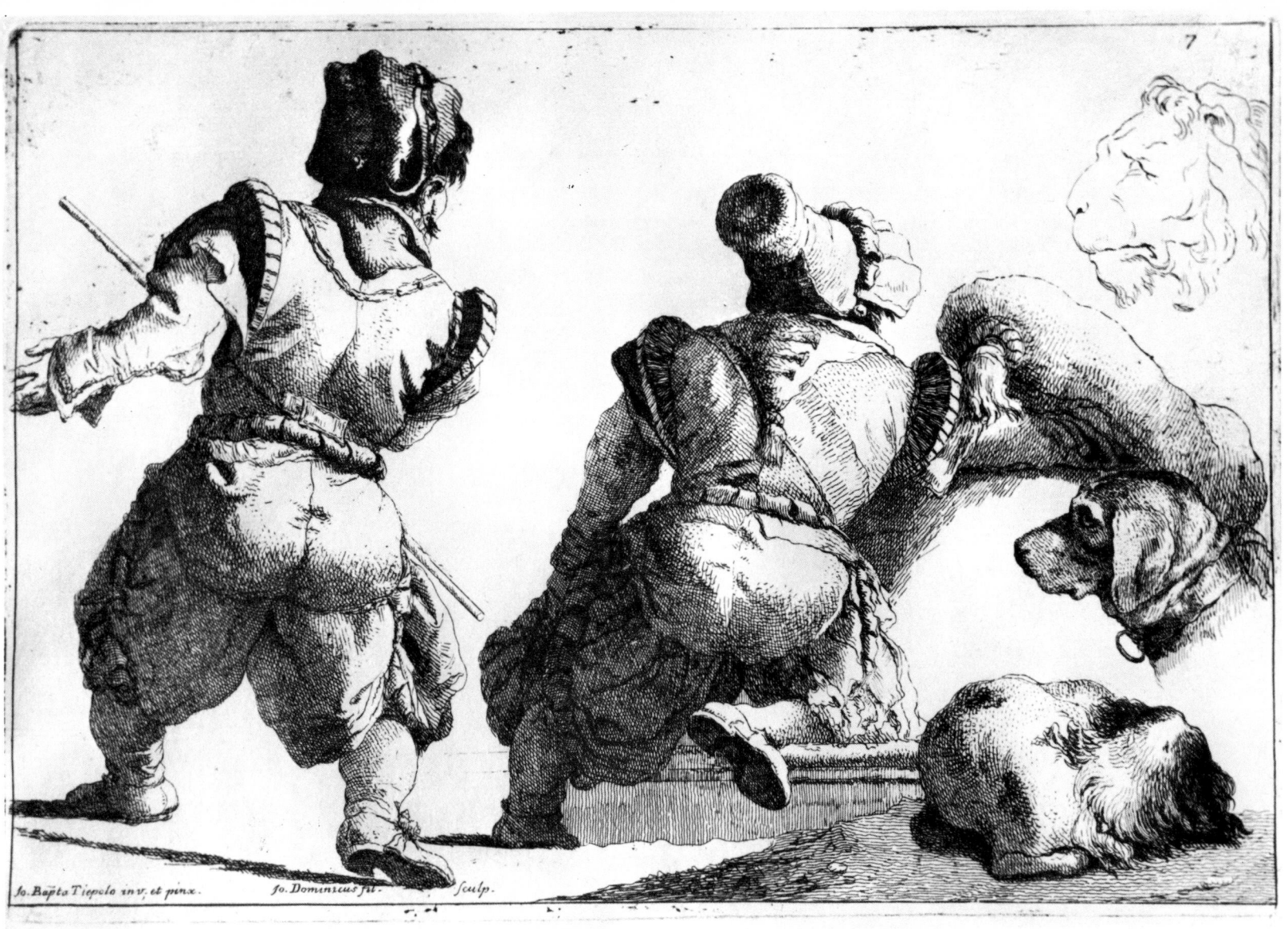

Jo. Bapta Tiepolo inv. et pinx. Jo. Dominicus fil. sculp.

153. Three kneeling youths seen from behind

202 × 293 mm. First state: before the inscription and the number; second state: 7 at top right; third state: with the inscription: *Joa: Baptta Tiepolo inv: et: pinx:* to the left, and *Joa: Dominicus Filius del et: fecit:* to the right.

According to Giandomenico's *Catalogue* the title is *Pagi con mascarone, è Rara*. This etching, like the two preceding ones, combines various details from Giambattista's works. Sack pointed to the similarity between these pages and those watching the *Marriage of Barbarossa* in Würzburg. According to Pignatti, on the other hand, only two of the pages are based on the fresco, and the one to the right on the *Adoration of the Kings* in the Alte Pinakothek, Munich. Knox maintains that this figure is also taken from the *Marriage* and identifies it with the one supporting the train of Beatrice of Burgundy. The parrot derives from a fresco by Giambattista, previously in the Zianigo villa, now in Ca' Rezzonico, Venice.

Bibliog.: De Vesme, 1906, 108; Sack, 1910, 113 and p. 338; Pignatti, 1965, LXVI; Knox, 1966, p. 585; Rizzi, 1970, 149.

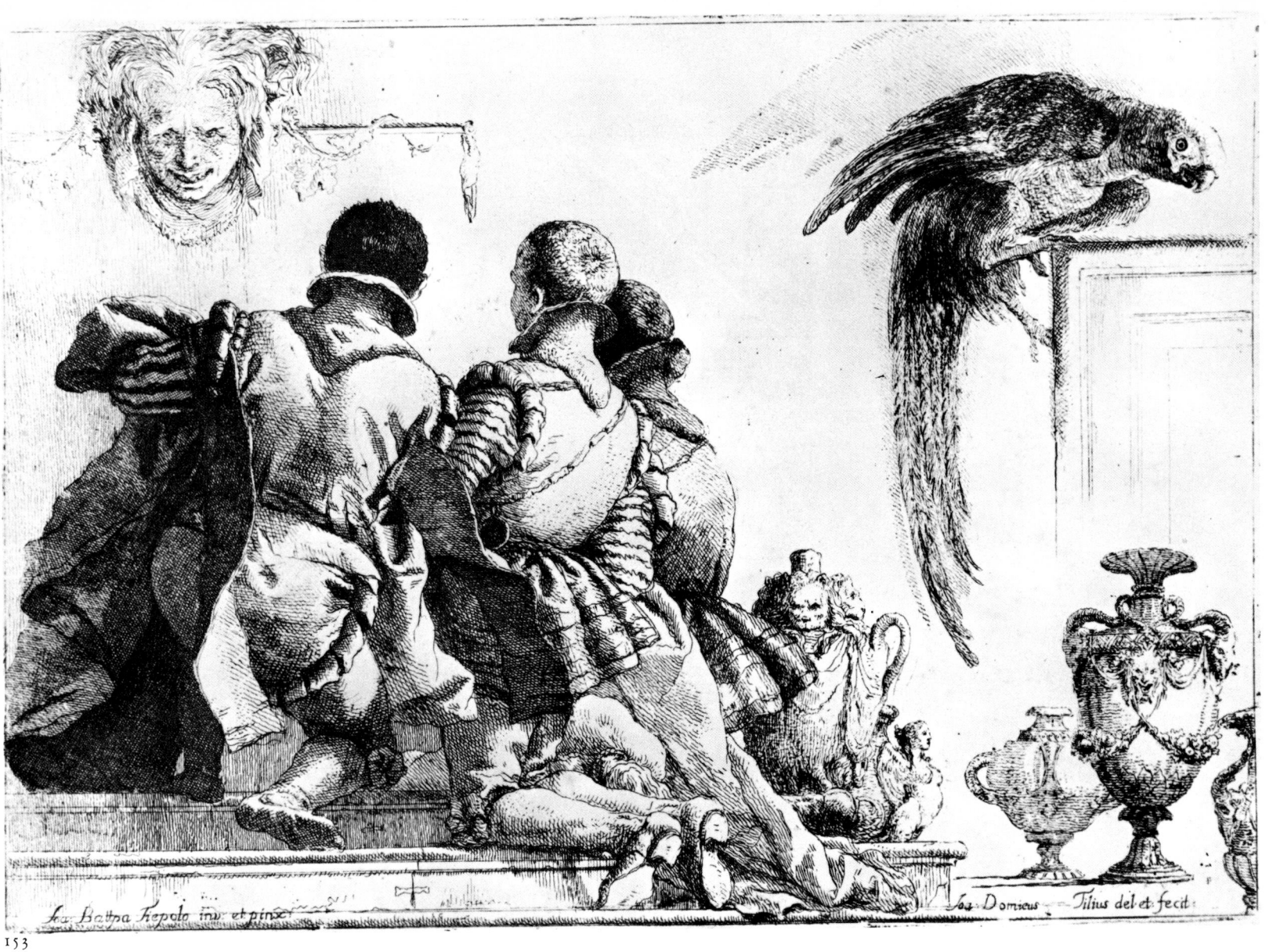

Ios. Battpa Tiepolo inv et pinx. Ios. Domicus Tilius del et fecit.

153

154. Trophies and Fanciful Heads

194 × 294 mm. First state: before the inscription and the number; second state: 7 and the inscription: *Ioan: Domicus [sic] Tiepolo inv: et: fecit:*, at top right.

The etching is rather rare, with drawings or details of frescoes by Giambattista juxtaposed in an unusual way; the mask, with its garland of vine-leaves, flowers and fruits, echoes a similar motif previously in the sacristy of the Zianigo Villa and now in Ca' Rezzonico. This is supported by Pignatti, who also mentions a drawing, probably by Giandomenico, in Dresden.

Bibliog.: De Vesme, 1906, 109; Sack, 1910, 115; Pallucchini, 1941, 386; Pittaluga, 1952; p. 155; Pignatti, 1965, LXIV; Rizzi, 1970, 150.

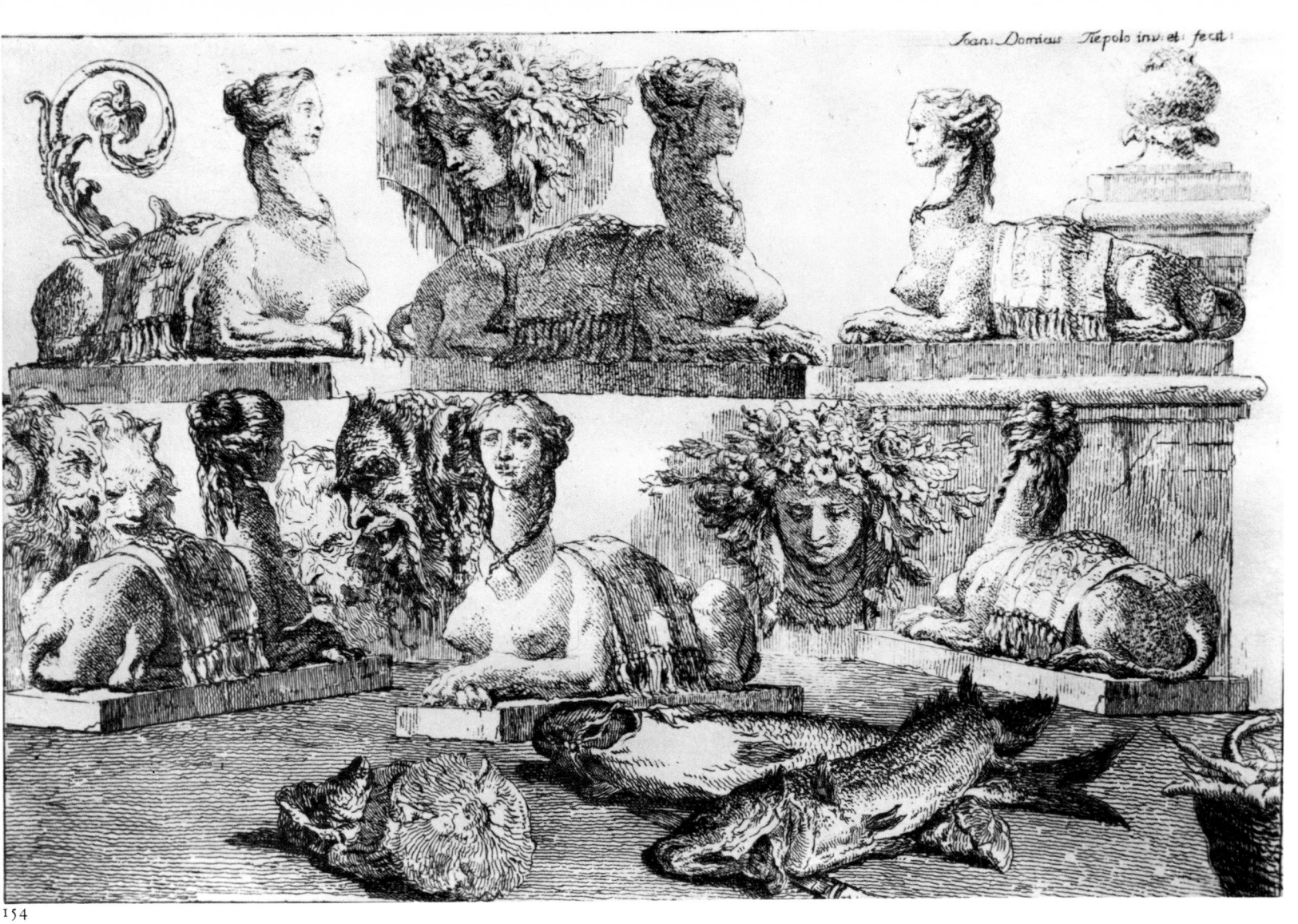

155. Arms and Roman insignia

213 × 274 mm. *7* at top right-hand corner. Above the armour to the right, in the bottom section, the inscription: *Io. Dominicus Tiepolo inv; et sculp.*; on a plate nailed to a pole, in the centre, the date *1774*.

The print combines various elements from Giambattista's works with Giandomenico's own inventions. It is etched on the same sheet as the next print.

Bibliog.: De Vesme, 1906, 112; Sack, 1910, 112; Pallucchini, 1941, 387; Rizzi, 1970, 151.

7

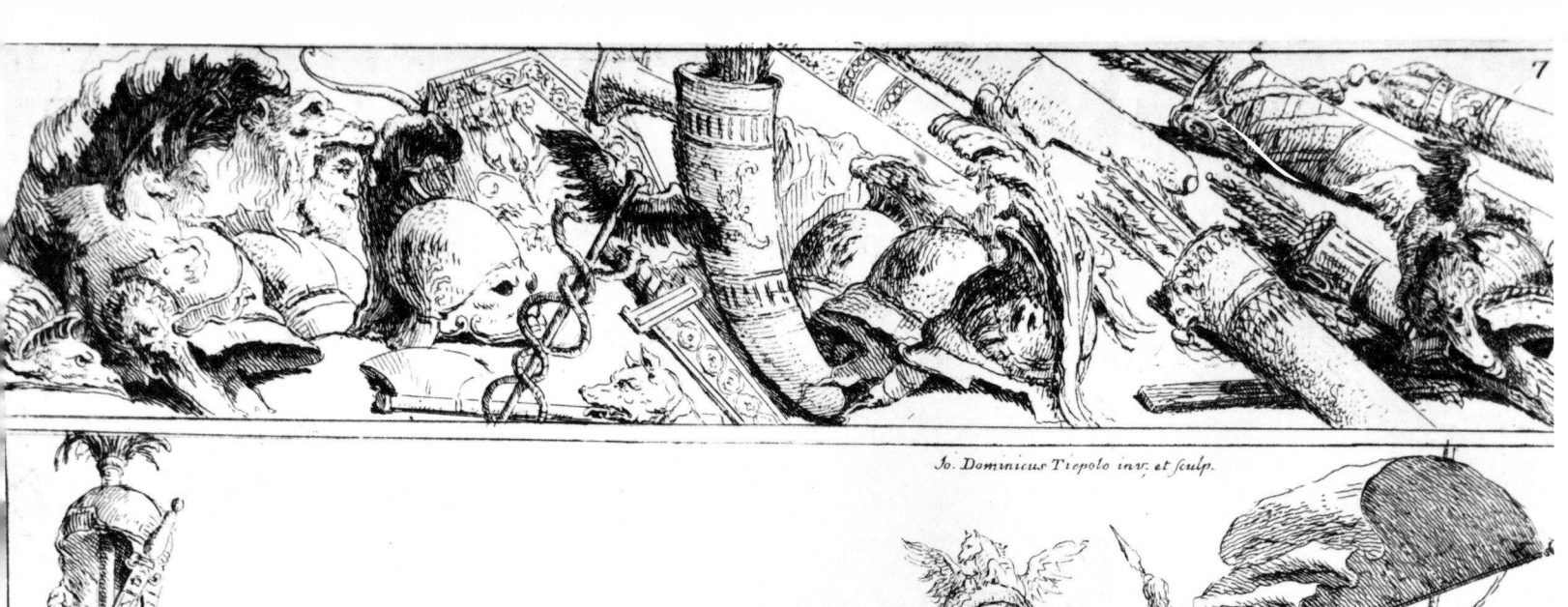

Jo. Dominicus Tiepolo inv. et sculp.

SPQR

155

337

156. Heads of satyrs and other grotesque heads

66 × 269 mm. Top left the inscription: *Io: dominicus Tiepolo inv; et sc.* The number *7* at top left-hand corner.

These are sketches of grotesque heads already used by Giandomenico in other compositions. On the same sheet is etched the previous print.

Bibliog.: Nagler, 1847, 51; De Vesme, 1906, 113; Sack, 1910, 112; Pallucchini, 1941, 388; Rizzi, 1970, 152.

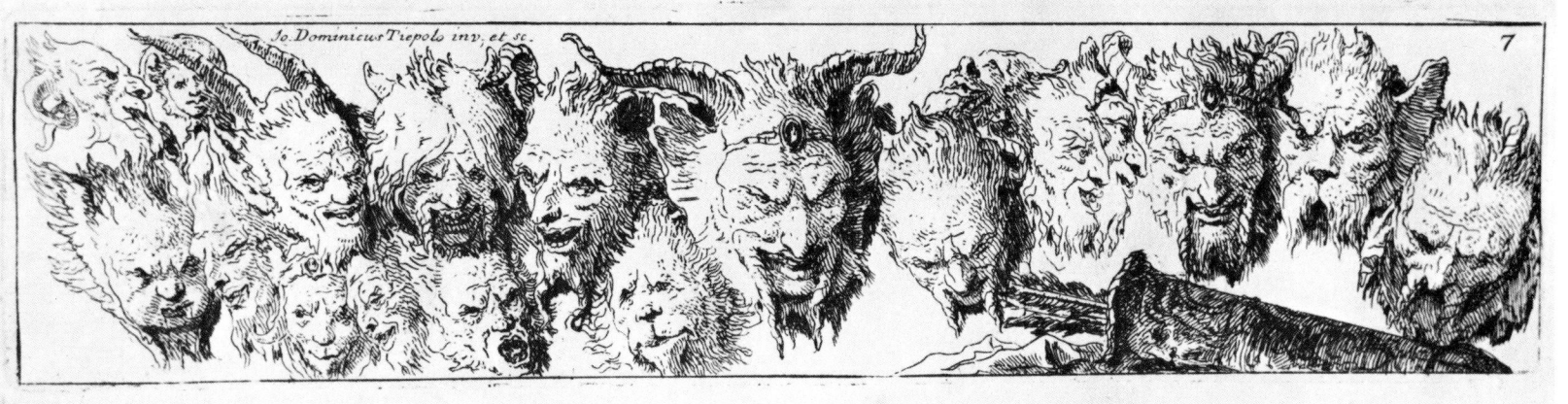

156

157. Dedication to Pope Pius VI

345 × 245 mm. *Beatissimo Padre | Fin da gran tempo avrei desiderato, Beatissimo (sic!) Padre, di poter racco | gliere in un solo Volume le operazioni disegnate, ed incise in Rame | del fú mio Padre, e da me stesso, e dal mio Fratello portati da natu | ral genio ad imitarne gli Studj, acciochè potessero servire al piace | vole trattenimento dei moltissimi Dilettanti di questa non ispregie | vole Professione; ma siccome questi prodotti per la maggior parte eb | bero la Sorte di nascere sotto l'ombra propizia di uno dei mag | giori Monarchi di Europa, a cui mio Padre ottenne l'altissimo ono | re di prestar servitù finché visse, cosí parèa, che dimandassero | quasi per diritto d'esser publicati sotto gl'Auspicj di un Sovrano, | che nello splendore della amplissima dignità di quell'ornamento li | fregiasse, che non potrebbero meritarsi per sè medesimi. E qual po | teva io implorar maggiore della Santità Vostra, che accoppia insie | me l'onore del Principato a quello singolarissimo del Supremo Sa | cerdozio nella Chiesa di Gesù Cristo? Ella come nata divinamente | alla felicità dei Popoli non potrà desiderare in Se stessa il giusto amo | re delle belle Arti, che forma l'ornamento più gradevole d'ogni Sovra | no. Dunque giacché il pietosissimo Iddio si è degnato dopo tanti | voti di concederla al Regimento del Cristiano Gregge, non vorrà | negarmi la giocondissima consolazione di accettare con paterna be | nignità il picciolissimo tributo, che Le offro della mia più umi | le, e profonda venerazione, e di accordare a questo debol Volume | l'altissimo Dono della Sua Protezione che lo renderà abbastanza | stimabile in faccia di tutto il Mondo, e prostrato ossequiosamente | al bacio de' Santissimi Piedi imploro il beneficio della sua Santa Be | nedizione. | Umilissimo, Devotissimo, ed obligatissimo Servitore | e Figlio Gioan Domenico Tiepolo.*

This dedication opens the edition of the etchings by Giambattista, Lorenzo and Giandomenico Tiepolo, published by Giandomenico in 1775.

Bibliog.: De Vesme, 1906, 114; Sack, 1910, 119; Rizzi, 1970, 153.

Beatissimo Padre

Fin da gran tempo avrei desiderato, Beatissimo Padre di poter raccogliere in un solo Volume le operazioni disegnate, ed incise in Rame del fu mio Padre, e da me stesso, e dal mio Fratello portati da natural genio ad imitarne gli Studj, acciocché potessero servire al piacevole trattenimento dei moltissimi Dilettanti di questa non ispregievole Professione; ma siccome questi prodotti per la maggior parte ebbero la Sorte di nascere sotto l'ombra propizia di uno dei maggiori Monarchi di Europa, a cui mio Padre ottenne l'altissimo onore di prestar servitù finché visse, così parea, che dimandassero quasi per diritto d'essere publicati sotto gl'Auspicj di un Sovrano, che nello splendore della amplissima dignità di quell'ornamento li fregiasse, che non potrebbero meritarsi per se medesimi. E qual poteva io implorar maggiore della Santità Vostra, che accoppia insieme l'onore del Principato a quello singolarissimo del Supremo Sacerdozio nella Chiesa di Gesù Cristo? Ella come nata divinamente alla felicità dei Popoli non potrà desiderare in Se stessa il giusto amore delle belle Arti, che forma l'ornamento più gradevole d'ogni Sovrano. Dunque giacché il pietosissimo Iddio si è degnato dopo tanti voti di concederla al Regimento del Cristiano Gregge, non vorrà negarmi la giocondissima consolazione di accettare con paterna benignità il picciolissimo tributo, che Le offro della mia più umile, e profonda venerazione, e di accordare a questo debol Volume l'altissimo Dono della Sua Protezione che lo renderà abbastanza stimabile in faccia di tutto il Mondo, e prostrato ossequiosamente al bacio dé Santissimi Piedi imploro il beneficio della sua Santa Benedizione.

Umilissimo, Devotissimo, ed obligatissimo Servitore
e Figlio Gioan Domenico Tiepolo

157

158. The Arts paying homage to the Papal Authority of Pope Pius VI

428 × 315 mm. On an open book, the inscription: *DOMENICO TIEPOLO INVENTO E INCISE ANNO 1775.*

This is the frontispiece to the edition of Tiepolo etchings (see note to pl. 157).
De Vesme mentioned that the sheet is often framed by a border design with a garland of oak leaves engraved by another hand.

Bibliog.: De Vesme, 1906, 98; Sack, 1910, 118; Pallucchini, 1941, 376; Rizzi, 1970, 154.

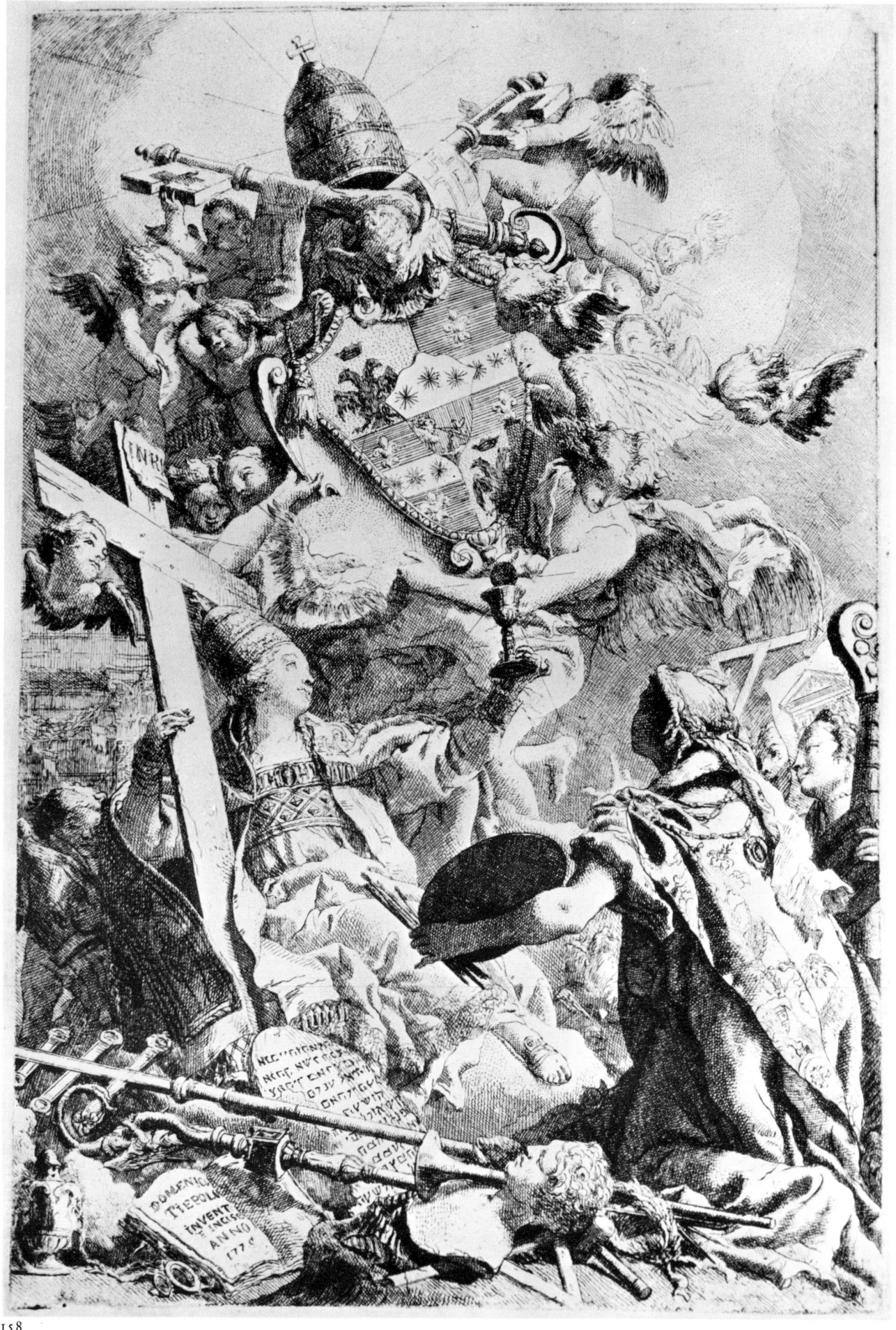

159. Series of Heads
Title page

145 × 108 mm. *Raccolta | di | Teste numero trenta | dipinte | Dal Sig.r Gio: Batta Tiepolo | Pittore Veneto | Al Serviggio di S: M: C: | Morto in Madrid | L'anno 1770 | Incise | da Gio: Domenico suo Figlio | divise in due Libri | Libro Primo.*

Apparently, the two series of the *Raccolta di Teste* were published for the first time, with a dedication to the Cavalier Alvise Tiepolo, ambassador to Pope Clement XIV Rezzonico (1769–1774), before the Pope's death in 1774. They were later included in the edition of Tiepolo etchings published by Giandomenico in 1775 with a dedication to Pius VI. They consist of two volumes, each of about thirty heads besides the two frontispieces (with the wording *Libro Primo* and *Libro Secondo*) and the dedication mentioned above. The thirty prints in the first series are numbered top right, those in the second bottom left. The first etching in each volume is a portrait respectively of Giambattista and of Giandomenico; the other heads were on the whole based on paintings by Giambattista (according to the inscription on the frontispiece) or on his drawings.

Knox has carried out a detailed study of Giandomenico's sources (1970/II) and can be consulted for further details.

Artistically, the etchings can be divided into two groups: the first is certainly earlier than the journey to Madrid (1762); the second later than 1770. See also note to pl. 240.

Bibliog.: De Vesme, 1906; 115; Sack, 1910, p. 338; Pignatti, 1965, LXVII; Knox, 1970, II; Rizzi, 1970, 155.

160. Series of Heads
Dedication

145 × 108 mm. *A sua Eccellenza | Il Sig. Alvise K:r | per la Ser.ma. Republica di Venezia. | Ambasciatore al Sommo Pontefice | Clemente XIV. | — Alcune parti di Pittura, che in questa collezione vengo di | publicare, dipinti del già deffonto Genitore, e da me | suo Figlio incisi in Rame, non possono certamente | esser meglio consacrati, che all'E: V:, che tanta parzia | lità, e prottezione, degnossi sempre allo stesso impartire | . . . mi dò l'onore di umil.te segnarmi | Di V: E: | Um:mo Div:mo River.mo Oseq.mo Serv:e | Gio: Domenico Tiepolo.*

Bibliog.: Nagler, 1847, 52; De Vesme, 1906, 116; Sack, 1910, 339; Rizzi, 1970, 156.

Raccolta

di

Teste numero trenta

dipinte

Dal Sig.r Giō: Batta Tiepolo

Pittore Veneto

Al Serviggio di S: M: C:

Morto in Madrid

L'anno 1770

Incise

da Giō: Domenico suo Figlio

divise in due Libri

Libro Primo

159

161. Series of Heads
Portrait of Giambattista Tiepolo

119 × 94 mm. First state: before the number. Besides the *1* at top right, there is a *60* in the top left-hand corner, to indicate that the series consists of that number of sheets. The print in the Udine Museum has the inscription *Secondo* at the bottom in the centre; it is probably a proof before the number.

According to Knox, the portrait is derived from a painting by Franz Joseph Degle, previously in the Staatliche Museen, Berlin, now lost (see also pl. 192). The painting was dated 1773, thus contributing a new factor to the dating of the *Series*.

Bibliog.: De Vesme, 1906, 117; Sack, 1910, 122; Knox, 1970/II, I/i; Rizzi, 1970, 157.

162. Series of Heads
Bearded old man

117 × 85 mm. First state: before the number; second state: *2* at top right.

Knox mentions a drawing which, if not the original itself, must be very similar to the lost original (fig. L).

Bibliog.: De Vesme, 1906, 118; Sack, 1910, 123; Knox, 1970/II, I/2; Rizzi, 1970, 158.

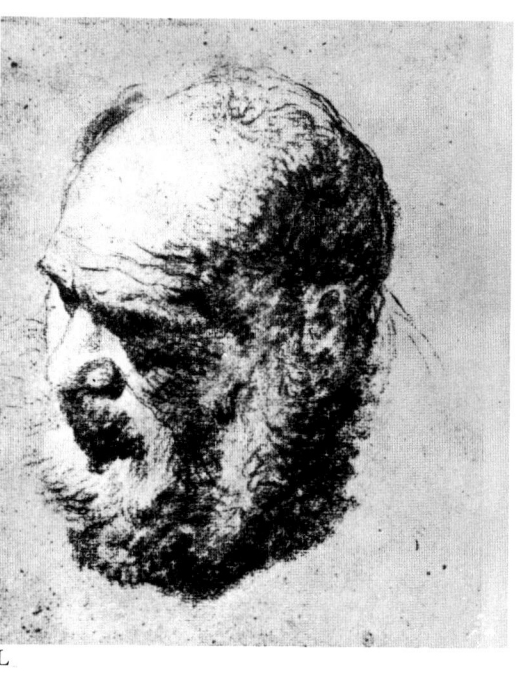

L

161

162

163. Series of Heads
Old man with a sword

124 × 104 mm. First state: before the number and with narrow margin at the bottom; second state: *3* at top right-hand corner and the sheet has been cut at the bottom and measures only 119 mm. in depth.

Sack wrote that Giambattista's original painting, from which the etching was derived, is in the Bosch Collection in Madrid. Knox connected the etching with the following works: Lepke sale, Berlin, 1929; Sotheby sale, London, 1956; Brunner Gallery, Paris, 1921; Galerie Cailleux, Paris, 1966.

Bibliog.: De Vesme, 1906, 119; Sack, 1910, 124; Knox, 1970/II, I/3; Rizzi, 1970, 159.

164. Series of Heads
Smiling old man

122 × 104 mm. First state: before the number, the sheet measures 154 mm. in height, and the left hand is visible, resting on a book and holding a sheet; second state: the height is cut down to 132 mm. the left hand, the book and the sheet have disappeared, and *4* has been added at top right.

According to Knox the etching was derived from Giambattista's painting sold in the Zay-Kolowrat sale, in the Dorotheum, Vienna, 1917.

Bibliog.: De Vesme, 1906, 120; Sack, 1910, 125; Knox, 1970/II, I/4; Rizzi, 1970, 160.

163

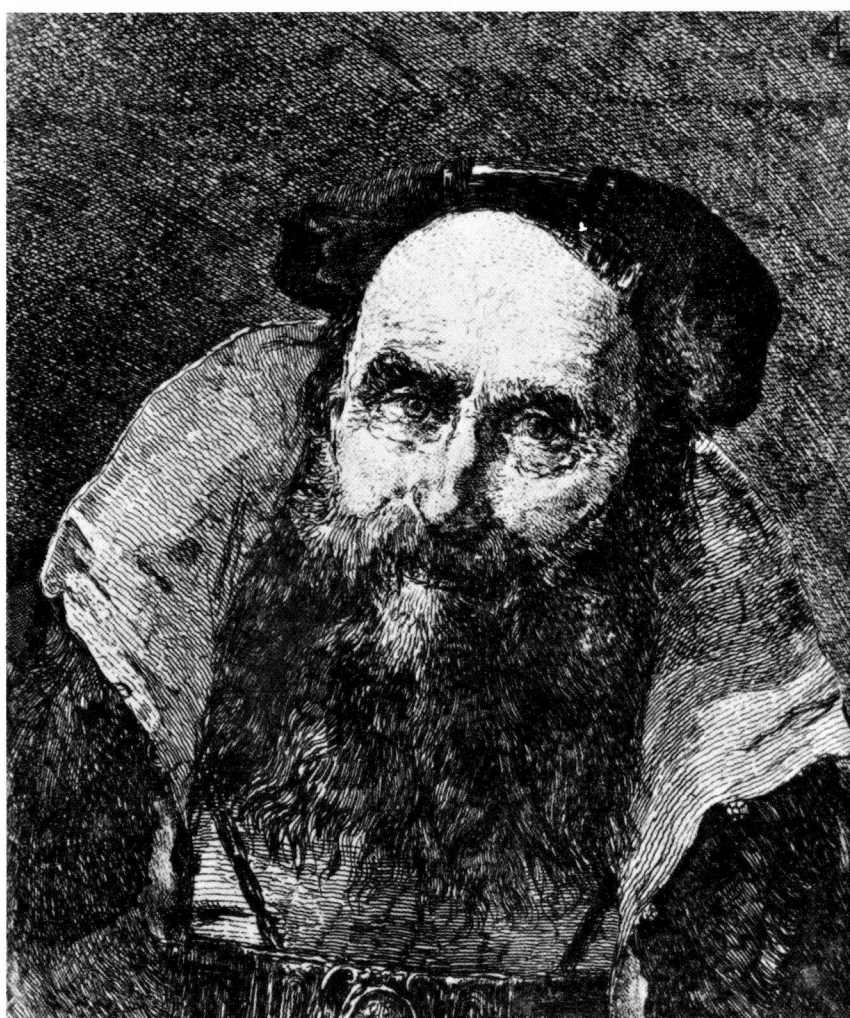

164

165. Series of Heads
Old man with a turban

136 × 107 mm. First state: before the number.

According to Sack, the etching is derived from a painting previously in the Vianelli Collection, Chioggia, and later in the Count Bullo Collection, Venice. Knox links it to works in the Dal Zotto Collection, Venice, the Mme de E. B. Ajura Collection, Paris, the Seligman Collection, New York, and a private collection in Milan.

Bibliog.: De Vesme, 1906, 121; Snack, 1910, 126; Knox, 1970/II, I/5; Rizzi, 1970, 161.

166. Series of Heads
Old man with small turban

137 × 109 mm. First state: before the number; second state: *6* at top right.

According to Sack, the etching is derived from a painting by Giambattista, formerly in the Weber Collection, Hamburg. Knox believes that the head was taken from the drawing in the Schlossmuseum in Weimar (No. 1447), attributed to Lorenzo Tiepolo, and links it with the following paintings: Böhler, Munich; Trop sale, Copenhagen, 1948; Spink, 1968; Sotheby sale, London, 1969; Malaspina Museum, Pavia. The etching is also stylistically close to the *Head of old Oriental* in the San Diego Fine Arts Gallery (Morassi, 1962, fig. 412). In the Martin von Wagner Museum at Würzburg there is a drawing by Johann Octavian Salver (1732–88), dated 1754, which is very close to this head. In the same museum there is a second sheet, also signed and dated 1754, of which the prototype can be identified with the head illustrated on pl. 167 (information kindly supplied by Nagia Rauf).

Bibliog.: De Vesme, 1905, 122; Sack, 1910, 127; Knox, 1970/II, I/6; Rizzi, 1970, 162.

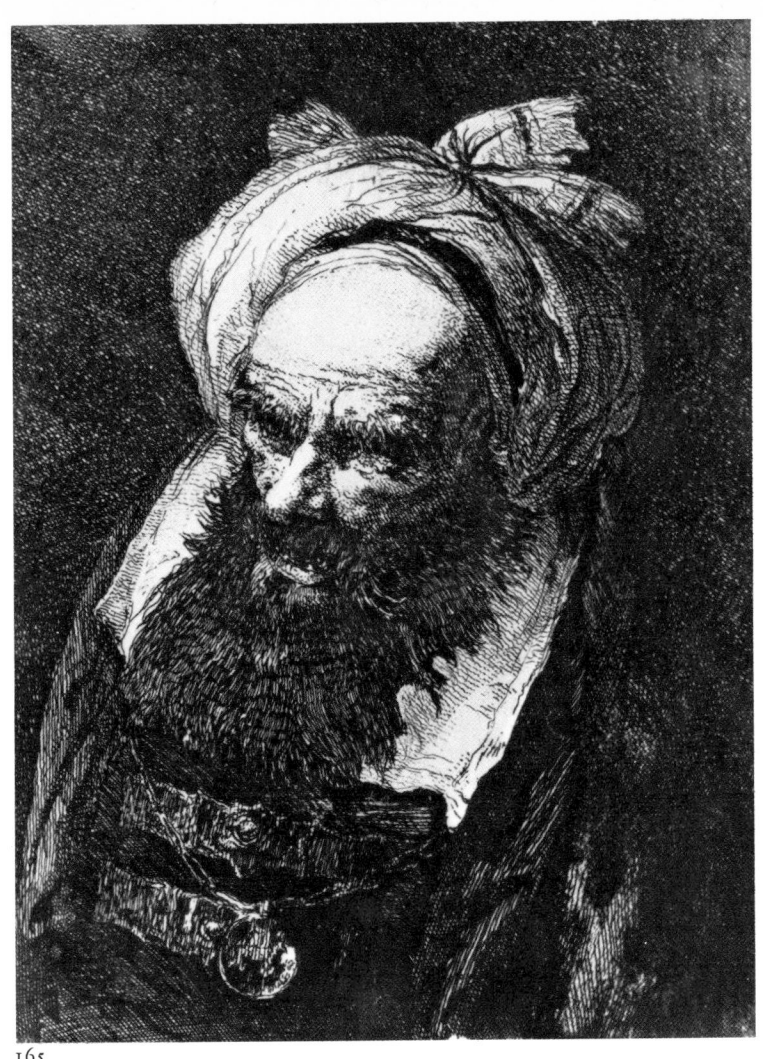

165

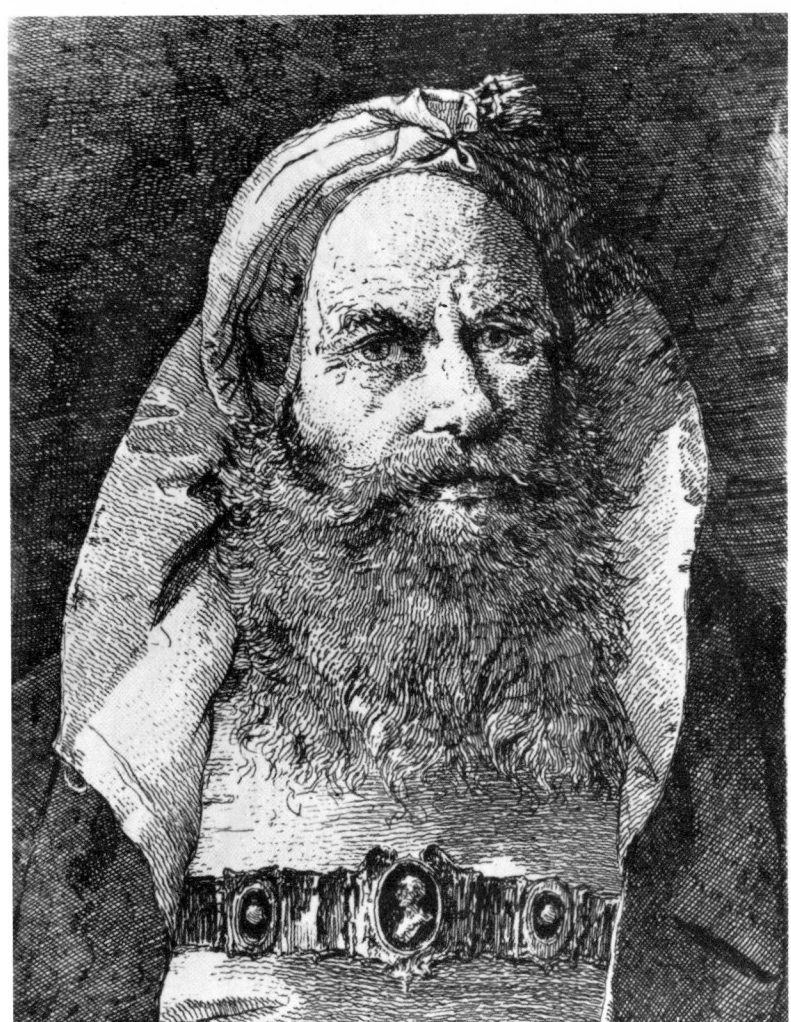

166

167. Series of Heads
Old man with a book

141 × 108 mm. First state: before the number; second state: *7* at top right-hand corner.

According to Sack, this etching is derived from a painting by Giambattista in the collection of the Marchesa de Perinat, Madrid.
Knox also points to the paintings in the Christie sale, London, 1966, and in the Chicago Art Institute (variation). A drawing in the Correr Museum shows a study for the hands.
See note to preceding plate.

Bibliog.: De Vesme, 1906, 123; Sack, 1910, 128; Knox, 1970/II, I/7; Rizzi, 1970, 163.

168. Series of Heads
Old man with magnifying glass

143 × 117 mm. First state: before the number; second state: *8* at top right-hand corner.

Sack linked this etching with a painting by Giambattista formerly in the Rudolph Kann Collection, Paris, and now in the Minneapolis Art Institute. According to Knox, it echoes both that painting and the one in the Alte Pinakothek, Munich. It can also be compared with a drawing in the Correr Museum showing a study of the hand holding the lens.

Bibliog.: De Vesme, 1906, 124; Sack, 1910, 129; Knox, 1970/II, I/8; Rizzi, 1970, 164.

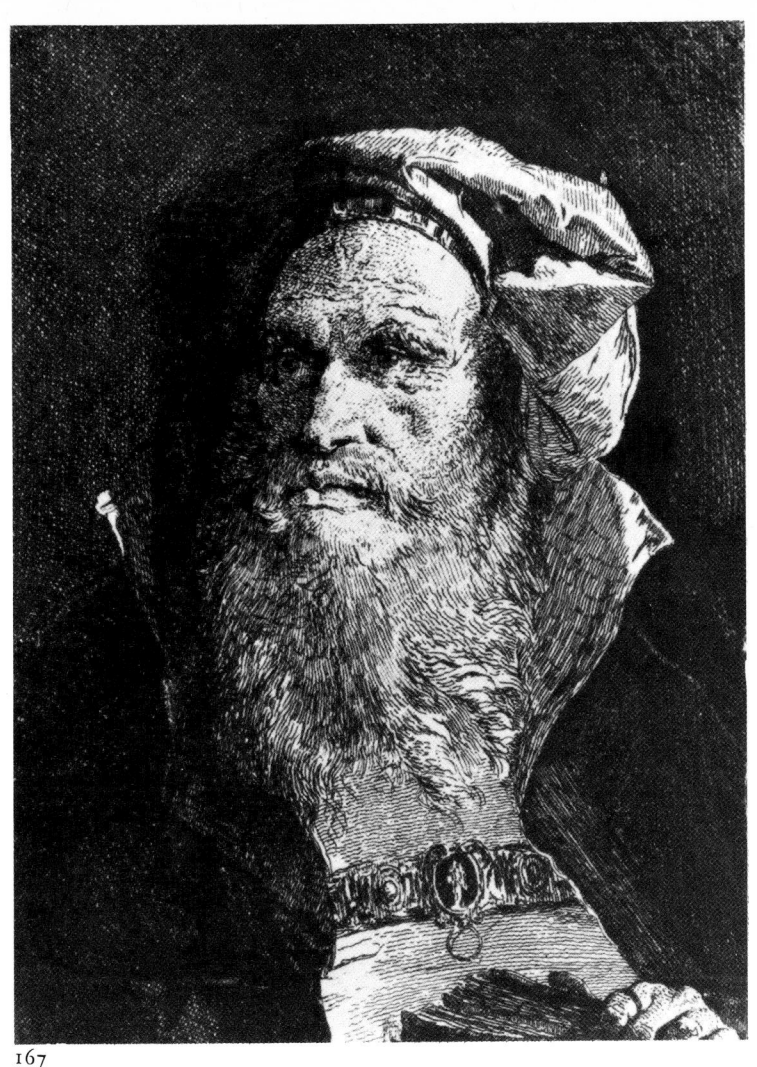

167

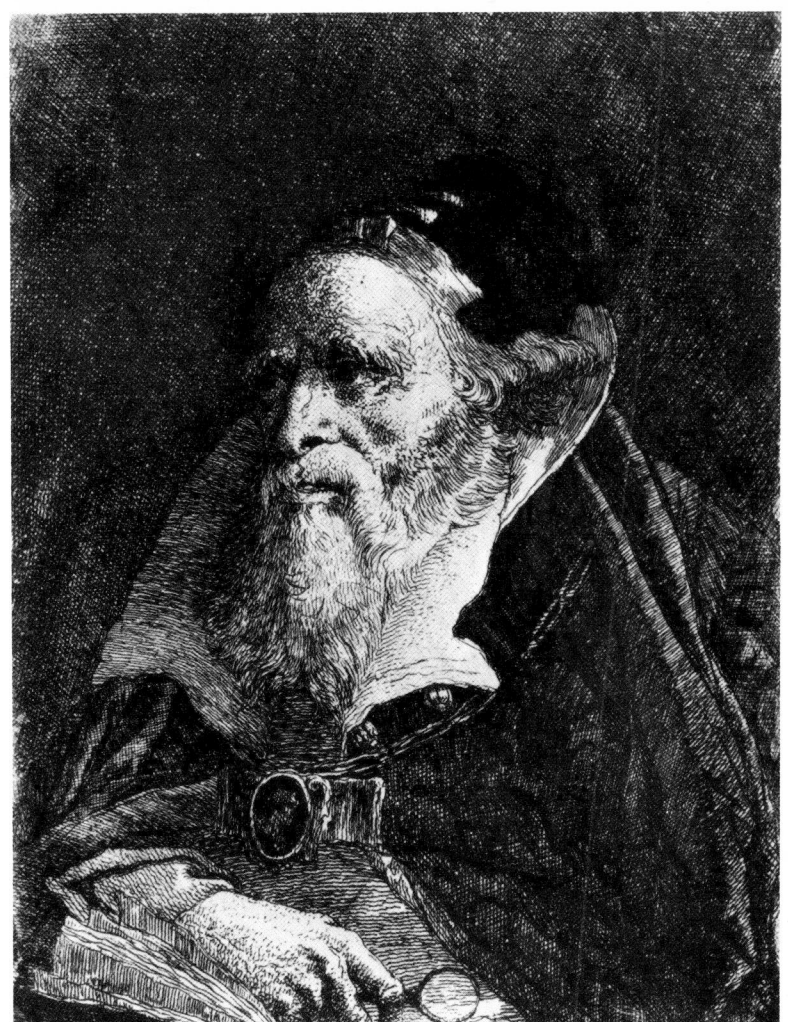

168

169. Series of Heads
Old man meditating

147 × 118 mm. Narrow margin at the sides. First state; before the number; second state: *9* at top right.

Morassi links this etching with the *Head* formerly in the Wildenstein Collection, New York; the work mentioned by Morassi, however, is related to another etching (see pl. 176). The etching illustrated here, is spite of certain alterations, could have been derived from the 'Head of an Oriental' in the Martin von Wagner Museum, Würzburg, by either Giambattista or Giandomenico. According to Knox, it has no connection with Giambattista's work.

Bibliog.: De Vesme, 1906, 125; Sack, 1910, 130; Morassi, 1962, p. 36; Knox, 1970/II, I/9; Rizzi, 1970, 165.

170. Series of Heads
Old man with a large hat

153 × 115 mm. First state: before the number and with *Do. Tiepolo* inscribed in reverse, bottom right; second state: beside the signature, *10* at top right.

The etching was based on a drawing in the Ashmolean Museum (fig. LI) and on the painting in the Hames Collection sold at Christie's in 1927.

Bibliog.: De Vesme, 1906, 126; Sack, 1910, 131; Pallucchini, 1941, 391; Pittaluga, 1952, p. 156; Pignatti, 1965, LXVII; Knox, 1966, p. 585 and 1970/II, I/10; Rizzi, 1970, 166.

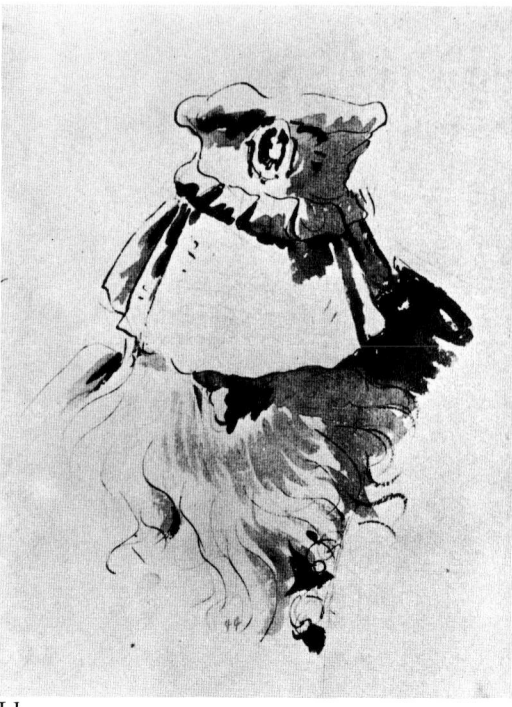

LI

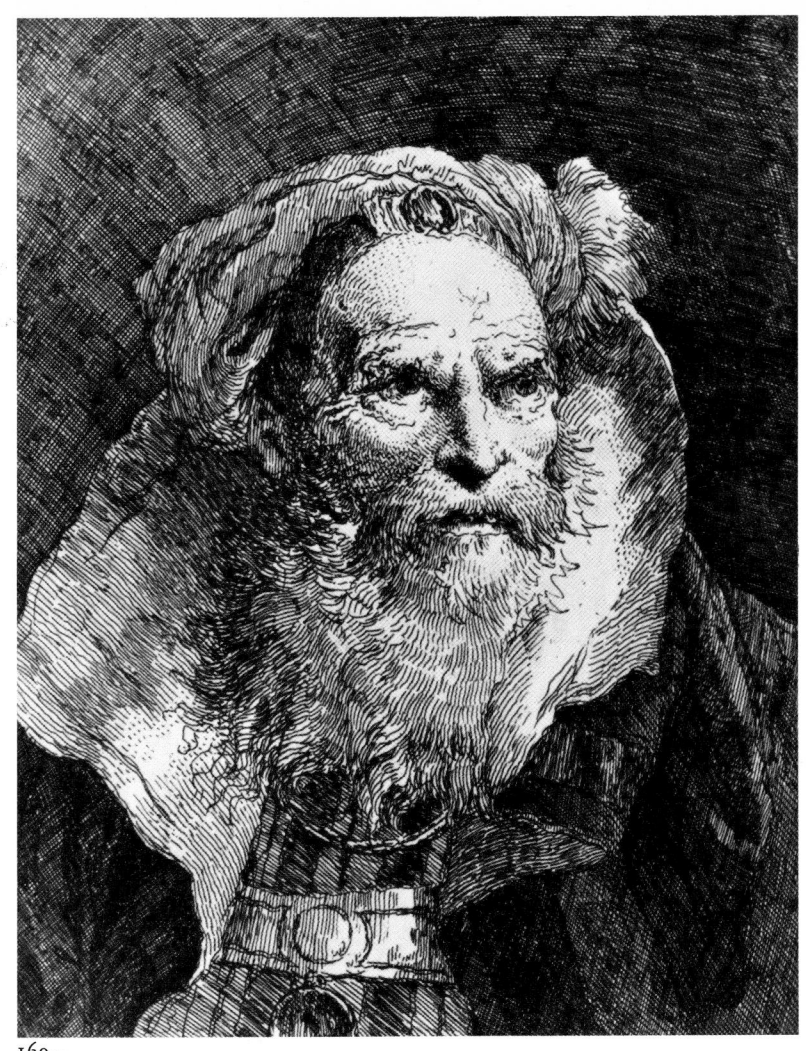

169

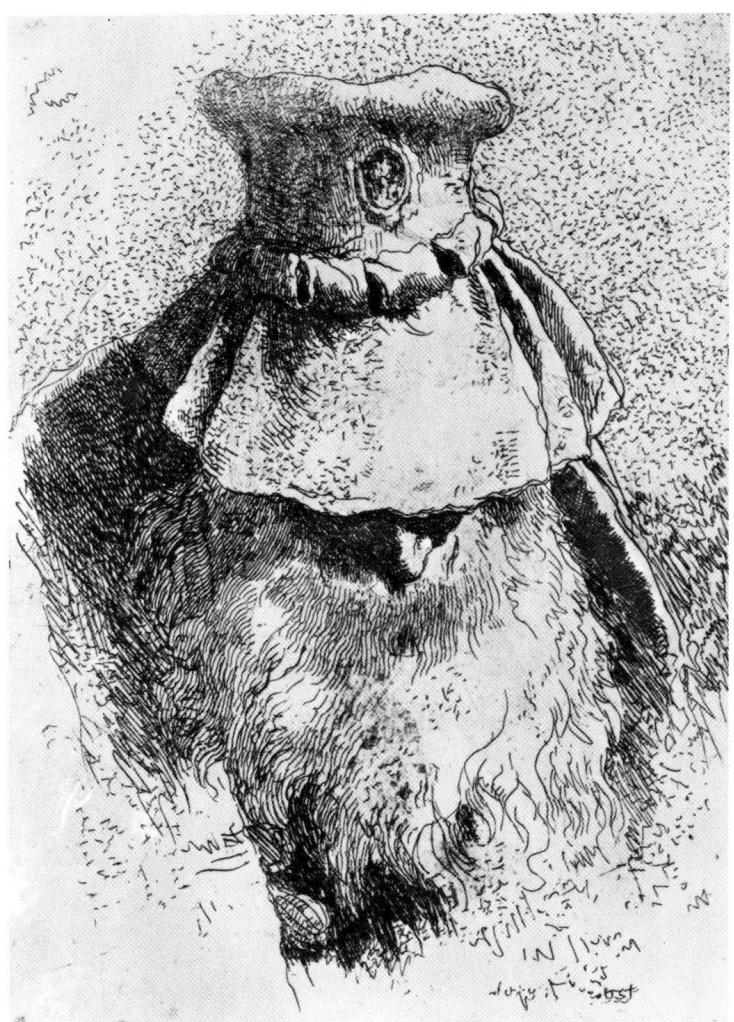

170

171. Series of Heads
Old man with bare head

138 × 110 mm. Without margin. First state: before the number; second state: no. *11* top right-hand corner.

Derived from the following paintings: Ambrosiana, Milan (Sack); Lazaro-Galdiano Museum, Madrid; Museum of Art, Philadelphia, and Malaspina Museum, Pavia (Knox).

Bibliog.: De Vesme, 1906, 127; Sack, 1910, 132; Knox, 1970/II, I/11; Rizzi, 1970, 167.

172. Series of Heads
A Pope with a jug

144 × 115 mm. First state; before the number; second state: *12* at top right-hand corner.

Based on the *Baptism of Constantine* painted by Giambattista in the parish church of Folzano and already engraved by Giandomenico (see pl. 134); it also recalls the drawings in the Cramer Collection, The Hague, and in the Correr Museum, Venice.

Bibliog.: De Vesme, 1906, 128; Sack, 1910, 133; Knox, 1970/II, I/12; Rizzi, 1970, 168.

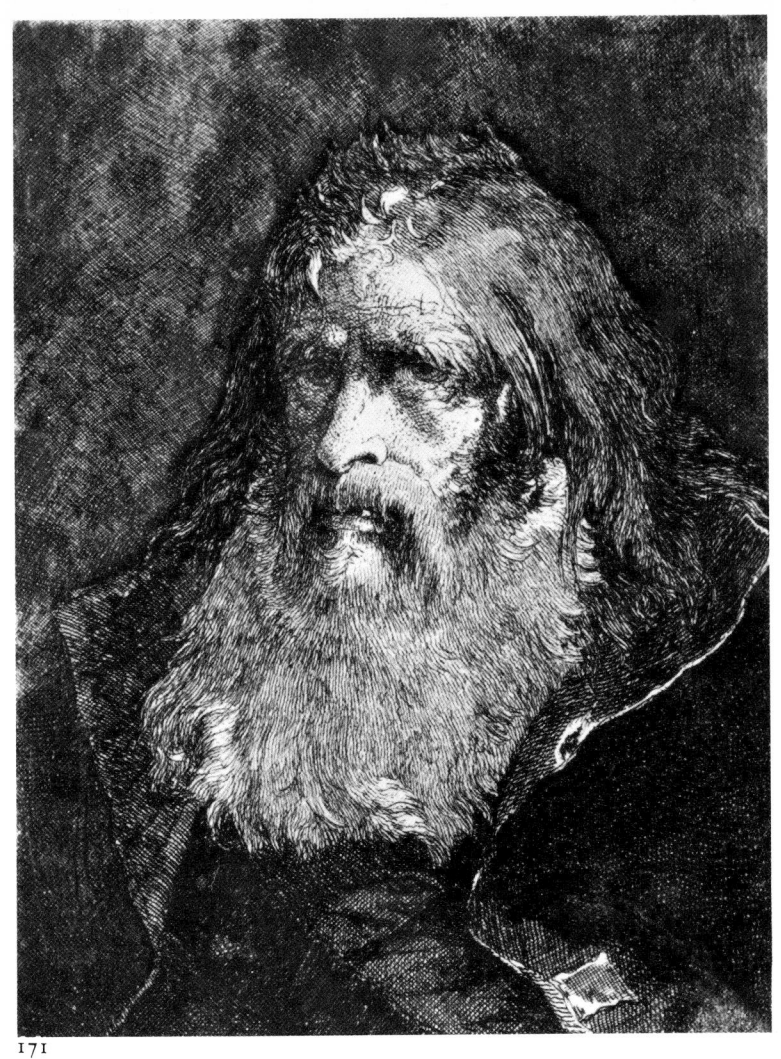

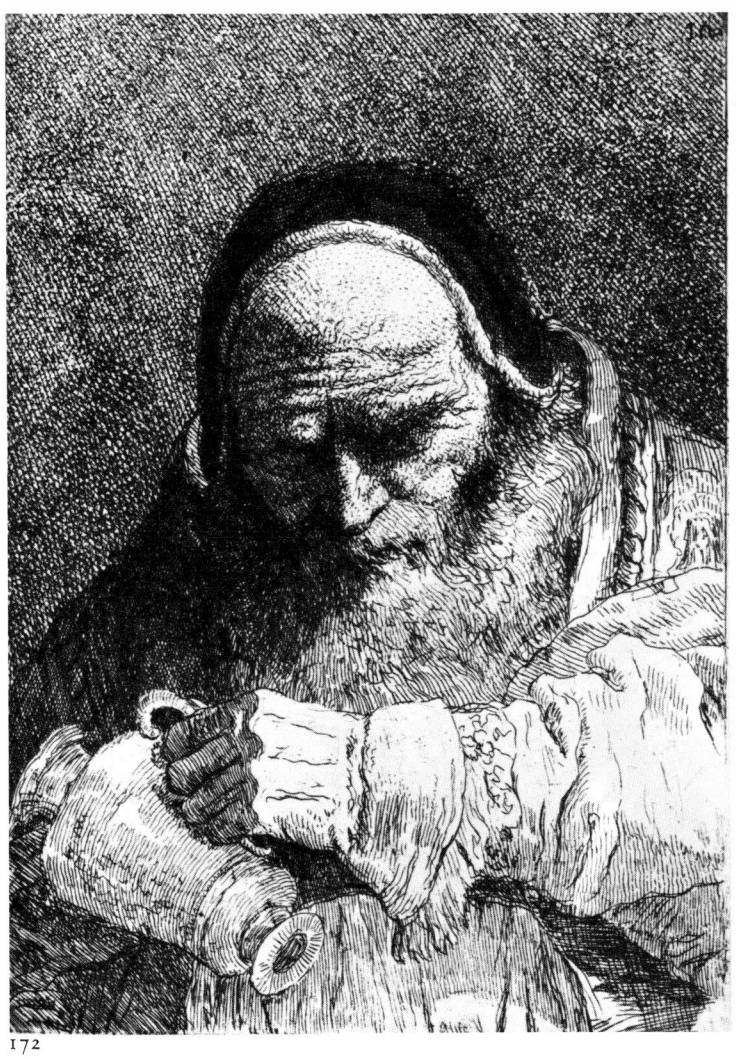

171

172

173. Series of Heads
Old man with bare head

149 × 113 mm. First state: before the number; second state; *13* at top right-hand corner.

According to Sack, it is derived from the painting in the Städelsches Kunstinstitut, Frankfurt, which was also engraved by Giandomenico (see pl. 105).

Bibliog.: De Vesme, 1906, 129; Sack, 1910, 134; Knox, 1970/II, I/13; Rizzi, 1970, 169.

174. Series of Heads
Old man with a beard

143 × 118 mm. First state; before the number; second state: *14* at top right-hand corner.

Sack linked the etching to a painting in the Rudolph Kann Collection, Paris, and to a variation without the hand in the Darmstadt Museum; Knox adds the paintings of Neumans, Paris, 1927, and in the Emilio Costantini Collection.

Bibliog.: De Vesme, 1906, 130; Sack, 1910, 135; Knox, 1970/II, I/14; Rizzi, 1970, 170.

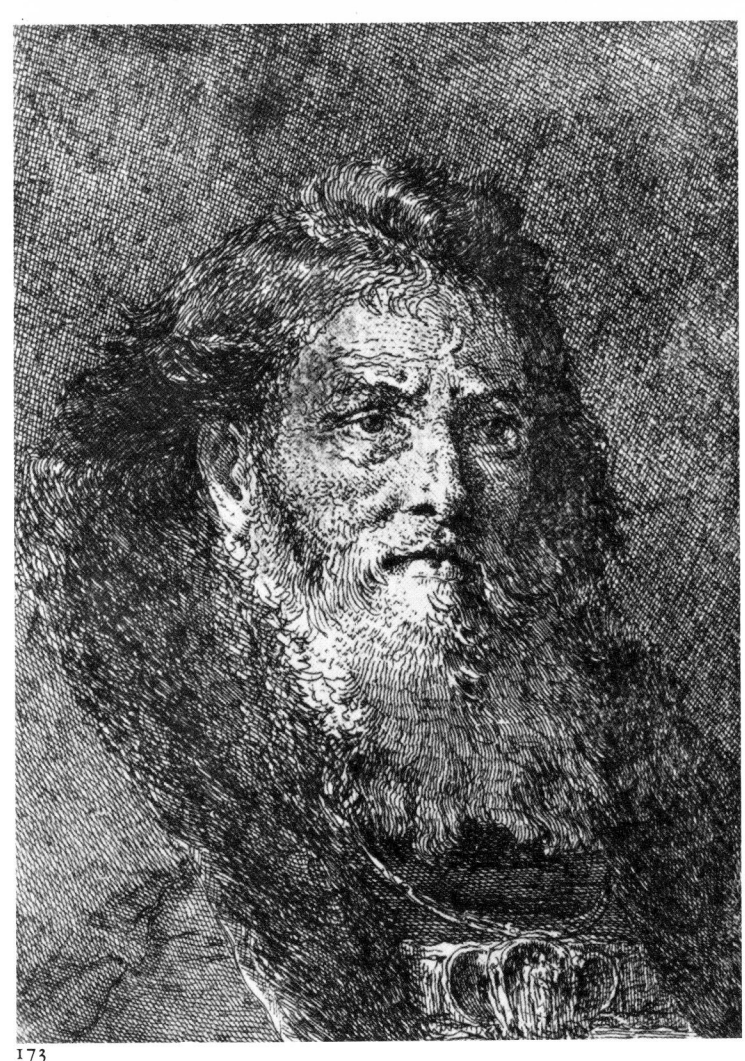

173

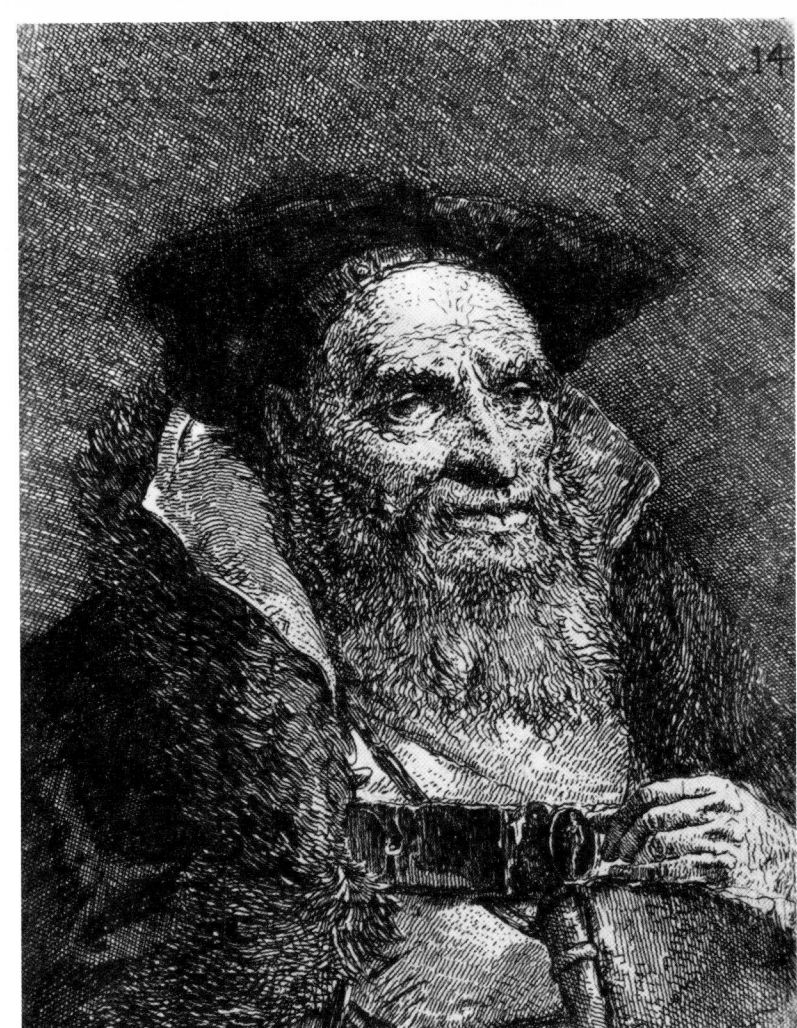

14

174

175. Series of Heads
Old man with an open book
141 × 109 mm. Bottom margin 4 mm.

According to Sack, it was derived from a painting in the Würzburg Museum, which Knox believes to be a copy by Lorenzo.
Knox mentions the paintings belonging to the Marchese Roi, Vicenza, and and those in the Pallavicini sale at Knight's, 1927.

Bibliog.: De Vesme, 1906, 131; Sack, 1910, 136; Knox, 1970/II, I/15; Rizzi, 1970, 171.

176. Series of Heads
Old man with a beard
138 × 108 mm. First state: before the number; second state: *16* at top right-hand corner.

Derived, as proved by Sack, from the painting previously in the Rudolph Kann Collection, Paris, now in a private collection in South America (Morassi).

Bibliog.: De Vesme, 1906, 132; Sack, 1910, 137; Morassi, 1962, p. 36, fig. 413; Knox, 1970/II, I/16; Rizzi, 1970, 172.

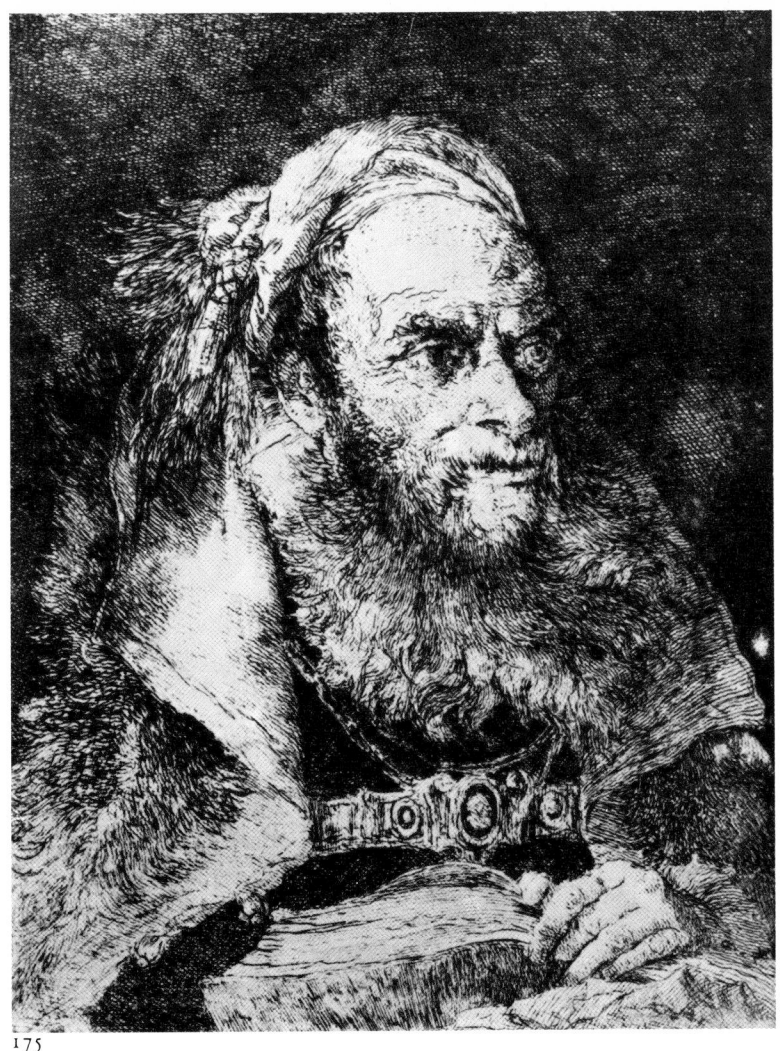

175

176

177. Series of Heads
Old man with a glove on his hand

143 × 115 mm. First state: before the number; second state: *17* at top right-hand corner.

Sack believed it to be derived from a painting previously in the Openich-Fontana Collection, Trieste, now in the Rusconi Collection, Trieste; Morassi also mentions a *Head of old Oriental* in a private collection in Zurich. According to Knox, the etching is also related to the following works: Nos. 1673 and 2183 in the Ca' Rezzonico, Venice; Grassi Collection, Florence; Schevitich sale, Paris, 1906; Weber sale, Hamburg, 1912; Sotheby sale, London, 1960; private collection, Milan.

Bibliog.: De Vesme, 1906; 133; Sack, 1910, 138; Morassi, 1962, p. 69; fig. 428; Knox, 1970/II, I/17; Rizzi, 1970, 173.

178. Series of Heads
Man with a moustache

144 × 116 mm. First state: before the number; second state: *18* at top right-hand corner.

Knox relates it to the following paintings: No. 1670 in the Ca' Rezzonico, Venice; Rudolph Kann Collection, Paris, 1907 catalogue, No. 130 (variant without hand or helmet, already mentioned by Sack); Henri Rouart sale, Paris, 1912.

Bibliog.: De Vesme, 1906, 134; Sack, 1910, 139; Knox, 1970/II, I/18; Rizzi, 1970, 174.

177

178

179. Series of Heads
Old man with a helmet

142 × 115 mm. First state: before the number; second state: *19* at top right-hand corner.

Giambattista's original, according to Sack, is in the Turner Collection, London. Knox also mentions the following paintings: Lilienfeld Collection, New York; private collection, Venice; Sir Charles Turner sale, Berlin, 1908; M. Adrien Fauchier Magnan Collection; Houston Galleries, Texas; Ing. R. Longhi (variant derived from the etching).

Bibliog.: De Vesme, 1906, 135; Sack, 1910, 140; Knox, 1970/II, I/19; Rizzi, 1970, 175.

180. Series of Heads
Young Moor

143 × 116 mm. First state: before the number; second state: *20* at top right-hand corner.

Derived from a detail of the altarpiece of *St. James of Compostela* in the Budapest Museum, already engraved by Giandomenico, and related to a drawing in the Talleyrand Collection (see pl. 132) (fig. LII).

Bibliog.: De Vesme, 1906, 136; Sack, 1910, 141; Knox, 1970/II, I/20; Rizzi, 1970, 176.

LII

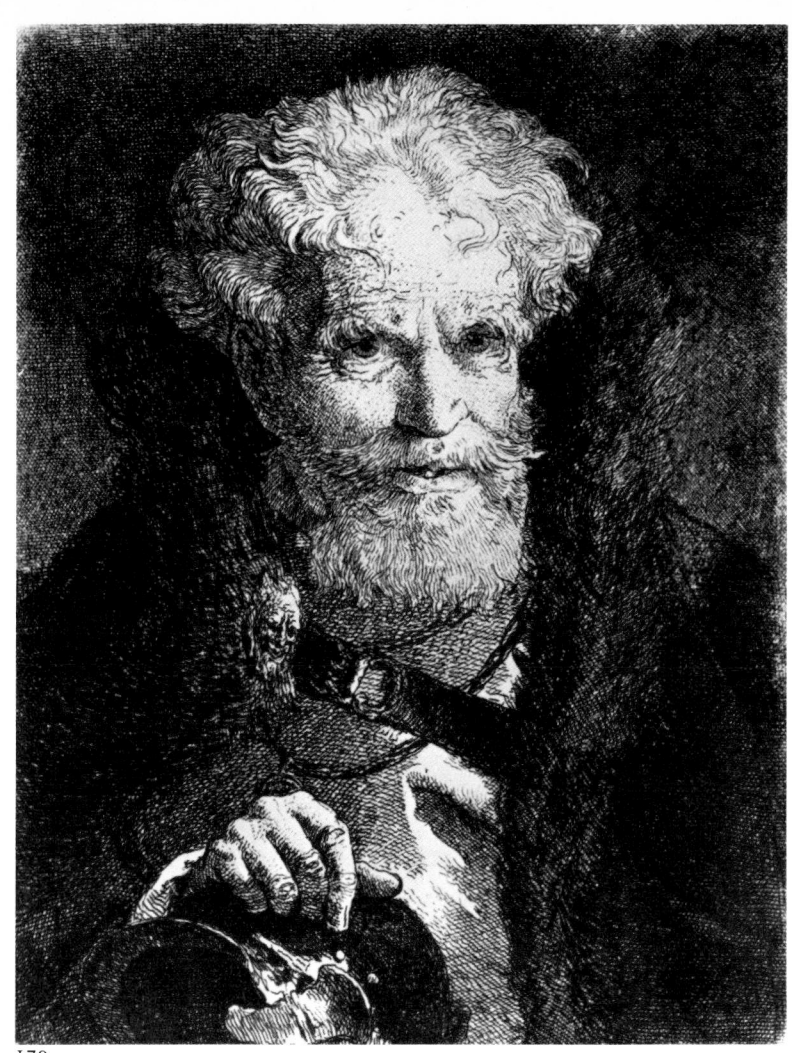

179

180

181. Series of Heads
Old man with bare head

143 × 102 mm. First state: before the num
ber; second state: *21* at top right-hand corner

Derived from a detail of the painting
of Sts. *Maximus and Oswald* in the
Pushkin Museum, Moscow; this i
confirmed by Knox.

Bibliog.: De Vesme, 1906, 137; Sack, 1910
142; Knox, 1970/II, I/21; Rizzi, 1970, 177

182. Series of Heads
Old man with a beard

132 × 103 mm. First state; before the num
ber; second state: *22* at top right-hand corner

Connected with a drawing in the
California Palace of The Legion of
Honor, San Francisco (fig. LIII).

Bibliog.: De Vesme, 1906, 138; Sack, 1910
143; Knox, 1970/II, I/22; Rizzi, 1970, 178

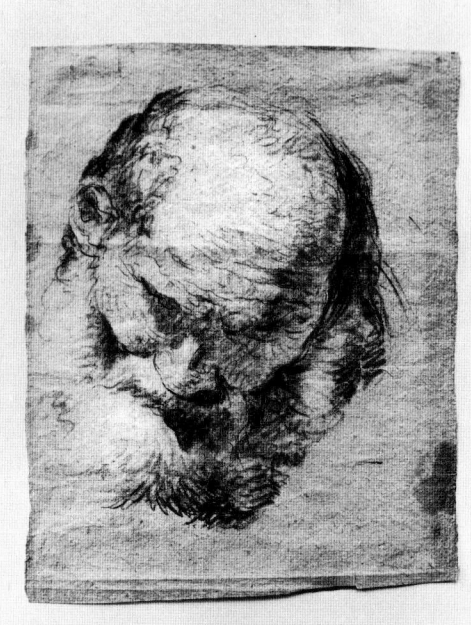

LIII

366

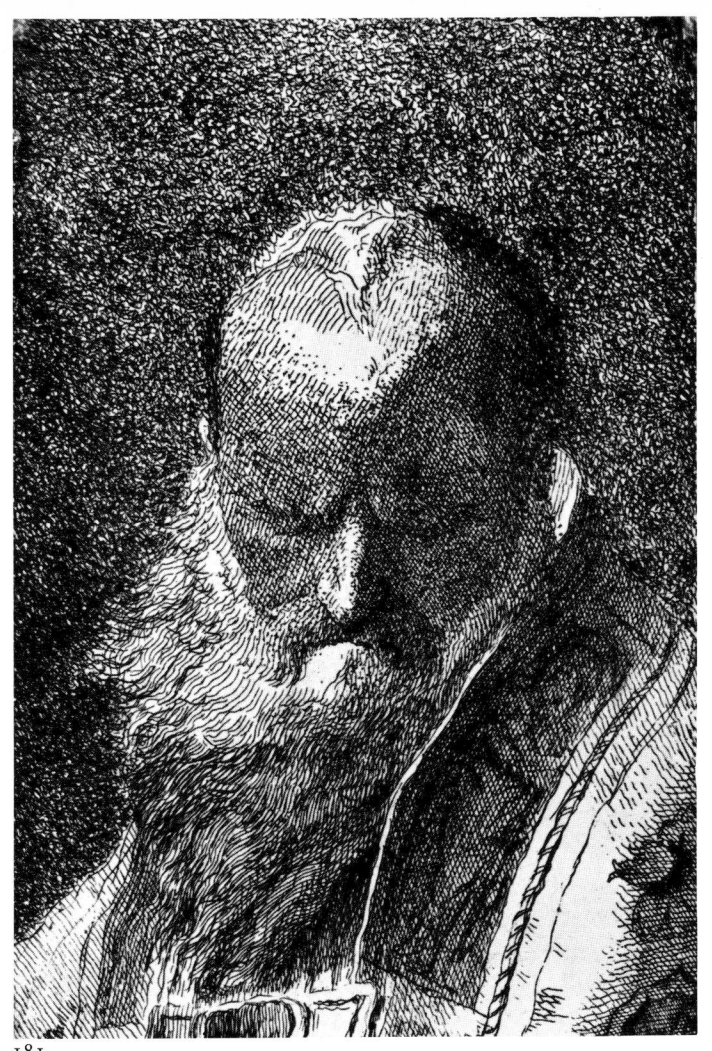

181

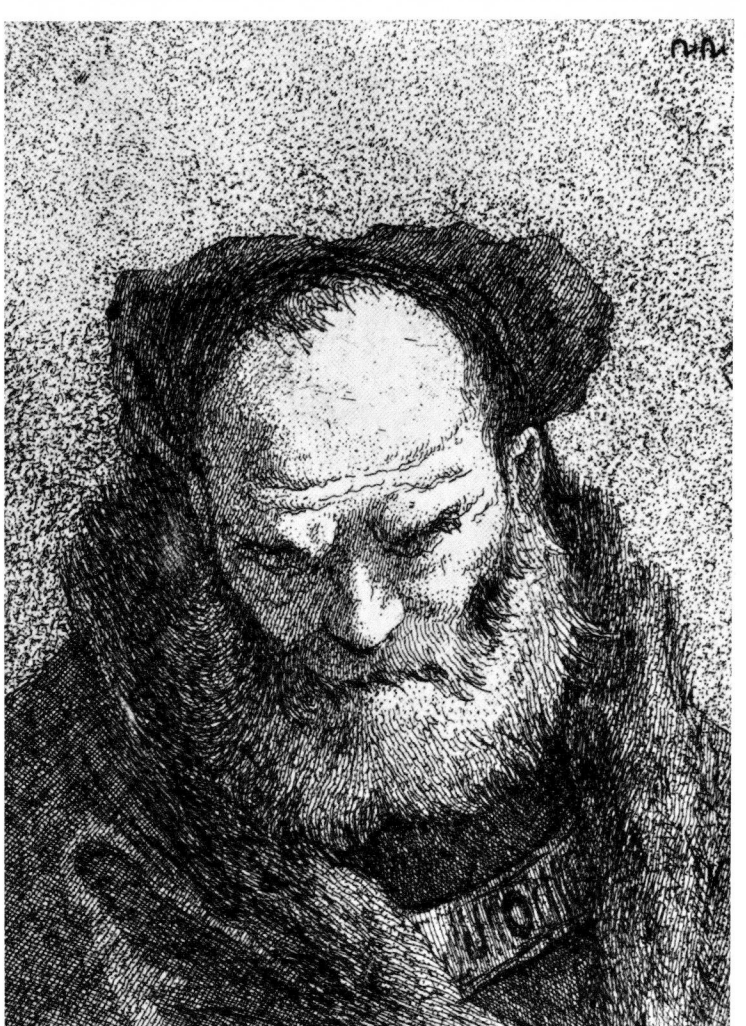

182

183. Series of Heads
Old man with a beard

134 × 105 mm. First state: before the number; second state: *23* at top right-hand corner.

Not connected with any known painting or drawing.

Bibliog.: De Vesme, 1906, 139; Sack, 1910, 144; Knox, 1970/II, I/23; Rizzi, 1970, 179.

184. Series of heads
Old man
in the manner of Rembrandt

133 × 108 mm. First state: before the number; second state: *24* at top right-hand corner. The print has been cut down to 138 mm. in depth.

Sack believed the original to be a painting in the Marchesa de Perinat Collection in Madrid; according to Knox, however, this painting was executed by Lorenzo and derived from the etching.

Bibliog.: De Vesme, 1906, 140; Sack, 1910, 145; Knox, 1970/I, I/24; Rizzi, 1970, 180.

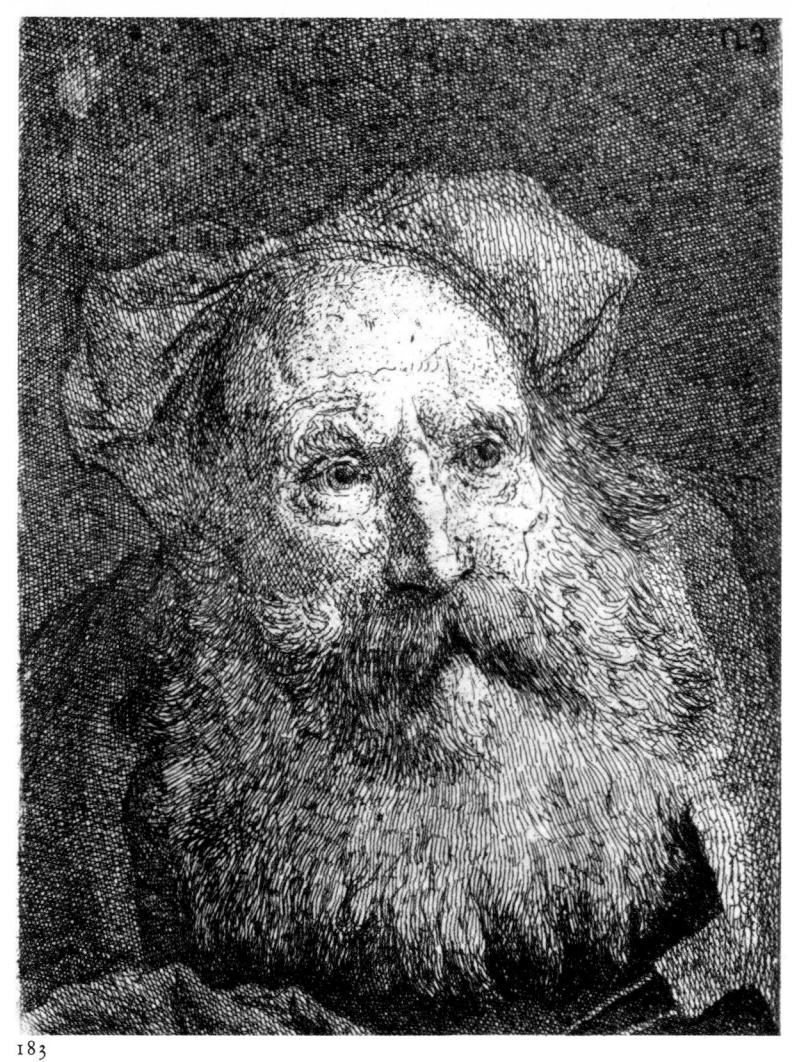

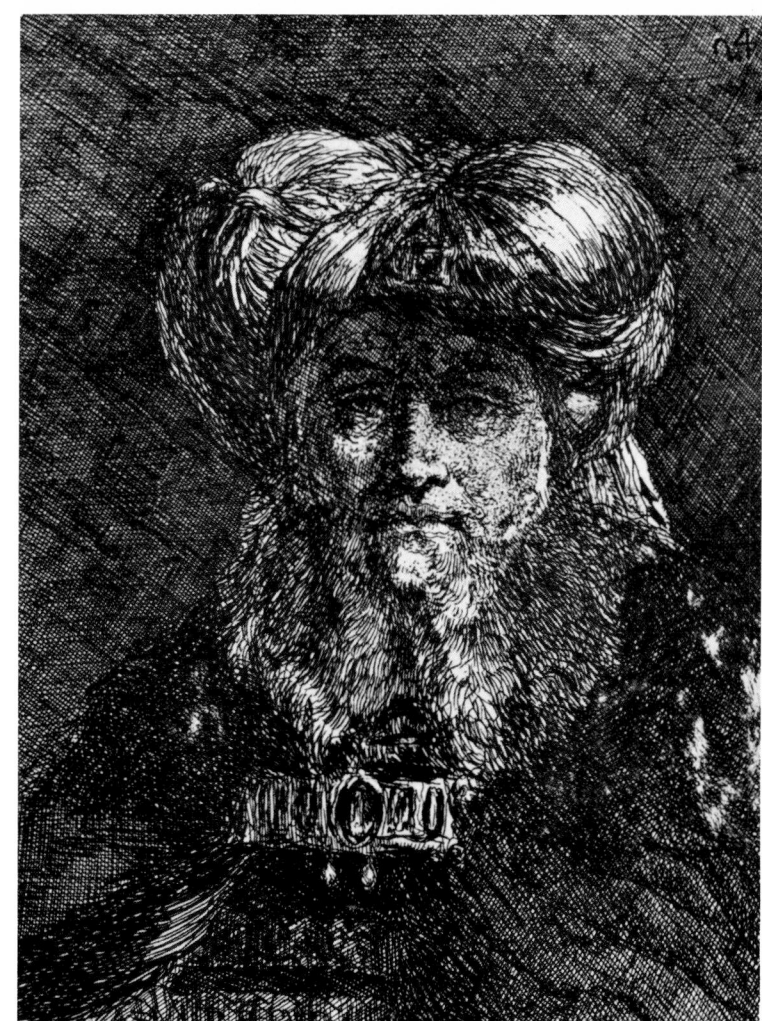

183

184

185. Series of Heads
Old man with a bracelet

148 × 108 mm. First state: before the number; second state; *25* at top right-hand corner.

Sack linked this etching with the 'Head of an Oriental' in the Martin von Wagner Museum, Würzburg.

Bibliog.: De Vesme, 1906, 141; Sack, 1910, 146; Knox, 1970/II, I/25; Rizzi, 1970, 181.

186. Series of Heads
Old man with a beard

149 × 110 mm. First state: before the number; second state: *26* at top right-hand corner.

Recalls, according to Knox, the paintings in the Jean Balachow Collection and in the De Perinat Collection (the latter had been pointed out also by Sack). A copy by Lorenzo is at Springfield.

Bibliog.: De Vesme, 1906, 142; Sack, 1910, 147; Knox, 1970/II, I/26; Rizzi, 1970, 182.

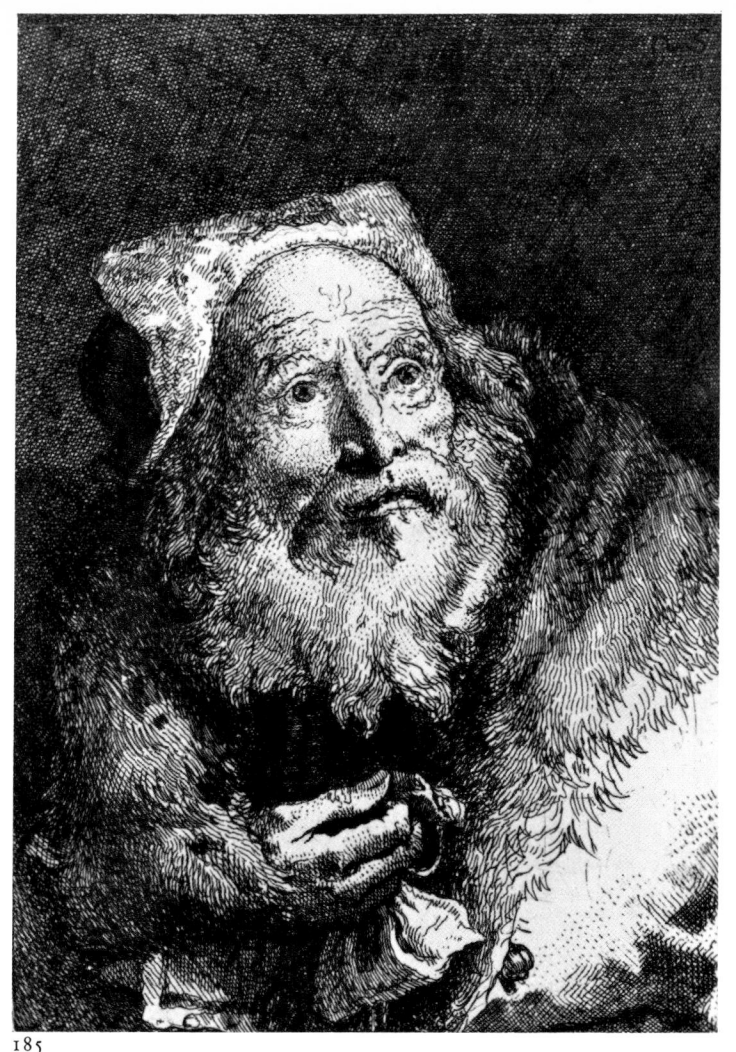

185

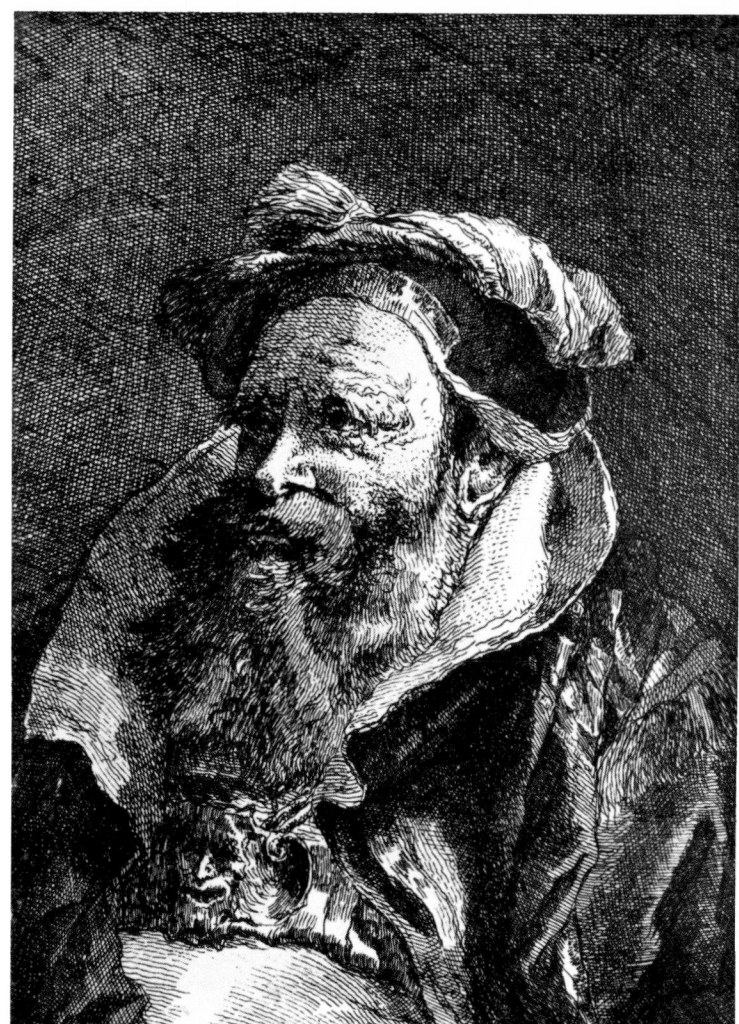

186

187. Series of Heads
Old man with a book

157 × 116 mm. First state: before the number, and with a margin at the bottom and on the right; second state: the sheet has been cut down to 139 mm. in depth and 107 mm. in width; *27* at top right-hand corner.

Based, according to Sack, on a painting in the Openich-Fontana Collection, Trieste; Knox relates it to works in the Prague National Gallery (previously Orloff), in the Baltimore Museum of Art and in the ownership of the American Art Association.

Bibliog.: De Vesme, 1906, 143; Sack, 1910, 148; Morassi, 1962, p. 41, fig. 411; Knox, 1970/II, I/27; Rizzi, 1970, 183.

188. Series of Heads
Old man with
his hat on his forehaed

151 × 107 mm. First state: before the number; second state: the sheet is only 144 mm. deep; *28* at top right-hand corner.

The photograph of a painting based on the etching is in the Witt Library, London (Knox).

Bibliog.: De Vesme, 1906, 144; Sack, 1910, 149; Knox, 1970/II, I/28; Rizzi, 1970, 184.

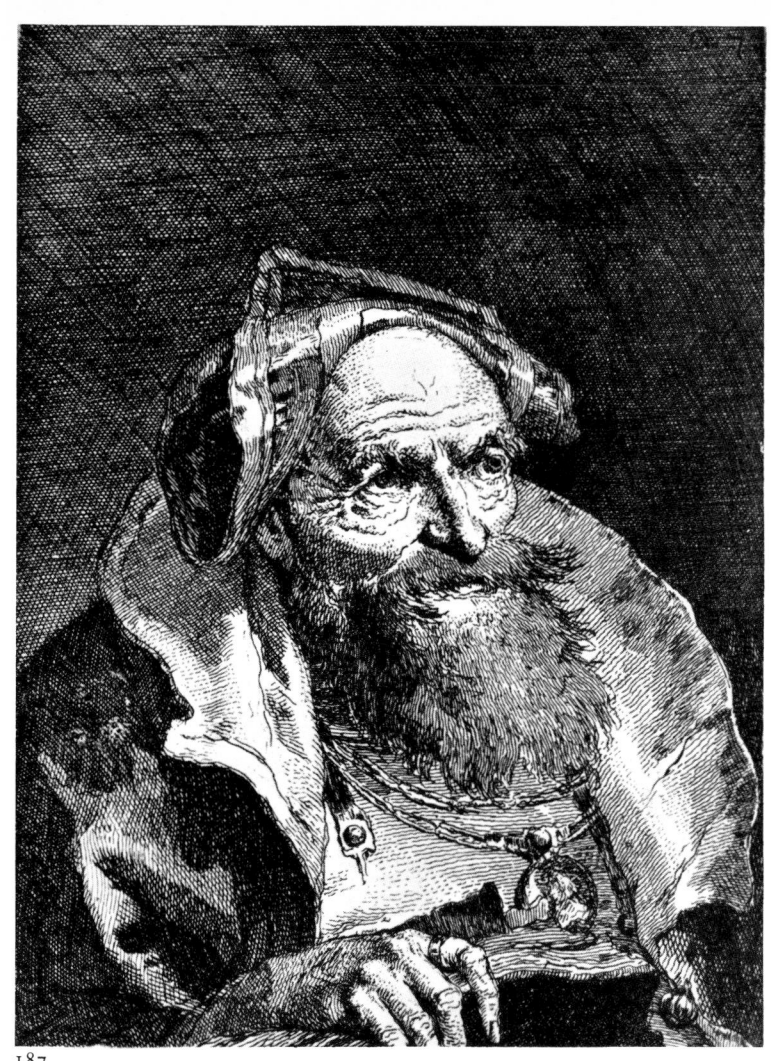

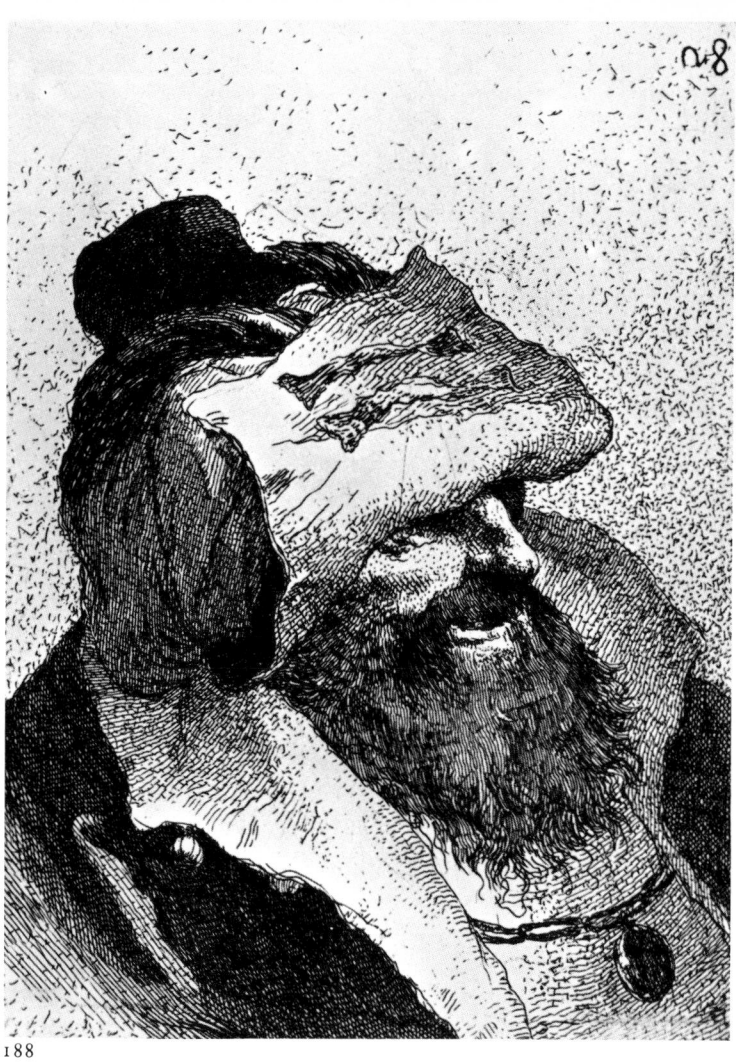

187

188

189. Series of Heads
The mathematician

152 × 121 mm. First state: before the number, the sheet being 160 mm. deep; second state: the sheet has been cut to 152 mm. in depth; *29* at top right-hand corner.

Connected, as Knox has pointed out, with paintings in the S. Fernando Academy, Madrid, and in a private collection in Udine. A drawing of the hand and paper is in the Correr Museum. The etching is also related to a drawing in the Schab Gallery, New York.

Bibliog.: De Vesme, 1906, 145; Sack, 1910, 150; Pignatti, 1965, LXVIII; Knox, 1970/II, I/29; Rizzi, 1970, 185.

190. Series of Heads
Old man with a beard

150 × 121 mm. First state: larger in size and before the number; second state: the bottom margin (22 mm.) has been reduced and the print is 150 mm. deep; *30* at top right-hand corner.

As pointed out by Pignatti, the preparatory drawing is in the collection of Count Antoine Seilern, London (Fig. LIV).

Bibliog.: De Vesme, 1906, 146; Sack, 1910, 151; Pignatti, 1965, LXIX; Knox, 1970/II, I/30; Rizzi, 1970, p. 186.

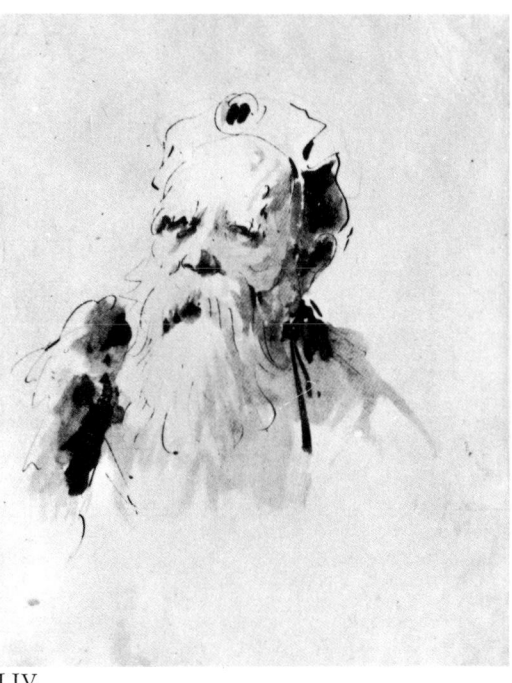

LIV

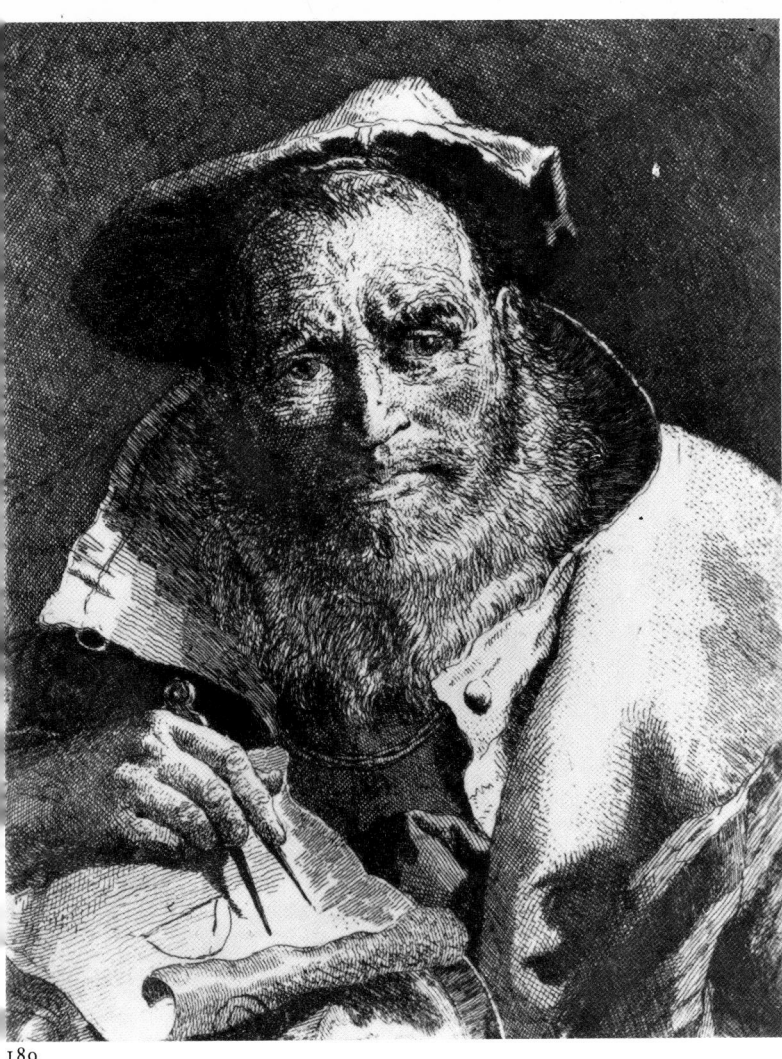

189

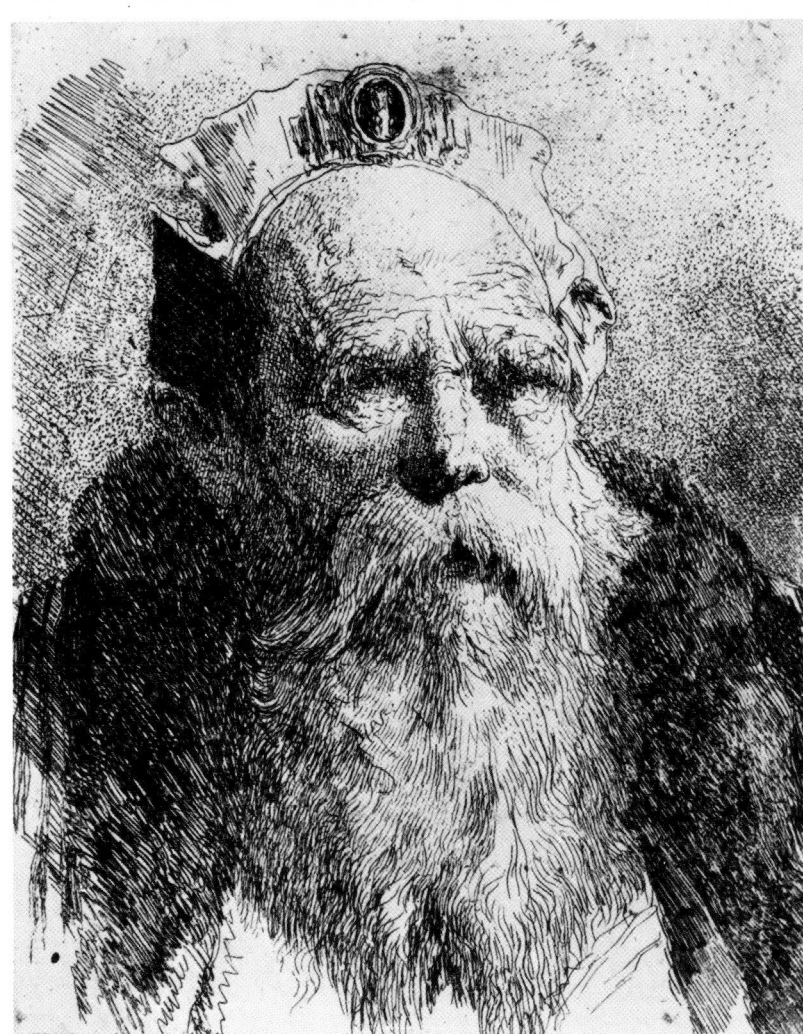

190

191. Series of Heads: Part Two
Title page

122 × 92 mm. *Raccolta | di | Teste N.º 30 | dipinte | dal Sig.r Gio.Batta Tiepolo | Pittore Veneto | al Servigio di S.M.C. | morto in Madrid | l'anno 1770. | Incise | da Gio. Domenico suo Figlio | divise in due libri | Libro Secondo.*

The title is here reproduced for the reader's benefit (fig. LV).

Bibliog.: De Vesme, 1906, 147; Sack, 1910, 152; Knox, 1970/II; Rizzi, 1970, 187.

Raccolta
di
Teste N.º 30
dipinte
dal Sig.r Gio.Batta Tiepolo
Pittore Veneto
al Servigio di S.M.C.
morto in Madrid
l'anno 1770.
Incise
da Gio.Domenico suo Figlio
divise in due libri
Libro Secondo.

LV

192. Series of Heads
Portrait of Giandomenico

119 × 95 mm. First state: before the number; second state: *30* at top left-hand corner; *1* at bottom left-hand corner. The version in the Udine museum has the inscription *Primo* at bottom left: it is a proof before numbers.

Sack pointed out that the etching is connected with Giandomenico's portrait in the Berlin museum, executed by Joseph Degle and dated 1773 (see also pl. 161).

Bibliog.: De Vesme, 1906, 148; Sack, 1910, 154; Knox, 1970/II, II/1; Rizzi, 1970, 188.

193. Series of Heads
Profile of an old man

122 × 85 mm. *2* at bottom left-hand corner.

De Vesme believed this head to be derived from the portrait of the artist Spinello Aretino, engraved on wood, which appears in the 1568 edition of Vasari's *Lives*. Knox identified the original in a detail of the fresco *Pietro Soderini entering Florence*, formerly in the Villa Soderini, Nervesa, and now destroyed. A drawing by Lorenzo, linked to this etching, was sold at Sotheby's in 1937.

Bibliog.: De Vesme, 1906, 149; Sack, 1910, 155; Knox, 1970/II, II/2; Rizzi, 1970, 189.

192

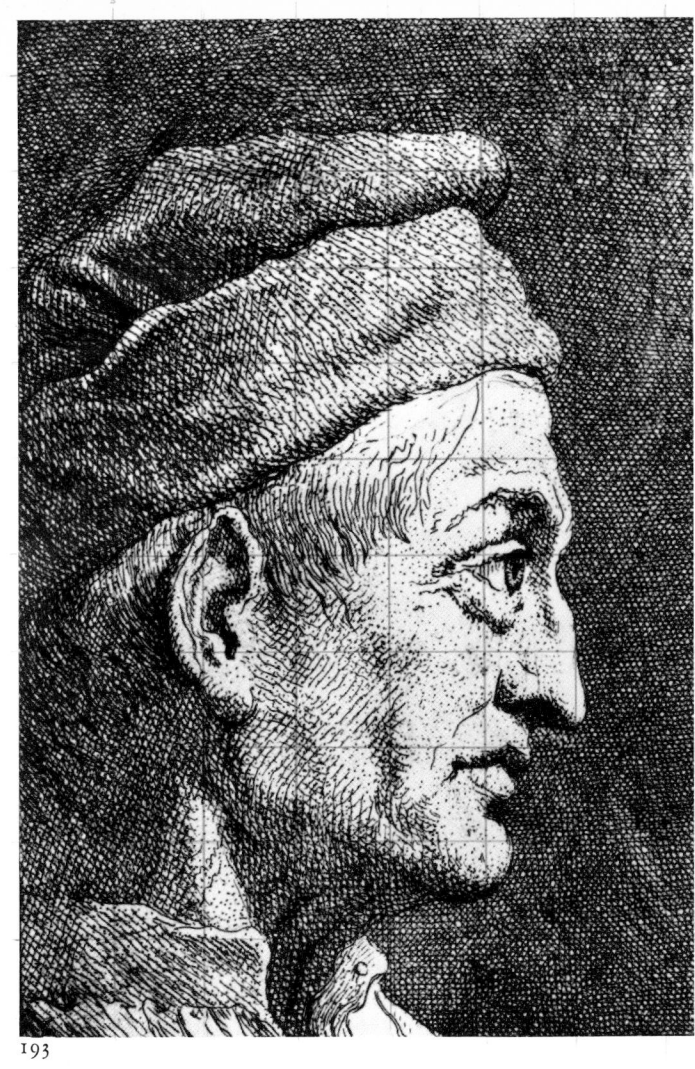

193

194. Series of Heads
Old man with a turban

112 × 90 mm. First state: before the num
ber; second state; *3* at bottom left-hand cor
ner.

As Knox has pointed out, the head
is derived from a painting in the Ra
sini Collection, Milan.

Bibliog.: De Vesme, 1906, 150; Sack, 1910
156; Knox, 1970/II, II/3; Rizzi, 1970, 190

195. Series of Heads
Old man in three-quarter view

118 × 80 mm. First state: before the num
ber; second state; *4* at bottom left-hand cor
ner.

There are no known related paintings
or drawings.

Bibliog.: De Vesme, 1906, 151; Sack, 1910
157; Knox, 1970/II, II/4; Rizzi, 1970, 191

194

195

196. Series of Heads
Old man with a beard and long hair

104 × 88 mm. First state: before the number; second state: *5* at bottom left-hand corner, with the signature *Tiepolo*.

This etching is derived from a drawing in the Atger Museum, Montpellier (fig. LVI).

Bibliog.: De Vesme, 1906, 152; Sack, 1910, 158; Pallucchini, 1937, p. 42; Knox, 1970, II, II/5; Rizzi, 1970, 192.

197. Series of Heads
Old man with a beard

117 × 83 mm. First state: before the number; second state: *6* at bottom left-hand corner.

The etching is related to a drawing in the Atger Museum, Montpellier, which was also used by Giandomenico for another etching (see pl. 214).

Bibliog.: De Vesme, 1906, 153; Sack, 1910, 159; Knox, 1970/II, II/6; Rizzi, 1970, 193.

LVI

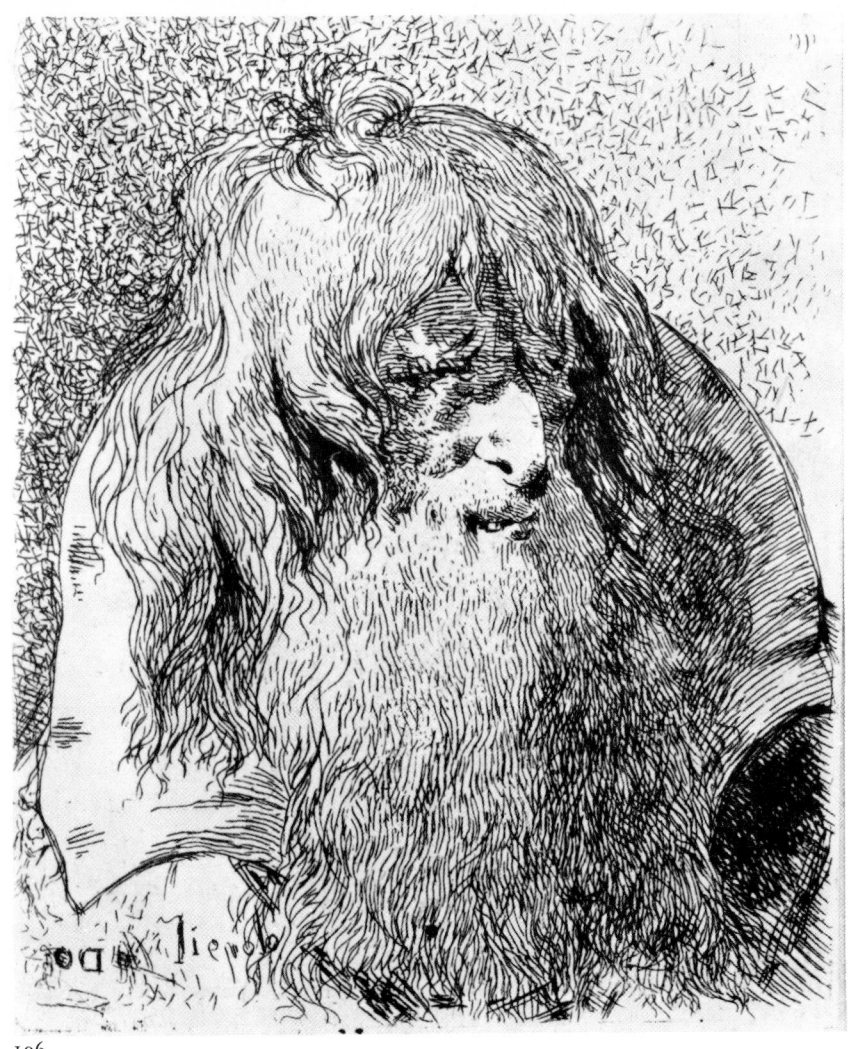

196

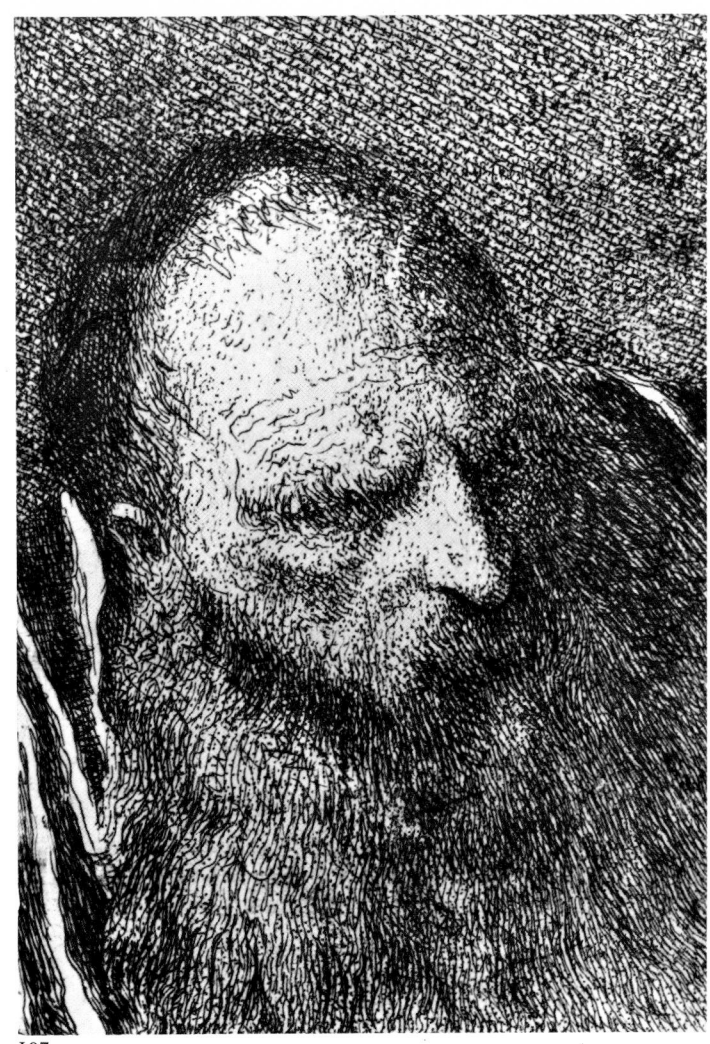

197

198. Series of Heads
Old man with a beard
113 × 83 mm. First state: before the number; second state: *7* at bottom left-hand corner.

The etching is derived from the *Banquet of Cleopatra* in the Archangel Museum, and is based on a lost drawing, probably by Giandomenico, who copied the head of one of the figures to the left of Cleopatra.

Bibliog.: De Vesme, 1906, 154; Sack, 1910, 160; Knox, 1970/II, II/7; Rizzi, 1970, 194.

199. Series of Heads
Profile of an old man
116 × 85 mm. First state: before the number; second state: *8* at bottom left-hand corner.

According to Sack, it is connected with a painting in a private collection in Berlin. Knox believes this head to be derived from a drawing in the National Museum, Warsaw, in which Giandomenico repeats a detail from the Palazzo Labia frescoes (fig. LVII).

Bibliog.: De Vesme, 1906, 155; Sack, 1910, 161; Knox, 1970/II, II/8; Rizzi, 1970, 195.

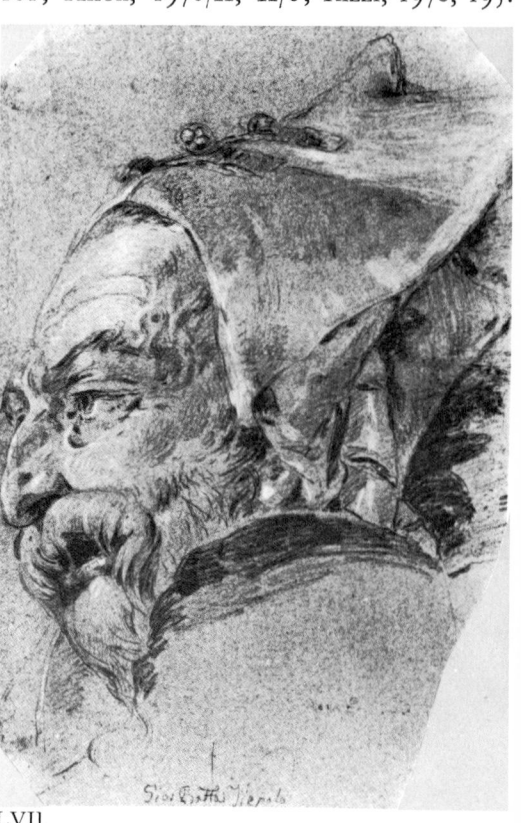

LVII

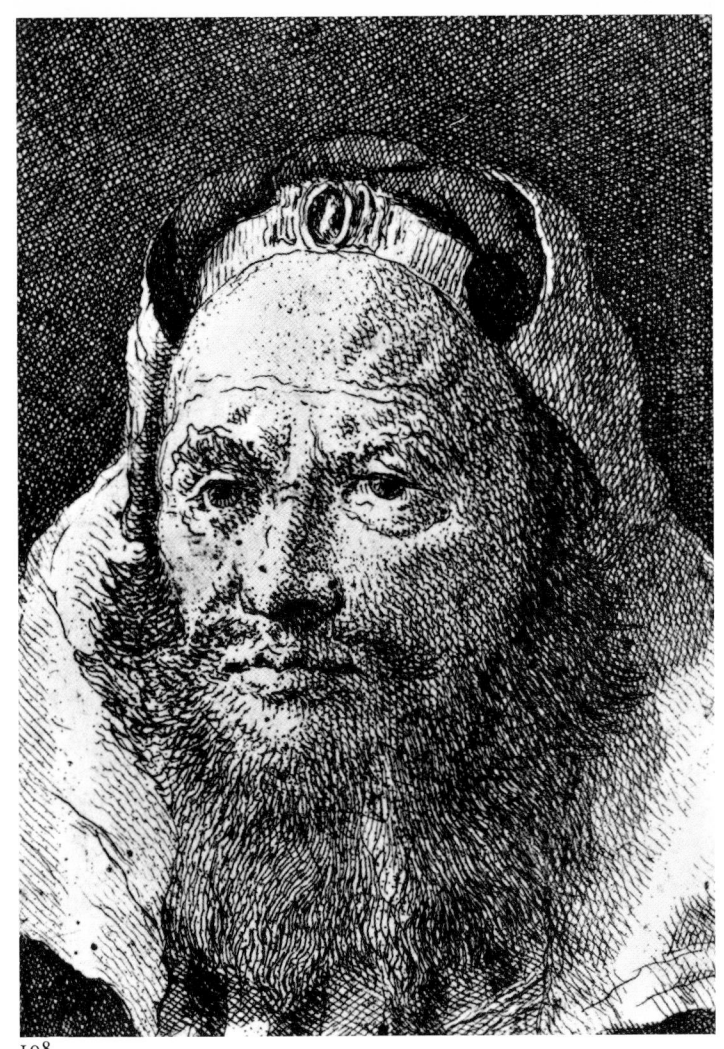

198

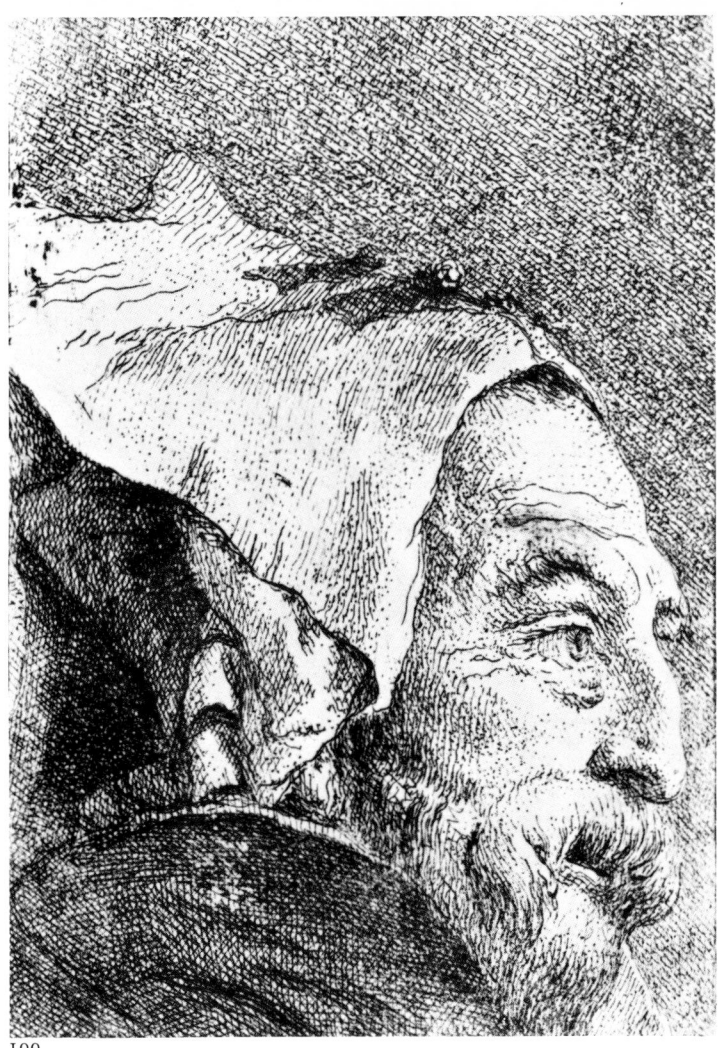

199

200. Series of Heads
Turk seen from the front

117 × 82 mm. First state: before the number; second state: *9* at bottom left-hand corner.

Not connected with any major works. Knox links it with a drawing formerly in the Richard Owen Collection, Paris (fig. LVIII).

201. Series of Heads
Turk with fur hat

117 × 84 mm. First state: before the number; second state: *10* at bottom left-hand corner.

Knox links it with the following drawings: Savile Album, Owen (fig. LIX); Colnaghi, 1952, No. 23; Montreal, 1953; No. 64; Matthiesen, 1963, No. 58.

LVIII

LIX

Bibliog.: De Vesme, 1906, 156; Sack, 1910, 162; Knox, 1970/II, II/9; Rizzi, 1970, 196.

Bibliog.: De Vesme, 1906, 157; Sack, 1910, 163; Knox, 1970/II, II/10; Rizzi, 1970, 197.

200

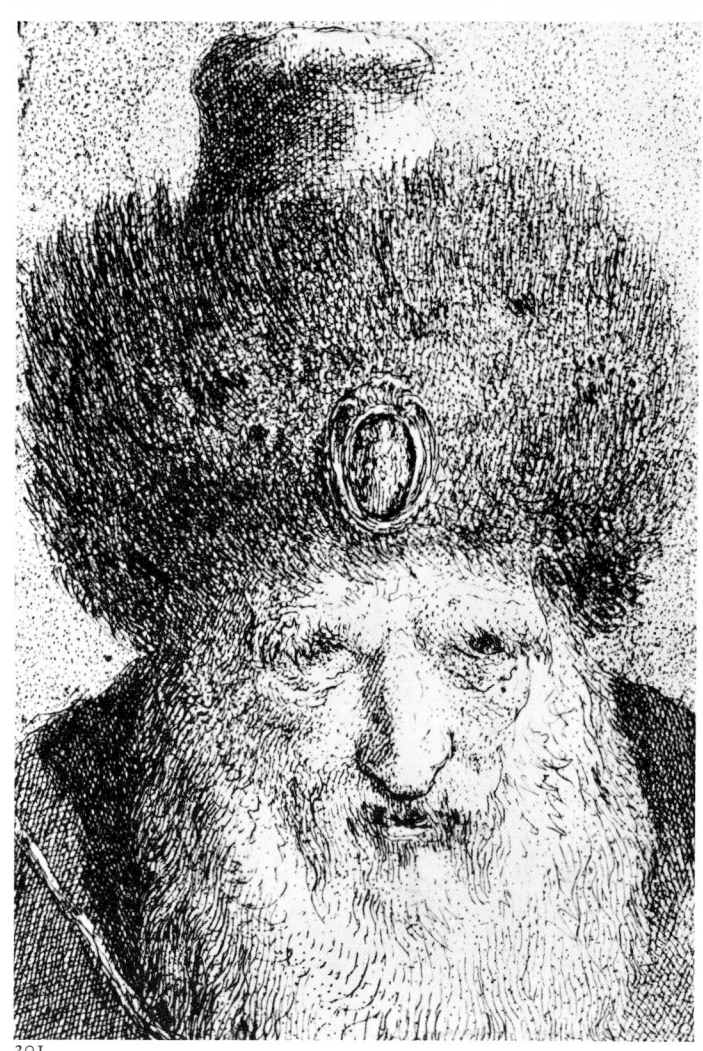

201

202. Series of Heads
Old man with a beard

122 × 90 mm. First state: before the number; second state: *11* at bottom left-hand corner.

Derived from a drawing in the Fogg Art Museum, Cambridge, Mass. (fig. LX).

Bibliog.: De Vesme, 1906, 158; Sack, 1910, 164; Knox, 1970/II, II/11; Rizzi, 1970, 198.

203. Series of Heads
Old man with a beard and a bare head

114 × 84 mm. First state: before the number; second state: *12* at bottom left-hand corner.

Knox relates the etching to a sheet in the Schlossmuseum, Weimar, executed by Lorenzo, and with a painting in the Agnelli Collection, Turin: *Halberdier* (part of the *Moses saved from the waters*, Edinburgh).

Bibliog.: De Vesme, 1906, 159; Sack, 1910, 165; Knox, 1970/II, II/12; Rizzi, 1970, 199.

LX

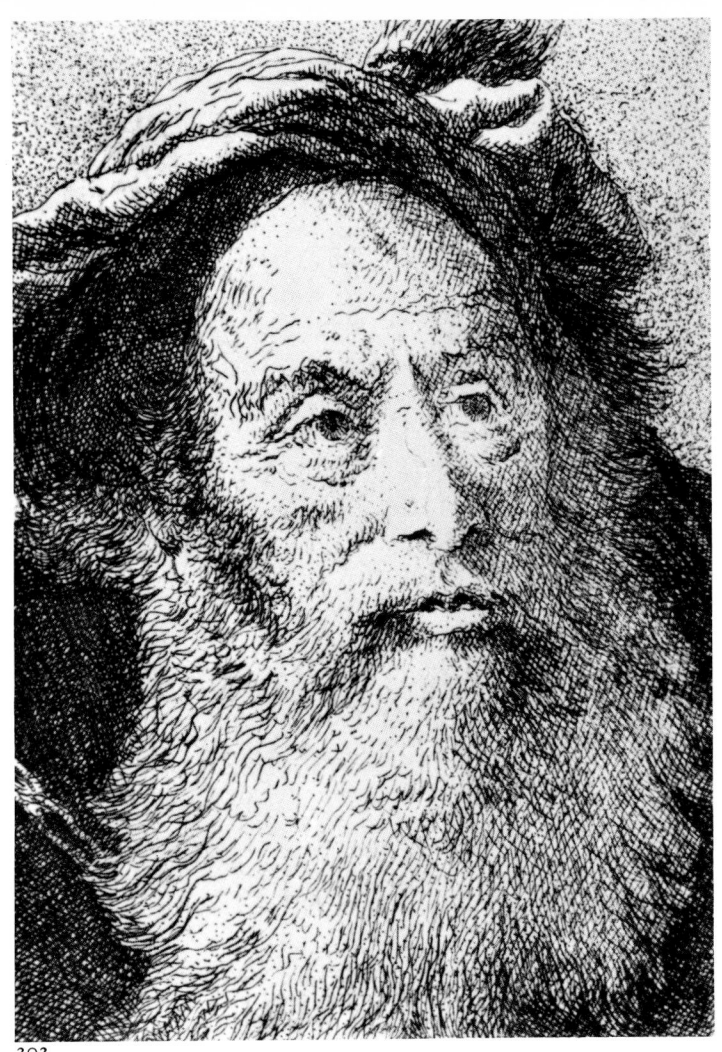

202

203

204. Series of Heads
Turk seen from behind

123 × 90 mm. First state: before the number; second state: *13* at bottom left-hand corner.

The head is derived from the *Banquet of Cleopatra* in the Archangel Museum, probably through a drawing by Giandomenico now lost (Knox).

Bibliog.: De Vesme, 1906, 160; Sack, 1910, 166; Knox, 1970/II, II/13; Rizzi, 1970, 200.

205. Series of Heads
Turk with a turban

121 × 86 mm. First state: before the number; second state: *14* at bottom left-hand corner.

Knox points out that the head is closely related to that of the standing figure in the centre of the *Road to Calvary* in S. Alvise, Venice.

Bibliog.: De Vesme, 1906, 161; Sack, 1910, 167; Knox, 1970/II, II/14; Rizzi, 1970, 201.

204

205

206. Series of Heads
Turk seen from behind

122 × 89 mm. First state: before the number; second state: *15* at bottom left-hand corner.

Not connected with any known painting or drawing.

Bibliog.: De Vesme, 1906, 162; Sack, 1910, 168; Knox, 1970/II, II/15; Rizzi, 1970, 202

207. Series of Heads
Turk seen from behind

120 × 79 mm. First state: before the number; second state: *16* at bottom left-hand corner.

Once again, not connected with any any know work.

Bibliog.: De Vesme, 1906, 163; Sack, 1910, 169; Knox, 1970/II, II/16; Rizzi, 1970, 203

206

207

208. Series of Heads
**Three-quarter view
of an old man with a beard**

123 × 91 mm. First state: before the number; second state: *17* at bottom left-hand corner.

This is derived from the *Banquet of Cleopatra* in the National Gallery of Victoria, Melbourne. The drawing, presumably by Giandomenico, which reproduced the head of the standing figure at the right of the scene, is now lost. See also pl. 240.

Bibliog.: De Vesme, 1906, 164; Sack, 1910, 170; Knox, 1970/II, II/17; Rizzi, 1970, 204.

209. Series of Heads
Profile of an old man with a hat

123 × 91 mm. First state: before the number; second state: *18* at bottom left-hand corner.

Like pl. 208, this head is also derived from the *Banquet of Cleopatra* in the National Gallery of Melbourne. Giandomenico's drawing, reproducing the head of the standing figure to the left, cannot be traced.

Bibliog.: De Vesme, 1906, 165; Sack, 1910, 171; Knox, 1970/II, II/18; Rizzi, 1970, 205.

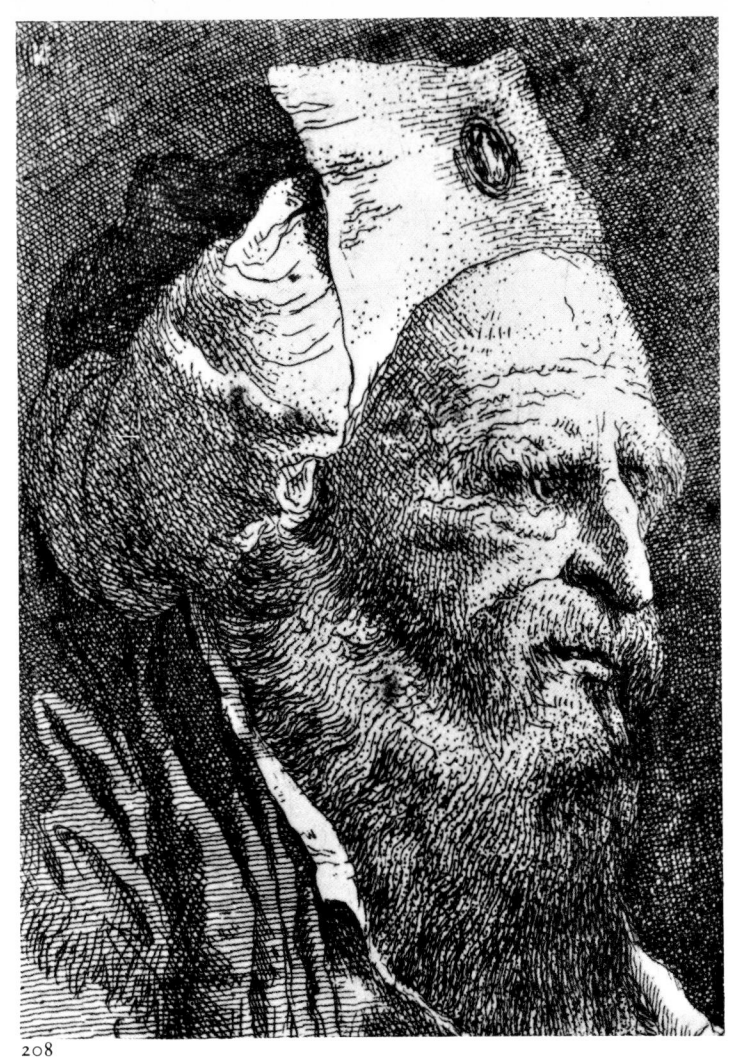

208

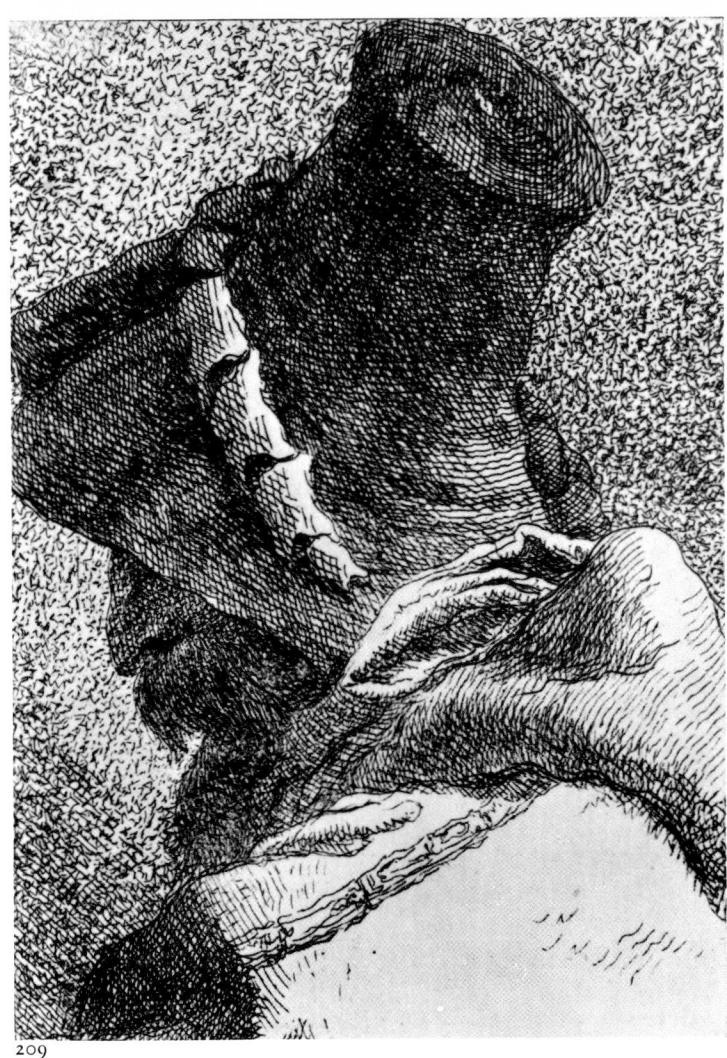

209

210. Series of Heads
Bearded old man with a hat

124 × 93 mm. First state: before the number; second state: *19* at bottom left-hand corner.

Related to a drawing in the Atger Museum, Montpellier (fig. LXI).

Bibliog.: De Vesme, 1906, 166; Sack, 1910, 172; Knox, 1970/II, II/19; Rizzi, 1970, 206.

211. Series of Heads
Old man looking downwards

123 × 89 mm. First state: before the number; second state: *20* at bottom left-hand corner.

The etching is derived from the *Martyrdom of St. Agatha* in the Basilica del Santo, Padua, from which it repeats the head of God the Father (Knox).

Bibliog.: De Vesme, 1906, 167; Sack, 1910, 173; Knox, 1970/II, II/20; Rizzi, 1970, 207.

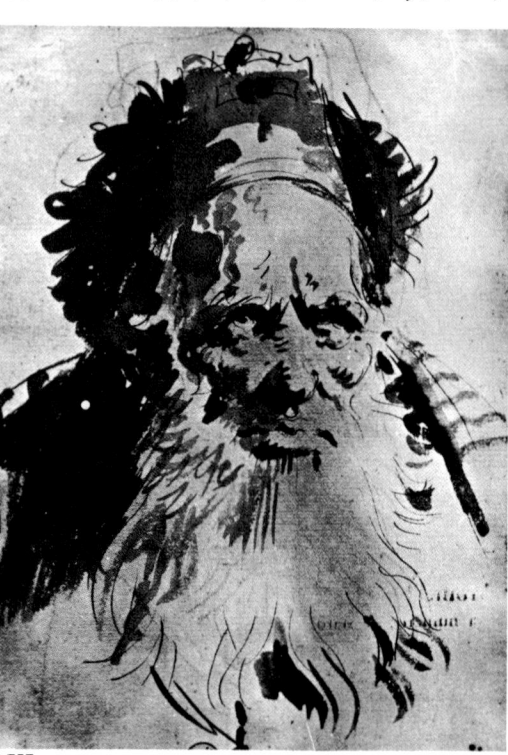

LXI

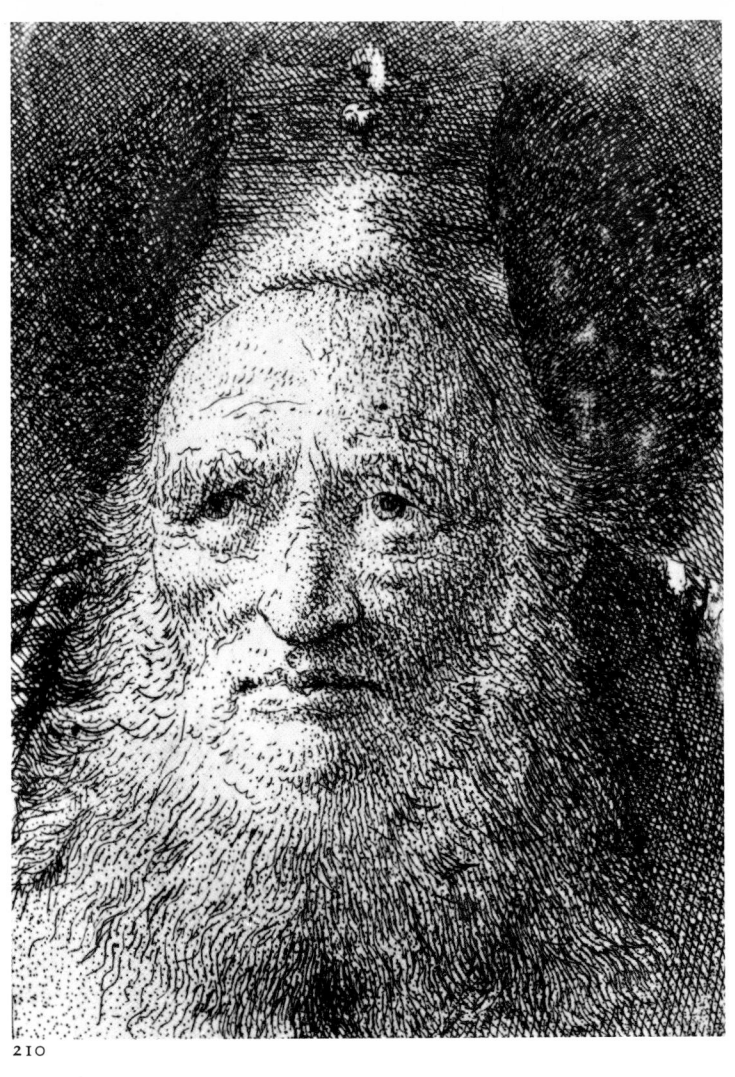

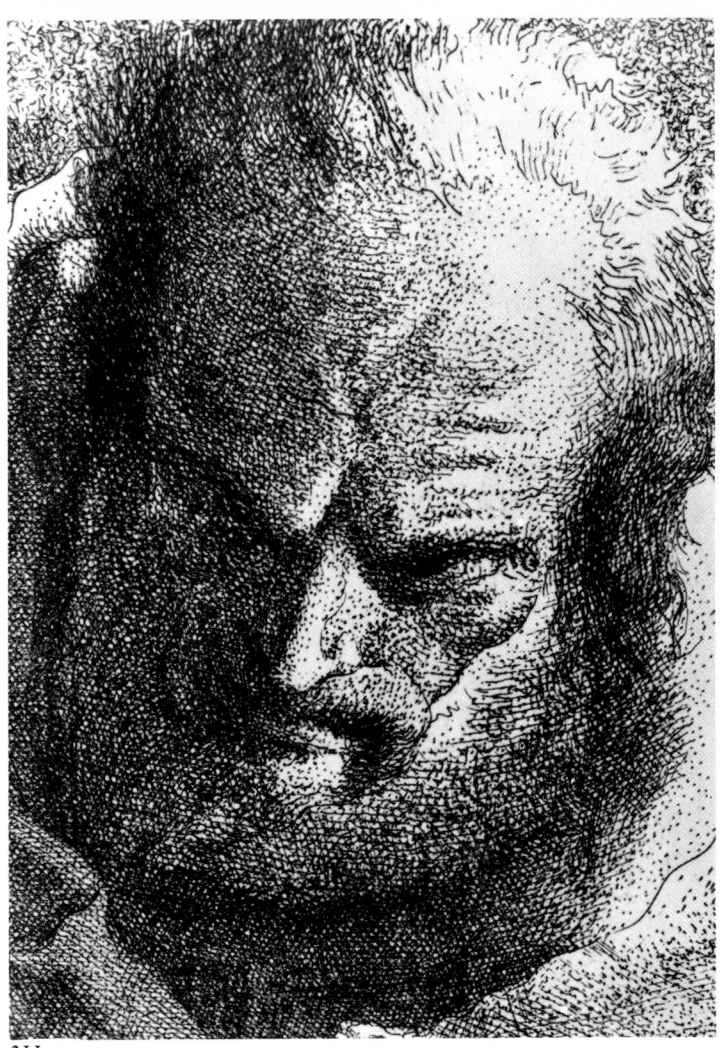

210

211

212. Series of Heads
Old man seen from the front

127 × 103 mm. First state: before the number; second state: *21* at bottom left-hand corner.

There are no links with any known paintings or drawings.

Bibliog.: De Vesme, 1906, 168; Sack, 1910, 174; Knox, 1970/II, II/21; Rizzi, 1970, 208.

213. Series of Heads
Profile of an old man with a beard

128 × 102 mm. First state: before the number; second state: *22* at bottom left-hand corner.

This head has no links with previous paintings.

Bibliog.: De Vesme, 1906, 169; Sack, 1910, 175; Knox, 1970/II, II/22; Rizzi, 1970, 209.

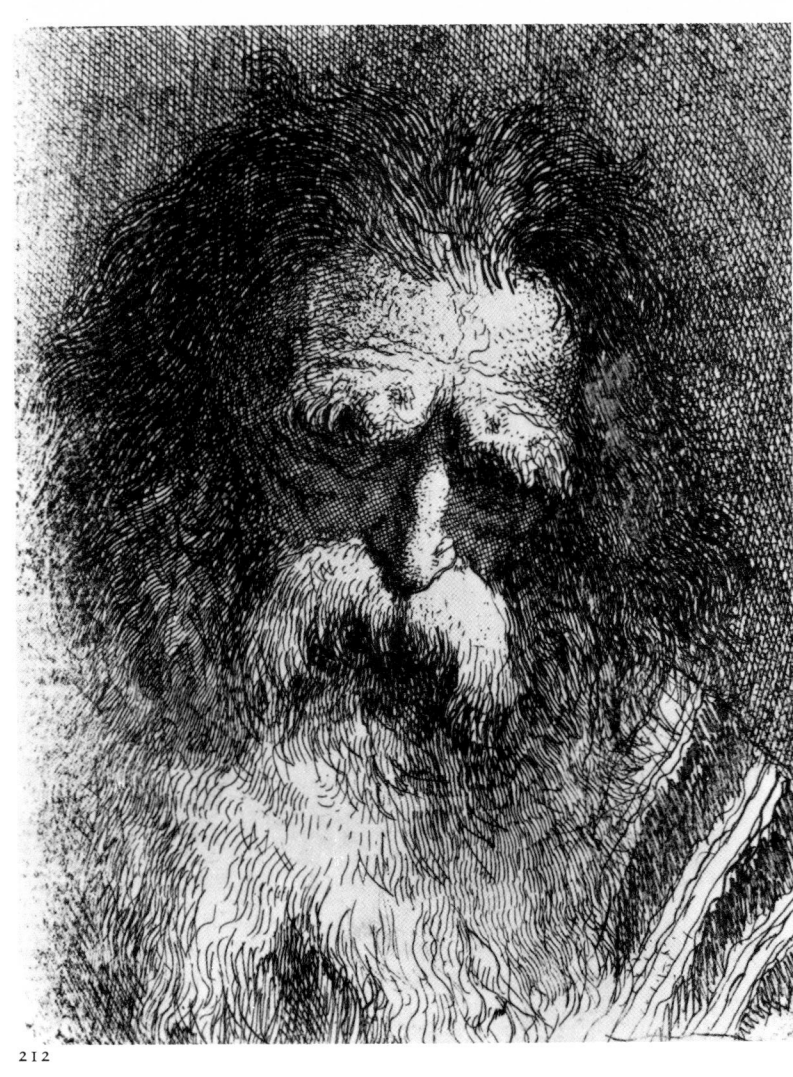

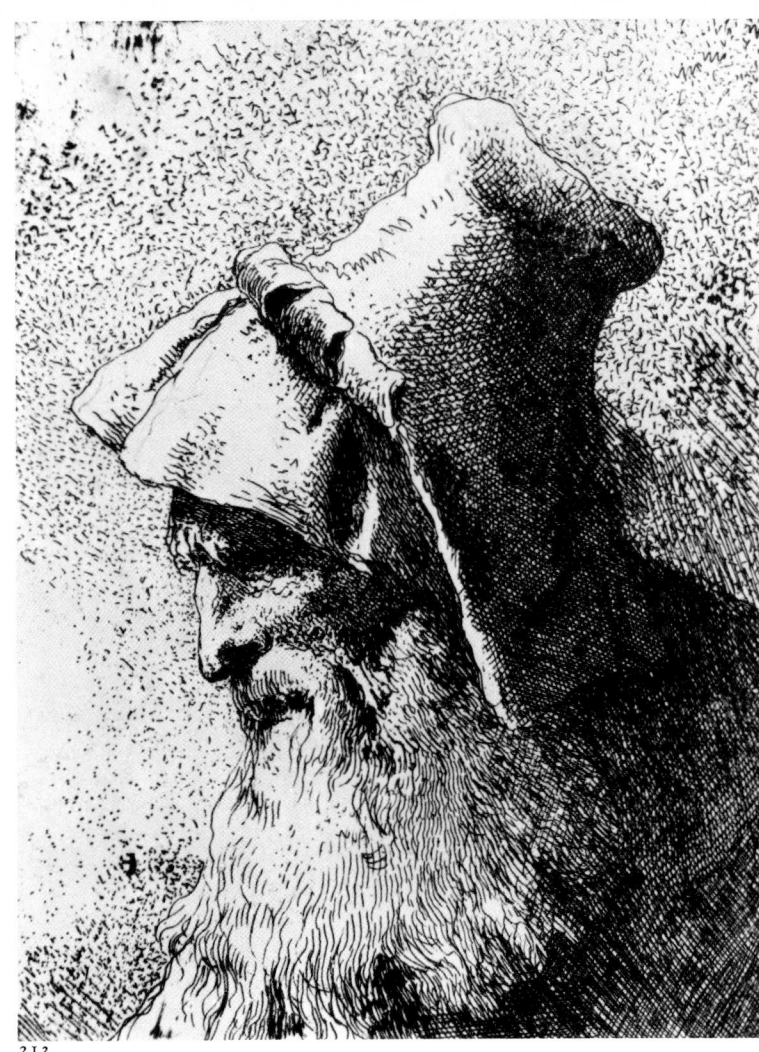

212

213

214. Series of Heads
Old man in a striped robe

127 × 100 mm. First state: before the number; second state: *23* at bottom left-hand corner. At the bottom, to the left, the signature *Do. Tiepol. f.*

The etching is similar to a drawing in the Atger Museum, Montpellier, already used by Giandomenico for pl. 197 (fig. LXII).

215. Series of Heads
Old man with conical hat

126 × 100 mm. First state: before the number; second state: *24* at bottom left-hand corner. At the bottom, to the left, the signature *Do: Tiepolo fe: | Tiepolo.*

Connected, according to Knox, with paintings auctioned in Vienna in 1930 and at other sales. It also recalls a drawing in the 'Savile' album, formerly in the collection of the late Richard Owen (fig. LXIII).

LXII

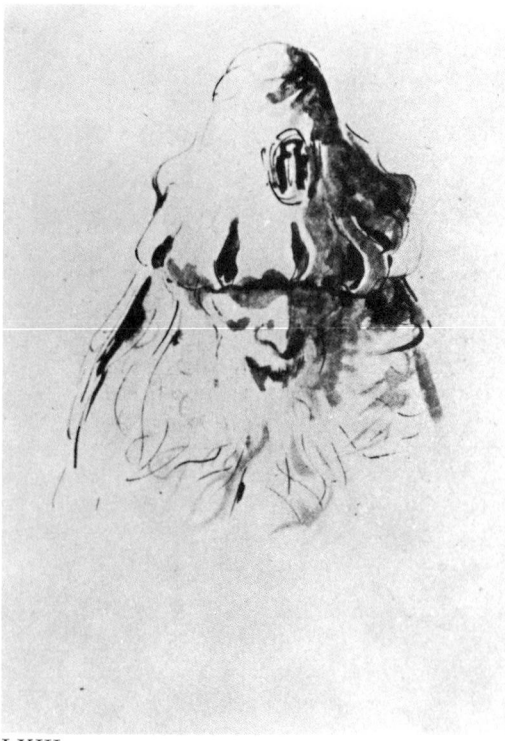

LXIII

Bibliog.: De Vesme, 1906, 170; Sack, 1910, 176; Knox, 1970/II, II/23; Rizzi, 1970, 210.

Bibliog.: De Vesme, 1906, 171; Knox, 1970/II, II/24; Rizzi, 1970, 211.

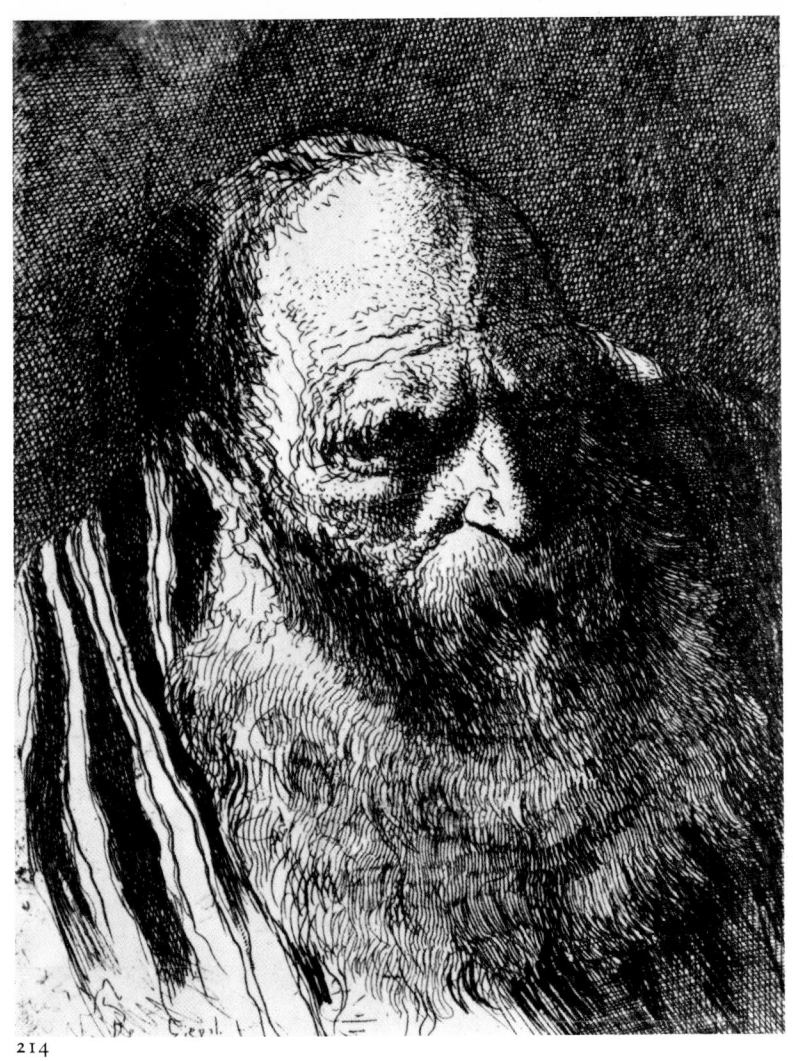

214

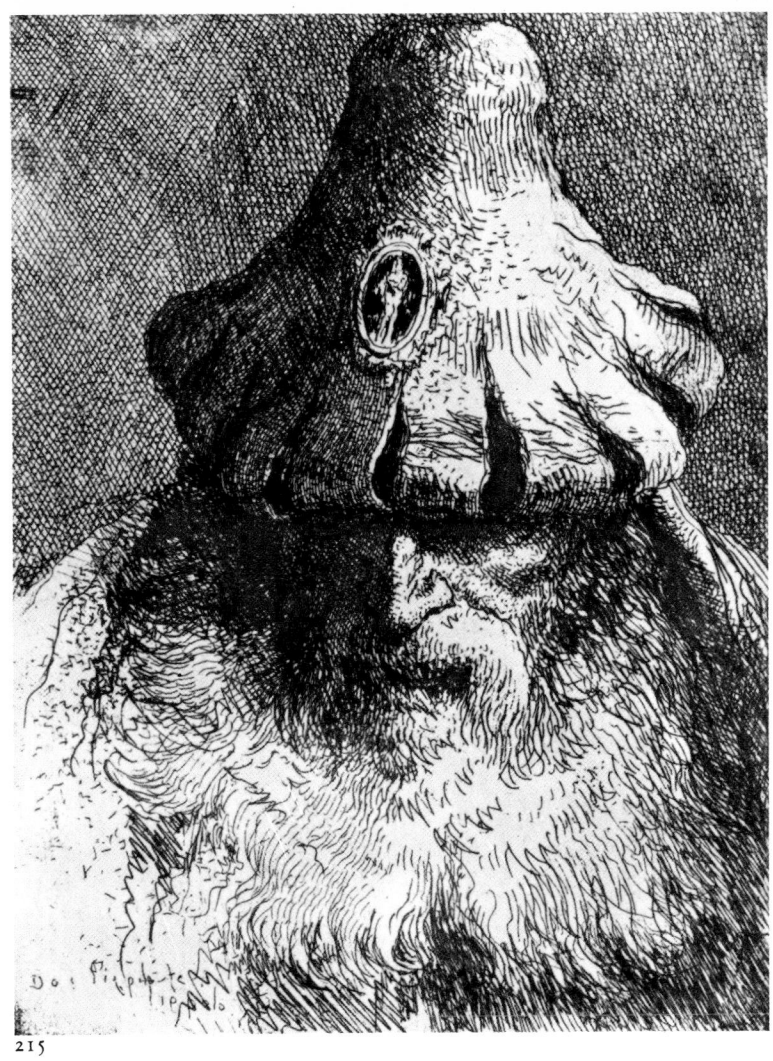

215

399

216. Series of Heads
Old man with a hat

134 × 102 mm. First state: before the number; second state: *25* at bottom left-hand corner.

There are no links with known paintings or drawings.

Bibliog.: De Vesme, 1906, 172; Sack, 1910, 177; Knox, 1970/II, II/25; Rizzi, 1970, 212.

217. Series of Heads
Old man with a beard

144 × 113 mm. No. *26* bottom left corner.

There are no links with known paintings or drawings.

Bibliog.: De Vesme, 1906, 173; Sack, 1910, 178; Knox, 1970/II, II/26; Rizzi, 1970, 213.

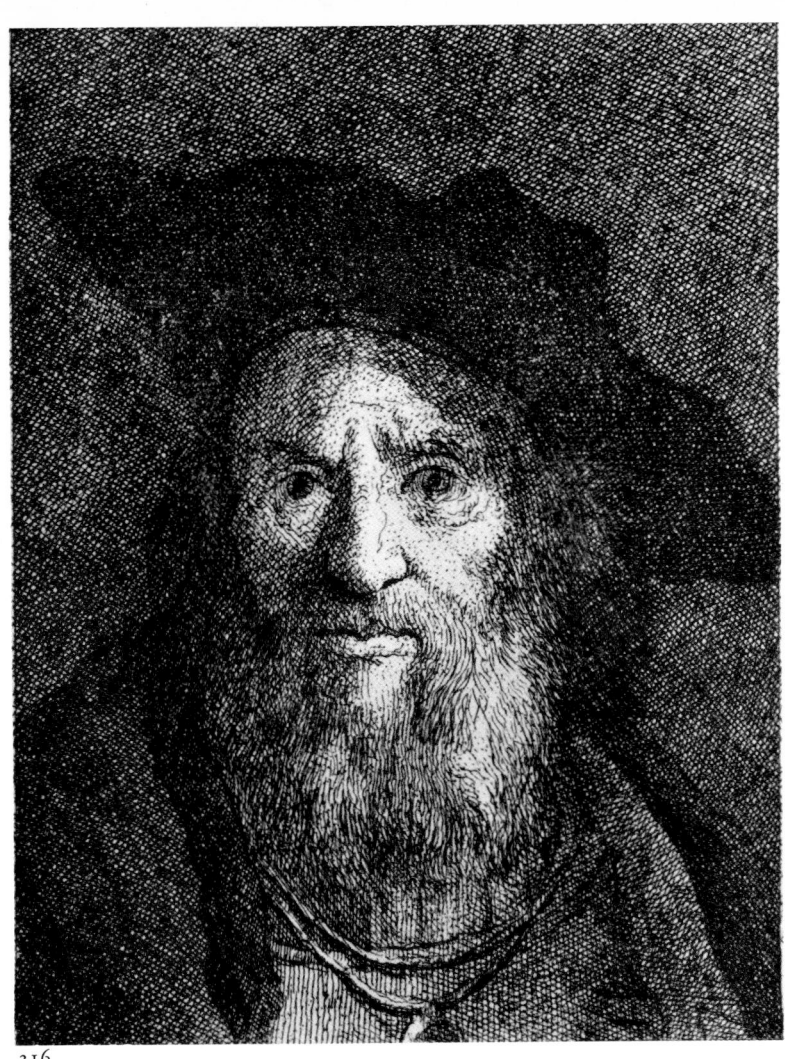

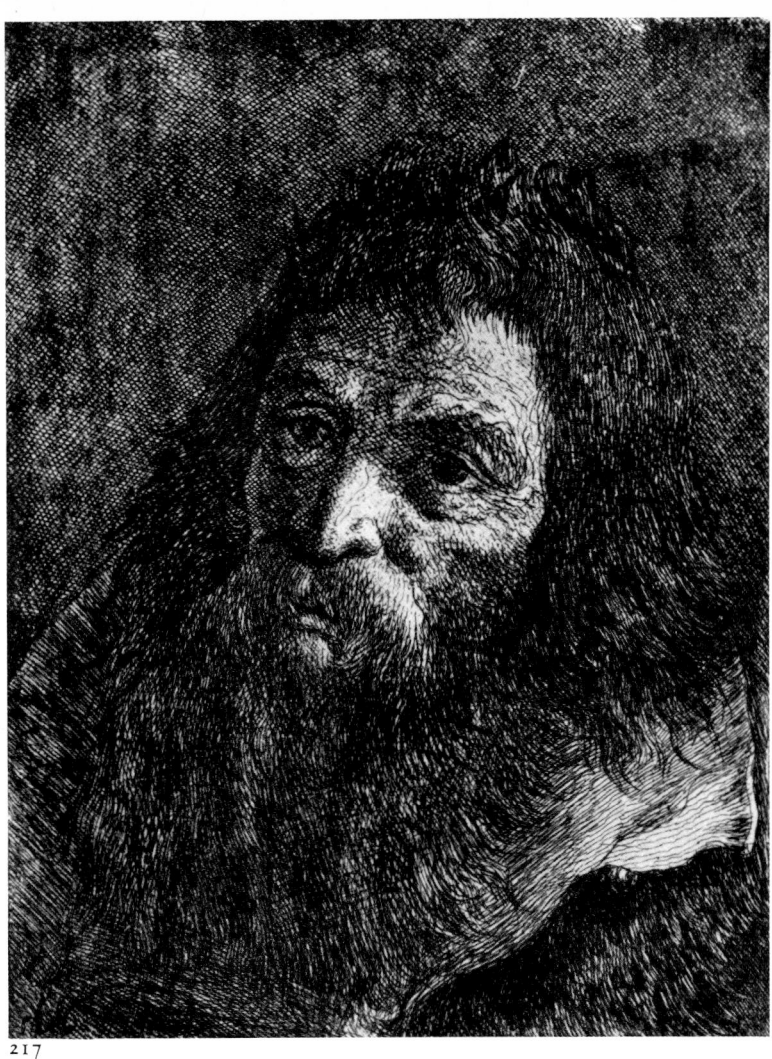

216

217

218. Series of Heads
Bearded old man with a cap

144 × 113 mm. First state: before the number; second state: *27* at bottom left-hand corner.

The source has not yet been found

Bibliog.: De Vesme, 1906, 174; Sack, 1910 179; Knox, 1970/II, II/27; Rizzi, 1970, 214

219. Series of Heads
Old man with a beard

132 × 110 mm. First state: before the number; second state: *28* at bottom left-hand corner.

The source is unknown.

Bibliog.: De Vesme, 1906, 175; Sack, 1910 180; Knox, 1970/II, II/28; Rizzi, 1970, 215

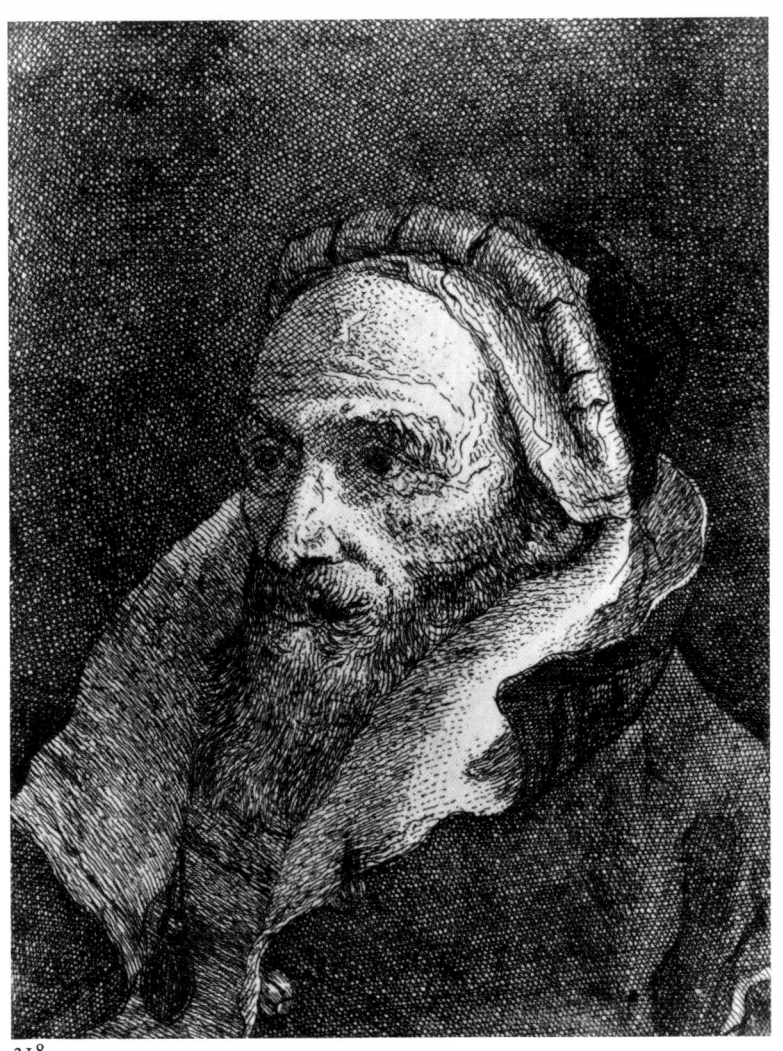

218

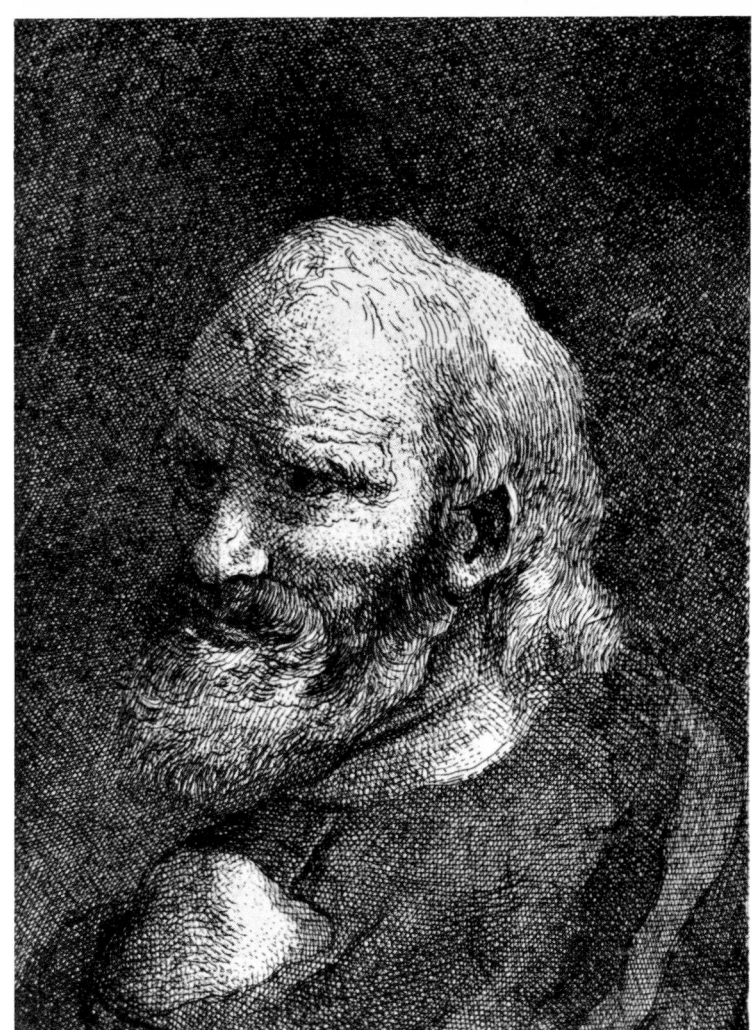

219

220. Series of Heads
Bearded old man with a hat

132 × 110 mm. First state: before the number; second state: *29* at bottom left-hand corner.

The source is unknown.

Bibliog.: De Vesme, 1906, 176; Sack, 1910, 181; Knox, 1970/II, II/29; Rizzi, 1970, 216.

221. Series of Heads
Old man with decorative cap

123 × 89 mm. First state: before the number; second state: *30* at bottom left-hand corner.

Based on a painting not yet identified.

Bibliog.: De Vesme, 1906, 177; Sack, 1910, 182; Knox, 1970/II, II/30; Rizzi, 1970, 217.

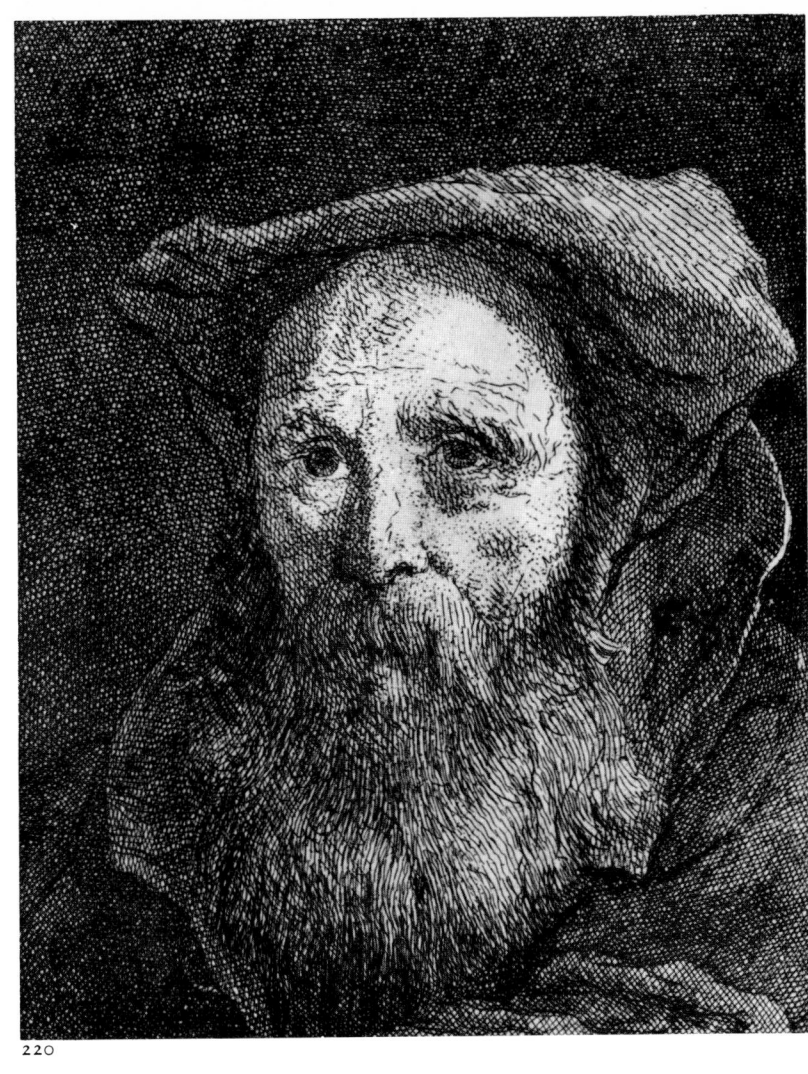

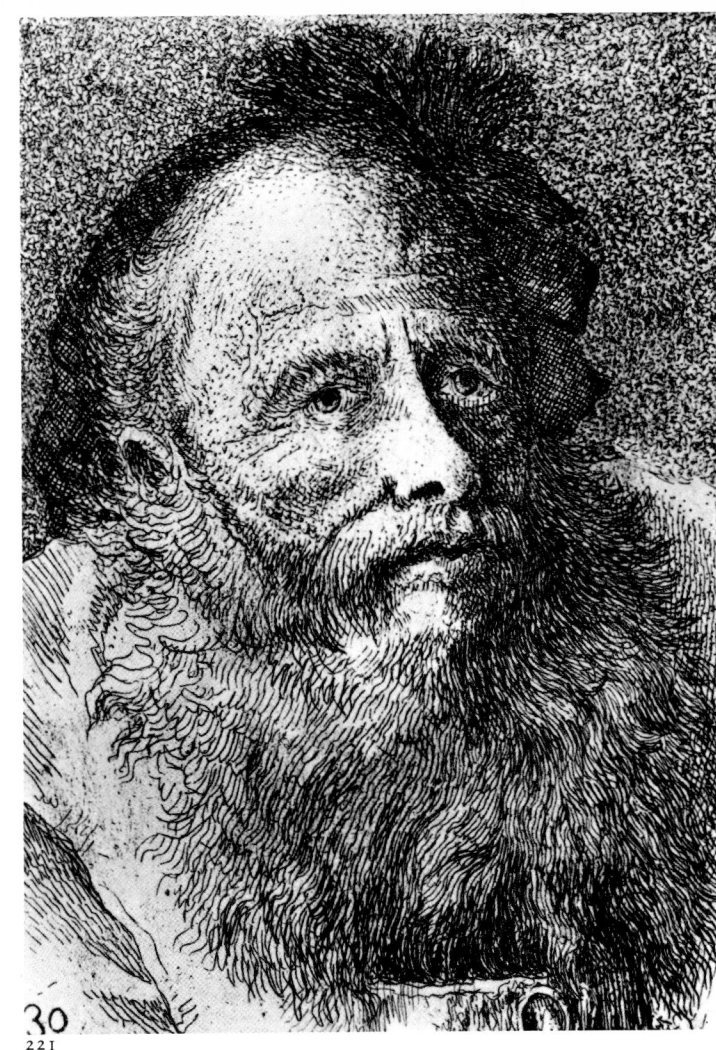

220

221

Lorenzo Baldissera, the son of Giambattista and brother of Giandomenico, was born in Venice in 1736. Trained in his father's workshop, he went to Würzburg in 1751, and returned three years later. In 1761 he was a member of the ' Fraglia ' (or Guild) of Venetian painters. In the following year he left for Madrid with his father and brother. There he married Maria Corradi, who apparently bore him no children. In 1768 he tried to enter the service of Charles III, but was rejected. Two years later, on the death of his father, he obtained a modest annuity from the Court after promising that he would not leave Madrid. In 1773 he was admitted among the Honorary Members of the Venice Academy. He died prematurely in Madrid in 1776.

Lorenzo, although conditioned by his father's teaching, was also influenced by the sophisticated style of Rosalba Carriera and, during the Spanish period, by the academic classicism of Mengs. He left ten etchings, of which nine derived from his father's paintings. His style is characterized by self-assured, parallel, lines, and by a plasticity which is more marked than in his father's and brother's works, although he remained indebted to them.

222. The vision of St. Anne

367 × 183 mm. First state: before the inscription and the number; second state: *24* at top left-hand corner; on the central pillar of the bridge, the letters: *G B T / F* (reversed). In the bottom margin, the inscription: *Ioannes Bapta Tiepolo inv et pinx. / Laurentius Filius del: et fecit.*

This is probably the print mentioned by Nagler under the title *The Child Jesus supported by angels, on a cloud, adored by two saints.*
The etching repeats, in reverse, the painting, also known as *St. Anne and St. Joachim offering the Child Mary to God the Father*, painted by Giambattista in 1759 for the church of S. Chiara, or convent of the Benedictine nuns, in Cividale; it was formerly in the Crespi Collection, Milan and is now in the Dresden Gallery (Rizzi, 1966, p. 200). The preparatory drawing for the head of St. Anne is in the Royal Museum of Fine Arts, Copenhagen (fig. LXIV).

LXIV

Bibliog.: Nagler, 1847; 1; De Vesme, 1906; 1; Sack, 1910, 1; Pallucchini, 1941, 407; Rizzi, 1970, 218.

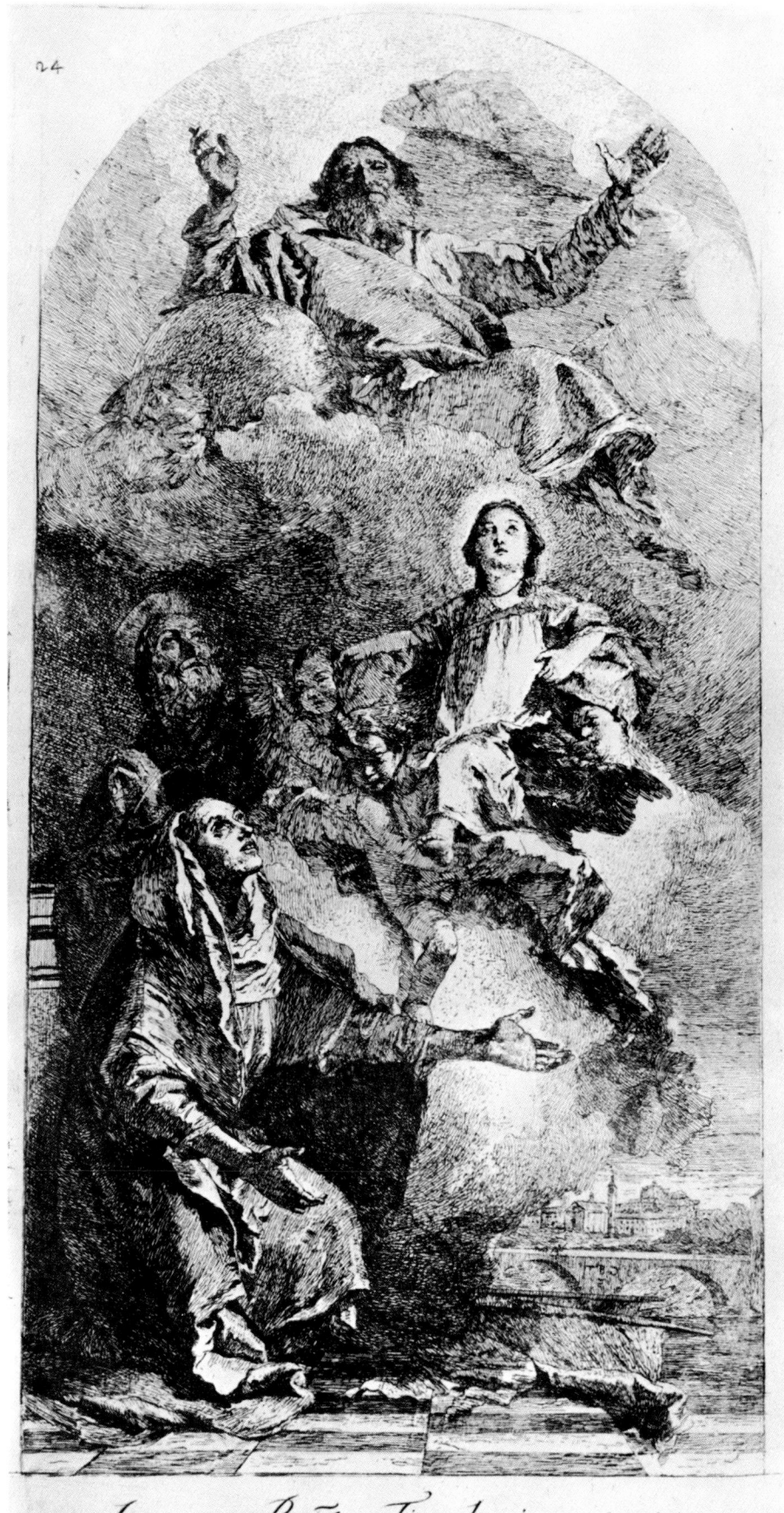

Ioannes Bapta Tiepolo inv et pinx.
Laurentius Filius del et fecit.

223. A miracle of St. Anthony of Padua

346 × 213 mm. First state: before the inscription and the number; the sheet is 378 mm. deep. Second state: with the inscription; *22* at top left-hand corner; part of the bottom margin has been cut off and the sheet is 348 mm. deep. Third state: reworked. In the bottom margin, to the left, the inscription: *Joannes Batta Tiepolo inv.* and to the right: *Laurentius Filius del et inc.*

It is derived from the altarpiece painted by Giambattista in cooperation with Giandomenico for the parish church of Mirano about 1754–60 (Morassi, 1962, p. 29).

Bibliog.: De Vesme, 1906, 2; Sack, 1910, 2; Pittaluga, 1962, p. 164; Rizzi, 1970, 219.

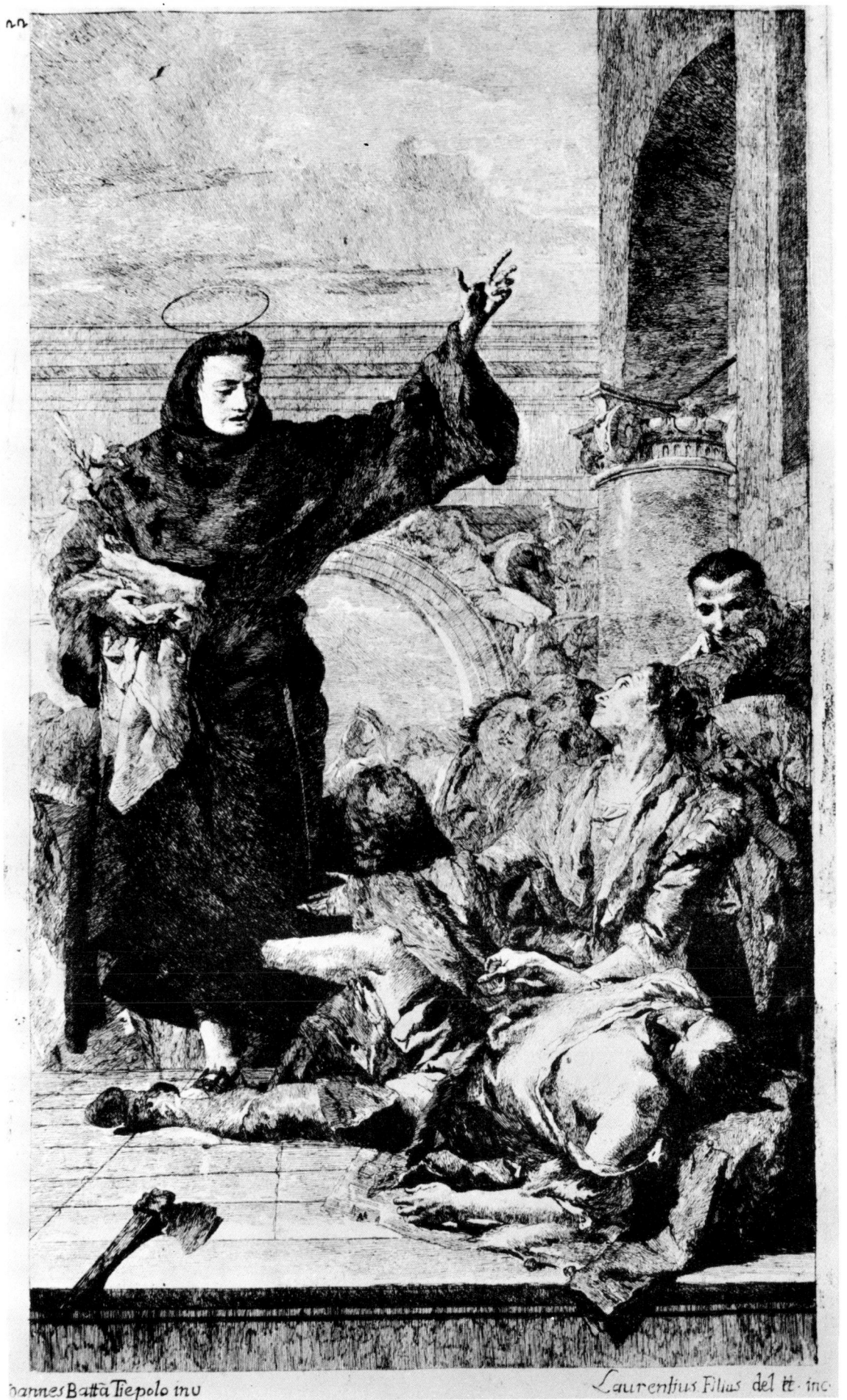

Joannes Batta Tiepolo inv

Laurentius Filius del et inc.

224. St. Thecla praying for the end of the plague in the city of Este

705 × 401 mm. First state: before the inscription and the number; the plate edges are uncleaned. Second state: *33* at top left-hand corner; the plate edges have been cleaned. At the bottom to the right, on the plate itself, the words *Gio. Batta Tiepolo f. | Lorenzo Tiepolo inc.* In the bottom margin, the inscription: *Joannes Batta Tiepolo inv. et pin. | Laurentius Tiepolo filius del. et inc.*

It is derived from the painting by Giambattista in the cathedral at Este, executed in 1759 (Morassi, 1962, p. 12).

Bibliog.: De Vesme, 1906, 3; Sack, 1910, 3; Pallucchini, 1941, 408; Pittaluga, 1952, p. 160; Rizzi, 1970, 220.

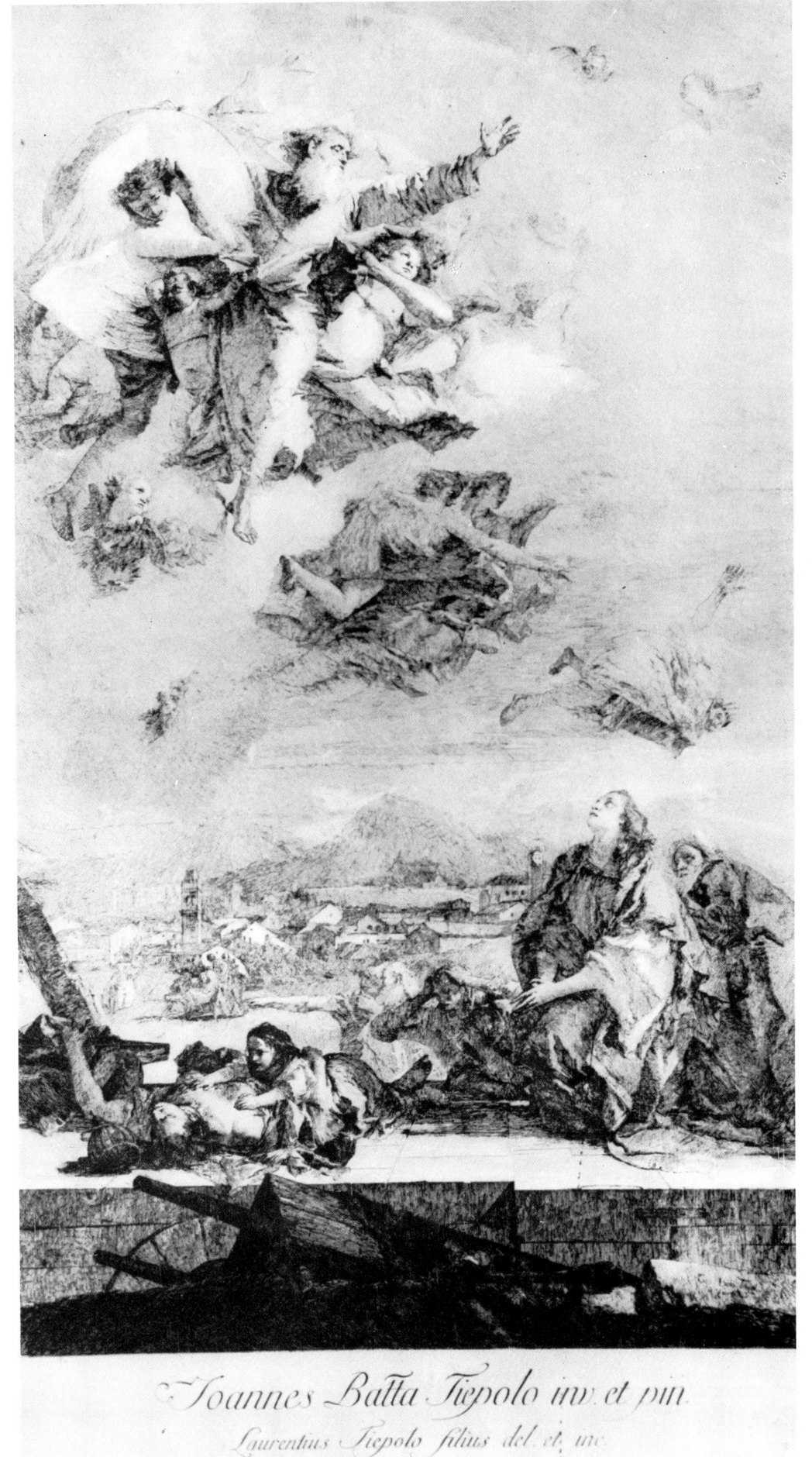

Ioannes Batta Tiepolo inv et pin

Laurentius Tiepolo filius del et inc.

224

225. Rinaldo and Armida

271 × 338 mm. First state; before the num
ber; second state: *14* at top right-hand cor
ner. In the bottom margin, the inscription
Joannes Bapta Tiepolo inv. et pinx. | *Lauren
tius Filius del. et fecit.*

Giambattista's painting, from which
the etching is derived, was formerly
in the Venetian palace of Count Ser
belloni, and later in the Cartier Co
lection, Genoa (as mentioned by Sack);
it is now in the Art Institute, Chicago.
It is datable about 1750–55 (Morassi
1962, p. 8).

Bibliog.: De Vesme, 1906, 4; Sack, 1910,
Rizzi, 1970, 221.

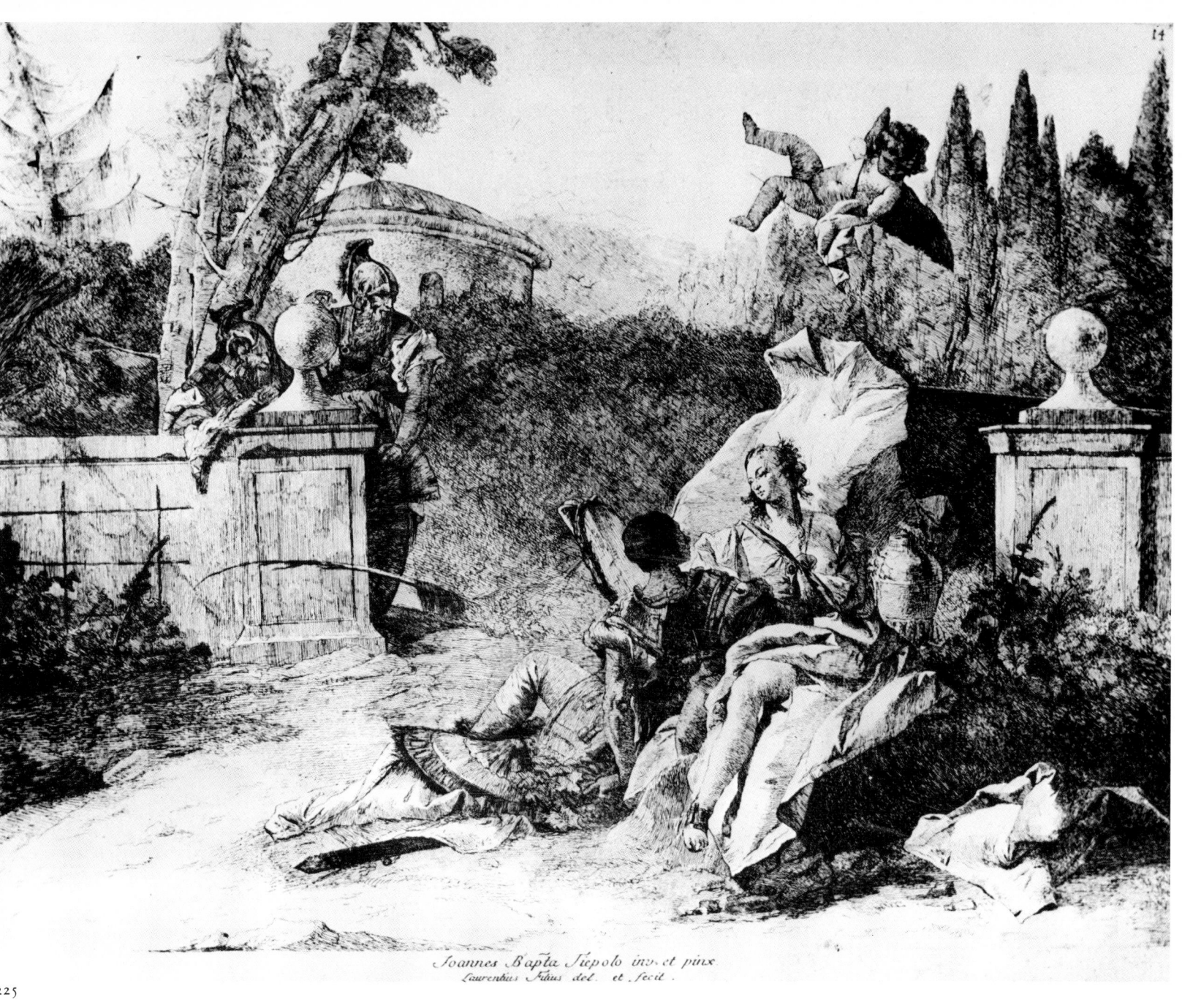

Ioannes Bapta Tiepolo inv. et pinx.
Laurentius Filius del. et fecit.

226. Rinaldo
looking at his reflection
in the magic shield

265 × 88 mm. First state: before the inscription; second state: with the inscription *Io. Bapta Tiepolo inv. et pinx.*, to the left, and *Laurentius Filius del. et fecit* to the right, in the bottom margin.

It is derived from the third episode of the polyptych in the National Gallery, London, formerly in the Rothschild Collection; the first two episodes were etched by Giandomenico (see pl. 128 and 129); no etching exists of the fourth scene.

Bibliog.: De Vesme, 1906, 5; Sack, 1910, 5 Rizzi, 1970, 222.

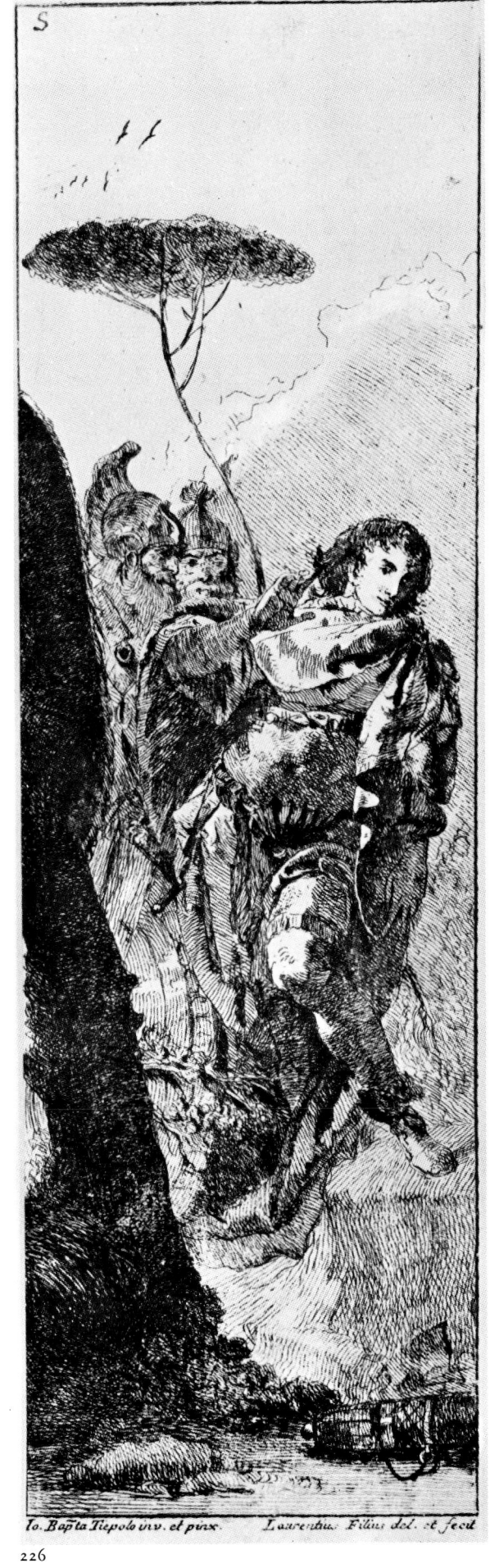

226

227. Rinaldo leaving Armida

207 × 281 mm. First state: before the inscription and the number; second state: *13* at top right-hand corner. In the bottom margin, the inscription: *Joannes Batta Tiepolo inv: pinx. Laurentius Tiepolo filius del et inc.*

According to Sack, Giambattista executed the painting, from which this etching is derived, for the Würzburg Residenz; it was later moved to the Alte Pinakothek in Munich.
It is datable about 1751–3 (Morassi, 1962, p. 30).

Bibliog.: De Vesme, 1906, 6; Sack, 1910, 6; Pallucchini, 1941, 406; Rizzi, 1970, 223.

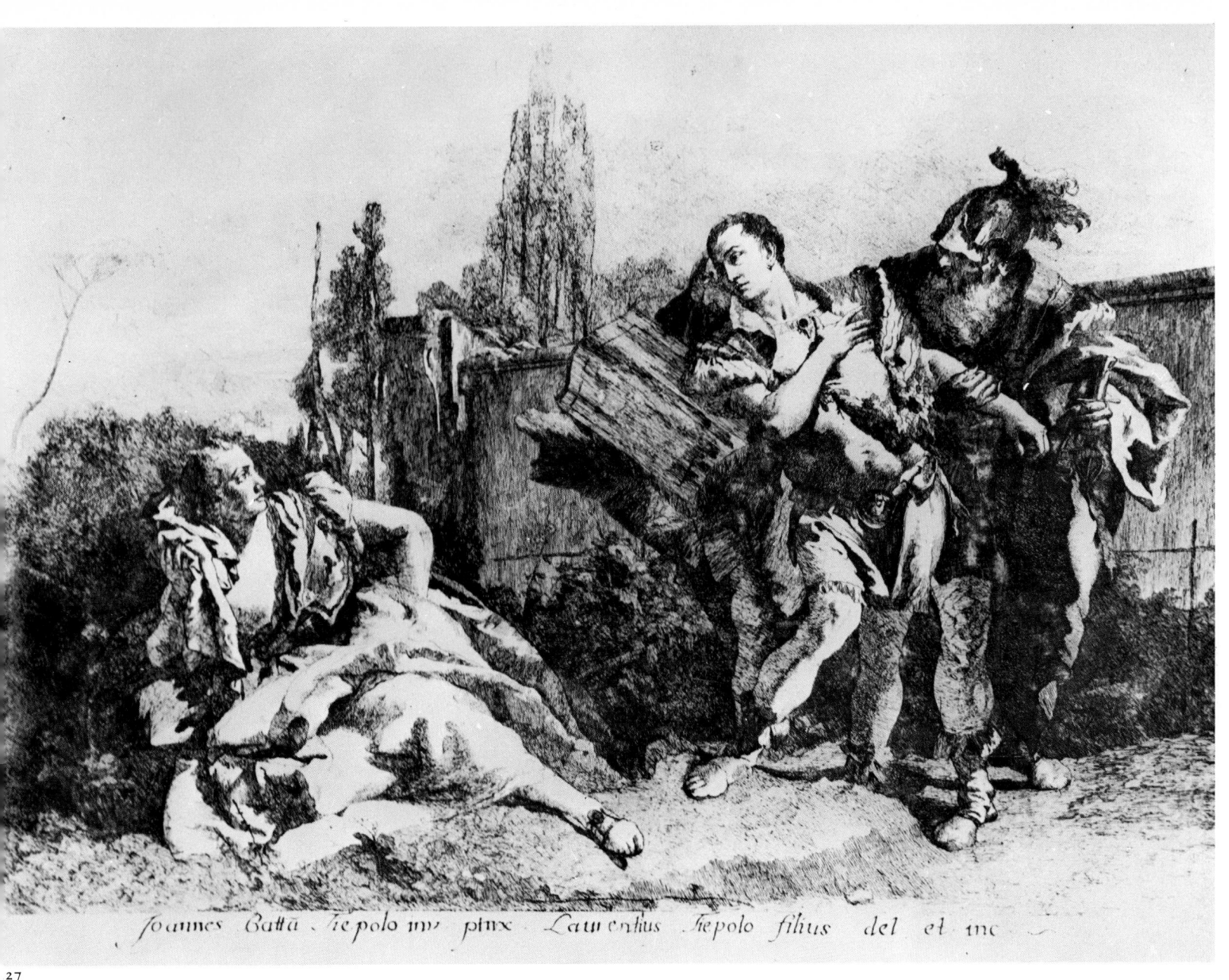

Joannes Batta Tiepolo inv pinx Laurentius Tiepolo filius del et inc

228. Monument
to the glory of heroes

664 × 495 mm. First state: before the number and the inscription; second state: with inscription, but before the number: third state: *43* at top left-hand corner. In the bottom margin the inscription *Ioannes Batt Tiepolo inv. et pinx. | Laurentius Tiepolo filiu del. et inc.* On the truncated pyramid: *ET DECVS IMPERIVMQVE ET OPES REGALIA IVRA MVNERA SVNT HERO: | VM MVNERA SED FIDEI*

Sack mentioned that in Giandomenico's catalogue this print is entitled *Magnificenza de' Principi. In Petroburg* and maintained that the painting was executed by Giambattista about 1762-70 for the Imperial Court at Moscow. The painting is lost (Morassi, 1962, p. 37). Its preparatory drawing was formerly in the Orloff Collection (fig. LXV). The paintings which inspired this and the next two plates formed a series with the one Giandomenico reproduced in his etching (pl. 147).

Bibliog.: De Vesme, 1905, 7; Sack, 1910, 7; Orloff Collection, 1920, 156; Rizzi, 1970, 224.

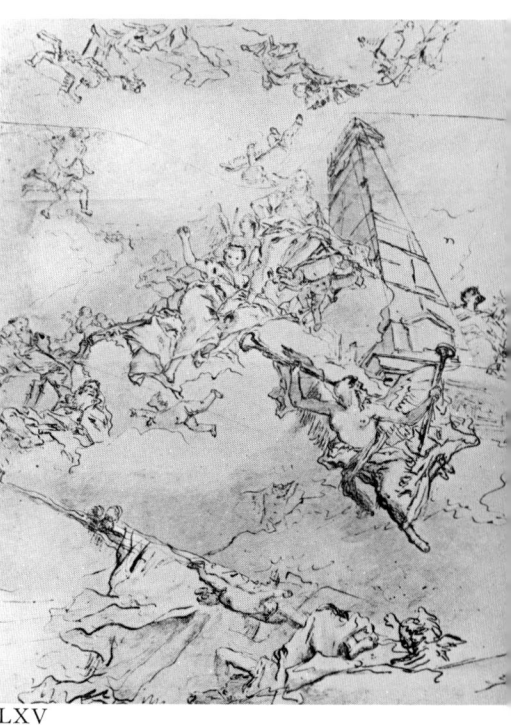

LXV

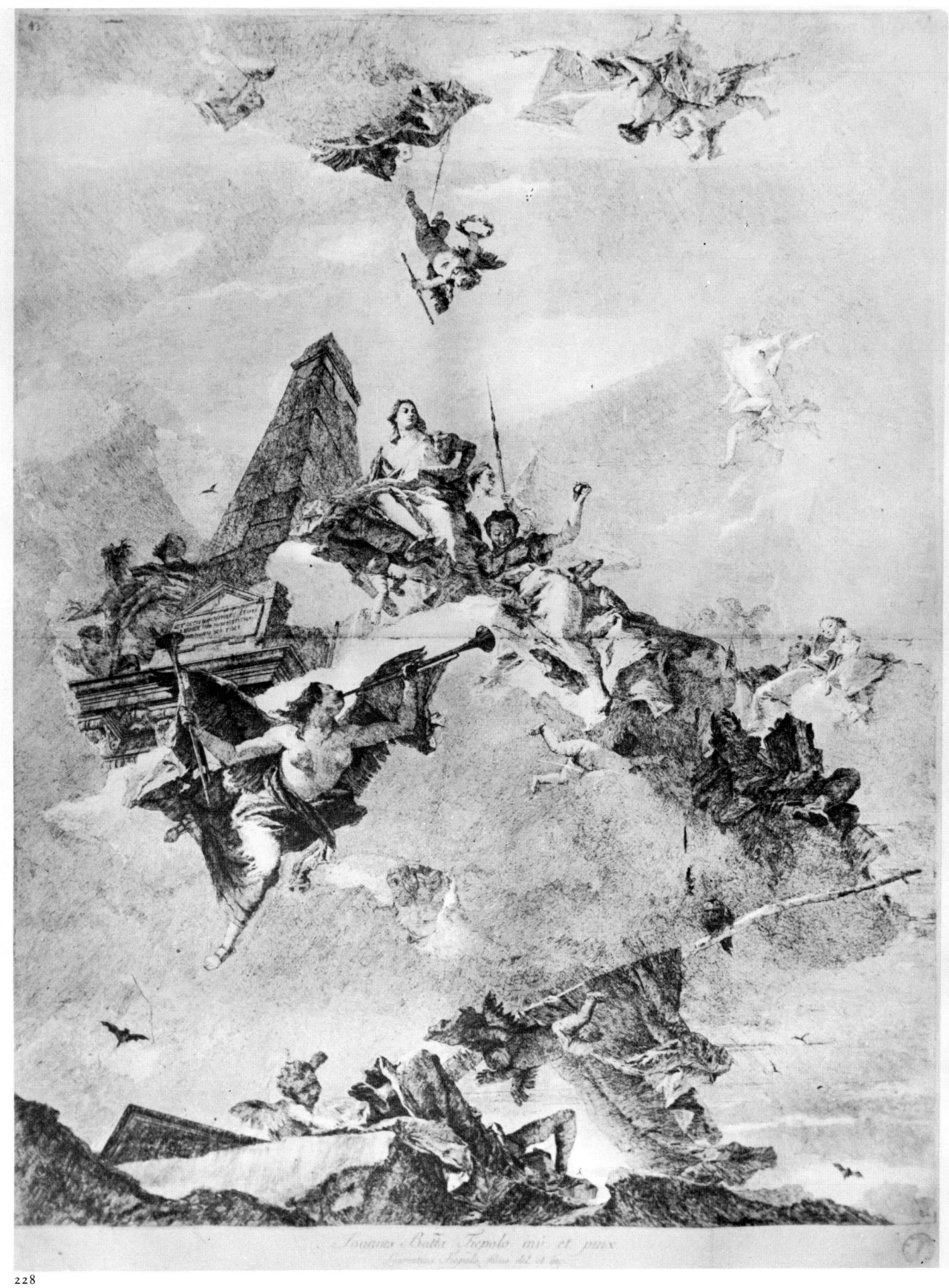

Ioannes Batta Tiepolo inv et pinx

Laurentius Tiepolo filius del et inc

229. The Graces and Mars

555 × 400 mm. First state: before the in
scription and the number; second state: be
fore the inscription but with *39* at top left
hand corner; third state: with the inscrip
tion *Ioannes Bapta Tiepolo inv; et pinx:* t
the left, and *Laurentius Tiepolo filius del; e
inc.* to the right, at the bottom.

Here again, Sack mentioned that ir
Giandomenico's catalogue the etch
ing carries the words *In Petroburgh*
he therefore maintained that it wa
derived from Giambattista's painting
executed for the Chinese Pavilion a
Oranienbaum, near St. Petersburg and
now lost. See note to preceding plate

Bibliog.: De Vesme, 1906, 8; Sack, 1910
8; Pallucchini, 1941, 409; Pittaluga, 1952
p. 164; Pignatti, 1965, LXXII; Rizzi, 1970
p. 225.

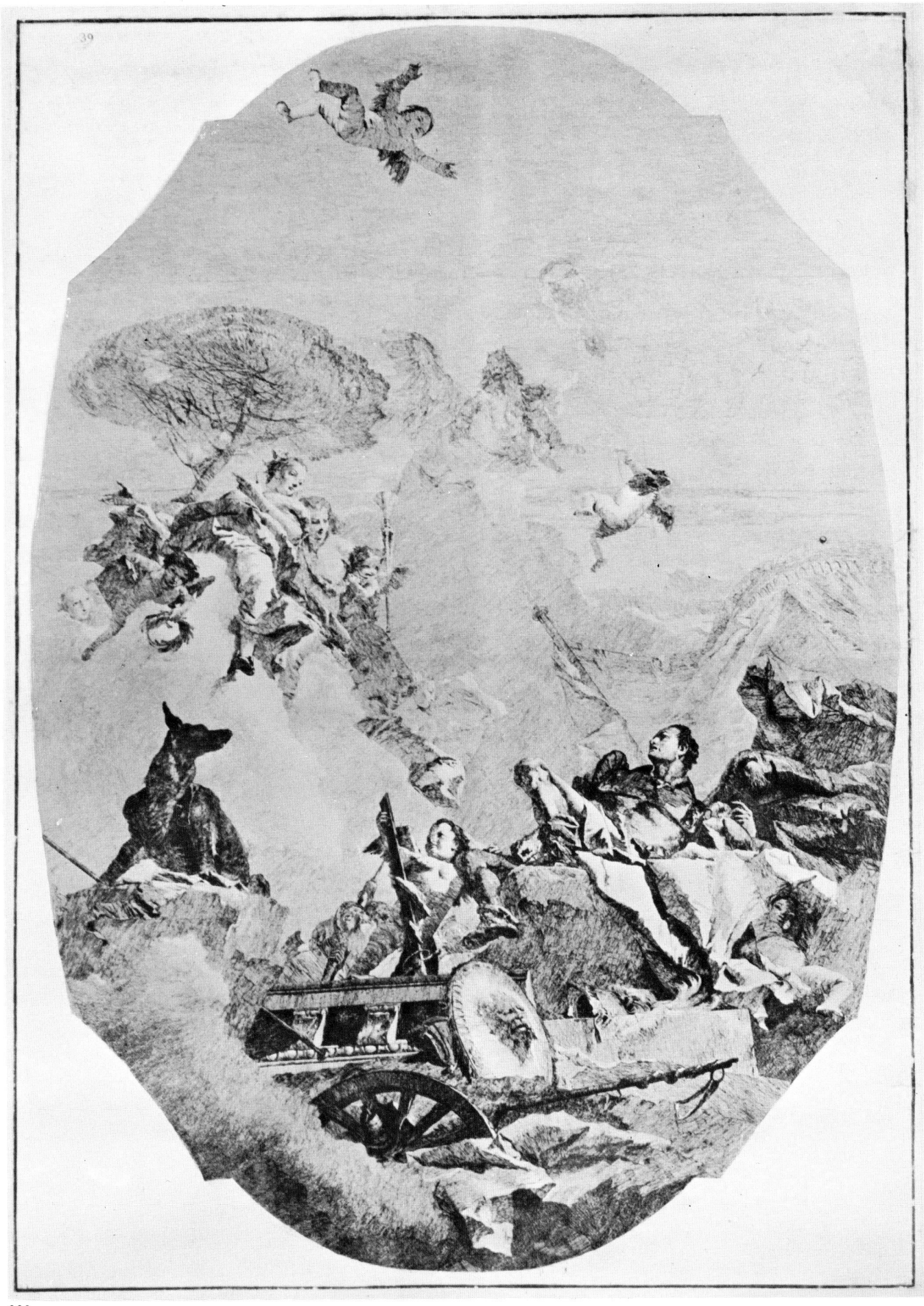

230. The Triumph of Venus

668 × 507 mm. First state: before the inscription and the number; the margins are damaged; second state: with the inscription but before the number; the margins have been cleaned; third state: *41* at top left hand corner. In the bottom margin, the inscription: *Ioannes Batta Tiepolo inv. et pinx | Laurentius Tiepolo filius del et inc.*

Listed by Nagler among Giandomenico's works; Sack mentioned the words *In Petroburgh* as part of the inscription in Giandomenico's catalogue and stated that the etching, by Lorenzo, is derived from a painting executed by Giambattista for the Imperial Court at St. Petersburg. See also note to pl. 228.

Bibliog.: Nagler, 1847, 38; De Vesme 1906, 9; Sack, 1910, 9; Pallucchini, 1941 411; Rizzi, 1970, 226.

Ioannes Batta Tiepolo inv. et pinx.
Laurentius Tiepolo filius del. et inc.

231. Four heads

71 × 60 mm. First state: *ante litteram* (Gabinetto Nazionale delle Stampe, Rome). At bottom right *J.T.F.*

This valuable, unpublished print, is the only document of Lorenzo's activity as an independent engraver, free from any intent to commemorate his father's work. The letter *J* in the monogram stands for *Gianlorenzo*, as in the two drawings in Würzburg (Fiocco, 1925–6, p. 20).

This humble subject, realistically presented in painstaking detail, can also be found in the paintings (see M. Precerutti Garberi, 1967, figs. 10–15). Unlike those based on his father's works, this etching is improved by a clear and well-spaced linearity with a predominance of parallels and given special character by the hatching, the free curves and the strong chiaroscuro. The small size of the print would seem to indicate an experiment—a vain effort to get away from his father's influence.

Bibliog.: Unpublished.

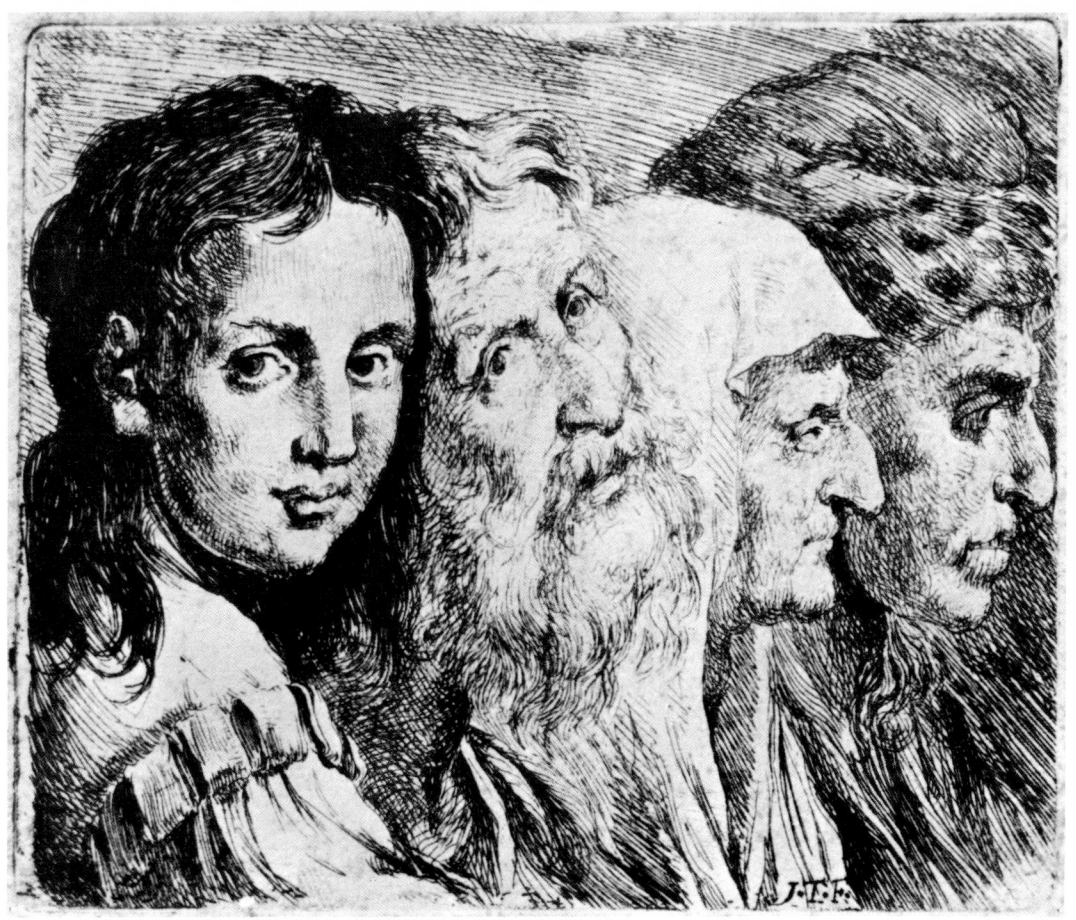

231

ETCHINGS PRODUCED IN COLLABORATION, LOST,
OR WRONGLY ATTRIBUTED.

232. Frontispiece to the first series of the Ricci-Giampiccoli landscapes

234 × 343 mm. Signed, to the left of the bas-relief: *Tiepolo*.

Giuliano Giampiccoli engraved and published, in Venice, two volumes comprising 36 landscapes drawn by Marco Ricci, with a dedication to Consul Joseph Smith and Antonio Maria Zanetti. A second edition appeared in 1775, after the death of Giampiccoli; it was edited by Teodoro Viero and the number of prints contained in it was increased to 48. In this edition it was claimed that Tiepolo had added the numbers to forty of the prints (*Jo. Bapt. Theopulus Fig. addidit*) while the frontispiece stated *adnitente Joanne Bapta Theopulo*. A third edition was published in Milan by the Vallardi brothers, followed by a fourth, and final, anonymous one. The problem of the attribution to Tiepolo of some of the figures in the Ricci prints was first raised by Mariette (*Abecedario*, 1858–9, IV, p. 392). He found an opponent in De Vesme, who, however, confused the original Ricci prints with those engraved by Giampiccoli.

Sack accepted the theory of Tiepolo's intervention, followed this time by De Vesme (1912), who, after a careful examination, agreed to attribute to Giambattista the scenes on the tympanum of the allegorical mausoleum appearing on the two frontispieces (etched rather than engraved with a burin like the rest of the series) and identified the subject of the first composition (*The meeting between Alexander and the wife of Darius*).

Vitali detected Tiepolo's hand in all the thirty-six prints of the first edition and agreed with Calabi in dating them 1753–62; this date was changed to 1753–9 by Alpago Novello, who took into consideration the death of the artist.

Some critics—Fiocco, Goering and Pallucchini—are doubtful about the attribution to Tiepolo of the figures in the foreground. Recently Bassi, Pilo, Pignatti and Passamani have declared themselves in favour of the attribution, while Pittaluga has strong reservations regarding the style of the figures and the doubtful chronology. A proof before letters by Ricci, part of the Remondini Collection (3832), was shown in the exhibition *Marco Ricci and the Belluno engravers of the eighteenth and nineteenth centuries* in Bassano (1968): it would seem to prove that Tiepolo really did contribute his own name to the forty etchings on which his name appears at the bottom —encouraged, according to Pilo, not by Giampiccoli but by Viero, presumably after Giampiccoli's death in 1759 and before Tiepolo's departure for Madrid (1762).

Recently, Frerichs has identified the subject of the second frontispiece (*The Justification of Timoclea*). She also questioned Mariette's statement by referring to a drawing by Marco Ricci, in the British Museum, which shows how he was capable of creating figures inspired by Venetian environment and how indebted to him are the great painters of the successive generation, Canaletto and Tiepolo included.

Furthermore, basing herself on the fact that in 1730 Giampiccoli was head of the Remondini workshop in Bassano and that he settled in Venice before 1738, Frerichs dated the two frontispieces 1739–40; this is further supported by the fact that Joseph Smith became Consul in 1744 (the title is missing in the dedication) and by comparison with the frescoes in the Palazzo Clerici (1740). To conclude, the present author believes that Tiepolo only executed the bas-reliefs on the tympanum of the mausoleum in the two frontispieces, datable about 1739–40; they are close in style to the *Scherzi* (short parallel lines with prevailing diagonals) even though they were more summarily executed. As far as the other sheets in the series are concerned, Giambattista might have contributed to them, but not in a clearly definable way. It should also be noted that Viero published the series about fifteen years after Tiepolo's hypothetical contribution and five after his death; this would seem to indicate the intent to add value to the series of etchings by using the name of the great Venetian painter.

Bibliog.: De Vesme, 1906, p. 394; Sack, 1910, p. 296; De Vesme, 1912, pp. 317–19; Vitali, 1927, p. 60; Calabi, 1939, p. 7; Alpago Novello, 1950, p. 485; Pallucchini, 1941, p. 75; Bassi, 1944, pp. 37–48; Pilo, 1963, pp. 166-84; Pignatti, 1965, XXXVIII; Passamani, 1968, p. 15 and 1970, p. 8; Frerichs, 1969, p. 189; Pilo, 1970, pp. 9–19; Rizzi, 1970, 231.

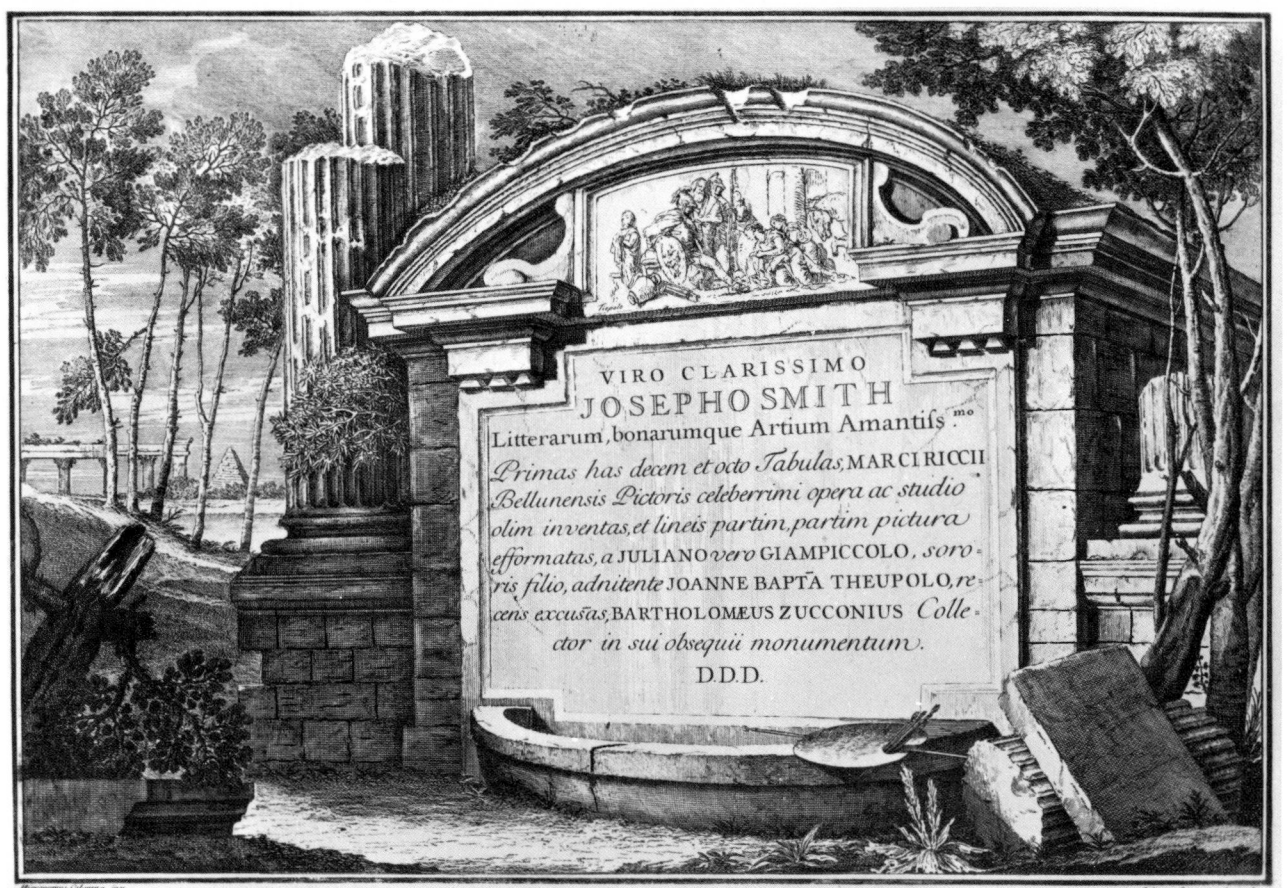

233. Frontispiece to the second series of the Ricci-Giampiccoli landscapes

234 × 343 mm. Signed *Tiepolo*, to the left on the bas-relief.

The engraving on the pediment of the allegorical tomb shows, as demonstrated by Dr. Frerichs, the *Justification of Timoclea*, a noblewoman from Thebes who killed one of Alexander's captains and was pardoned in view of her courage in carrying out the difficult deed. The drawings for the two frontispieces, excluding the relief on the pediment, were executed by Gerolamo Mengozzi Colonna, Tiepolo's collaborator.

See also note to preceding plate.

Bibliog.: De Vesme, 1906, p. 394; Sack, 1910, p. 296; Vitali, 1927, p. 60; Calabi, 1939, p. 7; Alpago Novello, 1940, p. 485; Pallucchini, 1941, p. 75; Bassi, 1944, pp. 37-44, 48; Pilo, 1963, pp. 166-84; Pignatti 1965, XXXVIII; Passamani, 1968, p. 15; ibid. 1970, p. 8; Frerichs, 1969, 189; Pilo, 1970, pp. 9–19; Rizzi, 1970, 232.

233a

233b

433

234. View of the Frari

304 × 460 mm. Signed: *Mich.l Marieschi del.t et inct. No. 17* in the series *Magnificentiores selectioresque urbis Venetiarum prospectus*.

Pignatti was the first who suggested (1964) attributing to Tiepolo the figures in engravings No. 9, 10, 11, 12, 13, 17, 19 and 20 of the series published by Marieschi in 1741. According to Pallucchini, if a contribution other than Marieschi's is admitted in theory, it is more logical that it should be by the hand of his contemporary Fontebasso rather than by Tiepolo. Pallucchini also believes that Marieschi tried to imitate Tiepolo or Fontebasso, 'i.e. to instil into some of his characters attitudes and movements in the manner of Tiepolo'.

Passamani is also doubtful about Pignatti's suggestion, first because the style of the figures attributed to Tiepolo does not match Giambattista's, and secondly because Tiepolo's contribution to prints published in 1741 would have been expressly stated, as in the case of the Giampiccoli edition. He suggests that the twenty sheets comprised in the edition should be dated between 1735 and 1741, believing them to be prompted by the demands of the German market. In the light of the most recent critical contributions, Pignatti's suggestion is not acceptable.

Bibliog.: Pignatti, 1964; idem, 1965, XLI; Pallucchini, 1966; p. 314; Passamani, 1970, pp. 48–9; Rizzi, 1970, 233.

235. The Canal Grande and Ca' Pesaro

341 × 463 mm. Signed: *Mich.l Marieschi del.t et inct. No. 19* in the series *Magnificentiores selectioresque urbis Venetiarum prospectus*.

See note to preceding plate.
Pignatti believes the etching to be derived from a painting in the Smith Collection (Sotheby sale 30 June 1965, n. 79). According to him, the figures in the foreground reproduce (or recall) Giambattista's style.

Bibliog.: Pignatti, 1964, 80; Dto., 1965, XLII; Pallucchini, 1966, p. 314; Passamani, 1970, pp. 48–9; Rizzi, 1970, 234.

Templum et platea F.F. Ord: min: Conuentualium usque ad uiam, qua itur ad D: Rocchi; cum schola D: Antonij ad dexteram, et alteram Passionis ad sinistram. Mich.¹ Marieschi del.¹ et sculp.¹

234

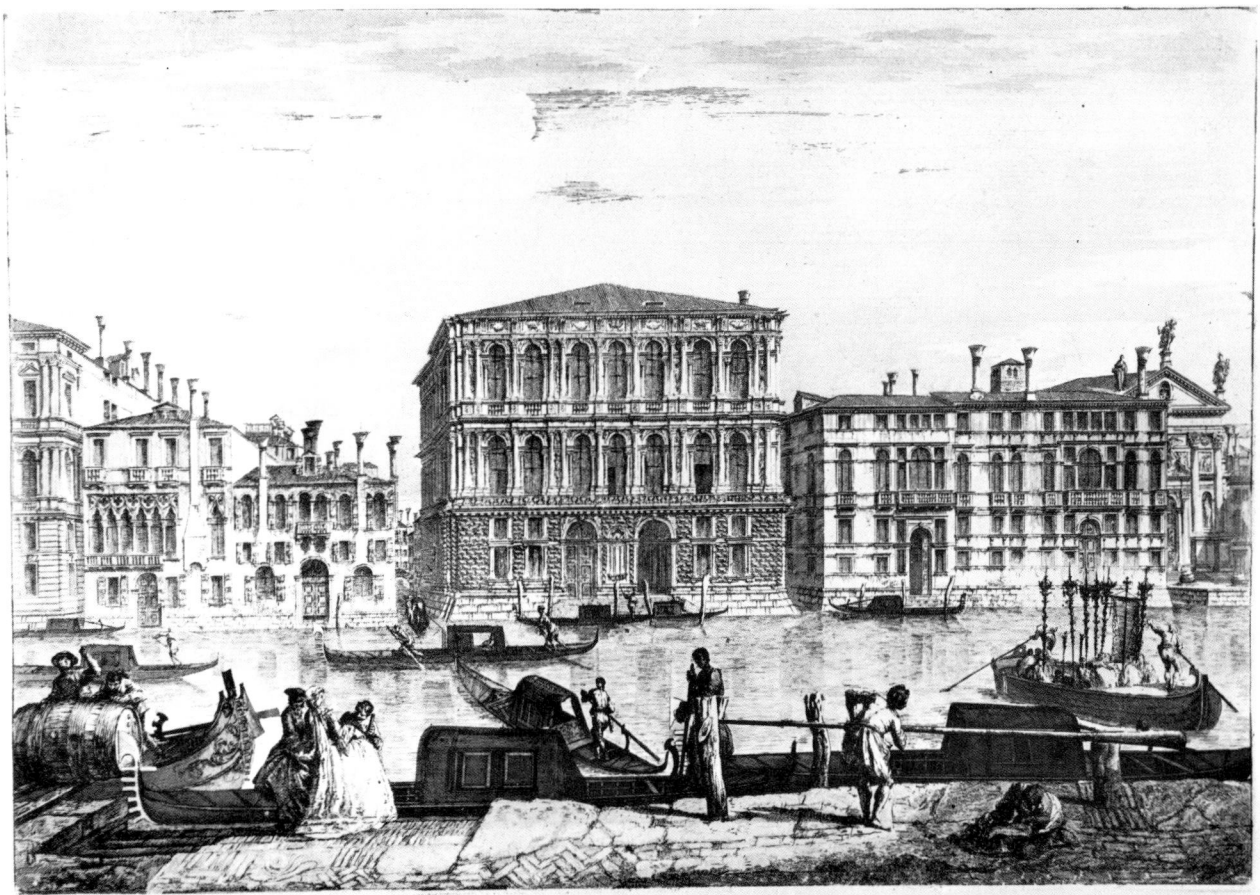

N.º 19. *Pisaurorum Familiæ Ædes ad Canalis magni marginem, una cum D: Eustachij templo dextrorsum, et sinistrorsum cum parte Corneliorum ædis.* Mich.¹ Marieschi del.¹ et sculp.¹

235

236. The four Evangelists
St. Luke

165 × 109 mm. First state: before the signature; second state: with the monogram *I.B.T.* in the margin, to the left (Rijksmuseum, Amsterdam).

De Vesme believed this print, and the three following ones, to be a fake by the hand of a German artist. Sack did not mention them. Byam Shaw cautiously suggests they could be among the first etchings by Giambattista, generally corresponding to the frescoes of the Sagredo Chapel in S. Francesco della Vigna (1743), engraved by Giandomenico (see pl. 115). Recent discoveries confirm the view of De Vesme. See also note to pl. 240.

Bibliog.: De Vesme, 1906, p. 392, 3–6; Byam Shaw, 1955, pp. 18–19; Rizzi, 1970, 227.

237. The four Evangelists
St. Mark

175 × 126 mm. Signed *Tiepolo pinx* (Rijksmuseum, Amsterdam).

See note to preceding plate.

Bibliog.: De Vesme, 1906, p. 392, 3–6; Byam Shaw, 1955, pp. 18–19; Rizzi, 1970, 228.

238. The four Evangelists
St. Matthew

155 × 109 mm. First state: before the signature; second state: the monogram *I.B.T.* in the margin, to the left (Rijksmuseum, Amsterdam).

See note to plate 236.

Bibliog.: Nagler, 1847, 10; De Vesme, 1906, p. 392, 3–6; Byam Shaw, 1955, pp. 18–19; Rizzi, 1970, 229.

239. The four Evangelists
St. John

175 × 126 mm. First state: before the signature; second state: with the monogram *I.B.T.* in the margin, to the left (Rijksmuseum, Amsterdam).

See note to plate 236.

Bibliog.: De Vesme, 1906, p. 392, 3–6; Byam Sham, 1955, pp. 18–19; Rizzi, 1970, 230.

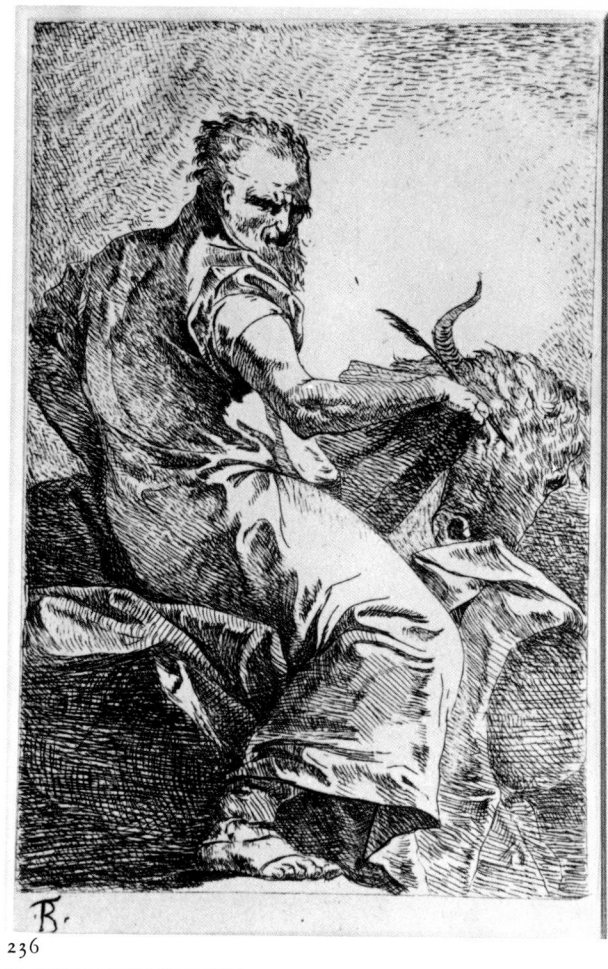

236

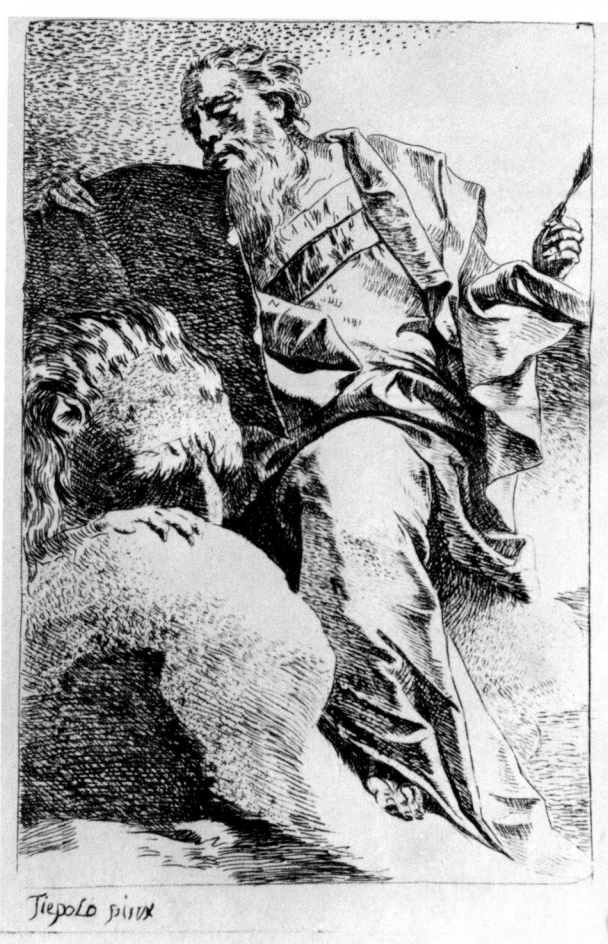

237

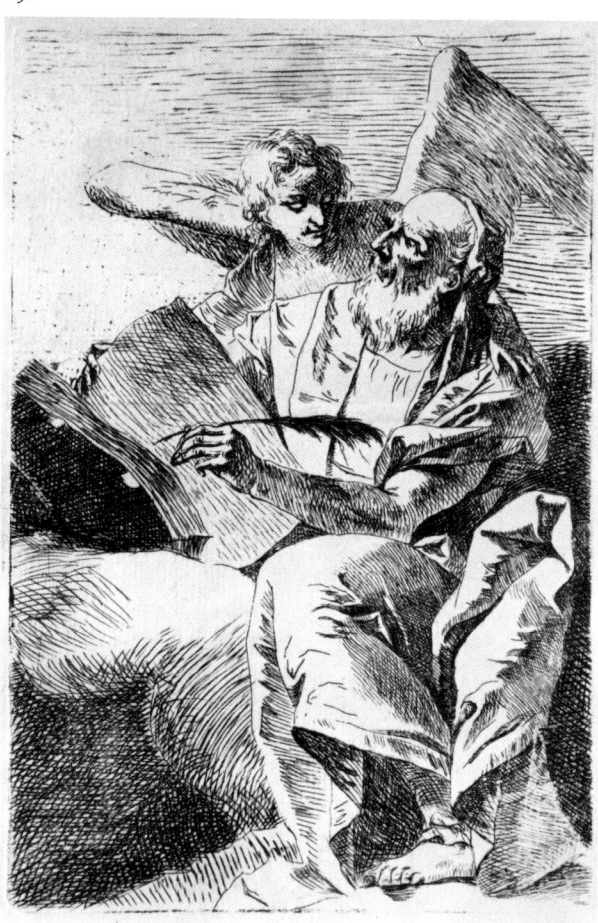

238

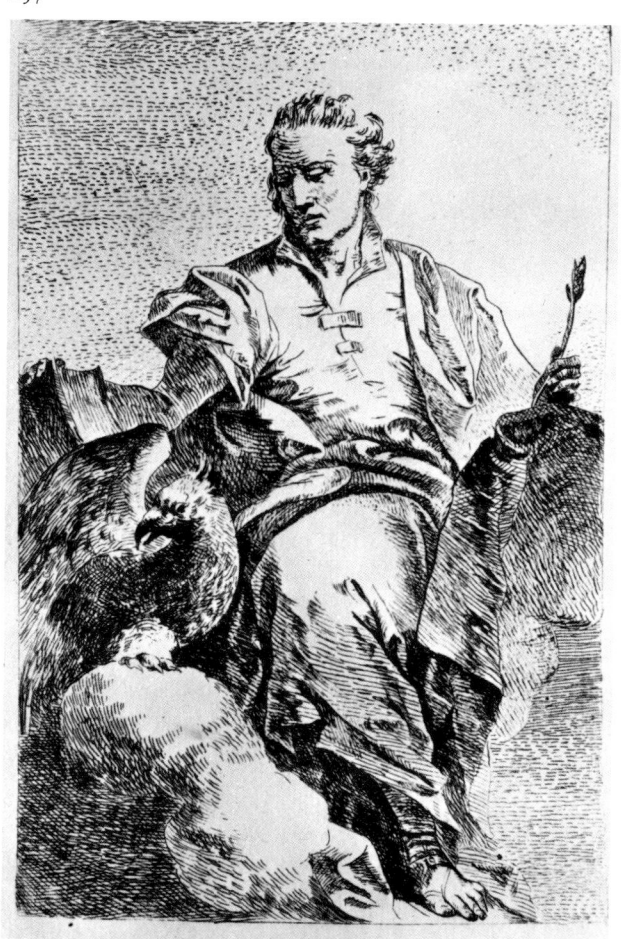

239

240. Old man with a beard

125 × 122 mm. First state: without lette
or number (Pavia, private collection).

De Vesme mentioned the existen
of copies of a certain number o
Heads included in the *Raccolta* en
graved by Giandomenico (pl. 15
221): they are inscribed, at the bo
tom, *Tiepolo del* and *I. G. Hertel exc*
A. V., beside a serial number. Fiv
sheets from the first series in the *Ra*
colta have been etched by Saint-No
This was also confirmed by Sack.
The unpublished sheet reproduce
here is clearly connected with th
originals by Giandomenico (see pa
ticularly the head reproduced in p
208), although its technique is di
ferent, more untidy, and points to
northern etcher, probably the autho
of the *Four Evangelists* (pls. 236–9).
In the bottom left-hand corner, on
can make out the initials *O. M.*, whic
would point to the German engrave
Matthäus Oesterreich (1716–78): th
vagueness of the writing, howeve
does not allow definite conclusion
to be drawn.

Bibliog.: De Vesme, 1906, p. 438; Sac
1910, 342.

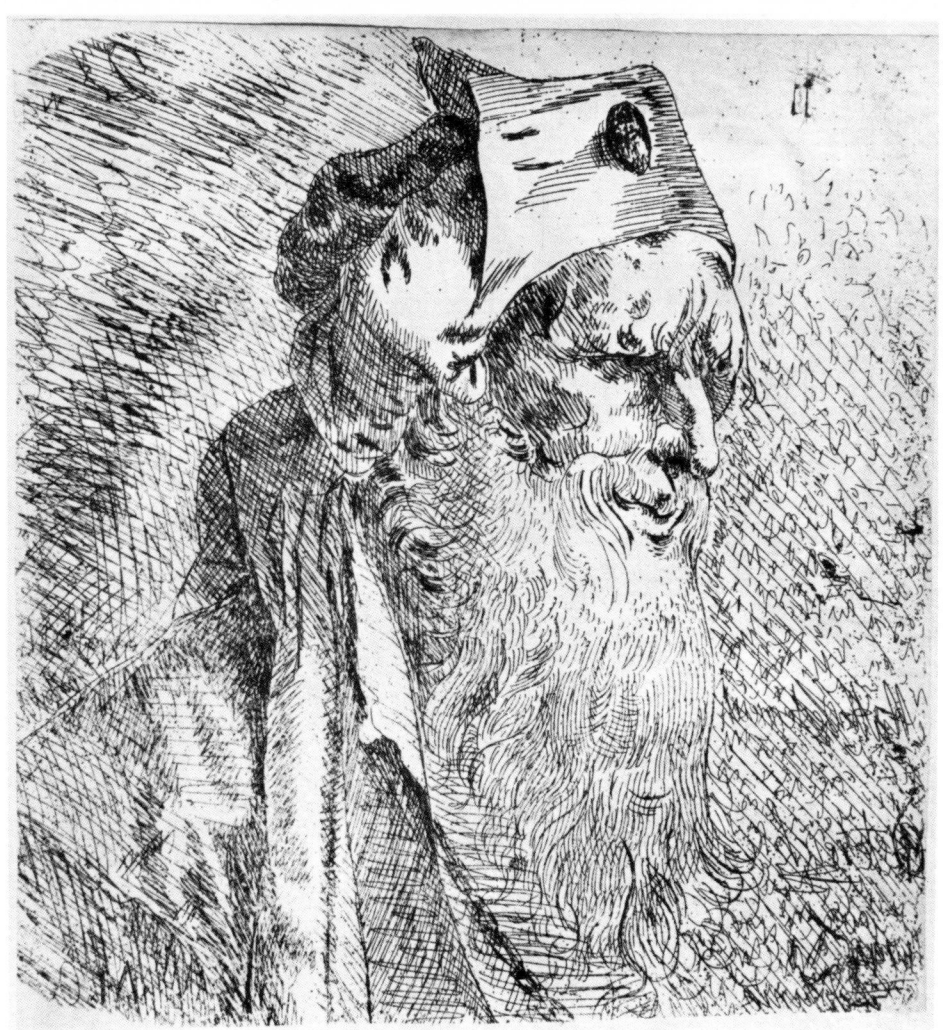

240

241. Roman ruins
Ruins of a royal palace

170 × 115 mm. First state: *2* bottom at left; second state: the number replaced by the inscription *Gio: Batta Tiepolo Inv. e Scul.* (Pavia, private collection); third state: inserted in the bottom margin, the wording *Di regale Magion superbo avanzo* (Budapest, Museum of Fine Arts).

242. Roman ruins
Ruins of a temple

170 × 115 mm. First state: *3* at bottom left (Pavia, private collection); second state: no number, but with the wording *Che non consumi tu, Tempo vorace. /n. 3 N.* (Budapest, Museum of Fine Arts, and Pavia, private collection).

243. Roman ruins
Fountain with a church

170 × 115 mm. First state: *6* at bottom left (Pavia, private collection).

244. Roman ruins
Ruins with apses and columns

170 × 115 mm. First state: *9* at bottom left (Pavia, private collection).

245. Roman ruins
Ruins with apse and fountain

170 × 115 mm. First state: *10* at bottom left (Pavia, private collection).

246. Roman ruins
Roman triumphal arch

170 × 115 mm. Third state: in the bottom margin, the inscription: *Cedon degli ann. ai colpi Archi e Trofei. / n°. 2 N.* (Budapest, Museum of Fine Arts, and Pavia, private collection).

41

242

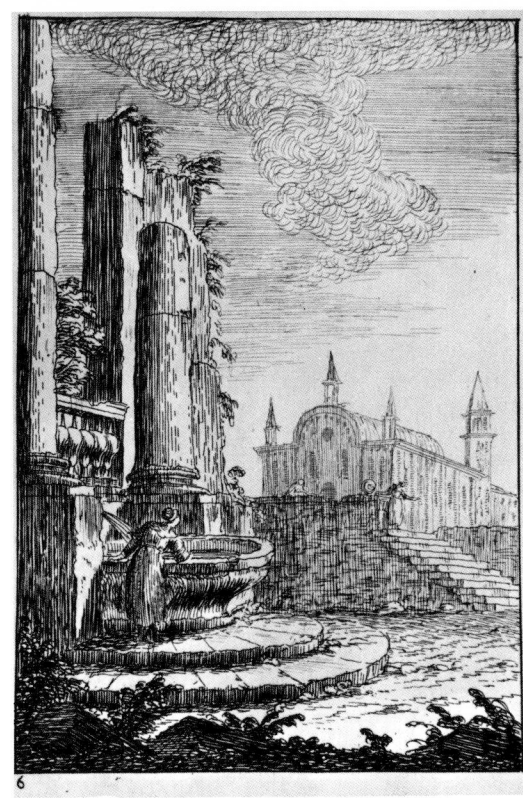

243

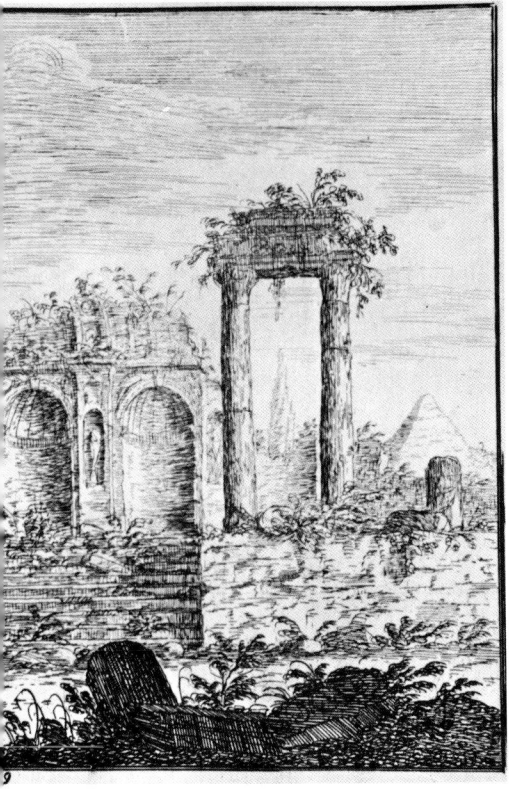

44

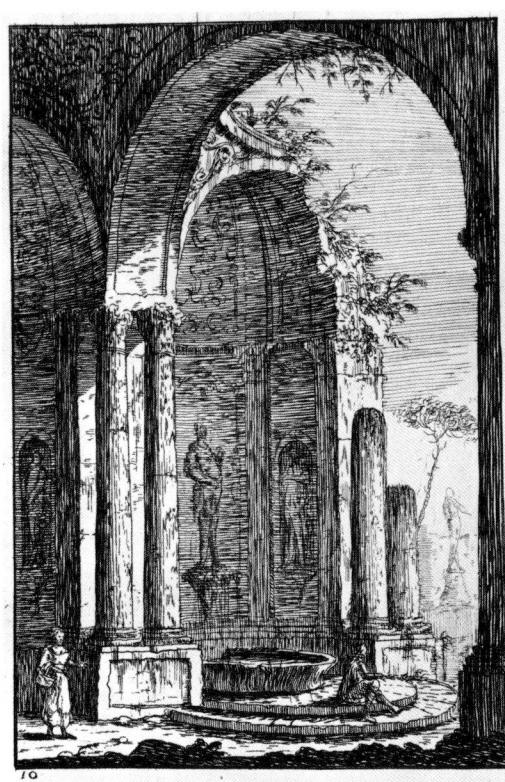

245

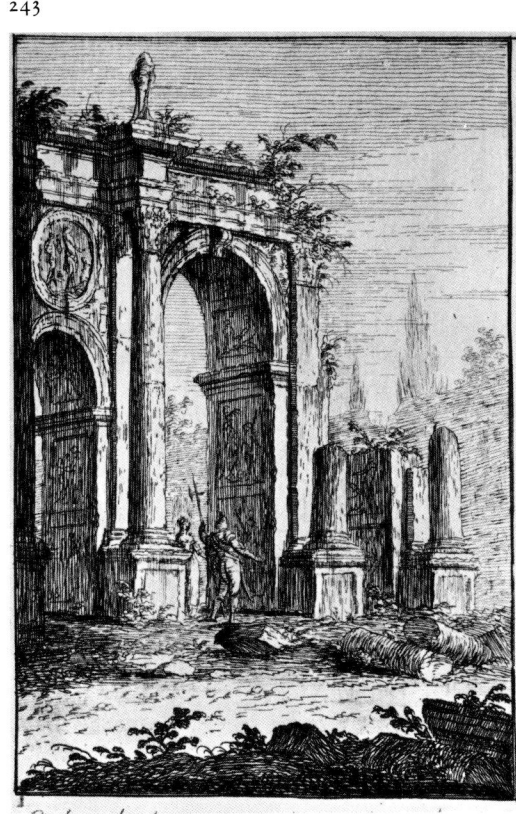

246

441

247. Roman ruins
Obelisk and mausoleum

170 × 115 mm. Third state (?): in the bottom margin the inscription: *Fastose Aguglie e Mausolei vetusti.* | *n°. 4 N.* (Budapest, Museum of Fine Arts, and Pavia, private collection).

248. Roman ruins
Monument with equestrian statue

170 × 115 mm. Third state (?): in the bottom margin the inscription: *Monumento che ancor l'età rispetta.* | *n°. 5 N.* (Budapest, Museum of Fine Arts, and Pavia, private collection).

249. Roman ruins
Ruins of an amphitheatre

170 × 115 mm. Third state (?): in the bottom margin the inscription: *Di regio Anfiteatro appena un'ombra.* | *n°. 6 N.* (Budapest, Museum of Fine Arts, and Pavia, private collection).

250. Roman ruins
Ruins of thermal baths

179 × 115 mm. Third state (?): in the bottom margin the inscription: *Di antiche Terme, nobili reliquie.* | *n°. 7 N.* (Budapest, Museum of Fine Arts, and Pavia, private collection).

251. Ruins with loggia

170 × 115 mm. Third state (?): in the bottom margin the inscription: *Loggie non piu ma sol di loggie imago.* | *n°. 8 N.* (Budapest, Museum of Fine Arts, and Pavia, private collection).

According to De Vesme, the series comprises at least ten sheets, which Nagler wrongly attributed to Giambattista, only mentioning eight etchings. In the first sheet, bottom left, De Vesme read the inscription *Gio: Batta Tiepolo Inv. e Scul.*, and lower down *Vicenza, Cristoforo Dall'Acqua*; he also noted that some sheets had, in the margin, an Italian verse. According to him, the series is a fake, since these etchings not only were not executed by Giambattista Tiepolo or his sons, but were apparently not even derived from any of their drawings. Sack also believed that Tiepolo's name was forged, and preferred to attribute the etchings to Guardi, or, even better, to Cristoforo Dall'Acqua, who would have exploited Tiepolo's name.

The present Author's research ha[s] put together eleven sheets, one o[f] them in three states and others i[n] two. The inscriptions and the num[-]bering seem to indicate that the serie[s] comprised twenty sheets.

They are the work of an anonymou[s] etcher, operating under Marieschi['s] influence and in the manner of Gia[n]francesco Costa, with whom, how[-]ever, he should not be confused, a[s] recently happened (Colnaghi, *Etching[s] and Drawings by Giovanni Battista Ti[e]polo and other Italian Artists of th[e] Eighteenth Century*, London, 29 Apri[l-] 22 May 1970, 8 and 12). Also to b[e] excluded is any connection with Cr[i]stoforo Dall'Acqua, whose name doe[s] not appear in these etchings and wh[o] produced only ' six scenic views (i[n] folio), from original drawings b[y] Giuseppe Galli-Bibbiena' (Moschin[i] 1924, pp. 144–5).

Bibliog.: Nagler, 1847, 8; De Vesme, 190[6] p. 394, 13–22; Sack, 1910, 38.

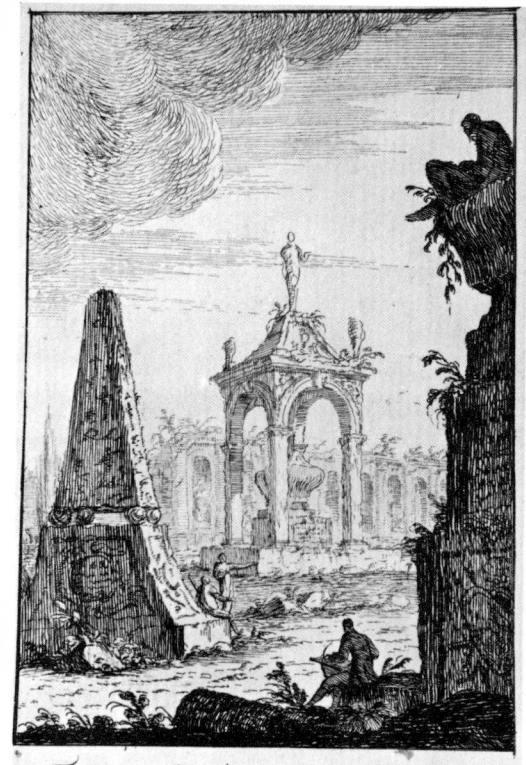

Fastose Iguglie e Mausolei vetusti.
n.⁴.N.

247

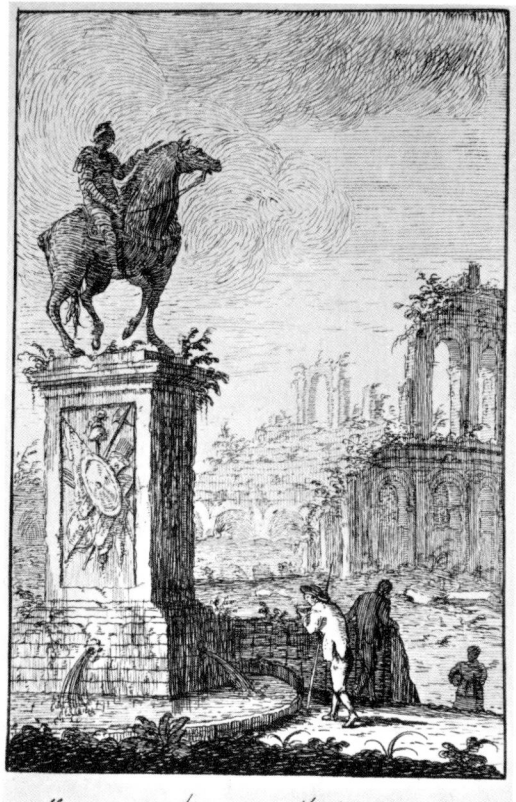

Monumento che ancor l'età rispetta.
n.⁵.N.

248

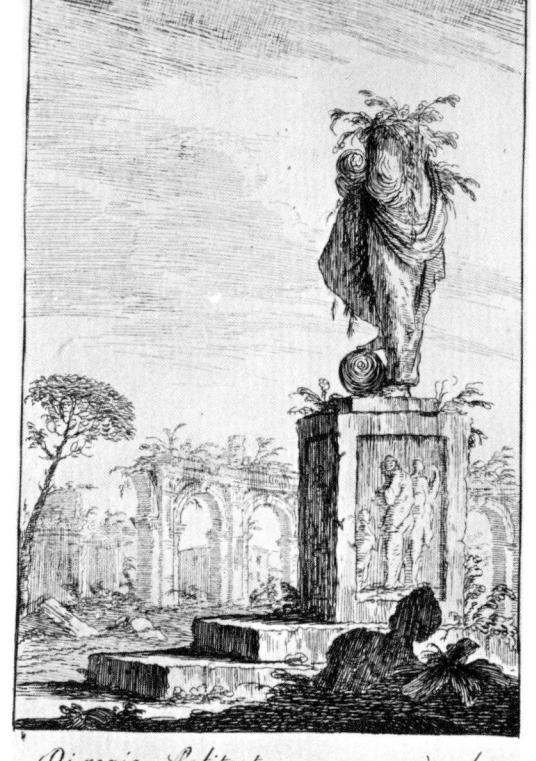

Di regio Anfiteatro appena un'ombra.
n.⁶.N.

249

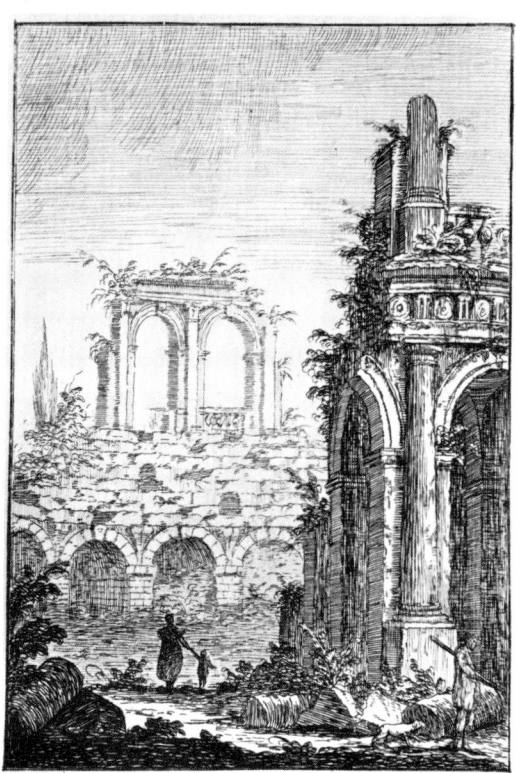

Di antiche Terme, nobili riliquie.
n.⁷.N.

250

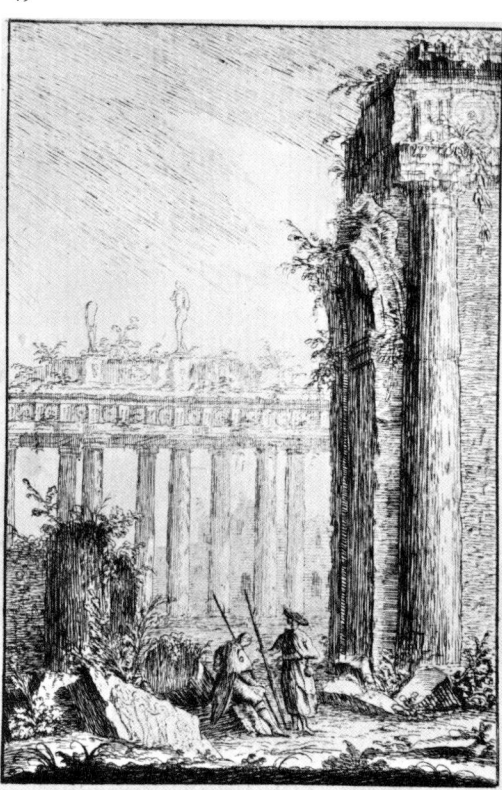

Loggie non più ma sol di loggie imago.
n.⁸.N.

251

443

252. Heads and masks

232 × 150 mm. Signed: *Tiepolo San.*, at bottom left; *Tiepolo*, at bottom right; *Algarotti*, at right centre; in the centre, to the right, Sack read, under the mask, the date *1744*

Sack attributed this etching to Giambattista, believing it to have been executed in cooperation with Algarotti; he also noticed the date 1744 which so far has not been found. His suggestion was rejected by Molmenti, De Vesme, Goering and Pittaluga, while Trentin, Hind and Pignatti prefer to attribute the sheet to Giandomenico.

Knox, who considers this sheet as ' one of the first specimens of Tiepolo's work in this medium ', points to analogies with Castiglione's works. At the 1970 Exhibition, the author observed that the handwriting of the inscription is late (almost typical of the nineteenth century), which throws doubts on the authenticity of the sheet (Algarotti died in 1764).

One should, however, add that since the inscriptions were executed in reverse, their style is not decisive. It is quite likely that Algarotti meant to write the word *Inv.* instead of *San.* to testify that the lower part of the sheet is derived from matrixes by Tiepolo. The engraving itself, however, is his work (not Giandomenico's or Giambattista's), as proved by comparison with the twenty-two etchings which he undoubtedly executed; this would then be his twenty-third.

Bibliog.: Sack, 1910, 38; Molmenti, 1911, p. 179; De Vesme, 1912, p. 316; Hind, 1921, 38; Goering, 1939, p. 152; Trentin, 1951, p. 19; Pittaluga, 1952, p. 128; Knox, 1960, p. 22; Pignatti, 1965, p. 8; Rizzi, 1970, 235.

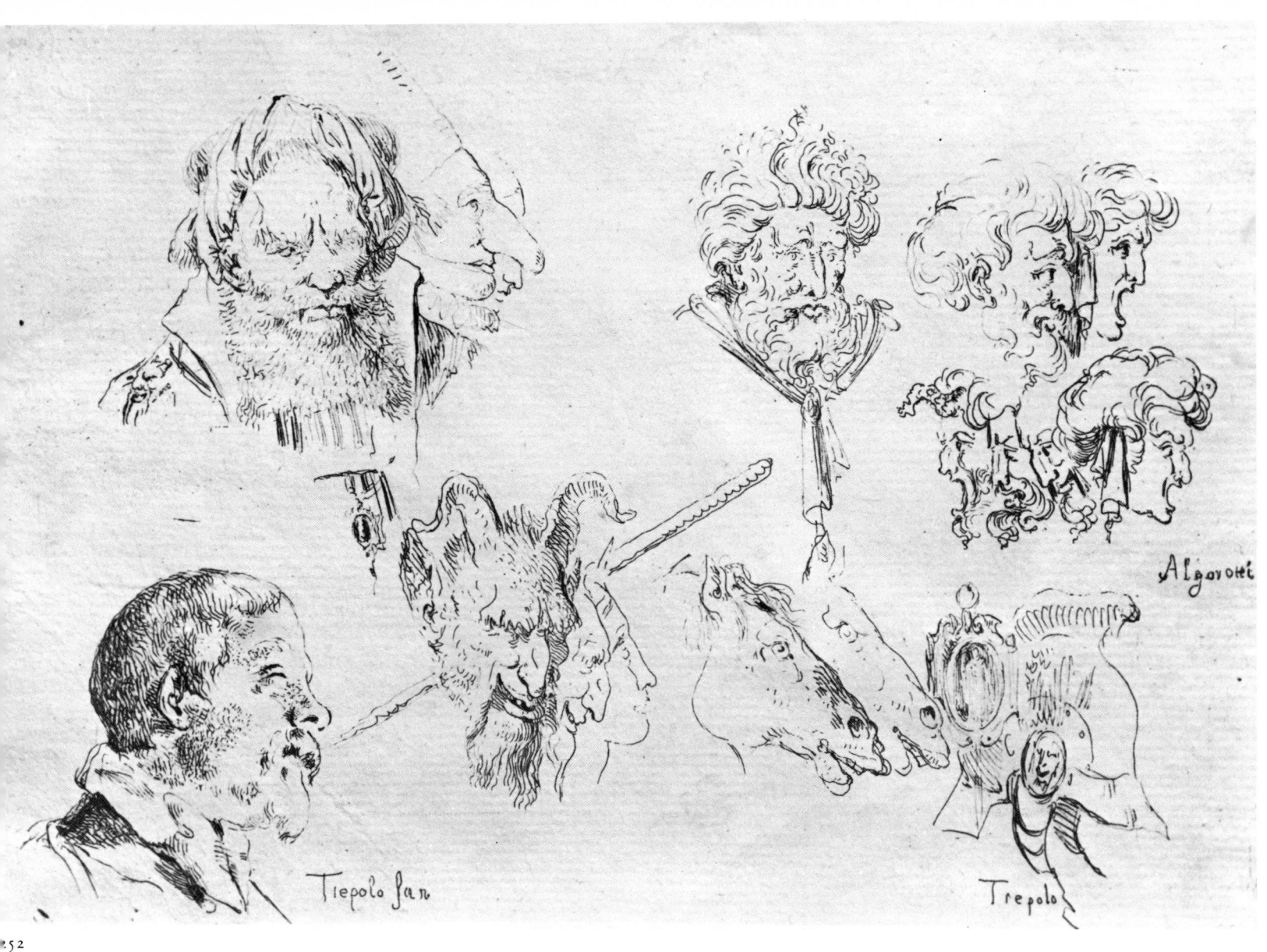

Tiepolo fan Algarotti

 Tiepolo

253. Individual Heads of a Passion

72 × 110 mm. (Formerly in the Kupferstich-sammlung, Dresden).

Mentioned by Nagler, this etching is included by De Vesme among those wrongly attributed to Giambattista because he could not trace it. Sack, who had seen the example formerly in Dresden, attributed it to Giandomenico, even though it was not signed, stating that it was derived from the third station of the *Stations of the Cross* in S. Polo. The sheet, which is not included in Giandomenico's catalogue, cannot be traced.

Bibliog.: Nagler, 1847, 8; De Vesme, 1905, p. 392, 2; Sack, 1910, 116.

254. Virgin and Child

71 × 60 mm. (Formerly in the Kupferstich-sammlung, Dresden).

Sack, who was the first to mention this etching, believed it to be a pendant to the small print by Giambattista depicting *St. Joseph and the Child* (see pl. 28) but attributed it to Giandomenico, who did not include it in his Catalogues. The etching is no longer in Dresden and must be regarded, like the previous one, as having been lost during the war.

Bibliog.: Sack, 1910, 117.

255-257. The Conception of the Virgin
St. Charles Borromeo
St. Francis supported by an angel

De Vesme mentioned that Cean Bermudez attributed to Giambattista, besides the series of the *Capricci* and the *Scherzi* and the *Adoration of the Kings*, also a *Conception*, a *St. Charles* and a *St. Pasquale*, derived from the paintings executed for the convent of Aranjuez, and a *St. Francis supported by an angel*. De Vesme, while identifying *St. Pasquale* with the saint reproduced in pl. 149, pointed out that there was no trace of the other prints; he thought this was due not so much to their rarity as to a mistake on the part of the Spanish biographer.

Bibliog.: Cean Bermudez, 1800, p. 46; Nagler, 1847, p. 100, 1, 6; De Vesme, 1906, p. 393, 7-10.

258. Jason and Medea holding a child by its head

The etching, without margin and in folio, is mentioned in the Winckler catalogue with the number 4714. De Vesme listed it among the sheets which were either doubtful or wrongly attributed to Tiepolo.

Bibliog.: De Vesme, 1906, p. 394, 12.

BIBLIOGRAPHY

Alpago Novello, L. *Gli incisori bellunesi*, Venice, 1940

Bassi, E. 'Problemi dell'incisione veneta del Settecento', *Emporium*, 1944

Byam Shaw, J. *Drawings and etchings by Giovanni Battista and Domenico Tiepolo*, Exhibition Catalogue, London, 1955

— *The drawings of Domenico Tiepolo*, London, 1962

Cailleux, P. *Tiepolo et Guardi*, Exhibition Catalogue, Paris, 1952

Calabi, A. *L'incisione italiana*, Milan, 1931.

— 'Nota su G. B. Tiepolo incisore', *Die graphische Künste*, 1939, p. 7

— *Incisioni del secolo XVII*, Milan, 1762

Canal, V. da. *Vita di Gregorio Lazzarini* (1732), ed. by G. A. Moschini, Venice, 1809

Catalogue de la Collection du Prince Alexis Orloff, Paris, 1920

Cean Bermudez, J. A., *Diccionario histórico . . .*, Madrid, 1800

Drawings by Giovanni Domenico Tiepolo, Christie's, London, 1965

Fenyö, I. *Disegni veneti del Museo di Budapest*, Exhibition Catalogue, Venice, 1965

Fiocco, G. *G. B. Tiepolo*, Florence, 1921

— 'Lorenzo Tiepolo', *Bollettino d'Arte*, 1925–6

— *La pittura veneziana del Seicento e Settecento*, Verona, 1929

Focillon, H. 'Les eaux-fortes de Tiepolo', *Revue de l'Art*, 1912, p. 411

Frerichs, L. C. J. 'De grootmoedigheid van Alexander', *Miscellanea J. Q. van Regteren Altena*, Amsterdam, 1969, p. 183

Garas, K., *La peinture vénitienne du XVIII siècle*, Budapest, 1968

Goering, M. 'G. B. Tiepolo', in Thieme-Becker, *Allgemeines Lexikon . . .*, Leipzig, 1939

— 'Die Stecher des 18. Jahrhunderts in Venedig', *Die graphische Künste*, 1941

Hadeln, D. von. *The drawings of G. B. Tiepolo*, Paris, 1927, 2 vols.

Haskell, F. *Patrons and painters*, London, 1963

Heincken, C.H. von. *Idée générale d'une collection complète d'estampes*, Leipzig and Vienna, 1771

Hind, A. M. 'The Etchings of Giovanni Battista Tiepolo', *The Print-collector's Quarterly*, 1921, p. 37

Knox, G. *Catalogue of the Tiepolo drawings in the Victoria and Albert Museum*, London, 1960

— 'A group of Tiepolo Drawings owned and engraved by Pietro Monaco', *Master Drawings*, 1965, No. 4

— 'Le acqueforti dei Tiepolo, scelte e annotate da Terisio Pignatti', *The Burlington Magazine*, 1966, p. 585

— *Tiepolo: a bicentenary exhibition 1770–1970*, Fogg Art Museum, Cambridge, Mass., 1970 (quoted in bibliographies as 1970/I)

— *Giambattista e Domenico Tiepolo: Raccolta di teste*, Udine, 1970 (quoted in bibliographies as 1970/II)

Knox, G., and Thiem, G. *Tiepolo*, catalogue of the Exhibition of Drawings, Stuttgart, 1970

Le Blanc, C. *Historie des peintres...*, Paris, 1868

Levey, M. *Painting in XVIIIe Cntury Venice*, London, 1959

Lorenzetti, G. *Un dilettante incisore veneziano del XVIII secolo*, Venice, 1917

— *Il quaderno dei disegni del Tiepolo al Museo Correr di Venezia*, Venice, 1964

— *Mostra del Tiepolo*, Catalogue, Venice, 1951

Mariette, P. J. *Abecedario*, Paris, 1858–9

Modern, H. *Giovanni Battista Tiepolo*, Vienna, 1902

Molmenti, P. *Acqueforti dei Tiepolo*, Venice, 1896

— *Giovanni Battista Tiepolo*, Milan, 1909

— *Tiepolo*, Paris, 1911

Morassi, A. 'Domenico Tiepolo', *Emporium*, June 1941

— *Tiepolo*, Bergamo, 1943

— *Tiepolo*, Bergamo, 1950

— *Tiepolo*, London, 1955

— *Dessins vénitiens . . . de la Collection du Duc de Talleyrand*, Milan, 1958

— *Disegni veneti del Settecento nella collezione Paul Wallraf*, Exhibition Catalogue, Venice, 1959

— 'La fuga in Egitto' di Domenico Tiepolo, Milan, 1960

— *A complete catalogue of the paintings of G. B. Tiepolo*, London, 1962

— Article on 'Tiepolo' in *Enciclopedia universale dell'arte*, Venice and Rome, 1965

Moschini, G. *Dell'incisione in Venezia* (1815), Venice, 1924

Mrozinska, M. *Disegni veneti in Polonia*, Exhibition Catalogue, Venice, 1958

Nagler, G. K., *Künstler Lexikon*, Munich, 1847

Pallucchini, A. *L'opera completa di Giambattista Tiepolo*, Milan, 1968

Pallucchini, R. 'Un gruppo di disegni inediti di Giambattista Tiepolo', *La critica d'arte*, 1937, p. 41

— *Gli incisori veneti del Settecento*, Exhibition Catalogue, Venice, 1941

— 'Nota per Giambattista Tiepolo', *Emporium*, 1944, p. 3

— *Gli affreschi di G. B. e G. D. Tiepolo alla Villa Valmarana*, Bergamo, 1945

— *La pittura veneziana del Settecento*, Venice and Rome, 1960

— 'A proposito della Mostra bergamasca del Marieschi', *Arte veneta*, 1966

Passamani, B. *Marco Ricci e gli incisori bellunesi del '700 e '800*, Exhibition Catalogue, Belluno, 1968

— *Acqueforti, disegni, lettere di G. B. Tiepolo al Museo Civico di Bassano*, Exhibition Catalogue, 1970

Petrucci, A. 'Il volto segreto dell'incisione italiana del Settecento', *Bollettino d'arte*, 1937–8, p. 540

— *Giandomenico Tiepolo: La fuga in Egitto*, Novara, 1947

Pignatti, T. 'Disegni e incisioni', *Mostra del Tiepolo*, Catalogue, Venice, 1951

— *Venezianische Veduten des 18. Jahrhunderts*, Nuremberg, 1964

— *Le acqueforti dei Tiepolo*, Florence, 1965

— 'In margine alla Mostra delle acqueforti dei Tiepolo a Udine', *Arte Veneta*, 1970

Pilo, G. M. *Marco Ricci*, Exhibition Catalogue, Bassano, 1963, p. 175

— 'Giambattista Tiepolo e le sue 'addizioni' alle acqueforti riccesche di Giuliano Giampiccoli', *Itinerare*, June 1970, Pordenone, p. 9.

Pittaluga, M. 'Sulle acqueforti di G. B. Tiepolo', *L'Arte*, 1939, p. 69

— *Acquafortisti veneziani del Settecento*, Florence, 1952

Precerutti Garberi, M. 'Il terzo dei Tiepolo: Lorenzo', *Pantheon*, January–February, 1967

Ragghianti, C.L. *Tiepolo: 150 disegni dei Musei di Trieste*, Florence, 1953

Ragghianti Collobi, L. 'Disegni del Tiepolo nel Museo Horne', *Critica d'arte*, 1968

Reade, B. 'Identified drawings by G. B. Tiepolo', *The Burlington Magazine*, 1939, p. 194

Reynolds, A.G. Identified drawings by G.B. Tiepolo, in *The Burlington Magazine*, 1940, p. 44

Reynolds, A. G., and Knox, G. *Tiepolo drawings from the Victoria and Albert Museum of London*, Exhibition Catalogue, Washington, 1961

Rizzi, A. *Disegni del Tiepolo*, Exhibition Catalogue (with introduction by A. Morassi), Udine, 1965

— *Mostra della pittura veneta del Settecento in Friuli*, Catalogue, Udine, 1966

— *La galleria d'arte antica dei Musei Civici di Udine*, Udine, 1969

— *I disegni antichi del Museo di Udine*, Udine, 1970

— *Le acqueforti dei Tiepolo*, Exhibition Catalogue, Udine, 1970

Sack, E. *Giambattista und Domenico Tiepolo*, Hamburg, 1910

Salmina, L. *Disegni veneti del Museo di Leningrado*, Exhibition Catalogue, Venice, 1964

Santifaller, M. 'Die Radierungen G. B. Tiepolos', *Pantheon*, 1941, p. 68

Seilern, A. *Italian paintings and drawings*, London, 1959

Trentin, G. 'G. Battista, G. Domenico e Lorenzo Tiepolo incisori', in *Arti*, 1951

— *Appunti su alcuni aspetti dei problemi tiepoleschi*, Venice, 1952

Vesme, A. de. *Le peintre-graveur italien*, Milan, 1906

— 'Paralipomeni tiepoleschi', *Scritti vari di erudizione e di critica*, Turin, 1912

Vigni, G. *Disegni del Tiepolo*, Padua, 1942

— 'Note su Giambattista e Giandomenico Tiepolo', *Emporium*, 1943, p. 14

— 'La Mostra udinese dei disegni del Tiepolo', *Arte Veneta*, 1965

Vitali, L. 'Nuove stampe di Giambattista Tiepolo', *Bollettino d'arte*, 1927, p. 60

D(e) W(itt), A. 'Disegni e stampe del Tiepolo', *Letteratura e arte contemporanea*, 1951

Zerner, H. *Venice in the Eighteenth Century, Prints and Drawings*, Exhibition Catalogue, Providence, Rhode Island, 1967

The following concordance lists the catalogue numbers from De Vesme's *Le peintre-graveur italien* (Milan, 1906), which until now has been the basic reference work for the etchings of the Tiepolos, with their corresponding numbers in this volume.

GIAMBATTISTA TIEPOLO

De Vesme Pages 381/392	Rizzi Plates
1	27
2	28
3	29
4	30
5	31
6	32
7	33
8	34
9	35
10	36
11	37
12	38
13	4
14	5
15	6
16	7
17	8
18	9
19	10
20	11
21	12
22	13
23	14
24	15
25	16
26	17
27	18
28	19
29	20
30	21
31	22
32	23
33	24
34	25
35	26

GIANDOMENICO TIEPOLO

De Vesme Pages 397/438	Rizzi Plates
1	67
2	68
3	69
4	70
5	71
6	72
7	73
8	74
9	75
10	76
11	77
12	78
13	79
14	80
15	81
16	82
17	83
18	84
19	85
20	86
21	87
22	88
23	89
24	90
25	91
26	92
27	93
28	65
29	66
30	57
31	108
32	109
33	110
34	39
35	40
36	41
37	42
38	43
39	44
40	45
41	46
42	47
43	48
44	49
45	50
46	51
47	52
48	53
49	54
50	115
51	116
52	117
53	118
54	125
55	126
56	127
57	98
58	130
59	149
60	121
61	56
62	131
63	132
64	60
65	55
66	62
67	61
68	63
69	106
70	97
71	59
72	114
73	133
74	105
75	99
76	100
77	101
78	122
79	119
80	120
81	123
82	58
83	134
84	135
85	136
86	137
87	138
88	103
89	104
90	139
91	140
92	141
93	142
94	146
95	143
96	144
97	107
98	158
99	124
100	148
101	147
102	111
103	64
104	113
105	150
106	151
107	152
108	153
109	154
110	128
111	129
112	155
113	156
114	157
115	159
116	160
117	161
118	162
119	163
120	164
121	165
122	166
123	167
124	168
125	169
126	170
127	171
128	172
129	173
130	174
131	175
132	176
133	177
134	178
135	179
136	180
137	181
138	182
139	183
140	184
141	185
142	186
143	187
144	188
145	189
146	190
147	191
148	192
149	193
150	194
151	195
152	196
153	197
154	198
155	199
156	200
157	201
158	202
159	203
160	204
161	205
162	206
163	207
164	208
165	209
166	210
167	211
168	212
169	213
170	214
171	215
172	216
173	217
174	218
175	219
176	220
177	221

LORENZO TIEPOLO

De Vesme Pages 440/444	Rizzi Plates
1	222
2	223
3	224
4	225
5	226
6	227
7	228
8	229
9	230

INDEX OF NAMES